THE BODY EMBLAZONED

'impressively rich . . . a fascinating cultural history' David Harley, *Medical History*

'absorbing and ambitious . . . astute and learned' John Carey, *Sunday Times*

'monumental . . . a remarkable study of a period unlike any before or since'
 Peter Bradshaw, *London Review of Books*

'provocative . . . a *tour de force* that promises to shape the questions scholars will ask for years to come.' John G. Norman, *Medievalia et Humanistica*

'fascinating, learned, and intelligent It deserves to be read widely.'
 Mary Bly, *Early Modern Literary Studies*

'daring . . . shrewd, assured' Roy Porter, *The Times Higher Education Supplement*

'sharp, resourceful . . . exciting, thought-provoking' Michael Kerrigan, *The Scotsman*

'[I]n this dissection of the culture of science, neither the science nor the culture gets short-changed.' W. F. Bynum, *Nature*

'compelling' *Textual Practice*

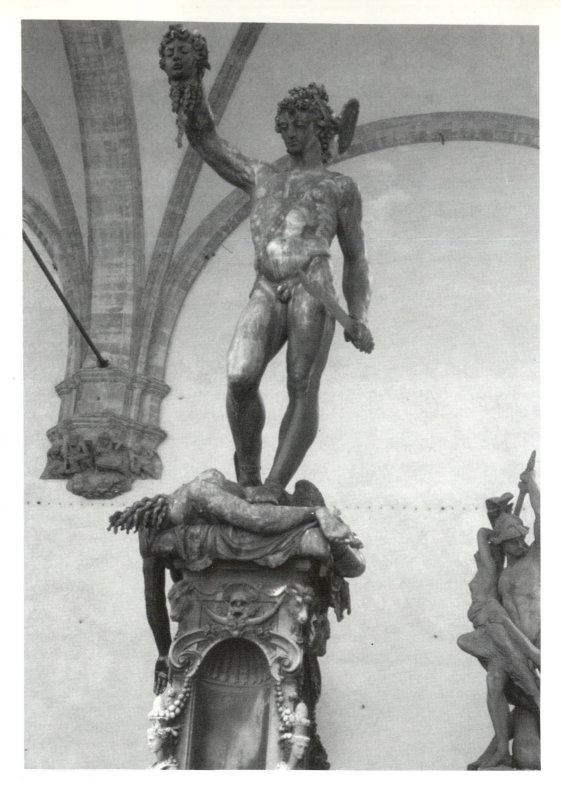

Frontispiece Benvenuto Cellini, *Perseus* (Piazza della signoria, Florence).

THE BODY EMBLAZONED

Dissection and the human body in Renaissance culture

Jonathan Sawday

London and New York

First published 1995
by Routledge
11 New Fetter Lane, London EC4P 4EE

Simultaneously published in the USA and Canada
by Routledge
29 West 35th Street, New York, NY 10001

Reprinted 1996

First published in paperback 1996

Typeset in Baskerville by
Ponting–Green Publishing Services, Chesham, Bucks
Printed and bound in Great Britain by
T. J. Press (Padstow) Ltd.

British Library Cataloguing in Publication Data
A catalogue record for this book is available from
the British Library

Library of Congress Cataloguing in Publication Data
A catalogue record for this book is available from the Library
of Congress

ISBN 0–415–04444–8 (hbk)
ISBN 0–415–15719–6 (pbk)

CONTENTS

FIGURES

PREFACE AND ACKNOWLEDGEMENTS

This book traces what I have come to call the 'culture of dissection' in the early-modern period. This period, in Europe, has long been known as the Renaissance – a 'rebirth' of arts, sciences, and letters following the so-called 'long millennium' of the medieval period. Few cultural historians would now be happy with such grand periodic gestures, and fewer still would accept at face value the claims of European humanism to have 'restored' classical culture from the grip of scholasticism. Nevertheless, our idea of the Renaissance is still (and for perfectly understandable reasons) informed by the great literary, scientific, artistic, and architectural achievements of that age. Those achievements seem to span the European continent, and the two hundred years of cultural history which is this book's subject. However, in this account, the 'monuments' of the European Renaissance – the works of Michelangelo, say, Leonardo da Vinci, or Shakespeare – where they are glimpsed, will appear in what may seem at first an unfamiliar light. For those great memorials to Renaissance thought and art are here viewed through the refracting prism of what, now, is termed 'science', in particular the science of human anatomy.

Why anatomy? The juxtaposition, for example, of Spenser's epic poem *The Faerie Queene*, a Cellini statue, or the paintings of Rembrandt, with an anatomical textbook may, at first, seem gratuitous, if not entirely tasteless. But the reasons for such juxtapositions will, I hope, become apparent in what follows. For it is not just that the period between the end of the fifteenth century and the end of the seventeenth century sees the birth of a 'new science' of the human body which places the human anatomy at the centre of this study. Rather, as I shall argue throughout this book, the early-modern period sees the emergence of a new image of the human interior, together with a new means of studying that interior, which left its mark on all forms of cultural endeavour in the period. It is a central thesis of what follows that we cannot properly understand the familiar (or less familiar) cultural legacy of the Renaissance, without attending to the birth of a science which was to

transform entirely people's understanding not only of themselves and their sense of identity or 'selfhood', but of the relationship of their minds to their bodies, and even their feeling of location in human society and the natural world.

The 'culture of dissection' is, then, the culture of enquiry: an incisive recomposition of the human body, which entailed an equivalent refashioning of the means by which people made sense of the world around them in terms of their philosophy of understanding, their theology, their poetry, their plays, their rituals of justice, their art, and their buildings. By concentrating on the literature of the period, I hope to show how this 'culture of dissection' reached down, in England, to the imaginative arts – in particular lyric and epic poetry – which (now) are seen to be entirely divorced from the empiricism of science. That divorce, particularly in twentieth-century Britain, perhaps less so in the United States or continental Europe, is held to be so complete as to be almost natural. How did this seemingly natural taxonomy of knowledge, and hence creative work, come about? What will appear unfamiliar is the extent to which the divorce between art and science, or reason and the imagination, was a consistently *negotiated* settlement. For a while, indeed, it appeared that there was no divorce required, since the scientists, or natural philosophers, and the poets and artists of that period, saw their endeavours as complementary. In their individual spheres, poets, philosophers, scientists, architects, and artists had begun the task of making new sense of the interior world of the human frame. For a brief period, which came to a close at the end of the seventeenth century, a view of knowledge flourished which was, paradoxically, both recognizably modern, and yet nevertheless entirely different from the ways in which we now hold the disciplines of enquiry to be organized. How that difference ended – and how a truly modern view of the world emerged – is also part of the story this book sets out to tell.

This book also tells stories of terrible cruelty, which are tinged by a form of dark eroticism. It traces an uncomfortable union between the legalized rites of violence familiar to the inhabitants of early-modern metropolitan communities, and the disinterested pursuit of 'nature'. The human body may, in the Renaissance, have been 'emblazoned' or embellished through art and poetry. But to 'blazon' a body is also to hack it into pieces, in order to flourish fragments of men and women as trophies. How that 'emblazoned' body came to be created is also the subject of our enquiry.

The opening chapters of the book, therefore, introduce the broad scheme of Renaissance understanding of the human body and its relationship to the mind, or soul. In Chapters 3 and 4 we visit the anatomy theatres of early-modern Europe, the playhouses of organized violence, in order to begin to understand the rituals which came to surround the body, and the taboos

which had to be overcome if the body was to be the object of investigation. In Chapter 5, we see how the body came to be represented in poetry, art, and science, in the period. Chapter 6 is concerned with the fundamental reordering of knowledge under the pressure of the Cartesian analysis of corporeality, and the ways in which that analysis seemed to be foreshadowed and (later) developed in poetry and art. In Chapter 7 we see how the binary divide of male and female was understood in the Renaissance, and how women, in particular, became the subjects of an ever more stringent regime of male investigation. Finally, in Chapter 8 we trace the emergence of 'masculine science' and the fragmentation of knowledge with which we have grown familiar in the modern world.

My enormous debt to generations of scholarship will, I hope, be apparent in what follows. I should, however, like to record my gratitude to a number of individuals who have shared with me their knowledge, enthusiasm, and especially their time whilst I was working on this book. They include: Warren Chernaik, Sarah Wintle, David Trotter, Patricia Coughlan, Sr Una Nelly, Neil Rhodes, Joanne and Don Sears, Susan Wiseman, Francis Barker, Dana Brand, Douglas Chambers, Peter Ucko, Nick Graffy, and my present and former colleagues in the English Department at the University of Southampton, particularly Isobel Armstrong, Bella Millett, Robert Young, John Peacock, (the late) A. J. Smith, Peter Middleton, Ken Hirschkop, Paul Hamilton, Kate McLuskie, and Maria Lauret. I am particularly grateful to Claire Jowitt and Ruth Gilbert for all their helpful comments and observations. Colleagues in The London Renaissance Seminar have provided a huge intellectual stimulus, particularly Ken Parker and Margaret Healy. Tom Healy has been, as ever, a source of information and wit. The contribution of Karen Lipsedge, at a late stage of the book's development, was enormous, as was the fund of patience and tolerance shown by Sarah Cahill, and Tricia Dever and Talia Rodgers at Routledge.

I should also like to acknowledge the assistance of individuals and staff in the following institutions: The British Library, London; The Library of University College London; The University of London Library; The Library of the Wellcome Institute for the History of Medicine; I. G. Murray, archivist for the Worshipful Company of Barbers; D. T. Barriskill, Guildhall Library, London; Julie Allum, Assistant Librarian for the Royal College of Physicians; Leiden University Library; The Henry E. Huntington Library and Art Gallery; The Library of University College Cork; St Andrews University Library; The New York City Public Library; and the Hartley Library at the University of Southampton.

I am grateful to the Committee for Advanced Studies at the University of Southampton, the British Academy, and the Fulbright Commission for

grants and awards which helped towards the completion of this project. I am particularly grateful to the Huntington Library for electing me to a Fellowship during a crucial stage of the research.

For permission to reproduce illustrations I should like to thank: British Library (Figs 3, 7, 28, 30); Leiden University Library (Figs 5, 6, 7); Bodleian Library, Oxford (Fig. 8); Wellcome Institute Library, London (Figs 10, 11, 23, 24, 25, 26, 27); Mauritshuis – The Hague (Fig. 18); Historische Museum, Amsterdam (Fig. 19); Bridgeman Art Library (Fig. 20); Cambridge University Library (Fig. 22); Glasgow University Library (Figs 31, 32); and Ancient Art and Architecture Collection (Frontispiece).

My final debt is the most difficult to acknowledge. Sue Blackwood not only provided strength and support during the period of this book's composition, but she showed me how it could be written. Needless to say, the faults which remain are for others to discover and myself to acknowledge.

Jonathan Sawday
Southampton, April 1994

PREFACE TO THE PAPERBACK EDITION

For the paperback edition of *The Body Emblazoned* I have silently corrected a small number of minor errors which found their way into the hardback edition. Tempting as it is to revisit the arguments presented here in the light of a number of responses from the book's readers, nothing else has been altered. Nevertheless, I owe my thanks to those individuals who, either in print, via e-mail, or in private correspondence, engaged with the ideas which are presented here.

One other opportunity is afforded me by appearance of this paperback edition, though it is one which I would have happily foregone: to acknowledge the many years of advice and encouragement I received from my father, D. H. Sawday, who died not long after the book was first published.

Jonathan Sawday
Southampton, May 1996

A NOTE ON SPELLING AND CITATION

In quoting from sixteenth- and seventeenth-century texts I have, wherever possible, used modern editions. Where these are not available, I have transcribed the text from the most reliable sixteenth- or seventeenth-century printed edition, retaining the old spelling, but silently altering i, j, v, and long s. Punctuation is retained as it appears in the early texts, unless confusion might arise. Proper names are given in their most recognizable modern English form (e.g. Vesalius rather than Wessels). Unless otherwise indicated, citations to the works of Shakespeare are to the New Arden edition, and to the works of Milton either to the Longman edition of Alistair Fowler (*Paradise Lost*) or the Longman edition of the *Shorter Poems* edited by John Carey. The following abbreviations are used for journal titles:

BHM *Bulletin of the History of Medicine*
BIHM *Bulletin of the Institute of the History of Medicine*
ELH *English Literary History*
ELR *English Literary Renaissance*
HLQ *Huntington Library Quarterly*
JEGP *Journal of English and Germanic Philology*
JHI *Journal of the History of Ideas*
JHM *Journal of the History of Medicine*
MH *Medical History*
MLN *Modern Language Notes*
MLR *Modern Languages Review*
MP *Modern Philology*
NQ *Notes and Queries*
PMLA *Publications of the Modern Languages Association*
PQ *Philological Quarterly*
RQ *Renaissance Quarterly*
RES *Review of English Studies*
SP *Studies in Philology*

1

THE AUTOPTIC VISION

INTRODUCTION: SOMATIC SCANDALS

Dissection might be thought of as a self-explanatory term, though that is not entirely the case. In its medical sense, a dissection suggests the methodical division of an animal body for the purposes of 'critical examination' (OED) – a neutral investigation of the morphology or structure of the object of study. But the metaphoric sense of the term leads us to an historical field rich in cognate meanings. Thus, a dissection might denote not the delicate separation of constituent structures, but a more violent 'reduction' into parts: a brutal dismemberment of people, things, or ideas. This violent act of partition tends to be associated with the related term (speaking conceptually) of 'anatomization'. In the literary sphere, dissection and anatomization have come to be associated with satire, and hence with a violent and often destructive impulse, no matter how artfully concealed. A literary/satirical dissection, then, may be undertaken in order to render powerless the structures within which the dissector's knife is probing. Anatomy, too, is an act of partition or reduction and, like dissection, anatomy is associated primarily with medicine. But, just as in the case of dissection, there lurks in the word a constant potential for violence.

Where did these cognate terms originate, and how did the modern, ostensibly neutral, scientific sense of 'dissection' or 'anatomization' come to be the predominant meaning of the word? In the early-modern period, and throughout Europe, a violent, darker side of dissection and anatomization was a constant factor in metropolitan culture. A 'science' of the body had not yet emerged. Instead what was to *become* science – a seemingly discrete way of ordering the observation of the natural world – was, at this stage, no more than one method amongst many by which human knowledge was organized. The darker sense of dissection, however, can be traced through a vast field of human knowledge in the sixteenth and seventeenth centuries. To this extent, in this enquiry, we shall virtually have to reconstruct the

1

cultural 'map' of knowledge within which men and women once worked. But scientific culture, especially in its infancy, cannot be separated from other cultural forms. In particular, in exploring the history of the body, we will have to trace the fear (or desire) which the prospect of anatomical knowledge of the body's interior seems to have excited.

Paradoxically, the very violence of dissective culture was a factor in the production of some of the more familiar structures of great beauty and vitality which we associate with the term 'Renaissance': epic and lyric poetry, drama, art, and, above all, architecture. But underpinning these aesthetic creations is the darker side of a dissective culture. Thus, in the sixteenth century, for example, we find the puritan propagandist John Foxe speaking of the Roman mass being 'anatomized with the abominations thereof'.[1] In deploying this precise, technical term, Foxe was not only hewing into pieces a rite which he despised, and thus reducing it (he hoped) to a powerless jumble of fragments, he was also constituting a form of words and a ritual as an organic body. Once this process of 'embodiment' was complete, then, rather than tilting at something as insubstantial as a rite, Foxe had created an adversary. The threat or the reality of violence runs through all Renaissance anatomizations, dissections, partitions, and divisions, whether we encounter the term in a medical sense or in a looser metaphorical set of registers. This is not surprising since dissection is an insistence on the partition of something (or someone) which (or who) hitherto possessed their own unique organic integrity. But dissection or anatomization is, as Foxe shows us, an act whereby something can also be constructed, or given a concrete presence. In medicine, anatomization takes place so that, in lieu of a formerly complete 'body', a new 'body' of knowledge and understanding can be created. As the physical body is fragmented, so the body of understanding is held to be shaped and formed. In medicine, too, anatomization takes place in order that the integrity and health of other bodies can be preserved. The anatomist, then, is the person who has reduced one body in order to understand its morphology, and thus to preserve morphology at a later date, in other bodies, elsewhere.

To deploy a phrase such as the 'culture of dissection' is to suggest a network of practices, social structures, and rituals surrounding this production of fragmented bodies, which sits uneasily alongside our image (derived from Burckhardt) of the European Renaissance as the age of the construction of individuality – a unified sense of selfhood. But, the 'scientific revolution' of the European Renaissance encouraged the seemingly endless partitioning of the world and all that it contained.[2] Robert Burton's *The Anatomy of Melancholy* (first published in 1621), with its vast superstructure of divisionary procedures (a text divided into parts, then subdivided into sections, members, and subsections), is a late but nevertheless paradigmatic

textual example of this delight in particularization. Once the process had been embarked upon it was, strictly speaking, endless. Who would call a halt to the ever more intricate investigation of nature? Burton's *Anatomy*, indeed, as it grew and grew throughout the seventeenth century, represented the panoptic, telescopic, proto-scientific imagination at work.[3] Far from being an intellectual aberration, as Burton has often been (mis)understood, the *Anatomy* is absolutely of its age. But partition stretched into all forms of social and intellectual life: logic, rhetoric, painting, architecture, philosophy, medicine, as well as poetry, politics, the family, and the state were all potential subjects for division. The pattern of all these different forms of division was derived from the human body. It is for this reason that the body must lie at the very centre of our enquiry. And it is in this urge to particularize that 'Renaissance culture' can be termed the 'culture of dissection'.

The emblem of this culture was the reductive deity of division *Anatomia*, whose attributes were the mirror and the knife. Those attributes were derived from the story of Perseus, the mythical hunter of the Medusa. In this book, the image of the Medusa – or rather her petrifying glare – is a constant theme. The Medusa stands for fear of interiority; more often than not, a specifically male fear of the female interior. But, as I hope will become evident, once the body has been partitioned and its interior dimensions laid open to scrutiny, the very categories 'male' and 'female' become fluid, even interchangeable. The attempt at conquering the Medusa's realm with the devices of *Anatomia* involved a confrontation between an abstract idea of knowledge, and the material reality of a corpse. And such a confrontation encountered one of the oldest taboos known within human culture. It meant violating that special domain which belongs to the dead. We still acknowledge this taboo, even when we claim to be subordinating such seemingly archaic, mythic, beliefs to the demands of science. But we are not always clear about its continuing existence.

The question of the status of the dead human body is a fraught one. It is particularly fraught since, throughout the world, many indigenous peoples have ceased to tolerate the western habit of 'acquiring' human remains for scientific (and sometimes non-scientific) investigation. This habit of 'acquisition' began in the period covered by this book, though it was not so much, in the initial stages at any rate, a case of western scientific culture appropriating the human remains of non-western cultures. Rather, some Europeans looked to the marginal members of their own societies – the criminal, the poor, the insane, suicides, orphans, even, simply, 'strangers' – as potential 'material' upon which they could legitimately practise their own researches and investigations into the human form. With the process of colonization in the 'New World' a new source of human bodies became available, though it

never entirely superseded the traditional sources (as Ruth Richardson has shown in her book dealing with the eighteenth and nineteenth centuries) which supplied the European anatomy theatres.[4]

All this might seem to be of only marginal interest to this study. Indeed, given that we, in the west, are all beneficiaries of the 'anatomical Renaissance' of the sixteenth and seventeenth centuries, it might be considered more tactful simply to keep quiet about the whole matter. However, the foundations of a western 'science' of the body were laid in the period which is our concern, and many of the academic institutions which fostered the study of the body may be thought of, themselves, as being 'Renaissance' foundations. Take, for example, the Royal College of Surgeons in London. The Royal College of Surgeons is derived from the unified Barber-Surgeons Company. This company had been founded in 1540 and, together with the College of Physicians, had operated as one of the regulating bodies for health care in early-modern London. The College's collections of human material originated with the Hunterian Collection formed in the mid-eighteenth century by John Hunter. These collections, then, form part of that taxonomic process of categorization and classification which began in the sixteenth century, but only reached its full extent in the years after the founding of the Royal Society in 1660. As Cressida Fforde has written, amongst the collections of the College can be found the enormous skeleton of 'The Irish Giant', Charles Byrne, who died in June 1783, in terror lest his body would be turned over to the anatomists. In order to thwart their desires, he requested that he be buried at sea. The request was in vain. The undertakers were bribed by the surgeons, and the body turned over to the anatomists: 'Byrne's skeleton today still forms the centrepiece of the Hunterian Museum in the Royal College of the Surgeons of England.'[5]

What unites this sad story of a frightened Irishman and a Renaissance foundation is this: the 'culture of dissection' was devoted to the gathering of information and the dissemination of knowledge of the 'mystery' of the human body. As such, its ends were proclaimed as being both 'useful' and 'noble'. But the 'culture of dissection' also promoted the beginnings of what Michel Foucault has analysed as the 'surveillance' of the body within regimes of judgement and punishment. The 'heroic age' of scientific discovery, initiated in Europe in the sixteenth century, was not a neutral or disinterested arena. It was a voracious consumer of the vestiges of the human frame. Within the ornate achitecture of the Renaissance and Baroque anatomy theatres, the body was produced (in a theatrical sense) as the flimsy vehicle for a complex ideological structure which stretched into every area of artistic and scientific endeavour in the early-modern period. The positive role of this new structure of knowledge was, undoubtedly, the establishment of a regime which was to spread incalculable benefit throughout the

population of early-modern Europe (though not, it has to be said, in equal proportions). The story of its heroic triumph has been told often enough. But in telling that story we should not neglect the darker side – which features a frightened dying man, a will whose provisions were ignored, and a surgeon bribing an undertaker.

Of course, such cavalier treatment of a dying man's wishes would no longer be tolerated. Or would it? In 1994 a scandalous story began to circulate in the Danish press.[6] At the University of Copenhagen, it seems, the practice of exhibiting corpses in the University's prestigious laboratories of forensic medicine to interested (and paying) members of the public had been flourishing since the early 1980s. Sensation-seekers (each paying fifty kroner) had been ushered into the laboratories to look at, and touch, the dead. Films and slides had been shown. Coffee had been served. The revelation of this (illicit) practice caused the University authorities deep embarrassment, and a police investigation was ordered. But was such voyeuristic manipulation of dead human bodies simply an aberration, a perverse footnote to the work of 'science'? Or was it the presence of a taboo that made it possible to demand an entrance fee (the price of a cinema ticket) for a very special kind of display?

In what follows, we shall be tracing other examples of such activity, but tracing them within a cultural and historical matrix. Within that matrix, it will soon become apparent that the Copenhagen 'scandal' (which is how we *now* understand such exhibitions) is by no means unusual. In fact, the very roots of a modern, scientific, western, understanding of the body, stretching back into the European Renaissance, united imaginative desire and voyeurism, together with complex patterns of religious belief, to produce, eventually, the ideal of a 'disinterested' field of investigation. It was only with the triumph of 'science', in its modern sense, during the later seventeenth century, that certain ways of understanding and looking at the body began to be categorized as perverse examples of morbid eroticism. Prior to that moment, events such as those which are alleged to have taken place in Copenhagen, would have been seen as a perfectly legitimate means both of funding the scientists' endeavours, and satisfying public curiosity. Indeed, science once actively encouraged such public displays of the dead. But the difficulty has been (and remains) how to understand such manifestations of what, now, is consigned to a different field of understanding, which borders on the criminal. In essence, we have lacked a history of the creation of the body as a cultural field of enquiry in the European Renaissance. Accordingly, in what follows, we have to move, often rapidly, between such disparate evidence as poetic texts, anatomical works, the historical record of the rituals of investigation, visual representation of the body, and philosophical accounts of the formation of modern frameworks for understanding not only

the body, but knowledge and (even) the very sense of selfhood. At the same time we have to move backwards in time, starting with our own sense of interiority, but tracing that sense back to its foundation, in the anatomy theatres, the courts (both legal and monarchical), the paintings and sculptures, the poetry, and the religious meditations of the sixteenth and seventeenth centuries. But looming over all these different cultural spaces and artifacts is a long shadow, which it is the task of this account, if not to dispel, then at least to explain. That shadow is cast by our own fascination with the structure and function of our own bodies – the fragile carapace in which we live our lives.

THE MEDUSA'S HEAD

AUTOPSY 1. Seeing with one's own eyes, eye-witnessing; personal observation or inspection. 2. Inspection of a dead body, so as to ascertain by actual inspection its internal structure, and *esp.* to find out the cause or seat of disease; post-mortem examination.

(Oxford English Dictionary)

When did the interior of the modern body make its appearance? The question asks us to focus on the nature of the conceptual tools with which we have come to understand our own bodies. Those tools are historically specific. To think of the body as a 'design', for example, is a peculiarly western, late twentieth-century form of response to the body's interiority, which is conditioned by a variety of technological and psychological factors: the role of modern medicine, the individual's disease history, the importance of computer technology, even the experience of 'planned' systems in our everyday lives.[7] Of course, the body has no 'design', but, looking into the interior, it is hard to shake off the impression that the body's internal organization is the product of careful thought, and even economical arrangement. Witnessing a modern post-mortem, Michael Dibdin has written:

The Argument from Design has long been discredited, but its seductive attractions are evident when you look inside the human body. Everything seems so lovingly packaged and arranged, like a cabin trunk stowed against breakage with just those items necessary for the voyage.[8]

When we apply our habitual modes of thinking to the prospect of our body-interiors, certain elements soon begin to appear as 'natural'. Is there anything, we might think, that is less fashioned or fabricated than the disposition of our internal organs? Yet, our understanding of those organs takes place within a larger mental framework which may be a product of culture just as much as it is a function of biology. Is even corporeality itself a constant? Whilst we might agree with the statement that 'the architecture

6

of both men's and women's bodies is largely hammered into place by genetics', nevertheless the body seems to possess its own specific forms of history which are ordered by a network of social and religious codes.[9] Caroline Walker Bynum has argued that medieval records of what we might call 'body-behaviour' at least beg the question of whether or not the body is the product of a cultural history. For the record of the body in pre-modern societies is one which is composed out of disturbingly unscientific phenomena: 'stigmata, incorruptibility of the cadaver in death, mystical lactations and pregnancies, catatonic trances, ecstatic nosebleeds, miraculous inedia, eating and drinking pus, visions of bleeding hosts.'[10]

What are we to make of such a divergent sense of corporeality? Is the body a carefully stowed cabin trunk, or is it, as here, a mysteriously chaotic entity? Is this divergence just a question of people's observing the body's internal processes within different cultural frameworks? Or did bodies, in some obscure fashion, behave differently prior to the advent of a scientific view of the world?

Whatever process is at work, the sense of interiority is inescapably central to the experience of the body within history. Yet, a feature of our sense of interiority is that it can never be experienced other than at second-hand. We may look into other bodies, but very rarely are we allowed to pry into our own. We may become familiar with the generalized topography of the body, via different media – photographs, X-rays, illustration, anatomical demonstration, written description, TV documentary – but all of these 'voyages within' (as the surgeon Richard Selzer has termed them) are journeys of exploration which encounter bodies other than our own. They are passages into THE body, but not MY body.

But is MY body any different from any other body? Below the skin, when we have allowed for differences of 'race' and gender, are not all bodies the same? The answer is no, not by any means. Not only do environment, diet, and the effects of illness and injury serve to distinguish one body from another, but when we have allowed for these circumstantial effects productive of general differentiation, we are still left with further marks of bodily individuality which may be perceived within the interior as much as upon the more accustomed exterior. F. Gonzalez-Crussi in his *Notes of an Anatomist* has recorded the reflections of Milton Helpern, the chief medical examiner of New York City who, in the course of performing countless autopsies, has remarked upon the fact that 'individuality stamps its mark on every part of the anatomy: no two hearts are entirely alike; the shapes of livers are never quite the same; branching vessels always ramify in a unique way.'[11] Our bodies, then, carry within themselves signs of their own individuality to an extent at least comparable with the visible signs of differentiation carried on our surfaces. The crucial difference is that these interior marks are largely

7

unknown – signatures of difference that we cannot hope to observe in ourselves, and rarely in others. Even those who are trained to explore the interiority of others are rarely called upon to categorize the signs of individuality – to name an individual, say, by the peculiar branching structure of this or that trachea. Hence, to know our own bodies, to know oneself (to evoke the familiar Renaissance motto 'Nosce te Ipsum') in the physiological and anatomical sense, is simply not possible. Richard Selzer writes:

> The sight of our internal organs is denied us. To how many men is it given to look upon their own spleens, their hearts, and live? The hidden geography of the body is a Medusa's head one glimpse of which will render blind the presumptious eye.[12]

But it is, perhaps, this very impossibility of gazing within our own bodies which makes the sight of the interior of other bodies so compelling. Denied direct experience of ourselves, we can only explore others in the hope (or the fear) that this other might also be us.

Given this impossible knowledge, that the interiors of our own bodies are endlessly deduced, but very rarely experienced directly, we are driven to understanding via representation and by trace. Those traces, often (though not always) encountered at moments of trauma or potential danger – the glimpse of a wound cavity, the fluids of the body and its expelled substances in sickness or in childbirth – are greeted with varying degrees of fascination and horror. When, in August 1917, Franz Kafka witnessed such a trace, his initial response appeared to be casually dismissive: 'in the swimming bath I spat out something red. That was strange and interesting wasn't it? I looked at it a little while and then forgot it.'[13] Blood – some *thing* strange and interesting – a prognostication of death, but one which, no matter how quickly dismissed or forgotten, holds the attention and, briefly, dare not even be named. The interior of the body is perceived by a trace which may also become a token, a harbinger of dissolution.

Selzer's image of the body hiding within itself a 'Medusa's head' is, of course, doubly significant within any account of the discovery of interiority. The familiar tale of the Medusa – one of the three gorgons who was slain by Perseus and whose head (even after decapitation) was able to petrify the onlooker – is immediately appropriate to any description of the potentially transgressive gaze of the subject who studies his or her own bodily interior. Perseus could not look directly at the face of his adversary and so stared into the reflection found in the polished shield given to him by the Medusa's sworn enemy, Athene. Selzer's image, then, conjures with a traditional fear of gazing directly at the body-object, for in its depths it may conceal the source of the individual's own dissolution. But other variants or elaborations of the myth indicate a different role for Medusa. Her severed head was said

to decorate the *aegis* of Athene, and thus offered a form of protection to those upon whom the *aegis* was bestowed by the goddess.[14] In some versions of the myth, the *aegis* itself was made from the Medusa's skin, flayed from her by Athene. Her blood was said to have been given to Aesculapius – mythical founder of surgery – drawn from veins in her left and right side: that from the left possessing the power to raise the dead, while that from the right could destroy whoever drank it.[15] What seems common in these circulations of myth is that the attributes of the Medusa – blood, head, and skin – are emblematic of a fragmented and dispersed body-interior – a profoundly ambivalent region – whose power can be somehow harnessed for good or ill.

The Medusa's head, as described by a twentieth-century surgeon, lurks within each individual. But in the image of the Medusa is the archetypal expression of body-fear, and one that appears to be linked to our ideas about gender rather than a common identity which transcends sexual difference. For Freud, the Medusa's head was symbolic of castration, expressive of the moment when: 'a boy, who has hitherto been unwilling to believe the threat of castration, catches sight of the female genitals, probably those of an adult, surrounded by hair, and essentially those of his mother.' [16]

In the myth of Perseus and Medusa the male protagonist confronts his female opponent and renders her powerless through a dispersal of her body parts. Or rather, her killing and healing power – her head and her blood – are appropriated by male archetypes: the wandering hero, and the surgeon or healer. Hélène Cixous, in her response to the Medusa myth, has argued for the necessity of winning back this dispersed female body – 'this uncanny stranger on display' – a project which, as soon as it is stated, suggests a further twist to the historical quest for the origin of modern interiority.[17] Recalling the moment when Kafka spat blood, for example, we might agree that for either men or women to spit blood is a sign of disturbance in the interior world – the calling card of the 'uncanny stranger'. But the cultural history of the body suggests that a body which *escapes* its boundary in this way – demanding attention by allowing its tokens of interiority to emerge on the surface – tends to be constructed, within widely different forms of representation, as female, whatever the biological sex of the subject in question.[18]

Of course, historical attitudes towards the male and the female interior are conditioned by preconceptions about gender. But, the possibility of representing the body-interior of both men and women as a feminized (and hence alien) region opens up a paradox for us when we come to consider the historical status of either male or female bodies within widely varying cultural discourses. Peter Stallybrass (following Bakhtin) has pointed out the ways in which, in the Renaissance, women were the subject of 'constant surveillance', since the female body seemed, in some way, 'naturally grot-

esque' – a body which potentially escaped any boundary or limit.[19] But if we consider the manner in which the body-interior of either women or men has been represented, then both appear to be subject to forms of surveillance. The female body, however, was the *locus* of a quite specifically gender-determined fear. Edward Shorter, in his *A History of Women's Bodies* writes:

> It is probable that male fear of demonic 'feminine' qualities had existed since the dawn of time. The high culture of Western civilization is drenched in this theme from the Greek tragedies on. Through popular culture as well rode a visceral male fear of women's magical powers.[20]

This male fear was not so much 'visceral' (as Shorter's own evidence illustrates) as it was, literally, a fear of the female viscera. The focus of this fear was the uterus, an organ held to possess its own will, 'a separate animal creature housed inside a woman'.[21] Thus, as we shall see, the uterus in pre-modern culture seemed to share a set of common attributes with disease. Like disease, the uterus operated according to its own laws, travelled at its own pace, hid itself from the searching gaze of natural scientists, and demonstrated its presence by a token: blood.

Menstrual blood has long been the focus of a network of taboos and phobias in western culture. Blood was (and still is) an emblem of life, particularly within a framework of christian symbolism. But blood is also a sign of sickness and injury. The menses, however, were emblematic of something more. The prohibitions surrounding menstruating women in a huge variety of European cultures over a vast chronological range have been well documented.[22] But one prohibition in particular alerts us to the peculiar nature of female interiority in western culture: the glance of a menstruating woman (Keith Thomas recounts, citing Aristotle) 'would tarnish a mirror'.[23] We have returned to the Medusa myth. No individual could endure the glance of the Medusa, and Perseus could approach her only with the aid of a polished shield – a mirror endowed with the magical power of Athene. Once the Medusa is slain, her glance conquered, then her blood is drawn off, her skin woven into a magical container, her head exhibited only to those to whom one wishes destruction. Her power, the interior and secret world of which she is the guardian and sole inhabitant, has been harnessed.

But what of our opening question? When did the modern body-interior first make its appearance? Historians of science tell us that human dissection 'began' about 300 BC, in the Nile delta, when Alexandria with its great medical school was founded. In the Royal Library of Brussels there exists a ninth-century figure of a foetus *in utero* said to be based on a second-century image.[24] But neither the Alexandrian 'origin' of human dissection, nor the survival of early illustrations helps us answer our question. All that we learn

from such images is that, at a certain moment, bodies were being opened in ways that seem to accord with our modern idea of what a 'science' of the body defines as 'inside' and 'outside'. The question is impossible to answer, not because we do not have the information, but because the very term 'body' is not universal. So, an anthropological response to our opening question might pause over the categories of 'outside' and 'inside', since these terms are not common to all cultures. A Melanesian, asked by Maurice Leenhardt what the west had contributed to the culture of the islands, did not reply by listing technological, scientific, or medical achievements, nor even (ironically) the disastrous disease history which was the product of western encounters with Pacific peoples (though that last category may have been implicit in what he said).[25] Instead his response undermined the very categories which framed the question: 'What you have brought us is the body.'[26] Just as in the Medusa myth, we soon learn that the question has to be recast. We cannot deal with 'the body' in any discussion of representation as though it existed in a realm divorced from other experience. What it is to be and have a body may rest on what your culture understands by the very term 'body'.

Let us rephrase the question. When did the western sense of interiority – that mark of individuality – emerge? Now the difficulty in answering is compounded by the presence of a taboo. In the west, the interior world can only be approached directly with great effort and considerable cost. Far easier (and more common) is to approach the body-core through a complex articulation of reflective glances – a structure of representation – of which the shield of Perseus is emblematic. Modern medicine, for all its seeming ability to map and then to conquer the formerly hidden terrain of the interior landscape, in fact renders it visible only through scenes of representation. The more graphic the representation, however, the more the subject whose body is the object of scrutiny is compelled to look. In this, the search for the experience of interiority begins to appear as perhaps uncomfortably close to contemporary theorizations of the consumption of pornography. 'The dissecting room', Cecil Helman writes, 'shows us the difference between erotic art and pornography, between human experience and the worship of parts.' That difference rests on a parallel reduction of wholeness into fractured partition, where the human form is displayed as 'slices of helpless meat, ripped out of context'.[27] The point is that, no matter to what level of reduction the body is pursued, its essential interior secrecy is preserved. Linda Williams, in her book *Hard Core* (whose subtitle – 'the frenzy of the visible' – could equally apply to the search for interior knowledge of the human form) follows Foucault and Gertrude Koch in arguing that film pornography is part of a 'drive for knowledge':

11

In contrast to both mainstream fictional narrative and soft-core indirection, hard core tries *not* to play peekaboo with either its male or female bodies. It obsessively seeks knowledge, through a voyeuristic record of confessional, involuntary paroxysm, of the 'thing' itself.[28]

Anatomy, too, desperately seeks to avoid playing 'peekaboo'. Yet, the 'thing' – the secret place, the core of bodily pleasure or knowledge of the body – always escapes representation. In similar fashion, the core of the body always escapes the view of the subject whose body is being explored.

Moreover, a set of taboos (far stronger than those which have surrounded 'indecent' or 'obscene' material) prohibits the contemplation of one's own body-core. Too active an interest in gazing into the interior of one's own cavities, even within the diagnostic context, may be held to be a morbid enterprise. Modern surgeons or physicians are careful to shield, wherever possible, any possible sight of our own interiors when we become 'patients'. Indeed, the very word 'patient' hints at the taboo connected with the body-interior. The word originally signified 'one who is able to endure pain and suffering with composure' (*OED*). The 'patient' is thus the individual who, though in pain, masks or conceals their interior discomfort, by allowing no visible sign of the interior disturbance to escape onto the exterior. To be a 'patient', then, is to hide a secret which is the awareness of the presence of the interior. No matter that we all 'possess' interiors, the stoic fortitude of the patient is an act of concealment. The body-interior, when it registers its presence, fractures the socially crafted exterior – the protective shell which we struggle to preserve.

The body-interior speaks directly of our own mortality. Hence, the sight of these hidden contours has traditionally been denied us since they are usually encountered only at the risk of enduring great pain and quite possibly death. The surgeon (even within the harshly empirical structures of western medicine) therefore enjoys a rare cultural status as mediator between the exterior and the interior worlds. The surgeon seems to share the iconic status of the artist (or the visionary) within our culture, since both are held to be in possession of a privileged gaze which is able to pass beyond common experience, through surface structures, to encounter a reserved core of reality.

In the world of the body as we experience it, those (rare) occasions when individuals are allowed to glimpse the Medusa's head of their own interiority are always structured by the mirror-effect of representation and transformation, which Hegel associated with the fabrication of the work of art.[29] But such knowledge can be profoundly disturbing. Richard Selzer has written of such a moment when a patient, being operated upon under spinal anaesthesia, catches a glimpse of the reflection of their own viscera in the polished

surface of the operating lamp. Selzer's response, as a surgeon, is immediate: 'I quickly bend above his opened body to shield it from his view.' In this act, the medical professional suddenly appears in a new guise: 'I am no longer a surgeon, but a hierophant.'[30]

Records of such moments, surrounded as they are by great distress, play a crucial part in our understanding of interiority – the sense of having or possessing an 'interior'. A recent account of a male experience of interiority is recorded in Robert Lawrence's record of his treatment subsequent to his being wounded in the British military campaign of 1982 in the Falkland Islands (Las Malvinas). What is interesting in this account is the way in which the possibility of the body's interior being 'feminized' within representation is made apparent. But the tendency towards 'feminization' is then compounded by a more disturbing possibility. Once the body has been represented and feminized, it is 'consumed' in a way which is directly comparable to the reproduction and consumption of sexualized images of the female by men. At the same time, the sudden encounter with interior images of the body marks a point of transition for the 'patient'. That transition is not only a liminal moment, where 'life' hovers on the edge of 'death', but where a whole set of core masculine values, enshrined in the codes of military prowess and tradition, are shown to be almost worthless. During the campaign, Lawrence, a young officer in the Scots Guards, was shot in the head by a high-velocity armour-piercing bullet. The bullet effectively destroyed some 45 per cent of Lawrence's brain, leaving a horrific wound. For teaching purposes, the army medical officer who had been in charge of the Field Ambulance unit during the campaign kept a photographic record of his unit's activities. These photographs included graphic images of Lawrence's wound as he lay on the operating table. They were described (by his father) as 'indescribably horrific, with blood and surgical instruments everywhere . . . the angles from which they had been taken were such that Robert's face was plainly recognizable.' Recognition is important, because this is not the interior of just any body that is to be viewed, but the record of the experience of viewing the interior of MY body. Lawrence is offered copies of the photographs, and seizes the opportunity, as his father recalls:

Robert thought they were marvellous. At last he could believe the miracle of his survival. We got another set printed and for several years he carried them in his wallet, producing them at every opportunity, almost enjoying the shock they brought to people, at least in the early days. After a while he became more circumspect and showed them to girls and women only if they absolutely insisted, as his mother had done with me. I have a feeling that in several cases insistence brought on a lack of resistance and he was able to take full advantage, in the nicest possible way, of course, of the sympathy thus engendered.[31]

Of course. But, with the exclusion of 'girls and women' from the circle of those who are allowed to see such images, and the implication that, like *risqué* postcards produced from the breast pocket, such material is for the consumption of men, the uncomfortable link between pornography and the sight of the interior of one's own body is reinforced. The 'genre' to which these photographs belong is that of the atrocity-photo, a product unique to modern warfare in the age of mechanical reproduction.[32] But, just as in the case of the *aegis* of Athene, which bore the head of the Medusa and was then copied by warriors for its protective power, so, here, a modern warrior returns and exhibits images of his interior, knowing the effect which will be produced. It is against just such a disturbing alliance that Lawrence's father, in this account, is struggling. Women who 'insist' (bold women? possible intimates?) are allowed a glance, but social propriety must eventually exclude the casual display of such images.

What are we to make of this confused record of the experience of interiority? Obviously, there is a sense of fascination – and equally a curiously narcissistic (but, under the circumstances, entirely comprehensible) exercise in self-reflexive *schadenfreude* – at work. But what of the status conferred upon the owner of such images of himself? That status is a function both of having survived, and of having gazed at the Medusa's head which is also his own head. The officer's belief in his own survival (if we are to trust the account) is only complete when his body has been reduplicated as 'foreign' – an object of the kind Hegel had proposed. But, like Perseus returning with his trophy, the young officer shows the gorgon's head (his own head) to those who insist, and the response is predictable: not petrification, perhaps, but its modern counterpart – shock, disgust, and fascination. Finally, there is the sexual frisson which this account is struggling to accommodate. That frisson is a function of the encounter with the body's interiority as a violation of a taboo – a violation similar to that felt by the surgeon who shielded the body of his patient from his or her own gaze. It is the presence of that taboo and its transgression by the survivor, rather than the sign of serious injury, which is manifested in the father's hint that his son has, perhaps, played too easily with the reactions that such images produce in others. The taboo, simply stated, amounts to an injunction: no one should be able to see such things of themselves and speak of them. Like Edgar Allen Poe's Monsieur Valdemar, who, frozen at the moment of death into a hypnotic trance, is heard to say 'I am dead', there are certain sentences which cannot be spoken. To say of the opened cranium 'This was (or is) me' is to produce exactly the response voiced by Robert Lawrence's girlfriend on being shown the images: 'She was so shocked she told him never to show them to her again.' The taboo which has been violated is, perhaps, one of the oldest known to human beings – that the interior recesses of the body are not

14

merely private to others, but peculiarly private – that is expressly forbidden – to the owner or inhabiter of the body. The encounter with the Medusa, then, a confrontation which is easily understood as an expression of male fear at the sight of the female genitalia, is significant, too, for what it tells us of any attempt at representing the secret world in the body-core.[33]

Matrices of discomfort, pain, death, and social prohibition separate us, in the twentieth century, from our bodily interiors. A paradox becomes apparent. Modern surgical techniques, the skilled technology of penetrative surgery allied to the apparatus of reproduction on film and photographic plate, have made it possible for us to gain unparalleled access to scenes of our own interiority. But in similar measure, the taboo still exists and we violate it at some risk of producing reactions akin to those displayed by Robert Lawrence's girlfriend. And, even if we risk the taboo, have we thereby discovered the precise mark of individuality which distinguishes MY body from all others? Roland Barthes, writing of the experience of gazing at images of himself, writes:

> 'But I never looked like that!' – How do you know? What is the 'you' you might or might not look like? Where do you find it – by which morphological or expressive calibration? Where is your authentic body? You are the only one who can never see yourself except as an image; . . . even and especially for your own body, you are condemned to the repertoire of its images.[34]

How much more extreme is the impossibility of knowing oneself other than through a 'repertoire' of images when we consider the interior as well as the exterior of ourselves.

Was it ever possible to gaze at the body's interior without encountering the boundaries of proscription? Or is it that the discovery of a densely packed interior – a complexly articulated internal volume of cavities, vessels, fluids, movement, process, and mechanism – is the moment when the interior becomes private? Which comes first – a sense of interiority and then privacy? Or are privacy and individuality, the discovery or enforcement of which is often associated with broad chronological categories of culture such as 'the modern' or 'early-modern', themselves a function of the discovery that we possess, or indeed are composed of, both an inside and an outside?

2

THE RENAISSANCE BODY
From colonization to invention

BODY AND SOUL AT WAR

In the twentieth century it is virtually impossible to think about the body outside a prevailing medical-scientific discourse. But it was not always so. What we consider to be primarily the focus of medical attention – the accounts of physicians, surgeons, anatomists, physiologists, biologists – has, in other epochs, been entertained under quite different categories of description. Those categories, bounded by theology and cosmology – the polarities of ritual – did not admit the possibility of thinking about the body as a discrete entity. In the west, prior to the 'new science' of the late sixteenth and seventeenth centuries, the body's interior could not be understood without recourse to an analysis of that which gave its materiality significance – the essence contained within the body. A belief in the presence of that essence, a belief, that is, in the existence of an *anima*, a soul or a thinking entity, necessarily informed any possible perspective of the body. To consider the body in isolation was not merely difficult but, strictly speaking, impossible, since the body's primary function, it was held, was to act as a vessel of containment for the more significant feature of the soul.

Soul and body were not, however, easy participants in a greater unity. Instead, they existed under the constraints of struggle. The body was perpetually at war with that which it found residing within itself. The body was (depending on your point of view) either the unwilling host to a nagging and parasitical arbiter of right and wrong, or it was the close prison which perpetually sought to constrain the expansionary desire of the soul. Each participant in this combat had the power to ruin its opponent. The body's gross physicality could ensure the endless enslavement of the soul to corporeal existence, defined, in the soul's terms, as punishment. Equally, however, the soul's desire to escape the terrestrial existence of the body involved the destruction of its temporary and temporal residence. We may trace this conflict to Plato's *Phaedo*, where the soul is described as striving to

16

achieve a disassociation from its bodily existence which will guarantee 'release from . . . all other human evils'. Those souls, on the other hand, which have cultivated too close an affinity with the body become 'tainted and impure'. Beguiled by the body, the impure soul is 'weighed down and dragged back into the visible world' so that at death, rather than fleeing towards God, it is 'imprisoned once more in a body'.[1]

Plato's depiction of a perpetual dualistic struggle between body and soul, transmitted via Neoplatonism, patristic authority, and medieval theology, is the dominant model for understanding the relationship between body and soul within western culture prior to the fifteenth century. To consider the body as an isolated phenomenon – as a discrete entity in Platonic terms – was simply not possible, since the body was only one half of a bifurcated whole. Such a bisection is still fundamental to our perception of what might constitute individuality within western societies. For Augustine and the patristic writers, the reality of a dualistic struggle was equally essential for their definition of the relationship between God and humanity. 'The corruptible Body', says Augustine, 'is a burden to the Soul.'[2] Only through shaking off this burdensome body could the soul achieve union with God. Though the form of this struggle could, on occasion, shift, the protagonists remained constant. The body seemed to turn towards a visible and material world, whilst the soul sought to encounter an invisible and immaterial mode of being. Such dualistic habits of thought were, it is true, challenged at certain moments, but challenges were short-lived and seemed invariably only to result in the reassertion of the struggle between interior and exterior.[3]

If anything, with the advent of the preliminary results of scientific investigation in the later sixteenth century, the interior war became even more fierce, since now fresh fuel was to be thrown onto the already blazing fire. Science gave an added impetus to the urge to peer into the recesses of the body. But Calvinistic theology, with its seemingly obsessive desire to chart the inner state of each individual's spiritual well-being, was to argue with a conviction equal to that of the scientist that the division between the realm of the body and the realm of the soul was now the concern of every thinking person. The internal human division, in other words, was now to be perceived as stretching into the sphere of all civil life.[4] The politics of the body – a politics which involve a form of self-reflexive violence – have begun to emerge.

What was at stake within this political sphere was mastery over the body, and control of its internal processes. The uncovering of the body's interior by natural philosophy, the growing awareness that the body-interior was composed of a dynamic system in perpetual motion, seems to have posed a very real threat to those who, prompted by the impulse of science, turned inwards. Donne's famous lines on anatomical doubt in the second of his Anniversary poems of 1612 ('Of the Progresse of the Soule') trace the

dimensions of this anatomical challenge. What Donne remarks upon in the poem is not merely ignorance of the body's operations (for all the discoveries of post-Vesalian science), but instead the unknowable quality of the body's own motions. It is the fluid processes (literally the movement of fluids) which offer the clearest challenge to human certainty:

> Knowst thou but how the stone doth enter in
> The bladers cave, and never breake the skinne?
> Know'st thou how blood, which to the heart doth flow,
> Doth from one ventricle to th'other goe?
> And for the putrid stuffe, which thou dost spit,
> Know'st thou how thy lungs have attracted it?
> There are no passages, so that there is
> (For ought thou know'st) piercing of substances.
> And of those many opinions which men raise
> Of Nailes and Haires, dost thou know which to praise?
> (Donne, *Poems*, 234–5)[5]

These verses demonstrate much more than simply pre-Harveian ignorance of blood circulation. Rather, Donne has opened the body only to discover that it seems to operate according to its own laws of hydraulic motion. The movement of gallstones, blood, and phlegm seems to challenge the laws of reason and the experience of observation. In a similar fashion the body's ability to excrete substances, or generate new substances from the interior casts a shadow over human perception. This sense of an inability to understand and hence control physical process never left Donne. He was always alert to the potential defeat of reason, once the body had become the object of his gaze. The body's interior architecture concealed dizzying depths and capacities, reservoirs of fluid, in which the imagination could soon lose itself. In a sermon preached before the King at Whitehall in April 1620/1, for example, we find Donne meditating on a text from Proverbs (25.16): 'Has thou found honey? Eat so much as is sufficient for thee.' Honey, Donne interprets as worldly honour, or the things of the flesh. How much can we eat, he asks, before we are spiritually gagging? In searching for an answer, an anatomical expedition into the body-interior must be mounted:

> We know the receipt, the capacity of the Ventricle, the stomach of man, how much it can hold; and we know the receipt of all the receptacles of blood, how much blood the body can have; so do we of all the other conduits and cisterns of the body; but this infinite Hive of honey, this insatiable whirlpool of the covetous mind, no anatomy, no dissection, hath discovered to us.[6]

Gazing into the body with the eye of science, an eye skilled in measurement, the body appears at first to be finite in its capacity in comparison to the mind's insatiability.[7] But as Donne's gaze into the body becomes more

18

intense, and as the authoritative tone of the passage (suggested by the collective 'We') gives way to a more personal note, doubt begins to intrude once more. Suddenly, under a more pressing analysis, the body is transformed. From being a safely measurable interior, it emerges as a reservoir of immense size and capacity:

> When I looke into the larders and cellars, and vaults, into the vessells of our body for drink, for blood, for urine, they are pottles and gallons; when I look into the furnaces of our spirits, the ventricles of the heart and of the braine, they are not thimbles.
>
> (*Sermons*, III. 236)

The eye has been deceived. A 'pottle' (according to the *OED*, approximately half a gallon) has been squeezed into a quart cup, the body's structure revealed as gloomy vaults, unsounded wells, panting furnaces, lakes of blood and urine.

'The concavities of my body are like another hell for their capacity.' So Sir Thomas Urquhart, in 1653, had observed in his translation of Rabelais's *Gargantua*.[8] Donne's evocation of an equally rapacious body-interior prompts us to understand this urge to master the body's processes within a directly political context. For the body's interior may be understood as 'grotesque' in that specialized sense associated with Bakhtin's analysis of the body.[9] Conflict between interior and exterior becomes, in this analysis, the new co-ordinates of a confrontation between the 'grotesque' and the 'classical'. As Peter Stallybrass and Allon White have observed, Bakhtin's 'classical body denotes the inherent form of the high official culture' whilst the 'grotesque . . . designates the marginal, the low and the outside from the perspective of a classical body situated as high, inside and central by virtue of its very exclusions'.[10] In a fluid process of metamorphosis, the uncovering of a body-interior, as in the case of John Donne's peregrinations through the body's 'larders and cellars', announces the discovery that what is inside the body is associated with 'low' culture. In Donne's anatomical journey, we do not encounter staterooms, halls, or a privileged public space. Instead, we wander through service chambers, and gaze into barely understood industrial processes. As we shall see, other travellers into the body-interior (most notably Edmund Spenser) encountered a rather different architecture. But for Donne, writing on the brink of scientific transformation of the body, the features which demand our attention are those associated with the opposite of cool, reserved, classical forms. Gallstones, blood, phlegm, nails, hair, and urine – substances which have to be expelled from the body – are the touchstones of the experience of interiority.[11] It is as if the encounter with the body's interior has suddenly revealed a vista of an alternative (and dangerous) mode of existence in which the marginal, the low, the anti-

rationalistic, reigns supreme. This, then, was the new battlefield in which the body–soul struggle was now to take place.

We can glimpse the outlines of this struggle in poetic depictions in the late sixteenth and seventeenth centuries of the relationship between body and soul. If we remain with Donne for a moment, and turn to 'The Extasie' – that exercise in Platonic dualism – we observe the body depicted as a 'prison' in which is forced to reside the 'great Prince' which is the soul. In accordance with traditional ideas, the soul is envisaged in corporeal terms – a tripartite union of higher and lower faculties. This embodiment of an incorporeal entity, as Burton explained in the *Anatomy of Melancholy*, led to a welter of conflicting opinion. Were souls to be understood as single or multiple? Did the body contain within itself three distinct principles – the vegetal, sensible, and rational – or were these merely faculties of some higher union?[12] Already, the subject or individual can be seen to exist in a fundamentally fragmented state. But, at the same moment, a different kind of bodily union is explored in Donne's poem. The body, though it is the vehicle by which souls may encounter one another, is also the inferior partner, the medium of physical feeling, and crucially a source of dislocation and imbalance. Informing the poem's logic is the language of domination and ownership – the language of the soul itself, since the poem's narrator (of necessity) speaks for the soul which is the very reasoning power allowing the poem utterance. Bodies, Donne writes, 'are ours, though they are not wee' and he continues: 'Wee are The intelligences, they the Spheare' (Donne, *Poems*, 47). The relationship between body and soul is not only akin to the relationship between the celestial spheres and the divine intelligence which allows movement, but akin to the very structures of linguistic utterance: 'We' – souls – speak; 'they' – bodies – hear and obey.

Or should obey. The body's refusal to obey, its ability to fracture the supposed desire of the soul towards communion with God, and its recalcitrant and rebellious longing for physical and sensual existence, delineates the battle-lines between material and immaterial existence, as well as between subject and object in a grammatical sense. Under the promptings of Calvinist theology, the battle for dominion became ever more ferocious. 'Mastery' over the body, the conquering of its desires, the endless war against the ravages of sin, or 'soul-sickness', is a feature of early-modern culture which provides the determining framework in which the body's internal dimensions were to be understood. Sir Thomas Browne's exclamation in his *Religio Medici* (1642) – 'I feele sometimes a hell within my self, *Lucifer* keeps his court in my breast' – can be interpreted perhaps more literally than we have tended to suppose.[13] Within this framework, and amongst puritans, what has been termed the 'inner anxiety' of Calvinist doctrine became institutionalized, producing a seemingly obsessive desire to scrutinize the

slightest 'perturbations' of the soul in its relationship to the exterior world in which the body was held to exist.[14] Hence, to peer into the body was to undertake a journey into a corrupt world of mortality and decay; it became a voyage into the very heart of the principle of spiritual dissolution. Within this mental universe, illness and sickness, the malfunction of the body, was a profoundly important spiritual state rather than a physiological problem to be encountered with the aid of medicine and technology. Written in the 1650s, Andrew Marvell's 'Dialogue Between the Soul and the Body' might stand as the definitive insider's account of the incessant internal war held to be taking place within each individual. The poem's opening is famous for its masterfully apposite display of a self-reflexive desire to escape the interior recesses of the body. But in demonstrating such desire, Marvell's poem also allows us access to a complex and contradictory fusion of puritan theology and new science in which the body appears as a sinister instrument of pain and torture. The soul opens the dialogue:

> *Soul* O who shall from this Dungeon, raise
> A Soul inslav'd so many wayes?
> With bolts of Bones, that fetter'd stands
> In feet; and manacled in hands.
> Here blinded with an Eye; and there
> Deaf with the drumming of an Ear.
> A Soul hung up, as t'were, in Chains
> Of Nerves, and Arteries, and Veins.
> Tortur'd, besides each other part,
> In a vain Head, and double Heart.[15]

To the poem's opening question – who shall raise me from this fleshly prison – there is, of course, only one answer: Christ. Christ, because of the willingness of the *Logos* to become flesh, can answer the soul's plea to escape the flesh. Yet for the moment, imprisoned within the body, the soul transforms the delicate organs of sensory feeling into the instruments of its own torture. Ironically, in terms of seventeenth-century psychological theory, it is through just these organs – eyes, ears, hands – that the soul was allowed to experience, however imperfectly, the outward world. But in Marvell's evocation of the body as a prison-house, the 'higher' organs of feeling – the *viae mediae* between terrestrial and spiritual experience – are emblematic of the soul's barren inner existence.

Perhaps the most striking image of the poem's opening stanza is that of the body transformed into a self-reflexive instrument of torture, with the networks of veins, arteries, and nerves performing the office of the chains of a gibbet. It is in this image that we can sense a conjunction between the theologically informed understanding of the body–soul relationship and the

searching gaze of pre-Cartesian science into the body's interior. To be gibbeted, to be exposed after execution to public gaze, was a fate reserved for the worst malefactors, since it compounded the punishment with a denial of christian burial. The soul's life in the body in Marvell's 'Dialogue' is, therefore, a very public form of death – a shaming and punishing ordeal of exposure. Yet, this image tallies not just with accounts of bodies gibbeted and exposed after execution, but with the records of contemporary anatomists, amongst whose skills was the preparation of demonstrations of 'arterial', 'venous', and 'nerval' figures. These preparations revealed to an admiring public a new image of the human figure, an image which traced the form of the body, whilst its material – flesh, tissue, organs, sinews – was, as it were, miraculously dissolved. The outline of the gibbet – a skeletal framework in which condemned bodies dissolved – and the spidery structure of the nerval figure appear congruent (see Figure 1). The new internal topography, which soon came to replace the older schematic diagrams of the arterial, venous, and nervous systems, revealed the body as a delicate lattice-work of interconnecting vessels which traced in outline the now dispersed body. Eerily, it is just such a dispersal of the body which the gibbet, a technological aid to the exposure of the condemned corpse, was designed to achieve. A sixteenth-century sentencing formula from Germany, for example, announced that the body 'shall remain on the gallows so that it shall be given over to the birds of the air and taken away from the earth.'[16] Refused burial, exposed to public view, the soul, too, was held to have been punished by not being granted peace.[17]

Marvell's opening stanza of his 'Dialogue' gives us, then, the co-ordinates of a new version of the otherwise perpetual warfare taking place within the confines of the body. It shows us, too, the transformation of punishment into art. Later, when we come to consider Rembrandt's role in the dissective culture of the late Renaissance, we shall return to the gibbet. But for the moment, it is enough to note that the soul's complaint is that of the gibbeted criminal, a living death in which peace and repose are for ever denied. Allied to this encounter with the anguished soul's plea for escape, is revealed an almost scientifically precise evocation of the body's internal structure. The internal war has now encountered a new possibility – the body is to be no longer the preserve of the dogmatic controversialist. Its contours are now open to the colder eye of science.

CREATING THE MECHANICAL REPUBLIC

The colder eye of science – the new science of the body – is associated with the 'discovery' or, more properly, the rhetorical deployment during the seventeenth century, of a new language with which to describe the body's

interior. This language is primarily associated with the post-Cartesian for-
mulation of the body as a machine. But to the natural philosophers of the
earlier seventeenth century, it was not a mechanistic structure that they first
encountered as they embarked upon the project of unravelling the body's
recesses. Rather, they found themselves wandering within a geographical
entity. The body was territory, an (as yet) undiscovered country, a location
which demanded from its explorers skills which seemed analogous to those
displayed by the heroic voyagers across the terrestrial globe.

The period between (roughly) 1540 and 1640, is, therefore, the period of
the *discovery* of the Vesalian body as opposed to the later *invention* of the
Harveian or Cartesian body. Guiding the followers of Vesalius was the belief
that the human body expressed in miniature the divine workmanship of
God, and that its form corresponded to the greater form of the macrocosm.
Such ideas did not vanish overnight, to be replaced by the clear light of
Cartesian rationality. Indeed, William Harvey himself leaned on a system of
beliefs inherited from Aristotle, which held that the universe and the human
body – the interior and exterior worlds – were united in the common bond
of correspondence. Within this system, features observed within the body
were held to replicate features to be seen in the world at large. Thus Harvey,
in the crucial eighth chapter of *De Motu Cordis*, wrote of the motion of the
blood through the animal body: 'We may call this motion circular in the
same way in which Aristotle says that the air and the rain imitate the circular
motion of the heavens.'[18] The key phrase in Harvey's statement is the word
imitation. Imitation, a central concept in Renaissance poetic theory, orders
the body, the world, and the heavens into a pattern of replication, in which
each component of the system finds its precise analogical equivalent in every
other component. What Michel Foucault has termed the 'finitude of a world
held firmly between the microcosm and the macrocosm' is thus rooted in
an endlessly repetitive interplay of metaphor, similitude, and comparison.[19]
It is probably not an over-statement to say that this vista of similarity lay at
the very heart of every intellectual endeavour of early-modern culture,
informing art, architecture, philosophy, theology, natural philosophy, and,
in particular, poetry.[20] Within this world the body lay entangled within a web
of enclosing patterns of repetition.

During this phase, which opened with the publication of Vesalius' *De
Humani Corporis Fabrica* in 1543, the interior of the body began to take on
most of its modern features: Eustachius mapped the ear, Fallopius the
female reproductive organs, Realdus Columbus and Fabricius of Aqua-
pendente the venous system, and Michael Servetus the pulmonary transit of
the blood. Like the Columbian explorers, these early discoverers dotted
their names, like place-names on a map, over the terrain which they
encountered. In their voyages, they expressed the intersection of the body

and the world at every point, claiming for the body an affinity with the complex design of the universe. This congruence equated scientific endeavour with the triumphant discoveries of the explorers, cartographers, navigators, and early colonialists. And in the production of a new map of the body, a new figure was also to be glimpsed – the scientist as heroic voyager and intrepid discoverer.[21] The body was a remote and strange terrain into which the discoverer voyaged. Just how remote, and just how strange, is suggested in an observation of Sir Thomas Browne. When, in his *Religio Medici* of 1642, Browne came to consider the 'wals of flesh, wherein the soul doth seeme to be immured', the trope which ordered his experience of the body's physicality was one which, even by seventeenth-century standards of poetic conceit, must have appeared to have been verging on the grotesque. Browne wrote:

> *All flesh is grasse*, is not onely metaphorically, but literally true, for all those creatures we behold, are but the herbs of the field, digested into flesh in them, or more remotely carnified in our selves. Nay further, we are what we all abhorre, *Anthropophagi* and Cannibals, devourers not onely of men, but of our selves; and that not in an allegory, but a positive truth; for all this masse of flesh which we behold, came in at our mouths: this frame we looke upon, hath beene upon our trenchers; In briefe, we have devoured our selves.[22]

Browne's vision of the body, a vision which hovers on the edge of what was later to be termed scientific understanding, collapsed exterior and interior, the known and the unknown, into a carnificatory process in which the body was the devourer of itself. What we hate and fear, the cannibal, the Medusa, was held to be residing deep within us, rather than encountered in some distant and remote land. Browne's image of the body as cannibalistic may have been derived from Montaigne's essay 'On Cannibals' (published in 1580) where we read that, at the point of death, the cannibal who was himself about to be cannibalized asserted his own superiority over those about to eat him by reminding them that he had once eaten their ancestors. Flesh is united to flesh in an unbroken round of eating and being eaten:

> These muscles . . . this flesh, and these veins are yours, poor fools that you are! Can you not see that the substance of your ancestors' limbs is still in them? Taste them carefully, and you will find the flavour is that of your own flesh.[23]

It was into this cannibalistic universe that the scientist journeyed when the body was opened. Browne's observation, building on the record Montaigne offered, announced an alien world of values in which the body existed. It was neither subject to laws of community, nor was it an emblem of civilization. Instead, it lived by its own animalistic desires. It is out of this delineation of the body's 'alieneity' – the sense of the body as alien to the

sensibility which inhabited it – that the material was provided for the construction of the natural philosopher as heroic explorer. In other words, the trope of the body as innately cannibalistic, meshing with puritan conceptions of the body's voracious hunger for physical satisfaction, engendered the peculiarly apposite conceit of the natural philosopher as a colonizing, and thus civilizing, force within the boundaries of the natural (and, by analogy, political) body.[24]

The microcosmic explorer of the body laboured on a project the dimensions of which were held to be every bit as dark as the interior of the continent of the newly 'found' americas. But the body's darkness, its strangeness, its alieneity did not preclude knowledge. The scientist who searched the cavities and recesses, the interior secrets, of the body was not faced with the 'ne plus ultra' confronting earlier, theologically-bound, patterns of knowledge. Instead 'Plus Ultra' – 'yet further', the motto of the Emperor Charles V – became the watchword of the natural philosophers.[25] Though, on occasion, warning voices might be heard, this project was conducted with boundless optimism. No limit was to be placed on the possibility of gaining understanding. The task of the scientist was to voyage within the body in order to force it to reveal its secrets. Once uncovered, the body-landscape could be harnessed to the service of its owner. In thus establishing the body as 'useful' – a key term amongst the natural philosophers of the seventeenth century – we are able to perceive the language of colonialism and the language of science as meshing with one another. To say of the New World that it was like a body, as Donne observed in 1622 when he addressed the Virginia Company as 'not onely a *Spleene*, to drain the ill humours of the body, but a *Liver*, to breed good bloud', was to explore a metaphor, but it was also to appropriate the body in the service of colonial expansion. 'The whole world', Donne's sermon continued, 'all Mankinde must take care, that all places be emprov'd, as farre as may be to the best advantage of Mankinde in general.'[26] The improvement of the whole world included everything contained within that world – land, vegetation, and bodies.

In this undertaking, part of that 'dominion over nature' which was the object of progressive western science throughout the seventeenth century, the body became subject to a new regime of language.[27] First it had to be colonized. The process was truly colonial, in that it appeared to reproduce the stages of discovery and exploitation which were, at that moment, taking place within the context of the European encounter with the New World. First came the explorers, leaving their mark on the body in the form of features which were mapped and named and inhabitants who were encountered and observed. The second stage mirrored the narrative of conquest and exploitation insofar as these newly found features and peoples

were understood as forming part of a complex economy – a system of production, distribution, and consumption – which was itself in perpetual movement. The project, then, was to harness this system to the use of the discoverer. Intrinsic to such a project was the creation of the body's interior as a form of property. Like property, the body's bounds needed to be fixed, its dimensions properly measured, its resources charted. Its 'new' owner – which would eventually become the thinking process of the Cartesian *cogito* – had to know what it was that was owned before use could be made of it. In order to achieve such knowledge the owner had to see it, to view the landscape; but view it not as an abstract projection of semi-mythical travel-ler's tales, but rather as an objective reality. In exactly similar fashion, Christopher Columbus, describing the wealth of the Indies on returning from his first voyage of 1492–3, observed that 'although there was much talk and writing of these lands, all was conjectural, without ocular evidence. In fact, those who accepted the stories judged by hearsay rather than on any tangible information.' Such a statement was echoed in the writings of Vesalius and his contemporaries who, in their urge to overturn Galenic authority, stressed the primacy of 'ocular evidence' in their explorations of the body. The important difference between their undertakings and those of classical authority, they continually claimed, was that, unlike Galen and those who followed Galen, they had *seen* the body with their own eyes. For Columbus, in the realm of exploration of the macrocosm, having seen what this new property might offer – gold, spices, cotton, mastic, aloes, slaves, rhubarb, cinnamon – the conclusion was that 'there will be countless other things in addition, which the people I have left there will discover.'[28] In similar measure, the human body was now understood to contain wealth, though of a kind peculiar to itself. So, in the 'Anniversary poems' that we have already glanced at, Donne writes of the body of Elizabeth Drury, the young woman who was the 'occasion' of the verses:

> The Westerne treasure, Eastern Spicerie,
> Europe, and Afrique, and the unknown rest
> Were easily found, or what in them was best;
> And when w'have made this large discoverie
> Of all, in her some one part then will bee
> Twenty such parts, whose plenty and riches is
> Enough to make twenty such worlds as this;
>
> (Donne, *Poems*, 233)

Poetic hyperbole? Of course. But the point is that Donne's language of praise and celebration was informed by the vocabulary of discovery and appropriation, so that colonialism and the discovery of the body appeared to complement one another. The rich resources of the new body/world would rejuvenate the old.

The language of property and appropriation came easily to Donne and his contemporaries whenever the body was considered. Reaching out to grasp this property, a rich land of promise, was not merely a right, but a duty which sanctified the actions of the colonialist. This, the justification which informed Donne's 1622 sermon to the Virginia Company, was discernible at other, perhaps less obviously appropriate moments. Donne's erotic hymn to the female body (Elegie XIX) deployed the language of discovery in order to evoke a sinister combination of sensuality and physical exploitation:

> Licence my roaving hands, and let them go,
> Before, behind, between, above, below.
> O my America! my new-found-land,
> My kingdome, safeliest when with one man man'd,
> My Myne of precious stones, My Emperie,
> How blest am I in this discovering thee!
> To enter in these bonds, is to be free;
> Then where my hand is set, my seal shall be.
>
> (Donne, *Poems*, 107)

'How blest am I in this discovering thee!' Donne's exclamation carried the full weight of a colonizing dynamic which might almost have stood as the credo of the enquiring seventeenth-century scientist. It was with just such a proprietal gesture that Vesalius, on the great title-page of the *Fabrica*, had himself pictured placing his right hand on the dissected female body, in a gesture of ownership (Figure 2) – a gesture which may bring to mind Donne's hand reaching out in Elegie XIX: 'Then where my hand is set, my seal shall be'. Just as the woman's body in Elegie XIX was transformed into an America, and hence was ready for subjection via discovery, first, and then the bonds of property and ownership, so the 'scientific' body was transformed into an object of discovery and a regime of ownership in which 'health' existed as a goal to be imposed on bodies which, operating according to their own perverse designs, too often seemed to find refuge in sickness.[29] But the Vesalian gesture of ownership is also a gesture of revelation. The right hand opens the woman's body to the gaze of all who care to see. Like Donne's roving hands, the roving hands of the anatomist have opened the body's cavities and claimed the body, if not for sex, then for knowledge. But then, what was the difference? As a licensed colonialist, or as a roving pirate of the bedchamber, or as an enquiring anatomist, the discourses of knowledge seemed to flow into one another.[30]

But knowledge of the body, despite Donne's portrayal of an easy erotic triumph, was in reality hard to come by. No matter how diligently the search of this new continent was conducted, its expanses were so (microcosmically) vast, its recesses so hidden, that understanding followed only after the

greatest exertion. The term that endlessly seems to structure the voyage into the body's interior in the seventeenth century was the 'America' which Donne's roving hands sought to clutch. The exultant yell of discovery in Donne's elegy on the female body – 'O my America!' – a cry of possession and feverish sexual excitement, echoes with just as much force when we hear it in the exclamations of the natural philosophers of the later seventeenth century. 'America' became synonymous with the triumph of the human imagination as it strove to unravel passages which seemed to become ever more tortuous, ever more complex. For Joseph Glanvill, a founder member of the Royal Society, the body's 'inward frame' was indeed 'an *America*', but it was also, therefore, 'a yet undiscovered Region' in which the scientist could win enduring fame and honour.[31] Glanvill's immediate contemporary, the poet and savant Abraham Cowley, expressed the case in similar fashion. Cowley, like Glanvill an enthusiastic proponent of the new science, saw the body as a *terra incognita* within which would be uncovered 'work enough for our posterity'.[32] Cowley was to claim that the whole scientific impulse of his own age was akin to the discovery of America. But others seemed less secure when faced with this vast prospect. The English anatomist, Walter Charleton, writing in 1680 seemed to balk at the huge labour which the colonization of this internal America would, of necessity, involve:

> There are yet, alas! Terrae incognitae in the lesser world, as well as the greater, the Island of the Brain, the Isthmus of the Spleen, the streights of the Renes and . . . some other Glanduls, the North-East passage of the drink from the Stomach to the Kidnies, and many other things, remain to be further enquir'd into by us, and perhaps by posterity also.[33]

The riot of geographical metaphors betrays a profound level of insecurity. No one individual could hope to encompass such knowledge. Despite the optimism of the internal voyagers, some were beginning to sense that the body's interior had become too vast, too complex; it demanded a pattern of investigation which would examine not its coasts, rivers, and tributaries, but something different. It was at this point that the machine-body, an automaton of movement whose existence had been postulated some fifty years earlier, emerged to stride, once and for all, within the body's interior.

The reduction of the body 'to a mere mechanical contrivance' may not have begun with Descartes, but the Cartesian formulation of 1637, which suggested that the operations of the body have to be analysed in terms of the 'many different automata or moving machines the industry of man can devise' represented the summation of half a century of voyages into the interior to which Descartes was the heir.[34] After Descartes, the image of the body as America was to be gradually (and one needs to stress the slow process of paradigmatic change) replaced by the image of the body as a machine.[35]

Mechanism offered the prospect of a radically reconstituted body. Forged into a working machine, the mechanical body appeared fundamentally different from the geographic body whose contours expressed a static landscape without dynamic interconnection. More than this, however, the body as a machine, as a clock, as an automaton, was understood as having no intellect of its own. Instead, it silently operated according to the laws of mechanics. We move, then, from an interior in which the body seems (as in Marvell's dialogue) to speak its own part, to the modern conception of a physiological system no more capable of speech than is an hydraulic pump – the machine with which Harvey himself had sought to explain the operation of cardiac valves.[36] As a machine, the body became objectified; a focus of intense curiosity, but entirely divorced from the world of the speaking and thinking subject. The division between Cartesian subject, and corporeal object, between an 'I' that thinks, and an 'it' in which 'we' reside, had become absolute.

The political implications of this process of thought were immense. Hitherto, the body had always been available as a rich source of metaphors with which to describe systems of government which were held to be both organic (and hence natural) and hierarchical. No longer was this the case. The easy familiarity with which early-modern political commentators could point to the body (mediated, it is true, by St Paul's more communitarian model) as a demonstration of monarchical authority was now open to question. Menenius' fable of the belly in Shakespeare's *Coriolanus* had become simply irrelevant in any literal sense. The soul's power within the body was no longer analogous to the king's power within the state, or even God's power within the universe: the triple bond of authority had broken down into a world of mechanical process. If God still existed, then he was certainly no architect, perhaps not even a creator in the older sense of a fashioning and forming deity. Rather he was a mechanic, an engineer, a watchmaker even, whose presence was no longer required for the continuing operation of the orderly movement of the machine.

Of course, the argument did not rest there. To many of the followers of Descartes and Harvey, the fact that the body could be thought of as a machine suggested that, like all machines, a maker was required. But the machine, others pointed out, could (and did) run without need of supervision. Once set in motion, the engineer's will or desire could have no effect on the whirling processes which now seemed to be in operation. We can trace the implications, within a political sphere, of these new conceptions of the body in Harvey's own work. In 1628, when *De Motu Cordis* first appeared (in latin) Harvey dedicated his discovery of circulatory processes to the monarch, Charles I. To the king, knowledge of the heart's operation within the body, Harvey wrote 'cannot be unprofitable . . . as being a divine

example of his own actions (so have ever men been wont to compare small things with great)'.[37] When, in 1653, an English translation of the text appeared (based on the latin edition of 1648) this language of similarity had undergone a subtle but nevertheless crucial shift. In 1653, the king, had he still existed, might have looked inside the body to discover 'a divine resemblance of his actions (so us'd they small things with great to compare).'[38] A divine 'example' has metamorphosed into a divine 'resemblance', an observation of similarity which is placed firmly within the historical past. In 1628, when the king was still on the throne of England, the heart was offered as an example of kingly rule. By 1653, in the turmoil of the new experiment in government which was the nascent English Republic, the sovereign heart had become no more than an example, one amongst many, by which the body was once known.

Was the transformation of the body into a machine responsible for this dethronement of a hierarchically organized body? Was it even possible that the turmoil of the revolutionary years in England in the 1640s and 1650s encouraged the creation of a radically different conceptual organization of the body?[39] We can see, for example, the organic language of the body still deployed within a political sphere in the lyrics of Richard Lovelace, whose posthumous collection of poems *Lucasta* (1659) abounded in images of bodily dissolution. But rather than the body being illustrative of the integrity of form, it was witness, now, to a collapse in hierarchies and order. Bodily form was dispersed into liquefaction, or jelly-like viscosity, or (as here in 'A Mock Song') an anatomical tumble of distributed structure which stretches over the cosmos:

> Now the *Sun* is unarm'd
> And the *Moon* by us charm'd
> All the *Stars* dissolv'd to a Jelly;
> Now the *Thighs* of the Crown,
> And the *Arms* are lopp'd down,
> And the *Body* is all but a Belly:[40]

Lovelace's lyric is an epitaph to the decapitated king. But in that act of violation of the sovereign body, Lovelace perceives a wider morphological dissolution. It is not just that the republican 'belly' has superseded the heart or sovereign power, but that the body as a whole (together with the universe of which it was once an emblem) has become translated into a carnivalesque and grotesque single organ.

Lovelace's language, however, is still the language of older hierarchies. But by the time the dissolving world of *Lucasta* was published, a different kind of struggle over the body had become apparent. Now, the body was to be positioned within a precisely delineated political sphere in order either

to validate the ancient system of hierarchy, or to challenge it with mechanism. But this struggle was unlike that earlier struggle between material and immaterial realms of being which had once taken place inside the body. Instead, this new contest took place outside the body, as the natural philosophers of the later seventeenth century sought to trace the implications of 'mechanical philosophy'. So, the anatomist Samuel Collins offered a body understood in Hobbesian terms, where the 'oeconomy of the Body politick' was held to resemble the 'body material' in that both conformed to the 'best constitution of monarchical government'.[41] Against Collins's aristocratic (and anachronistic) interior monarchy, others arrayed the mechanical republic wherein might be discerned:

> All things . . . joyned together, as in a clock, one cannot be without the other, neither is the most despicable wheel less necessary than the hand of the Clock itself without which it cannot be accounted a Clock.[42]

Thus the Dutch anatomist, Paul Barbette, in 1659 challenged the age-old Galenic definition of the body as being composed of parts with varying degrees of 'nobility'. Such hierarchies, it was clear, could not be sustained within the mechanical republic.

Whatever precise political structure ruled within the body, the natural philosophers who now entered the body were sure of encountering processes susceptible to logical analysis, rather than mystical affinity. The development of the machine image dramatically transformed the attitude of investigators towards the body's interior, and towards their own tasks of investigation. They no longer stood before the body as though it was a mysterious continent. It had become, instead, a system, a design, a mechanically organized structure, whose rules of operation, though still complex, could, with the aid of reason, be comprehended in the most minute detail. At least, that was the theory. As early as 1620, in the *Novum Organum*, Francis Bacon had claimed that investigation should proceed by principles which would concentrate on 'number, weight, and measure . . . a combination of physics and mathematics that generates practice'.[43] Bacon's stress on 'number, weight, and measure' was, it is true, an echo of scriptural injunction.[44] But it was also understood as a call to a mechanics which opened the door to a vision of the body in which human ingenuity would unravel the mechanism as surely as it was known that the mechanism had been constructed according to clearly defined mechanical theory in the first place. 'In mechanical things', Thomas Willis wrote in the 1660s:

> when any one would observe the motions of a clock or Engine, he takes the machine itself to pieces to consider the singular artifice, and doth not doubt that he will learn the causes and properties of the Phaenomenon.[45]

31

The mechanical body dispelled doubt, uncertainty, and indecision. A tech-nology of the body had become apparent; a technology, moreover, which could itself be investigated, reflexively, with the aid of technology. For Henry Power, an exponent of the mechanical philosophy, the body's technological processes, no matter that they resided in the smallest parts and the most subtle motions, were to be discerned through the ingenious application of what he termed 'modern industry', which had produced 'artificial Eys' (microscopes) with which to peer into the body.[46] The body as a mechanism was now itself subject to mechanism, a technique, a field of productive labour which relied on ingenious invention and instrumentation. Measure-ment took over from description, the 'power' of the soul gave way to a sequence of mechanical movements.[47] Hierarchy was overthrown, and the mystery of continental interiors replaced by the silent forces of springs, wheels, and cogs, operating as a contrived whole. The modern body had emerged: a body which worked rather than existed.

TREASONABLE BODIES

But are these theories and images of the body in the sixteenth and seven-teenth centuries anything other than abstract conjunctions, or anything more than metaphoric shifts? Did the individual experience of the body alter as the paradigms, within which the natural philosophers worked, shifted or crumbled? It might be possible to trace the creation of the interior of THE body, but what has happened to MY body – the body experienced as the young officer wounded in the Falklands campaign was to experience it mediated through invasive surgery and the technology of photographic reproduction? Let us conclude, then, with two accounts of the experience of MY body in the early-modern period. They are accounts engendered at that point when the body most demands attention, when a regime of health gives way to one of sickness, and the subject becomes a 'patient'. If, at any point, it is possible to trace the language of the body's interior pressing upon subjective experience, then that point must be reached when the body's presence is signalled through discomfort and pain. What was learned at such moments?

In November 1623, John Donne fell dangerously ill. Out of the illness came Donne's pious record, the *Devotions upon Emergent Occasions*. The *Devotions*, written out of an illness which (so Isaac Walton was to record in 1640) 'brought him so near to the gates of death, and . . . saw the grave . . . ready to devour him', emerged as a testimony to the sudden and awful fitfulness of human life in early-modern society.[48] The sequence of twenty-three meditations, expostulations, and prayers begins, famously, with an evocation of surprise – the astonished understanding, on the part of the

writer, that in an instant he has moved from a state of health to one not merely of illness, but of imminent extinction:

> Variable, and therefore miserable condition of Man; this minute I was well, and am ill, this minute. I am surpriz'd with a sodaine change, & alteration to worse, and can impute it no cause, not call it by any name. We study *Health*, and we deliberate upon our *meats*, and *drink*, and *Ayre*, and *exercises*, and we hew, and wee polish every stone, that goes to that building; and so our *Health* is a long & a regular work; but in a minute a Cannon batters all, overthrowes all, demolishes all; a *Sicknes* unprevented for all our diligence, unsuspected for all our curiositie; nay undeserved, if we consider only *disorder*, summons us, seizes us, possesses us, destroyes us in an instant.
>
> (*Devotions*, 7)[49]

No matter how architecturally massive the foundations and the structure of health, it was a work destroyed in a moment in warlike images of siege and overpowerment. Death was comprehended as an external force, threatening from without. It was no less surprising for all that it might have been anticipated. The sufferer understood the disease as rooted in alien forces which have penetrated the body's defences. The task of the physician, in this 'medical model' of illness was to assist the patient in combating the intruder. In this sense, Donne's conception of his body in illness might seem strikingly modern, even if the spiritual significance invested in the process of being ill appears entirely pre-modern.[50]

But another image of death reverses this ontology. As the illness recorded in the *Devotions* progressed, a new image of decay began to overshadow the writing. Hitherto, Donne, his doctors, their consultations, their prescriptions, remedies, and blood-lettings had been at war with death and disease in the hope of securing the body from the ravages of an external threat. But, the patient began to realize in the 10th meditation, this was to misunderstand the nature of disease and, crucially, the nature of the body through which the disease was working. As he moved closer towards death, Donne began to construct a new image of the relationship between his body and the disease which was scouring it. It was not that the body has to be saved from forces situated outside itself, but, rather, it had to be purged from its own internal and treasonous desire to destroy itself. That desire could be discerned in the body's refusal to speak – in its determination to preserve its tendency towards destruction through a veil of secrecy and silence: 'that which is most *secret*, is most *dangerous*' wrote Donne before observing that: 'The *pulse*, the *urine*, the *sweat*, all have sworn to say *nothing*, to give no *Indication*, of any dangerous *sicknesse*' (*Devotions*, 52). The silent body refused to register the onward processes of dissolution. The signals of health and sickness – the strengthening or weakening of the pulse, the constituency,

appearance (even smell and taste) of the body's fluids, registered nothing. Just as in *King Lear*, the sovereign will has been challenged by dumbness and silence. Cordelia, however, concealed nothing but her love. Donne's sick body, by comparison, concealed its illness only so that a rival power could work more efficiently. The sick John Donne and the disease were locked together in combat, but this combat was one in which the body refused to take the part of the human will which should have animated the corporeal life of the speaking and thinking subject. Instead the body and its potential destroyer have formed an alliance:

> The *disease* hath established a *Kingdome*, and *Empire* in mee, and will have certain *Arcana Imperii, secrets of State*, by which it will proceed, & not be bound to declare *them*. But yet against those secret conspiracies in the State, the *Magistrate* hath the *rack*; and against those insensible diseases, *Phisicians* have their *examiners*; and those they imploy now.
>
> (*Devotions*, 52)

The body had become the rebellious subject, hoarding its own knowledge of illness, and hiding within itself the constitution of the rival who, unless the rack prevailed, would eventually unseat the rule and order of the body's erstwhile owner. The language of treason, rebellion, conspiracy, and physical torture – a torture deployed not by the disease but by the physicians – was now determining the progress of illness. In order for the body to be saved, it had to be made to speak and confess.

The language of treason soon began to dominate the record of sickness. In the following meditation, Donne developed the familiar microcosmic conceit of the heart and the sovereign being equivalent in their respective spheres:

> the *Braine*, and *Liver*, and *Heart*, hold not a *Triumvirate* in *Man*, a *Soveraigntie* equally shed upon them all . . . but the *Heart* alone is in the *Principalitie*, and in the *Throne*, as *King*, the rest as *Subjects*.
>
> (*Devotions*, 56)

Within the political entity of the body, the heart was at once the most vital primary organ, and the most dangerously sensitive to the onset of disease. Of the diseases which beset the heart, it was 'intestine poysons bred in our selves by pestilential sickness' (as the meditation concluded) which were most crucial. At the risk of over-simplifying this richly allusive text of illness, Donne had moved from an understanding of his disease which was rooted in images of war against hostile forces, to one that was indebted to a more complex (and perhaps more traditional) view in which the illness and the body were joined together in a treasonable betrayal of the subject. This latter model was a product of an understanding of the body which was bound to

assert the essentially unknowable nature of its internal processes. The body was, at its core, a mystery capable of acting with its own will, and according to a set of rules of which the subject who inhabited that body had little or no knowledge. Hence, the language of physical violence which intrudes into these passages, for the subject was, in a literal sense, now at war with one part of his constitutive individuality.

The similarities between the treatment of disease within the 'rebellious' body, and the treatment of the rebellious subject within the body politic are, of course, immediately apparent. Donne's language of secrecy and conceal-ment, against which is deployed a language of examination, torture, proof, and punishment in order to define the course of his own disease, gives a kind of interior substance to Foucault's analysis of state punishment in the early-modern period, where the end of the ritualistic drama of execution is to reassert the sovereign's rights within the social order.[51] Thus Donne could describe his illness in the language of an arraignment for felony: '[The Physicians] have seene me, and heard mee, arraigned me in these fetters, and receiv'd the evidence; I have cut up mine owne *Anatomy*, dissected myselfe, and they are gon to read upon me' (*Devotions*, 45).

In the context of health and disease, we can understand that what is at stake is the wronged principle of 'health' itself. But what role was the self who spoke these words fulfilling? Self-reflexively playing both parts, Donne was at once the subject of investigation (the disease was his own disease), and the chief investigator (the disease belonged to his rebellious body). Insofar as the *Devotions* can be said to provide us with a truthful account of early-modern illness, they seem to indicate a fundamental uncertainty about the nature of illness, and even selfhood. Arising out of this uncertainty, we can glimpse a parallel uncertainty about the nature of the body through which the illness is working. These doubts were not just products of varying degrees of ignorance or (medical) incompetence. Instead, they were prod-ucts of the new instability which had come to surround the body.

What was the nature of this instability, and what had given rise to it? Donne survived the illness of 1623, though he was to fall dangerously ill again in 1625 when he contracted consumption, before eventually dying in 1631 of stomach cancer. By modern standards, three major life-threatening illnesses in the space of less than eight years would be thought desperately un-fortunate in the life of a man in his mid to late fifties. By seventeenth-century standards, however, Donne enjoyed relatively good, even robust health, given that, of those three illnesses, he managed to survive two of them. What is of importance to us, however, is not so much Donne's own disease history, but the understanding of the body which was betrayed in these moments of ill health. The body, bound within a newly fashioned dualistic universe in which 'it' had begun to exist as distinct from 'we', worked according to its

own rules. Disastrously, those unknown rules could bring about the over-throw of both 'it' and 'us'. Bodies, then, were hostile entities in which people were forced to spend their days. Even if they acknowledged ownership (an ownership which, in sickness, is clearly refused) their allegiance was entirely provisional. An alternative regime, once established within the body, para-doxically found not merely a refuge, but shelter and succour from an ally all too easily led into forming new alliances and treaties. The body, in other words, worked through its own largely unknown political constitution. Donne's images of illness and treason may seem extravagant to us; but to his contemporaries such comparisons were by no means far-fetched. Marvell's image of the body twisting in pain within its own finely spun frame of self-torturing nerves was no more than a further manifestation of this war between 'us' and 'them', the interior and the exterior realms. Francis Osborne, for example, the historian and friend of Hobbes, deployed just such images in his historical survey of the reigns of Elizabeth and James which was published in 1658. 'It may be concluded no less necessary', Osborne wrote, looking back on the Jacobean state:

> to dissect and make inspection into the defects of a dead king, or ruins of a tattered State, then for a Physitian to anatomize a body whose life was through evill and extravagant courses forfeited to the Law: by both honest men may be cured, and commonwealths better governed.[52]

The defeat of sickness and the establishment of political order were two sides of the same coin. A state in rebellion was a body in sickness. The diseased body was an image of rebellion. These images were not merely metaphors, but statements of a self-evident truth which structured the individual's experience of illness and health.

With the triumph of mechanism, however, such images soon began to appear as obsolete. Not only was the body refashioned, but the relationship between body and subject was, in similar measure, reconstituted. The perverse and secretive designs of the potentially rebellious body gave way to an altogether different understanding of the relationship between the body and the thinking entity – the 'we' who resided in 'it'. Let us look at an alternative text of illness. In 1665 Robert Boyle published his *Occasional Reflections upon Several Subjects*. Boyle, of course, seems to belong to a different intellectual universe from that inhabited by Donne. He was a member of the first council of the Royal Society, and the author (in 1662) of the experimental proof of the proportional relation between elasticity and pressure ('Boyle's Law'). But the *Occasional Reflections* was a theological rather than scientific work. In it, we read of the natural philosopher's encounter with an illness which, as with Donne's sickness some forty years earlier, produced a series of pious reflections on mortality and decay. Like

Donne, Boyle too was at first surprised by the onset of a life-threatening disease. But there the resemblance ends. As the disease progressed, so Boyle conjured into his mind his knowledge and understanding of the mechanical body:

> if I had call'd to mind what my curiosity for Dissections has shown me, and remembered how many Bones, and Muscles, and Veins, and Arteries, and Gristles, and Ligaments, and Nerves, and Membranes, and Juices, a humane Body is made up of, I could not have been surprised, that so curious an Engine, that consists of so many pieces, whose Harmony is requisite to Health, and whereof not any is superfluous, nor scarce any insensible, should have some or other of them out of order.[53]

The wonder of the machine is not that it has suddenly failed, but that, given its complexity, it works at all. A radical shift has taken place, one that has the effect of rendering the body if not less frightening, then at least less malignant, and certainly less powerful. For, as we compare Donne's account with Boyle's, we can begin to see how the body's interior has undergone a complete transformation. The language of treason, treachery, duplicity, and secrecy is abandoned. Equally, the body which Donne encountered in his anatomical stroll of 1621/2, a body composed of gloomy and vast vaults and cellars, is nowhere to be found. The transformation which has taken place involves far more than the adoption of one set of metaphors at the expense of another set. Instead, it entails the subject in fundamentally refashioning their relationship to their own body. Effectively, the body has been silenced. It has become a subject mechanism, a contrivance, which, if it malfunctions, may be restored to its proper functioning state through the imposition of the professional technology of medicine. Equally, the body has been divested of its latent capriciousness. Like the mechanically contrived universe in which the body now existed, chance and random occurrence appear to have been banished.[54] Finally, the body was no longer a sovereign entity in the constitution of the individual. It offered no challenge to individuality, and set up no rival or competing alternative to the subject. The struggle between inside and outside, a material and a non-material being was over.

But of course, this triumphant overthrow of body-fear never took place. What Boyle's text offers us is an idealized view of the scientific conquest of the body. This is how one *should* feel, Boyle is saying, if the body is no more than a machine. To recall the account of Robert Lawrence's ordeal which we looked at earlier, the fact that it was possible for a young man in Britain, in the 1980s, to carry around with him an image of his opened cranium, points not to the triumph of mechanics, but to the deep-seated and still current taboo which surrounds the body's interior regions. It is the presence of that taboo, equally, which brought the paying customers into the post-

mortem rooms of Copenhagen University. The divide which we perceive, then, when we juxtapose the two records of illness composed by John Donne and Robert Boyle in the seventeenth century has little to do with banishment of this fear, and rather more to do with the body being reconstituted within distinct regimes of discourse. Both those regimes are with us still, and they structure our everyday experience of our own bodies. The traditional understanding of the body-interior – a region of fear which belongs to the Medusa – exists uneasily with a new interior which is the product of science. But if science – which created Boyle's 'curious engine' – sought to banish the Medusa from our imaginations, it proved a far weaker adversary than Perseus. How the Medusa lived on, and how science struggled to bury her for ever, is the framing narrative of our story.

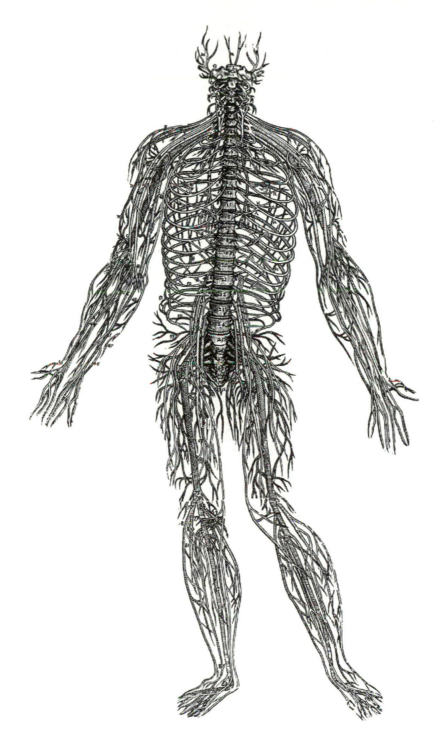

1 The nerve system from Vesalius, *De Humani Corporis Fabrica* (1543). 'A delicate lattice-work
. . . traced in outline the now dispersed body' (p. 22).

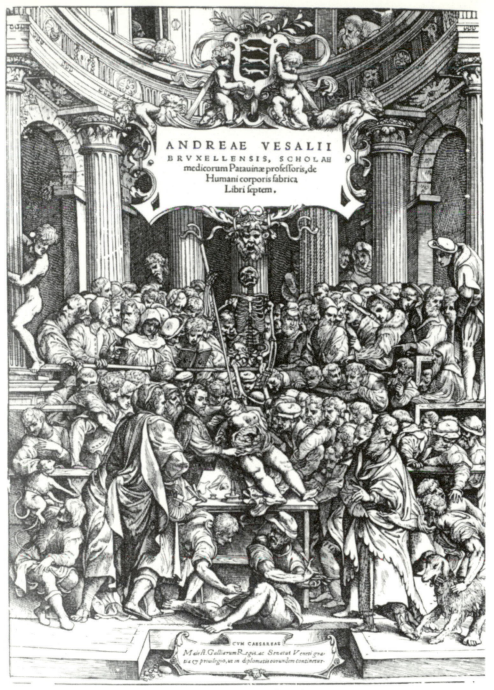

2 Title-page from Vesalius, *De Humani Corporis Fabrica* (1543). 'At the central point . . . an opened womb' (p. 70).

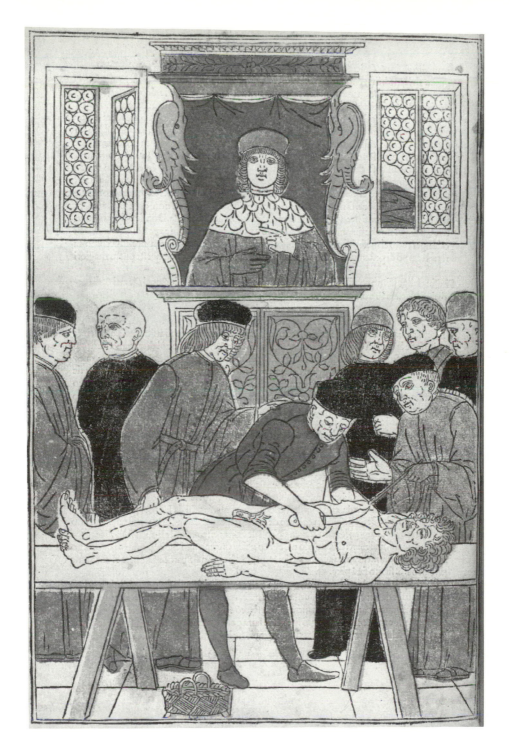

3 Dissection scene from Johannes de Ketham, *Fasciculo de Medicina* (1493) 'A hierarchical presentation of knowledge . . . a demonstration of mortality' (p. 65).

Questo è il diritto Tempio qui à canto dimostrato in pianta , il quale rappresenta la parte di fuori, & è tutto di opera Dorica sì come per il disegno si può comprendere : Circa alle particolar misure io non mi stenderò, percioche dalla pianta si potrà comprendere il diritto per essere questo, quantunque egli sia picciolo, propor- *tionatamente disegnato, & traportato con le proprie misure da grande a picciolo.*

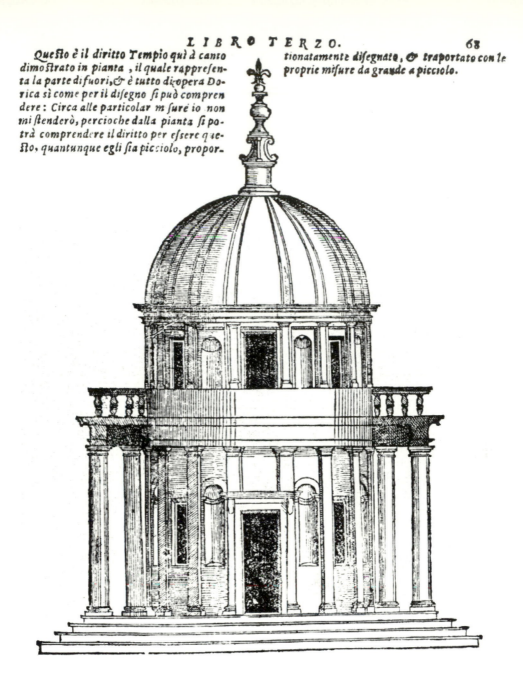

1 4 *Ho dimo-*

4 Bramante's Tempietto: the church of S. Pietro in Montorio in Rome (c. 1505), from Sebastiano Serlio, *Tutte L'Opere di Architettura* (1619). 'That sacred temple made in the image and likeness of God' (p. 70).

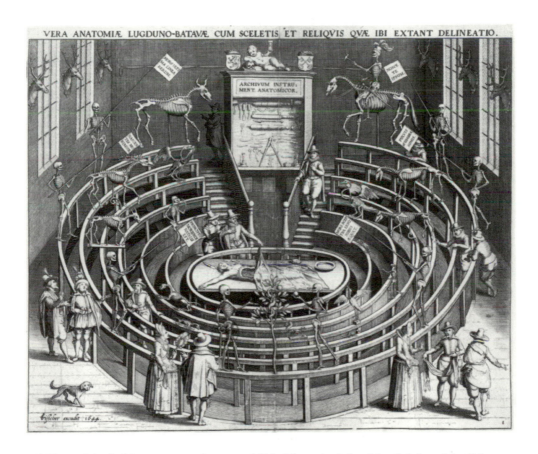

5 View of the Leiden anatomy theatre c. 1610. 'The principle of death is born' (p. 74).

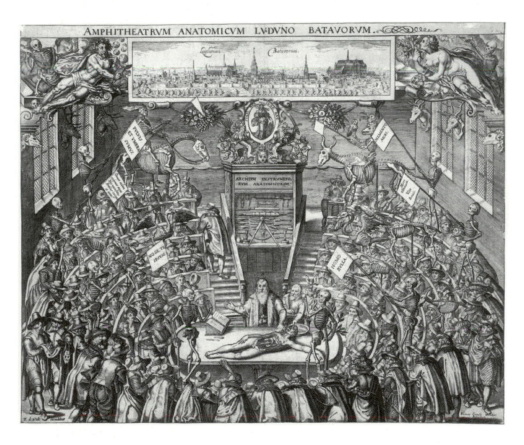

6 View of the Leiden anatomy theatre c. 1609. 'The principle of eternal life' (p. 75).

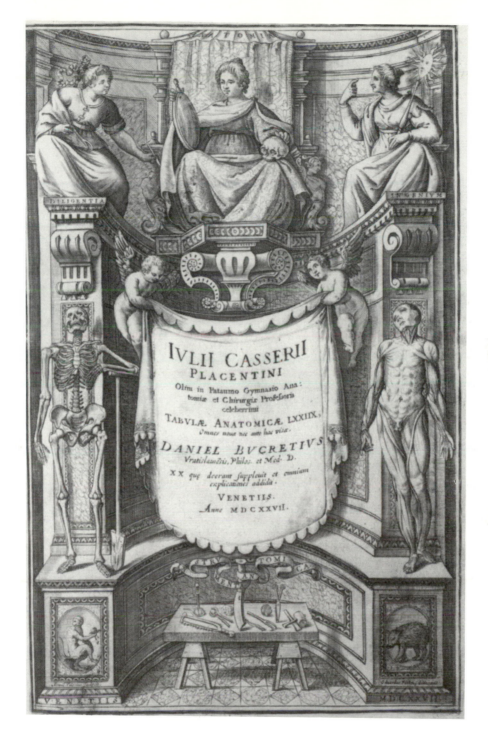

7 Title-page from Julius Casserius, *Tabulae Anatomicae* (1627). 'A reminder of the self-knowledge gained through the reflective discipline of anatomy' (p. 73).

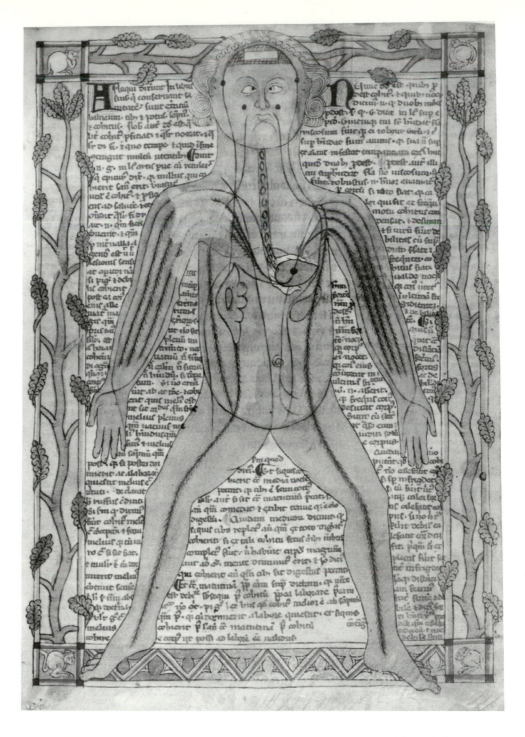

8 Arterial figure (thirteenth century) from MS Ashmole 339 (Bodleian Library). 'An opaque body, super-imposed on top of the text' (p. 134).

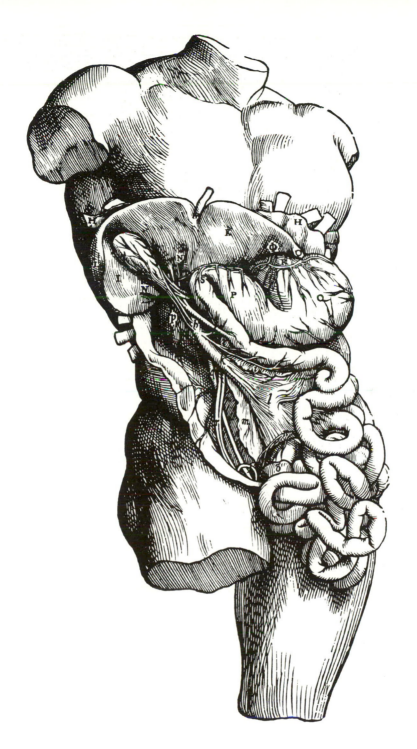

9 Dissected torso from Vesalius, *De Humani Corporis Fabrica* (1543). 'Alive and . . . at the same time . . . no more than carved stone' (pp. 101–2).

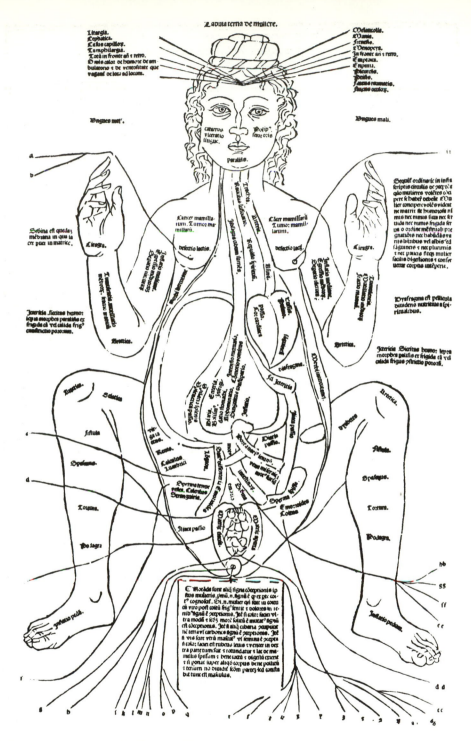

10 Gravida figure from de Ketham, *Fasciculus Medicinae* (1491). 'In sorrow thou shalt bring forth children' (p. 105).

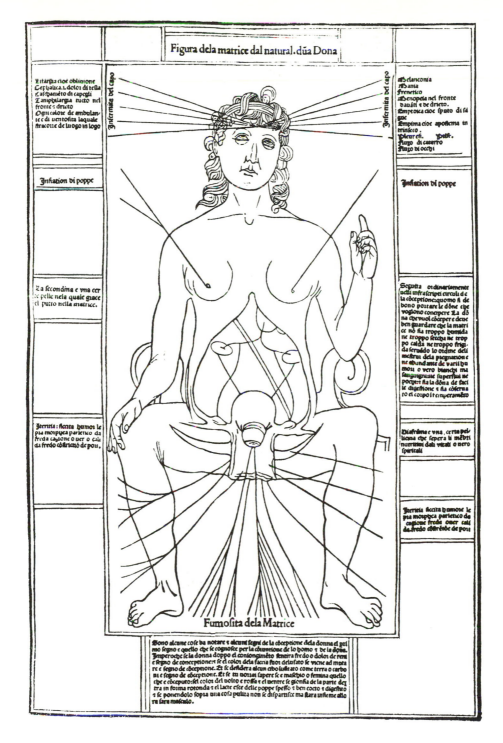

11 Gravida figure from de Ketham, *Fasciculo de Medicina* (1493). 'A growing division and specialization of knowledge' (p. 134).

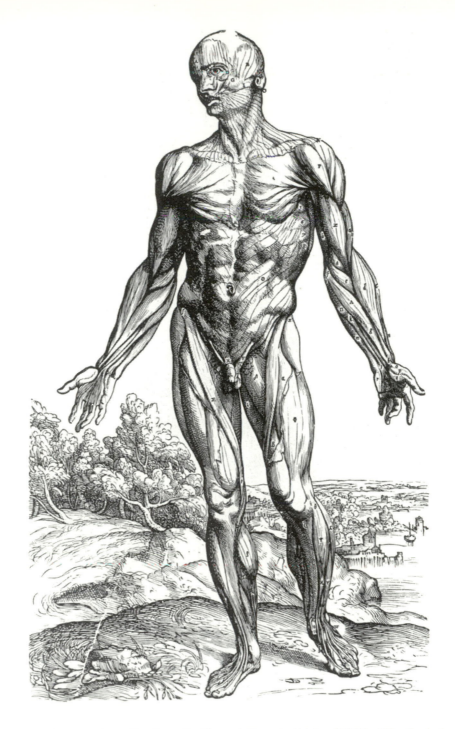

12 Dissected figure from Vesalius, *De Humani Corporis Fabrica* (1543). 'The body is an accomplice to . . . the dissective process (p. 112).

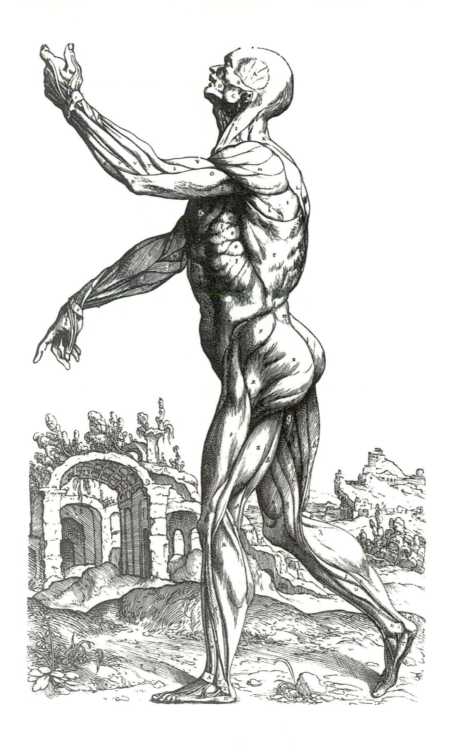

13 Dissected figure from Vesalius, *De Humani Corporis Fabrica* (1543). 'The social world was ... equally subject to the devouring force of time and death' (p. 115).

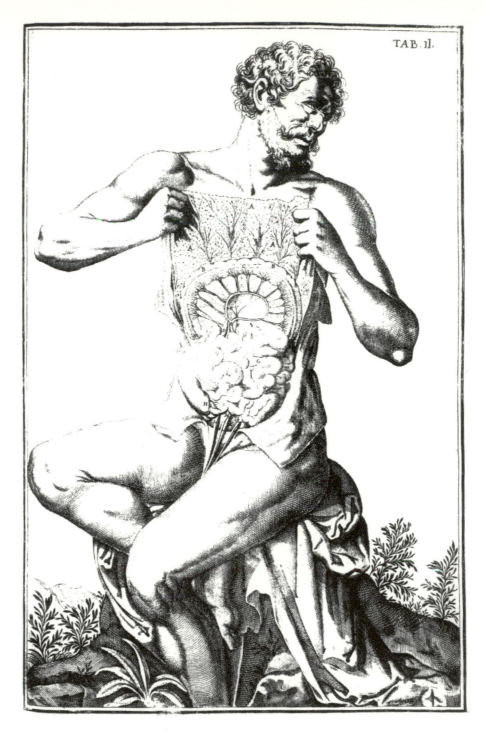

14 Self-demonstrating figure from Spigelius, *De Humani Corporis Fabrica* (1627). 'Representative of the convention of self-dissection' (p. 113).

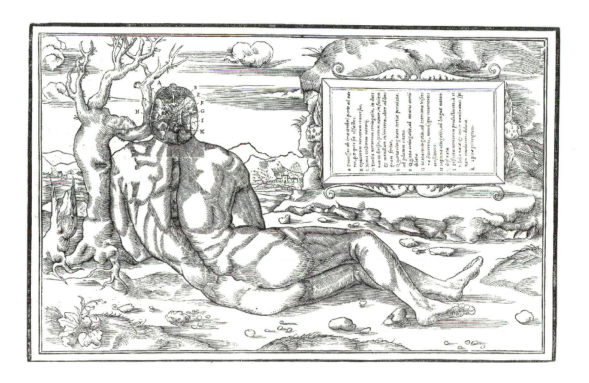

15 Dissected figure in a landscape from Charles Estienne, *De dissectione* (1545). 'An assertion of the naturalness of the fate which has overtaken the body' (p. 116).

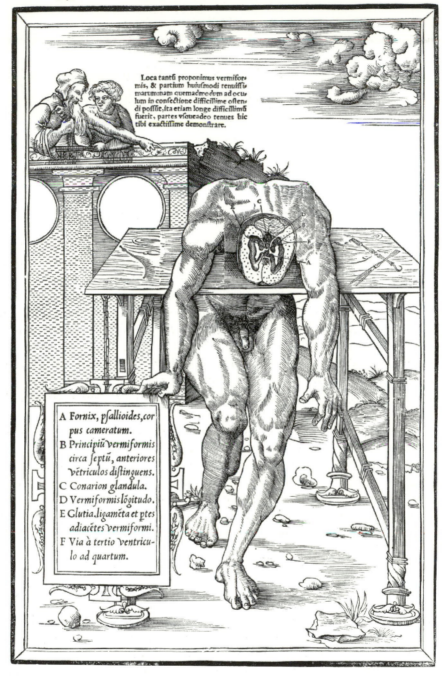

Loca tantū proponimus vermifor-
mis, & partium huiufmodi tenuiffi-
marum:nam quemadmodum ad ocu-
lum in confectione difficillime often-
di poffit,ita etiam longe difficillimū
fuerit, partes vſeueadeo tenues hic
tibi exactiffime demonftrare.

A Fornix, pſallioides,cor
 pus cameratum.
B Principiū vermiformis
 circa feptū, anteriores
 vētriculos diſtinquens.
C Conarion glandula.
D Vermiformis lōgitudo.
E Glutia.ligamēta et ptes
 adiacētes vermiformi.
F Via à tertio ventricu-
 lo ad quartum.

16 Brain dissection from Charles Estienne, *De dissectione* (1545). 'The body echoes the
juxtaposition of a maintained . . . and a ruined fabric (p. 117).

THE BODY IN THE
THEATRE OF DESIRE

GENERATIONS OF KNOWLEDGE

We are accustomed to think of the 'anatomical Renaissance' of the sixteenth and seventeenth centuries in Europe as a triumph of rational enquiry which heralded a 'modern' or 'scientific' understanding of the human frame.[1] The age of Vesalius and, later, Harvey, marked the production of ever more 'accurate' maps of the body's processes, maps whose representational validity is daily tested by twentieth-century western surgeons and physicians. The history of this discovery of the body is, above all, a cumulative project, with each generation of observers standing, metaphorically, on the shoulders of the previous generation. We should pause over this map of cultural transmission for a moment for what it tells us of our own desire to establish authority, precedent, and certainty.

Knowledge of the human body, in this schema, is patrilineal. It was rooted in the classical medicine of Alexandria in the third century BC, amplified by Galen, and then transmitted by his followers in the second century AD. Following the capture of Alexandria by the Arabs in 642, medical knowledge became the preserve of the arabic 'commentators' who reached the height of their influence under the caliphs of Baghdad in the ninth century. From thence, translated from arabic into latin, medical knowledge was passed to the school of Salerno in the tenth and eleventh centuries, where it spread outwards so that, by the thirteenth century, four major centres of medical teaching were flourishing in Europe: Salerno, Bologna, Montpelier, and Paris. With the fall of Constantinople in 1453, and the subsequent influx into western Europe of Greek scholars, the Graeco-arabic tradition was extended by the humanists who, for the first time since the age of Galen, were able to recover Greek medical texts in all their original 'purity'. But with this recovery of the original writings of Galen, a contradictory challenge to Galenic authority was mounted; one that called into question the wisdom of accepting the tenets of ancient medicine without also testing classical writ against the experience of the body itself. It was at this point, in the early

sixteenth century, first with the dissemination and ultimately with the questioning of Galenic medicine under the humanists and their successors – Günther of Andernach in Paris, John Caius in Cambridge, and, of course, Vesalius and his followers in Padua – that the conditions for an 'anatomical Renaissance' were established.[2]

This patrilineal diagram of understanding, with medical knowledge passed from father to son in a line of descent, was roughly the diagram with which sixteenth-century commentators and investigators worked. It was, it need hardly be said, a determinedly Euro-centric model in which the achievements of arabic medicine were subsumed under the category 'transmission', and each 'transmitter' was judged on the extent to which they had succeeded or failed in passing on a text which was linguistically 'pure', that is 'uncorrupted' by the thoughts and opinions of the commentator with access to the Greek 'original'. The comments of an English Galenist and anatomist, Thomas Gale, in the 1560s, were representative of this mode of thinking. Having surveyed the supposedly mythic origins of medicine in the esoteric writings of Hermes Trismegistus, and traced this revealed knowledge via Chiron, Apollo, and Aesculapius to the writings of Hippocrates and Galen, Gale offered a summary of the contributions of Abu Ali ibn-Sina (Avicenna) and Graeco-arabic commentators on the Galenic tradition. For Gale, these authorities have failed or succeeded only according to the extent that they have remained true to their Greek progenitors. Ali ibn al-Abbas al-Majusi, for example, known to the west as Haly Abbas, the first to attempt to offer an account of medicine in its entirety in producing the *Kitab al-Maleki*, which became the source of the *Liber pantegni* of Constantine the African in the eleventh century, was glossed over. Similarly, Albucasis, whose treatise on surgery *al-Tasrif* was used extensively in Europe throughout the middle ages, was all but ignored. For Gale, these figures are simply shady precursors of the great European teachers of the thirteenth and fourteenth centuries: Lanfranc, Henri de Mondeville, and Mondino de' Luzzi. Gale and his contemporaries thus stood as the heirs to an unbroken tradition of knowledge which, though it wandered like Odysseus, was ultimately to be traced to an origin which was divine rather than human, western rather than oriental. As Gale observed:

> All these which I have spoken of, of what countrie so ever they were, they tooke their originall and foundacion, of our Father Hippocrates, and Galen, although they found out many thinges, appertaining to the arte of medicine . . . all these men of what countrie so ever they were, they have drunk of the water that flowed out of their [Hippocrates' and Galen's] wells.[3]

Gale's model of knowledge of the body was structured around the polarities of finding and losing. The west once 'knew' the body, but 'lost' that

knowledge to the east.[4] Only with the reintegration of eastern knowledge into western systems of affiliation, could knowledge and understanding be held to be, once more, within a public domain. What is reproduced here is a model of transmission which accords, strikingly, with that which Edward Said has mapped for European humanistic knowledge in general. The authority of such knowledge, Said writes, 'comes not only from the orthodox canon of literary monuments handed down through the generations, but also from the way this continuity reproduces the filial continuity of the chain of biological procreation'.[5] Or, as Thomas Gale writes, it is the authority of the twin fathers, the 'originall and foundacion', which each generation inherits from its predecessor.

There are signs here of an Oedipal struggle at work. The combination of a doubly fathered masculine western knowledge of Greek medicine married to the passive, eastern tradition of transmission, in order to reproduce the humanist scholar as heir-apparent to 'science', is an uncomfortable union. Does the humanist lapse into veneration of his forefathers or does he strive to displace them? At what point must the 'originall and foundacion' be challenged? It is this painful rite of passage, one of denial, on the one hand, and recovery, on the other, which structures western medicine, and particularly western anatomical knowledge in the early-modern period. As we shall see, this struggle was one of a number of such confrontations which took place in the anatomy theatres of Europe in the sixteenth and seventeenth centuries.

Immediately, then, we can see how the body could be the scene of a particular kind of tension in the sixteenth century in which these regimes of knowledge could be tested. Are there, though, alternative ways of understanding the 'anatomical Renaissance' which emerged from this conflict? The patrilineal model, sketched above, silently passes over the wider, cultural or technological influences on this process of repetition and transmission. Yet, historians of medicine have certainly come to ask what part was played in the phenomenon of the 'anatomical Renaissance' by such factors as population growth, commercial links, increased access to the technology of print and the growth of literacy, the development of urban economies, the rise of professional organizations, and the influence of religious debate in western Europe.[6] Such factors, the cultural base upon which the medical superstructure was raised, are, if not inherent within the patrilineal model, then at least as important to our historical understanding as the skills of the translators and codifiers of the early sixteenth century. But even when these factors are taken into account, have we explained in any way the extraordinary fascination with the operation of their own bodies which seemed to possess the imagination of Europeans during the 'age of discovery'? Why, in Bologna, Padua, Paris, Marburg, Leiden, Amsterdam,

and London did crowds flock to the anatomy theatres to see, with their own eyes, bodies dissected?

These crowds, which made up the audiences at anatomy demonstrations in early-modern Europe, were not composed solely of students of medicine and members of the medical profession. Rather, they were the fashionable, educated elite, members of the court, wealthy merchants, senior administrators, even princes themselves. At Bologna, for example, where representatives of the civil authorities, the papal power, and the spiritual church would gather to witness dissections, public notices were posted indicating the day and time at which anatomical demonstrations would take place.[7] Equally, no educated English traveller, in the late sixteenth and early seventeenth centuries, making a journey through Holland and the Low Countries, would neglect to pay a visit to the famous anatomy theatre at Leiden University, as did John Evelyn in August 1641, when he wrote in his diary that 'amongst all the rarities of this place, I was much-pleased with the sight of the anatomy-school, theatre and repository adjoining.'[8] The Leiden theatre, perhaps because of its very extravagance, seized the imagination of those who visited it. In 1651, when Sir William Davenant published *Gondibert*, the Leiden theatre was to become the model for the 'Cabinet of Death' to be found in 'the house of Astragon', Davenant's vision of a utopian scientific community.[9] Equally, the anatomy theatres at Bologna and Padua rivalled the classical antiquities in their attraction to foreigners. English travellers, returning to their own country from the continent, sometimes expressed dismay that public anatomical dissections did not flourish to the extent that they were encouraged abroad. In 1627, George Hakewill, the influential controversialist and Oxford divine, remarking that no public anatomical demonstrations had been offered at Oxford until 1624, complained of his own university: 'I have not a little wondered . . . that an universitie so famous in forraine parts as this of Oxford, was never to my knowledge provided of a publique lecture in this kinde, till now.'[10] Similarly, in 1649, John Hall, the poet and the friend of Hobbes and member of the Hartlib circle, demanded: 'Where have we constant reading on either quick or dead *Anatomies*?' and thus registered his dissatisfaction with the occasional demonstrations given at the College of Physicians and the Hall of the Barber-Surgeons in London.[11] The anatomy theatre was a register of civic importance, an index of the intellectual advancement of the community, an advertisement for a city's flourishing cultural and artistic life. 'It may be chance', Richard Wilson has observed, 'that the best preserved Renaissance play house is the Anatomy Theatre . . . at Padua.'[12] Certainly there was a cultural conjunction between the two sets of auditoria which indicates the *symbolic* importance, as much as the intellectual utility, of the anatomy theatre in early-modern urban communities. It was this kind of importance which prompted Samuel Hartlib, in

1659, to promote a translation into English of a Dutch proposal by Louis de Bils to establish an anatomy theatre and collection at Rotterdam. The translation was undertaken as a means of consolidating in England 'that reputation for Anatomicall discoveries and skill that this nation hath of late deservedly enjoy'd'.[13] If Rotterdam was to have an anatomy theatre to rival those at Leiden and Amsterdam, then should not London have another to complement the dissection halls of the Physicians and Barber-Surgeons? Understanding of the body, particularly in England after the civil war and Restoration, begins to appear as a source of national prestige, the equivalent, perhaps, of today's 'Big Science'.

In trying to provide an answer as to why anatomy seemed to exert such a fascination, and why communities were willing to put themselves to the considerable expense of building the ornate structures which were the Renaissance anatomy theatres of Europe, we have to step outside the patrilineal model of intellectual history. We have to cross the boundary into an altogether more intangible world of imaginative and symbolic desire, where ritual, intellectual curiosity, and the sovereign rites of justice and punishment, merge into a fascination with the human interior which begins to appear to us as much darker, much more morbid even, than can be suggested by the clear lines of affiliation and descent of knowledge from one generation to the next, mapped by the humanists themselves.

JULIET AMONGST THE ANATOMISTS

Philipe Ariès, the historian of death and childhood, describes the rise of anatomical science in the seventeenth century in the following way:

> The almost fashionable success of anatomy cannot be attributed solely to scientific curiosity. It is not hard to understand; it corresponds to an attraction to certain ill-defined things at the outer limits of life and death, sexuality and pain.[14]

Ariès goes on to suggest that, in the nineteenth century, a fascination with such 'ill-defined things' became categorized as 'disturbing and morbid phenomena', a union of Eros and Thanatos which, though conceived in the late fifteenth and early sixteenth centuries, was not named until 'the clear-cut moralities of the nineteenth and twentieth centuries' began to look more closely at the underlying psychological impulse behind the urge to delve into the body's dimensions. In Ariès's account, it is the location of a 'fashion' for anatomy within a larger, imaginative, exploration of the dimensions of sexuality and pain which is of potential interest. Such a determined placing of the anatomist's endeavours outside a purely utilitarian or rationalist frame of reference has the effect of making us question a conventional diagram of

the history of science, in which the exploration of the human body is held to be a discrete undertaking, divorced from wider, perhaps disturbingly unscientific, cultural phenomena. But the problem which is then posed is this: to what, precisely, does the imaginative construction of dissection answer? We might go further. Is it possible to conceive of a 'poetics of dissection', an imaginative construction of anatomy which fed upon the emerging scientific exploration of the human frame, a science which in the Renaissance was in its infancy, whilst it also lent to that science devices associated with art, poetry, and architecture, by which anatomy was to be incorporated into the canons of human enquiry?

The 'fashion' for anatomy in the Renaissance, once we begin to look outside the boundaries of texts which we would now term 'scientific', is everywhere apparent. The plethora of works which appeared in England in the late sixteenth and early seventeenth centuries containing the word 'anatomy' in the title, testify to this sudden, and seemingly overwhelming, fascination. 'Anatomy': the very word was a modish phrase, a guarantee of a text's modernity. John Lyly's *Euphues: The Anatomy of Wyt* (1578), Philip Stubbes's *Anatomy of Abuses* (1583), Thomas Nashe's *Anatomie of Absurditie* (1589) and of course Robert Burton's *Anatomy of Melancholy* are perhaps the most famous examples of an urge to appropriate the language of partition. But these texts, significant as they are to literary historians, represent only a small proportion of the numerous 'anatomies' which began to appear after the 1570s. Religion, death, women, time, war, sin, the soul, the individual, and, especially in England, catholicism, all could be, in some way, 'anatomized'.[15] Was it the possibility, as Walter Ong has suggested, of developing 'spatial models for thought' through the presentation of knowledge as a 'Body', which encouraged this 'fad of performing intellectual anatomies', or was it something perhaps more simple, but much more spectacular?[16]

Appropriately, and following Richard Wilson's hint of the conjunction between the anatomy theatre and the playhouse, we might begin our search for the root of this fascination with the stage rather than the dissection table, and with a later rather than an earlier text. On Saturday 14 November 1696 Edward Ravenscroft's *The Anatomist or The Sham Doctor*, a play largely based on a French farce *Crispin Médecin* (1674) by Noël Le Breton, was first performed at the New Theatre in Lincolns Inn fields in London. Ravenscroft's *The Anatomist* was, in the words of contemporary commentators, an 'extraordinary . . . prosperous success' which 'pleases the Town extremely'. The play was performed (together with Peter Motteaux's *The Loves of Mars and Venus*) during the following week before an appreciative audience. Thereafter the play was rarely absent from the London stage, being pro-

duced at regular intervals throughout the eighteenth century, until its popularity began to decline in the 1790s.[17]

What ensured the popularity of a play which, on the surface, might strike today's reader as a somewhat slight piece? It is true that *The Anatomist* deploys the conventional cast of stereotypes – the lecherous old man, the spendthrift son, the faux-naïf daughter, the scheming maid and man-servant, the worldly-wise mother, the pompous father – with some skill and technical precision. The result is an energetic (if somewhat conventional) satire on sexual double standards, avarice, and cupidity. But it is neither the play's wit nor its comic invention which guaranteed the huge success that it enjoyed throughout the eighteenth century. Rather, I would suggest that it is the macabre presence on stage of a corpse which comes to life and protests against its own anatomization which drew the audience into the theatre.

Here an unlikely conjunction of dramatic texts becomes significant. Shakespeare, of course, had experimented with the device of 'resurrection' in a number of plays. *Othello, The Winter's Tale, Pericles*, and, above all, *Romeo and Juliet*, were plays which featured the revivification of female figures, as though death was to be understood, in some measure, as a liminal state. *Romeo and Juliet* was to be especially significant in this context. In 1748 David Garrick staged his revival of *Romeo and Juliet* in a form which bore little relation to the 'Shakespearean' text we have inherited. A few years later, in 1756, we find Garrick's *Romeo and Juliet* performed alongside Ravenscroft's *The Anatomist*.[18] Such a juxtaposition may strike us today as being tasteless in the extreme. Yet there is something peculiarly apposite in such an unlikely conjunction when it is replaced within the cultural matrix of the early-modern theatre. Throughout the eighteenth century, *Romeo and Juliet* was performed as an elaborate hymn to erotic death. In Garrick's version, the final act was preceded by an ornate staging of the 'funeral' of Juliet, and, as though to underline the liminality of the corpse, the lovers were allowed some sixty-five lines of dialogue with one another within the Capulet tomb. We can only guess at the effect of a theatrical event which would have followed such an orchestrated hymn to the erotic spectacle of a dead woman, with Ravenscroft's *The Anatomist*.

Had Garrick known Shakespeare's 'source' text – Arthur Brooke's *The Tragicall Historye of Romeus and Juliet* (1562) – the performance of *The Anatomist* and *Romeo and Juliet* would have struck him as being all the more significant. For, in Brooke's version of the story, the climax of the play within the Capulet tomb is invested with a fear not just of death or premature burial, but with a literal dismemberment of the living by the dead which is suffused with morbid eroticism of the kind which Ariès has isolated. As Brooke's Juliet contemplates her descent into the tomb, for example, she

imagines the carcass of Tybalt by whose side she is to be laid. Seized with dread, her living body seems to anticipate an icy after-life:

> A sweat as colde as mountaine yse, pearst through her tender skin,
> That with the moysture hath wet every part of hers,
> And more besides, she vainely thinkes, whilst vainely thus she feares,
> A thousand bodies dead have compast her about,
> And lest they will dismember her, she greatly standes in doubt.[19]

Shakespeare's text, though it did not evoke the dismemberment of Juliet which Brooke had imagined as he translated his Italian source, also conjured with the potential eroticism of the grave into which Juliet had descended. For Romeo, contemplating the 'dead' Juliet, the corpse is an idealized spectacle of female beauty, a focus of a desire which manifests itself in necrophilous jealousy:

> Ah, dear Juliet,
> Why art thou yet so fair? Shall I believe
> That unsubstantial Death is amorous,
> And that the lean abhorred monster keeps
> Thee here in dark to be his paramour?
> (*Romeo and Juliet*, V.iii.101–5)

Unlike *Romeo and Juliet*, however, Ravenscroft's play was a comedy. It was as if, having evoked the morbid fascination of the audience with the spectacle of the dead Juliet, the eighteenth-century impresarios diffused that energy with a comic variation on a related theme. Such comic investment in a corpse was not to be seen again on the London stage until the belated appearance of Joe Orton's *Loot* in September 1966, a play whose treatment of what Orton termed the 'taboo ingredients' of death and its associated rituals challenged the Lord Chamberlain's office (in December 1964) to withhold a licence until the treatment of the body in the play was more seemly.[20] What might be termed (anachronistically) an Ortonesque motif lies at the centre of *The Anatomist*: an image of death and resurrection concealed behind the masque of comic burlesque, innuendo, and deviously cynical manipulation.

The role of corpse, in Ravenscroft's drama, conceals criminality, duplicity, and licence, which the play sets out to dissect. The corpse is a focus of attention, a site of investigation, a field in which to demonstrate technical skill (or lack of it), and, crucially, a place of refuge from the outraged guardians of sexual morality. But the shelter which the corpse offers is flimsy, since it is constantly in danger of being opened, in much the same way that each of the characters risks being publicly laid open to the gaze of a morality which should condemn the pursuit of pleasure and wealth. The traditional *vanitas* image of the corpse, therefore, where the dead human body stands

46

as a silent admonition against the unalloyed pursuits of the flesh, is inverted so that it is only by actively becoming the corpse that it is possible to reach out for pleasure or money. To obtain the delights of the flesh, the play seems to say, we first have to be willing to become flesh. And once we are flesh, what happens when the anatomist catches our eye?

The play's energy rests on the willingness of individuals to become corpses in the pursuit of pleasure. Set against this ironic form of surrender to the flesh, the fear of exposure, division, and partition, is embodied (literally) in the expressed horror of dissection; horror which seems like a comic refocusing of Juliet's horror of dismemberment in Shakespeare's source:

CRISPIN.	I beg your pardon, I'll stay no longer in this room.
BEATRICE.	Why so?
CRISPIN.	The very thought of that damn'd Incision Knife puts me into a cold sweat. I'll stay for you in the street.
BEATRICE.	Away, you Sot.
CRISPIN.	I had rather be a Sot than an Anatomy, I will not have my flesh scrap'd from my Bones. I will not have my Skeleton in Barber-Surgeons-Hall.
BEATRICE.	Stay but a little.
CRISPIN.	Yes in the street. There I shall not be in danger of your damn'd Amputation Knife, and your Dismembering Saw, with a Pox to him.
BEATRICE.	Alas! Poor Crispin.
CRISPIN.	Fear makes me think everything. I see an instrument to rip me up from the Systole to the Dyastole.
BEATRICE.	He had a mind to be acquainted with your inside, Crispin.
CRISPIN.	The Devil pick his Bones for't. I shall never recover myself till I get out of this cursed place.[21]

Harvey's pursuit of knowledge of the workings of the heart has, here, been comically refocused as a ripping up of the body 'from the systole to the dyastole'. Perhaps, too, there is another Shakespearean moment lurking within Ravenscroft's appropriation of the language of dissection. The first appearance of Macbeth summons up the spectre of a grim dissector of rebellion, who 'with brandish'd steal' leaves his opponent 'unseam'd ... from the nave to th'chops' (I.ii.17–21). In Ravenscroft's drama, however, the audience are reminded that the 'curious mechanism' now being opened by science rather than retributive justice (though the two were allied, as we shall see) is also a human being. But human beings have to be punished, and that is the secondary purpose of the anatomy lesson. Within this punitive framework, punishment and public dissection are twins, continually linked to one another in the course of the play. Indeed, the play itself is offered, in the epilogue, as a kind of body upon which the audience are invited to pronounce as though they were judicial anatomists. The epilogue (in the first performances of the play) was spoken by the actor playing the part of

Crispin, who, in earlier scenes had narrowly escaped anatomization. It begins:

> Good People! Save the Body of our Play,
> From those who to dissect it Yonder stay,
> Like Surgeons on an execution day.
> Ev'n e're it dyes they'll mawl it, I'm afraid;
> And you'd think't hard, like me, in such a dread,
> To be dissected, e're you're hang'd, and dead.[22]

To be dissected before death is, metaphorically, a fate peculiar to a play-wright. But, when *The Anatomist* first appeared, and throughout its eighteenth-century history, the play answered to a popular fascination which revolved around the ambiguous figure of the surgeon-anatomist whose servants were, in reality, to be found at the numerous execution scenes which took place in London (and in every other centre of medical education in Europe) throughout the early-modern period, waiting to claim the dead for the anatomy theatres. The popularity of *The Anatomist* hinges on this actuality; the theatrical performance of the post-execution anatomization has entered the theatre itself.

But had it ever left the theatre? The popular dread of dissection has been traced by Ruth Richardson, in her *Death, Dissection and the Destitute*, to the passage of the 1832 Anatomy Act, which empowered the authorities to confiscate the bodies of dead paupers for dissection. This act superseded the 1752 Murder Act which sanctioned 'penal dissection' as a specific form of punishment subsequent to execution.[23] Richardson's remarkable work, with its focus on nineteenth-century anatomical culture, inevitably glosses over the earlier period which is our concern. Long before the passage of the 1752 Act, however, bodies were being transported from the scaffold to the anatomy theatre. This spectacle, as we shall see, could indeed give rise to popular horror of the kind described by Richardson. But at what point does fear give way to fascination, and even a form of desire, or, to use Ariès's terms, 'the attraction of ill-defined things'? We can see, for example, desire and horror surfacing in Thomas Nashe's *The Unfortunate Traveller* (1594) when Jack Wilton, the fictional narrator, is sold by his creditor Zadoch to Doctor Zacherie as a possible candidate for the anatomy slab in Rome. Wilton is examined by the anatomist, purchased, and then locked up to await dissection:

> Oh, the cold sweating cares which I conceived after I knew I should be cut like a French summer doublet! Methought already the blood began to gush out at my nose. If a flea on the arm had but bit me, I deemed the instrument had pricked me. Well, well, I may scoff at a shrewd turn, but there's no such ready way to make a man a true Christian as to persuade himself he is taken up for

an anatomy. . . . Not a drop of sweat trickled down my breast and my sides, but I dreamt it was a smooth-edged razor tenderly slicing down my breast and my sides. If any knocked at the door, I supposed it was the beadle of Surgeon's Hall come for me.[24]

Crispin's 'cold sweat at the thought of that damn'd incision knife' in *The Anatomist* had been anticipated, by at least one hundred years, by Wilton's 'cold sweating cares' at the prospect of being transformed into the stuff of a tailor's workshop. And beyond Nashe, and Ravenscroft, lay Arthur Brooke's Juliet with her 'sweat as cold as mountain yse' at the thought of the living dismemberment she might have to endure in the Capulet tomb. Separating the two earlier texts from the historically later text of Ravenscroft, however, is the triumph of the anatomists over the body. Brooke, Nashe, and Ravenscroft might be thought of, then, as bracketing the complete discovery and subjection of the body to science within a parenthesis of fascinated horror.

Nashe and Ravenscroft knew their audience. They knew, too, that in evoking the spectacle of penal dissection they were drawing upon a set of morbid fears which could easily be transformed into a set of barely suppressed desires. This combination of fascination and horror was a highly visible part of the metropolitan culture Nashe and Ravenscroft sought to depict. What they had alighted upon was the possibility of reanimating an object which the anatomists had transformed into a commodity. What would it feel like, they ask, to be dissected? Imagining one's own dissection was a compositional device unique to early-modern culture. Not even Edgar Allen Poe (whose dread of premature burial was matched only by his fascination with the possibility of liminal existence) was to portray the subject with quite the intensity of his sixteenth- and seventeenth-century precursors. Jack Wilton, in Nashe's text, is alive to a moment of sexual frisson – a hint of transgressive desire – in his sensual dreams of the 'smooth-edged razor tenderly slicing down my breast and my sides'. Such dreams of dissection surfaced in other texts of the period. Can there, for example, be any love poem whose opening lines seem more tastelessly calculated than these with which the poem known as 'Gascoigne's Anatomie' (*c.* 1573) begins?

> To make a lover knowne, by plaine Anatomie,
> You lovers all that list beware, lo here behold you me.
> Who though mine onely lookes, your pittie wel might move,
> Yet every part shal play his part to paint the pangs of love.[25]

Yet, there is a peculiarly appropriate quality to the image when we recall the didactic power of the anatomized cadaver to hold the attention of an

audience. What is more searchingly difficult to accommodate is the union of sexual desire and anatomization, the oscillation between *memento mori* and *memento amore* glimpsed in Gascoigne's poem, or in a sonnet by John Davies of Hereford, published in 1605, where the speaker of the poem imagines that he has been transformed by his mistress into an anatomized corpse. The mistress is an adept at the *longeurs* of the dissection table, and displays, so the text has it, a remorseless pleasure in the slow dispatch of the speaking corpse who is left pronouncing on their union:

> Who have bin so Anatomiz'd by thee
> That every *Nerve* hath felt thy Rigors hand!
> Out of my *Hart*, and *Braines* that hand hath squiz'd
> The *Spirits* that either *Life*, or *Sence* maintain[26]

To feel the hand of the dissector is to arouse a shiver of erotic anticipation, a (necessarily momentary) vista of desire. The mistress is 'Rigor' personified – rigour, and rigor mortis – a dream of death which can 'squeeze' the body in uniquely pleasurable ways.

Predictably perhaps, John Donne, in his poems of the 1590s, could rarely resist the compulsive attraction of the dissection slab. Imagining his own posthumous dissection ('The Dampe') was paralleled by an intense curiosity as to what, exactly, the insides of his own love-tormented body would look like once it was laid open ('The Funerall'). In 'A Valediction: Of My Name in the Window' Donne transformed his own scratched name ('this ragged bony name') into 'My ruinous Anatomie' – an act of apparent self-abasement which simultaneously managed to preserve his influence upon the window flung open by the woman to admit new lovers, whilst dispersing his physical presence in an anatomical tumble of 'body, bone/. . . muscle, sinew, and vein' (Donne, *Poems*, 24). In the poem 'Loves Exchange' we are returned to the penal dissection table, onto which the poet seems to have voluntarily clambered to await his partition as an example to future lovers:

> If I must example bee
> To future Rebells; If th'unborne
> Must learne, by my being cut up, and torne:
> Kill, and dissect me, Love; for this
> Torture against thine owne end is,
> Rack't carcasses make ill Anatomies.
> (Donne, *Poems*, 32)

There is, here, a disturbingly literal quality about Donne's evocation of the grim ritual of post-execution dissection; 'rack't carcasses', bodies, that is, which had felt the full weight of proof by torture prior to execution, or which had endured the terrible sentence of drawing, hanging, and quartering,

would indeed have made 'ill anatomies'.[27] But equally disturbing is the glimpse of erotic desire which the spectacle of penal anatomy appears to have promoted. What is vital to this macabre theatre of punishment is that the subject actively seeks his or her own dissection. The passivity of the corpse on the dissecting table is not merely attractive, but an expression of a desire for the most complete subjection to the 'rigour' of punishment.

Such erotic dreams of partition lingered in poetic texts until well into the seventeenth century. So, amongst the series of poems Richard Lovelace addressed to his mistress 'Lucasta' in his 1659 collection, we find a masturbatory dream of death and dissection which echoes Donne's pose of voluntary surrender to the enquiring knife of the mistress-anatomist. Unable to sleep for thoughts of his Lucasta, Lovelace's restless poetic persona engages in a fetishistic evocation of the crucifixion and resurrection:

> Now on my Down I'm toss'd as on a Wave,
> And my repose is made my Grave;
> Fluttering I lye,
> Do beat my Self and dye,
> But for a Resurrection from your eye.

But when the mistress appears, the promised resurrection and retumescence has become suddenly unattainable. Deeper levels of physical dissolution are required, levels which can only be reached with the aid of the anatomist's knife:

> Ah my fair Murdresse! Dost thou cruelly heal,
> With Various pains to make me well?
> Then let me be
> Thy cut Anatomie,
> And in each mangled part my heart you'l see.[28]

The mistress has become the recipient of a projected fantasy of dissection. Only by voluntarily accepting the most complete form of physical surrender which can be imagined, and which involves the transformation of the beloved into a nemesis with a scalpel, is the poem able to demonstrate the truth of the desire which has been expressed. It is only when he is her 'cut Anatomie' that each part will, metonymically, demonstrate the desire of the whole.

What I have termed the 'surrender' in these texts to anatomy is akin to the oscillation of desire uncovered in sado-masochistic exchanges between the urge to dominate and be dominated.[29] That is not, of course, to deny that these texts might also exist as extreme participants in the elaborate Petrarchan game of self-abasement before the beloved object which was so much in vogue in the sonnet sequences of the late sixteenth century.

Anatomized lovers are, quite clearly, logical extensions of that urge towards self-reduction which is evident in, say, Sidney's *Astrophil and Stella* (1591) where a characteristic pose of the love-torn narrator is that of a willing victim in the ornate and delicate strife of Love. Within this convention, the reduction of the lover by the mistress is, if rarely a consummation, then at any rate devoutly to be wished:

> On *Cupid's* bow how are my heart-strings bent,
>> That see my wracke, and yet embrace the same?
>> When most I glorie, then I feel most shame:
> I willing run, yet while I run, repent.[30]

Thus, Astrophil is frozen into a delicious and quivering immobility (akin to the 'fluttering' and beating self of Lovelace's poem) at the very thought of Stella. But the phrase 'heart-strings', a conventional poetic trope, is suddenly reanimated within an anatomical context. On the anatomy table, the subject's body was indeed 'bent', but within the anatomic poem, the male subject was able to perceive (and embrace) his 'wracke' which was both gloriously displayed whilst it was shamefully reduced. The disembodied poetic voice which imaginatively sought (or commanded) its own reduction on the anatomy table was caught in a transitory process – an expression of liminality – which conforms to that state subsequently described by Freud in his work on masochism. Freud's analysis of masochistic desire helps us to understand these curious texts of partition, in which physical disintegration at the hands of the beloved gives way to a concentration on suffering for its own sake. The urge to endure such suffering, an urge rooted in the masochist's desire to provoke punishment from the last representative of the parent, results, says Freud, in 'the turning back of sadism against the self'. This compulsion, Freud concludes, 'has the significance of an erotic component' so that 'even the subject's destruction of himself cannot take place without libidinal satisfaction'.[31] Within such a diagram of self-reflexive violence, Ravenscroft's comic oscillation of characters who assume, alternately, the guise of dissector and dissectee, or Nashe's creation of sensual dreams of dissection (from which his narrator is rescued by his mistress), or the auto-anatomic impulses evident in the love poems we have briefly touched on, begin to appear as texts of self-abnegation in which anatomization is an expression of desire rather than horror.

But these texts are also imaginative exercises, not case histories. They are fictive expressions of desire, mediated by formal device and generic constraints, not direct manifestations of desire itself. It is at this point that the psychoanalytic explanation begins to appear, if not inadequate, then at least in need of some greater understanding of the culture which produced such

texts.[32] And it is at this point that we have to turn to an exploration of the dissective culture out of which grew these strange dreams of anatomy. What was it that took place in the anatomical theatres of early-modern cities which could have given rise to such acute longing, or such vivid dreams of punishment and partition?

4

EXECUTION, ANATOMY, AND INFAMY
Inside the Renaissance anatomy theatre

PUNISHMENT

'Penal dissection' – the codification by statute of a set of rules under which the corpse could be dismembered after death for the utilitarian investigation of the body's internal structure – is held to have begun, in England, with the passage of the infamous 'Murder Act' of 1752. The overt context for the passage of the 1752 Act was a response to a perceived break-down in law and order on the part of the authorities. What was needed, it was felt, was a punishment so draconian, so appalling, that potential criminals would be terrified at the fate which awaited them in the event of their detection. Clearly, simple execution was not enough. Some new horror was called for which would thwart delinquent desires on the part of the unruly metropolitan populace. Hence, the Act delineated the full, ferocious, outlines of the practice of 'penal anatomy'. Designed so that 'some further terror and peculiar mark of infamy be added to the punishment of death' (§1), and 'to impress a just horror in the mind of the offender and on the minds of such as shall be present' (§2), the Act provided for the execution of a capital sentence within two days of its pronouncement by the judge or magistrate.[1] Dissection was to be understood as a specific alternative to the other form of public display encouraged by the authorities – the gibbeting of the corpse after death (§5). Following the execution of the offender, providing that the execution had taken place in the environs of London, the body was to be 'immediately' conveyed by the sheriff or his deputies to:

> the Hall of the *Surgeons Company,* or such other place as the said company shall appoint for this purpose, and be delivered to such person as the said company shall depute or appoint . . . and the Body so delivered to the said company of Surgeons, shall be dissected and anatomized by the said Surgeons.

Whether the body was to be dissected or gibbeted, the Act was perfectly clear as to the express fate of the felon's body:

54

in no case whatsoever the Body of any Murderer shall be suffered to be buried; unless after such Body shall have been dissected and anatomized as aforesaid; and every such judge or justice shall, and is hereby required to direct the same either to be disposed of as aforesaid, to be anatomized, or to be hung in chains, in the same manner as is now practised for the most atrocious offences. (§5)

The Act concluded by prescribing a sentence of seven years transportation for anyone found guilty of attempting to remove the body after execution (§10).

The Act was designed specifically to evoke horror at the violation of the body and denial of burial to the offender. The denial of burial, in particular, was intended to evoke an added dimension to capital punishment, in that it drew upon widespread belief that lack of a proper burial was not merely a disgrace to offenders and their families, but involved the posthumous punishment of the criminal's soul which would not rest whilst the remains lay ungathered within sanctified ground.[2] Additionally, of course, the Act appeared to reintroduce to the spectrum of punishments available to the authorities something of the spectacle of public dismemberment, which had been the fate of traitors and other heinous offenders under the older Elizabethan and Jacobean dispensation. But the difference, now, was that public partition of the corpse, rather than being an act of violence performed on the criminal body on behalf of the wronged sovereign, was instead yoked to a greater public good. The criminal body was torn apart, but no longer in an attempt solely, as Foucault describes the drama of public execution, to reconstitute 'a momentarily injured sovereignty'.[3] In keeping with a rational philosophy of punishment, two birds were now to be killed with one stone: the demands of 'justice' (mingled with the prospect of deterrence) could be met, whilst, equally, the needs of 'science' could be fulfilled. The criminal could, even after the point of death, be made to perform a public service.

The passage of the 1752 Murder Act, however, rests on earlier practices. Indeed, the wording of the Act clearly indicates that it was no more than a legislative initiative which attempted to regulate a practice which was already in existence. Dissection or gibbeting was to be the sentence for those convicted of murder 'in the same manner as is now practised for the most atrocious offenders'. The net was simply being spread wider, whilst the Act also released professional medical men from participation, even by proxy, in a spectacle which had collapsed into little more than an undignified brawl. Long before 1752, 'penal dissection' had been part of the lexicon of punishments available to the authorities, though its precise legislative status was ambivalent. But on the part of those who witnessed capital punishment in the metropolitan centres of early-modern Europe,

55

the *symbolic* participation of the surgeon-anatomist in the complete ritual of judicial death was clearly apparent. This participation arose out of a purely utilitarian need on the part of the anatomists: their demand for bodies. Demand originated in various quarters. Dissections had been performed at the University of Oxford since 1549, when the University's statutes laid down that medical students had to see at least two dissections in the course of their studies. At Cambridge, Caius College was receiving two bodies a year for dissection by 1565. As early as 1505 the Guild of Surgeons and Barbers, in Edinburgh, was granted the body of one executed felon each year for the purposes of dissection. In London, the Act of 1540 which united the Companies of Barbers and Surgeons also provided for the supply of corpses for anatomization. Four executed criminals each year were granted to the new united company.[4] The College of Physicians in London was granted the right to dissect four criminal corpses in 1564/5, though anatomical lectures at the College, in the early years at any rate, were fairly rare events.[5]

These figures suggest that, prior to the early seventeenth century in England, the claiming of the felon's body from the hangman by surgeons or their representatives would have been a relatively infrequent occurrence. How visible such post-execution dissection might have been depends, clearly, on the number of executions which were performed in total in any given centre where anatomical instruction was also taking place. Statistics for the rate of execution in sixteenth-century England are difficult to determine with any real degree of accuracy. But if we confine ourselves to executions taking place in London at Tyburn, which was the source for most of the bodies for the Barber-Surgeons and the Physicians, a clear pattern seems to emerge. An average figure of 560 annual executions performed at Tyburn has been calculated for the final eleven years of the reign of Henry VIII – the period during which the 1540 Act providing for the supply of corpses to the Barber-Surgeons was passed.[6] Four corpses out of a possible total of 560 victims of the executioner suggests that dissection as an additional form of punishment would hardly have impinged to any great extent on the popular mind.[7] But as we move through the reigns of Edward VI (560 executions annually at Tyburn), Mary (280), Elizabeth (140), and James I (140), it becomes apparent that, gradually, as demand for bodies rose, and as the supply of bodies from the scaffold seems to have fallen, so the visibility of dissection must have increased.

The situation begins to alter in the seventeenth century. For example, as we have just seen, in 1564/5 the College of Physicians was allowed no more than four bodies each year from the scaffold. But by 1641, when an Act for the enlargement of the College's privileges was passed, the College was legally dissecting six criminal corpses each year. At the same time, the rates

of execution had dropped off considerably. In the year that the College was granted the right to six bodies, it has been suggested that no more than 90 executions were being performed annually in London and Middlesex. Not only were the Physicians hoping to secure bodies. The Company of Barber-Surgeons, and the two universities, were also anxious to obtain 'material'. Additional demand arose from the Royal Society which, under its charter of 1662, was given the right to obtain bodies for dissection. Furthermore, there is no means of ascertaining how many corpses were demanded for the private research of virtuosi anxious to participate in this new branch of knowledge, though the fact that there was such a demand is indicated by the strict rules governing private anatomies contained within the various statutes promoting dissection under the auspices of the Barber-Surgeons and the Physicians.[8] At the same time, other City guilds and companies, including the butchers, the tailors, and the waxchandlers, seem to have had a more than passing interest in obtaining bodies to develop the (lucrative) skills of embalming.[9] In other words, by the time we reach the period of Harvey in the mid-seventeenth century, when, as we saw earlier, intellectuals such as John Hall, Samuel Hartlib, and Robert Boyle were keenly promoting the importance of dissection, the anatomy theatre had become an increasingly likely destination for the body of the executed felon.

The rhythms of anatomy were governed by the progress of the seasons and the legal year. Given the absence of any form of preservative agent, anatomy was not a summer undertaking. The theatres could only be endured in cold weather. As Donne (again) sardonically observed in the first of his anniversary poems (1611), the 'body will not last out, to have read/On ever part . . . Nor smels it well to hearers' (Donne, *Poems*, 220). Legally, the anatomist had to await the various assizes before claiming material. This fact was specifically recognized in the ordinances governing the establishment in 1624 of the Tomlins Readership at Oxford, described by Frances Valdez as 'the first anatomical lectureship at a British university'. Under the rules governing the Tomlins Readership, dissections were to be arranged within two days of the Lenten Assizes. At other times of the year, anatomical demonstrations had to be given on osteology, or on another area of the lecturer's interest.[10]

For all the growing statutory provision for the supply of corpses for the anatomy tables, it is nevertheless possible to sense what might be termed a crisis in the provision of corpses for the various anatomy schools in the kingdom by the end of the seventeenth century. Prior to the passage of the 1832 Anatomy Act, the result of this crisis is well known in the records of the sensational activities of the early nineteenth-century Resurrectionists.[11] But the problem did not begin in the eighteenth century. By the last years of the seventeenth century, some local authorities were willing to take fairly drastic steps to ensure that the anatomy theatres were sufficiently supplied. In

Edinburgh, for example, where the bodies of the executed had been made available to the anatomists much earlier than in London, the ever increasing demand was met by designating whole new categories of corpses as possible sources for dissection. An act of the town council (2 November 1694) summarized the provision of corpses hitherto, and then ordered new sources of supply. These sources were precisely defined, and allow us a chilling insight into the monetary value attached to the bodies of the citizens. So the bodies of foundlings 'after they are off the breast', the bodies of 'such as may be found dead in the streets', and the bodies of 'such as die violent deaths, . . . who shall have nobody to own them' were to be made available to the anatomists. In addition, other bodies could be demanded: foundlings who had died after being weaned and after having been put to school could be claimed unless their friends reimbursed the kirk treasurer 'whatever they have cost the town'; the bodies of infants stifled at birth and unclaimed by any citizen; and the bodies of 'such as are *felo de se* [suicide] when it is found inquestionable self murder and have none to own them'. An economy has become evident, a market in corpses regulated by the laws of supply and demand and policed by the authorities, in which bodies have become a form of property to be either claimed or bought by the living.[12]

The growing commodification of the corpse is made apparent in the set of proposals (already alluded to) for an anatomy theatre at Rotterdam outlined by Louis de Bils which, in 1659, the Hartlib circle had translated into English. The Dutch plan makes interesting reading, since what it amounted to was nothing less than the creation of a corpse economy similar to (though more advanced than) that later to be found at Edinburgh. Under the original initiative of de Bils, who owned a number of corpses that had been specially prepared and preserved, it was suggested that he should receive from the authorities:

> all the bodies of those that shall be executed by the hand of justice, whether military or Civil, as also of those strangers that shall die in the Hospitals, in all parts belonging to the States General; and so dissect the said carkasses in such manner as himself shall think good for the satisfieing his own curiosity, and the promoting of knowledge for the common good.[13]

The funding for this project, and thus the funding for the proposed Rotterdam theatre, was to be derived from the entrance charges and fees levied on those attending the anatomy demonstrations. A subscription system might also be set up which would, de Bils calculated, guarantee an income of some 20,000 Flemish pounds per annum, and consume the bodies of fifty criminal or alien corpses each year.[14] The similarity of this project to the 1980s scandal of the Copenhagen 'displays' is clear. But where, in the modern example, public fascination was turned to private gain, in the

seventeenth century this fascination was to be anchored to the public good. Equally clear was the eventual intention, amongst the virtuosi who constituted the Hartlib circle, to establish a similar project in London. Reference to the dissection of 'strangers' also alerts us to the ways in which such a corpse economy must, presumably, have already been in existence in other European countries long before the 1650s. Under the anatomy statutes promulgated at Bologna in 1422, for example, bodies originating within a radius of thirty miles of the city were not allowed to be dissected at the university. Similar prohibitions affected the supply of corpses to the anatomy theatres at Genoa, Perugia, Pisa, Florence, and Padua.[15] One can only assume that, in order to conform to these statutes, some form of trade would have had to have taken place between the various anatomical centres.

What was the popular response to the incursions of the anatomists? Here we meet contradictory evidence. On the one hand there was clearly a degree of loathing for those who came to the foot of the gallows in order to claim the dead for science. But, equally, these new investigators of the human frame were perceived as figures of great social importance, and their studies soon became the focus of intense interest.[16] The evidence for disgust at their activities is widespread. In 1725, some twenty-five years before the statutory provision for penal dissection was enacted, Bernard Mandeville wrote his classic account of the scenes which took place at the site of execution. Having commented on the disorder and squalor of the proceedings, Mandeville observed:

> The tragedy being ended, the next Entertainment is a squabble between the surgeons and the Mob, about the dead bodies of the Malefactors that are not to be hanged in Chains. They have suffer'd the Law (cries the Rabble,) and shall have no other barbarities put upon them: We know what you are, and will not leave them before we see them buried. If the others are numerous, and resolute enough to persist in this Enterprize, a Fray ensues[17]

Mandeville's account forms part of that eighteenth-century abolitionist dismay at the riotous scenes which took place at execution sites. But his description (which ends with a plea for the proper regulation of anatomical supply, a plea which the 1752 Murder Act can be thought of as incidentally meeting) hints at a number of features which were common throughout the seventeenth century and which came to be deplored during the eighteenth. There was the struggle between the spectators and the surgeons, with the strong suggestion that the latter were in some form of disguise, or at least concealing their intentions towards the corpse ('We know what you are'). This struggle was motivated by a desire to see the criminal corpse properly interred ('we will not leave them before we see them buried') and disgust at what must have seemed like an arbitrary and additional punishment ('they

have suffer'd the Law'). In other words, dissection seems to have enjoyed a quasi-legal status. It was a further punishment inflicted upon the body by authorities who had already exacted the full revenge allowed by the law.

One of the earliest accounts of a post-execution dissection in England is to be found in the diary of Henry Machin (1498–1563). On 24 February 1561, Machin recorded the execution of eighteen men and two women. Significantly, only one of the victims, whether a man or a woman we do not know, was claimed by the Barber-Surgeons 'to be a notheme at ther halle'.[18] Machin mentions no struggle for the corpse. Yet there were struggles long before Mandeville's account. The records of the Barber-Surgeons show regular payments to the Beadle of the Company in recompense for the beatings he endured at the hands of the mob in his efforts to retrieve corpses, and of gifts made to the hangman each Christmas in order to secure bodies direct from the scaffold.[19] The Beadle of the College of Physicians, who was the individual responsible for procuring corpses, received a payment (by 1690, three shillings and four pence – a substantial sum which may well have reflected the difficulty of obtaining bodies) for each anatomy performed on the College premises.[20] The problem for both surgeons and physicians lay in the fact that, under their respective statutes which allowed them to claim corpses from the gallows, responsibility for demanding and removing the bodies lay entirely with their own representatives. It was up to the anatomists themselves, rather than the civil authorities, to arrange the transaction. In 1587, for example, the antiquary John Stowe recorded that the body of a felon hanged at St Thomas a Watering was 'begged by the Chirurgions of London, to have made him an Anatomie'.[21] The need for the Barber-Surgeons to 'beg' such bodies suggests that, no matter what rights their charter may have given them at the scaffold, they nevertheless had to assert their privileges with force.

Who were these individuals whose remains were transported to the anatomy tables in early-modern England, and who played the central (though unacknowledged) role in the anatomical theatres of the seventeenth century? Only occasionally have their names survived. In 1566, a certain 'John Figgen' was anatomized and later buried at Great St Mary's Church Cambridge; and we know of a 'Master Hutton' who was anatomized at Caius College Cambridge in 1601.[22] Occasionally, we can glimpse the outline of a narrative emerging, a story of criminality which ends on the dissection slab, and which allows us momentary access to the complementary pursuits of criminal justice and scientific curiosity. For example, amongst the numerous accounts of executions left by Henry Goodcole, the ordinary or minister who attended criminals at Newgate in the early seventeenth century, we read the story of Thomas Shearwood and Elizabeth Evans, known as Counterey Tom and Canberry Bess. The couple were notorious murderers and thieves

operating in London in 1634–5. Arrested, they were tried, convicted, sentenced and then executed in April 1635. Shearwood was hanged and then gibbeted, but the fate of Elizabeth Evans was to be hanged and then publicly dissected at the Barber-Surgeons' Hall. Shearwood and Evans were to meet again after death. After Shearwood's body had been gibbeted at Gray's Inn fields, then moved to St Pancras and finally exposed at King's Cross, the skeleton was taken to the Barber-Surgeons' Hall, there to join the skeleton of his former criminal accomplice.[23] Why was it the fate of Elizabeth Evans to be dissected, whilst Thomas Shearwood was gibbeted? Since it was the Surgeons rather than the sentencing judge who determined who was to be anatomized, a female body must have been of more interest than a male.[24]

Direct references to anatomization tend to appear when something extraordinary seems to have occurred. For example, the 'reviving' of the victim, after being cut down from the gallows, was by no means uncommon. Sometimes, these instances of 'miraculous' revivals were the result of clumsy executioners. At other times there is evidence that the hangman and the victim (or friends of the victim) were in collusion.[25] It is possible that revival was more likely where the anatomists were paying close attention to the corpse. As professional physicians, signs of life would be more readily observable to them. The anatomization of 1587 recorded by John Stowe (above) offers a particularly gruesome instance of an anatomy taking place on the still-living body of an executed felon. Stowe's account continues:

> after hee was dead to all mens thinking, cut downe, stripped of his apparell, laide naked in a chest, throwne into a carre, and so brought from the place of execution through the Borough of Southwarke over the bridge, and through the citie of London to the Chirurgeons Hall nere unto cripplegate: the chest being there opened, and the weather extreeme cold hee was found to be alive, and lived till the three and twentie of Februarie, and then died.[26]

Nashe's dream of dissection, it seems, may not have been a dream at all. An even more spectacular occurrence of revival seems to have taken place at the College of Physicians around 1651. A woman named Anne Green, hanged for infanticide, was cut down half an hour after her execution, and taken to be anatomized. The 'learned Doctors and Chyrurgeons', taking the woman out of her coffin, observed that she had begun to stir 'whereupon Dr. Petty & others, caused a warm bed to be prepared for her; and after 14 hours she came to herself'. As the author of the story points out, this Lazarus-like tale is evidence of 'the great handiwork of God'.[27] The anatomists intervened even when the family and friends of the victim may have felt reasonably assured that the corpse would receive burial. Their intervention was unpredictable, and neither money nor social class could guarantee that an execution victim would escape their attentions

particularly as demand for bodies was rising throughout the seventeenth century. The antiquary Anthony à Wood recorded such an intervention in the case of a Mr Greenfield, hanged for murder at Tyburn on 26 September 1689: 'A rich Coffin was prepared for him to bury him at Paddington; but the company of Chirurgeons, by virtue of a warrant, obtain'd the corpse and so carried it to their hall to be anatomized.'[28] 'He made a penitent end', Wood concludes.

From eighteenth-century accounts we know of the riotous scenes of disorder which accompanied the ritual of execution in the early-modern period: the long drawn out procession, the scenes of debauchery and drunkenness, the sexual promiscuity which seems to have been such a feature of these gatherings, the linguistic transformation of the spectacle of punishment into a carnivalesque celebration of the body's physicality. Earlier accounts, however, tend not to dwell on these scenes. The chroniclers (and there were many, pandering to public fascination) were more interested in recording what was said rather than what was done at such moments. Certainly, there is no record to compare with the 'dissection riots' which were to take place in the later eighteenth century.[29] But Mandeville's record of public opposition to the servants of the anatomists, together with the indirect evidence of the accounts of the Physicians and the Barber-Surgeons, suggest that popular resentment at the sequestration of the corpse ran deep. But what took place next, within the anatomy theatre itself, was of an altogether different order. If the scene around the gallows was one of semi-riot, the Renaissance anatomy theatre presented a very different face. The carnivalesque display of justice which took place outside the theatres now gave way to a theatrical ritual of investigation which struggled to transcend the spectacle of disorder and to assert, instead, the order of creation, the harmony of the universe, and the wisdom of God, before whose last and greatest creation – in the form of the twisted corpse of a criminal – the anatomist and his audience now stood. But the ritual of investigation which followed can only be understood when we recall that the corpse which was carried into the theatre had been retrieved from a chaotic, violent, and hostile spectacle of judicial power.

There is a danger of misunderstanding the 'meaning' of anatomy, and its singular importance in early-modern culture, if we fail to place this peculiar form of investigation within the larger scope of the criminal investigation which, inevitably, preceded public dissection. What took place within the Renaissance anatomy theatre, then, was intimately connected to what had taken place immediately before the body arrived on the dissection table. It is only with the passage of time and with it the shift, in the later eighteenth century, away from the spectacle of public execution of capital sentences to what has been described as the rise of a 'calculated economy of punish-

ments', that anatomical investigation could begin to take place within a sphere which might be termed 'disinterested'.[30] Prior to that shift, and throughout the sixteenth and seventeenth centuries in England and other European states, the remarkable achievements of the 'anatomical Renaissance' took place in a context which was, in reality, far from disinterested. In this earlier period, the felon, the executioner, the anatomist, and the various advisers and assistants – the technologists of medico-criminal jurisdiction over the body and their accomplices – each played a carefully orchestrated part in the complete spectacle which constituted the culture of dissection. This culture was very different from the eighteenth-century cultivation of 'necessary inhumanity' described by Ruth Richardson as a foundation-stone in the erection of a 'defensive barrier, which permits the anatomist to execute tasks which would, in normal circumstances, be taboo or emotionally repugnant'.[31] What the Renaissance anatomist strove to achieve in the dissection theatre was not 'clinical detachment' but, instead, a form of cultural location. The body had to be 'placed' within a nexus of complementary discourses, so that its full symbolic significance would be appreciated by those gathered to watch its progressive disintegration.

Our images of Renaissance dissection have come down to us through the illustrations and engravings, the paintings, and sketches, which preface the texts of anatomy or which commemorate the anatomists themselves. Those images testify to a fascination with the shadowy outline of a remarkable spectacle much of the meaning of which has now been lost to us. By the time Hogarth drew his famous image which forms the last of his 'Four Stages of Cruelty' sequence (1751), the complex iconographical message of the anatomy theatre had already begun to fade. But anatomy, in the early-modern period, was a spectacle at least as compelling – though far more ordered – as the tumultuous spectacle of execution. Indeed, it is more accurate to think of the relationship between execution and the anatomy demonstration as two acts in a single drama. Public dissection in the years before Harvey was not *primarily* designed to demonstrate the facts of physiology to a professional gathering. That role would come much later. Instead it illustrated the rich complexity of the universe and its central physical component: the human body. Anatomies were performed in public, then, as ritualistic expressions of often contradictory layers of meaning, rather than as scientific investigations in any modern sense. When, in the later seventeenth century, a more detailed investigation of the human body was required, then it became apparent that the public anatomical demonstration was almost useless. In the earlier period, the age of Vesalius rather than Harvey, the centrality of the public anatomical demonstration rested as much on the dignity which was thereby invested in the anatomist, as on its utility as a branch of natural science.

The Renaissance anatomical theatre combined elements from a number of different sources, drawing together various different kinds of public space in order to produce an event which was visually spectacular. Thus, in the construction of these theatres, we can discern the outlines of the judicial court, the dramatic stage, and, most strikingly, the basilica-style church or temple, as shadowy architectural precursors. Indeed, churches, as large public buildings, were frequently used as temporary accommodation for anatomy theatres.[32] Unlike a church, however, the anatomy theatre was also a place of symbolic confrontation which took place on a number of simultaneous levels. First there was the confrontation between the naked cadaver and the anatomist and his assistants, a confrontation between the living and the dead. Secondly, this confrontation expressed a view of knowledge itself which was at a point of metamorphosis: for the anatomist who searched in the body for its structure rather than in the texts of ancient authority, was the concrete representative of a new conception of knowledge, one that professed to rely on the experience of phenomena rather than the experience of textual authority. We might understand this second layer of confrontation as being a transformation in the forms of knowledge. Thirdly, the anatomist, in his scientific jurisdiction over and above the criminal body, expressed the symbolic power of knowledge over the individual, a continuation of the process by which the individual was forced, on the gallows, to acknowledge the legitimacy of the sovereign power over his or her body. Finally, the anatomist was representative of the community's own investment in cultural and intellectual concerns. He stood as the living embodiment of a 'progressive' technological regime, in which knowledge was to be made publicly available for the benefit of all within the community, at the expense of the individual who, either through criminality, poverty, or simply the fact of being 'foreign' was forced to surrender his physical integrity for the public good.

The confrontational boundaries of the Renaissance anatomy lesson are relatively clear. The terms which described the ritual – 'disputation' or 'demonstration' – were expressive of the old methods of scholastic debate structured around an oppositional confrontation between two interlocutors, one of whom (the text) need not even have been physically present at the moment of the disputation. Confrontation in the anatomy theatre, however, tended to operate in a triangular fashion, rather than in the dialectic mode familiar from Renaissance logic and poetry. This is to say that, rather than a dialogue being established between (say) Aristotle and his humanistic respondent, a more complex pattern of interchange between three authorities took place. Those authorities were the Text (Galen, perhaps, or commentaries on Galen), the Body (the cadaver stretched out beneath the anatomist's pedestal), and the Anatomist himself. These three authorities

jostled with one another until, eventually, under the influence of Vesalius and his followers, one node of this structure began gradually to dissolve. The confrontation between the body and the anatomist came to replace the tripartite division of textual authority, living authority, and the passive authority of the body. Of course, the text did not disappear completely, but rather it became ancillary to the more dramatic interchange which the anatomist and the corpse now were able to reproduce.[33]

The complex, beautiful, yet oddly dislocating images of the Renaissance anatomy lesson have attracted, in recent years, a wealth of commentary from historians of medicine. Traditionally, it used to be thought that in the pre-Vesalian anatomy theatre, the body was dissected by relatively unimportant menials, whilst the prestigious figure of the anatomy professor concentrated on reading from the written texts of Galen. But recently this fairly simple diagram of transmission of knowledge has begun to be questioned. Do the images of dissection scenes to be found in Renaissance anatomical texts depict what 'really' happened within the Renaissance anatomy theatre, or are they, instead, programmatic statements as to the intellectual resources of this new science? Is, for example, the anatomy scene which was first published in the *Fasciculo de Medicina* (Figure 3) of 1493/4 a depiction of a common Renaissance practice? If so, what does this image tell us? Are the body, the dissector, and the anatomy lecturer (if that is who is represented in the elevated chair) arranged in a hierarchical presentation of knowledge in which authority is invested in the rhetorical gestures of the young man speaking from the lectern, rather than in the activity of dissection itself which takes place in the foreground? Or, does the image tell a more complex story, one in which we observe not only a pedagogic process in operation, but a demonstration of mortality, with the three central figures – the seated young man, the older man wielding the dissection knife, and the out-stretched body – illustrating the downward passage from youth, to maturity, to death? Is the important confrontation the one which takes place over the body itself, or is it the speaking figure who should hold our attention?[34]

It was not until 1543, when Vesalius published his *De Humani Corporis Fabrica* that the outlines of what we might term 'moral anatomy' began to appear. And it was at this point that the relatively undifferentiated structure of the anatomy theatre itself was transformed. What was once simply a convenient space in which to bring together a corpse, an audience, and an anatomist, was redesigned to emerge as a *theatricum anatomicorum* – a purpose-built structure dedicated to a single use. The moment of its appearance marks a profound change in the status not only of this new science of the body, but in the whole panoply of investigative process. The anatomy theatre as a 'temple of mortality' was a unique creation of the late Renaissance, one

that hints at a complete culture which was to spread into all forms of human endeavour in the period.

ANDREAS VESALIUS AND THE TEMPLE OF MORTALITY

Our readings of Renaissance images of dissection are, inevitably, informed by our understanding of the great title-page of the Vesalian *Fabrica* (Figure 2).[35] But, we need to remember that the swirling crowd scene with which the *Fabrica* opens was an extravagant idealization of anatomy. It served to announce the conceptual framework in which investigation was to take place. That investigation would lead the reader of the *Fabrica* through the body, dismantling and then reassembling the complete structure. The title-page does not, therefore, represent what 'actually happened' inside the Vesalian theatre. But, what it helps us to understand is the intellectual texture of the performance so that we can begin to comprehend something of the contradictory emotions of desire and horror which anatomization seems to have engendered within early-modern culture.

Vesalius' crowded scene conveys a complex message to the onlooker, which offers a commentary on the past and a statement as to the future. In the Vesalian title-page, the science of the body is revealed as one that receives popular endorsement. The anatomist, Andreas Vesalius himself, who stands to the left of the cadaver as we look at the image, is shown surrounded by his contemporaries who are frozen in a moment of furious concentration. Only Vesalius seems aware of us, the onlookers and (given the context of the image as a title-page) potential readers. It is for us (not the audience surrounding him, most of whom cannot see what Vesalius has just revealed) that he peels back the surface tissue of the female cadaver's abdomen, teasingly hinting at what the pages of his work will reveal in more and more detail. It is as though he is inviting us to step inside the theatre, to join the crowd who have gathered to watch this dynamic confrontation between living and dead authority.

Looking at earlier depictions of anatomy demonstrations, no matter how we understand the detailed intellectual roles and dispositions of the various figures, what irrevocably shifts in the Vesalian image is the sudden eruption of a crowd into the anatomy theatre. Earlier images seem entirely static by comparison. Their stasis is not simply a function of different techniques of representation. Rather, the cool detachment (something much more akin to that eighteenth-century 'necessary inhumanity' described by Richardson) which we observe in pre-Vesalian scenes is a function of the relative absence of the onlooker. The artist who illustrated the title-page of the Vesalian *Fabrica* chose deliberately to fracture this abstraction. Rather than depict the Renaissance anatomization as taking place within a reserved space of

detached enquiry, with a few figures bending over the cadaver, the dissection scene was suddenly packed with onlookers. It is as though the crowd with which Shakespeare's *Julius Caesar* opens has suddenly burst onto the stage, destroying the stately progress of choric commentary. In visual terms, the artist chose to represent what was, in effect, a cross-section of an anatomy demonstration. The Renaissance anatomy theatre, by the time Vesalius had come to occupy the chair at Padua, took place within a circular structure. The very few images which have survived of Renaissance anatomy theatres, and the existence of the surviving Paduan theatre itself (constructed long after the time of Vesalius), agree with one another in this respect: these constructions were concentric wells, into which the audience would have peered down on to the cadaver and the anatomists working at its side. But the image in the *Fabrica*, though it is suggestive of circularity, is, in fact, a hemisphere. It is as though the complete structure, the surrounding basilica (which is, we see on close inspection, an open-air arcade) with its massive architectural supports, together with the concentric rings of benches, has been cross-sectioned along the diameter which passes through the cadaver. The picture plane is then set back slightly from the line of this transverse section.

What is the significance of this structure? First, we become aware that at the centre of the concentric hemisphere of benches, bodies, and colonnades lies the corpse which is allowed to protrude slightly towards us, the viewers, beyond the line of the cross-section. The opened centre of the female corpse, the womb, lies at the centre of this imagined circle. Rearing above the outstretched figure, on the vertical line marked by the womb and the central pillar of the surrounding architecture, stands the skeleton, its wand gesturing back towards the female body from which, in symbolic terms, it once emerged. Secondly, we note Vesalius himself, standing on the left of the corpse as we look into the image, but looking out of the picture at the viewer – one of only two figures who seem aware of a world outside the plane of the image. With his right hand, Vesalius peels open the body to reveal the womb. The corpse, passive beneath her dissector's hand, gazes directly at Vesalius – the only figure in the image so to do save one, the spectral figure in the surrounding audience who stands to the left of the youth reading the book. That spectral figure, gazing down in sadness from the outer ring of the benches, strikes a pose which is curiously reminiscent of the iconic image of the poet Dante, contemplating the souls of the damned in hell. This Dantesque figure has attracted the attention of the figure wearing a cap to his left, who gestures towards him whilst addressing two other bearded men listening attentively to his explanation of who it is that they are standing beside. The other figure gazing out of the picture plane is also located in the outer ring of benches: a seated young man whose left arm, with its

67

ostentatiously fashionable slashed brocade, is flung forward. This brocaded arm is attracting considerable attention. To the left of the young man, a seated, bearded figure gazes directly at the outstretched arm whilst, behind the young man, another bearded figure (holding a closed book – a counterpart to the youth still reading on the left of the skeleton) turns to his companion and points *not* at the dissected corpse but, rather, towards the arm, as though ensuring that its presence has been registered. At the far right of the image stands yet another young man, gazing down at the dissection, whose right leg is clothed in (again) fashionably slashed hose. These two figures, the young man with the brocaded arm and the man with the slashed hose, have led one commentator on the *Fabrica* scene, Luke Wilson, to observe that these designs 'suggest, in context, surgical incisions or crude representations of the muscles dissected', a device which 'gives the peculiar sense that the body is permeable to vision'.[36] One further figure must be noted. On the far left of the image, clutching a column, stands a naked man who gazes down at the dissection, and thus stands as a counterpart to the figure of the man in slashed hose. This naked figure, often taken to be a representation of surface anatomy, is also being gazed at by the bearded figure on his left, who has turned away from the dissection altogether to contemplate this arrival onto the scene.

The image is, we can see, extraordinarily complex in its articulation and its production of numerous rival centres of attention for the viewer. The dissection at the centre is constantly challenged. In the foreground, for example, there are no less than three different small dramas enacted for our benefit. On the left, a monkey (often taken to be symbolic of animal vivisection) escapes from the seated figure onto whose shoulders it has clambered. In the centre of the image, beneath the dissection table, two figures (again, traditionally taken to be the pre-Vesalian dissectors now banished from the activity which takes place above them) squabble over surgical instruments. On the far right, a figure with a dog (the dog reminiscent, once more, of vivisection) and his companion beg for the attention of one of the two classically clothed figures who frame the foreground of the dissection itself. Their importuning gestures are, as it were, silenced by the figure who has leaned over from the benches above them. These three small dramas parallel the three dramas taking place in the outer benches: the appearance of the naked figure, the comment caused by the sepulchral figure, and the attention which is devoted to the young man with the slashed and brocaded arm.

One last group of devices needs to be noted. From the gloom surrounding the semi-circular arcade inside which the dissection is taking place, shadowy figures are emerging. One of them, is, perhaps, a woman. Meanwhile, from the balcony depicted at the top of the image, two figures lean out to gaze at

the scene below them. The entablature over which they peer carries a motif displaying an ox's head and a lion's head – the lion of the Venetian state and the ox of Padua. The sight-line of these figures is, however, obscured by the most important component (speaking functionally) in the whole image, the ornate suspended cartouche, which announces the book's authorship, its author's provenance and position, and the title of the work. Above the cartouche, operating as part of the suspension mechanism which disappears into the (imagined) dome of the basilica, is an armorial shield supported by two *putti*. The shield carries the punning device of Vesalius himself – three weasels *courant* on a sable field – a play on the vernacular form of his name: Andreas Wessels.[37] Finally, we note how the whole scene is taking place on a slightly raised platform – or a stage – before which, as admiring spectators, we stand.

What, then, are we looking at? Clearly, this is not a representation of an actual anatomy lesson taking place. But if it is a symbolic performance, what is the meaning of its symbolism? The crucial structural component, which holds the image together despite the distraction of the small dramas played out amongst the audience, is the strong central vertical axis formed (looking from the bottom to the top of the page) by the cartouche bearing the privilege at the foot of the page, the almost vertical disposition of the corpse, the skeleton above the corpse, and the suspended armorial crest and cartouche which hovers at the very centre of the basilica, precisely over the opened womb. Everything in the image rotates around this axis: the audience, Vesalius, the various dramatic interludes, the benches, the Corinthian columns supporting the arcade and entablature, the rounded outer arches and square columns, and the surrounding gloom. Bathed in light, whose source lies on our side of the picture plane, we look into a theatre which is also one half of a basilica surrounded in gloomy shadow. The effect of theatricality is heightened by the platform, or stage, upon which the action is taking place. Indeed, one commentator has suggested that the architectural surroundings were indeed adapted from woodcuts of theatres found in printed editions of Terence (1497) and Plautus (1511).[38]

But an alternative model for the Vesalian theatre existed. If it were possible imaginatively to reconstruct the exterior of the building within which the dissection scene in the *Fabrica* is taking place, then what we would be looking at is a building similar (in size and proportion) to Bramante's Tempietto, the basilica church of S. Pietro in Montorio built in Rome after 1505 (Figure 4). This building was considered to be of great importance by later Renaissance architects, not least for its symbolic association with the early christian *martyrium* – small churches erected to commemorate a place of religious association such as the location of a martyrdom.[39] Bramante's Tempietto was built to commemorate the spot in Rome where St Peter was

said to have been crucified. These circular structures can be understood as attempts to 'christianize' classical forms, whose 'originals' can be discerned in the remains of the Temple at Tivoli or the Temple of the Vesta at Rome. But the small, circular temples also possessed another significance for the Renaissance architect. In the design of temple-style churches, following Vitruvian ideals, the architect had to be careful to dispose the structural elements according to the ideal pattern of proportion to be uncovered in the human body. Vitruvius provided the rule:

> since nature has designed the human body so that its members are duly proportioned to the frame as a whole, it appears that the ancients had good reason for their rule, that in perfect buildings the different members must be in exact symmetrical relations to the whole general scheme.[40]

Here is that familiar figure of 'Vitruvian Man', the outstretched human form which delineates a square, or a circle, centred on the navel whose circumference is marked by the hands and feet. A Renaissance commentator on Vitruvius makes the message clear for us. The proportions for the design of christian temples are to be taken from 'nowhere else than that sacred temple made in the image and likeness of God, which is man – in whose make up all the other wonders of nature are comprised'.[41] Turning back to the Vesalian image, we can see how the artist has subtly evoked the Vitruvian figure. Within the semi-circular, Tempietto-style structure of this imaginary or ideal anatomy theatre, the human figure's opened lower cavity forms the mid-point, the axial principle, around which the complete design rotates. If we were to imagine this image in three dimensions, what would we see from our point of view outside the picture plane? A basilica, cross-sectioned to create an amphitheatre, and at the central point of the cross-section, an opened womb.

At this point, the meaning of the great title-page of the *Fabrica* of Andreas Vesalius becomes apparent. What is depicted is no less than a demonstration of the structural coherence of the universe itself, whose central component – the principle of life concealed within the womb – Vesalius is about to open to our gaze. The *Fabrica* appeared in 1543, the same year that Copernicus' *De Revolutionibus Orbium Coelestium* appeared: a remarkable coincidence in the history of discovery of both the macrocosm and the microcosm. But the Vesalian image is suggestive of something more than a coincidence. For in its concentric design Vesalius' title-page seems to throw down a gauntlet to Copernicus. As Robert S. Westman has demonstrated, Copernican theory – the heliocentric construction of a mathematical universe – rested not only on observation and calculation, but on an aesthetic derived in part from Horatian ideas of decorum, and in part on Neoplatonic ideas of symmetry and order. Such ideas were very much in circulation within the intellectual

ambience of Padua in which both Copernicus and (later) Vesalius were located.[42] In the *Fabrica*, the anatomical universe revolves around the conjunction of the womb and the tomb within the 'magnificent temple' – Copernicus' own phrase for the universe itself.[43] It is not the sun, the title-page of the *Fabrica* insists, which lies at the centre of the known universe. The world is neither geocentric, nor heliocentric, but uterocentric: the womb is our point of origin, hence its central placement in the image. But, ironically, rising pictorially out of the womb appears the skeleton. If the womb marks our point of entrance into the world, then Vesalius' own left hand, with its finger raised in a gesture of signification as well as rhetoric, guides our attention back to the skeleton, our point of departure: 'Nascentes Morimur' – we are born to die.

A drama of life and death is, then, being played out within the circular confines of the temple of anatomy which has itself been bisected for our instruction. Surrounding this drama, clustered on the concentric benches, are not living spectators but a co-mingling of the living and the dead, their posthumous existence suggested by the curiously blank eye-sockets (Vesalius himself excepted) with which they survey all that is taking place before them. Emerging from the surrounding gloom of ignorance into the light of knowledge and understanding, others are arriving to pack the concentric circles of the Vesalian universal theatre, ironically oblivious to the *memento mori* which has arisen amongst them. A detail, or rather a playful joke, alerts us to their refusal to face their own mortality. As one spectator peers from between the bony legs of the skeleton which dominates the dissection, another is actually pushing the bony left hand of the skeleton aside with his head, as he leans over the dissection table. It is as if the skeleton is no longer of significance to these witnesses. Only for Vesalius, still living and gesturing towards the skeleton, and ourselves, who gaze at the scene from the world outside the picture plane, is the full significance of the skeleton apparent. But what of the small dramas which are also taking place on the benches? Each of these: the naked figure, the spectral figure, the young man reading, the figure with the slashed arm, the monkey, the squabbling assistants, the figure with the dog, can be envisaged as contributing to the rich allusive web of meaning enfolded within the title-page. The spectral figure gazing down on the scene, for example, though it may remind us of Dante who imaginatively passed from life into the circles of the dead in the *Divina Commedia*, is also reminiscent of the iconic image of Death or Time, who stands in the world's anatomy theatre, quietly surveying the human attempt to unravel his mystery.[44] The young man reading (an echo of the young man reading in the *Fasciculo* scene) is suggestive of youth endeavouring to understand the world according to formulaic precepts contained in written texts, unable to realize that the most significant feature of the world is contained within the

conjunction of womb and skeleton. The older man, who has closed his book (as though realizing the futility of written observation), answers the figure of youth by gesturing towards the dissective arm beside him.[45] Again, the figures in the foreground, undoubtedly offering a commentary on older anatomical practices, also echo the central message of the image. Thus, the ape who distracts two of the spectators on the left of the image symbolizes the distracting power of human ingenuity, deflecting the understanding from contemplation of the central truth now understood by Vesalius and those who follow his left hand.[46] The assistants beneath the dissection table similarly ignore the truth revealed above them, whilst the importuning figure of the owner of the dog, on the right of the image, endeavours to distract classical authority (hence the antique clothes of the figure who has turned momentarily aside from the dissection) by reminding it of earlier anatomical reliance on animal dissection. Classical authority, however, brushes aside this memory, anxious to learn of its errors revealed in the Vesalian theatre.

But it is the central figure of the dissected human being to which we must return. The Vesalian title-page demonstrates the dense intellectual super-structure surrounding the anatomical reduction of the criminal body in the Renaissance anatomy theatre. This superstructure transformed the body. From being an object of contempt or horror, whose provenance was the gallows, within the theatre the corpse was remoulded into an iconic lesson in human destiny. How far this process could be taken is suggested by another set of illustrations of a Renaissance anatomy theatre. Figures 5 and 6 show the anatomy theatre at Leiden University in the early seventeenth century. The Leiden anatomy theatre was the creation of Peter Pauw who was appointed to the chair of anatomy in 1589. Pauw, together with Harvey, had studied at Padua, and the Leiden theatre was modelled on its Paduan precursor, though it was slightly larger. These two images, first published in 1609–10, need to be viewed sequentially in that, together, they form a composite image which allows a narrative to unfold that is very similar to the one which informs the Vesalian title-page. Looking, first, at the view of the empty anatomy theatre (Figure 5), what we see is an extravagant archi-tectural lesson in human mortality. Ranged amongst the surrounding con-centric benches are skeletons, human and animal, reminiscent in their iconographic significance of the Vesalian skeleton. Unlike the Vesalian skeleton, however, they carry moralizing inscriptions, familiar to a Renais-sance reader: 'Nosce te Ipsum' (Know Thyself), 'Pulvis et umbra sum[u]s' (we are dust and shadows), and the message informing the Vesalian image, 'Nascentes Morimur', (we are born to die). These, and similar inscriptions, tell us that the Leiden theatre was far more than a place in which to bring together the criminal corpse, the anatomist, and an audience to witness the

mere facts of dissection. Instead, the theatre was an architectural lesson in human mortality – a cabinet of death, described in Davenant's *Gondibert* (1651) as a 'dismall Gall'ry, lofty, long, and wide' in which were hung:

> . . . *Skelitons* of ev'ry kinde;
> Humane, and all that learned humane pride
> Thinks made t'obey Man's high immortal Minde.[47]

Various details ranged around the central well of the anatomy theatre help us to understand the symbolic domain of this cabinet of death. Above the cabinet of instruments, for example, we see a *putto* resting on a skull bearing an hour-glass, a familiar figure of mortality. A woman is shown in the bottom right hand corner of the image, smilingly raising her hand in benediction over what, at first glance, looks like a piece of fabric. Closer inspection reveals the object she is contemplating to be a flayed human skin, depicted as though it were a concrete expression of the theologically informed metaphor of the body as the 'garment' of the soul. In the left foreground, another woman and her companion gaze at one of the skeletons. In her hand she holds a looking glass. The title-page to another anatomical work, Julius Casserius' *Tabulae Anatomicae* (1627) (Figure 7) helps us to understand the looking glass motif in this context. At the top of Casserius' title-page we see the seated figure of *Anatomia*, flanked by *Diligentia* and *Ingenium*. *Anatomia* rests a looking-glass on her knee. We can deduce that the image in the mirror shows a hierarchical display: the face of *Anatomia*, the face of *Ingenium*, and the skull which is balanced on the knee of *Anatomia*. In the Leiden engraving, therefore, the looking-glass is not so much a *vanitas* image, as it is a reminder of the self-knowledge gained through the reflective discipline of anatomy.

Dominating the image of the empty theatre is the cadaver itself, placed at the centre of the concentric arrangement of benches and skeletons. Disposed on the anatomy table in a sacrificial pose, the cadaver suggests the Vitruvian figure once more. The right hand of the corpse is thrown out so that it nearly touches the innermost ring of the concentric circles. This somewhat inelegant suggestion of a Vitruvian figure reminds the onlooker of the old tradition of understanding the human image as a principle of proportional design. But the cadaver, though it appears to draw our eye (as it has the eyes of the two spectators who voyeuristically raise the cover to gaze at what is hidden from us), is not, symbolically, the most important component in the image. That role is reserved for the montage of two skeletons posed on either side of a tree, around which is curled a serpent. One of the skeletons carries a spade, whilst the other is shown offering an apple. The iconographic significance is unambiguous: Adam and Eve are poised at the moment of the fall, when death entered the world. At once, the complete

meaning of the theatre becomes apparent. The collection of animal skel-
etons, symbolizing the dominion over creation once held by Adam and Eve,
the moralizing instructions borne by the human skeletons in the theatre, all
are expressive of the triumph of death, frozen, as it were, at the very moment
of its first appearance. Indeed, the banner which hangs over Adam's head
points the moral for us: 'Principium Moriendi Natalis est' – the principle of
death is born. It is within this ornamental lesson that the human body, which
lies on the dissection table, has been opened.

In Figure 6, which shows the same theatre crowded with spectators, we can
see that an extraordinary transformation has been effected. The corpse (still
hinting at the Vitruvian figure) has been opened to display. A great civic
occasion is taking place, symbolized by the depiction of the view of Leiden
at the top of the image and, below it, the seal of the university. The
spectators, a more orderly crowd than that to be found in the Vesalian
theatre, throng the surrounding benches. But for all the realism of the
image, it still carries a heavily charged symbolic layer of meaning. That
symbolic meaning is to be found in the disposition of the anatomist (Peter
Pauw himself), the corpse, and the skeletons of Adam and Eve. These
skeletons have been moved to allow us, the viewers of the image, an
unobstructed view of the dissection. But the movement of the skeletons also
performs another function. If we look above the head of the anatomist, we
see a great pair of dividers, hanging, impossibly, precisely over the head of
the anatomist. In the view of the empty theatre, these dividers are shown as
much smaller, and contained within the cabinet labelled 'Archivum Instru-
ment. Anatomicor.'. In the crowded theatre, they have been advanced out
of the cabinet and opened, so that they form the apex of an equilateral
triangle, whose base is formed by the corpse, and whose two other angles
rest on the skeletons of Adam and Eve. At the centre of the triangle is the
face of Pauw, the anatomist, whose right hand gestures towards the opened
text, whilst his left hand clutches an organ, which, we may speculate, has just
been removed from the thoracic cavity of the opened corpse.

Is Pauw clutching the heart itself? We cannot know for certain. But in the
theatre, the criminal corpse has been not merely transformed but trans-
figured. The dividers (symbolizing God, the divine architect of the human
temple) hover above Pauw as though sanctioning his explorations into the
human frame. The triangle which they now form, an illustration of the
trinity, rests on the cadaver which has been opened. Adam and Eve have
been moved aside to allow us to see the second, fallen but now regenerated
Adam, outstretched on the dissection table. The semi-Vitruvian pose of the
cadaver is also, we note, reminiscent of the image of Christ after the
crucifixion. The triangular articulation, then, of the figures becomes clear,
as does Pauw's gesture of benediction towards the opened text. For what we

see in this image is not merely a dissection of a criminal, and nor is it simply a lesson in civic pride. Rather we are looking at an elaborate reworking of the symbolism of the last supper itself. The sacrificial pose of the corpse (from which the heart appears to have been removed), the delineation of the anatomist as though he were a priest at a mass – or, given the protestant context a communion – the movement of Adam and Eve, the first parents, to either side of the dissection, all of these elements are combined to display the final injunction of Christ at the last supper: this is my body, take and eat. What Pauw, in other words, has demonstrated to the audience which surrounds him is not the principle of death, which the empty theatre symbolized, but the principle of eternal life.

The contemporaries of Nashe and Donne were troubled by strange visions of anatomy and dissection. Bodies were fragile organisms, which seemed to blench before the dissector's scalpel. Yet, the dream of dissection was oddly compelling, at least as those dreams were realized in erotic poetry. And we can now understand why this was so. The anatomical Renaissance, the reordering of our knowledge of the human body which took place in Europe in the sixteenth and seventeenth centuries, was not merely a moment of high intellectual excitement. Instead, the discovery of the body was grounded in older, traditional, patterns of symbol and ritual which these idealized views sought to depict with such extreme care. The confrontation which had taken place outside the anatomy theatre, on the gallows, was transformed once the body had been taken inside the theatre. Instead of being a mere object of investigation, the criminal corpse was invested with transcendent significance. The human body was indeed a temple, ordered by God, whose articulation the divinely sanctioned anatomists were now able to demonstrate.

Looking at these images, we can also begin to understand the ritualistic drama which surrounded the Renaissance anatomy demonstration: the careful allocation of seats according to social rank, the playing of music (as at Leiden and Padua) during the dissection, the procession which heralded the entrance of the anatomists, the organization of the lesson 'with all possible ceremonies and means', the chillingly formulaic words with which, at Bologna for example, the anatomy lesson would begin: 'Our subject for the anatomy lesson has been hanged.'[48] All of these elements bore witness to a confrontation in the forms of knowledge which guided the understanding of the human body. But such a confrontation was only one of many taking place within these elaborate and beautiful structures. At Padua and Leiden, and in the theatres built in their image, the living faced the dead, knowledge faced ignorance, civic virtue faced criminality, and judicial power confronted the individual. As a theatrical performance, indeed, the anatomy demonstration rivalled the stage for the hold it exerted on those who flocked

75

to these Vitruvian structures. The *locus anatomicus*, the site of anatomy, the French anatomist Charles Estienne wrote in 1545, should be a structure worthy of a display comparable to 'anything that is exhibited in a theatre'.[49]

No structure quite comparable to the great Renaissance anatomy theatres of continental Europe has survived in England, and neither do we possess images to rival those which show us the interior of the Leiden anatomy theatre. The little evidence that we have, however, indicates that, like their continental equivalents, English anatomy theatres sought to communicate a philosophical as well as a physiological lesson to their audiences. But philosophy and physiology could provide the matter of drama within such a structure. It was surely the dramatic quality of the Renaissance anatomy theatre which led to the commission of the master stage-designer and architect, Inigo Jones, to design in 1636 the new anatomy theatre for the Barber-Surgeons at their premises in Monkwell Street in London. Jones must have found the commission congenial, influenced as he was by continental architectural theorists who, as we have seen, under the guidance of Vitruvius, stressed the proportional principles of the human frame as the basis for architecture. What could be more appropriate, to an architect who had studied Vasari's conception of buildings as representations of bodies, than that he should set out to design a building in which the body itself was the focus of interest?[50] Jones's theatre was modelled on the theatre in which Harvey had first studied anatomy, the *teatro anatomico* at Padua. The surviving plans of the theatre (in Worcester College Oxford) show us an elliptical rather than circular structure, but the interior view (now in the Guildhall library, London) also hints at ornate embellishment. Ranged around the walls of the theatre, figures were placed which echoed the ornamentation of Leiden, or even the idealized world of the Vesalian theatre, with its statuesque figures clinging to the surrounding columns. The correspondence is underlined when we recall that Jones had designed a structure in the *tempietto* style for the funeral of James I in 1625.[51] A description, published in 1708, makes clear what was contained in the interior of Jones's anatomy theatre. The theatre was:

> commodiously fitted up with four degrees of seats of cedar wood, and adorned with the figures of the seven liberal sciences, and the twelve signs of the zodiac. Also containing the skeleton of an ostrich, put up by Dr Hobbs, 1682, with a busto of King Charles I. Two humane skins on the wood frames, of a man and a woman, in imitation of Adam and Eve, put up in 1645. A mummy skull, given by Mr Loveday, 1655. The skeleton of Atherton with copper joints (he was executed) given by Mr Knowles, in 1693. The figure of a man flead, where all the muscles appear in due place and proportion, done after the life. The skeletons of Canberry Bess and Country Tom (as they then call them), 1638; and three other skeletons of humane bodies.[52]

76

Just as in the Leiden theatre, then, Adam and Eve made their skeletal appearance, reminding the audience of the principle of death which reigned within the theatre. The presence of the skeletons of executed criminals reminds us, too, of the role of criminal investigation in the development of anatomy. But what are we to make of the image of the slaughtered King Charles I, surrounded by this strange collection of flayed bodies, skeletons of notorious criminals, and curious animals? Perhaps it was no more than a post-1660 demonstration of loyalty that introduced the image of Charles into the theatre. But there is something singularly appropriate in placing a representation of the most notorious victim of the scaffold on display within this context. The image of the king alerted the audience to the sovereign principle of justice under whose dispensation bodies were conveyed to the theatres. Under the signs of the zodiac (a representation in pagan form of the christian heaven which was also an imaginative recreation of the anthropocentric universe of the *Fabrica*), and beneath the image of Adam and Eve, the harbingers of death, the king, whose own violent death was understood as a typological sacrifice on behalf of the English people, presided over the work of anatomists who were able to endow even the most criminal body with a form of posthumous benediction. It was as if the anatomy theatres had reclaimed the bodies of the outcasts consigned to them, investing them (however briefly) with a transcendent significance. This transcendence was part of the drama of punishment – a second act of redemption which formed the sequel to the violence of the gallows.

Inigo Jones's theatre was demolished in 1784. We can only surmise as to the precise nature of the rituals which took place within such a building. The records of the Barber-Surgeons and the Physicians, however, testify to the care with which anatomical rites were to be fulfilled. In 1596, for example, it was ordered that fellows of the College of Physicians should 'wear of wool or silk or other fit materialls at meetings, funeralls, feasts, anatomical demonstrations, and when they meet in consultation'.[53] The ritual importance (as opposed to the practical necessity) of the anatomy demonstration is underlined by its being classed with important public events. In 1662, Samuel Pepys, who four years previously had been 'cut for the stone', attended an anatomy demonstration, appropriately on the 'kidneys, ureters. etc'. The subject of the anatomy was 'a lusty fellow, a seaman that was hanged for a robbery'; the dissection took place in Jones's theatre at the Barber-Surgeons Hall. At the start of the demonstration, Pepys observed the entrance of 'the reader, Dr. Tearne, with the Master and Company, in a very handsome manner . . . and his discourse being ended, we walked into the Hall, and there being a great store of company, we had a fine dinner.' After the dinner, ever alert to new sensations, Pepys returned to the anatomy theatre in the company of Dr Scarborough 'to see the body alone'. There,

Pepys stretched out his hand: 'I did touch the dead body with my bare hand: it felt cold, but methought it was a very unpleasant sight.'[54]

There is something compelling at this sudden vision of the diarist tentatively reaching out to touch 'with my bare hand' the anatomized corpse. Beneath the image of the executed Charles I, whose successor Pepys had welcomed back to the country, and watched over by a collection of skeletons and skins, Pepys's action seems to compress the contradictory urges with which we have been concerned into one single moment, expressive of a paradoxical fascination with the dead body which goes beyond mere voyeurism. It is possible to see, in Pepys's gesture, an old pattern of belief surfacing. That belief elevated the criminal body to a similar symbolic status enjoyed by the body of the sovereign. For, in England, just as the sovereign touch was held to cure scrofula (tubercular inflammation of the lymph glands), so contact with the criminal corpse was held to be therapeutic.[55] This belief was given a form of added currency, in the 1660s, by the decision of the recently restored Charles II to revive the old custom (fallen into decay under Charles I) of holding ceremonies at which 'touching' took place.[56] But, as in all such patterns of belief, the power contained within the object was ambivalent. The criminal body was touched, but only at the cost of overcoming abhorrence. Indeed, it was the power of the body to instil such profoundly contradictory emotions which was the guarantee of its efficacy. This combination of loathing and profound fascination was the source of the ritual of Renaissance anatomy. What we must now consider is the nature of this loathing and fascination, an amalgam of emotional responses which we may group under one single heading: infamy. The presence of infamy within the anatomy theatre is the point at which we can conclude this section of our investigation.

INFAMY

In tracing the passage of the corpse from the gallows to the anatomy theatre, we have explored a conjunction between the discourses of medicine and state-sanctioned punishment which, in modern times and amongst western states, has been strenuously resisted. A moment's reflection will indicate the great distance which sets us apart from sixteenth- and seventeenth-century culture in this respect. In Britain a Royal Commission on Capital Punishment was established in 1949, with the task of investigating the (then) existing policy of capital punishment by hanging. The Commission's brief was soon expanded to include an examination of the question of other possible methods of execution. Amongst the other possibilities canvassed was execution by a hypodermic injection of a lethal drug. But who would administer such an injection? The Commission took evidence from the British Medical Association and the Association of Anaesthetists. The BMA

was resolute: 'No medical practitioner should be asked to take part in bringing about the death of a convicted murderer. The Association would be most strongly opposed to . . . a method of execution which would require the services of a medical practitioner.' The BMA's opposition went so far as to preclude a physician administering a sedative to the condemned on the night before execution, since 'this too would require unprofessional conduct'.[57] Opposition amongst British physicians was mirrored in the response of the American Medical Association at the (rather more likely) prospect of their members being asked to participate in the execution of a capital sentence. The sensitivity of physicians, as has been frequently observed, is based on the view that their profession is one which is dedicated to preserving life when there is hope of doing so. These high and humane ideals are held to be traditionally encompassed within the Hippocratic Oath, the very existence of which, so it has been claimed, points to the traditional and ancient role of the physician as a healer of bodies, a care which should be extended even to the bodies of the condemned.

In the past, however, such a finely drawn distinction between the art of the healer and the skills of an executioner did not exist. On the contrary, early-modern understanding of the human body is firmly anchored in the willingness of the body's investigators to participate in the execution process in claiming for the anatomy table the bodies of the executed. We need to distinguish, though, between the direct participation of surgeons, physicians, and anatomists (or their representatives) in the mechanics of execution, and the indirect, symbolic, participation of the anatomists in the complete ritual of punishment. Some degree of direct participation by the medical profession in the rites of execution has long been acknowledged amongst historians of medicine. But it has equally been held that this participation was more often by proxy, or at one remove, since, as we have seen, it was the representatives of surgeons and anatomists, the servants of the College of Physicians, for example, rather than the anatomists themselves who were present at the scaffold.

But was this always the case? An early thirteenth-century manuscript, the *Anatomia Magistri Nicolai Physici* bears witness to a different history. This work, whose origins lay in the arabic *Kitab al-Maleki* of Ali ibn al-Abbas al-Majusi, court physician in Baghdad at the end of the tenth century, observes that:

> Among the ancients dissection was practised upon the living and the dead. The anatomists went to the authorities and claimed prisoners condemned to death; they tied their hands and feet, and made incisions first in the animal or major principal members, in order to understand fully the arrangement of the *pia mater* and *dura mater*, and how the nerves arise therefrom. Next they made incisions in the spiritual members in order to learn how the heart is

arranged and how the nerves, veins, and arteries are interwoven. Afterward they examined the nutrient organs and finally the genitalia or subordinate principal members. This was the method practised upon living bodies.[58]

The charge that anatomists were also vivisectionists was to haunt the theatres of dissection throughout the early-modern period. This accusation seems to have arisen in the writings of Celsus and Augustine, and has always been vigorously contested by medical historians.[59] But what is of greater interest, in this grim account by a medieval translator, was the *form* of the participation of the anatomists in the proceedings. It was not just that anatomy as a discipline benefited from the scaffold through the provision of corpses, but that the explorers of the human body were themselves the executioners. If this account is true, then there was very little distance between the ritual of execution and the opening of the body to knowledge. This confusion of roles, or (less charitably) this assumption of a dual role on the part of the anatomist-executioner was of crucial importance to the rise of anatomical science in the Renaissance.

Some Renaissance anatomists were very much aware of the conjunction between their science and the executioner's skill. The attraction of this conjunction lay in the concept of sovereign justice. The executioner, at the moment of execution, stood as the sovereign's representative, an embodiment of sovereign power. Thus, the anatomist who was also the executioner might be perceived as partaking in this nexus of sovereignty. The Veronese anatomist Alessandro Benedetti, author of the influential *Anatomice, sive historia corporis humani* (first printed at Venice in 1502), began his account of the human body by invoking classical precedent in which the executioner, the anatomist, and the sovereign appear as one and the same person:

> Tradition holds that kings themselves, taking counsel for the public safety, have accepted criminals from prison and dissected them alive in order that while breath remained they might search out the secrets of nature. . . . The kings did this carefully and more than piously.[60]

Whether or not this story was true (and Benedetti's modern translator is at pains to point out that this story is derived from Celsus) need not concern us. What does concern us, on the other hand, is the way in which Benedetti's text, having evoked this spectre of sovereign penal vivisection, rapidly distanced itself from such practices. Such customs, he continued, were forbidden by the christian religion since 'it is most cruel or full of the horror inspired by an executioner'. Horror would give way to despair and loss of 'hope of a future life' on the part of the victim: precisely the effect which the 1752 'Murder Act' was, much later, designed to achieve.

It was also true that both the author of the thirteenth-century text and Benedetti placed their stories of anatomical execution firmly in the classical

past. Did anatomical execution take place in the early-modern period? Evidence suggesting a degree of direct participation is hazy. A fourteenth-century Royal permission under the seal of John of Aragon allowed the medical faculty of the University of Lerida to insist that execution by drowning or suffocation should be substituted for beheading where the body was destined for dissection.[61] There is evidence, too, that at Pisa in the sixteenth century, Fallopius 'may have carried out toxicological experiments on those condemned to death'.[62] Moreover, study of the ritual of execution in Germany and Holland in the early-modern period has noted how the hangman was held to be a medical authority of some influence in the community. His skills were called upon in the setting of bones, for example. Numerous cases of hangmen practising medicine in the Dutch Republic from the 1590s through to the late 1790s have been recorded. Again, German executioners throughout the seventeenth and eighteenth centuries were allowed to perform autopsies on the bodies of delinquents handed to them.[63] In some sense this intersection of the trade of the executioner and the profession of the physician in the early-modern period should not be surprising. After all, both physician and hangman were adept at practising their skills on a common object: the frail human body. Both had to be inured to the spectacle of suffering which, in either case, might be thought of as a product of their professional activity. The presence of physicians at executions in the modern period further testifies to an inevitable point of contact between medical technology and the technology of state-sanctioned punishment. Approaching from different ends of the spectrum, as it were, the physician and the executioner seemed to meet over the outstretched body of the condemned felon.

This intersection of the arts of curing and the arts of punishment in the early-modern period rested on an equivalent layer of proscriptions. Popular belief may have endowed the hangman or executioner with certain powers, but he was also, as we might expect, the focus of certain fears. His trade with the dead, his existence as the corporeal representative of the final stages of the law at its most extreme and rigorous, and the fact that he was *de facto* the last incarnation of sovereign power over the body, all conspired to construct a finely poised network of taboos and jurisdictions around his person. In a curious measure, the executioner in early-modern societies seems to have enjoyed a mirror image of the power which embraced the sovereign, as though both shared their potency over the bodies of individual members of the community. Like the sovereign and his or her family, the executioner and his family in early-modern communities were circumscribed with a network of traditional beliefs. But unlike the touch of the sovereign, which, at certain times, possessed the power to cleanse, the executioner's touch produced 'infamy'. Like a contagious disease, 'infamy' would descend on

those who were tainted by coming into contact with the executioner's person, or even objects associated with him. Anything handled by the executioner was tainted, as were his goods, his children, and his money. Touching the gallows could produce infamy, so that an elaborate ceremony was required to protect the artisans involved in its construction.[64] The executioner's status in the community was thus highly ambivalent. On the one hand his company, goods, and family were to be shunned. But equally, as both the representative of the sovereign, and the means by which the felon was dispatched to meet divine judgement, he was the focus of a network of superstitions which made him analogous to the sovereign. And such beliefs lingered on. As late as 1821, we find the following French account of the executioner's role as the final bulwark against chaos and social disorder. For the executioner is:

> an extraordinary being, and in order that he may become part of the human family there must exist a special decree, a *fiat* of that creating power. . . . Yet all grandeur, all power, all subordination rests on the executioner. . . . Remove this incomprehensible agent from the world, immediately order is superseded by chaos, the thrones crumble and society disappears.[65]

The rhythms of this account may (even in translation) strike the English reader as oddly familiar: is there here an echo of the 'Degree' speech of Ulysses in Shakespeare's *Troilus and Cressida*? Certainly, the sentiments are familiar. The executioner, like the ordered hierarchy of degree itself, stands as society's guarantee of stability. But his person occasioned both fear and disgust.

We can now begin to comprehend the full significance of the ritualistic design of the Renaissance anatomy lesson. For it is *against* the possibility of 'infamy' that the Renaissance anatomist was struggling. Just as kings no longer performed executions, though the execution was performed in their name, so the anatomist, whose searches were now involving him in an ever more intimate relationship with the criminal corpse, sought to distance himself from 'infamy'. This struggle, a symbolic attempt to stand aside from the corpse, even whilst science was urging the investigator to stand closer, is made clear in Benedetti's account of the anatomy lesson. The anatomist's first task, prior to beginning his dissection, is to undertake 'ritual purifications of the physicians' souls . . . and we propitiate their offense with prayers'.[66] The text is unambiguous. An offence is about to be committed.

Here, then, is the social context for understanding the final moments of a play such as Cyril Tourneur's *The Atheist's Tragedy* (1611). D'Amville, the atheist of the play's title and author of his nephew Charlemont's downfall, claims from the judges his nephew's body after it has been executed. He wishes to perform a dissection since:

I would find out by his anatomy,
What thing there is in Nature more exact,
Than in the constitution of my self.
Me thinks my parts, and my dimensions, are
As many, as large, as well compos'd as his;
And yet in me the resolution wants,
To die with that assurance as he does.
The cause of that, in his anatomy
I would find out. –
(*Atheist's Tragedy*, V.ii.142–9)[67]

The moral dimension of post-execution dissection has been invoked by D'Amville, as if the scalpel can reveal the contours of an individual psyche. But to claim the right of anatomization is to stand perhaps too close to the gallows oneself, as D'Amville indeed discovers. Having been granted permission to dissect his nephew's body, D'Amville then proceeds to claim the equivalent right of executing his nephew himself. Tourneur has underlined D'Amville's contempt for any moral order by having his villain willingly associate himself with two practices – anatomy and execution – tainted by infamy. The executioner is pushed from the scaffold, and D'Amville seizes the axe, which prompts one of the judges to warn him of the risk he is running: 'My Lord; the Office will impress a mark/Of scandal and dishonour on your name' (V.ii.229–30). Which indeed it does – the axe is lifted and (in one of the more sensational stage reversals in Jacobean tragedy), D'Amville bungles the event and becomes his own executioner: he strikes his own brains out. The moral, of course, is that D'Amville's contempt for the divine order of the universe will be punished. But of interest to us is the fashion in which D'Amville is portrayed in the play as not only an atheist, but a natural scientist, who, like Marlowe's Faustus, believes that there is no limit to the enquiring grasp of human reason. Such an investment in the forces of reason is shown to be transgressive, a threat to the 'superior power' which orders life and death. Hence, D'Amville, the would-be anatomist and the failed executioner of others (though not of himself), is also driven by a Faustian urge to outwit death. Confronted by the bodies of his two sons, he orders the accompanying physician to 'inspire new life/Into their bodies' from the extracted spirit of gold (IV.i.89–91). Science and the belief in a 'superior power' confront one another, and out of the confrontation comes the punishment of the atheistic will, which acknowledges no other power but reason.

The Atheist's Tragedy, then, illustrates the transformation of a set of social taboos into a literary moment. But this observation may prompt a new question. Is D'Amville, the atheistic anatomist-executioner, who claims no fear of death (but in reality is suffused with dread of the final moment) the

focus of a fear which borders on desire? We have seen how dissection and desire may operate within the same sphere, and Tourneur's play conjures adeptly with this possibility: atheism, science, incest, the charnel house, violent death, and dissection seem to jostle one another within the play, as it investigates how an entirely amoral personality would function. Such patterns of desire would seem to respond to the ambivalent spectacle of dissection. The lover who seeks anatomization is demanding from the beloved anatomist access to a form of sexual self-surrender, which, whilst it hints at transgressive fulfilment, also endlessly defers the moment of dissolution. The corpse and the anatomist, or the lover and the beloved, rely on one another to produce a timeless signification, a release from punishment, an entry into a remoulded world of spectacle. But, this economy of domination and surrender, flowing between corpse and dissector, is also a public activity, a voyeuristic fantasy of peering and prying which takes place before an audience.

Insofar as we can reconstruct the extraordinary ritual of the Renaissance anatomy theatre, then what we witness is the desire to neutralize the possibility of transgression. The anatomist's vocation, his dealings with the dead and with the criminal outcast, the necessary transactions with the 'taboo' figure of the executioner and his assistants, all these factors had to be countered in some way. In order not to be held as the equivalent of Tourneur's atheist, the anatomists struggled to demonstrate the body's order within the context of a spectacle, which was itself a reinscription of order. If, outside the theatre of anatomy, chaos and misrule governed the proceedings, then, once the body had been transported into the theatre, a new regime came into being. No longer criminal, it was now held to exist within a larger sphere of signification. The body, hovering, as it were, on the brink of science, was now to be appreciated as harmonious proof of the greater complexity of God's creation. In asserting, as forcefully as possible, the dignity of a body which, perhaps moments before, had been an object of penal display, the anatomist also asserted his own dignity and the dignity of his science. A final paradox has become apparent. Rather than simply demonstrating his power over and above the criminal body, the anatomist was perversely subject to the ontological status of the body. Only if he could reclaim for it, on its behalf, its full divine significance, could his own investigations be carried forward. It was as if the dissector and the dissected entered a form of transaction in which dignity could be mutually negotiated between them. To understand this economy leads us, therefore, back to the body: the subject of the following chapter.

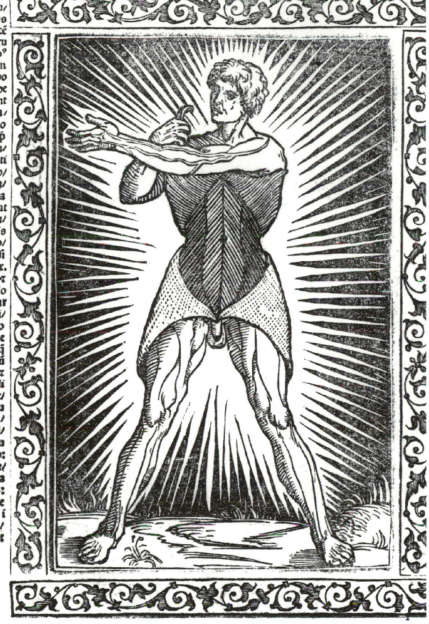

¶In hac fi/
gura hēs du/
os musculos
obliquos afcē/
dētes:ʠ se icru
ciāt cū duob⁹
defcēdētib⁹in
alia figura po
fitj:qui qdē de
fcendēteo funt
fupra iftos a/
fcēdētes: τ to
tus vnus ex p
dictis muscu/
lis defcēdenti
bus fupra po/
fitj i alia figu/
ra cum corda
fua fupequitat
obliʠ muscu/
lū vnū ex iftis
afcēdētib⁹ob/
liʠ:τ faciūt fi
mul figurā.x.
litte̅r graece:τ
iftoꝝ musculo
rū et pars car
nea ē a lateri/
b⁹:Corde ɓo
eoꝝ funt i me
dio ventris:ʠ
funt et duarū
pelliculaꝝ: τ
bn̅t vnā pelli
culā tm̅ fupe/
qtantē muscu
los lōgos: a/
lia vero pelli/
cula ē ifra mu
fculos lōgos:
ʠ adheret cor/
dis latitudina
liū musculoꝝ:
τ iftae cordae
ē̅t terminanf i
lineaꝝ:ʠ ē ime/
dio vētris:vt
vides.

17 Self-dissection from Berengarius, *Commentaria* (1521). 'Knowledge . . . of the whole, or
 scripturally complete, individual' (p. 118).

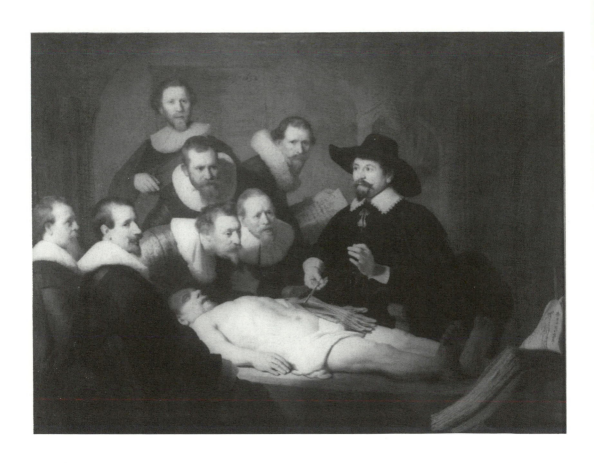

18 Rembrandt, *The Anatomy Lesson of Dr Nicolaes Tulp* (1632). 'An act of deviant will . . . necessitated punishment as an act of civic intellect' (p. 154).

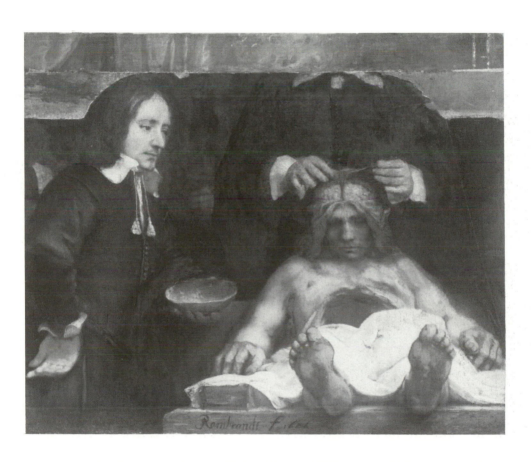

19 Rembrandt, *The Anatomy Lesson of Dr Joan Deyman* (1656). 'A specific Cartesian problem' (p. 156).

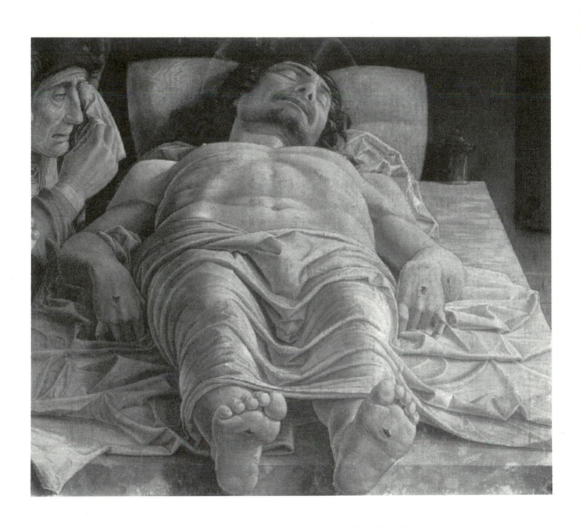

20 Andrea Mantegna, *Lamentation over the Dead Christ* (c. 1478–85). 'The echo of Mantegna's dead Christ . . . in the body of Fonteyn' (p. 157).

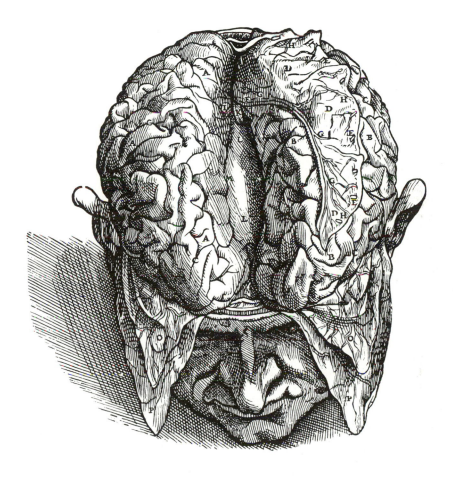

21 Brain dissection from Vesalius, *De Humani Corporis Fabrica* (1543). 'The man who seems to have reappeared . . . in Rembrandt's painting' (p. 155).

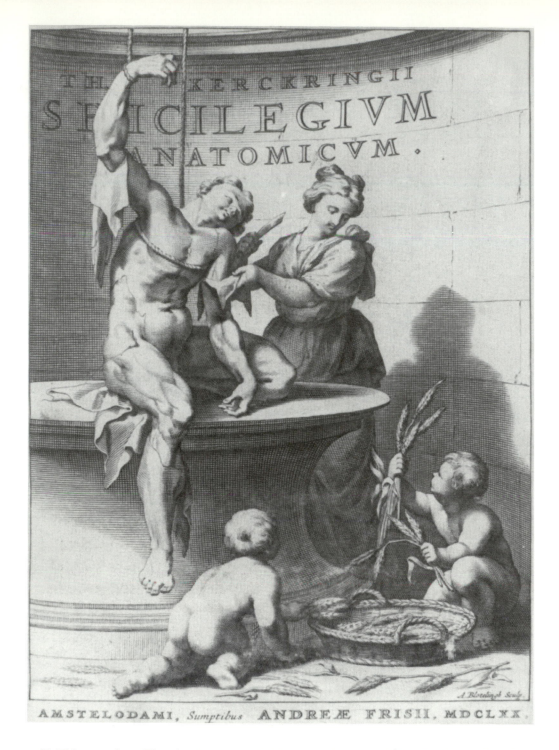

22 Title-page from Theodor Kerckring, *Spicilegium anatomicum* (1670). 'Preferring the role of goddess of knowledge to . . . goddess of fertility' (p. 183).

Superior iecoris lobus inuersus hic intelligatur, vt manifestiores sint portæ & folliculi fellis insertiones.

23 Dissected figure against a tree from Charles Estienne, *De dissectione* (1545). 'A reference to the Marsyas story' (p. 186).

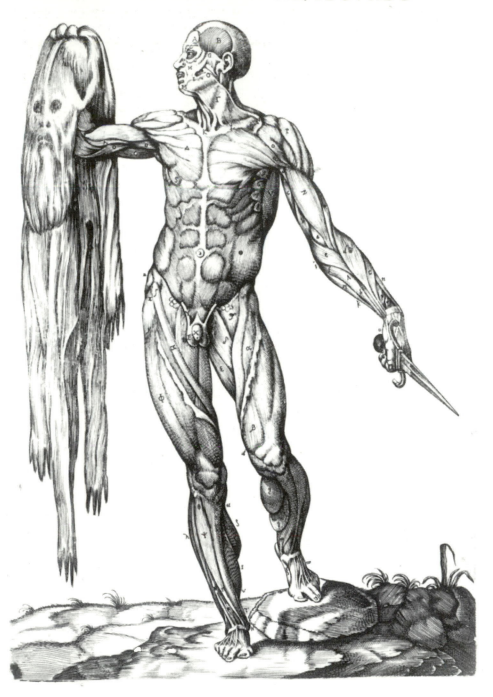

24 Flayed figure from Valverde, *Historia de la composicion del cuerpo humano* (1556). 'Marsyas and Apollo have merged into a single flayed figure' (p. 186).

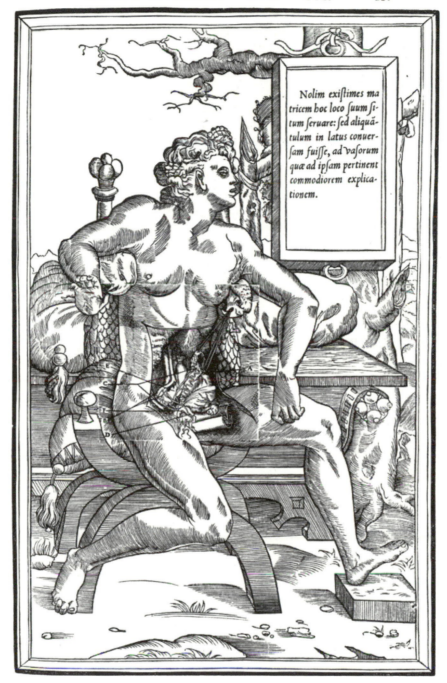

Nolim exiſtimes ma
tricem hoc loco ſuum ſi-
tum ſeruare: ſed aliquã-
tulum in latus conuer-
ſam fuiſſe, ad vaſorum
quæ ad ipſam pertinent
commodiorem explica-
tionem.

25 Dissected female figure from Charles Estienne, *De dissectione* (1545). 'Reinterpretations
of a key . . . erotic text' (p. 194).

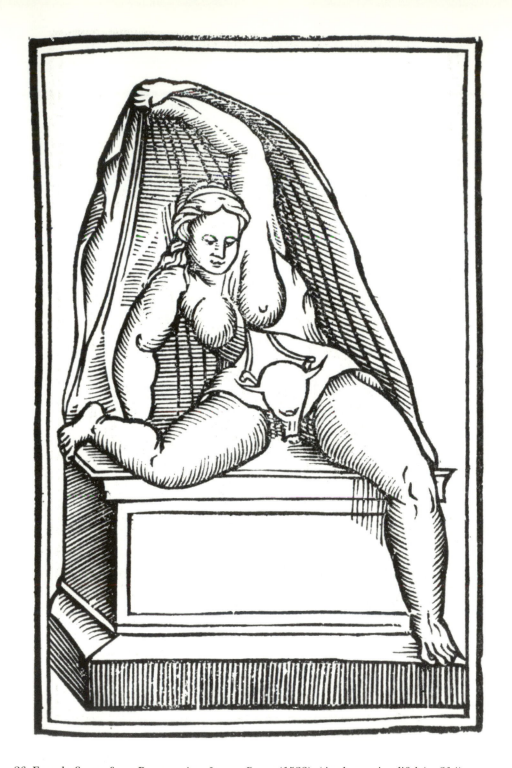

26 Female figure from Berengarius, *Isagoge Breves* (1522). 'Art becoming life' (p. 214).

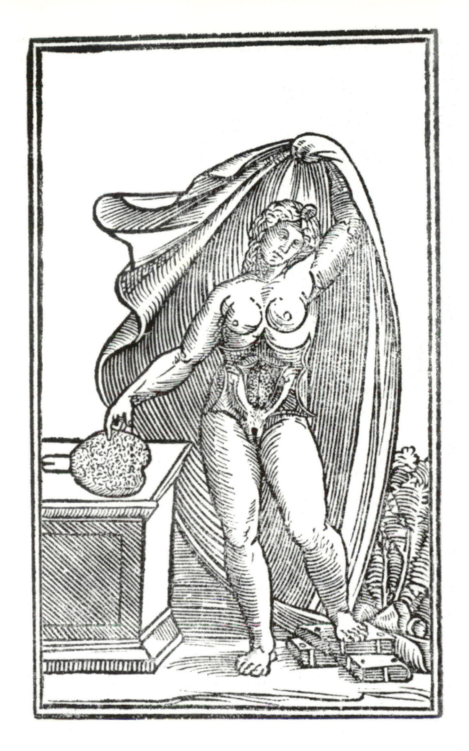

27 Female figure from Berengarius, *Isagoge Breves* (1522). 'Her identity ... is entirely determined by the uterus' (p. 215).

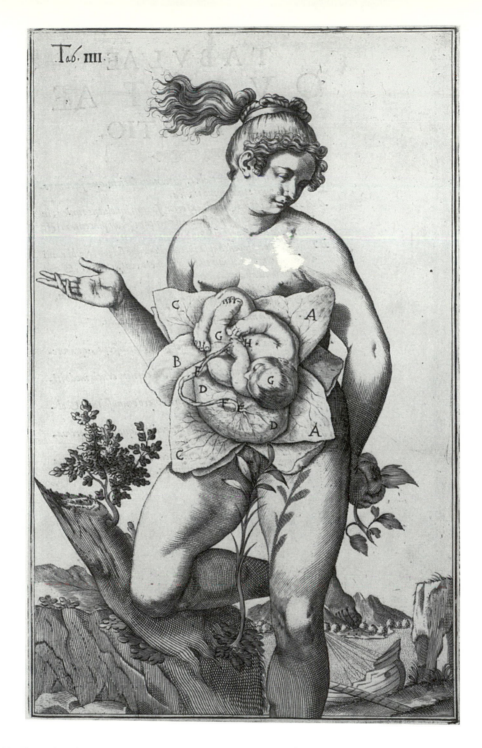

28 Flowering foetus from Spigelius, *De formato foeto* (1627). 'Female subjects . . . represented as willing participants' (p. 216).

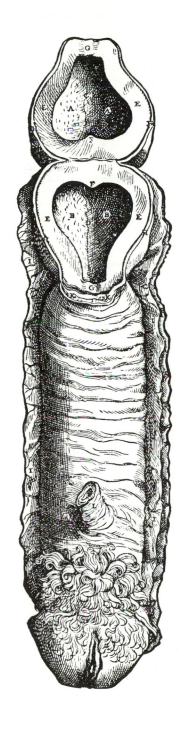

29 Excised vagina from Vesalius, *De Humani Corporis Fabrica* (1543). 'The female body was held to be monstrous and grotesque' (p. 221).

30 Dissected female figure from Spigelius, *De formato foeto* (1627). 'Baroque images of the Virgin' (p. 222).

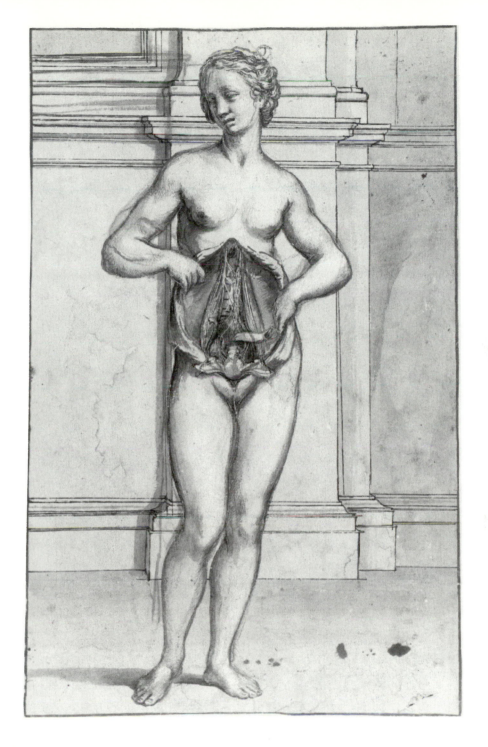

31 Dissected female figure by Pietro Berrettini, 1618. 'No more than the vehicle for a vagina' (p. 223).

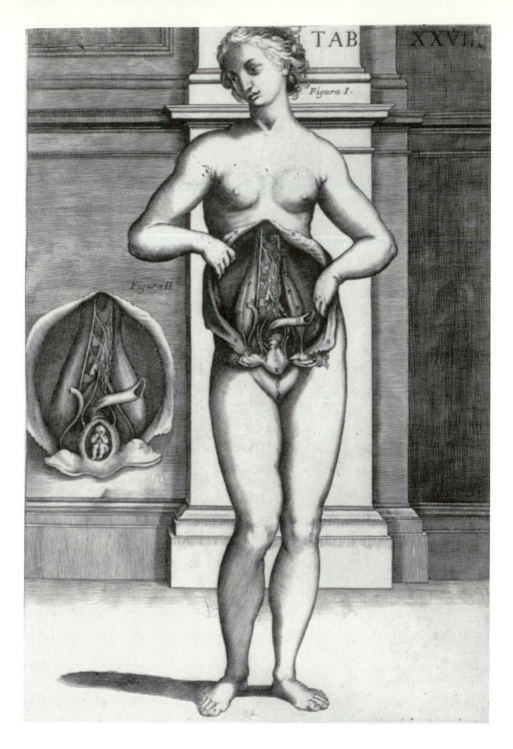

32 Dissected female figure engraved by Gaetano Petrioli (after Berrettini), 1741. '. . .
reminders of the dangerous power of the female sexual organs' (p. 223).

5

SACRED ANATOMY AND THE ORDER
OF REPRESENTATION

THE CORPOREAL UNIVERSE

Our understanding of the body-interior in the Renaissance tends to be subsumed (for understandable reasons) by the representation of the body-exterior. The dazzling displays in high Renaissance and Baroque art of volumetric proportion – of bodies which possess depth and substance as though they were alive but frozen in time – has tended to blind us to the construction of an interior body-space. But for the artists of the period, certainly, the discovery of interior space was as important as the ability to render surfaces into convincing registers of depth. Failure to understand the disposition of the body's interior, they argued, would render all attempts at depicting its exterior futile. Conversely, the surface should suggest an interior. Vasari, in his life of Michelangelo, stressed this transaction between surface and depth. Describing Michelangelo's *Pietà* in Rome, for example, Vasari thrilled to the interior anatomy of the dead Christ:

> It would be impossible to find a body showing greater mastery of art and possessing more beautiful members, or a nude with more detail in the muscles, veins, and nerves stretched over their framework of bones, or a more deathly corpse.[1]

'The fine tracery of pulses and veins are all so wonderful that it staggers belief', Vasari continued. Paradoxically, then, in order to show the deathly quality of the Christ, the artist needed to be able to suggest a living interior anatomy which reached down as far as the skeletal framework. Similarly, Sebastiano Serlio, in his influential treatise on architecture (published in 1537 and translated into English in 1611) linked anatomical discovery and the science of proportion to argue that, without knowledge of the interior configuration of the body, representation of its exterior was impossible: 'And as those paynters are much perfecter that have seene, and perfectly beheld, right Anatomies, then others that only content themselves with the

outward bare shew of the superficiencies, so it is with perspective workers.'[2] Anatomy and perspective shared a common tendency. Both, Serlio suggested, were concerned with volume rather than surface. Any attempt at rendering surface convincing without an understanding of volume was to be content with the 'bare shew of superficiencies' rather than the full complexity of the body functioning within space.

Space, the positioning of the body within a three-dimensional matrix, was the key to anatomical understanding. And the discovery of space was one of the key conceptual shifts which took place in Europe in the early-modern period. According to Lucien Febvre, 'since the seventeenth century and the time of Descartes generations of men have made an inventory of space, analyzed it and organized it. . . . This great undertaking had hardly begun in the sixteenth century.'[3] The study of anatomy *was* the study of the organization of space. For, if it was nothing else, anatomy was concerned with volume, and hence it became the testing-ground for that key experiment, which was the transmission of three-dimensional space onto the flat surface of canvas, wood, fresco, or copper-plate. The organization of space within a picture frame, moreover, carried with it a philosophical dimension which bore directly onto the work of the anatomists. The effectiveness of perspectival systems of representation depended upon the viewer's relationship to the picture plane. As John White observes, perspective:

> related the real and the pictorial worlds in a new way. It gave the observer a central position analogous in a way to the central position of man in the neo-platonic universe. It united the proportionality of the pictorial world to that of music and architecture, and of man himself, indeed to that of the divine mathematics of the universe on which all beauty depended and from which all natural objects were to a greater or lesser degree a departure.[4]

But the body was not only the preserve of figurative artists. Given the rich tapestry of symbol and ritual which shrouded the investigation of the body within the early-modern period, it should come as no surprise that, to the poets of the late sixteenth and seventeenth centuries, the dissected body presented an alluring object. Evidence of the body's attraction as a source of meditation and instruction is everywhere apparent in the literature of the period. In the poetry of Spenser, Donne, Herbert, and their lesser-known contemporaries, the body was of the highest significance. In its corporeality and its fragility, in its median nature linking the human and the divine, in its concentration of opposites – pleasure and pain, salvation and damnation, eros and thanatos – the body almost disappeared under the sheer weight of poetic tribute of which it was the recipient. It was this recycled procession of poetic evocations of the body which endowed late sixteenth- and seventeenth-century writing with its physicality; to the extent that what

literary critics used to term 'metaphysical' writing should, more properly, be termed simply the writing of physicality. To the contemporaries of the Renaissance anatomists, the language of the body, moreover, was enthralling: the body was an ever present source of tropes, metaphors, similes, and figurative twists. When, for example, Sir Henry Wotton, in his *Elements of Architecture* (1624), spoke of a building's 'Ledges' being 'interlayed like *Bones*', or its angles being 'firmly bound' since they were 'the *Nerves* of the whole *Edifice*', he was reflecting a widely held view that the universe as a structure was organized anthropocentrically, and the artist's chief endeavour was to replicate that structure in the world of representation.[5]

It was not, of course, coincidental that the body should be the continued object of such an admiring gaze at this moment in time. With the new understanding of the body, attendant on the researches and discoveries of the anatomists and the natural scientists, came a reawakening of interest in the body's *penetrable* nature. Hence, poetry of the early-modern period did not rest at surface appearance when it turned to the body (as it almost always did). The body was evoked, rather, so that it could be peered into, opened out, 'displayed'. In metaphorically prising apart the body's structure, poetry seemed to echo the ever more intense inward gaze of the heroic voyagers into the body-interior – the heirs of Vesalius – whose journeys were celebrated, amidst pomp and ritual, in the anatomy theatres of Europe. 'Man is a shop of rules', George Herbert observed in 'The Church-porch', his prefatory poem to *The Temple* (1633), 'a well-truss'd pack,/Whose every parcell under-writes a law' (Herbert, *Poems*, 37).[6] Here, in miniature, was an embryonic anatomy: unravel the 'pack' and, like a sequence of Russian dolls, more 'parcells' were uncovered, all demanding to be opened. But therein lay the problem for both poets and anatomists. For it was one thing to affirm the wisdom and order of the created universe as it was depicted in the finely wrought construction of the human body; it was quite another actually to embark upon the task of unravelling this 'shop of rules'. Once the penetrable nature of the body had been understood, then came the larger task – making sense of what was encountered in this new interior. So, Herbert's meditation continues:

> Salute thyself: see what thy soul doth wear.
> Dare to look in thy chest; for 'tis thine own:
> And tumble up and down what thou find'st there.
>
> (Herbert, *Poems*, 37)

Herbert's 'chest' is, ambiguously, both the body-interior and an item of furniture. As such, it is oddly reminiscent of Michael Dibdin's twentieth-century image of the body as a 'cabin trunk stowed . . .with just those items necessary for the voyage'. The difference, however, is in the untidy confusion

which confronted the seventeenth-century observer when the trunk was opened. In Herbert's lines, dedicated as they are to proclaiming the union between a physical and spiritual existence, we can glimpse both the transgressive nature of the interior gaze, and the potentially chaotic defeat of human reason once it had penetrated the soul's garments. Thus, while the chest may be 'thine own', an effort of will is required to commence the search. And while the body may indeed be a 'well-truss'd pack', once it had been opened the viewer was left frantically rummaging through the contents, only with extreme difficulty making sense of what had been displayed.

But of course, Herbert's lines are not to be taken literally (as I am doing here). They are, in true 'metaphysical' style, describing a spiritual rather than a physical search, and, in so doing, they are harkening back to the old classical tradition of 'Nosce te Ipsum' – Know Yourself. That, however, was not the point. While it was undoubtedly true that Herbert was exploring through metaphor the realm of psyche, it was also true that his metaphors of investigation – the 'dare' which was the challenge of the interior gaze, the 'tumble' which was the search itself – indicated a sense of confusion and transgression which was grounded in an awareness of physicality; as though what was revealed in this interior world was to be understood only with extreme difficulty and only after ceaseless effort. In this, the efforts of poets and anatomists were curiously allied. For all their continual assertions that the body mirrored the harmonious orchestration of the universe, what they confronted in reality was something else: a structure of such bewildering complexity, such a confusion of function and organic integrity, that the outcome of every such interior voyage hovered on the edge of disaster.

Thus, the poetry of the body in the sixteenth and early seventeenth centuries was everywhere tinged with scepticism and doubt of a kind registered in Donne's 'Anniversary' poems of 1611–12. When, a dozen years earlier, Sir John Davies published his 'oracle in two Elegies' which was *Nosce Teipsum* (1599), his French models – Montaigne, Pierre de La Primaudaye, Philippe de Mornay – unerringly showed him the manner in which doubt itself could become the matter of poetry.[7] For *Nosce Teipsum* is in essence a ravishing elegy on the prospect of doubt, confusion, dislocation, and the defeat of reason. That defeat, rooted firmly in patristic interpretations of the fall, was imagined at its most compelling, even seductive, when the natural philosopher dared to turn the gaze inward. The inwardly directed gaze traversed not simply regions of doubt, but transformed the body into the *locus* of all doubt. It was as if the body had been rendered, in philosophical terms, alien territory. Just as we have seen Donne in his sickness discovering in the body an obdurate refusal to acknowledge the mastery of the thinking and speaking 'I', so Davies uncovered rather more than simply metaphors of uncertainty when he, too, turned to the body:

> We seeke to knowe the moving of each *Spheare,*
> And the straunge cause of th'ebs and flouds of *Nile*:
> But of that clocke, which in our breast we beare,
> The subtill motions, we forget the while.
>
> We that acquaint our selves with every *Zoane,*
> And passe both *Tropickes,* and behold both *Poles*;
> When we come home, are to our selves unknowne,
> And unacquainted still with our owne *Soules.*
>
> (Davies, *Poems,* 9)

To exclaim that Davies, like Herbert, was concerned with spiritual rather than physical process is, subtly, to miss the point once more. While it is incontestable that Davies, in much the same fashion as Herbert thirty years later, was primarily concerned with the riddling paradox of the soul's binary existence, it was the body which provided him with the language with which to explore human uncertainty. The body, once entered, seemed to Davies and his contemporaries to be like territory owning no allegiance. The restlessly enquiring gaze of a colonialist project – which surges from pole to pole and traverses both the tropics of Cancer and Capricorn – might ultimately be defeated by the body's stubborn resistance to science, knowledge, and, as we have seen, ownership.

It was to be a French epic poem which confronted this dilemma. It is, surely, one of the ironies of literary history that the single most influential poem in England during the first half of the seventeenth century should have been written by a Frenchman, and should have become virtually unread (and possibly unreadable) within a hundred years of its appearance. Nevertheless, for a host of English poets of the late sixteenth and seventeenth centuries, the work of Guillaume de Saluste, Sieur du Bartas – known simply as Du Bartas – represented for nearly fifty years the summit of perfection in heroic poetry.[8] Indeed, it was not until the publication of *Paradise Lost* in 1667 that English poetry was able to offer any text so enormous in scope, or so ambitious in plan, as the two major works of Du Bartas: *La Semaine ou Création du Monde* (1578) and *La Seconde Semaine* (1584). When, between 1598 and 1608 Joshua Sylvester published what was to become the standard English translation of Du Bartas – *Bartas His Devine Weekes* – he was following a fashion which had swept Europe. Sylvester's translation of the protestant vision of creation which he found in Du Bartas ensured his own literary reputation for a generation, and added his name to a distinguished list of English translators – including Sir Philip Sidney and James VI and I – who had attempted to scale the heights of Du Bartas's reinterpretation of the scriptural history of humankind. In 1633 – the *annus mirabilis* of English lyric poetry which saw the publication of the first collected editions of Donne,

Herbert, and Abraham Cowley – a collected edition of Sylvester's translation of Du Bartas appeared. It was a measure of the popularity of the work that this was the sixth complete edition to appear in the seventeenth century. But it was at this point, when the lyrical experiments of Donne and his contemporaries first became available to a wider public, that the hold of Du Bartas on the minds of English writers and thinkers began to slacken its grip. One further reprinting of the work appeared (in 1641), before it was consigned to the archives of literary history, where it lay until the Victorian archaeological endeavours of the Reverend Alexander Grosart retrieved Sylvester and Du Bartas from absolute obscurity.

That Du Bartas should have vanished so completely from sight is more than an illustration of the vagaries of literary taste. For it was not shifting literary fashion alone which led Wordsworth, in 1815, to pronounce the overdue obsequies on the achievement of Du Bartas and Sylvester:

> Who is there now reads the *Creation* of Dubartas? Yet all Europe once resounded with his praise; he was caressed by kings; and when his Poem was translated into our language, the *Faery Queen* faded before it.[9]

The explanation for the eclipse of Du Bartas in the Restoration (and the advent of Milton – who owed so much to his French forebear) is as much a part of the history of science as it is the history of literature. The plunge into limbo of the hexameral poet (and of those English poets who imitated him too slavishly) was a function of the reordering of knowledge itself under the impetus of the new science of the seventeenth century. Du Bartas is thus the watershed, the point at which the disjunction between two discourses, hitherto held to be interpenetrable, becomes complete. Henceforth, it was simply not possible to attempt what Du Bartas had attempted: to fuse (in the words of Susan Snyder, the modern editor of Du Bartas) 'Genesis . . . theological speculation, contemporary science . . . pseudo-science, and moral reflection'.[10] Milton, for one, learned the lesson. If *Paradise Lost* sought to explain the operation of creation, then it was through the drama of a nascent science of psychology – an essay in temptation and surrender – rather than through a poetico-philosophical survey of knowledge, that such a lesson could be forced home.

The 'Divine Weeks' was the last gasp of older scientific *mentalités*. It was an exercise in pre-Vesalian, or pre-Copernican thought which struggled to express the harmonious frame of the universe at the very point when, under the pressure of new science, that frame was collapsing. For Du Bartas, order was a function of time – as the complete hexameral tradition itself exemplified. The divine 'week' of creation – and the subsequent (and inevitably incomplete) poetic 'week' of human history from the fall to the last judgement – was expressive of the chronologically ordained order of the

universe. With the creation of time – a chronological imperative mirrored in the poem's vast structure – order was imparted to chaos:

> Th'immutable devine decree, which shall
> Cause the Worlds End, caus'd his originall:
> Neither in Time, nor yet before the same,
> But in the instant when Time first became.
> I meane a Time confused; for the course
> Of yeares, of monthes, of weekes, of dayes, of howers,
> Of Ages, Times, and Seasons is confin'd
> By th'ordred Daunce unto the Starres assign'd.
>
> (Du Bartas, I.112)

This vision of time governing the dimensions of creation, a concept inherited from Plato and refined by Aristotle, was to prove seductive to those who came after Du Bartas.[11] For Sir John Davies, for example, whose poem *Orchestra* (1596) set out to hymn the order of the creation in terms of the harmonies and rhythms of what Du Bartas termed time's 'ordred Daunce', time was 'the measure of all moving', a formulation indebted to Aristotle.[12] Similarly, in the 'Mutabilitie Cantos' which were to close Spenser's *Faerie Queene* in the 1609 edition of the poem, it was temporal order – the regulated (and immutable) cycle of chronology – which defeated the potential chaos of Mutabilitie's challenge to cosmic hierarchy. To pre-Baconian science, and to the poetry which inherited the tenets of that science, time and order were virtually synonymous; indeed, what was *dis*-order but an absence of the governing principle of time, a retreat into an unstable world of continual flux?

But to the inflexible rule of time, new science offered an alternative: the advent of spatial rather than temporal order. Space was the new object of attention in the seventeenth century; and it was this attention which was to make the chronological imagination of Du Bartas (so entrancing to poets such as Spenser) redundant. Space, whether conceived of as the limitless voids revealed by post-Copernican theory, or the dense articulation of space within the minute interstices of post-Vesalian dissection, not merely challenged the supremacy of *Chronos*, but revealed possibilities hitherto undreamed of. The new philosophy of Francesco Patrizi, for example, published in the work of that name in 1591, posited the priority of space in what has been termed 'the order of time and being'.[13] Patrizi's *spatium* – a forerunner of Newtonian conceptions of space, and a prelude to the discovery of the possibility of spatial infinity – could be thought of as an anticipation of Hobbes's brusque, post-Cartesian demolition of scholastic philosophy on the grounds of corporeal rather than temporal existence. In *Leviathan* (1651) Hobbes was to dismiss 'vain philosophy and fabulous

traditions' with an assertion of the primacy of spatial order – the body – over all other definitions:

> The World (I mean not the Earth onely . . . but the *Universe*, that is, the whole masse of all things that are) is Corporeall, that is to say, Body; and hath the dimensions of Magnitude, namely, Length, Bredth, and Depth: also every part of Body, is likewise Body, and hath the like dimensions; and consequently every part of the Universe, is Body; and that which is not Body is no part of the Universe: and because the Universe is All, that which is no part of it is *Nothing*; and consequently no where.[14]

Was it this rejection of time in favour of space which was to make Milton's universe appear so densely corporeal? Certainly, with body came measurement – the prospect of fixing the universe onto a set of co-ordinates whose relationship could be explored via the processes of human reason – as Adam was to discover in *Paradise Lost*. But to foreground space in favour of time was to lose something as well. The mystical relationship between body and soul, for example, even the necessity of the presence of a divine architect, were undermined to a degree from which a theology (let alone a poetics) of existence was never to recover.

The new philosophy of human reason, operating within a universe which was to be understood as corporeal in nature, and infinitely vast, alerted the enquiring minds of natural scientists to new prospects of doubt, disturbing *chimeras* of the imagination. At heart, lay the problem of sensory experience itself. If the universe, and all that was contained in it, was indeed to be understood as corporeal, then how trustworthy was the mind – the reasoning faculty – which measured its dimensions? The problem was analogous to the difficulties proposed by the triumph of Euclidean space in the realm of pictorial art. Perspective – held to be a science of the representation of bodies within space – was nothing more, after all, than a trick by which the mind was led to believe that a two-dimensional figure existed, absurdly, in three dimensions.[15] The struggle of the imagination when confronted with new orders of spatial organization can be immediately understood in Hamlet's lament: 'I could be bounded in a nutshell and count myself a king of infinite space – were it not that I have bad dreams' (II.ii.254–6). Shakespeare's Hamlet – a prototype of the new scientist – struggled to escape from the harsh dictates of time and memory at almost the same moment that Patrizi was proclaiming the triumph of space over time. In the course of that struggle, however, Hamlet asserts no more than the quasi-mystical relationship between bounded space and a supra-rational existence governed by the force of imagination. Hamlet's 'bad dreams', the intervention of imagination and fantasy, are the dreams of memory and time – the ghostly presence of the past pressing itself onto the present. Just as the natural scientist can

take no particle of nature on trust, so Hamlet must test (again and again) the untrustworthy data he has received. In a series of experiments, whose hypothesis is provided by the Ghost, whose subjects are the court of Claudius, and whose methodology is a patchwork of mime, performance, and word-play, Hamlet endeavours (fruitlessly) to establish the relationship between cause and event. His tools are the tools of the natural scientist – observation and analysis – but mediated by older methods of understanding, inhabiting the sphere of rhetoric rather than natural philosophy. The results obtained, inevitably, are hopelessly inadequate in explaining the nature of the world within which Hamlet has found himself enmeshed. In what might certainly be read as a commentary on the new science of the body, Hamlet eventually finds himself repeating the nocturnal explorations of Vesalius, turning over the disjointed members of corpses in a graveyard. At the very moment when a corporeal philosophy of the body is displayed most dramatically, Hamlet's imagination triumphs over reason, and leads him to the metaphysical assertion of the triumph of time over the body. 'Dost thou think Alexander looked o' this fashion i'th'earth?' Hamlet asks his co-philosopher Horatio (V.i.191–2). At which point imagination leads him to trace the processes of decay which transform the body of Alexander into the bung which stops a beer barrel: 'Alexander died, Alexander was buried, Alexander returneth to dust, the dust is earth, of earth we make loam, and why of that loam whereof he was converted might they not stop a beer-barrel?' (V.i.201–5).

Hamlet's corporeal philosophy, then, is vanquished by a more powerful agent in human affairs: the transforming force of human imagination over reason. For all the Hobbesian certainty which was to argue that all is corporeal, Hamlet's soliloquy amongst the graves demonstrated the absurdity of such a project. This, as Horatio observed, was 'to consider too curiously to consider so' (V.i.199). But to consider 'curiously' was precisely the task corporeal philosophy set itself. Or rather, it was a refusal to set about the task of such curious analysis that would, in the opinion of Bacon and those who swallowed his precepts, prove to be the undoing of a new science. So, against the weight of Hamlet's imagination, which over-rides his analytical impulse to uncover through experiment the truth of the decaying nature of the state, a counter-weight of curious analysis was proposed. It was this new order which Francis Bacon announced when, in 1605, he published *The Advancement of Learning*.

For Bacon, dissection – the partition of bodies as spatial entities – was a paradigmatic example both of what was wrong with science, and what was possible through science. In common with his contemporaries, Bacon envisaged the body as essentially an alien territory. Against the tendency of the body to conceal within itself its own peculiar modes of operation,

Bacon offered the dissective scalpel of the anatomists. But Bacon (writing, it sometimes seems, in total ignorance of continental anatomists) saw this investigation of the microcosmic body as everywhere thwarted by hesitancy, a distaste for embarking upon ever more curious and minute expeditions into the human frame. 'In the inquiry which is made by Anatomy', Bacon wrote:

> I find much deficience: for they inquire of the *parts*, and their *substances*, *figures*, and *collocations*; but they inquire not of the *diversities of the parts*, the *secrecies of the passages*, and the *seats or nestlings of the humours*.[16]

Bacon's conception of the body was governed by spatial metaphors. The body did not contain organs or processes so much as minute apportionments of space. The body cavity was made up of 'passages and pores . . . cavities, nests and receptacles' which it was the task of the anatomist (and, if necessary, the vivisectionist) to probe and record.

Knowledge of the body was vital to the Baconian project because, of all the multitude of examples of spatial organization that were to be observed in the universe, the body appeared to Bacon to be the most complex. Hitherto, Bacon argued, that complexity had been concealed by inherited modes of thought, in particular the old belief in correspondence. 'To speak therefore of Medicine', Bacon began magisterially, 'the ancient opinion that man was *microcosmus*, an abstract or model of the world, hath been fantastically strained' (*Advancement*, 109). It was not, Bacon reasoned, the affinity of the body with what was contained within the world that guaranteed its unique place in creation, but rather its 'compounded' nature:

> But thus much is evidently true, that of all the substances which nature hath produced, man's body is the most extremely compounded. For we see herbs and plants are nourished by earth and water; beasts for the most part by herbs and fruits; man by the flesh of beasts, birds, fishes, herbs, grains, fruits, water, and the manifold alterations, dressings, and preparations of the several bodies, before they come to be his food and aliment. Add hereunto, that beasts have a more simple order of life, and less change of affections to work upon their bodies: whereas man in his mansion, sleep, exercise, passions, hath infinite variations: and it cannot be denied but that the Body of man of all other things is of the most compounded mass.
>
> (*Advancement*, 109–10)

The complexity of the body is, then, a function of what it eats rather than what it does. Like Montaigne's cannibal, exulting over those who are about to eat him by reminding them that he has eaten his captors' ancestors, Bacon envisaged a universe of bodies all dedicated to a devouring round of eating and being eaten. At the top of this primitive food-chain was the human body, an infinitely rapacious receptacle of all other bodies. Bacon proposed, then,

two complementary frameworks in which an understanding of the body as space might be possible. In one segment of the investigation, the body was a gathering of spaces – receptacles – which lay hidden from all but the most intense scrutiny. But in its primary definition – a body which eats other bodies – the reason for such a complex articulation of bounded space became clear. The body was a devourer of that which surrounded it in the world. Hence the need for such 'cavities, nests, and receptacles' – secret places where the all-consuming body could hoard the animal and vegetable wealth of the world which it had plundered in order to continue its own existence. Bacon's understanding of the body, remote as it may seem to a modern understanding based on physiological function, meshed with alternative spheres of discovery. Just as traveller's tales told of mythic continents whose savage interior was populated by races devoid of all the marks of civilization, so the Baconian body bore in its design the significations of hitherto unknown space, concealing voracious and hence 'uncivilized' appetites. The colonial subject, or rather the object of a colonialist enterprise, was not necessarily to be found only after long and perilous foreign voyages. Rather, the alien and savage 'other' could be located within the minute and hidden pores contained beyond the body-surface. Hence Bacon's proposal for a 'multitude of anatomies', conducted with all the organizational resources of a scientific expedition into the interior of a newly 'found' land. The object of this quest was not the uncovering of form and function. Rather, exploration was to be devoted to revealing the hitherto concealed inhabitants of the new world, whose only end was the betrayal of the body-state. The list of inhabitants awaiting discovery (and hence, it was to be hoped, extinction) was, as might be expected, lengthy: 'imposthumations, exulcerations, discontinuations, putre-factions, consumptions, contractions, extensions, convulsions, dislocations, obstructions, repletions, together with all the preternatural substances, as stones, carnosities, excrescences, worms, and the like' (*Advancement*, 114). The linguistic riot of latinisms is suggestive of an unbridled taxonomic urge, a sensuous delight in the naming of phenomena, and a cornucopian treasury of observation. The penetration of this new world via a 'multitude of anatomies' promised its own peculiar form of mastery (and wealth) to the heroic discoverer.

But how, and using what method, would the undertaking commence? Bacon, as has so often been observed, was no practical scientist, but rather a propagandist for science.[17] Nowhere in the *Advancement* did Bacon indicate a practical means of investigation. For all his impatience with the natural philosophers of his own day, he seemed indifferent to the difficulties which confronted actual anatomists when they stood before the cadaver. The body was the supreme example of spatial organization, but the space of the body – unlike time – appeared to contain no inherent principle of construction.

True, bodies, as Hamlet for one had demonstrated in the graveyard, were subject to time and decay. But, conceived of ontologically, the body simply rested in space. The anatomist's task, then, was fraught with difficulty. An order of the body had to be devised. If time existed in measurable units (seconds, minutes, hours, days, weeks, months, seasons, years) what were the units out of which the body was composed, and into which it could be divided and subdivided?

THEOLOGY AND SCIENCE

When Du Bartas came to celebrate the 'devinest Maister-Piece of Art' which was the human body, his own metaphors were gilded with images of the body as a painterly creation. God was the 'Admired Artist, Architect devine' (Du Bartas, I.276) in whose greatest work – the human form – was discovered a representation, not only of the universe and all that it contained, but a pictorial assembly of the creator himself. Humanity was an exercise in divine self-representation or self-portraiture. God worked, moreover, as a true Renaissance artist, not in studied isolation, but in the busy co-operation of an *atelier*. The obscure collective of the *fiat* of creation – 'Let US make man' (Genesis I.26) – was interpreted by Du Bartas to suggest the gathering of artistic powers, rather than the Trinity, attendant on this most complex of all projects.

Such an image of the external appearance of the body – the poet's attempt to 'paint the Prince of all thy works' (Du Bartas, I.276) – was informed throughout by the belief in the body as a microcosm of creation. In this, Du Bartas was following conventional patterns of illustration familiar to any Renaissance poet, artist, or, for that matter, scientist. Vasari, in his *Lives of the Artists*, for example, had begun his account of heroic artistry by describing God as the first artist, and humanity as the first example of plastic form moulded by divine reason:

> the Divine Architect of time and of nature, being wholly perfect, wanted to show how to create by a process of removing from and adding to material that was imperfect in the same way that good sculptors and painters do when, by adding and taking away, they bring their rough models and sketches to the final perfection, for which they are striving. He gave his model vivid colouring; and later on the same colours, derived from quarries in the earth, were to be used to create all the things that are depicted in paintings.[18]

God was thus an archetype of the painters and sculptors who were to crowd Vasari's pages, and the human body was to be understood as the first product of art. Pictorial or sculptural representation, then, imitated this original moment of creation in all its detail, down to the very substances used in the

manufacture of the art object. This act of imitation did not rest at the surface texture of the body, but inhabited the complete form – interior as well as exterior. So, as we have seen in Vasari's account of Michelangelo's *Pietà*, the touchstone of artistic genius was the ability to suggest a pulsating life beneath the marble or painted surface. In a similar fashion, Du Bartas did not rest at the surface appearance of things. Having depicted 'the World's Epitome' (Du Bartas, I.274) in all its external splendour, the verses paused at the next stage of the task – the accurate depiction of the inner world, the body's own disposition of internal space.

It was at this point that Du Bartas began to stumble. For, in confronting the internal dimensions of the human figure as opposed to its external appearance, and in scanning the volume and depth of the body rather than its outward texture, Du Bartas found himself plunged into a new world of discovery where the maps seemed untrustworthy, or even flatly contradictory. Where was he to begin? 'First with my Launcet shall I make incision,/To see the Cells of the Twinne Braines devision . . . ?' (Du Bartas, I.280) the poet-anatomist asked, only to be immediately confronted with another problem. 'O, how shall I on learned Leafe forth-sett/The curious Maze, that admirable Nett . . . ?' (Du Bartas, I.281). How was the body as a three-dimensional spatial entity to be both represented and celebrated in the two dimensions of print or portrait?[19] Opening the human body was one thing, Du Bartas seemed to be learning, recording its form was yet another.

Bewildered by the complexity of the structure which lay before him, Du Bartas could only pose a series of questions. Portraiture had to give way to a rational enquiry which was nevertheless immediately defeated by what it had encountered:

> Shall I the Harts un-equall sides explaine,
> Which equal poize doth equally sustaine?
>
> Or, shall I cleave the Lungs, whose motions light,
> Our inward heat doo temper day and night . . . ?
>
> Or, shall I rip the stomachs hollowness . . . ?
> (Du Bartas, I.281)

The rhetorical thrust of this series of questions suggests the complexity of the structure of the body, which, although it hymns the mind and method of the creator, left the poet-anatomist in a state of bafflement. With the growing understanding that he was ill-equipped for the anatomical investigation upon which he had embarked, Du Bartas turned the task over to the professionals – the anatomists themselves:

> But, now me list no neerer view to take
> Of th'Inward Parts, which God did secret make;
> Nor pull in peeces all the Humane Frame:
> That worke, wear fitter for those men of Fame,
> Those skillfull sonnes of *Æsculapius*:
> *Hipocrates*; or deepe *Herophilus*:
> Or th'Eloquent and artificiall Writt
> Of *Galen*, that renowned *Pergamite*.
> (Du Bartas, I.282)

The body, despite all attempts at poetic deconstruction, was still 'secret', the preserve of a triumvirate of antique rather than contemporary authorities: Hippocrates, Herophilus (physician under Ptolemy I), and Galen. Du Bartas's despairing retreat before the complexity of the human form was, however, more than a flight towards classical texts. In drawing back from the interior of a body 'which God did secret make', Du Bartas had encountered the dimensions of a theological problem which was not to be resolved until long after the 'anatomical Renaissance' had run its course. In reaching back to older certainties, the poem fairly accurately measured the problem which the new science of the body had occasioned. For, in their ever more searching investigations, modern anatomists seemed to have disrupted for ever the harmonious correspondence of body and world which it was the original task of a poem such as the 'Divine Weeks' of Du Bartas to celebrate. The poem was thus not merely in retreat before a complex organization of one area of human knowledge, but in retreat before knowledge itself, which had been recast by the heirs to the 'sonnes of Æsculapius' into a form which was glitteringly novel, but frustratingly devoid of unifying principles of structure. In fact, the history of the representation of the body in science in the early-modern period was a negotiation between these two irreconcilable positions. In one position, we may understand the body as still existing within a theologically ordained universe. But in the alternative position, one which, with hindsight, seems to have been the inevitable consequence of the methodologies of 'new science', the body was liberated from theology, only to be made subject to the equally stringent demands of scientific method. How artists, scientists, and poets negotiated these two positions was indicated by the development of a form of representation which we may term 'sacred anatomy'.

'Sacred anatomy' was rooted in a theology and a fashion which manifested itself in practices which can be traced back to a period long before Vesalius began his incursions into the human frame. Because our own context for understanding the practice of anatomy is primarily scientific, it is easy to forget the religious dimension of anatomical understanding. Prior to the sixteenth century, however, the practice of dismembering and eviscerating

cadavers was widespread. Such activities were part of a belief system common throughout Europe. Two practices in particular were of importance within this context: the practice of 'dispersed burial' by the nobility, and the veneration accorded the remains of saints. In England, as Elizabeth Brown has recorded, the division of corpses for religious ends seems to have begun in emulation of the example of the saintly Edmund of Abingdon who died in 1240 at Soisy.[20] Edmund's body was buried at the Cistercian monastery of Pontigny, but his heart remained at Soisy. This custom seems to have been developed most ostentatiously by English monarchs. Henry I, for example, had ordered that his entrails, brain, and eyes should be buried at Rouen, while the rest of his body was despatched to England to be buried at Reading. Richard I ('coeur du lion') indulged in an even more elaborate self-dispersal, ordering that his heart be buried at Rouen, his brain, blood, and entrails be buried at Charroux, and his body (or what remained of it) be sent to Fontevrault to lie beside his mother, father, and sister. The reasons for this practice were various. A desire to secure the (multiple and simultaneous) prayers of the faithful, for example, may have been a motive in some cases, while there was a suspicion that, amongst religious foundations in whose environs the body parts of the nobility were interred, a divided body would represent a maximization of possible income. One body, in other words, once it had been dispersed, could efficiently yield an income for any number of institutions. But the practice attracted considerable hostility on the part of the church hierarchy. In September 1299, Pope Boniface VIII's bull 'Detestande feritatis' was promulgated, following a series of debates amongst the Paris theologians as to the acceptability of dispersed burial. 'Detestande feritatis' outlawed the practice on pain of excommunication, a penalty which the English knight, Sir John Meriet, seems to have willingly endured when he himself removed his dead wife's heart from her body in order to have it buried apart from the rest of her corpse. Despite the new legislation, dispersed burial was a sign of status, a sign acknowledged and exploited by Cardinal Berengar Frédol when, in 1308, he obtained dispensation from the Pope to have his body buried in as many places as he wished.

The amateur anatomization undertaken by Sir John Meriet found its counterpart in the treatment accorded the bodies of saints or those deemed to have lived exemplary and holy lives. Piero Camporesi has detailed the extraordinary activities undertaken by the nuns of Montefalco who, in August of the same year (1308) that Cardinal Frédol obtained his desire to have his body scattered over the landscape, opened their 'saintly' companion Sister Chiara. The Augustinian nun had died 'in an odour of sanctity' and it was felt that the body was worthy of preservation. The nuns' decision to undertake the embalming process themselves, Camporesi records (following his seventeenth-century source), was motivated by the desire to ensure

that the body, which had been 'a living temple to the holy ghost', should not be contaminated by male hands. Following the dissection and embalming, during which various signs of Sister Chiara's holiness were observed inscribed within her organs, the remains were exhibited annually on the eve of the Feast of St John the Baptist. Camporesi observes:

> The uninhibited familiarity with which the nuns of Montefalco opened corpses, removed intestines, heart, liver, gall, dissected the organs, bored into skulls, extracted brains, embalmed bodies, powdered mummies, opened and shut coffins, repeatedly manipulated age-old cadavers, may be disconcerting nowadays, but the nuns . . . were only one among a number of communities indulging in such activities.[21]

The account of such rituals, together with the analysis of the status of the body as a reservoir of 'anthropophagic pharmacology' in the medieval period, and the fact that the body-parts of the nobility were being conveyed to and fro throughout Europe, points to the emergence of 'sacred anatomy'.

If we look at pre-Renaissance images of the internal organization of the body, and then compare them to Vesalian images of the body in dissection, we can see the influence of 'sacred anatomy' on the process of representation. Figure 8 shows a thirteenth-century understanding of the interior organization of the body. This image, which depicts the arterial system, forms one of a series of five: its companions demonstrating the bones, nerves, muscles, and veins. Initially, of course, it is difficult for the modern viewer – accustomed to the dense internal fabric of the body which modern technologies of reproduction have made available – to see beyond what it is all too easy to understand as the 'primitive' nature of the image. Of course, 'we' don't 'look like that' inside. But neither, in our internal structure, do we 'look like' the Vesalian image (Figure 9), taken from the *De Humani Corporis Fabrica* of 1543, although this conforms rather more to our expectations of how our internal landscape should appear. In the Vesalian illustration, the abdomen has been opened and the internal structures seem to tumble in a confused mass from the suddenly redundant flaps of muscle which, hitherto, would have concealed them from sight. The point of these images is not that they demonstrate an evolution in understanding, so much as they illustrate quite different *modes* of understanding the relationship of the body-interior to the world beyond the body's boundaries. Twentieth-century anatomical illustration, with its sharply delineated colour schemes, the clear differentiation between the multitude of different nerves, veins, and arteries, the poised volumetric and cleanly cut tubular structures, the play of light and shadow, is a convincing illusion of the body-interior, designed to aid the understanding of the relative disposition of the parts. In

fact, it no more depicts what an actual interior looks like, beneath the scalpel, than does the Vesalian image. Rather, it seems indebted as much to contemporary electrical wiring diagrams (and the established conventions of illustration), as it is derived from the reality of dissection. That is not to question either its utility for modern medicine or its skill in execution, but simply to underline the point that art is as much the dynamic behind the act of representation as is science.[22]

It is immediately apparent, however, just how much the Vesalian plate and familiar modern images share in common with one another in terms of representing the body in space. Both images use perspective to transcribe the three-dimensional interior of the body onto the flat surface of the page. In the case of the Vesalian image, the controlling device is that of slightly rotating the body around its vertical axis in relation to the picture plane, so that it seems to turn away (or towards) the onlooker. Through this device – achieved through the interplay of light and shadow – two effects are produced. The first is to suggest a dynamic, or tensed, bodily form. Even though so little of the body is, in reality, on display, it accords with the common Vesalian practice of suggesting that the body is still, in some measure, alive. The second effect, more subtle, is to disassociate the body in space. The body floats against the bare white surface of the page, anchored to a system of knowledge through the keying mechanism of letters which relate the revealed structures to the text of the *Fabrica*. Just how much art had gone into the production of the Vesalian image is suggested by the accompanying text:

> The twelfth figure of the fifth book which immediately follows the preceding complete figure in the sequence of dissection. In it the peritoneum has been dissected away, the omentum removed, and we have also fractured some of the ribs so that the entire hollow of the liver could be drawn more conveniently. The orifices of the stomach are seen since it, as well as the intestine, has been pushed down to the left in order to bring into view part of the mesentery.[23]

The body, then, has been carefully rearranged, with structures removed, or pushed to one side, or 'fractured' to enable art to intervene within the body cavity. But, of course, not one word of the description to be found in this passage from Vesalius' text can possibly be a truthful account of the production of this particular image. The torso, which has been 'opened' and then carefully drawn, so as to suggest the interplay of light and shade on a living object which is (somehow) self-supporting, is also, in its amputated state, an attempt at representing the body as a fragment of antique statuary. 'Art' thus circumscribes the complete image – showing us a body as though

it were alive (which it cannot be) and, *at the same time*, as though it were no more than carved stone. The body has thus been yoked to a set of complementary discursive frameworks: the discourse of antiquity and classical art, and (through its dissociation from anything other than the vestiges of textual apparatus inscribed on its many surfaces) to the regime of knowledge to be found elsewhere, in the written inscriptions of the anatomical investigation. As Glenn Harcourt has described the Vesalian image, what we are actually looking at 'is in essence pictorially reconstructed as a carefully crafted, albeit fragmented artifact'.[24]

This binary structure – the body is both alive and a wrought inanimate object – represented the condition of knowledge which, some thirty years later, Du Bartas was to recall in the 'Divine Weeks'. As we have seen, when Du Bartas confronts the bewildering internal articulation of the created human form, he retreats from the task, fleeing towards the older certainties of classical knowledge. In exactly similar fashion, the Vesalian image – through an interplay of classical form and empiricism – suggested that knowledge had reached a cross-roads. The body itself has emerged from remote classical antiquity, whilst its internal dimensions, cascading over its opened surfaces, have become subject to the eye of scientific observation. If, however, we once more compare the two images of the body-interior with one another – the thirteenth-century image and its sixteenth-century successor – a new set of problems becomes apparent in our attempt at understanding the processes of division. In some sense, the earliest image is far more recognizably 'human' than is the Vesalian. In attempting to show the arterial system, the medieval artist was nevertheless anxious that the overall composition of the human form should also be appreciated. The body has a face, hair, and schematic, two-dimensional representations of the limbs. At the same time, the body is oddly rendered transparent – we are able to see both the exterior and the interior at the same time. It is as though the artist is allowing us to peer *through* the body's surface, rather than *into* its structures. In other words, the body resists any easy incursion into its interior, by retaining the signs of a surface 'barrier'. The medieval image, then, stands in sharp contra-distinction to the later image. In the Vesalian image the body's dissociation from the external world is complete. The particular structure under examination has superseded any totalized image of the body so that, in the words of Glenn Harcourt once more 'the image is . . . so closely circumscribed as to become both visually and conceptually dissociated from the physical body.'[25]

Looking at the medieval delineation of the body-interior, what is most remarkable (to modern eyes) is the relative emptiness of the body cavity. But this emptiness is deceptive. The dissecting nuns of Montefalco, having removed the heart and intestines of their dead sister with razors, and felt

inside the gall-bladder, knew that bodies were not empty spaces. Rather, the 'truth' of such images lay in their evocation of the divine human form – a harmonious and complete bodily structure, poised on top of the 'authority' of the classical medical text which surrounded the figure. These earlier anatomical figures, often termed 'frog-like figures' because of their squatting posture, represented the established convention of anatomical illustration, in the west, until the fourteenth century.[26] After Vesalius, such images soon began to lose their currency in Europe. The body's dissociation into discrete structures became the norm. For one particular aspect of anatomy, however, the 'frog-like' posture still possessed a degree of utility. This was in the demonstration of the pregnant female body, the *gravida* as it was known. The *gravida* illustrations shown in Figures 10 and 11 were published, respectively, in de Ketham's 1491 medical compilation *Fasciculus Medicinae* and in the vernacular edition of the same text published in 1493. Again, it is not the 'accuracy' or 'inaccuracy' of these figures as representations of the human interior which is our concern. What, rather, do they tell us of a shifting conceptual model of the three-dimensional body-interior?

No matter to what level the dissection has reached, the body in these images is still alive. In both pre- and post-Vesalian illustration, of course, this convention was taken to extraordinary lengths, as flayed and dissected bodies ambled through pastoral landscapes, or reclined in richly furnished chambers, as though oblivious to the violent reduction to which they had been subjected. In similar fashion, in de Ketham's 1491 illustration (Figure 10), the woman's face peers impassively back at us, as though ignorant of, or simply uninterested in, the transforming and incisive analysis to which she has been subjected. So, whilst we examine her own body-interior, she regards the spectator with a blank and unknowing stare, refusing to acknowledge her subservience to science and representation. The same is not quite true of the re-engraving of this figure for the 1493 edition of the work (Figure 11). Still seemingly oblivious of the subjection of her body to the rigours of anatomy, she turns her head slightly and lifts her eyes heavenwards. It is as though the human body and the life lived by the human subject exist in divided and distinguished realms. How, then, do we 'read' these images? As a refusal to acknowledge the space of the body? Or as a deliberate, figurative gesture which allows no hint of realism – the tortured contortions of death for example – to intervene between the reader and a scientific understanding of the body's interior?[27] The clue to that understanding, and hence the meaning of the images to the fifteenth-century observer, was conveyed in details which, to the modern eye skilled in assessing the utility of these images for 'science', are easily overlooked. These images are not merely anatomical demonstrations of the pregnant female body. Rather, they are redolent of an understanding of the body which

sought not just to divide the corpse, but to assert the centrality of the body, even in division, to the key articles of the christian faith. Looking once more at the 1491 illustration, therefore, we note the woman's raised hands which are held, half-opened, towards the viewer. At the same time, we also need to note that the tiny foetus which she carries in her womb is covering her face from the viewer. In the 1493 illustration, as well as the gaze which is turned towards the heavens, we note how the artist has carefully poised the hands of the subject, so that one finger is raised, whilst the other rests on the knee. At this point an analysis in terms of the rhetorical store of Renaissance gestures, rather than in terms of the history of science, allows us to understand the significance of these *gravida* figures as a function of 'sacred anatomy'.

Michael Baxandall, in his exploration of fifteenth-century Italian art, has observed that 'although there are no dictionaries to the Renaissance language of gestures . . . there are sources which offer suggestions about a gesture's meaning.'[28] To the fifteenth-century onlooker, the 'meaning' of the figure shown in de Ketham's work resided as much in the gestures as in the anatomical inscriptions which flow over the body. Renaissance orators and preachers had developed a highly stylized 'language of signs' as had, for example, members of religious orders bound to silence, such as the Benedictines. Through the language of gesture the Renaissance artist was able to communicate with the spectator a variety of shades of meaning and interpretation. De Ketham's illustrations develop three of these gestures. In both the 1491 and 1493 images, the hands of the figure are disposed in a way that accords with gestures which allowed this subtle form of communication to take place. An early sixteenth-century formula, for example, records that: 'whan thou spekyest of any heauenly or godly thynges to loke up and pointe twowards the skye with thy finger. . . . And when thou spekest of any holy mater or devocyon to holde up thy handes.'[29] The 1491 figure, therefore, not only demonstrates anatomical knowledge, but she also speaks of some 'holy mater or devocyon'. But which holy matter? A comparison, for example, of Fra Angelico's *The Coronation of the Virgin* of 1440–5, one of the frescos in the church of S. Marco in Florence, shows a similar stylized gesture repeated by the six figures arranged beneath the coronation scene.[30] Is the 1491 *gravida* a representation of the Virgin – the type of the pregnant woman – who has been rendered anatomically transparent? Certainly, in the fourteenth century, illustrations of the Visitation were produced which depicted infants nestled within the chest cavities of both St Elizabeth and the Virgin Mary.[31] The covered face of the foetus in the 1491 illustration leads us to a different, but equally rich, allusive interpretation. The covered face of the tiny figure expresses, in the language of gesture, shame – an equivalent and much-used gesture in depictions of fallen humanity.[32] The complete

meaning of the 1491 figure now becomes available to us. This is 'sacred anatomy' in its fullest sense: the pregnant body, together with its appetites and desires, is not ideal, but fallen. The human foetus acknowledges the sin of Adam and Eve by covering her face. At the same time, the reader or spectator is reminded of the inflexible commandment of God directed at Eve: 'in sorrow thou shalt bring forth children' (Genesis 3.16) – a grimly appropriate reminder, given the context and spectatorship of such an image.

It is tempting to read the 1491 illustration and the re-engraving of the image in 1493 as engaged in a species of theological dialogue with one another. In 1493, the expression of shame is removed, and the figure speaks, rather, of 'heauenly or godly thynges'. It is as though the chronologically later depiction has softened the image in some measure, and chosen to remind the viewer not of the Fall, but of redemption. Certainly, if 1491 represents the curse of Eve, 1493 echoes, more directly, images of the Virgin. The open-legged stance, the raised left hand, the slight tilting of the head are reminiscent of contemporary depictions of the Virgin. All that is missing, of course, is the Christ-child who, presumably, lies hidden from sight in the undissected womb.[33] 'Most fifteenth-century pictures are religious pictures', Baxandall has observed, before going on to remark that pictures 'came within the jurisdiction of a mature body of ecclesiastical theory about images'.[34] This theory, according to a late thirteenth-century dictionary, suggested a threefold purpose behind the production of images: to instruct the simple (i.e. unlearned), to bring to mind the mystery of the incarnation, and to excite feelings of devotion in the beholder.[35] The attempt to depict the body-interior in these pre-Vesalian texts should not be divorced from this brand of religious didacticism. The artists who devised the fifteenth-century figures we have been looking at, as well as later Renaissance images, did not work within the isolated medical categories with which we have become familiar. Rather, the purpose behind such works was to remind the humanist onlooker of the divine nexus which united the body, the soul, and God into a harmonious scheme. This programme was just as important as the production of a guide (in the modern sense) to the interior organization of the body.[36] Such programmes, however, were fractured with the advent of the post-Vesalian practice of anatomy, for all that Vesalius, as we have seen, sought to remind his audience of the tradition of 'sacred anatomy' on the title-page of his own work. The confusion of Du Bartas, then, is understandable in terms of a radical reorganization of human knowledge. If the body had been 'liberated' from theology, it had become subject to 'science'. But paradigmatic shifts are gradual. Long after a 'science' of the body had appeared to dispel a 'theology' of the body, the artistic conventions of 'sacred anatomy' exerted a powerful hold on the devices – the forms of representation, the controlling metaphors of

description – by which the dissected body, and hence the body-interior, was to be understood.

We have already seen how, in their interior ornamentation, the Renaissance anatomy theatres sought to proclaim the sacred quality of the confrontation between the anatomist and the cadaver. Within these richly decorated 'temples', the criminal corpse was opened so that the 'pattern' of the divine could be traced in its physical reality, rather than metaphorical abstraction. Just as Du Bartas, in the Divine Weeks', was to describe the creation of the Adamic body as an essay in God's self-portraiture, so the anatomist who opened the body undertook an exploration into the central mystery of God's operation in the world. The core of this mystery lay in the representational tradition of the doctrine of incarnation – that God was willing to redeem fallen humanity from its bondage to physical existence (and hence mortality) by allowing Himself to assume human form in the figure of the Son. Anatomical texts, too, were constantly alert to the mystical dimension of the incarnation. The type of fallen humankind who, in the guise of an executed criminal corpse, was carried into the anatomy theatre, was also the potentially redeemed figure of the 'second Adam'. After all, had not Christ also been condemned as a malefactor and put to a public and shameful death? The Leiden anatomy illustrations, as we have seen, developed this conceit through a complex articulation of symbol and decoration. But this framework of belief operated at every level in Renaissance anatomical texts even when, as practical guides to dissection, they sought to instruct the trainee physician in his craft.

Within the framework of a specifically Calvinist theology in sixteenth- and early seventeenth-century England, the anatomists and the theologians were, for a time, able to work with one accord. The scriptures, so they argued, indicated the centrality of the human form to an understanding of God's design. The enquiring researches of the anatomists did not violate this design but sought only to trace its detail. The dissection of the human form was not a challenge to theology. When properly understood, it was a sanctified process which was akin to theological reasoning which opened the scriptures to human interpretation. Sir Thomas Browne's ringing affirmation, in 1642, of the non-metaphorical truth that 'we are the breath and similitude of God' was only a relatively late meditation on this fundamental belief which united Calvinist theology and anatomical science.[37] As the central component of creation, the last day's work in Du Bartas's terms, the human frame stood in an analogical relationship not only with all that was contained within the created universe, but with the creator himself. Thus, for the physician Francis Herring in 1602, the body was to be understood as an 'epitome' of 'whatsoever is more largely in that spacious and gorgeous Pallace and Theatre delineated'.[38] The theatre of the world and the theatre

of the body are met in the anatomy theatre – a play of correspondence which would have been familiar to a divine such as John Woolton, Bishop of Exeter. In his treatise *Of the Immortalitie of the Soule* (1576), Woolton linked microcosmic patterns of thought to anatomical theology to produce an extra-scientific rational for human dissection. If the body was created as a microcosm of God's creation, then it also contained a 'store of Miracles and wonders, to occupie our mindes, if we will vouchsafe to geeve the looking on'. The anatomist's explorations into the body might even be understood as conforming to speculations attributed to St Paul: 'that God may be felt and handled in some sort' when the body becomes the object of attention – an observation which many would have counted heretical.[39] In a second work, published in 1576 under the punning but theologically apposite title *A New Anatomie of Whole Man*, Woolton took this theology of anatomy a stage further, arguing that if christian doctrine were itself properly anatomized, then it would be understood that the anatomist's chair and the preacher's pulpit were not rivals to one another, since 'as Galen divinely writeth anatomy deduceth the creature to some knowledge of his creator.'[40] Other theologians turned to anatomy purely for its informational content. It is within this context that we can understand John Weemes (or Wemyss), the prebendary of Durham in the early 1630s, who published in 1627 his *Portrait of the Image of God in Man*, a work whose title suggests the conflation, once more, of anatomical knowledge and christian exegesis, mediated through the arts of representation. Weemes argued that an understanding of the internal features of the body was proper to an understanding of God's own handiwork, in that, for example, the anatomical construction of the brain, the heart, and the liver (the traditional sites of the tripartite division of the soul) gave evidence of God's care and foresight for the human creature.[41]

The anatomists had, then, two interlocking strands of thought to draw upon as they conducted their researches into the human body. The body's construction was evidence for the work of God, and the doctrine of the incarnation endowed the body with a special status. Allied to this form of reasoning were Neoplatonic arguments. Protestant interpretations of God's work could be meshed with Neoplatonic reasoning to offer a syncretic defence of the new science. Francesco Giorgio's *De harmonia mundi* (1525) may have proclaimed that the hidden harmonic construction of the body would never be uncovered by 'the cruel diligence of the anatomists, who cut up and divide dead bodies', but others argued quite differently.[42] For a Neoplatonic philosopher of the cast of Pontus de Tyard, for example, the human body was fashioned on the harmonic proportions described in the *Timmaeus*. In the *Solitaire Seconde* – de Tyard's discussion of the ravishing effects of music first published in 1555 – it was the 'diligence' of the ancients, 'not horrified at the cruelty of anatomy', who assured themselves of the

exterior and interior proportions of the body 'from which you know the musical consonances to be drawn'.[43]

These 'encyclopedic' accounts of human knowledge, forerunners to Bacon's syncretic system of enquiry, understood knowledge of the human body to be one of the foundation stones of intellectual enquiry. As such, they were the precursors to the greatest anatomical encyclopedia of the age: Burton's *The Anatomy of Melancholy* – a work which (as we shall see) drew on both the intellectual and the empirical possibilities of anatomy to offer a synthesis of human knowledge. The project of these encyclopedic writers was to assert the harmonious scope of human and divine understanding.[44] Nowhere were such arguments deployed more strenuously, or at greater length, than in the vast encyclopedic work of Pierre de La Primaudaye, whose *L'Academie Françoise* began to appear in 1577 and was not completed until its final publication in four volumes at Geneva in 1608–9.[45] The importance of La Primaudaye's work to Scottish and English writers (including William Drummond of Hawthornden and Sir John Davies) has only recently begun to be fully realized. Within its enormous scope, *The French Academie* (to give it its English title) proposed an organization of knowledge into a series of 'dayes' in a similar fashion to that offered by Du Bartas. These were not, however, to be understood as days of creation, but, rather, the individual days of work and discussion which the fictional participants in the 'academy' – four young men of Anjou – allocated to their task of learning the knowledge of God and human wisdom under the leadership of an older companion. The subject of Part II of *The French Academie* was the anatomized human body, a theme which was pursued by considering, first, God himself as a divine anatomist. The figure of God as an anatomist must have appealed to the human anatomists of the sixteenth and seventeenth centuries, for it seemed to offer one further means of sanctifying their task. But equally, it possessed a rhetorical power which appealed, for example, to Donne, versed as he was in metaphors of division and separation. If 'gluttonous Death' in Holy Sonnet 5 'will instantly unjoynt/My Bodye and soule' (Donne, *Poems*, 324) then God, as an anatomist, is able paradoxically to reclaim the integrity of the whole, as Donne made clear in one of his sermons:

> God's first intention, in the most distastefull physick, is health; even God's demolitions are super-edifications, his anatomies, his dissections are so many re-compactings, so many resurrections; God windes us off the skein, that he may weeve us up into the whole peece, and he cuts us out of the whole peece into peeces, that he may make us up into a whole garment.
>
> (Donne, *Sermons*, IX.217)[46]

The resurrected body – the garment of the soul – is recompacted through a form of reverse anatomization by God. For La Primaudaye, writing in a

harshly protestant vein, God the anatomist was more akin to His human counterpart, devoted to separation rather than to 'super-edification'. Moreover, La Primaudaye's anatomical God was concerned with rituals of punishment rather than investigation as a discrete process. God, wrote La Primaudaye, 'seeth whatsoever lyeth most secret and hidden . . . and is able to make as it pleaseth him an anatomy of both body and soul, and to send them both to everlasting hell fire' (La Primaudaye, 346).[47] Bacon's demand for anatomies which delved into the secret cavities and receptacles of the body-space was met, in a religious context, by the true anatomist who was a dissecting and punishing God. Divine or sacred anatomy thus entered the body cavity and uncovered the inward configuration of fallen humanity.

The English translators of *The French Academie* were particularly alert to the anatomical element in La Primaudaye's theological scheme. When the first English translation appeared (in 1594), and in the collected edition of 1618, the second section of *The French Academie* opened with an unsigned preface which explored the implications of sacred anatomy. Anatomy, the preface recommended, was to be studied for its medical and preventative utility. But more important than this was the lesson of the Psalmist, King David, who was adopted as a kind of proto-anatomist:

> That we ought to make this use of the anatomicall consideration of our bodies, the kingly Prophet DAVID teacheth us most divinely by his own example, when after a view taken of the admirable work of God in fashioning him in his mothers womb, he breaketh forth with this saying, I WILL PRAISE THEE, FOR I AM FEARFULLY AND WONDERFULLY MADE, MARVELLOUS ARE THY WORKS AND MY SOUL KNOWETH IT WELL. And surely unless we tread in the steps of this worthy king and propound this as the scope of all our travels in searching out the severall partes of our bodies, that God our creator and gratious preserver may be praised, worshipped, and feared thereby, we shall never know ourselves aright, and as we ought to do, but rather joyn with the most part of men who not using their skill in this behalf as a ladder to climb up by unto God, stick fast in the very matter and forme of their bodies, so that many of them become mere naturalists and very atheists . . . because they . . . follow after some small streames of . . . knowledge.
>
> (La Primaudaye, sig. 2F)

David's exultation (Psalms 139.13–14) pointed to an alternative programme of knowledge to that proposed by Bacon. The danger of anatomy lay in those anatomists who refused the implications of sacred anatomy and sought to explain simply the 'matter and form' of the body, rather than the fideistic implications of following in the steps of the divine anatomist. But for Renaissance anatomists, as Vesalius had explained to his patron Parthonepius in 1538, study of 'the ingenuity and workmanship of the Great Architect' underpinned their labours.[48] Led by such divine examples, it was

left to the anatomists to create perhaps the most enthralling (or bizarre) artistic convention of the period. The science of the body was to become not something to be performed only on dead corpses removed from the execution scaffold, but on the anatomist's own body. In the following section we shall see how 'sacred anatomy' gave rise to the most compelling of all anatomical images: self-dissection.

THE RHETORIC OF SELF-DISSECTION

In 1615, the anatomist and physician to James I, Helkiah Crooke, published his syncretic compilation of anatomy *Microcosmographia*. Crooke's work, based largely on the observations of continental anatomists, proved to be a popular textbook. No doubt much of that popularity lay in the lavish illustrations drawn from the works of Vesalius and his contemporaries which were chosen to illustrate the text.[49] In common with the English divines who understood the implications of 'sacred anatomy', Crooke offered a justification of his task in theological rather than scientific terms:

> Whosoever doth well know himself, knoweth all things. . . . First he shall know God, because he is fashioned and framed according to his image, by reason whereof, hee is called among the Divines, the Royal and Imperiall Temple of God; he shall know also the Angels, because he hath understanding as they have; he shall know the brute beasts, because he hath the faculties and sence and appetite common with them.[50]

Rooted in the words of the Delphic Oracle – 'Nosce te Ipsum' – the anatomist's task amounted to much more than the utilitarian study of the human frame. Throughout the sixteenth and seventeenth centuries, in the texts of French, English, German, Venetian, and Dutch anatomists, the injunction that to know oneself was to know God was continually repeated.[51] But those words – know yourself – also suggested a dramatic and convincing demonstration of the anatomist's skill in an alternative mode of representation. What if they were to be taken literally? To open the body of another was, it was true, part of the process of achieving generalized understanding of the human frame and its creator's wisdom, but the words also led the enquiring human subject to a form of self-analysis. Moreover, that analysis meshed with the rigours of Calvinist self-examination *and* a tradition of pictorial representation to be found in overtly catholic contexts. Anatomizing the self, in a spiritual sense such as that recommended by protestant divines, found its physical counterpart in the urge to imagine the human anatomical subject as in some form or another *participating* in its own dissection. It is not difficult to link this anatomical trope with Calvinist ideology. Under Calvinist precepts, obsessive inward scrutiny was the duty of

every believer, a never-ending process of spiritual self-reckoning, whose object was to assess one's standing with God. At times of sickness, in particular, the task was to explore the conscience in order to understand the scourge of illness as part of God's plan of salvation or damnation, operating at an individual level.[52]

It was, though, in the realm of visual art (an unlikely place in which to find Calvinism mirrored) that the process of anatomical self-scrutiny came to play the most important part in the representation of the anatomized human body. In Helkiah Crooke's textbook, anatomy was considered to be not only the gateway to theology and philosophy, but also helpful to 'all Artificers and Handy-Craftsmen', as well as to poets and painters. Renaissance theorists of art and architecture, building (as we have seen) on Vitruvian ideas, had long understood the importance of anatomical study to the pictorial realization of the human body. Leonardo da Vinci's anatomical studies bore witness to this impulse. Leonardo proudly claimed:

> I have dissected more than ten human bodies, destroying all the various members and removing the minutest particles of flesh which surrounded these veins, without causing any effusion of blood. . . . And as one single body did not suffice for so long a time, it was necessary to proceed by stages with so many bodies as would render my knowledge complete; this I repeated twice in order to achieve the differences. And though you should have a love for such things you may perhaps be deterred by natural repugnance, and if this does not prevent you, you may perhaps be deterred by fear of passing the night hours in the company of these corpses, quartered and flayed and horrible to behold. . . . Concerning which things, whether or no they have all been found in me, the hundred and twenty books which I have composed will give verdict 'yes' or 'no'.[53]

The frisson of morbid delight is here self-evident. But, for all his rapacious consumption of bodies in the proto-gothic ambience of his nocturnal studio, Leonardo contributed little of substance to contemporary understanding of the human body. His drawings and notes, intended for a projected study of the human figure according to a programme he had devised in 1489, remained unpublished until well after his death. What this unrealized project would have amounted to, Martin Kemp has suggested, was 'not so much an anatomical book as a far-reaching exposition of man's role in the natural order of things'.[54] Such an exposition would have been a further exercise in the tradition of 'sacred anatomy'.[55] Leonardo's demand for anatomical knowledge on the part of artists was conceived of as part of a wider anatomy of human nature itself. In representing the movement of the human body informed by anatomical study, the artist, in Leonardo's words, would 'reveal to men the origin of their second – second or perhaps first – cause of existence. Division of the spiritual from the material parts.'[56] This

111

division of the human subject (prefiguring the Cartesian division of the seventeenth century) echoed throughout the work of Renaissance theoreticians of the visual arts.[57] If the human body was indeed the measure of all things, then the artist's task was, through the process of representation, to display that principle of measurement at work in the world at large.[58]

But it was not enough simply to affirm the Vitruvian truth of the central importance of the human form. Didacticism demanded that the figure demonstrate that truth. If the body, rendered into its constituent parts on the anatomy slab, could be made to speak then it would have to speak of its own participation within the process of self-analysis. It was out of this set of theoretical co-ordinates that the extraordinary convention of 'living anatomy' was born. Until well into the eighteenth century, the conventions of anatomical illustration demanded that the figure, even at the very deepest stages of dissection, should be represented as still alive. The Vesalian 'musclemen' for example, stroll through a pastoral landscape, casually allowing themselves to be gradually deconstructed, oblivious to the literal impossibility of such a reduction (see Figures 12 and 13). The escape of these cadavers from the confines of the anatomy theatre into the world at large is one of the most disturbing and yet fascinating motifs in Renaissance art. But what do they signify? For commentators working within the scientific tradition, these images illustrate a fundamental set of assumptions about the status of the human body as an object of attention in early-modern culture: 'the fact that in the sixteenth century there was no separation between morphology and function'.[59] More recently, it has been suggested that what is represented in these images is a sign that:

> the heroic human subject of the anatomy has not been completely conquered. By the end of the 'musclemen' series a skeleton is all that remains – yet the bones are poised to retain signs of human suffering. They function as *memento mori* rather than medical illustrations.[60]

Whilst it may be true that morphology and function were inseparable in the period, what is remarkable about these images is, in fact, their *acquiescence* in their own anatomical reduction. It is as if the Vesalian body is an accomplice to (rather than resistant towards) the dissective process. Even on the title-page of the *Fabrica* we can see a hint of this shared conspiracy between anatomist and subject. Looking at the title-page once more (Figure 2), we can see that the woman who is being dissected has been positioned in such a way that she is looking directly into the face of her dissector. In thus staring into the face of the anatomist, she seems to share in our experience of the image. We, as audience to the complete scene, look at Vesalius, her body, and the surrounding spectators. She, as the *raison d'être* for all this activity, is by no means simply a passive object for our

112

contemplation. She too is watching the process of dissection which is mirrored in the face of her dissector.

This sense of acquiescence – of a willing participation on the part of the anatomized subject – is displayed even more dramatically in the work of the contemporaries of Vesalius, as well as in images produced long after the first appearance of the *Fabrica*. Figure 14 shows a self-demonstrating figure published in 1627, which is representative of the convention of self-dissection to be found in early-modern anatomical texts. What informs such images is the extraordinary degree of co-operation which they seem to display in 'submitting' to the dissective process. Anatomy is shown to be a science which (contrary to what we might expect) seems to animate the body, and endow it (albeit temporarily) with a life of its own so that it could assist in the engaging spectacle of its own division. Three reasons may be adduced for the development of this convention of living self-anatomy. The first we can surmise as being rooted in the reality of how, in the early-modern period, bodies came to be in anatomy theatres. As the recipient of bodies from the execution scaffold, the anatomist was fully implicated in the ambivalent rites of judicial power. As we have seen earlier, the anatomist and his assistants, though they proclaimed the dignity of their study through the ritual which took place in the theatre itself, were nevertheless working at only one remove from the grim business of public execution. We have seen, too, how the executioner and his fellow workmen were seen as uncomfortable members of the community. Although they exercised a sovereign power over the body which, in the popular mind, endowed them with occasionally supernatural powers, they were also considered to have been unfit for full participation in the life of that community. With the advent of dissections in which the anatomist participated actively (rather than have assistants performing the brutal and messy business of dissection), it is easy to see how he (just like the executioner) could be held in deep suspicion by the community in which he practised his trade. Leonardo's account of nocturnal dissection makes us aware of this distrust or even fear. Leonardo's description of private anatomy suggests a secretive task, performed in the isolation of the studio. But it was the highly ambivalent and emotionally charged spectacle of public dissection of a criminal corpse which helped give rise to the artistic convention of depicting anatomical subjects as performing the act of dissection on themselves. Paradoxically, whilst the decoration and ornamentation of the anatomy theatre proclaimed the dignity of the science of the body, the anatomist himself, in the illustrations which formed such an important feature of the textbooks, allowed himself to be banished from the site of his labours. So, instead of an anatomy being performed *on* the body of a recently executed criminal, the illustrations show us a corpse conspiring with its own demonstration, in order to confess the truth of the

study which has been embarked upon. The body, in other words, complied in its own reduction and thereby confessed to the power and truth of this new branch of human enquiry. We can understand this act of confession as almost perfectly analogous to the complete meaning of the pre-anatomical ritual of execution as analysed by Michel Foucault. Namely, that the body:

> has produced and reproduced the truth of the crime – or rather it constitutes the element which, through a whole set of rituals and trials, confesses that the crime took place, admits that the accused did indeed commit it, shows that he [sic] bore it inscribed in himself and on himself, supports the operation of punishment and manifests its effect in the most striking way.[61]

If for the term 'crime' in Foucault's account, we understand the demonstration of the truth of 'knowledge' of the body, then we can see how, in these self-demonstrations, the body is indeed (as Foucault writes) 'the partner of a procedure'.

But confession to the truth of what was demonstrated in the body-interior was just one element in the convention of self-demonstration. The second element in the development of the convention of self-demonstration, one which was perhaps a product of the convention rather than the mainspring for its adoption and continuation, may be discovered in a feature of these illustrations which has now entirely vanished from the textbooks of medical science. A feature of Renaissance anatomic illustration is the intrusion of the cadaver into a landscape (Figure 15), or even an ornately decorated private chamber. Corpses were not inevitably shown *in situ* on the dissection table. So, knowledge of the body, in these texts, was presented as knowledge of a living rather than dead body. As we have also seen, the body, in the Vesalian images that illustrated particular structures in detail, was anchored to a regime of knowledge both through the keying mechanism which mapped text and image on to one another, and through the tradition of representing the human body as classical statuary. This dual device – whereby the anatomized body was still participating in the sensory world, and yet it also occupied a place in the tradition of classical fragments – was what (literally) animated dissected cadavers in their rural or domestic frames. In some sense, what was shown in these images was an assertion of the 'naturalness' of dissection. The dissected body was not shown to be forcibly wrenched from the world of the living. So, the dissected cadavers are to be understood as liminal figures, existing at the margin of living society, while, equally, they participate in a new community of the dead. In this respect, the Vesalian figures echoed an older, pre-modern, set of beliefs about the status of the dead in respect to the living. Within 'primitive societies', Clare Gittings has observed, 'death . . . marks the beginning of a waiting or liminal period, culminating in a more decisive change'. That change took place much later

114

than the 'moment of death' which is so significant in modern, western, belief systems. Frequently, in traditional societies, it was the decomposition and reburial of the body which marked the moment of transition from 'life' to 'death'.[62] The Vesalian figures are particularly revealing in this respect. The 'musclemen' have fled the social world, evoked in the townscape in the background, to reside as isolated inhabitants of an arcadian and idealized pastoral world. The city which lies behind them expresses a human world in which they can no longer participate.[63] But, as solitary inhabitants of arcadia, the musclemen gesture towards that established tradition of admonition which is summarized in the motto *et in arcadia ego* – 'Even in Arcadia there am I, Death'. The relevance of this tradition of the arcadian reverie of death was, inevitably, of huge significance to anatomic illustration. The skull (Death) which spoke and warned the observer of its ironic presence even in the midst of delight, allowed anatomic illustration to participate in what we might term the grammar of death. That is to say that the dissected corpses which signalled their own conscious awareness of themselves as inhabitants of the community of the dead, and who held themselves open to the viewer's gaze, were being allowed to speak directly to the viewer of their own (and hence the viewer's) mortality.[64] Thus, they paradoxically asserted the triumph of death and time whilst they appeared to rejoice in a liberation from death guaranteed them by the reductive process of dissection. The triumph of death – or the assertion of the rule of time in human affairs – was a subtext which ran through the first two books of Vesalius' *Fabrica*, so that a tension was continually suggested between the analysis of the body conceived of as inhabiting space, and its material fate at the hand of time. From the complex title-page, with its skeletal *memento mori* in the dissection scene, through the eloquent skeletal plates which showed skeletons supported on a spade, or a skeleton contemplating a tomb, and so through the dissection of the 'musclemen', the illustrations offered a commentary not only on human anatomy, but on human destiny. This conceit was one that could be found in numerous sixteenth- and seventeenth-century anatomical text-books.[65] What we might term the moral lesson of 'sacred anatomy' was further reinforced by the classical ruins which were features of the Vesalian landscape. The ruin motif was a device whereby the viewer was encouraged, once more, to understand the wider significance of the image. The ruin spoke of mutability in human affairs. The social world from which the cadaver appeared to have escaped was shown to be equally subject to the devouring force of time and death. This moral significance of the ruin was certainly appreciated by later, predominantly eighteenth-century, responses to Vesalius when the *Fabrica* was re-engraved and reinterpreted.[66]

The Vesalian plates suggest, therefore, that the complete project of Renaissance anatomy embraced a wide spectrum of possible moralized

readings. The dissected human body in isolation signified very little because, in terms of the paradigms of natural science, the body could not yet provide its own rationale for division. It was only after the great anatomical explorations of the late sixteenth and seventeenth centuries that it became possible to view the body in spatial isolation, with the implied context provided by the rigours of scientific investigation. Instead, in these earlier images, the body needed to be contextualized, juxtaposed with other motifs, shown in extravagant postures, in order to demonstrate the full human and divine significance of the anatomist's skills. It was as if the devices of art were engaged in a form of propaganda on behalf of this new discovery of the human world. So, in these images, the anatomist anxiously glanced back to familiar motifs and well-rehearsed programmes, and thus he maintained the older truth of his new science in terms to which his audience would have been able to respond. The key to that truth – the endlessly repeated defence – was that the anatomist was *not* disrupting the body. Rather, the body willingly allowed the anatomist to assist the general process of decay and dissolution. Anatomy (as it was represented pictorially) was not, therefore, artificial. It was simply a demonstration of the eventual shared fate of all bodies. Hence, in the illustrations to the *De dissectione partium corporis* of Charles Estienne and Estienne de la Rivière, published at Paris in 1545, we see motifs very similar to those to be found in Vesalius but realized in a more extravagant form.[67] Once more, the body was still alive, and once more enormous effort was invested in producing woodcuts the majority of which were, from a purely medical point of view, entirely redundant.[68] Figures 15 and 16, for example, are taken from Estienne's sequence of brain dissections. In these images the body is shown in different locations: the enclosed space of a chamber, or a landscape whose features seem to echo the mass of the body. The images are striving to offer a context for the dissection which is, above all, an assertion of the naturalness of the fate which has overtaken the body. Hence, the body in Figure 15 is shown to be in curious harmony with its surroundings. Its bulk echoes the mass of the pollarded tree against which it leans. The shattered tree stump and the scattering of small stones and pebbles, equally, speak of fragmentation, decay, and the eventual return of the body to the earth which, in scriptural terms, is its point of origin. The body in Figure 16, on the other hand, confounds all perspectival reason. Here, the body has been bisected by the surface plane of the table over which it slumps. But in the delicately poised motion of the hands (one of which helps to support the cartouche which labels the various structures under dissection) we see signs of life. The important features of the image, again, are its evocation of the body as living, and the architecture in the background, one plane of which is shown to be complete, whilst the other, receding into the distance, is tumbling into

decay. The body echoes this juxtaposition of a maintained fabric and a ruined fabric. Below the table all is complete; above the table interior fragmentation has begun.

These pre-Vesalian French images have been termed 'mannered, even surrealistic' and virtually useless as anatomical studies, since the size of the dissected area is such that 'no one could learn brain anatomy from them'.[69] The fact that the anatomical sections of these images were mortised into the original woodblocks, it has been argued, suggests that the original complete woodblocks were never intended as anatomical studies in the first place.[70] Yet, Estienne's undoubtedly disturbing and powerful figures were produced as part of an anatomical text, whatever the provenance and manufacture of the illustrations. It was as an 'anatomy' that they were designed to be viewed; but an anatomy of what, exactly? Once more, 'sacred anatomy' seems to have been the controlling conceit. The dissected subject was contextualized within a scriptural framework which spoke of a wider understanding of the decay of humanity and of the works of humanity. It was as if these images had anticipated Shelley's ironic traveller recounting his discovery of the gigantic, shattered, human form of Ozymandias. At the same time, the one figure that is not present in these images is that of the anatomist who has conducted the dissection. Instead, like Ozymandias, he is banished from the scene, while his works are scattered over the landscape, expressing the immortality of fragments.

The conceit of the absent anatomist reached its most extravagant expression in the convention of self-demonstration which we have already glanced at, and which provides us with the third and final element in the establishment of the convention of living anatomy. In using the form of analysis proposed by Foucault – that of the body 'speaking the truth' of its own knowledge – we easily miss the full implications of 'sacred anatomy' in the design of these figures. The core of the self-reflexive gesture, which allowed the anatomized subject delicately to lift and peel back its own skin, lies in the doctrine with which we have already become familiar – 'Nosce te Ipsum'. What the device of self-demonstration guaranteed was a literal interpretation of the searching, inward gaze recommended by philosophical self-examination. But this inward gaze also gestured towards a tradition of representation which was to become familiar in later, Baroque, images: that of Christ in self-dissection, exposing his own sacred heart.[71] Prior to this form of representation, however, there was an equally consonant set of images of Christ in self-demonstration: the image of the risen Christ exposing the wound in his side, or gesturing towards that wound, or allowing the Virgin to palpate the wound. Christ was thus understood as the subject of a gaze whose end was the establishment of the truth of his own resurrection – a process analogous to the scientific scrutiny of the human interior.

This device was further associated with a set of interpretations of Christ's injunction at the last supper, where, prior to the crucifixion, Christ partitioned his own symbolic body, offering it to the surrounding disciples.[72] In performing this act of sacred self-demonstration prior to his execution, Christ participated in a form of reversed penal anatomy. First, he divided his own body, then his body was punished in order to redeem fallen humanity, and finally, he rose again, triumphing over mortality. For the human subject of anatomy, on the other hand, offered up as a sacrificial object of human law, the process involved the same components, but in the reverse order. First judgement, then punishment, and finally division in lieu of (perhaps) future resurrection. The object, however, of human (as opposed to divine) division was knowledge rather than redemption. Nevertheless, so powerful was the set of symbolic meanings invested in the figure of the self-dissecting Christ, that it came to inhabit the visual depiction of anatomization at every level. We can see these codes operating in one of the earliest printed anatomical texts, establishing a tradition to rival the elaborate language of gesture informing, for example, the *gravida* figures of de Ketham. Those figures, we have seen, directed the viewer's gaze *away* from the inward configuration of the body-space, towards the mystery of the incarnation. But self-demonstration functioned in the opposite manner – underlining the disturbing conjunction of a living body and an opened interior. In Figure 17 we see an early example of self-demonstration, taken from the *Commentaria* of Berengarius (Giacomo Berengario da Carpi) on Mondino's fourteenth-century dissecting manual, published at Bologna in 1521.[73] The fact that the anatomical structures of the chest and abdomen are barely alluded to in the image is beside the point. This dramatic semi-Vitruvian figure, etched within a surrounding aura of light rays (whose source is the figure itself), symbolized not anatomical knowledge of the body-interior, but philosophical and religious knowledge of the interior of the whole, or scripturally complete, individual. The human body is here redeemed even as it peels back the surface covering of skin, which falls like discarded cloth over the subject's thighs. Everything in the image – the splayed feet, the statuesque pose, the rays of light – speaks of divine proportion, understood through the internal scrutiny of the human frame which the subject must pursue out of its own will, and thus follow the example of Christ offering his own heart, or in the conventions of the Eucharist, his own body, to the witnesses who surround him.

The convention of the human figure in self-demonstration was, then, part of a dense network of sacred imagery surrounding the figure of Christ in the various stages of the passion. The symbolic partitioning of Christ's body, the exposure of his wounds, and the (later) image of the exposure of the sacred heart, were appropriated in the cause of 'science'. These images seemed to

have circulated around a fairly stable set of interpretations centred on punishment, redemption, and proof – elements which were immediately relevant to the process of anatomical investigation in the early-modern period. That these anatomical texts gestured so strongly in this direction is suggested not only by the individual images themselves, but also by the entirely self-conscious manner in which anatomical textbooks invoked an overtly sacred interpretation of the human form. Berengarius, for example, in his *Commentaria* of 1521, not only produced images of the human body in dissection, but also a striking image of an *ecorché* or flayed crucifixion figure, as though to remind the spectator that the anatomized human body was also the sanctified temple of the incarnation. Moreover, the ambiguous nature of such anatomical representation – the confusion between a state of being and non-being – can also be related to specifically pictorial traditions of the depiction of Christ after the crucifixion. Regina Stefaniak has described the body of Christ both within the tomb and after the Resurrection as it was realized in pictorial art, in a way which entirely accords with our experience of these anatomical images:

> Hidden in the tomb for three days between death and rebirth, absent to scripture, the exact state of the body of Christ was mysterious – both dead and sleeping, perhaps also intermittently awake but profoundly abstracted. After the Resurrection, however, the transformed body of Christ was even more paradoxical: there and not there, passing through closed doors or multiply sighted in widely scattered locations.[74]

In a similar fashion, the anatomically divided body, discovered in the images we have been studying, seemed to float in an equivocal space. Dead and not dead, oblivious to its own partition, stumbling through the countryside or sprawled over a chair or table – the subject of dissection, equally, seems to have occupied a profoundly ambiguous cultural space.

The artistic counterpart of the act of self-demonstration can be found straddling both catholic and protestant traditions. In some sense these later images are related to that Baroque delight in strain, contortion, and self-reflexivity. Like a Bernini statue, the intention was to perceive the human body 'in movement . . . [in] a transitory state'.[75] Indeed, Bernini's statue of S. Bibiana in Rome was commissioned, in 1624, following the discovery 'in two glass receptacles, of the body of a martyred virgin'.[76] Here is an iconic anatomical artistic moment: the dead body, discovered in its crystalline vault, could be reanimated through the artist's power of representation so that it could be appreciated as both living and dead in almost the same moment. In much the same way, the self-demonstrating cadaver seemed to transcend its own mortality in a fantasy of self-reflexive exploration. In similar fashion, in English poetry, Richard Crashaw's fascination with the erotic potential of

Christ's passion revolved around the possibility of evoking the literal or physical presence of the body of Christ in self-reflexive torment. Amongst the divine epigrams published in Crashaw's *Steps to the Temple* of 1648, we find a meditation on Christ's words in John 10.9: 'I am the door. By me, if any man enter in, he shall be saved' (Douai version).[77] 'Ego sum ostium' – 'I am the door' – is a self-reflexive motto worthy of the anatomical figures who hold themselves open to our gaze. It was interpreted by Crashaw thus:

> And now th'art set wide ope, The Speare's sad Art
> Lo! hath unlockt thee at the very Heart:
> Hee to himselfe (I feare the worse)
> And his owne hope
> Hath *shut* these Doores of Heaven, that durst
> Thus set them *ope*.
> (Crashaw, *Poems*, 17)[78]

Christ's body, pierced in the side, becomes a door through which salvation and the kingdom of heaven may be gained for all except the soldier, who, with his spear's 'sad Art', opened the 'door' to everyone except himself. The soldier's fate is a distillation of the anatomist's fear. Like the soldier who pierced the body of Christ, the anatomist is part of the punitive machinery which takes as its object the agonized human body. But it was the erotic potential of the image which was so striking – a fantasy of opening and penetration akin to the erotic self-demonstration of the body in dissective images, and one which is repeated in the epigram 'On our crucified Lord Naked, and Bloody':

> Th'have left thee naked Lord, O that they had;
> This Garment too I would they had deny'd.
> Thee with thy selfe they have too richly clad,
> Opening the purple wardrobe of thy side.
> O never could bee found Garments too good
> For thee to weare, but these, of thine owne blood.
> (Crashaw, *Poems*, 44)

Here, Crashaw has expressed the erotic fragility of the naked body of the crucified Christ, with the 'purple wardrobe' of the pierced side allowing new garments – blood – to swathe the sacred body. In his poem 'On the wounds of our Crucified Lord', Crashaw discovered in the body of Christ a quiveringly vulnerable *locus* of quasi-erotic metamorphosis. Bleeding wounds become mouths; mouths become tear-filled eyes. Deliberately confusing the integrity of the passive body parts which are subject to such agony, Crashaw has created a response which is explicitly erotic, as the poem turns to address the weeping figure of Mary Magdalene who is witness to the crucifixion:

120

> This foot hath got a Mouth and lippes
> To pay the sweet summe of thy kisses:
> To pay thy Teares, an Eye that weeps
> In stead of Teares such Gems as this is.
> (Crashaw, *Poems*, 25)

The fact that the addressee of the poem was associated with the type of the Fallen Woman – the Prostitute – gives an added twist to the poem's panting set of exchanges. The dying Christ, whose wounds are showered with kisses, 'pays' for them with tears and blood which are themselves Gems.

The point of contact with the anatomists' images lies in the opening of the hitherto passive body-interior to public scrutiny. 'As a wounded hero', Stefaniak has observed, Christ 'was like a woman' within the cultural nexus of sixteenth-century religious and social attitudes. The 'willingness of the divine victim' to submit to the penetration of the crucifixion – the thorns, nails, the soldier's spear – enabled a 'further inflection of the woundedness metaphor into feminine erotic response', so that the 'violence of the passion' could be 'displaced to sixteenth-century women'.[79] Such a tradition, in which the human body of Christ could be 'identified with nurturing female flesh' had not entirely vanished by the seventeenth century: as Crashaw's poem on a lactating Christ suckling his mother demonstrated.[80] Crashaw's poems on the passion seem to establish themselves within the androgynous tradition of representation, while at the same moment they gesture towards the anatomist's public demonstration of the body's secretive interior. To modern readers, versed in the dominant modes of anglo-american (one is tempted to say puritan) criticism, it may well be that such attitudes make Crashaw's poetry deeply uncomfortable.[81] But if anything, the sequence of latin epigrams which Crashaw published in his *Epigrammatum sacrorum liber* of 1634 are even more explicit in their eroticization of the willing victim. They, too, speak directly to the self-demonstrating anatomical images:

> O harsh faith! did you wish to prolong my sorrows?
> O cruel fingers! have you discovered God in this way?[82]
> (Crashaw, *Poems*, 400)

Thus Crashaw has Christ address Thomas, the doubting enquirer, who, in his desire to establish the truth of the Resurrection, scrutinizes the opened body with all the intensity of an anatomist. The point, however, lies not in the epigram's protesting tone, but in the grammatical model it proposes for understanding the self-dissective figure. Both Christ and the cadaver can show themselves, allow themselves to be displayed, in order to satisfy the sceptical curiosity of the onlooker. The dead *can* speak to the living, and

121

proclaim the truth (whether that truth is religious or scientific) which is present in their own bodies.

But if the catholic tradition tended to stress the *passive* nature of Christ in his passion, protestant versions of the theme tended to place emphasis on active self-scrutiny. This emphasis, in turn, led to the development of the imaginative participation of the observer in the stages of the passion. Translated into a profane context, this sacred trope could be turned into an extraordinary series of conceits which centred on the partition and division of the (male) opened body by surrounding onlookers, or even the mistress – the implied reader of the text. Predictably, perhaps, the poetic version of anatomized subjects (whether sacred or profane) performing their own dissection, in English culture, was to be found in its most complete (and complex) form in the work of John Donne. Donne's poetry (as much as his prose) is replete with self-reflexive images of dissection. 'My ruinous Anatomie' was an enduring object of fascination for Donne, whether he was addressing a mistress or addressing God. Attracted to this new science, Donne seems to have had anatomical information readily to hand.[83] But it was not just for its informational content that Donne pursued anatomy. Rather, he recognized the rhetorically powerful possibilities in the conventions of self-demonstration – conventions which the fascinatingly theatrical ritual of Renaissance anatomy made even more alluring to this most theatrical of all poets. God, of course, was the chief anatomist. It was God who could anatomize the body and soul so that 'we are brought to a better knowledge of ourselves', as Donne observed in one of his sermons (*Sermons*, IX.256). But a more striking possibility was that he, John Donne, could play the part of the anatomist, *and* play the part of the dissected subject. It was if Donne sought to occupy both of the central roles in the swirling excitement of the Vesalian title-page, commanding the attention of an audience as much for his skill as a dissector, as for the revelation of what his own internal spaces would look like. The anatomy theatre, in other words, became the perfect *imaginative* stage in which Donne could perform, over and over again, the drama of his own self-presentation, a function of that tendency to make himself 'the centre of things, the object of contemplation'.[84]

Adopting such a stance allowed yet another possibility: the poet in dissection could also replicate the passion of Christ, the supreme example of self-demonstration. Holy Sonnet XI, for example, allows us to watch this self-reflexive activity in operation:

> Spit in my face you Jewes, and pierce my side,
> Buffet, and scoffe, scourge, and crucifie mee,
> For I have sinn'd, and sinn'd, and onely hee,
> Who could do no iniquitie, hath dyed:
> But by my death cannot be satisfied

> My sinnes, which passe the Jewes impiety:
> They kill'd once an inglorious man, but I
> Crucifie him daily, being now glorified.
> Oh let mee then, his strange love still admire:
> Kings pardon, but he bore our punishment.
> And *Jacob* came cloth'd in vile attire
> But to supplant, and with gainfull intent:
> God cloth'd himselfe in vile mans flesh, that so
> He might be weake enough to suffer woe.
>
> (Donne, *Poems*, 298)

Having claimed the central position within the passion narrative and become the object of contemplation and punishment, Donne suddenly switches roles, and becomes the punisher, the crucifier of Christ, who is 'cloth'd' (much as in the Berengarius image, or in Crashaw's epigrams) 'in vile mans flesh'. This self-reflexive grasping after two roles – an anatomist who performs his own anatomy, or a crucifier who is also Christ – echoed the self-reflexive tendency which is so familiar to any reader of Donne's poetry or prose.[85] It was contemporary practices of representation, just as much as Donne's reading of the church fathers, which led him, in John Carey's words, to import 'anatomical density' into his writing.[86] What seems to have urged Donne forward in this tendency (as Carey expresses it) 'towards vivisection' is a sense of wanting to overcome the body's *resistance* to penetration and division; and there was no clearer example of acquiescence than the cadaver which opened its private recesses to the public gaze. But, once bodies had been entered in this way, it was difficult to make sense of what was encountered within the internal cavities and recesses – and of course, no body was more difficult to gaze at (or into) than one's own body. But it was exactly this difficulty which returned Donne, time after time, to the processes of self-contemplation. So, in the rapt meditation which was Donne's 'Obsequies to the Lord Harrington', the poet adopted an extravagantly solipsistic position. As the moon rises 'to mee' so:

> All the world grows transparent, and I see
> Through all, both Church and State, in seeing thee;
> And I discerne by favour of this light,
> My selfe, the hardest object of the sight.
>
> (Donne, *Poems*, 247)

Though the surface reality of human affairs ('Church and state') seems to have become suddenly available to the meditative eye, it is the self, 'the hardest object of the sight' rather than the exterior world which claims attention. Imagining his own dissolution into constituent components under this transforming interior gaze was a characteristic trope of Donne's. We

have seen Donne in the poem 'Loves Exchange' evoking the awful reality of post-execution dissection where the victim of love becomes a punished 'example' to 'future rebells'. Such a spectacle was rarely one from which Donne's imagination shrank. Time after time, in his profane verse, Donne imagined his own body transformed into a cadaver and thus becoming the object of an admiring enquiry. We might term this an exchange of 'sacred anatomy' – the discovery of the mystery of the incarnation within the human body – for 'profane anatomy', or the discovery of a purely earthly passion residing in the body-interior. 'Profane anatomy' animated the self-dissection which underpins the aptly entitled 'The Dissolution', with its conceit of the 'mystery' of the 'subtile wreath of hair' (her hair) which, better than any anatomical *or* sacred structure can 'tye those parts, and make mee one of all' (Donne, *Poems*, 58). Self-demonstration is evident in the procession of images to be found in 'A Valediction: Of My Name in the Window' where the poet's scratched name on a window pane ('this ragged bony name') demonstrates the possibility that his own body can be imagined as clear and yet reflective glass (Donne, *Poems*, 26). Just like the martyred virgin, discovered encased in glass and then transformed into art, Donne sought to transform his own body into an object of contemplation and (profane) veneration. In such poems, the dissective impulse was rooted within two anatomical conceits available to Donne's contemporary readers, both of which were functions of the practice of 'sacred anatomy', but transformed into its profane counterpart. In the 'Valediction' the clear anatomy of the poet both teaches (it is 'all confessing'), whilst it also 'cleare reflects thee to thine eye' – allowing the observer (the mistress) self-knowledge in the 'glass' of a divided human form.

For Donne, versed in the precepts of 'sacred anatomy', the glassily transparent (or semi-opaque) body also showed God 'as a glass, but glimmeringly and transitorily, by the frailty both of the receiver and the beholder'.[87] This hazy, shimmering, image of God in the human interior was reflected in the difficulty of anatomizing the divine. Christ, of course, was the subject of a penal anatomy, as Donne pointed out in his translation of the neutral latin verb *solvere* (to be found in the vulgate text of 1 John 4.3) as 'dissect': 'and for that matter of beleefe, he that beleeves not all, *solvit Iesum*, as S. John speakes, he takes Jesus in peeces, and after the Jews have crucified him, he dissects him, and makes him an anatomy' (*Sermons*, VIII.146). But to dissect Christ, in this context, was to perform an anatomy on a body of doctrine rather than the divine body. The divine body seemed as difficult to anatomize as Donne's own body, though that did not prevent Donne from attempting the dissection, and finding not anthropomorphic structures but, rather, allegorical figures of the body's parts:

124

there is never braine, nor liver, nor spleene, nor any other inward part ascribed to God, but onely the heart. God is all heart. . . . And then, though in the scriptures, those bodily lineaments, head and feet, and hands, and eyes, and eares be ascribed to God, God is never said to have shoulders; for . . . shoulders are the subjects of burdens, and therein the figure of patience, and so God is all shoulder, all patience.

<div align="right">(Sermons, IX.135)</div>

If God himself resists anatomization (despite His anatomical skills which are skills of composition as much as reduction), then it is the poet-anatomist's own body which must make do. Searching within his own body for a heart ('The Legacie') in the guise of profane self-anatomist, Donne demonstrates his casually knowing attitude towards the process of self-dissection. Endeavouring to be both subject and object of the contemplation ('Mine own executor and Legacie'), Donne opens his body. But 'When I had ripp'd me, and search'd where hearts did lye', he discovers nothing except 'something like a heart'. It was not, then, a perfect heart which could only be discovered in Christ's body, but rather the imperfect replica of the sacred heart – 'not good . . . not bad . . . as good as could be made by art' (Donne, Poems, 19).

The sickness which produced Donne's record of illness which we have already traced in the Devotions of 1624, also mobilized the devices of self-anatomization. In the ninth meditation, for example ('Medicamina Scribunt'), we have observed Donne observing his own physicians, who have retired to consult together. Nothing, we might have expected, could be more potentially passive than to be the object of professional medical scrutiny when one's body is racked by sickness. But this was not Donne's stance. Rather, he grasped after the self-reflexive (and central) position of the self-demonstrating human anatomy:

They have seene me, and heard mee, arraigned me in these fetters, and receiv'd the evidence; I have cut up mine own Anatomy, dissected myselfe, and they are gon to read upon me.

<div align="right">(Donne, Devotions, 45)</div>

The anatomy here is (once more) penal. Although the significance of the self-examination performed by Donne is devoted towards a spiritual end, what is insisted upon within the sequence of images is a medicino-legal enquiry. But it is also an invocation of Christ as Christus Medicus – Christ the healer – with a difference: for, in urging his own active participation in the proceedings as his physicians are shuffled off into a Galenic huddle, Donne assumes the Christ-like role of spiritual healer of the ravages of sin manifested in sickness which contort his own body.[88]

These images, then, are part of a complex language of symbolic representation to which the new science of anatomy turned as it commenced its

interior voyages. Drawing on traditional, scriptural, tropes and metaphors, the anatomists appropriated the visual language of christian symbolism in a complex rhetorical defence of their discipline. Taken up by a modishly alert poet such as Donne, old ideas were suddenly recast into a set of striking metaphors. It was as if a fusion between science and poetry had taken place, with the catalyst being the entirely traditional framework of christian symbolism. When we trace the emergence of this language in literary texts such as the sermons, poems, or meditations of Donne and his contemporaries, we soon become aware of the mistake which generations of commentators have made in understanding metaphysical writing of the seventeenth century as simply 'witty', rather than 'visual'.[89] There are no more 'witty' conceits than Donne's insistence on self-dissection. But those images are firmly grounded in a tradition of pictorial representation of the human body, which was itself part of the dense language of exegesis and interpretation of the central mystery of the incarnation and passion. And the tradition lingered on. It was not until well into the eighteenth century that the body's interior volume began to occupy the centre of the stage, unmediated by a dense fabric of scriptural tradition. Prior to that release of the body from theology, the anatomists struggled to express a harmonized view of the created fabric of the body, so that their own researches and scriptural doctrine, rather than jostling one another, simply replicated the authenticity of each system of knowledge. Once we have studied such images, it is possible to see how and why the anatomists strove to dignify their science in terms of the language and images of the scriptures. What other totally authenticating framework for enquiring human reason was on offer? At the same time we can see how, especially under the prompting of a Calvinist theology, protestant divines saw in this new science a complement to the authority of the scriptures. 'Every particular man is himselfe *Templum spiritus sancti*, a Temple of the Holy Ghost', Donne wrote in a sermon of 1619 (Donne, *Sermons*, II.217), a claim he repeated many times in his career. But if this were true, then how much more significant were the scalpels which opened the body in the hands of anatomists?

'God's first care of man was his body, he made that first; and his last care is for the body too, at the Resurrection' (Donne, *Sermons*, III.83), so Donne observed in 1620. But by then he had abandoned his greatest experiment in anatomical investigation: the Anniversary poems of 1611–12. Perhaps no work of Donne's has attracted quite the weight of analysis these composite texts have produced.[90] But within the conventions of 'sacred anatomy' that we have been tracing, the overall possibilities of meaning are at least clear in outline. Essentially, then, Donne offered in 'An Anatomie of the World – The First Anniversarie' and its sequel 'Of the Progresse of the Soule – The Second Anniversarie' a meditation on the possibility of applying the dissective structure to an analysis not of any one specific body, but of the whole

world. That world was conceived of as a vast, lingering, cadaver, hovering between life and death in much the same way that the anatomists depicted the body as both dead and alive conspiring in its own dissolution and partition. Even the form of publication which Donne developed (but did not pursue) for the poems – an annual memorialization and meditation – was reminiscent of annual anatomical demonstrations such as the Lumleian lectures at the College of Physicians.[91]

For us – the modern readers of this meditation on the theme of 'sacred anatomy' – one of the chief difficulties of the poems lies in their deliberate blurring of the syntactical relationship between subject and object. Who or what is being dissected? Who or what is doing the dissecting? Who is supposed to witness the operation? But this blurring of roles (or attempt at holding down all roles simultaneously) is completely consonant with the tradition of sacred self-dissection. The role of corpse (the world), the role of anatomist (the speaking voice of the poems), and the role of audience (readers of the text) are all present in the verses. However, the precise demarcation lines which separate their individual functions (cadaver, anatomist, audience) are deliberately confused. Just as in the anatomical illustration, corpses can speak, anatomists become corpses. The poems thus oscillate between an address to the world as audience of the anatomy lesson, and an evocation of the world as subject of the anatomy. Within this latter structure, Donne also places himself and us – the narrative voice and the readers. Insofar as they (or we) are part of the anatomized world, they are also subject to dissection. As if to underline this all-inclusive possibility – a possibility which mirrors the self-reflexive figures who, in the pages of Renaissance anatomical textbooks, hold themselves open to investigation – Donne insists, at each of the five refrains in 'The First Anniversarie', on emphasizing that this is 'our Anatomie' which is under investigation. 'Our Anatomie' thus signifies not just Donne speaking in the collective voice, but the inclusion of reader and anatomist/poet in the progressive dissection of the world and all that is contained within it.

Yet, by mapping these complex and beautiful meditations onto the traditions of anatomical illustration, something still escapes any rational analysis of the poems. It is as if they defy a logical system of enquiry into their structure and meaning. The focus of that defiance, the mainspring of the poems' obstinate refusal to allow themselves to be subjected to the forms of investigation which they themselves seem so eloquently to enunciate, resides in the ambiguous invocation of the 'She' who is also the subject of the poetic meditation. That 'She' might be anyone or nobody – the soul of the world, the Virgin, Elizabeth I, and, of course, the young girl – Elizabeth Drury – who, we are told, is the 'occasion' of this exercise in funeral oratory. The impossibility of fixing even a generalized name to the repeated feminine

third person singular pronoun, can be understood as a rehearsal of one of the central themes of the two poems: the eventual defeat of all powers of human rationality. So, as we read through the sequence of meditations, learning more and more about the cadaver/world under investigation, the processes by which human reason inquires into the structure of the world and the body is subjected to an ever more searching level of sceptical questioning until, in the second poem, 'Of the Progresse of the Soule', all enquiry into 'accidentall thinges' has to be terminated in favour of a simple evocation of the soul's joy at its arrival in heaven. Knowledge itself, then, is under the dissector's knife in the sequence of poems. Knowledge of the world, revealed through the intense gaze of the anatomist into both structure and function, is shown to be fragmentary compared to the eventual felicity of the soul, released from the body and united with God.

In thus fleeing out of the body, and leaving it, in the words of 'The Second Anniversarie', as 'a rustie Peece, discharg'd. . . flowne/In peeces' (Donne, *Poems*, 232), the poems scatter the world/body over the page in much the same way that the progressive disintegration of the human body was witnessed in the anatomists' textbooks and their demonstrations. What is left intact, however, is the soul, fleeing over the universe in an alternative image of heroic exploration, one which is conducted on a cosmic scale. Having left the dissected and partitioned world behind, the soul shoots freely through the material universe:

> And as these starres were but so many beads
> Strung on one string, speed undistinguish'd leads
> Her through those Spheares, as through the beads, a string,
> Whose quick succession makes it still one thing:
> As doth the pith, which, lest our bodies slacke,
> Strings fast the little bones of necke, and backe;
> So by the Soule doth death string Heaven and Earth;
>
> (Donne, *Poems*, 233)

Donne has not, quite, been able to leave the body behind even in this entranced meditation. This, however, was the sum of the anatomists' labours as they struggled to express the harmony of religious mystery and the advancing tide of scientific rationalism. If all else was falling into a collapsed and fragmentary rubble of displaced body parts and Cartesian doubt, still the soul itself seemed intact. But Donne's investigation of the outer possibility of 'sacred anatomy' reminds us of the network of allusion, metaphor, and structure into which the body-interior was mapped in early-modern culture. If the Anniversary poems of 1611–12 offer us an anatomy of the whole world, that process of dissection is nevertheless mediated by the dissected human body. Even if, by the end of the anatomy, all that was left

was the speaking voice of the poet pronouncing the obsequies on all mortal human endeavour, nevertheless, the body's centrality to the text's procession of images, conceits, and intellectual analysis was reaffirmed. Earlier in his career, Donne had expressed this paradox – that in order to slough off the body its existence must first be acknowledged as the *via medea* linking spiritual and mortal existence – in his exercise in Neoplatonic analysis, 'The Extasie':

> To'our bodies turne wee then, that so
> Weake men on love reveal'd may looke;
> Loves mysteries in soules do grow,
> But yet the body is his booke.
>
> (Donne, *Poems*, 48)

What David Novarr, in his account of 'The Extasie', calls 'the prerogatives of the body', simply cannot be denied.[92] The body was indubitably *there*, and the fact that it was also possible to open it up to analysis made its physical presence all the more insistent. But Donne's lines also lead us to a further stage of our analysis. The image of the body as a book, a text there to be opened, read, interpreted, and, indeed, rewritten, was a persuasive one to the early explorers of the human frame. It is as a book – the *liber corporis* – that we must now consider the body in early-modern culture.

THE BOOK OF THE BODY

Writing in the 1570s, Du Bartas was to protest at the impossibility of ever finding a way through the 'curious Maze' of the body, a difficulty which was compounded by the prospect of transcribing this bewildering structure into a text. But anatomists, as well as poets, were confronted with a seemingly invincible difficulty. That difficulty was taxonomic, since it expressed the absence, in Renaissance accounts of the human body, of a sufficiently complex system of definition with which to organize the structure that was now being revealed in dissection. 'Of the parts of the Body, there be many divisions', Robert Burton had observed at the start of his own account of the body's taxonomy.[93] It was as if, having penetrated the interior, the explorer wandered through the new topography of the human world, bereft of reliable maps, and with guides who were proving increasingly untrustworthy. In Galenic physiology, the system inherited by Vesalius and his contemporaries, two complementary methods of definition were in operation. The body could, first, be divided into a structure of 'similar' and 'dissimilar' parts. The 'similar' parts were those features common to different organs or areas of the body: skin, fat, tissue, bone. 'Similar' parts were complemented by 'dissimilar' parts: the actual composite organs themselves, of which the most

important were held to be the heart, the brain, and the liver. These three were held to represent, in the secondary system of classification, the 'noble' or 'principall' organs of the body. All else was 'inferior'.[94] Obviously, such a vocabulary of nobility and inferiority offered endless metaphorical possibilities within a political sphere. The body seemed to be the ultimate guarantee of an organization of society which was profoundly hierarchical, and stretched back via St Paul to the Platonic idea of the state as an organism (*Republic* 5.462d). It was this taxonomy, of course, which lay at the heart of Menenius' fable of the Belly in Shakespeare's *Coriolanus* (I.i.96–155).[95] That it was still a metaphor whose currency possessed a degree of value as late as the 1650s was suggested by the overall conceit of Hobbes's *Leviathan* – a text indebted to organicist arguments.[96] But by the time *Leviathan* appeared, in 1651, a new set of theoretical conceptions of the body had already appeared, whose origin may be traced to the acceptance of Cartesian modes of analysis: the body (and therefore society) could be analysed in terms of a machine. And machines, of course, possess neither nobility nor inferiority.[97]

But neither the machine, nor the Galenic system of classification, was of much help to a practical anatomist when he stood before a corpse, fresh from the gallows, surrounded by an expectant audience. If, with his knife, his task was to trace both the structural integrity of the organism, and, at the same time, assert the harmonious scope of the theology of creation and incarnation, some method had to be devised by which the body could be rendered into its constituent parts. More than this, time was pressing. Even as he stood before the corpse, the signs of decay were creeping over the outstretched form, so that his own labours would soon be lost in a morass of corruption which would render any investigation not merely unpleasant, but impossible. A technological impasse had been arrived at. As anatomical investigation became ever more detailed, more time was needed to complete the detailed dissection that was necessary. But time was the one element denied the anatomist by biological process. Hence, the anatomy demonstration (which, by the time of Harvey, lasted for some three days on any one corpse), was also a rapacious business.[98] Racing against decay, anatomists were always keen to have a supply of corpses available, one after the other, freshly killed, so that, having moved through one area of investigation, the corpse could be discarded and a new area of dissection laid open on a new body. Vesalius, for example, whose reputation no doubt secured him a fairly plentiful supply of material (though, in common with his contemporaries, he occasionally resorted to grave robbery, as we shall see later), staged his demonstrations so that they could keep pace with the rhythm of judicial execution, as an eyewitness account records:

After dinner, he [Vesalius] said, I shall demonstrate the remaining inner

muscles of the thigh, and perhaps also of the leg with the foot to complete the whole anatomy of the muscles of the body. For tomorrow we shall have another body – I believe they will hang another man upon which I shall demonstrate to you all the veins, arteries, and nerves. For this subject is now too dry and wrinkled.[99]

This account (a record made by Baldasar Heseler of a series of dissections undertaken in late January 1540 in the church of San Francesco at Bologna before the medical faculty and local worthies) leaves us in no doubt as to the proximity of the hangman and the scientist. Did Vesalius influence the programme of executions to fit in with the progress of his demonstrations? At any rate, this report of the famous anatomist at work indicates the ways in which the body, once it had been transported into the theatre, became the blank canvas upon which the dissector mapped complex interlaced structures. The body was the anatomist's stage, upon which he outlined a complete text.

There was something peculiarly dynamic about the production of this new 'text' of the body. If the Renaissance anatomy demonstration represented an inscription of knowledge on the body's surface, then it was a text which was, in some measure, jointly authored. A whole panoply of participants – defending and prosecuting counsel, magistrates, gaolers, executioners, assistants, those responsible for organizing and advertising the occasion, anatomists, sellers of tickets, refreshment providers – had to be organized and their various activities synchronized in order to obtain this moment of inscriptive authority over the human form.[100] What determined the rhythm of the event was a biological fact: that after death micro-organisms initiate the process in a corpse which we term 'decay'. A disjunction, then, had opened up between the complex articulation of the body, as it was to be seen displayed in the pages of anatomical textbooks, and the decaying reality which was transported from the scaffold to the packed theatres in which the audience waited. Theoretically, of course, the issue appeared much simpler. Writing in 1615, Helkiah Crooke, for example, held that the anatomist's task was a simple reversal of 'nature' by 'art':

> Nature first lineth out the masse of the Seede, the warp of the body, and after that with the worf filleth up the empty distances: first she layeth out the foundations, rayseth the stories, bindeth the joyntes and plastereth the walles, till it come unto a perfect building. Art on the contrary takes it asunder peece and peece, proceeding from that which is more to that which is lesse compounded, till at length it come unto the very ground worke or foundation.[101]

This architectural conceit, which was repeated again and again in both anatomical and theological texts, reinforced the scriptural idea of the body as the 'temple' of the incarnation, and God as the divine 'architect' of that

construction.[102] But, in practice, the architectural conceit held no clues for an anatomist whose scalpel was poised over the material reality of the body. Despite this practical difficulty, Vesalius' text deployed an architectural mode of analysis in that it envisaged the body as 'constructed', and it sought to replicate this construction (in reverse order to that chosen by Crooke) by gradually building up the various detailed segments into an organized whole. So, the Vesalian text began with the skeleton, and then considered the muscles, the vascular system, the nervous system, the organs of nutrition and the abdominal viscera, to end with the brain. But such a procedure was of no use to the anatomist at the moment of dissection. If, in theory, he sought to *construct* a body out of its various components, in practice there was neither the time nor a sufficiently flexible taxonomic system to achieve such a leisurely project.

Practical dissection, then, demanded a different method of procedure from that displayed in theory. One possibility was to see the body as an organism with a 'top' and a 'bottom', so that the anatomist began with the head and worked down to the feet. This, the so-called 'natural' order of dissection, was the method favoured by Jacob Mosau in 1598, when he published his *A General Practice of Physick* – a translation of Christopher Wirtzung's *Ein Newes Artzney Buch* – claiming that dividing the body in this way was 'easie and methodicall, descending from the head to the foot'.[103] An alternative (and equally impractical) procedure was to separate the two 'halves' of the body, slicing it down the middle, and simply opening it as though it were a book, whose spine was (literally) the human spine. The anatomist thus opened up the body so that it lay 'flat' on the dissection table: again, a hopelessly inadequate system of practical dissection, though one which (in theory once more) might have provided 'complex teaching aids'.[104] In practice, then, the anatomists followed the old 'order of anatomy' recommended in the *Anathomia* of Mondino, composed in the early fourteenth century. The anatomist dissected the body according to its rate of decay, commencing with the abdominal viscera, and then moving on to the thoracic cavity, the head, and, finally, the external members – the limbs. This was the order adopted, for example, by the publisher of Vesalius' text when it appeared in an English version in 1553.[105] The method was one which understood time and decay – the twin poles of anatomy as a moral enterprise – as the determining factor in the process of dissection. In William Harvey's words: it was the 'glass' (i.e. hour-glass) which determined the progress of the dissection as the anatomist moved from 'the lower belly, nasty yet recompensed by admirable variety' on to the 'parlour' (i.e. thorax), and finally 'the divine banquet of the brain' – a phrase which, incidentally, perfectly expresses the anthropophagistic tendency of Renaissance anatomy.[106]

A tension had developed between the ideal anatomization, which took place only in the pages of textbooks, and the practice of dissection which was situated in the anatomy theatre. This tension mirrored the intellectual debate over authority which Vesalius and his followers initiated in challenging Galen's observations by an appeal to the body rather than to the text. Body and text, then, were involved in a twofold struggle with one another. The body was one possible authority, but its organization was mysteriously complex and, because of the biological tendency towards decay, continually eluding the practical dissector. The text was another possible source of authority, but how could bodies be represented in texts when, in their material reality, they seemed to crumble and dissolve before the eyes of the onlooker?

How this tension was resolved is demonstrated by the invention of a new device for 'fastening' the representational body within a text: a 'keying mechanism'. This device enabled the dissected body to be displayed through the use of indicator lines and alphabetical or numerical systems of identification.[107] So familiar is this device in the twentieth century, which can be found in every area of modern life – from complex electrical diagrams to the simplest 'flow charts' delineating an ordered sequence of functions – that it seems almost inconceivable to imagine a world without such a vocabulary of representation. But this vocabulary is a product of a society which is fundamentally technological in its operation, and such a society was only just emerging in early-modern Europe. Illustrations of machinery – where the viewer could see complex mechanical systems opened out in a very similar fashion to the opening of the body in anatomical works – did not begin to appear until the second half of the sixteenth century.[108] When such illustrations started to appear – in cut-away diagrams, with systems of lettering relating the illustration to an explanatory text – it was the experience of the representation of the body which allowed the mechanical illustrator such immediate access to a highly successful mode of representation.[109] But this development was rooted in the transcription of the volumetric proportions of machines or bodies into the two-dimensional world of textual representation. We can understand, then, the bewilderment of the fourteenth- and fifteenth-century anatomist, confronted with the task of translating an evermore complex structure in three dimension onto the flat surface of a sheet of paper or vellum. Quite literally, there was no convention of representation which could be deployed. And hence, too, the different methods of partition which were adopted prior to the general acceptance, in the late fifteenth century, of a relatively stable, codified, 'language' of visual representation.

If we look again at an early image of the dissected body (Figure 8) we see that the thirteenth-century body is (literally) surrounded in text, which is

itself surrounded by an ornamented border. This border, existing close to the boundaries of the page, constrains the text but is itself disrupted by the body: the head and the feet overlap the surrounding ornamentation. The effect is suggestive of an opaque body, super-imposed on top of the text, partially obscuring the written word from our view. What has happened in the later images thus becomes clear: text and image have been separated from one another as much as they are linked together by the keying mechanism. The uneasy co-existence, in the earlier image, of text and body on the page has vanished. It is not difficult, for example, to see how the 1491 and 1493 images (Figures 10 and 11) anticipated later Vesalian and post-Vesalian depictions of the body. The super-imposition of the body on top of the text, as in the thirteenth-century figure, disappears, to be replaced by an intervention of text *within* the body. Graphically, then, the relationship between body and text has been reversed. Rather than the body resting on the text, the text now begins to rest on the body. This can be understood as a further anticipation of Vesalian practice. Vesalius' words at the Bologna dissection of 1540 presented a body 'upon which' structures would be made apparent. In the 1491 image (Figure 10), the various structures are named, so that the body begins to look not unlike a map. Indeed, it is difficult, given the date and Mediterranean provenance of this image, to resist the comparison with pre-Columbian maps of the world.[110] The body was a collection of hollow cavities, roughly suggested rather than closely surveyed. In the 1493 image (Figure 11), the key transformation was the banishment of the text beyond the border-lines. The page was sectioned into a central rectangle containing the body, and a series of surrounding rectangles, which contain the text to which the observer's eye was drawn by the indicator lines. Much later, as we shall see, Phineas Fletcher's anatomical poem, *The Purple Island* (1633), was to apply this technique to poetry. For the moment, however, it is enough to appreciate how the 1493 image represents a growing division and specialization of knowledge, so that the understanding of each part of the body has itself been anatomized – sectioned into its own discrete 'box'. The body has ceased to be the ruling principle by which knowledge of its own structure was ordered. In the 1491 image, the latin text was scattered over the page, and tilted out of the horizontal as it followed the contours of the body. With the 1493 image, on the other hand, the conventions of print production (as opposed to manuscript delineation) have been observed.[111] The body exists in its own dissociated space. The text (now in the vernacular) also exists in its own segmented collection of spaces, operating according to a different set of spatial criteria.

The inter-relationship of text and body on the page, a mirror of the confrontation between text and body in the anatomy theatre, was related to the Renaissance conception of the body as itself being constituted as text –

as the *liber corporum* – the book of the body written by God. God was thus the author of different kinds of text: the book of the world (i.e. the created universe) and the book of scripture (the Bible).[112] But, it was argued, in order to allow human reason to follow the divine complexity of these textual creations, God left an *epitome* just as Vesalius published an *epitome* of his own book of the body. The anatomist, then, who 'read' the anatomy (relating body and text together in the anatomy theatre) was reading two different kinds of text: a text written by human agency (the observations of his predecessors) and a text written by God, comprised of all the different members, sections, subsections, and partitions revealed in dissection. The task was to re-create, in order to read, the precise system of division by which the body-book had originally been composed by the divine author. This process of reconstruction through partition was a feature of the Vesalian *epitome*, in that the reader or viewer was encouraged to cut out different structures from the page and assemble them to produce 'manikins' of the human form.[113]

This cycle of texts which become bodies, and bodies which become texts, allows us to understand the equally complex language of textual division as anatomy which informed so much early-modern discussion of method. The Platonist philosopher Pierre Charron, for example, offered a concise definition of the body-text principle in his *La Sagesse* of 1601 (translated *c.* 1606), when he wrote that 'Man' is 'a summary recapitulation of all things, and an Epitome of the world . . . gathered into a small volume'.[114] It was within this tradition that Robert Burton's *Anatomy of Melancholy* appeared: an anatomy of textuality, as well as a textual investigation of the world and all that it contained. Following his appearance in the guise of Democritus Junior – the satirical anatomist of the world – Burton reminded his readers of the principle of division by which the human body could be understood. Dividing the body into 'Parts Contained' and 'Parts Containing' (a method derived from Hippocrates, and related to the Galenic 'dissimilar' and 'similar' system), *The Anatomy of Melancholy* first established the principles of division which dominated the complete work whose subject was division itself. Citing the texts of the anatomists (ancient and modern) as his authorities, Burton then offered the human body as an 'epitome', and concluded his 'digression of the anatomy of the body' by commending it as 'a preparative to the rest'. It was as if the reader of *The Anatomy of Melancholy* who turned from the text to the body had turned from the great *compendium* which was Burton's work, to the divine *epitome* which was the human form.[115]

The body – a material object in space – was gradually made available as a model or pattern for any spatial organization of knowledge. Indeed, we still preserve remnants of the inter-relationship of bodies and texts in the anthropomorphic language of books. That language, in early-modern

culture, underpinned a whole set of related analogies. Books were composed of parts that could be read and interpreted in the same way that bodies were made up of parts that exhibited signs of their health or decay to the skilled reader – the physician – who 'interpreted' the signs of the body. The physician, equally, had to possess a sense of the ideal body – structurally coherent, organically whole, sound in all its parts – in order to understand a body which had been disrupted in any way. To this conceptual model, early-modern anatomy made a vital contribution. The complete problem of 'method' – a problem which was of pressing importance to Renaissance commentators on all branches of human science – was investigated within the concrete space of the body rather than the abstract space of knowledge.[116] The grammatical debate over logic and rhetoric – the ordering of discourse associated in particular with the work of Pierre de la Ramée (Ramus) – can be mapped without much difficulty onto the language of anatomy, or *vice versa*. Three 'epiphenomena' (to adopt Walter Ong's terminology) thus appeared to align themselves at a single point in time: the exploration of the body in space, the debate over the order of discourse amongst logicians and rhetoricians, and the transcription of the three-dimensional body into the format of the mechanically reproduced book. These three issues can be thought of as related elements of a larger problem: how was knowledge to be systematically ordered? Within the realm of logic, Walter Ong has speculated that with the invention of printing came a much greater commitment to space – the organization of knowledge according to spatial co-ordinates. The technique of printing after the invention of movable type – where letters in a font are cast from a 'matrix', and then dispersed into 'text' in an infinite number of possible permutations – corresponded, Ong has suggested, to the Ramist development of organizing discourse in space: the familiar 'telescoping arrangement . . . where the notion of locus yields other loci, these still further loci, and so on'. The matrix (literally, of course, womb) is thus a 'place' from which the font (another 'place') is drawn in order to produce the 'elements of discourse, reduced to a visually apprehensible and manoeuvrable form'.[117]

This ordering of discourse was akin to the progressive partitioning of the body in anatomical demonstration, and thus indebted to a language of the body at every point. So, the Renaissance anatomist distinguished between two different kinds of anatomy: practical and theoretical, as Helkiah Crooke illustrated:

> either it signifieth the action that is done with the hand, or the habit of minde, that is the most perfect action of the intellect. The first is called practical Anatomy, the latter theorical [sic] or contemplative, the first is gained by experience, the second by reason and discourse.[118]

136

Crooke's division of anatomy into the practical (a product of experience) and the contemplative (a product of 'reason and discourse') accords strikingly with Ramus' distinction in the realm of dialectic between 'exercise' and 'precepts', where 'habit and experience . . . make clear what calm reflection . . . cannot understand'.[119] But this correspondence should not be surprising since, by the time Crooke published his syncretic anatomical compendium, there were literally hundreds of Ramist works available. Of greater significance is the way in which Ramist methods of partition and division, as a means of ordering discourse, were informed by corporeal images. Discourse was thus translated into a spatial continuum which rested on the idea of progressive division of the body. To cite just one (late) example amongst the many variations on this theme: Alexander Richardson, whose *The Logicians School-master* appeared in 1629, observed that:

> in a mans body, every member hath his own matter, and forme, and all the members together make up a common matter, and a common forme of the whole . . . the body also is made of organicall parts, and they give matter and forme to it: then the simular [sic] parts containe the matter and forme of the organicall, and the similar parts are made of a portion of the matter, and of the formes of the elements.[120]

From this interplay of organic similarity (which corresponded to the anatomists' ordering of the body into the similar and the dissimilar), Richardson deduced that the principle of division (or 'distribution', to use the term common to both logicians and anatomists) should underpin the production of any discourse:

> If you mean to make any long discourse of any thing, divide it, for it gives greater light, and helpe to your owne memorie, and to the people, hence distributions are the chiefe things in Art: hence many call their bookes partitions.[121]

The generation or construction of discourse, then, relied on the division of the topic. This device accorded with the anatomical method proposed by Crooke where 'Art' takes the corpse 'asunder peece and peece, proceeding from that which is more to that which is lesse compounded, till at length it come unto the very ground worke or foundation'.[122] The tension between deconstruction and reconstruction of the body, or between the theoretical and practical demonstration of anatomy, was mirrored in the relation between the division of topic and the subsequent production of discourse.[123]

This process was evident in an altogether different sphere of Renaissance writing: in the sonnet sequences of the late sixteenth and early seventeenth centuries. The (female) body was a text there to be 'read' and 'interpreted' by the lover–narrator. This trope seemed to possess an unrivalled fascination

for the Petrarchan sonneteer. To cite just one example, in Sir Philip Sidney's *Astrophil and Stella* (1591) we observe, in Sonnet 67, how Stella is a text there to be 'translated' (line 5) and thus opened to interpretation (line 12). Like a scriptural text, 'Stella' bears her own gloss as an aid to interpretation, which also functions as a controlling device against which the reader–lover must struggle. So, the 'reader' of Stella is encouraged to:

> Looke on againe, the faire text better trie:
> What blushing notes doest thou in margine see?[124]

Ironically, given the body-text conceit, early editions of *Astrophil and Stella* gave a slightly different form of line 7: 'Looke ore againe, the faire text better prie'.[125] To 'prie' into the text emphasizes the act of reading which must, voyeuristically, force its way into the secretive folds of the body-text, whilst the more neutral 'trie' rests at a passive level of interpretation.

This interplay of textuality over and within the body did not die away after Harvey and his followers had developed a more mechanistic language of anatomy. The image was too dramatic and too apposite to be abandoned simply because a new 'science' of the body had been developed. Henry Vaughan's collection of poems *Olor Iscanus*, when it first appeared in 1651, for example, opened with an extravagant homage to the conceit of texts as (dead) bodies in the publisher's epistle to the reader:

> The *Author* had long agoe condemn'd these *Poems* to *Obscuritie*, and the *Consumption* of that further *Fate*, which attends it. This *censure* gave them a *Gust* of *Death*, and they have partly known that *Oblivion*, which our *Best Labours* must come to at *Last*. I present thee then not onely with a *Book*, but with a *Prey*, and in this *kind* the first *Recoveries* from *Corruption*.[126]

The familiar conjunction of text and body is, here, endowed with a moment of anatomical realism in that the poems consigned to oblivion are held to have tasted (with a latin pun on *gustus*) death and its sequel – decay – in their consignment to oblivion. From that process of decay and dissolution, they are rescued by being transformed from the mortal fate of manuscript into the immortal realm of (printed) text. As if to underline this conjunction of text and bodily dispersal, the second poem in the collection, the morbidly erotic 'The Charnel-house', plays with the anatomical dispersal of the body within the controlling conceit of bodies anatomized within texts. So, the narrator of the poem, alive to new sensation, enters the charnel house which is also an anatomical textbook:

> Blesse me! what damps are here? How stiffe an aire?
> *Kelder* of mists, a second *Fiats* care,
> Frontspeece o'th'grave and darkness, a display
> Of ruin'd man, and the disease of day;

138

> Leane, bloudlesse shamble, where I can descrie
> Fragments of men, Rags of Anatomie;
> Corruptions ward-robe, the transplantive bed
> Of mankind, and th'Exchequer of the dead.
> How thou arrests my sense? How with the sight
> My *Winter'd* bloud grows stiffe to all delight?
> *Torpedo* to the Eye! whose least glance can
> Freeze our wild lusts, and rescue head-long man;
> Eloquent silence! able to Immure
> An *Atheists* thoughts, and blast an *Epicure*.
>
> (Vaughan, *Works*, 41)

But, as the atheist in Tourneur's play has already shown us, the spectacle of the fragmented body did not, of necessity, point to some higher purpose. A feverish excitement, rather than pious reflection, might be the result of such a journey. It was, of course, precisely the moral function of anatomy as a spectacle to 'Freeze our wild lusts' and 'blast an *Epicure*'. However, the narrator of the poem, characterized as an *amateur* of anatomical display, is not so much in the charnel house as turning over the leaves of an anatomical text (hence the technical use of the term 'Frontspeece'). Voyeuristically the narrator enjoys the spectacle of fragmentation that has been encountered, so that the blood (in a sexual pun) does indeed become 'stiffe to all delight'. As the poem progresses, however, the 'fragments' become less and less textual and more and more corporeal. Erotic delight seems to give way to a meditation on mortality. By the end of the poem, in fading light and darkness, the narrator leaves the charnel house which is also 'my sad library' with the 'notes' which are to be the poem. But what, precisely, has been gazed at? Textual representations of the fragmented body, or bodies transformed into textual 'display'?[127] And beyond these reflections, what has been the quality of the experience? A sad and gloomy foretaste of mortality? Or a frisson of the erotic?

Vaughan's mid-century meditation on fragmentation seems to return us to that ambiguous desire which the spectacle of anatomy seems to have aroused in those who beheld it in early-modern societies. In this section, we have traced the webs of meaning which seemed to enfold the Renaissance body as it lay open on the page or within the anatomy theatre. In England, in the final years of the sixteenth century and the opening years of the seventeenth, these intersections of ritual, meaning, and scientific practice were to become of enormous imaginative importance. But what if the poet-anatomist could actually enter that space, and wander inside the body? We have already seen Bacon and Donne sensing the possibility that the body was composed of an infinite series of cavities. The transforming gaze of the spectator of those cavities, Donne realized, need not be constrained by an

existence outside the body. In imagination, at any rate, it might be possible to voyage into the body which would thus appear like Hamlet's nutshell: a place of infinite space. In 'La Coronna' – Donne's meditation within a more overtly catholic tradition – 'Immensity' had been imagined as 'cloysterd' in the Virgin's womb (Donne, *Poems*, 290). This fantasy of perspectival projection required a voyage of the imagination into the reserved interior of the body. What did the body look like once its depths had been entered? How would it be possible to wander within the structures which the anatomists were now revealing within the theatrical performance of the anatomy ritual?

6

THE UNCANNY BODY

IT'S ALL ONE: THE DIDACTIC BODY
BEFORE DESCARTES

In Zurich, at the end of the first world war, James Joyce first met Frank
Budgen. Budgen was to become friendly with Joyce, and was to become
fascinated, too, with the progress of Joyce's *Ulysses*. Questioned as to the
'model' for his book, Joyce advised Budgen to read the almost unknown
seventeenth-century poet, Phineas Fletcher. 'My book', Budgen later re-
called Joyce explaining:

> is the epic of the human body. The only man I know who has attempted the
> same thing is Phineas Fletcher. But then his *Purple Island* is purely descriptive,
> a kind of coloured anatomical chart of the human body. In my book the body
> lives in and moves through space and is the home of a full human personality.

Budgen was unsatisfied with Joyce's throw-away comments, which were
perhaps designed to put him off the scent as much as they were to provide
him with a key to reading *Ulysses*. But to the objection that such a book could
only be a partial account of the human personality, Joyce responded: 'If they
had no body they would have no mind. . . . It's all one.'[1]

Joyce's denial of any Cartesian split, his assertion that mind and body
informed each other to an extent that the body as much as the mind should
lie at the psychological, structural, and imagistic centre of his work, links
Phineas Fletcher's epic *The Purple Island* (1633) with Joyce's modernist
attempt at reintegrating body and mind. What *Ulysses* was to offer was the
possibility of uniting body and soul in a fully bodied personality – the eating
and defecating modern Odysseus who was Leopold Bloom. But Joyce was
wrong in believing Fletcher to be unique, though his poetic antecedents had
been long forgotten by the time *The Purple Island* was discussed in Zurich. In
England in the early years of the seventeenth century, hovering on the brink
of the Cartesian moment, a group (almost a 'school') of poets emerged,

141

whose writings could indeed be described as 'coloured anatomical charts'. Their project was doomed from the start. Their hope was to unite the extraordinary vision of the body which science was now unfolding before them in the anatomy theatres, with a theologically informed understanding of human destiny. Descartes (and later Hobbes and the virtuosi of the Royal Society) were to ensure that these syncretic epics of physicality were made redundant within a very few years of their publication.

Who were these pre-modernists? David Kynloch was one, about whom little is known other than that, at Paris in 1596, he published a didactic poem (in latin) entitled *De hominis procreatione*. Kynloch's two-book epic of heroic verses on the anatomized human body, like Joyce's *Ulysses* according to the formula supplied in the so-called 'Linati Schema', structured each of its chapters around a different organ. Tracing the body from its divine origin, and mapping its anatomical structures, Kynloch unfolded the plan of spiritual and physical salvation.[2] Kynloch's syncretic epic was to be followed by other texts that sought to harmonize an emerging scientific discourse with religious modes of thought. Common to these works was their all-inclusive, encyclopedic, quality, together with what we might term a positively Joycean understanding of the body as the organizing principle of the universe itself. As such, they can be understood as some of the earliest attempts at reconciling the 'new philosophy' (which threw Donne into such cycles of doubt) with the traditional modes of understanding inherited from the middle ages. Kynloch, then, was not alone in his somatic visions. The writings of John Norden, Henoch Clapham, John Hagthorpe, and the mysterious 'Ro. Un.' may now be considered of little scientific importance in themselves.[3] What they do provide us with, however, is some sense of the means by which new science was now being promulgated (or challenged) amongst a wider audience. We tend to assume that access to new ideas in early-modern culture was relatively unmediated – the views of Copernicus, Vesalius, and their peers are held to have been disseminated in the works that they published, or in the commentaries and responses to which their works gave rise. But in the arena of early-modern science, particularly within what William Ashworth has termed 'the cultural matrix of sixteenth-century natural history', the methods by which information was made available were extraordinarily diverse. Hieroglyphics (dictionaries of symbolic images), coins and medals, fables, myths, adages and epigrams, together with emblems, were some of the alternatives to the large-scale treatise by which information about the natural world reached a wider audience.[4] In this, Renaissance natural philosophy was perhaps no different than is contemporary science. Few, these days, outside of specialist disciplines supported within institutions, read the scientific papers or have access to the electronic media in which discoveries or observations are announced and

debated. Instead, scientific information is culled from a huge variety of sources, most of them second- or third-hand: syncretic journals, encyclopedia articles, popular scientific biographies and 'explanations' (which occasionally reach best-seller status), articles in the 'science section' of the press, and, of course, television programmes devoted to particular topics in the public eye.[5] And this is to ignore perhaps the most important genres of all by which science reaches a largely 'non-scientific' audience: Science Fiction and Fantasy – genres perhaps closest of all to the 'Romance' form of the Renaissance. As such, any future historian of science would gain a very partial view of the 'cultural matrix' of twentieth-century science, were he or she to ignore such material.

In the early years of the seventeenth century in England, there was a widespread fascination with 'science', however that term could be understood. But 'science' was a disturbing entity. Donne's expression of universal doubt in the Anniversary poems was, perhaps, not an isolated phenomenon, but a product of a widely held sense of dislocation, the evidence for which exists in the now unread works which attempted to harmonize traditional theology with new philosophy. We should also be alert to the commercial orientation of these works. For the reader who would be hard-pressed to find the quite large sums demanded in the sixteenth and seventeenth centuries for a technical work (particularly if it contained costly illustrations), the slim pamphlet format in which many of the popularizing works appeared was shrewdly calculated to appeal to the shadow of what was later to become a 'mass' readership.[6] Commercial considerations, too, can be glimpsed in the teasing titles of these works which often hinted at revelation, or access to secret knowledge.[7]

Informing all of these syncretic or populist works was a tradition of writing which reached back to the classical form of the didactic poem. In the sixteenth and seventeenth centuries, poetic theorists such as Sidney and Puttenham, influenced by Italian poetic theory to be found in the works of Scaliger, Minturno, and Fracastoro, looked back to classical antiquity, to the tradition of philosophical enquiry which was rooted in poetry. Horace and Virgil, in the *Ars poetica* and the *Georgics*, for example, were seen by Puttenham as developing a form in which 'honest and profitable artes and sciences were treated in antiquity', whilst Sidney's comments on the poet as the true philosopher-teacher in the *Apology for Poetry* (1595) were to be influential for over a century.[8] Popularizing scientific poems of the Renaissance looked back past Horace and Virgil, to the work of Hesiod, Empedocles, Arastus, and Lucretius. Humanist scholarship was uncovering such texts and arguing (as did Fracastoro in his *Naugerius* of 1555) that poetry should both convey information and indicate the order and perfection of the universe as a whole.[9] It was the relative absence of such poetry

which led Henry Reynolds to complain in 1633 (ironically, the year in which Fletcher's epic of the body was published) of the inferiority of the moderns as natural philosophers to the ancients.[10]

Of all the popularizers who were active in the period, only one has enjoyed a kind of critical half-life since the seventeenth century: John Davies of Hereford (?1565–1618). Davies was a prolific occasional writer, a satirist, a sonneteer, a love poet, a devotional writer, and a contributor to anthologies. He was (and is) all too easily confused with his much more famous namesake, Sir John Davies.[11] But Davies of Hereford is a key figure for understanding the ways in which, in England in the early seventeenth century, science was introduced into the public arena via poetry. In a series of long poetico-philosophical treatises – *Mirum in Modum* (1602), *Microcosmos* (1603), *Summa Totalis* (1607) – Davies of Hereford presented his vision of a harmonized science of the universe and the human body.[12] These three texts, taken together, formed a unified project, a vast syncretic enterprise which surveyed all of human knowledge in an effort to achieve a theologically ordered prospectus of the world. And standing at the very centre of the cosmos were the human body and the human soul – the 'abstract' of God, the centre of the centre.[13] So, as the reader moved through the three verse treatises, he or she learned first of the anatomy and physiology of the brain, which acted as a preface to an appreciation of the reasoning faculty of the human mind. The second treatise introduced the anatomy of the thorax, and the function of the 'affections' or 'passions' to be found in the heart. Finally, in *Summa Totalis*, in the form of a 'divine week' such as that composed by Du Bartas, the reader saw how the whole superstructure of creation was harmoniously conjoined with the human form.

The poetics of humanism – the privileged status accorded poetic discourse which Sidney explored in his *Apology* – was the mainspring of these now forgotten poetic treatises on the natural world. In their riddling, correspondence-laden, tropes and similes, Davies of Hereford and his contemporaries sought to describe the texture of the cosmos, and to recompose it before the reader. Poetry, they believed, was the appropriate form for displaying this cosmic unity. It was Sidney who, following classical theory, had argued that poetry possessed the power to delight whilst offering instruction. More importantly, the poets of natural philosophy sensed that the structure of metaphor expressed an underlying unity, which was held to inhabit the natural world. The world was structured according to a gigantic act of repetition – a continual recapitulation – and that repetitive tendency was best mirrored in the compressed language and rhythms of poetry. But these syncretic or encyclopedic poets also felt the pressure of an alternative construction of the natural world.[14] It was as if they were realizing only one half of the Baconian project. 'Order requires that we particularize,' Davies of

Hereford wrote in *Mirum in Modum*, but particularization – an energetic intervention, for example, into the controversy of whether or not the dividing wall of the heart, the *septum*, contained invisible 'doors' – was introduced only as a prelude to abstraction, out of which would be derived unity.[15]

Such abstractions were crumbling, and not just inside the anatomy theatres of early-modern Europe. Cartesianism, if it did not *prove* that the soul and the body were distinct from one another, nevertheless destroyed the fabric of unity which the poetics of correspondence had woven. In 1643, Descartes, looking back on his philosophical work of the 1630s in the course of his correspondence with the Princess Elizabeth of Bohemia, sensed that the kernel of his own philosophical reflections lay in their construction of the human subject as alien from itself. It was not, then, that bodies were machines distinct from minds, or that the mind existed or did not exist as a pilot in a ship, which was the radical heart of Cartesian philosophy, at least as Descartes understood it. Rather, it was the sense that the human being was now estranged from itself in a way which, a few decades earlier, would have been inconceivable. Indeed, in some measure it was *still* inconceivable. Thus, Descartes wrote to the Princess Elizabeth, his undertaking defied the everyday experience of what it was to be human, to be a unified being:

> It does not seem to me that the human mind is capable of conceiving at the same time the distinction and the union between body and soul, because for this it is necessary to conceive them as a single thing and at the same time to conceive them as two things; and this is absurd.... I supposed that your Highness still had in mind the arguments proving the distinction between the soul and the body, and I did not want to ask her to put them away in order to represent to herself the notion of the union which everyone has in himself without philosophizing. Everyone feels that he is a single person with both body and thought so related by nature that the thought can move the body and feel the things which happen to it.[16]

But this feeling of unity, of resistance to any kind of philosophical fragmentation, was undercut by the Cartesian distinction which has already been posited. The Princess Elizabeth may of course have continued to *feel* that she was 'a single person' but as a Cartesian subject, she also had to acknowledge that such feelings were only possible when she ceased to reflect on the nature of the 'link' between soul and body. The point was that the 'link' may or may not have existed. But insofar as it was impossible to prove its existence one way or the other, no matter how strong the feeling of its presence, the 'link' was held in abeyance: a wished-for feeling of security which was not, any longer, sustainable through rational enquiry.

The impossibility of sustaining the 'link' between soul and body was itself based on a radical anatomy of the human subject. Indeed, it was the

susceptibility of the body (as opposed to the mind) to the process of division which confirmed the distinction between body and mind inherent within the Cartesian project. Since bodies could be divided whilst minds appeared to be entirely resistant to division, then, as Descartes observed in the sixth of the *Meditations on the First Philosophy*, no matter that as a 'thinking thing' the subject may have perceived itself as 'one single and complete thing', the human subject was bifurcated.[17]

From that profound division, flowed the larger division of discourse which took place at some point in the seventeenth century. It was just not possible to assert the underlying unity of all things once the central principle of the cosmos, the human subject, had been so radically bisected. If the subject was, at best, a fragile unity which collapsed under the pressure of Cartesian analysis, then what else was stable in the universe? As an 'epitome' the human body had once been anatomized, only to discover in its multiple divergence of parts an endless repetition of the structural coherence of the macrocosm. But that structure of repetition – the poetics of existence which rested on simile and metaphor – was no longer in operation. The thinking thing, when it began to think, found not repetition and hence similarity, but chaotic divergence, asymmetry, a collection of pieces. Out of this collection of parts it would, eventually, be possible to manufacture an assembly – a human being which, possessing the form of humanity, was nevertheless understood as essentially split. The paradigmatic text of bifurcation would be Mary Shelley's 1818 creation of the monster in *Frankenstein*, an assemblage of parts offered as a critique of the implications of the Cartesian divide. The alienated subject – a potential monster – had arrived, the child of mechanism, rather than Freud. Not until James Joyce's efforts at recompaction in Zurich led him to read the poetry of Phineas Fletcher – one of the many (though perhaps the strangest) progenitors of Leopold Bloom – would the supremacy of the Cartesian monster be challenged. But it is the birth of the Cartesian monster which concerns us at this stage of the enquiry into the culture of dissection.

REMBRANDT AND DESCARTES IN THE ANATOMY THEATRE

Was the Cartesian subject the invention of Descartes? Or did Descartes simply offer one of the first systematic accounts of a position which was already well rehearsed by the time the *Discourse* and the *Meditations* appeared? It is, for example, perfectly easy to read Donne's 'The Extasie' as a Cartesian poem *avant la lettre*. Thus, in a Cartesian reading, Donne's 'subtle knot' linking body and soul would be an anticipation of the Cartesian search for some locality where the 'completeness' of the individual might be observed

– a location that was eventually to result in Descartes's claim that the pineal gland was the place where the soul exercised its functions within the body. What seems entirely Cartesian in Donne's pre-Cartesian text (speaking historically) is the language of 'alieneity' to which the poem has recourse. 'We' are composed of two parts in the poem: 'us', the 'intelligences', the thinking entity, that which gives the poem utterance; and 'them', the 'spheare' (or 'spheares' as the 1633 edition of Donne's *Poems* insisted), who have no voice in the poem, but on whose behalf words are spoken. The speaking subject of the poem, or the poem's own act of utterance, is a unified 'I'. Yet, that 'I' is aware of the incomplete state which it is struggling to resolve. Much later, the attempted resolution of the dualism which inhabited Donne's poem was perfectly expressed in Descartes's letter to the Princess Elizabeth: 'everyone *feels* [my emphasis] that he is a single person'. But feelings were not enough, as Descartes was able to demonstrate through his attempt at anatomizing body and soul, where one entity (body) was shown to be divisible, whilst the other (soul) resisted any attempt at fragmentation.

Descartes's reflections on dualism were not fully available until 1641, by which time he had published the *Discourse on the Method* (1637) and the *Meditations on First Philosophy*, together with the first six sets of the *Objections and Replies* (1641). And Donne's 'The Extasie' was in circulation long before then, though it was not printed until 1633.[18] The poem was not, therefore, 'Cartesian' in the strict sense of having been written under the influence of the philosophical reflections of Descartes. But if it was not, then was it possible that 'Cartesianism' was in circulation before Descartes came to formulate his own position?

Clearly it was. The evidence for that circulation will not, however, be found in philosophical treatises. Rather, we have to look to the intellectual, artistic, and political *milieu* in which Descartes found himself in the years during the 1630s when he was formulating his philosophical position. Looking back (in a letter to Mersenne of 1639) on his earlier career, Descartes offered the following anatomical reflection:

> The number and the orderly arrangement of the nerves, veins, bones, and other parts of an animal do not show that nature is insufficient to form them, provided you suppose that in everything nature acts in exact accord with the laws of mechanics, and that these laws have been imposed on it by God. In fact, I have taken into consideration not only what Vesalius and the others write about anatomy, but also many details unmentioned by them that I have observed myself while dissecting various animals. I have spent much time on dissection during the last eleven years, and I doubt whether there is any doctor who has made such detailed observations as I. But I have found nothing whose formation seems inexplicable by natural causes.[19]

Seven years earlier, in 1632, Descartes was investigating these mechanical laws by comparing the anatomical theories of Harvey with the results of his own anatomical explorations (both practical and literary) to which this letter to Mersenne seems to be referring.[20] The reference to Vesalius and the eleven years of dissective work takes us back to 1628 – the year of publication of Harvey's *De Motu Cordis* and the year in which Descartes first visited Holland. It was in Holland, particularly in the University of Leiden, and in the recently founded University of Amsterdam (1632), that public anatomy was to reach its zenith. In the spring of 1629 Descartes moved permanently to Holland, living first at Franeker, then (1630) in Amsterdam, followed by Leiden (1632). In Amsterdam, Descartes lived in the Kalverstraat quarter of the city, now one of the chief shopping centres of modern Amsterdam, but then the quarter inhabited by the city's butchers. There he was to be found purchasing carcasses for dissection.[21]

In late 1631 and early 1632, whilst Descartes was exploring the butchers' shambles of Amsterdam, Rembrandt was also working in the city on his most important commission to date: the painting which was to become *The Anatomy Lesson of Dr Nicolaes Tulp* (Figure 18). Like Descartes, Rembrandt, too, had studied the works of Vesalius: and not just the literary work. Many years later, in 1669, a visitor to Rembrandt's residence just two days before the artist's death was to record that amongst the possessions 'gathered over long years by Rembrandt van Ryn" were to be found 'vier stucks gevilde Armen en beenen door Vesalius geanatomoseert' – 'four flayed arms and legs anatomized by Vesalius'.[22] Was it possible that Descartes, busily gathering animal carcasses and studying the works of Vesalius, and Rembrandt, preparing to work on his anatomy of an anatomy lesson, would have encountered one another, either in the butchers' stalls, or beneath the city scaffold, or in the anatomy studios of Amsterdam and Leiden?

We do not know. But we do know that the butchers' shops and the gallows were sites of real attraction to Rembrandt as well as to Descartes. 'Rembrandt seldom depicted life outside his studio,' Svetlana Alpers has written, before observing that one of the few spectacles which did draw the artist away from the studio was the prospect of depicting death.[23] Much later in his career, Rembrandt was to depict the gibbeted corpse of Elsje Christiaens, hanging from the scaffold, having been executed in May 1664 for murder – the first woman to be executed in Holland for twenty years. As Alpers has demonstrated, this drawing of a dead woman is of a piece with Rembrandt's other, earlier, treatments of dead organisms: the *Child with Dead Peacocks*, the *Self-Portrait with Dead Bittern* (1639), a drawing of butchers working on a carcass of a pig, and the extraordinary, horrific, *Slaughtered Ox* of 1655. The *Slaughtered Ox* (see cover illustration) is an essay in exhausted violence, or the after-effects of violence. An eviscerated animal carcass is shown sus-

pended from a gallows-like structure, whilst a young woman peers round a door, surveying the scene. Such images (Alpers writes) show 'the dark side of the master's touch' where slabs of paint draw our attention to 'the kinship between pigment and human flesh'. In these paintings, 'Rembrandt . . . identifies the painter with the role of one – butcher, hunter, surgeon – whose hand cuts and delves into the body.' More significantly, we begin to discern how Rembrandt could identify 'with both the slayer and the slain'.[24] Here is that effect which, much later, Hegel was to uncover as the artist's transforming vision beneath the surface of reality, an incisive gaze *into* the object. But what is truly transforming is not just Rembrandt's depiction of dead animals or (even) people, but his fascination with the juxtaposition of decay and the realization of living, animated matter. With the exception of the grim image of Elsje Christiaens, who stiffens in isolation on her ghastly pole, Rembrandt's attention was caught by the dramatic possibilities of a contrast between life and death. Thus, the depiction of death is usually heightened by the hint of life to be found elsewhere in the composition. His 1639 self-portrait displays this impulse quite clearly. In this image, the artist gazes quizzically at us from behind the suspended dead bird, which appears to hang (once more) from a miniature gallows, on which the artist's signature can be discerned.

Why should Rembrandt have wished to identify himself with dead creatures? Why the interest in showing animals as if they had, somehow, been the victims of an execution? Of course, a painting such as the *Self-Portrait with Dead Bittern* hints at a certain quality of luxury and consumption which would not be foreign from all that we know of Rembrandt's lifestyle. But this biographical, or gastronomic, interpretation does not answer to his other depictions of up-ended, slaughtered, animals. More precisely, it does not tell us anything of Rembrandt's perhaps most famous sequence of images of dead matter: his 'anatomy' paintings of 1632 and 1656. But what happens if we approach these images as addressing a specifically Cartesian problem fostered by the culture of dissection in Holland in the early seventeenth century?

Rembrandt's *Anatomy Lesson* (1632) appears to record a moment – an event – frozen in time: the second public anatomy conducted by Dr Tulp, the recently appointed praelector, or public anatomist, to the Amsterdam Guild of Surgeons. This demonstration took place on 31 January 1632. Gathered around the cadaver are a group of the wealthier members of the guild, who had paid (just as the audience at a public anatomy paid) to be included in the portrait. The date, 31 January 1632, was important in the civic calendar of Amsterdam. This was the last day of the political year, the day before the election of new burgomasters and aldermen. But, in January 1632, the date was to be doubly significant, since it was in that month that

the new University of Amsterdam was opened as an explicit challenge to the intellectual and civic importance of Leiden.

Rembrandt's painting was thus charged with political resonances. Anatomy (as we have seen in the case of the elaborate construction of the Leiden anatomy theatre) was a register of civic importance, a dignified expression of the intellectual vitality of the community. Here, then, were the wealthy members of the Amsterdam surgeons, gathered around the body of an executed criminal, asserting their *gravitas*, their status as representatives of the intellectual elite of the city, in the very month that Amsterdam was proclaiming to the world its ambition to be a centre of European learning to rival the hitherto dominant position of Leiden.[25] The executed criminal's body may thus be understood as the point of convergence of different registers of social meaning. The body is the matrix of a demonstration of civic and corporate power, a bourgeois regime of order and stability. As with Vesalius' street criminals, dissected in Bologna nearly a hundred years earlier, we know the name of the felon. The criminal who Rembrandt shows being dissected is one Adriaen Adriaenszoon, otherwise known as Aris 't Kint, convicted of stealing a coat and executed on 31 January 1632. Adriaenszoon was a resident of Leiden.[26]

Of course, any criminal body would have served the purpose. But it must surely have appealed to the surgeons' sense of irony that their demonstration of what Francis Barker has termed 'an act of penal and sovereign domination which is exemplary and substantive, symbolic and material, at one and the same time', should have been conducted at the expense of a citizen of Leiden, and captured by an artist born in the rival city.[27] In any case, over the body of Adriaenszoon, the Amsterdam bourgeois celebrated their own civic virtue. But civic virtue was not the only theme of the painting. Although the painting celebrated a particular moment, it was also nothing more (or less) than a fictional re-creation on the part of Rembrandt, underlined by a dense sub-stratum of theology and moral reflection. This could not have been the record of a 'public anatomy' as a fully theatrical performance of the type performed at Leiden, since, in 1632, Amsterdam possessed no public anatomy theatre. Instead, as recent commentators on the painting have observed, this image deploys the characteristic studio effects of the genre of group portraiture of the period, particularly in respect of the play of light and shadow, to make an idealized statement about anatomy, rather than the record of an event. This idealized dimension to the painting is suggested by the fact that only the left lower arm of Adriaenszoon is shown dissected – a procedure which, given the 'economy' of cadavers, would have been extremely unlikely. By the time Tulp (in reality) came to the lower arm of his subject, Adriaenszoon would have been barely recognizable as a human corpse.

That point of recognition is vital to the painting's programme. Commentators on the painting have isolated that programme, and hence the central paradox of the *Anatomy Lesson*, in the following terms. Tulp and his surrounding surgeons are investigating the human hand, the organ which (along with the intellect) differentiates the human as a tool-making animal from the rest of creation. So, Tulp mediates with his forceps between the written authority of the text (shown in the lower right foreground of the painting) and the corporeal reality of Adriaenszoon. Tulp is demonstrating to his colleagues both the mortality of the human body (the corpse is a corpse and nothing more), and the immortality of the soul (the body is a 'temple' created in the image of God) endowed with a cognitive faculty, as the unique structure of the hand indicates. The picture oscillates, then, between a pessimistic and optimistic spectrum of meaning. At one end of the spectrum we are asked to reflect on our own mortality, whilst at the other end, we are urged, nevertheless, to celebrate the wisdom of God who has reserved for humanity a special place in the creation.[28]

By the time that Rembrandt came to paint the *Anatomy Lesson*, a genre of such paintings had emerged in Holland. Thus, Aert Pieterszoon had commemorated the anatomical prowess of Dr Sebastiaen Egbertszoon in 1603, Michael and Pieter van Miereveld had memorialized Dr Willem van der Meer in 1617, Thomas de Keyser had painted Egbertszoon (once more) in 1619, and Nicolaes Eliaszoon (Pickenoy) had painted Dr John Fonteyn in 1625. Later, after Rembrandt's painting, Christian Coevershoff was to portray the town physician of Enkhuizen, Dr Zacheus de Jager in 1640, and Rembrandt himself was to return to the theme, with the remarkable, foreshortened, image of the human body in his *Anatomy Lesson of Dr Joan Deyman* of 1656 (Figure 19). Though all these paintings differ from one another in the disposition of the figures, in the dynamic quality of the construction, and in the painterly techniques employed, one factor is constant: a group of men surround a corpse (or, in the case of de Keyser's painting, a skeleton), which is the signifier of their profession and skill, and their identity as a group constituted out of some of the leading members of the political order of their respective cities. We can understand these paintings – visual icons of protestant science – as part of that struggle against 'infamy' or the taint of the gallows which seems to have animated the investigators of the human frame in early-modern societies. By publicly proclaiming their civic and intellectual worth, the surgeons who clustered around a dissected corpse offered a challenge to any potential charge of having become tainted members of the community. But the corpse performed a more important function, even, than registering this kind of resistance on behalf of the surrounding professional men. In its passivity, its stark nudity and whiteness, it seems to highlight the sober clothing of the

dignified bourgeoisie who surround it, and thus the corpse may be understood as the traditional *vanitas* figure of the seventeenth-century portrait.[29] For all the dignity of the surrounding surgeons, the corpse, in all its whitened other-worldliness, reminds the onlooker of human mortality which will, eventually, triumph even over these icons of civic power and rectitude. For the moment, however, even if their power is provisional, they have triumphed over death. Or, at least, the order which they represent has (in terms which Hobbes was later to make familiar within English political theory) subjugated the mortal body to the immortal nexus of the civic bonds which unite them.

It was also true that the artists responsible for these anatomical gatherings were drawing on an explicitly christian iconography and, in effect, reversing that pattern of meaning in order to support the social and political order of their patrons. The adoration of a dead body, as it was depicted in the numberless 'deposition' scenes of the Renaissance, had been long venerated. But, in the 'deposition' scene, the body of Christ was surrounded by sorrow and pity: a prelude to the joy of the Resurrection. In 1630/1, Rembrandt had painted such a moment of conquest over death in his *Raising of Lazarus*. There was nothing, however, Lazarus-like in the cycle of anatomical paintings. In fact, their primary objective was to proclaim the absolutely unambiguous subjection of the mortal body to scientific and political power – a quality which (perhaps surprisingly) can be discerned in the artist's 1639 composition *The Entombment of Christ*. The intensity of the onlookers' gaze, then, in Rembrandt's image of the anatomists, is the intensity not of adoration or lamentation, but the furious concentration of intellect. That concentration was directed towards a corpse which was the embodiment of a potentially destructive and alien force. Just as Christ was condemned and executed amongst thieves, so the anatomized subject displayed in this image represented an order – that of the stranger, the thief, or the murderer – which had to be violently subdued by the magisterial and rational judgement of the city.

The corpse, then, was the remnant of a deviant 'will' – a potential threat to the social fabric mastered by the rational power. Like nineteenth-century British photographs of the members of the Raj, surrounding the body of a slain tiger, the bourgeois of Amsterdam or Leiden surrounded a human corpse which had become (as in the nineteenth-century 'hunting trophy' image) much more than the record of a moment. The corpse was the visual representation of the 'civilizing' force of the human intellect over the bestial world of the tiger, the criminal, or (even) the ox. A double triumph was, then, to be glimpsed: a triumph of rationality and its child – skill, or *techne*. But Rembrandt's portrait was different in one crucial aspect from such static images found either in the work of his immediate forebears or in the self-images of imperial rule in the nineteenth century. In Rembrandt's *Anatomy*

Lesson something was happening, movement was taking place, a movement which returns us to Descartes.

Between 1628 and 1640 – the years during which he was resident in Holland – amongst the problems to which Descartes devoted attention was that of the role of the will (*voluntas*) in human action. Choice, Descartes wrote in the *Rules for the Direction of Mind* (composed shortly before leaving for Holland in 1628) was a function of the will, but a function which must be subordinated to intellect. Thus the philosopher should 'think solely of increasing the natural light of reason . . . in order that in all the happenings of our life, our intellect may show our will what alternative to choose'.[30] But by the time Descartes came to publish his *Meditations on First Philosophy* in 1641, his view had been substantially modified. In 1641, he wrote that the cause of error lies in the unrestrained liberty of the will, since 'the scope of the will is wider than the intellect.'[31] The will was indifferent to truth or falsehood, evil or good, and hence, because its 'scope' was broader than the intellect, any mastery of the will by the intellect was entirely provisional. Intellect (or the faculty of understanding – *facultas cognoscendi*) was God given, but in the human soul it was a mere remnant ('slight and very finite') of divine understanding. From the optimism of 1628, then, Descartes had arrived at the fundamental pessimism of 1641. Intellect, he had come to believe, was all too easily subverted by the boundless will. This movement between optimism and pessimism is similar to, though not identical with, the spectrum of meaning which can be located in Rembrandt's *Anatomy Lesson*. And here we can sense the conjunction between the Cartesian struggle of will and intellect, and Rembrandt's portrayal of the domination of intellect over the aberrant will of the executed felon. In this conjunction the Cartesian nature of Rembrandt's image is suddenly realized. In the picture, mediating between text and body – the rational intellect and the criminal will – Tulp's forceps are delicately probing the *flexorum digitorum* muscles of Adriaenszoon's left hand. By pulling on these flexor muscles, the (dead) fingers are made to curl, a gesture which Tulp echoes with his own (living) left hand.[32] Thus was established the Cartesian 'truth' of bourgeois order and rationality. A miracle appears to have taken place. One intellect (Tulp's) has animated two bodies, one of which is living, and the other is dead. In the dead body, the will – *voluntas* – has been extinguished, but the mechanism – 'the laws of mechanics' which, Descartes was to explain to Mersenne in 1639, inhabit all of nature – was still in operation. In the extinction of Adriaenszoon's will, lay the triumph of Tulp's intellect: a demonstration that in order to preserve the moral fabric of the social order from the deviant will of those who, like Adriaenszoon, stole a coat, the most extreme and *rational* violence must be deployed.

Dutch winters are cold, and they were colder still in the seventeenth

century. For all that we know, then, Adriaenszoon's decision to steal a coat in the January of 1632 may have been an entirely rational act. But to the dignified upholders of the status quo, represented by the surgeons in Rembrandt's painting who were used to acting not only as medical practitioners, but as extensions of the punitive apparatus of the law, such philosophical niceties were beside the point. Theft represented an act of deviant will, which necessitated punishment as an act of civic intellect. Observed in this way, Rembrandt's *Anatomy Lesson* did indeed mark a moment, but one that was far removed from the specific event of the January of 1632. The moment that it encapsulated within the layers of paint was itself multi-layered – a compact and dense archaeology of corporate power over the individual, of mind over the body, intellect over the will, property over dispossession, civic identity over isolation, 'us' (as Donne had written) over 'them'. Descartes's own contribution to the culture of dissection has usually been understood as the radical anatomy of mind and body. But the question, we can now see, should be rephrased. What was the contribution made by the culture of dissection to the evolution of Cartesian thought? The answer to that question must be traced via the obscure route of the philosopher and the artist from the butchers' stalls, to the gallows, to the artist's studio, to the great anatomy theatres themselves.

In 1656, Rembrandt returned to the anatomy studio in order to freeze another moment of rational intellect in triumph over deviant will. *The Anatomy Lesson of Dr Joan Deyman* (Figure 19) commemorated Tulp's successor Joan Deyman (or Deijman) to the praelectorship of the Amsterdam Surgeons' Guild. But it also celebrated the winter execution of another thief: Joris Fonteyn who was hanged on 27 January 1656. The painting, as it has survived, is only a fragment of the original, which once showed a group of eight figures from the Surgeons' Guild arranged around Fonteyn, with the anatomist – Deyman – standing at the head of the body, delicately probing the brain.[33] The remarkable foreshortened image of the cadaver – an effect perhaps heightened since the loss of such a large area of the canvas – lends itself to comparison with another such experiment in perspectival representation of the human body, Mantegna's *Cristo in scurto* ('Foreshortened Christ') or *Lamentation over the Dead Christ* of c. 1478–85 (Figure 20).[34] Comparing the two paintings with one another – one a devotional work from the fifteenth century, the other an exercise in seventeenth-century scientific commemoration – reinforces the sacred sub-text of anatomical culture that we traced earlier. Rembrandt's second anatomical painting reproduced, far more realistically than the Tulp painting, the reality of a seventeenth-century dissection. Even so, the painting does not quite represent the usual procedure of a dissection. Fonteyn's body has been eviscerated, and now his dissector, Deyman, has begun the third (rather than second) stage of the

enquiry. In seventeenth-century anatomical practice, Deyman should have moved to the thorax, and demonstrated the heart and lungs to the audience. Either Rembrandt or Deyman chose to ignore this stage. Instead, the anatomist has removed the top of the skull, which has been given to the young assistant whose attention is fixed on Deyman's 'reflection' (or turning inside out) of the dural membrane which surrounds the brain itself. The left and right cerebral hemispheres have been exposed as a prelude to what would have happened next: the anatomist would prise apart with his fingers the two hemispheres, in order to reach down into the centre of the brain.

If Rembrandt's painting begins with Mantegna's sacred image, then Vesalius' anatomical text provides the detail of the composition. Even by the mid-seventeenth century, Vesalius' images in the *Fabrica* still provided the standard record of dissection. The images of the brain in the *Fabrica* were remarkable both for their clarity and the manner in which they showed how the complex dissection should be conducted. Rembrandt, with his interest in Vesalius' work, would surely have known these famous images of the human brain. Certainly, by comparing the *Anatomy Lesson of Dr Joan Deyman* with the *Fabrica* it is possible to see exactly the stage in the dissection of Fonteyn's head which had been reached. Figure 21 shows Vesalius' third figure of brain dissection from Book VII of the *Fabrica*. This is the stage upon which Deyman is about to embark. The similarity between the two figures is remarkable. Indeed, it is as if Rembrandt had combined two images. The body is that of Mantegna's Christ, but with the terrible hollowness of evisceration so evident, and observed from a slightly lower viewing point than Mantegna had allowed. The head, however, has been propped up, so that what we see is an echo of the Vesalian image, observed from this new viewing point which is itself considerably lower than that chosen for the observer who looks at the Vesalian plate.[35]

In order to produce his images, Vesalius at some stage used the heads of two bodies – a bearded man and the heavily featured clean-shaven man who seems to have reappeared, in a shadowy form, in Rembrandt's painting. Vesalius' use of two heads in order to illustrate a single structure may seem surprising, but this probably reflects Vesalius' own belief that the brain needed to be dissected while still fresh in order to see details which rapidly decayed. Vesalius, it is said, 'constantly importuned the magistrates to allow him to take the heads of executed criminals so that he might dissect the brain while still warm', and it was probably from such a source that the heads shown in the brain series were derived.[36] In Rembrandt's painting, we have already noted how a whole stage of the dissection has simply been ignored. It is as if the body had been hurriedly eviscerated in order to arrest the general decomposition of the corpse, and thus to allow Deyman to begin the brain dissection whilst the corpse was still 'fresh'. Seen in this way, Rembrandt's

painting begins to appear as programmatic as his earlier anatomy portrait of Tulp and his colleagues. But what, then, was the programme that Rembrandt had in mind?

It is, inevitably, Descartes who provides us with the answer. Just as in the Tulp portrait, Rembrandt, in the *Anatomy Lesson of Dr Joan Deyman*, had a specific Cartesian problem in mind, and one that was hugely topical amongst the anatomists of Amsterdam in 1656. The dissection of the brain, if we follow the procedure outlined by Vesalius, would have led, in just three more plates, to the exposure of the pineal gland or *conarium*. In 1649, in *Les passions de l'âme* ('Passions of the Soul') Descartes had publicly identified the pineal gland as the location of the 'point of interaction between soul and body . . . within the brain'.[37] Descartes had reasoned that the pineal gland was the 'seat' of the soul, since there was no other single organ in the brain which could combine dual sensory data in order to produce a single perception.[38] Descartes's belief that he had identified the 'location' of the soul was the result of a number of observations. Of particular importance was the 'phantom limb' phenomenon in which a subject continues to feel pain in a limb which has been amputated, and which therefore no longer exists. The pain, however, is real enough. It was the soul, Descartes argued, residing in the brain, which felt the pain of a hand, for example, which had been amputated. Descartes published this view in the *Principia Philosophiae* of 1644, but the identification of the pineal gland as the location for the soul can be traced back to the very early 1640s.[39] At this time, however, close observation of the pineal gland was held to be extremely difficult, since it was felt that it rapidly decayed after death. This belief is central to our understanding of Rembrandt's painting. Descartes outlined the problem to Mersenne in a letter of April 1640. Having reaffirmed his view that 'there is only this gland to which the soul can be so joined', Descartes wrote:

> I would not find it strange that the gland *conarium* should be found decayed when the bodies of lethargic persons are dissected, because it decays very rapidly in all other cases too. Three years ago at Leyden, when I wanted to see it in a woman who was being autopsied, I found it impossible to recognize it, even though I looked very thoroughly, and knew well where it should be. . . . An old professor who was performing the autopsy . . . admitted to me that he had never been able to see it in any human body. I think this is because they usually spend some days looking at the intestines and other parts before opening the head.[40]

Rembrandt's portrayal, in his *Anatomy Lesson of Dr Deyman*, of a dissection which appears to have skipped over a complete stage of the carefully ordained ritual in order to open Fonteyn's brain, appears, then, as a direct response to Descartes's frustration. It is as if Rembrandt (or, indeed,

Deyman), following Descartes, had deliberately challenged the received methods of dissection. And just as Descartes had turned his attention away from the purely mechanical phenomena of movement, which Rembrandt had portrayed in his 1631/2 painting of Tulp, in order to concentrate in the 1640s on the operation of the brain, so, in 1656, Rembrandt too set out to show the primacy of the brain in the investigation of what it was that constituted the human being. That it should have been 1656 in which the Amsterdam surgeons asked Rembrandt to portray them digging for Fonteyn's soul, in a brain brought fresh from the scaffold, may itself have been no coincidence. Though Descartes had been dead six years by the time the painting was commissioned, Cartesianism was very much a live topic in Amsterdam that year. In 1656 Descartes's *Les passions de l'âme* – with its detailed discussion of the pineal gland – was translated into latin and published in Amsterdam. In that same year, Spinoza was excommunicated by the Jewish authorities of Amsterdam for expressing sympathy with Cartesianism – an irony of philosophical history since it was to be Spinoza in the *Ethics* (1678) who sardonically attacked the Cartesian doctrine of the soul's location in the pineal gland.[41] Deyman's public excavation, then, into the skull of Fonteyn in Rembrandt's painting was an event charged with intense religious significance to those who had followed the debate.

It is, of course, possible to 'read' Rembrandt's *Anatomy Lesson of Dr Joan Deyman* in exactly the opposite way to that proposed here. Is the significance of the Christ-like posture of Fonteyn Rembrandt's ironic commentary on the blasphemous project upon which Cartesian science was embarked? Mantegna's painting – an object of pious devotion – was famous in the seventeenth century, and existed in numerous copies.[42] Were the citizens of Amsterdam in 1656, on entering the Guild-Room of the Amsterdam Surgeons' Hall where the painting was hung, expected to notice the echo of Mantegna's dead Christ in the body of Fonteyn? Did Rembrandt expect them to recoil in horror at the implications of Cartesian science, and recall the devotion and pity with which Mantegna's Christ was surrounded? Or does the painting celebrate the gaze of rational science (embodied in the dispassionate face of the young assistant who surveys his master's handiwork) and the victory over yet another criminal will which Deyman, in keeping with the very latest views of Descartes, was about to bring into the light?

In some sense, Descartes never really left the confines of the anatomy theatre. In the very early part of his career in 1629, soon after he had arrived in Holland and under the stimulus of the anatomical culture he now inhabited, Descartes began work on his unpublished treatise, *The World*, the concluding section of which, *The Treatise on Man*, dealt with human physiology. Eighteen years later, towards the end of his life, and having gained a pension from the King of France, he returned to the anatomy theatres of his

earlier days and began the incomplete project which became known as the *Description of the Human Body*. By then, the famous passage in the *Discourse on the Method* had made him known as the 'inventor' of Cartesian man: the monstrous *bête-machine*. To those who understand the nature of the human organism, Descartes wrote, it would not seem strange that:

> knowing how many different automata or moving machines the industry of man can devise, using only a very few pieces, by comparison with the great multitude of bones, muscles, nerves, arteries, veins and all the other parts which are in the body of every animal, will consider this [human] body as a machine, which, having been made by the hands of God, is incomparably better ordered, and has in it more admirable movements than any of those which can be invented by men.

Given this similarity between machines and bodies, would it therefore (Descartes asks) be possible to become confused as to the distinction between the human 'machine' made by God, and the purely artificial 'machine' made by human reason? The Cartesian answer (though not Mary Shelley's) was No. The first point of differentiation, Descartes maintained, was that the artificial machine would have no access to language. Secondly, since the artificial machine could only act according to the 'disposition' of its various organs, it would need 'a particular disposition for each particular action', and, hence, a probably infinite number of organs. This was because the artificial machine would lack the 'universal instrument' of reason.[43]

Descartes knew this to be the case because, like Rembrandt, he had seen (either in the public anatomy theatres, or the private studios, or, even, in his own experiments) the 'dead' machine in operation. On 31 January 1632, Adriaen Adriaenszoon had lain inert and, as far as it was possible to tell, lifeless. But his fingers had moved. The reasoning power which had moved his hand was not his own, but that of another: Dr Tulp. A single rational power had moved two bodies *at the same moment*. Providing there was a reasoning power with access to the machine – even if that access was indirect – then the divine technology of the human being still possessed the potential for movement. It was in the anatomy theatres of Leiden and Amsterdam that Cartesian man was born, in the person of a grotesquely twitching criminal corpse, at the behest of the medical and judicial authorities of the city. Elsewhere in Europe, however, a different form of alieneity was being pursued. If, in Amsterdam and Leiden, Descartes and Rembrandt found themselves puzzling over the same problem, then, first in Ireland and then in England the 'alieneity', or otherness, of the body was being encountered at an even more fundamental level. In order to trace this quite different form of 'alieneity', we must go back some thirty years or more to the appearance of Edmund Spenser's *The Faerie Queene*.

SPENSER AND THE JOURNEY INTO THE UNCANNY

The creation of 'Cartesian Man', at some point in the early seventeenth century, was also the moment at which an alienated human subject was born. Gazing introspectively into the interior in Cartesian meditation, the human subject had become aware that the 'self' was an apparently contingent mechanism. There was nothing innate in the construction of human identity. So, 'selfhood' – the sense of having or being a unified self – was maintained only when the self ceased to think about the self. In the formulation of the *cogito*, only the 'I' that was aware of itself thinking could announce the certainty of existence. And, paradoxically, in the very moment of certainty the sense of wholeness, as Descartes had explained to the Princess Elizabeth, collapsed. Expressed thus, 'Cartesian Man' is a creature abstracted from the world and from its own sense of identity. 'Know Thyself' thus begins to express not so much self-knowledge as self-division: the fate of Marlowe's Faust or Milton's Satan. Bereft of a home, wandering in a mist of confusion and uncertainty, the human subject oscillated, now, between unthinking unity, and reflective dislocation.

In the twentieth century, a very different means of describing this sense of dislocation has emerged. In 1919, Freud offered the untranslatable sense of that which is 'unheimlich' to describe the radical alieneity which the human subject, after Descartes, was supposed to endure. Freud's account of Hoffmann's tale, 'The Sandman', sought to unravel that eerie sense of dislocation which he described as a sense of the 'unheimlich' or 'uncanny'. The uncanny, Freud wrote, 'is that class of the frightening which leads back to what is known and familiar':

> Heimlich . . . from the idea of 'homelike', 'belonging to the house', the further idea is developed of something withdrawn from the eyes of strangers, something concealed, secret. . . . The notion of something hidden and dangerous.[44]

Could this 'class of the frightening' be discovered inside the human body? John Donne, in his *Devotions* of 1623, certainly understood his diseased body as a place of treachery, concealing something 'secret . . . hidden and dangerous'. Freud, however, had a different location of body-fear in mind. At the end of his account of Hoffmann's tale, Freud drew out the psychoanalytic parallels which, he believed, furnished 'a beautiful confirmation of our theory of the uncanny':

> It often happens that neurotic men declare that they feel there is something uncanny about the female genital organs. This *unheimlich* place, however, is the entrance to the former *Heim* [Home] of all human beings, to the place where each one of us lived once upon a time and in the beginning.[45]

Here is the psychoanalytic basis for an account of the Medusa's head which

lies within the body-interior: the fear as Freud went on to observe, of 'inter-uterine' existence. The 'uncanny' – the return of the familiar or (as Freud says elsewhere in the essay) the 'double' – is that point at which a web of strangeness seems to enclose what has long been known and understood. At the same time (as Freud would have it), for the 'neurotic' male, the concealed and secret nature of the female genitals alerts us to the 'unheimlich' nature of the place which was, once, the entrance to the home of all of us: the female body. But is it only the female body which (to men) is held to be both 'heimlich' and, following the logic of Freud's 'Sandman' analysis, 'unheimlich'? For men and women, the sexually undifferentiated body-interior is a region of eerie unfamiliarity made doubly eerie (and thus uncanny) by the knowledge that this unfamiliar geography is also part of ourselves. This is that interior landscape which is so rarely glimpsed except (as the young officer wounded in the Falklands War reminded us) under conditions of such extreme distress.

Freud's understanding of the body as a 'heimat' has an ancient ancestry, which still informs our everyday thinking about our own bodies. Imagined as a constructed entity (as Vesalius and the anatomists imagined it), this familiar but unfamiliar place can be deconstructed in a purely architectural trope of the imagination. A cycle of reflection begins to surround the body: to imagine it (familiarly) as a home, it has to be *constructed* as such, but, in order to embark on the construction, it has to be deconstructed in the first instance and imagined as a scattering of parts. In modern scientific discourse, we are familiar with this language of construction and deconstruction. We speak, for example, of amino acids as the 'building blocks' of nature, out of which, through the mechanism of evolution, complex amalgams are formed which will eventually be identified as 'bodies' themselves constructed out of myriads of cells. Thus, the body (whether animal or human) is both unified *and* fragmented. Though the body would appear to be a single organism, this is not, in the biological sense, entirely true. In the early part of the twentieth century, the journalist, lawyer, and naturalist, Eugène Marais, observed of the termite communities that he had studied in the South African veld that they should properly be understood 'not as a heap of dead earth, but as a separate animal at a certain stage of development'.[46] Modern biological understanding of bodies as composite entities is reflected in older, religious, networks of belief. We have already seen St Paul's description of the christian community as resembling a 'body'. But the metaphor of the community, allied to the architectural composition of the constructed entity of the body-fabric, returns us to the notion of the 'house' of the body – a community rather than an architectural structure. Ben Jonson's poem, 'To Penshurst' (1616), for example, alerts us to the early-modern sense of a 'house' as an undoubtedly idealized social network of

160

affiliation and reciprocity and of mutual obligations which are something more than bricks or mortar.[47] This idea is not only ancient, but found outside a purely western tradition of understanding. A. K. Coomaraswamy, describing an Indian temple, the Kandarya Mahedo, has observed that: 'the human frame, the constructed temple, and the universe being analogical equivalents, the parts of the temple correspond to those of the human body no less than to the universe itself.'[48] If for 'temple' we substitute the word 'church' then the analogical equivalence is placed within an equally ancient christian context. To the anglo-saxons, for example, ideas of hall, church, and body were naturally analogous, as the Old English poem *The Ruin* – described as being in the tradition of 'sacred anatomy' – demonstrates.[49] 'Sacred anatomy' finds its expression in medieval texts, too: Robert Grosseteste's *Le Chasteau d'Amour* and the homily *Sawles Warde* (both from the first half of the thirteenth century) together with Passus IX ('B' Text) of *Piers Plowman* can be placed within this tradition.[50]

What, though, of Freud's 'neurotic' sense of male unfamiliarity with the 'unheimlich' female genitals? Can such psychoanalytic ideas help us to understand a sixteenth-century text? The psychological paradigms available to the sixteenth-century reader were, clearly, entirely alien to those which we have derived from Freud. However, as an entrance to the 'house' of the body, which is also the universal 'heimat', the female genitalia may, indeed, reveal the opening to a strange and secret place which is the body-interior. But, to the extent that we inhabit the Cartesian body, this 'heimat' need not only be sensed in neurosis. Or to put this another way, literary traditions of construction of the body-entity suggest that 'our' relationship with 'our' bodies is (if Freud is correct) continually 'neurotic'. The body is familiar and unfamiliar – that which we know best and yet not at all.

The idea of entrance into the unfamiliar familiar finds its precise parallel in the ornate construction and deconstruction of the body-house encountered in Spenser's *The Faerie Queene* – the house of Alma (*FQ* II.ix). And to at least one anatomist of the period, Spenser's text was to prove crucial to an understanding of the body as both a fabric and a place where 'we' reside. Freud's account of the body as 'unheimlich' lays special emphasis on the female body as the location of strangeness. In *The Faerie Queene* a multitude of female bodies are encountered, some of which are indeed dangerous objects of both desire and horror (Acrasia, for example, or Duessa). Chief amongst the objects of desire is the 'Queene of Faeries' herself, encountered by Arthur in his dream of Gloriana (I.ix.13). Gloriana is composed of a sequence of doubles who 'shadow' the recipient of the whole poem: Elizabeth I. In his 1589 letter to Sir Walter Raleigh, Spenser explained that, in the figure of the Faerie Queene, there could be glimpsed 'glory in my generall intention'. But the Faerie Queene also denoted 'the

most excellent and glorious person of our sovereine the Queene'. The sovereign figure was herself re-doubled, so that she 'beareth two persons'. She could be appreciated as both a political persona and a private individual who was 'a most vertuous and beautiful lady'. These complementary elements were reflected in the compounded name of Belphoebe – a name which united Cynthia and Phoebe, aspects of the character of Diana, another poetic persona of the 'real' Elizabeth.[51]

Female personae, both negative and positive, stalk the narrative landscape of the poem which was addressed to a woman concealed behind a shimmering and fluid series of 'guises'. Freud's description of the 'unheimlich' might lead us to think of the poem as a homage to male neurosis, an interpretation which is given all the more substance when we recall Spenser's own description of the poem as a 'darke conceit', whose purpose was to 'fashion a gentleman or noble person'. Thus, the (male) reader of the *The Faerie Queene* is 'fashioned' into a social being. Or, as Stephen Greenblatt observes, a 'self' is born into a 'cultural system of meanings', in which Spenser's text is just one of the many 'control mechanisms' at work to shape and define social identity.[52] The somatic impulse, the uncovering of the body as the familiar unfamiliar, is part of a process of self-discovery and, hence, self-creation. The House of Alma episode is a crucial passage in the complete 'fashioning' project of the *The Faerie Queene*. Alistair Fowler has described the House of Alma section of the poem as forming the 'core canto' of Book II, since its subject is 'an extended allegory of human nature'.[53] But 'human nature' was not, for Spenser, some disembodied abstraction. Instead, if there was any 'nature' to be uncovered within the individual, then it lurked at the point where the body and the self conspired to produce a social identity – a 'fashioned' existence, comprised of bodily gesture and demeanour, attitudes, values, and networks of behaviour. The correspondence between the courtly poetic of Spenser, intent on 'fashioning' the social identity of his reader, and Descartes, intent on investigating how or where identity is located, begins to emerge and then merge. For both the poet of courtly identity, and the (later) philosopher of bourgeois identity, the probable home of that identity was the same: the 'heimat' provided by the body.

Freud's 'body', unfortunately, is no easy place of refuge. And neither was Spenser's. Its familiarity as a 'heimat' is also 'heimlichkeit' – a place of secrecy and reserve. And out of the body's innate secrecy is fashioned the 'unheimlich' – a sense of the uncanny. In other words, what we might expect to encounter within the House of Alma is the 'double', a mirror-like structure of reflection. But we must recall the lesson of anatomical and religious art at this point: once the body has been entered and gazed into, then it is constructed as a feminized landscape, whatever its biological sex may be. What, then, are the features of the House of Alma? First, it is

undoubtedly feminine. Alma – the soul – is the governing power of the region, and the body-house is 'her' body, 'her' location. Strangely enough, however, the body of Alma has no marks of biological sexual difference. Instead, there are two 'entrances' to the body: the mouth and the anus.[54] Secondly, the House of Alma is a place of retreat and safety for Guyon and Arthur at this point in their odyssey. Their arrival at the entrance to the castle secures for them relief from the alien and uncivilized hoards who surround the construction. These 'vile caytive wretches' swarm 'like Gnats', a mysterious and inhuman enemy which (historically) can be associated with Spenser's own experience of what he believed to be the wild and savage 'otherness' of the Irish amongst whom he was living as he was writing this section of the poem.[55] What is also to be remarked about these enemies of protestant 'temperance', as they seek to thwart the retreat of the knights into the house of temperance, is that they are mysteriously unbodied. 'Hewing and slashing' their way through these 'idle shades', in a description culled from Virgil's account of Aeneas' visit to the underworld (*Aeneid* VI.260–93), the knights discover that 'though they bodies seeme, yet substance from them fades' (*FQ* II.ix.15). From this world of bodies without substance, the knights gain sanctuary within the body. But, crucially, the knights remain unaware both of the existence of the castle as a body, and the possibility of the body-structure through which they wander being a simulacrum of their own bodies. Thus the double, associated with the 'uncanny' (and forming part of *The Faerie Queene*'s structure of doubles), makes its appearance in the text. The knights would appear to have retreated from a disembodied world of shadows without substance into a bodily domain. In actuality, however, they have retired from the dangerous shadow world into the world of their own bodies: the familiar but unfamiliar 'heimat'. At this point the text's 'neurotic' strategies become apparent. The 'House of Alma' exists as a 'defamiliarizing' structure, transformed through allegory into an emblem of what Freud would term 'neurosis'.[56]

Significantly, for Freud, it was the entrance to the female body which the 'neurotic' saw as 'unheimlich'. Significantly, too, for Guyon and Arthur, it is the body's entrances which appear to be the strangest part of the complete structure. As in all such anatomical journeys, the Delphic injunction – 'Know Thyself' – echoes through Alma's halls. But knowing yourself can be an uncomfortable experience, particularly if you don't realize that it is yourself that you are viewing. Spenser's commentators have noted, for example, the structural similarities between the 'House of Alma' and the earlier (in terms of narrative chronology) 'House of Mammon' (II.vii) episode of the poem. In that earlier passage, Arthur approached Mammon's dwelling, but suddenly became aware of another entrance 'a little dore . . . next adjoiyning' the larger entrance to Mammon's realm. This proves to be the entrance

to Hell. It is outside this double-gated structure that Arthur pauses: 'th'Elfin knight with wonder all the way/Did feed his eyes, and fild his inner thought' (II.vii.24). In similar measure, the entrances to the House of Alma – the mouth and the anus – are described in a way which makes them appear as virtually conjoined:

> Therein two gates were placed seemly well:
> The one before, by which all in did pas,
> Did th'other far in workmanship excell;
> (*FQ* II.ix.23)

But it is only when Arthur and Guyon stand inside the House of Alma, much later, that we can begin to unravel the double anatomical structure which the knights had first encountered outside Mammon's house, and then again as they enter Alma's castle. So, passing through the body-building of Alma, the knights reach the 'back-gate', the 'Port Esquiline', where waste is disposed of. Here, having traced in their own journey from the stomach to the bowels the waste disposal systems of Alma's castle, as if they were themselves food, the knights pause, as Arthur had earlier paused before the Cave of Mammon:

> Which goodly order, and great workman's skill
> Whenas those knights beheld, with rare delight,
> And gazing wonder they their minds did fill;
> For never had they seene so straunge a sight.
> (*FQ* II.ix.33)

Or never, at least, from the inside. This stress on the scopic ('beheld', 'gazing', 'seene') is an important part of the journey. It is not enough to 'read' the 'book' of the body in order to understand it. Rather, the body has to be opened out, displayed, so that its interior dimensions are truly known and experienced. By this stage, having (as it were) ingested the knights, Alma is ready to reveal to them the true nature of this doubled structure into which they have retreated. As each feature of the body-world is disclosed to them, it is as if the realm of the body has become as alien or other-worldly as the savage disembodied world from which they had fled. What Alma shows them, at last, is that the journey they have embarked upon is a voyage into the interior which brings them face-to-face with simulacra of themselves: a truly strange ('unheimlich') sight. Their own social identities are to be displayed within a mirror of themselves.

Ascending from their contemplation of the 'great workmans skill', visible in the construction of the back-gate of the structure, the knights are ushered into a 'goodly parlour' which is the heart, the seat of Alma. There they are greeted by a 'lovely bevy of faire Ladies', and the strangest encounter of all

begins. For, as the two knights each proceed to court one of these female figures, it is revealed that their chosen paramours are aspects of their own social identities. The 'bevy of faire Ladies' are the affections, or moods, arranged (as A. C. Hamilton notes) 'according to degrees of inwardness' (*FQ* II.ix.35 (note)). 'Inwardness' is the key to the mystery which is being probed. For the two companions chosen by Arthur and Guyon ('Prays-desire' and 'Shamefastnesse') are, self-reflexively, mirrors of their own inward motivation. This revelation causes consternation. Arthur is 'inly moved' and tries 'with faire semblaunt' to 'hide the breach' in his own social fabric which the revelation has caused. But his blushes ('change of colour') serve only to disclose the inner man. Guyon chooses a companion who is 'straunge' in her attire and in her passions – a strangeness which he cannot comprehend. But Alma informs him of her (and hence his) identity:

> Why wonder yee
> Faire Sir at that, which ye so much embrace?
> She is the fountaine of you modestee;
> You shamefaste are, but *Shamefastnesse* it selfe is shee.
>
> (*FQ* II.ix.43)

An explanation which covers him (literally) in the signs of confusion that he struggles to conceal:

> Thereat the Elfe did blush in privitee,
> And turned his face away; but she the same
> Dissembled faire . . .
>
> (*FQ* II. ix. 44)

The point about a blush is that it cannot be concealed. A private blush is no blush at all. And as Guyon attempts to conceal the marks of confusion, his female mirror does the same. Within the structure of 'doubles', or the familiar unfamiliar, two knights (who reflect aspects of a single identity) enter a body (their own body) and meet two women (equally aspects of a single identity) who are reflections of themselves. Thus, a 'breach' has been created in the social identity of the characters which must be healed through conquest of these (potentially) unruly passions – a path which will eventually lead to the violent ransacking of the 'Bower of Blisse' (II.xii).

The body through which the knights have wandered, and wondered at, is not an abstracted entity but a representation of social identity. There is, then, no discovery of an 'innate' human nature within Alma's realm. Instead each knight has actively chosen the identity with which he will face the world. The revelation of that act of choice, so deeply concealed that the very choosers are oblivious to their own motives, is revealed in an allegory of retreat, flight, and sanctuary. Retiring into the inner world – of which the

165

human body is the icon – in an attempt at escaping the chaotic exterior, the place of safety is shown to be neither a refuge nor a sanctuary. Rather, it is the location of disturbing images of the self's attempts at concealing itself within an inner fortress of stable identity.

Described thus, 'The House of Alma' begins to appear not merely as a neurotic text (as Freud was to understand that term), but one which, in twentieth-century terms, borders on the schizophrenic. For it is in schizophrenia (as Gilles Deleuze describes it) that the body-surface begins to break apart, so that the body begins to exist as 'fragmented parts': a dissociation of form and structure. And, in the mirror of identity into which Spenser's knights gaze, there is more than a hint of that 'mirror' subsequently described by Jacques Lacan. Lacan has traced the subject's search for identity, reflected in dreams of a 'fortress' towards which the subject 'flounders' in search of a 'lofty remote inner castle'.[57] This is exactly the experience of Guyon and Arthur in their flight from the disembodied exterior to the fully bodied interior of their own selves.

But what, in the meantime, of the reader who was supposedly being 'fashioned' by the unfolding of this journey into inwardness? Here, in figuring the reader within the narrative, the episode allows one last twist of the uncanny to appear. Led by Alma upwards into the human brain, after their disturbing encounter with themselves, the knights enter a series of rooms, which correspond to the three higher faculties of the soul: imagination, reason, and memory. In the chamber of memory ('th'hindmost of thre') they meet the 'man of infinite remembrance'. This Borgesian figure, Eumnestes, is accompanied by his assistant, Anamnestes, a figure of forgetting. Wondering at his library, the knights see two books 'Briton Moniments' and the 'Antiquitie of Faerie Lond' (FQ II.ix.59). In the final stanza of the canto, 'Burning with fervent fire', they begin reading and, in this final image, the cycle of reflections is completed to embrace the reader of The Faerie Queene. In the following canto, the contents of these texts located within the House of Alma are displayed as part of the text of The Faerie Queene. The poem itself, then, does not only exist in the exterior world, but also in the mediation between memory (Eumnestes) and forgetting (Anamnestes) – a variation on the familiar Platonic idea that all knowledge is but a memory of what had once been known but is now forgotten. Spenser's reader is reading an account of what the knights are reading which is itself located within themselves. This dizzying mise en abîme or illusion of infinite regress, located within the interior world of the human mind, is a reflection of the process of fashioning through reading which Spenser's letter to Raleigh explained as being the design of the whole endeavour.[58]

But is such an interpretation of 'The House of Alma' consonant in any way with the sixteenth- and seventeenth-century reader's experience of the

text? If the text's purpose was to 'fashion' a reader and, in this process of fashioning teach him or her that there is nothing 'natural' about human nature or the powers of the mind, then where would we uncover evidence for the awareness of such a purpose, let alone its realization? Or are we to understand that *The Faerie Queene* has waited first for Descartes's discovery of the alieneity of the human subject – an alieneity which is so delicately constructed within the House of Alma – and then for Freud's moment of revelation of the 'unheimlich' nature of the body?

Appropriately enough, it was an anatomist, very soon after the publication of the great folio edition of Spenser's collected works in 1611, who realized the implications of Spenser's account of the inward nature of both body and mind as a construction. When, in 1615, Helkiah Crooke's anatomical textbook *Microcosmographia* appeared, English readers had before them a synthesis of both ancient and modern accounts of the structure, appearance, and function of the human body. Crooke's work also contained the all-important Vesalian and post-Vesalian illustrations which had created a new standard by which to measure the representation of the human frame. Crooke, who had studied in Leiden, where he took his medical degree in 1597, was well versed (as we have seen) in the Delphic tradition of 'moral anatomy' as it was to be found in the Leiden anatomy theatre. Not surprisingly, therefore, his text book was laced with references to the spiritual dimensions of anatomy – dimensions which were still visible in Rembrandt's painting of 1632.

But as the reader worked through *Microcosmographia*, watching the progressive dismantling of the human frame, an alternative and shadowy presence began to make itself felt. For, although *Microcosmographia* relies almost completely on the work of continental anatomical sources, it is also a text within which can be glimpsed Spenser's vision of self-reflection, culled from Crooke's reading of *The Faerie Queene*. So, in the preface to the twelfth book of *Microcosmographia*, Crooke surveys the whole project upon which he had embarked:

> Our Webbe now weares neare the threds. The glory and beauty of this stately mansion of the *Soule* we declared in the first Booke. The outward walles we dismantled in the second. The cooke-roomes & Sculleries with all the houses of office and roomes of repast we survayed in the thirde. The geniall Bed and Nursery we viewed in the fourth and fift. In the sixt we were ledde into the riche parlour of pleasure wherein we were entertained by a bevy of Damzels, one *Modest* as modesty itselfe, another *Shamefaste*, another *Coy*, another *Jocund* and merry, another *Sad* and lumpish, and a world of such *Passions* we found inhabiting in the little world. . . . From thence we ascended in the seaventh booke, by staires of Ivory into the presence chamber, where the Soule maketh her chief abode; there we saw the counsell gathered, the records opened, and

dispatches made and signed for the good government of the whole family. . . . Now we are arrived near the principals of the building, where we may see how they are joined, how they are fastened, and bound together, how they are coverd and defended. . . and finally in the next and last booke wee shall with God to friend come unto the principals themselves and to the very foundation and groundworke whereon the whole frame is raised.[59]

'Now gins this goodly frame of Temperance/Fairely to rise' Spenser had written at the opening of the Bower of Blisse episode (*FQ* II.xii.1). For Crooke, just as for Spenser, the body-building, traversed through that Renaissance delight in *allegoria*, contained a complex economy of functions – a distribution of government throughout the whole edifice which was also the morally and spiritually 'temperate' individual who was to be 'fashioned' by the poem, and surveyed by the anatomist. The equivalence of this passage from Crooke's anatomical text with Donne's wandering through the great cellars and vaults of the human fabric in his sermon is clear. But where Donne's passage encountered only volume and concavity – a sequence of empty spaces – Crooke's world is peopled with a consort of inhabitants: the 'passions', ruled over by the queen of the whole mansion, the soul. To a seventeenth-century reader, however, the echoes would have been unmistakable. Reading Crooke's account of the body, they would also have recognized the stately passage of Spenserian stanzas over the text.

Crooke's allegorical transformation of the body echoes in almost every detail the 'House of Alma' passage of *The Faerie Queene*, which had first appeared in 1590, and then had been republished in 1596, 1609, and 1611. Crooke, in his dismantling of the body, followed the 'order of dissection' (moving from stomach, to thorax, to head) which is also the order followed by Spenser's knights, Arthur and Guyon, as they move through the body which is also a castle. Linguistic parallels between the two texts mirror the structural similarity. Thus, Guyon and Arthur pass from a 'kitchen-rowme' (II.ix.28) into the 'goodly parlour' of the heart (II.ix.33), just as Crooke led the reader through the 'cooke-roomes' into the 'riche parlour' of the passions. Within the heart, the 'lovely bevy of faire Ladies' bear a passing resemblance to Crooke's 'bevy of Damzels'. In Spenser's castle of Alma, as we have seen, can be found '*Shamefastnesse* it selfe' (II.ix.43) a figure whom Crooke splits into two individuals: 'Modest as modesty itselfe' and 'another Shamefaste'. Reading Crooke's description, it is as if the anatomist had an opened copy of *The Faerie Queene* in front of him rather than either an anatomical text or a cadaver, a suspicion which is confirmed on turning back to Book II of *Microcosmographia* ('Of the Whole Bodie and Lower Belly'), where Crooke quotes the famous arithmetic stanza of Spenser's poem (II.ix.22) as a preface to the anatomical journey he is inviting the reader to undertake:

> The Frame thereof seemd partly circulare,
> And part triangulare, O work divine;
> These two the first and last proportions are,
> The one imperfect, mortall, foeminine;
> Th'other immortall, perfect, masculine,
> And twixt them both a quadrate was the base,
> Proportioned equally by seven and nine;
> Nine was the circle set in heavens place,
> All which compacted made a goodly diapase.
>
> <div align="right">(FQ II.ix 22)</div>

By quoting this stanza in particular, Crooke was explicitly inviting the reader of his anatomical text to make a comparison between it and *The Faerie Queene*. But to what end? Ever since Sir Kenelm Digby's attempt at interpretation of this stanza, in 1644, its geometric intricacies have puzzled Spenser's readers.[60] But, for Digby, writing within a Cartesian frame of reference, the 'meaning' of the stanza seemed clear. Expressed in the opposition of geometric figures, perfection and imperfection, mortality and immortality, male and female, was the Cartesian riddle of:

> the joyning together of the two *different* and indeed *opposite* substances in Man, to make one perfect compound; the *Soul* and the *Body*, which are of so contrary a nature, that their *uniting* seems to be a miracle.[61]

Digby's 1644 reading of the stanza pointed to something else as well. For it was Digby who noted that, at this point in *The Faerie Queene*, Spenser's poetic method seems to have gone mysteriously awry. In Digby's words:

> In this Staffe [stanza] the Author seemes to me to proceed in a different manner from what he doth elsewhere generally through his whole book. For in other places, although the beginning of his Allegory or mystical sense, may be obscure, yet in the process of it, he doth himself declare his own conceptions in such sort as they are obvious to any ordinarie capacitie: But in this [stanza], he seemes onely to glance at the profoundest notions that any science can deliver us, and then on a sudden (as it were) recalling himself out of an Enthusiasme, he returns to the gentle Relation of the Allegorical history he had begun, leaving his readers to wander up and down in much obscuritie.[62]

In Digby's account, the arithmetic stanza seems to disrupt the smooth onward unfolding of what Spenser termed (in his letter to Raleigh of 1589) the 'darke Conceit' of the poem, ushering the reader into a realm which has suddenly become unconnected from the easy transaction between surface and depth which the reader had been negotiating as the allegory was pushed forwards. Like Arthur and Guyon in the House of Alma, the reader is left 'to wander up and down in much obscuritie'.

It was this sense of unfamiliarity that the English anatomist, Helkiah

Crooke, sought to evoke in quoting this stanza as a preface to his anatomical journey. In Spenser's 'House of Alma', the shock of the unfamiliar is a feature of the 'uncanny' world which the knights have encountered as they move through the body-structure. As their journey takes them through ever more artificial constructions, so their sense of wonderment grows. The joke, of course, is that what they are gazing at is themselves – an idealized version of what they seek to aspire towards. But such a journey into the body and (for Spenser) into the mind was only possible before Descartes's explorations among the slaughtered animals and criminal bodies of Amsterdam which Rembrandt was to paint. After Descartes, body and mind would appear to exist in universes which, closely adjacent as they were, ran parallel to one another. Spenser's view of the matter was that there was no real distinction between body and mind, since, as he imagined his knights discovering in their journey through themselves, both body and mind could be particularized – a view to which Robert Burton was to subscribe in *The Anatomy of Melancholy*.[63] The mind, too, could exhibit itself on the surface of the individual's body (the blushes of confusion experienced by the knights) in ways which were uncontrollable by the human subject. The best that could be hoped for, in order to maintain the social fabric of identity, was concealment. Like Descartes, however, Spenser glimpsed that the key to understanding the inner world was in the abstracted gaze of self-reflection. The product of that process (and again Descartes comes to mind) was not, however, foreseeable. For Descartes, the outcome was the creation of a machine-body, existing as parts, and an intellectual faculty which could never be divided. But, for Spenser (who, like Descartes, had seen enough bodies torn into pieces in the brutal mechanism of government, within which he was a not altogether insignificant instrument), the necessity of mental division lay at the root of his design. How else was the social being to be fashioned in 'vertuous and gentle discipline'? In an attempt at breaking down that mental structure, in order to remould it through the circulating devices of allegory, Spenser created a text which was itself fashioned out of visions of dislocation and dissociation: mirrors of social identity and selfhood. After Freud, it would be possible to put a name to this flight of the imagination into its own internal mechanisms – neurosis, or even schizophrenia. But, whatever label we wish to attach to the inward journey of Spenser's knights, the result was the same: the human subject had encountered the 'other' not in some external and as yet undiscovered region, but nestled uncomfortably within its own deepest recesses.

THE SOMATIC EPIC OF PHINEAS FLETCHER

In 1633, in the year following Rembrandt's depiction of two bodies moved by one intellect, Phineas Fletcher's *The Purple Island* was published. Fletcher's

text chronologically bridges the divide we have been tracing between the pre-Cartesian exploration of identity in *The Faerie Queene*, and the post-Cartesian creation of the body as irredeemably 'other' to the thinking faculty. But *The Purple Island* is a text which missed its moment. By an irony of literary history, Fletcher's poetic account of the integration of body and soul was a victim of the Cartesian disjunction between mind and body. After Descartes (and before Freud and Joyce) who would care to invest so much effort in creating such a somatic epic? In twelve cantos of between thirty and ninety stanzas each, Fletcher undertook to divide the human body with all the attention to detail that can be found elsewhere only in the anatomical textbooks of the period. That poetry could no longer perform such a task – that poetry was no longer considered the proper vehicle for such a task – has been axiomatic in most attempts at understanding the poem since the seventeenth century. Poetry, now, belonged to the realm of the 'Phancie' or 'Phantasy' (later, the 'Imagination'); the body was the preserve of a science which jealously policed its own borders. Rembrandt's second anatomy painting of 1656 is emblematic of this cleavage between the discourses of reason and imagination. If we see the painting as a translation of Mantegna's lamentation over the body of Christ, then its eviscerated, hollow, core, and the probing figures which reach into the sutures of the brain, speak of a wholly new understanding of embodiment. Mystery may still have been the preserve of poetry, but explication belonged, now, to a different order of discourse. How, then, could a text such as Fletcher's be read (let alone replicated)?

So, Fletcher's poem has been held to exist as a 'strange' object which lies outside the paradigms by which a 'Renaissance poetic' has been constructed. Despite Joyce's admiration for Fletcher's epic of the human body, few other nineteenth- or twentieth-century readers shared his enthusiasm. Fletcher's poem was to be described as 'the strangest' poem in existence, an 'incongruous dragon of allegory', a 'strange anatomical ditty' which expresses a 'theme of unusual ugliness and aridity'.[64] In 1912, H. E. Cory wrote of the Spenserian poets in general (and Fletcher in particular) that they had produced 'strange perverted works', which betrayed the hand of 'curious, half-diseased, half-divine poets'.[65] This is not, simply, the forceful voice of evaluative criticism before the advent of Leavis and Richards. Fletcher's work, instead, seems to have struck (appropriately) some sort of nerve, a nerve which Joyce and the advent of modernism were to probe even more deeply when *Ulysses* appeared. Indeed, early twentieth-century views of *The Purple Island* are echoed in the earliest responses to the publication of *Ulysses* in February 1922. Virginia Woolf's famously misguided comments to T. S. Eliot on *Ulysses* ('underbred . . . the book of a self-taught working man . . . a queasy undergraduate scratching his pimples') are almost precisely those which were attached to *The Purple Island*.[66] Fletcher's work was equally

'untaught' since, *de facto*, to write of the science of the body in poetry was to misunderstand 'science' – a product of reason rather than imagination. For Edmund Gosse, in 1894, Fletcher's work was 'ugly', though it was also 'ingenious, cleverly sustained, and adorned as tastefully as such an unseemly theme can be by the embroideries of imaginative writing. . . a work which resembles none other in our language'.[67] Thirty years later, in 1924, Sir Edmund (as he had become) was to describe *Ulysses* as having 'no parallel . . . an anarchical production, infamous in taste, in style, in everything'.[68]

Woolf and Gosse were both responding to the materiality of *Ulysses*, its determination to give the body its due. Joyce had described his endeavour (to Carlo Linati) as 'the epic of two races . . . and at the same time the cycle of the human body'. *Ulysses* (Joyce continued) was to be understood as a 'kind of encyclopedia' where 'every hour, every organ, every art' was 'interconnected and interrelated in the somatic scheme of the whole'.[69] Insistence on a 'somatic scheme' infuriated the world inhabited by Gosse and Woolf – two otherwise unlikely companions-in-arms. The point was that, in drawing such attention to the body's material existence, the canons of civilized enquiry had been violated. Of course, it was one thing to investigate the body in the scientific sense. But to celebrate the body in all its physicality (one which went beyond mere sex) was more than could be stomached. In this respect, early attempts at the suppression of *Ulysses* may be understood as part of a long tradition of post-Cartesian thinking. If the body was 'other', the source of that which Freud described as 'unheimlich', the remnant, for Descartes, of a deviant 'will', the *locus* of the grotesque, a challenge to the cool, reserved space of classical forms, then, of course, it had to be expelled. But Fletcher's earlier epic, though it undoubtedly set out to police the contours and the interior of the body, in much the same way that 'science' was to embark upon a similar act of surveillance, also looked back to the harmony of body and soul which the old metaphors of correspondence had once traced. In this sense, *The Purple Island* was the very last gasp of the old mentality, a mentality which was not to be seen again until Freud and Joyce turned inwards once more.

The unlikely conjunction between the early-modern somatic epic of Fletcher and Joyce's *Ulysses* points to more than just a similarity in theme together with a hostile critical reception. As every reader of *Ulysses* knows (and many who have never read *Ulysses* at least know this of it), Joyce set the activity of the book in Dublin, on 16 June 1904: 'Bloomsday' as it was afterwards to be known. In choosing this date, Joyce, in Ellmann's words, was paying an elaborate tribute to his wife Nora, since this was the day upon which Joyce and Nora Barnacle enjoyed their first rendezvous – a walk at Ringsend. The day of 16 June 1904 became the day on which Stephen Dedalus and Leopold Bloom embarked upon their modern odyssey around

and through the city, with each hour of the day between dawn and dawn of the following day (as the Linati Schema made clear) organized around an elaborate system of colours, mythic figures, 'technic' (style), sciences and arts, meanings, symbols, and, of course, bodily organs.

In this blurring of 'reality' (a text which marks the first meeting of Joyce and Nora Barnacle) and 'artificiality' (the careful organization of various schemes), Joyce's text begins to appear as a Renaissance work. The complex organizing system of *Ulysses* (particularly in terms of chronology) would have appealed to any Renaissance poet, and especially a poet schooled in the equally elaborate episodic system of imagistic correspondence developed by Spenser. This is not surprising. If the complex numerical structures of Dante's *Divina Commedia* (which the young Joyce had claimed to be 'Europe's Epic') as much as Homeric epic gave birth to Joyce's text, it was (equally) Dante, Virgil, and Homer who structured Renaissance explorations in the genre. Thus, Renaissance epics tend to operate on a complex, but nevertheless logical, system of chronological patterning. Spenser's *The Faerie Queene* for example, had been devised (so Spenser told Raleigh) on a pattern which corresponds to the Faerie Queene's 'annual feast xii dayes, upon which xii severall dayes, the occasions of the xii severall adventures happened'.[70] No matter that this design was never executed, the point was that generic convention dictated that the epic should pattern itself around such a structure – or at least pretend to this kind of order. For Milton, who also incorporated Dantean patterns of numerology into the time-scheme of *Paradise Lost*, the 'unit' of time was the divine 'month' of 33 days (also the number of the years of Christ's life), which was computed from the Bible to record the time between the first exaltation of Christ and the expulsion from the garden of Eden.[71] In similar measure, scriptural time, as we have seen, patterned the chronological framework of Du Bartas's 'Divine Weeks' written in the hexameral tradition of the 'days' of creation.

James Joyce's various schema and plans for *Ulysses* are as complex as any Renaissance organization of epic. Taking seriously any of Joyce's comments about his work (particularly a comment which might lead to 'interpretation') is a risky undertaking but, if we accept the risk, then another point of congruence between Joyce and Fletcher emerges. Renaissance poets were fascinated by the *construction* of time in their epics, since time could be organized and reorganized to provide shifting levels of correspondent meaning which gestured towards other (usually scriptural) texts. More than this, 'time' – considered as the passage of epochs – was understood as, essentially, cyclical. The 'Mutabilitie Cantos' with which Spenser cut short *The Faerie Queene*, for example, imagined time as not a linear movement but a cycle of return. Linearity existed outside of historical time, in the unfolding of providential history which was held to be operating according to God's

divine plan. Human history, then, was understood as movement within the larger (and largely unknowable) unfolding of providential history. The Renaissance poet, and particularly the 'Poet historical' which is how Spenser described himself, had to reflect such patterns of time in the narrative that was under construction. As Spenser put it:

> For the Methode of a Poet historical is not such as an Historiographer. For an Historiographer discourseth of affayres orderly as they were donne, account-ing as well the times as the actions, but a poet thrusteth into the middest, even where it most concerneth him, and there recoursing to the thinges forepaste, and divining of thinges to come, maketh a pleasing Analysis of all.[72]

Spenser was, perhaps, over-stating the case in respect of the historiographer, but the point remained. The poet should organize the narrative so that it reflects or even replicates the patterns of time and history which were understood as flowing through human affairs.[73]

A very similar awareness of time is evident in *Ulysses*. The compressed chronology of the book occupies the single Dublin day of 16 June 1904. But each of the hours of that day (which unfold in a linear pattern) relates to the larger cyclical movement which begins and ends (for Telemachus/Stephen) at dawn. Later, in writing *Finnegans Wake*, Joyce was to admire 'Vico's positive divisions of human history into recurring cycles', so much so that 'Time' was to become one of the protagonists of that book.[74] But *Ulysses* also developed another structural principle. If Bloom and Stephen are moving through the chronology of a single Dublin day, they are also moving through a structure largely unknown to them, yet one which, like Dublin itself, is intensely familiar: the human body. Each hour of the day is also reserved for a different organ, the presence of which over-rides, as Ellmann describes it, 'the dichotomy of body and soul, to reveal their fundamental unity'.[75] According to the Linati schema, the narrative moves through kidneys, skin, heart, lungs, oesophagus, brain, blood, ear, muscles, bones, eye, nose, matrix/uterus, 'locomotor apparatus', skeleton, nerves, 'juices', to climax, in 'Penelope' with 'fat'.[76]

The Purple Island, as a progenitor (amongst many others) of *Ulysses*, can justifiably claim to be the one work which, in its dual pattern of time and the body, marks an equivalent attempt at over-riding any dichotomy between mind and body. The fictional date on which the poem takes place is as carefully marked as Bloomsday was to be. As the poem opens, a group of shepherds have met to elect one of their number, Thirsil, as their poetic spokesperson and May-Lord. This meeting, we are told, takes place on or about 21 May as the sun passes from Taurus to Gemini: 'The warmer sun the golden Bull outran,/And with the Twins made haste to inne and play' (*PI* I.1).[77] This May setting is underlined by Fletcher's dedicatory letter to

Edward Benlowes which is dated 1 May 1633.[78] The May setting – together with the allied evocation of spring and rebirth – addresses the poem's theme of regeneration and rebirth of the human personality within a protestant vision of salvation. But against the poem's spring – a mythic construction of literary fables of rebirth culled from Virgil, Spenser, and Du Bartas – is set the uncertain present. Fletcher's conception of human history was one tinged with nostalgic longing. The present was degenerate, a sad retreat not just from the golden world of pastoral myth, but (as the Spenserian poets in general complained) from recent providential history, in which England had (briefly) appeared to be a 'saved nation'. Increasingly alienated from the court, the Spenserians took Spenser himself as the symbol of virtue abused: 'all his hopes were crost, all suits deni'd;/Discourag'd, scorn'd, his writings vilifi'd' (*PI* I.19). This sense of retreat into the past – the re-creation of the gilded pastoral world – signals the poem's intervention in its own political moment.[79]

Politically the poem sets out to create the physical 'body' of England in the poem, which co-exists alongside the anatomized human body which is the ostensible subject matter. Just as Joyce was to describe *Ulysses* as an epic of 'two races' (the Irish and the Jews) and, at the same time, the 'cycle of the human body' – an oscillation between the macrocosm and the microcosm – so *The Purple Island* was to interfuse the providential salvation of England under James I, figured as the regeneration of the body-politic, with the regeneration of the soul and body in Christ. Thus, the Island which is also a body is safe as long as it has no dealings with the continent. Ignorance is also pre-lapsarian innocence:

> None knew the sea; (oh blessed ignorance!)
> None nam'd the stars, the North carres constant race,
> *Taurus* bright horns, or Fishes happy chance:
> *Astrea* yet chang'd not her name or place;
> Her ev'n-pois'd ballance heav'n yet never tri'd:
> None sought new coasts, nor forrain lands descri'd;
> But in their own they liv'd, and in their own they di'd.
>
> (*PI* I.51)

But such happiness is transitory:

> Witness this glorious Isle, which not content
> To be confin'd in bounds of happinesse,
> Would trie what e're is in the continent;
> And seek out ill, and search for wretchednese.
>
> (*PI* I.53)

This familiar complaint against human reason (one that echoes Sir John Davies's *Nosce Teipsum*, and was to be reworked in *Paradise Lost*) sits oddly

within a text that is largely intent on the explication of knowledge of the human body. Nevertheless, as a 'saved island', the body which is also England is an armed fortress. As Thomas Healy has noted, Fletcher's anatomy of the body is one that has constant recourse to an elaborate language of defence.[80] Each organ seems to crouch within encircling walls, moats, and structures which are designed to confuse 'invading enemies' (*PI* II.12) and, by implication, the eyes of prying anatomists.

This language of militant hostility towards the outside world – a hostility in which the body is created as a refuge – also represents the direct political programme of Fletcher's anatomy. The poem's ferocious protestantism is a continuation, in this respect, of Fletcher's violently anti-catholic poem *The Locusts* (1627) which looked back to the events of the Guy Fawkes conspiracy (1605) in order to warn the monarch of the 'Italianate', 'Jesuitical', power of Roman catholicism. In *The Locusts*, England was a floating (protestant) island, which contained the sole means of the whole world's salvation: the protestant church steered by Christ. Equally, the period of composition of *The Purple Island* (*c.* 1607–15), was a time of intense suspicion of all signs of catholicism both at home and abroad.[81] Moreover, when the poem was published, in 1633, Archbishop Laud had been installed as primate of the English church – an appointment which, for some, seemed to be a symbol of departure from the puritan ideal of the primitive church. We are, then, able to understand *The Purple Island* as a text schismatically riven by the contradictions of its politics. Its xenophobia, its retreat into castellated structures, its violent evocation at the very end of the poem of the late James I as a typological forerunner of the return of the armed Christ (*PI* XII.55) – all of these tropes and images are designed to evoke a sense of continuous vigilance against the supposedly encroaching forces of Roman catholicism. It is within this political moment that Fletcher elected to display the human body as a dismantled structure – a schizophrenic collection of fragments behind which the poet-narrator hides, terrified of the hostile exterior world.

Anatomical time in the poem is organized with all the precision of an early seventeenth-century anatomy demonstration. The order of dissection, however, is the Vesalian order rather than the practical order common amongst the anatomists themselves. Anatomical information is culled from a variety of continental sources: chiefly Vesalian and post-Vesalian *compendia* – an irony given the poem's distrust of all forms of knowledge derived from the continent.[82] So, the anatomy begins on the afternoon of the poem's first 'day' with a description of the bones, veins, arteries, and nerves (Canto II), and then moves on to the abdomen during the following morning (Canto III), the thorax on the second afternoon (Canto IV), and the head (Canto V) on the whole of the third day. This three-day structure, of course, mirrors the usual three-day structure of the Renaissance anatomy lesson. Each canto

describes the various anatomical features, transforming them, via simile and metaphor, into an extended allegory of the body, imagined as a world or community of interests given a precise geographical location. Following these anatomical cantos, the remaining four 'days' of the hexameral tradition are devoted to the war between sin and virtue for possession of the Island, a war that only ends on the seventh day with the return of the armed Christ and the marriage of the daughter of the ruler of the Island to her prince. The ruler is the intellect, whilst the daughter is Eclecta – the English church – and the prince is James I.

Described thus, the poem seems to refer us back to the old patterns of microcosmic replication, or the didactic tradition transmitted by the contemporaries of Davies of Hereford. Here, it seems, is poetry in retreat before science – a Baroque poetico-political fantasy which was to be made redundant with the post-Harveian dedication to mechanical structure. But what of the elaborate scholia – the marginalia which cluster around the poetic text as a validation or authentication of the flights of poetic fantasy? It is as if the poem has arrived complete with its own interpretation based on the spare observations of the new scientist: the Baconian philosopher intent on prying into the infinite recesses of Nature. Denying the validity of human knowledge, the poem represents itself as nevertheless anchored to the new systems of knowledge which were being revealed in the anatomy theatres. Dedicated to a theological regime of austere, xenophobic, puritanism, *The Purple Island* also exists as one of the most extravagant fantasies of poetic transformation to appear during the seventeenth century. Little wonder that modern readers have recoiled before the poem in bewilderment.

We can only understand Fletcher's text (and all its contradictions) once it is replaced within the 'culture of dissection' out of which it grew. Within that culture, the human form was, indeed, the ultimate source of knowledge, since, as a created entity, it existed as the 'portrait' of God. Central to the body's significance in the divine plan was the doctrine of the incarnation, the willingness of the *logos* to become 'flesh' (John I.14). The central mystery of the poem, then, was in its depiction of the dissected shell of the body as providing a medium with which to understand the creative intent of God. The poet-anatomist was thus a guide through the bewildering mazes of the human form. Even when (or, rather, especially when) the body had been reduced to a scattering of decomposed parts, the divine footprints could be traced:

> That mighty hand in these dissected wreathes,
> (Where moves our sunne) his thrones fair picture gives;
> The pattern breathless, but the picture breathes;
> His highest heav'n is dead, our low heav'n lives:

177

Nor scorns that loftie one thus low to dwell;
Here his best starres he sets, and glorious cell;
And fills with saintly spirits, so turns to heav'n from hell.

(PI IV.9)

This pre-Harveian understanding of the heart's operation within the body is determined by theology rather than anatomy. God has created an image of his throne within the fractured space of the human body which (even when dead or 'breathless') is still able to persuade the onlooker of the truth of the vision of creation. In order for this 'low heav'n' to live immortally, the 'highest heav'n', which is the incarnate Christ, must die. In other words, Fletcher had adopted the moral design of the Renaissance anatomy theatre – the optimistic rather than pessimistic lesson in immortality which the Leiden illustrations demonstrated – in order to explicate the incarnation. In poetic terms, the poem has offered a 'breathing' picture of this mystery, an adaptation of the familiar Renaissance theoretical understanding of poetry, culled from the *Ars Poetica* of Horace, of creating a 'speaking picture'.[83]

In more ways than one, however, *The Purple Island* sought to create a speaking picture. A great deal of the critical attention which has been devoted to Fletcher's epic has concentrated on the poem's dense surrounding and supporting display of anatomical information in the elaborate marginal notes. Is Fletcher's anatomy 'correct'? Did he, in any way, anticipate Harvey? Where did he gather his anatomical knowledge?[84] Less charitably, the juxtaposition of the transformation of the body via allegory with the elaborate apparatus of footnotes, has led to the view that here is pedantry of the very worst kind: a poetic which, in an orgy of self-congratulation, displays its own scholarship, whilst undercutting the reader's task of unravelling the elaborate allegory which has been constructed.

Looking at any page of *The Purple Island* (particularly in its seventeenth-century format) it is as if, facing one another, are two entirely discrete discourses. To say of the 'scientific' marginalia that they 'support' or 'authorize' the 'poetic' fabric is to take only one step towards interpreting the relationship between the two. The relationship between the central and the marginal has become one of the fascinated objects of contemporary literary theory.[85] And it is a theoretical paradigm – an oscillation between a 'closed' text and an 'open' text – which helps us to understand the structural 'double-text' which is *The Purple Island*. The elaborate marginalia of Fletcher's poem correspond to the deployment of such glosses and notes in the production of scriptural texts, a development which can be traced back to the twelfth century.[86] But, equally, two discourses – the poetic and the scientific – seem to oppose one another over the page, as though a moment of transition in the history of discourse were on display. That moment is the

point at which science and poetry finally struggle free of one another, with the 'marginal' text appearing as a proto-scientific descriptive narrative in its own right, whilst the 'central' poetic text is the remnant of a 'pre-scientific' view of the world bounded by the theology of the microcosm. The object over which these two texts wrestle with one another is the human body, subjected to two different forms of understanding. In one form, the intricacies of allegory structure the understanding whilst, in the 'new' form, Baconian reason has shrugged itself free of the circulating enclosure of correspondence.

Such a view of the poem takes us closer to the design of *The Purple Island*, but it makes of it a text which is almost uncannily prescient of empirical science. In terms of seventeenth-century poetic theory, however, Fletcher's design was quite clear. Poetry, Sidney had written in the most frequently cited passage of the *Apology*, is an 'art of imitation', an attempt at re-creating or refashioning the objects which are to be found in nature: 'for so Aristotle termeth it in his word *mimesis*, that is to say, a representing, counterfeiting, or figuring forth – to speak metaphorically a speaking picture – with this end, to teach and delight.'[87] Or, as Julius Caesar Scaliger phrased it in his *Poetices* (1617): 'Poetry and the other arts represent things as they are, as a picture to the ear.'[88] This theory of imitation was endlessly rehearsed in Renaissance poetic treatises. Not surprisingly, *The Purple Island* conforms to this theoretical programme. It provides, literally, a 'picture to the ear', but a picture which is derived from the anatomical illustrations that were now appearing in the beautiful (and costly) anatomic textbooks of the age. These illustrations, as we have seen, sought to achieve more than just specific understanding of the structure of the human frame. Rather, they spoke of the divine order of the universe as it could be seen represented or imitated in the body. Hence, Fletcher's stress on 'pattern' and 'picture'. For the body is the 'pattern' (in the sense of a replicated object, rather than in the sense of an original) which his poetry will reproduce in the 'picture' that it gives the ear. Even in terms of typographic lay-out, the poem reproduces this central component of Renaissance poetic theory. Just as we have seen anatomy developing a complex system of relating text and image on the page – anchoring the visually reproduced body to the written word via 'keying' mechanisms – so *The Purple Island* has compartmentalized knowledge. The poetic body – the visual image – speaks in the eloquent language of gesture via metaphors, similes, and the devices of figurative language. This language is then harmonized with the revealed knowledge of the human form pursued in the anatomy theatre. What tends to appear to us as a struggle between two discourses should more properly be understood as an attempt at synthesis. Recalling the emblematic status of the body within the anatomy theatre – a body which, despite its criminal associations, also speaks of the

divine – we can see how Fletcher has re-created within poetry the complete design of both the anatomy theatre and the anatomy textbook.

The Purple Island is, then, one of the last examples of 'sacred anatomy' – a system which was to collapse before the Cartesian construction of the mechanical body. What, though, of the strangeness of the body, its 'unheimlich' nature, as it was encountered by Spenser's knights as they voyaged into the House of Alma? Here, a further series of parallels circulating within the culture of dissection can be glimpsed. We have already seen how the body could be reproduced as part of that emerging discourse of colonization and appropriation which, in the early years of the seventeenth century, was becoming a political reality. These were the years, too, during which Fletcher's poem was taking shape. At the same time, a series of works were now being published which sought to marry the form of the 'voyage narrative' – a feature of early colonizing discourses – with the prospect of the interior journey into the body.[89] One of the devices which these narratives deployed was the creation of the human body as a strange or unknown geography. Joseph Hall's *Mundus alter et Idem* (1606), for example, which was translated and published as *The Discoverie of a Newe World* (*c.* 1608), announced itself as: 'a discoverie and no discoverie, of a world and no world, both knowne and unknowne, by a traveller that never travelled'.[90] Hall's work took the form of a voyage into a strange and sinister land of allegorical mystification – a region of misshaped and grotesque human forms which inhabited the internalized region of the human body. *The Purple Island,* too, located itself within this language of discovery and strangeness. Thus, the poet-narrator, Thirsil, opens his poetic anatomization by describing the island–body as 'A place too seldome view'd, yet still in view;/ . . . A forrain home, a strange, though native coast' (*PI* I.34). Set against the restless colonization of the New World, the island is an antidote to the search for 'farre distant worlds' (*PI* I. 38) of European discovery and conquest, a return into the uncanny 'familiar' into which the Spenserian knights had once fled.

This creation of the body as the uncanny familiar may be understood as the direct creation of the anatomical gaze into the interior world of the body. Here is the last of the many paradoxes which structured the encounter with the human form in the seventeenth-century. For, even as *The Purple Island* was announcing the essential harmony of the christian scheme of redemption and salvation with the revelation of the body as a new entity, that same body was being reconstructed in a way which would make it appear stranger still. If *The Purple Island* of Phineas Fletcher represented an attempt at introducing the scientific body into the fabric of poetic imitation, it was an attempt that ended in failure. By the time Fletcher's wonderfully ornate structure had appeared, the anatomists of the seventeenth century believed that they had found, at last, the key to the conquest of the Medusa's gaze.

We have already seen Descartes and Rembrandt probing with their respective techniques the interior space of the body and announcing that the body was stranger than could ever have been imagined by the allegorists. Their discovery was that the body was entirely silent. Unlike the communities of the body to be found within Spenser's or Fletcher's narratives, the body could not speak since it had no faculty of speech. Rationality lay elsewhere. Severed in two, the body was abandoned to the mechanical universe. Of course, the body was still beautiful, but its interior beauty now had all the charms of an abandoned ruin rather than a sacred temple. Many years after Fletcher's attempt at harmonizing science and religion, and long after Descartes's mechanical body had come into being, the English anatomist Walter Charleton was to revisit the body as though it were a gigantic gothic structure, a site of wonder reared by previous ages which now appeared as though it was the architectural creation of a vanished race of giants, a place of abandoned ritual which was undoubtedly impressive, but also somehow excessive, even barbaric. Thus, the body was a massive and empty monument rather than a community such as Spenser or Fletcher had imagined it to be. Looking at the brain, for example, Charleton wrote:

> Who can look into the Sanctum Sanctorum of this Temple, the Brain, and therein contemplate the pillars that support it, the arch'd roof that covers and defends it, the fret-work of the ceiling, the double membrane that invests it, the resplendent partition that divides, the four vaulted cells that drain away impurities, the intricate labyrinths of arteries.[91]

But there Charleton, the admiring tourist, stopped. This was the body as it had once been understood: an opulent mansion or dwelling-place. For all his admiration of this architectural structure, Charleton understood the body as something entirely different. It was no more, after all, than a 'wonderful engine', designed and constructed according to mechanical principles: 'a system of innumerable smaller engines, by infinite wisdom fram'd and compacted into one most beautiful greater automaton'.[92] The body (as Descartes had predicted) should properly be understood as no more than a machine. We have returned to the anatomy studios in which Descartes and Rembrandt sharpened their gaze. Appropriately, it was a Dutch anatomist, Isbrand de Diemerbroeck, professor of anatomy at the University of Utrecht, who pronounced the obsequies over the fashioned body created in Renaissance poetry. Anatomy, he wrote in 1672, was now 'the common practice of all men', the universal mechanical science, the 'Eye of all solid knowledge whatsoever'.[93] But this 'common practice' was not the practice in which Fletcher had delighted. From this point onwards, the body was to be the exclusive preserve of scientists dedicated to the mechanical

exploration of the interior volume. Not until Freud and Joyce, in our own century, was the legacy of mechanism to be challenged.

At this point we need to shift the emphasis of our enquiry away from the body to the act of display. If we now know something of the complex investment in meaning which centred on the anatomical division of the body in early-modern culture, then what happens if we cease to think about 'the body' as an entity possessing neither gender nor identity? What has been implicit throughout this account so far is that the practice of anatomy in early-modern culture is an activity in which the chief participants are men: judges, executioners, anatomists, and (for the most part) spectators were all male. More often than not, the bodies into which they gazed were also male. But we have also seen how the subject of that gaze – who was also represented as participating in the process of division – was not infrequently female. Is the culture of dissection, therefore, an exclusively male activity? If it was, then what do we learn by replacing a specifically female body into the theatre of division alongside the textual female body? This dense super-structure of representation took place over the bodies of *people* who, normally, had suffered violent death. People, of course, are not just bodies: they possess webs of identity which are (at least in part) a function of a further binary division into men and women. In peering into the recesses of the human form, the anatomist was confronted at every turn with the remnants of this human difference, and it is the nature of that difference that concerns us in the remainder of this book.

7

THE REALM OF *ANATOMIA*

Dissecting people

MYTHS OF DIVISION AND ORIGIN

Anatomia was a woman. We have already seen her allegorized and enthroned
on the title-page of Julius Casserius' *Tabulae anatomicae* of 1627 (Figure 7),
where she sits flanked by *Diligentia* and *Ingenium*, holding a mirror and a
skull: an elaboration on the traditional *vanitas* figure. In the engraving of
the Leiden anatomy theatre, *Anatomia* is present in the guise of the two
women who have visited the theatre, one of whom carries a plumed mirror,
whilst the other surveys a flayed human skin (Figure 5). Much later, in the
seventeenth century, we see her at work on her art on the title-page of
Theodor Kerckring's *Spicilegium anatomicum* (Amsterdam, 1670) (Figure
22). As she flays a suspended male figure, *putti* offer her scythed corn, as
though attempting to distract her from her business.[1] Pausing only to note
their offerings, flaying knife in hand, she continues with her task of revealing
the inner man – preferring the role of goddess of knowledge to that of *Ceres*,
goddess of fertility. On the title-page of Govard Bidloo's *Anatomia humani
corporis* of 1685, *Anatomia* is revealed by Time, who draws back the curtain to
show her enthroned, once more, and holding a scalpel, as Fame celebrates
her prowess, and her assistants (three small *putti*) study a skull, a dissected
arm, and an anatomical engraving.[2]

The attributes of *Anatomia* – the knife and the mirror – return us to the
Medusa myth, and that structure of reflective glances and reductive instru-
ments associated with the donations of Athene and Hermes to Perseus –
the hunter of the Medusa. The title-page of Casserius' *Tabulae anatomicae*
(Figure 7) indicates the extent to which *Anatomia*, emblematically, inherited
the attributes of Athene. The mirror which she balances on her knee allows
the onlooker to see the skull, in just the same way that Perseus could see
(and defeat) the Medusa with the help of Athene's polished shield. Like a
personification of Justice, *Anatomia* stands equipoised, a scalpel in lieu of a
sword, fulfilling her role in the anatomy theatre as an extension of the Law.

But, as we have also seen in the writings of Gascoigne, Donne, Nashe, Davies of Hereford, and Lovelace, *Anatomia* was also a mistress of erotic reduction – a fantasy expression of male surrender – whose chief attribute was the power to divide. As such, she may be associated with other Renaissance figures of division – all of them female once more – who are invocations of doubleness: Cowley's *Alecto*, in his abandoned epic *The Civil War*, or Spenser's *Ate* in *The Faerie Queene*. The function of both *Alecto* and *Ate* was the ability to cause a bifurcation or dissection of entities which were once whole and united. So, *Anatomia*'s origins were doubled. She was, on the one hand, a figure whose ancestry might be traced back to benign images of justice, prudence, and wisdom – goddesses associated with Apollo, the god of clear sight, and Hermes, the god of understanding, interpretation, and healing. The association of *Anatomia* with Apollo, however, alerts us to her icono-logical role in her darker form, as the deity of reductive division; it was Apollo who punished the satyr Marsyas by flaying him – a story made familiar in the Renaissance by Ovid (*Metamorphosis* VI.384–5). In her darker form, too, she was associated with the fury *Alecto*, daughter of Zeus in the *Aeneid* (VIII.323ff.) who appears in the *Iliad* (XIX.91–4) as *Ate* – a dream-inducing and protean figure.

This ancestry of *Anatomia* – with its negative and positive aspects – seems to express the ambivalent status of anatomy in early-modern culture that we have already explored through images, rituals, architecture, and literary texts. At which point, though, did the female deity *Anatomia* become separated from a male progenitor? As recounted in Hesiod, the first anatomy was also a birth: Hermes split open the head of Zeus to release Athene.[3] But it was surely Jove/Jahweh/Zeus (as Renaissance commentators remind us) who performed the first anatomical division of the human creature in order, paradoxically, to create anatomical difference. In Plato's *Symposium* we read that the founding moment of all difference, the creation of the attraction of both opposites and similarities, originated in the divine anatomical separa-tion performed by Zeus in exasperation at the insolence of humanity which was originally a tri-sexed and spherical species. Zeus, as Aristophanes re-counts, found a means of preserving the human race by making them weaker: 'I will cut each of them in two . . . they shall walk upright on two legs. If there is any sign of wantonness in them after that, and they will not keep quiet, I will bisect them again, and they shall hop on one leg.'[4]

But, of course, Zeus never went that far, contenting himself with a bisection assisted by Apollo who positioned the face of the newly formed creature so that 'having the evidence of the bisection before his eyes he [sic] might behave better in future'. Was this the first moral anatomical demon-stration? Certainly, it was the first encounter with that other 'half' which was to haunt the European literary imagination in the Renaissance. The

Aristophanic fable, interpreted with the help of christian Neoplatonic exegesis, became a key text of origin to Renaissance commentators; a narrative of division in which could be located the origin of sexual difference.[5] In the judaeo-christian tradition, too, *Anatomia* as a function of the deity's creative power makes a fleeting appearance at the moment of human sexual origin. As the story was told in Genesis, God's first intervention in the life of his human creature was the act of separation by which the body was opened, its integrity disturbed, in order to produce sexual difference. As Mieke Bal has persuasively argued, it is important to realize that the creation of sexual difference in Genesis does not of necessity need us to posit the priority of male over female. The first body, that of *ha-'adam* was 'unique and undivided . . . the body of the earth creature'.[6] Possessing no mark of sexual differentiation, *ha-'adam* waited for sexuality to be conferred on it through its maker's intervention:

> it is the tension between the *same* and the *different* that creates sexuality. The earth-being has to be severed, separated from part of itself in order for the 'other half' of what will then be left to come into existence.[7]

In Bal's account of the origin of sexual differentiation, as it was told in the Genesis myth, we can trace the shadowy outlines of a series of chronologically later, interlocking stories of separation and division. The creature which waited in a trance-like state (akin to Christ before the Resurrection), had to be 'separated from part of itself' by Jahweh, a division which allowed it to live and witness its own separation. This separation 'from part of itself' was echoed in Ovid's version of the Marsyas myth, at the point when Apollo's flaying prompted the satyr's agonized cry: 'Quid me mihi detrahis?' – a phrase which may be translated as 'Who is it that tears me from myself?'

The story of the punishment of Marsyas is easily understood as a tale of both separation and origin. The attraction of the Marsyas myth for Renaissance artists lay not only in the scope it afforded for exploring the human figure in anatomically explicit contortions, but in its affinity with Dionysian ordeals, reinterpreted within a scriptural framework, which could then be understood as a paradigm of the artist's own self-figuration. The duel between Marsyas and Apollo was, after all, a test of skill – *techne* – in which each strove to outdo the other in the production of art. Marsyas, having lost to the superior *techne* of Apollo, was then transformed into the matter of art. But, as Edgar Wind has observed, the story also expressed the process 'by which the terrestrial Marsyas was tortured so that the heavenly Apollo might be crowned'.[8] Understood thus, the Marsyas story can be related to christian agonies of the passion – the torture of the mortal God who was then reborn in his divinity. Titian's *Flaying of Marsyas* (*c.* 1570–5), now in the Archiepiscopal palace at Kremsier, is the most famous painterly rendition of the

story which has come down to us. But the theme was attempted by Guilio Romano (*c.* 1526), Raphael in his fresco in the Stanza della Segnatura in the Vatican (c. 1510), and Melchior Meier (c. 1581).

As Arthur Golding retold the Marsyas myth in his 1567 translation of Ovid, the agony of living anatomical reduction was evoked in all its horror:

> For all his crying ore his eares quight pulled was his skin.
> Nought else he was than one whole wounde. The griesly bloud did spin
> From every part, his sinewes lay discovered to the eye,
> The quivering veynes without a skin lay beating nakedly.
> The panting bowels in his bulke ye might have numbred well,
> And in his brest the shere small strings a man might tell.[9]

The horror of this passage is also suffused with a frisson of the erotic, which jostles uncomfortably with an emerging discourse of scientific exploration. Science informs the discovery, the numbering, and the telling (recording) of the body's organs. But the body is also caught in a moment of violent homoerotic possession; stripped of his skin, Marsyas is transformed into 'one whole wound', into which curious spectators gaze. Organic features – veins, bowels, sinews – are 'quivering', 'beating nakedly', and 'panting'. This is a fantasy of anatomical separation – a vivisection which lays open the still functioning body in order to possess its core.

The function of such a representation within the discourses of judgement, sentencing, and execution is clear: first comes the trial of Marsyas, then the sentence, then the ordeal itself.[10] Its manifestation in the anatomy theatre was equally evident. In the interior view of the Leiden anatomy theatre, a female figure gestures in benediction over a flayed skin, whilst the rendition of *Anatomia* on the title-page of Kerckring's 1670 text is reminiscent of the Marsyas–Apollo confrontation. Not surprisingly, Marsyas had appeared in earlier anatomical textbooks. In the 1555 (second) edition of Vesalius' *Fabrica*, the confrontation can be seen in the form of an historiated initial letter 'V' – an appropriate choice given the author's name. A less explicit reference to the Marsyas story can be seen in an illustration which had appeared ten years earlier when Charles Estienne's *De dissectione partium corporis humani* was published at Paris in 1545 (Figure 23). Here, a male figure has been suspended against a tree, with the abdomen slit open to reveal the interior organs, a pose visually reminiscent of Golding's (later) evocation of the 'panting bowels' of Marsyas, as well as the historiated figure which appeared in 1555. In Valverde's Spanish textbook of 1556, and in keeping with the convention of self-dissection, Marsyas and Apollo have merged into a single flayed figure who holds a knife in one hand and in the other, his own skin (Figure 24) – an image which, it has been suggested, forms a complex allusion to Michelangelo's ironic self-portrait in the *écorché*

figure of St Bartholomew in the Sistine chapel paintings.[11] It is not, I think, coincidence that the interest in Marsyas on the part of artists in the sixteenth century should have arisen at the moment when the anatomical exploration of the human frame was reaching a pitch of excited discovery. The confrontation between Marsyas and Apollo perfectly expressed the contradictory emotions to be uncovered in the realm of *Anatomia*. Her servants were dedicated to achieving knowledge of the human body in order to alleviate pain and suffering, and yet that knowledge was only gained at the cost of enormous pain to the victims who, eventually, arrived in the anatomy theatres. As extensions of the law, the anatomists were part of the apparatus of trial, judgment and sentence. Marsyas, too, was tried and found wanting, and executed by the superior knowledge of the god of clear sight who had been the assistant of Zeus at the first anatomical division of male and female.

If we return to that myth of separation and origin, as retold by Milton in *Paradise Lost*, we can see how elements of all these disparate accounts – the Aristophanic account, the Genesis story, the living dissection of Marsyas in Golding's translation of Ovid, the sexualization of science – were combined. When Milton came to rewrite the scriptural account of origin, in Book VIII of *Paradise Lost*, his verse seems to invoke a dream of dissection, comparable to those other dreams we have encountered in English poetry of the late sixteenth and early seventeenth centuries. But the difference is that Adam's experience of the creative anatomist, who embarks on his task of constructing a body in much the same way as the reader of an anatomical text such as Vesalius' *Epitome* was encouraged to construct a body, begins with a gentle sleep of surrender rather than a shiver of horror:

> Mine eyes he closed, but open left the cell
> Of fancy my internal sight, by which
> Abstract as in a trance methought I saw,
> Though sleeping, where I lay, and saw the shape
> Still glorious before whom awake I stood,
> Who stooping opened my left side, and took
> From thence a rib, with cordial spirits warm,
> And life-blood streaming fresh; wide was the wound,
> But suddenly with flesh filled up and healed:
>
> (*Paradise Lost* VIII. 460–8)

The potential violence of the act of creation has been suppressed by Milton in favour of a rapt and trance-like meditation on the nature of mortal surrender to divine knowledge. And yet, the congruences between Golding's violent version of Ovid, and Milton's dream-like version of Genesis are startling. God/Apollo has created within the male body a 'whole wounde' (Golding) or a 'wide. . . wound' (Milton). But where, in Golding's verses,

the subject is left quiveringly vulnerable to the compulsive gaze of science, in Milton's much later account the subject is allowed the possibility of witnessing not only his or her own bodily dispersal, but also a recompilation as another, a sight which allows the closure of the wide wound with suddenly tumescent 'flesh'.[12] Just as in the Aristophanic account of the creation of human sexual difference, here in Milton's version, the disruption of the body by the 'shape' is followed by an act of healing and (partial) restoration. But the account also echoes another manifestation of divine anatomy – the act of self-demonstration performed by the second Adam: Christ whose body was also dispersed and punctured by 'the wound', which, as Richard Crashaw understood the metaphorical transformation, became the 'doors' (Crashaw, *Poems*, 44) through which believers gained salvation.

These texts of division, separation, creation, and restoration transport us far away from the anatomy theatres of early-modern Europe, for all that those theatres sought to express the iconography of sacrifice and redemption. But were they so far removed? Was the culture of dissection only to be found in the ornate buildings and texts of the anatomists? A clue to the diversity of that culture – its manifestation in distinctly different spheres of activity – is provided if we concentrate on the question of gender. In both the Aristophanic and the Miltonic text, divine anatomy was male – an extension of the creative power of Jove/Jehova – whilst in the Renaissance anatomy theatre, *Anatomia* rather than *Anatomius* was the deity of the place. *Anatomia* – symbolizing the cultural domain of the Renaissance science of the body – was a goddess who appeared in a variety of guises. She might be the dream of a male creative force subsumed into the mythological practice of a female vindicatrix. Or she might appear as a benefactor of humanity. As the judaeo-christian God, she was present at the creation not only of difference, but division and disunity within Paradise in opening and dividing the Adamic body, so that 'it' might become 'he', and 'he' might encounter 'she'. But how were these circulating discourses of gender, origin, and separation expressed within the Renaissance culture of dissection? If anatomy was the science of revelation of the secrets of the body and the process by which (as in the Marsyas myth) a hitherto concealed clarity was revealed, then what became clear about the nature of human sexual difference in the anatomy theatre? How did the culture of dissection conspire in the creation of sexual difference and the construction of gender?

DECAYED APPETITE: THE FEMALE BODY IN THE RENAISSANCE COURT

If *Anatomia* was the goddess of reductive division, she presided over a court that was stridently masculine. And as we have seen, a male fantasy of

anatomical surrender to the cruel diligence of a mistress of erotic reduction was at least an imaginative possibility. The task, now, is to trace that fantasy to its roots in the culture of the Renaissance court. Why the court? In order to understand the ways in which the 'culture of dissection' could flourish under such a different guise, we need to make a slight detour from the anatomy theatre into an altogether more precious (and increasingly precarious) world: in particular, the courts of François I of France, and the English courts of Elizabeth I, James I, and Charles I. In the extravagant literary creations of these aristocratic and privileged cultures, the more brutal dissective culture which we have been tracing was still present, but it appeared in a different form, concealed beneath a glittering literary culture of artifice which existed as a highly wrought means of allowing the inhabitants of the court to communicate a set of crucial aesthetic and social values amongst themselves.

Anatomy theatres and the court were closely linked with one another, in the early-modern period, for a wide variety of legal, medical, professional, and, above all, symbolic reasons. The anatomy theatre as a register of a community's intellectual prowess explains something of that affinity. Moreover, the theatres formed part of the apparatus of punishment which stemmed from the sovereign's power over the bodies of his or her subjects. Intellectually, the anatomy theatres provided a forum in which one of the chief ideological claims of the sovereign could be tested. If the sovereign's power was rooted, ultimately, in God, then the ability of the anatomist to trace the lineaments of the divine in each individual body became an important part of the mechanism by which that power was reinscribed, over and over again, upon society at large. Each body dissected within the ornate surroundings of the Renaissance anatomy theatre represented a triumph of the sovereign's power over criminality. With each dissection, the onlookers were reminded of the great super-structure of religious authority which linked the bodies of the subjects to the incorporeal body of the king. If, from the pulpit, subjects were reminded of their duty to the monarch, then from the well of the anatomy theatre (as much as from the scaffold) they were reminded of the penalty of failing in that duty. Moreover, the court could also be a place of healing. The monarchs who, in England, 'touched' their subjects for the 'King's Evil' were not simply victims of the superstitions of a traditional society. Instead, both subject and monarch were re-enacting the framework of belief in which the sovereign acted as 'physician' to the political body. The 'healthy' nation depended on the power of the 'sovereign-physician' to remedy ills within the body-politic. How important this framework of belief was, as part of the political order of things, is indicated by those occasions when the healing nexus between monarch and subject was challenged in any way. Subjects who claimed such power for themselves were

189

liable to be investigated by the Privy Council itself, as happened in the autumn of 1637 in a case in which William Harvey was directly involved.[13] The sovereign was God's representative on earth. As such, he or she possessed something of the attributes of Christ in his guise as 'Christus-medicus' – Christ the Physician. Holbein's 'Great Picture', representing the Union of Barbers and Surgeons in 1540, perfectly expressed this relationship. In Holbein's portrait, Henry VIII sits, surrounded by his Physicians, Surgeons, and Barbers. Above the group, on the king's left hand, is a tablet which addresses the monarch:

> Sadder than ever had the plague profaned the land of the English, harassing men's minds and besetting their bodies; God, from on high pitifully regarding so notable a mortality, bade thee undertake the office of a good Physician. The light of the Gospel flies round about thee on glowing wings; that will be a remedy for a mind diseased, and by thy counsel men study the monuments of Galen; and every disease is expelled by speedy aid.[14]

Holbein's portrait represents a statement of the ideal relationship between the monarch and the political nation. That it was an ideal which still informed the views of Henry's descendants is suggested by the fact that, in 1617, James I applied to the Company of Barbers and Surgeons to have the painting copied, and in 1627 the painting was borrowed and taken to Whitehall 'for the Kinge to see'.[15]

The final reason for the existence of a link between the court and the anatomy theatres lay in the reality of preferment and patronage. Obviously, in early-modern societies, anatomy theatres were entirely urban phenomena. The theatres of dissection were constructed in the great metropolitan centres – Paris, London, Amsterdam, Rome – or else where there already existed universities and medical schools such as Oxford, Leiden, Montpelier, Padua, or Bologna. They occupied a position in the urban community analogous to the playhouses. The anatomy theatres were fashionable places in which to see and be seen. Those who practised within them were also recipients of that structure of patronage which dominated the law, the church, and the universities in the political life of the community. In Holland, of course, the anatomy theatres tended to register civic status. But in England, Italy, and France, anatomists such as Vesalius, or, later, Harvey, enjoyed the protection and even the friendship of the monarch or those close to the sovereign power. The court, even in England during the early seventeenth century, when court and country were supposedly growing apart from one another, still represented the route of preferment for a clever and ambitious physician who had learned his trade, in part, in the anatomy theatre. To hold one of the important medical offices in the court – King's

Physician, Sergeant-Surgeon, Royal Surgeon, or King's Barber – represented the height of professional achievement.

Thus, a cycle of symbolic and actual power united the anatomy theatre and the royal court. The monarch held the nation's 'health' in charge, on behalf of God. The monarch, too, commanded the bodies of the subjects. Subjects who failed in their duties towards the monarch might find themselves, eventually, on the dissection slabs of the anatomists. The anatomists traced the handiwork of God in each body brought to them, and thus reaffirmed the monarch's power over the bodies of the people. It was the anatomists who were responsible for training the physicians who, in turn, if they were clever enough, ambitious enough, or simply adroit courtiers, might win the right to attend the monarch's corporeal body, just as the monarch attended the incorporeal body of the nation.

This, of course, was the theory. The reality of the culture of dissection as it flowed through the rarefied atmosphere of the court was somewhat different. In the sixteenth and seventeenth centuries, as we have seen in the poetry of Donne and his contemporaries, a strange fantasy of anatomical surrender seems to have, briefly, flourished. How did this fantasy relate to the world of Greenwich or Whitehall? Poetry, or, more specifically, poetic fantasy of male surrender to female division, provides an answer. Male surrender to female dissection should be understood as a simple reversal of a familiar Renaissance poetic trope – the 'blazoning' of the female body. The blazon as a poetic form – usually understood as a richly ornate and mannered evocation of idealized female beauty rendered into its constituent parts – may seem worlds apart from the corporeal reality of an anatomy theatre. But, as we have already seen, the anatomy theatres themselves were decked out with all the ornate trappings of what we might call a corporeal aesthetic. If Spenser's 'House of Alma' could help to structure an anatomical investigation, then, in similar measure, the blazon formed a significant part of the culture of dissection which produced the partitioned body. But the importance of the blazon lay in its partitioning not of any indiscriminate body, but of a specifically female corpse.

To use the word 'corpse' to describe the poetic object of the blazon may seem deliberately reductive. After all, was not the blazon form, beloved of Renaissance poets, a delicate orchestration on the theme of the life-enhancing qualities and virtues of the mistress who was the subject and (on occasion) recipient of the blazon? In the hothouse atmosphere of the French court in the early sixteenth century, however, and in the English Elizabethan, Jacobean, and Caroline courts of the seventeenth century, something far more sinister was on display. The ancestry of the blazon was by no means rooted in literary idealism. The word 'blazon' was derived from the heraldic device worn on a shield (*OED*). But this meaning was itself

derived from the literal sense (in Old French) of shield itself, so that the 'blazon' was not originally a proclamation, an ornamentation, an illumination, or a device for 'blazoning' heraldic codes. All of these were much later senses. Instead, the 'blazon' *was* the shield, a protective instrument for use in war. But protective of whom and against what? David Norbrook has observed that:

> the vogue in the sixteenth century for the blazon, the detailed enumeration of the parts of the woman's body, can be seen as reflecting the new scientific mentality with its mastering gaze, its passion for mapping the world in order to gain power over it.[16]

This comes close to the mark. The 'vogue' for the blazon was a part of the scientific urge which was displayed in Renaissance anatomy theatres. Not surprisingly, then, this new, scopic, regime of division and partition was reflected in a surge in popularity of the blazon in the second half of the sixteenth century, particularly in France. During the fifteenth century no more than two or three blazons – that is poetic collections or individual poems which featured the French word *blason* in the title – were written. During the early years of the sixteenth century, however, a growing number of such titles began to appear, so that, by 1530, something like twenty or so *blasons* had been produced. Between 1530 and 1580 – the Vesalian period – the genre seems to have simply exploded. By 1580, it has been calculated that over 250 French *blasons* had been produced or were circulating.[17]

The 'blazon' as a shield – a meaning which was to be appropriated for heraldic purposes – allowed men to vie with one another in the production of art. Female body parts – eyes, eyebrows, breasts – could be bandied about in poetic *blasons* and *contreblasons*. More often than not, this poetic contest, in which the competitors traded their mistresses' (real or imagined) bodies with one another, disguised what Thomas Laqueur has described as 'a powerful homoerotic quality as women seemed to mediate and create bonds between men'.[18] Women, however, had little active say in this process. Indeed, women appear to have been little more than (in Eve Kosofsky Sedgwick's words) 'a more or less perfunctory detour on the way to a closer but homophobically proscribed bonding with another man'.[19] The female body may have been the circulating token, but it was male desire which valorized the currency. Furthermore, for all that the literary historians have understood the blazon as associated with an idealization of female beauty, its origins were, in reality, rather more corporeal. So, although Guillaume Coquillart's *Blason des Armes et des Dames* (composed for the coronation of Charles VIII at Rheims in 1484) took the form of a debate between war ('armes') and love ('dames'), the poetic contest between the poets Alexis and Estées, which began two years later, was of a rather different quality. The

Grand Blason de Faulses Amours (1486) by Alexis was a satire and apology for women, conducted in the form of a debate between a gentlewoman and a monk. But the answer of Estées, *Contreblason de Faulses Amours* (1512), recast the terms of the contest: the protagonists were a prostitute and a nun debating the topic of carnal love. The *Contreblason* of Estées set the tone for succeeding exercises in the genre, which became more and more obviously sexualized. Pierre Danché's *Blasons de la Belle Fille* (1501), for example, set out to enumerate the erotic attractions of young women, and was the precursor for the most famous (and notorious) series of blasons – those gathered under the title *Blasons Anatomiques des Parties du Corps Fémenin* – the 'anatomical blazons of the female body' – which first appeared in 1536.[20]

The *Blasons Anatomiques* began life as the creation of Clément Marot, one of the so-called *Grands Rhétoriqueurs* associated with the courts of François I and his sister Marguerite d'Angoulême (later Navarre).[21] In 1535, whilst in exile in Ferrara, Marot composed the erotic *Blason du Beau Tétin*, said to have been inspired by Olympo da Sassoferrato's praise of the breasts of Madonna Pegasea.[22] The following year, the first edition of *Blasons Anatomiques* appeared, an anthology which, by the time the 1550 edition was published, contained poems by Scève, Belleau, Chapuys, and, of course, 'anon'. *Blasons Anatomiques* was, then, an anthology which, with each successive edition, grew to include the work of more and more poets anxious to be associated with this flourishing genre. *Blason* produced *contreblason*, *contreblason* gave way to *contre-contreblason*, an ever expanding exercise of male wit, flourishing the female anatomy before the eyes of other, admiring, male readers. The 'shield' (in both the protective and heraldic senses) which the female body provided for these poets was composed of an amalgam of features and organs. Foreheads, eyebrows, mouths, teeth, sighs, stomachs, thighs, knees, and feet gave way to more sexually overt exercises: Rochetel's 'Blason du Con' was answered by Chapuys's 'Du Con de la Pucelle' and 'Autre du Con'. The anonymous 'Blason du Cul' was answered by 'Aultre Blason du Cul', and so on. Chapuys's 'Blason du Ventre' is representative of these texts:

> Ventre plus blanc que n'est pas albastre,
> Ventre en été plus froid que plastre,
> Dont le toucher rend la main froide,
> Et je ne sçay quoy chaud et roide;[23]

Male desire ('chaud et roide') was the true subject of these verses. But desire for what? Men read each other's *blasons* in order to become 'chaud et roide' – hot and rigid. The emblazoned female body was the *locus* of desire, as (in Nancy Vickers's words) each 'celebratory conceit inscribes woman's body between rivals: she deflects blows, prevents direct hits, and constitutes the field upon which the battle may be fought.'[24]

These texts appeared within the court culture of François I, in the first half of the sixteenth century. The culture of the French court, Frances Yates has argued, was one which self-consciously proclaimed itself as instituting 'an imperial *renovatio*', an aggressive appropriation of letters, arts, and science which would herald a revitalized sense of national destiny.[25] Within this context, the *blason* and the anatomy text soon begin to appear as different sides of the same coin. In the production of both poetic *blason* and anatomic text, male competitors within this intensely competitive culture strove to outdo one another, using images of the fragmented body as their currency. This currency circulated within the court at Fontainebleau, where François had gathered together poets and artists such as Marot, Leonardo, Andrea del Sarto, and Cellini, together with a remarkable devotion to the production of printed works. Leonardo's anatomical notes and drawings, in particular, were known in the French court, where a contemporary (the Cardinal of Aragon) records having looked at his drawings and notebooks.[26] At the same moment that the poetic dissection of the female body was being celebrated as the height of taste, fashion, and wit, the Fontainebleau milieu was also encouraging the production of costly anatomical scientific texts.[27] Undoubtedly, these scientific texts were influenced by the 'sexualized' culture of the court. The images of the dissected female form to be found in Estienne's *De dissectione* of 1545, for example (Figure 25), were not merely posed in an extravagantly sexualized manner, but they were also reinterpretations of a 'key' Renaissance erotic text: Perino del Vaga's sequence of engravings showing gods and goddesses copulating with one another.[28] As Laqueur has observed, Estienne's images were produced within a court culture which can be understood as a 'powerfully gendered cultural venue', where the Diana in Benvenuto Cellini's *Nymph of Fontainebleau* presided over the entrance to the palace as 'the object of an unmistakable male gaze'.[29] Significantly, in this context, Cellini claimed that the highlight of his own career was the casting of the statue of Perseus – the conqueror of the Medusa's gaze – for the Loggia de' Lanzi in Florence. Cellini's *Perseus*, though it was commissioned in 1545 by Cosimo I, at the end of the artist's Fontainebleau period, and was designed for a Florentine rather than French setting, was nevertheless iconic of the masculine culture of the court of François. Here was the classic gesture of the *blasonneur*. Cellini's Perseus (Frontispiece) towers over the contorted and decapitated body of the Medusa, brandishing her head aloft, his sword unsheathed and poised in an exaggerated display of phallic power over his female opponent.[30] Cellini's *Perseus* echoed the anatomical blazoning of the female body in which the court of François I delighted. It is not difficult to see Cellini's image as an essay in aggression and conquest, where the disturbing female gaze is mastered by a mythic hero who can thus demonstrate his masculine

potency.[31] At the same time, Cellini's figure is a strangely androgynous icon, for all its triumphalist posturing. It is the Medusa who faces the world, not Perseus. Modestly, he lowers his eyes and seems to shelter behind her blazoned head. But the Medusa, rather than glaring out into the world, has herself been mastered. Her eyes are lowered (echoing the bashful visage of her victor) as though she and her conqueror have both become objects of consumption – 'an emblem of . . . political and sexual specularity'.[32] As in the myth, the Medusa, eventually, protects Perseus. But protects him from what? The tradition of the *blason* provides an answer. Cellini's Perseus flourishes aloft part of a once beautiful woman – now transformed into a monstrous figure of antique myth – whilst his own youthful body, with lowered eyes, is consumed by the gaze of other men.

The *Blasons Anatomiques* operated within a very similar sexual economy: female body parts were held aloft as tokens of intellectual mastery. Male opponents, like the rivals to Andromeda or the guests of Polydectes in the Perseus myth, could (it was hoped) be silenced by the badge of mastery which the female body in the hands of the male betokened. But in what ways did this highly wrought, masculine culture mesh with the world of the anatomy theatres? In 1543 the 'definitive' edition of *Blasons Anatomiques* appeared.[33] This, of course, was the year of publication of the Vesalian *Fabrica*. In more ways than one, however, the erotic *Blasons Anatomiques* and the career of Vesalius seemed to correspond. The medical career of Vesalius had, effectively, begun in Paris, where (in 1533) he had commenced his studies under Guinterius Andernacus (Guinther of Andernacht), Jean Fernel, and the foremost anatomist in Europe: Jacobus Sylvius (Jaques Dubois). It was at Paris, in the medical school, that Sylvius established a reputation such that, in the words of a contemporary (Loys Vassé): 'From everywhere flocked to him Germans, English, Spaniards, Italians and others of all nations who all agreed that the like of this admirable and almost divine man was not to be found in the whole of Europe.'[34] Within the cosmopolitan culture of the Paris of François I, Vesalius developed his practice of nocturnal raids on the cemeteries and gibbets of the city, intent on gaining body-fragments. His most frequent haunts were the great gibbet at Montfaucon, to the north of the city, and the Cemetery of the Innocents.

In 1536, the same year in which the *Blasons Anatomiques* began to circulate, and following the outbreak of war between the Emperor Charles V and François I, Vesalius left the city and returned to Louvain. It was there that he embarked upon his sensational 'construction' of a cadaver:

> While out walking, looking for bones in the place where on the country highways eventually, to the great convenience of students, all those who have been executed are customarily placed, I happened upon a dried cadaver. . . .

195

> With the help of Gemma, [the mathematician, philosopher, and physician Regnier Gemma] I climbed the stake and pulled off the femur from the hip bone. While tugging at the specimen, the scapulae together with the arms and hands also followed, although the fingers of one hand, both patellae and one foot were missing. After I had brought he legs and arms home in secret . . . I allowed myself to be shut out of the city in the evening in order to obtain the thorax which was firmly held by a chain. I was burning with so great a desire . . . that I was not afraid to snatch in the middle of the night what I so longed for. . . . The next day I transported the bones home piecemeal through another gate of the city . . . and constructed that skeleton which is preserved at Louvain.[35]

This Frankenstein-like story is reminiscent of Leonardo's account of similar secret, nocturnal, dissections, while it is also a foretaste of a later 'construction' of a female body which Vesalius was to undertake in preparation for the *Fabrica*. Here, though, was the practical realization of Leonardo's intellectual programme of 'building up' a human image ('cresciere l'uomo'). Vesalius' act of construction might also remind us of the project which lay behind the cumulative *Blasons Anatomiques* that were now appearing in Paris. With each edition of the *Blasons*, so a new addition to the eroticized female body was produced. Just as Vesalius was, later, to encourage his readers to 'construct' their own anatomized bodies from the sheets made available in the *Epitome* of 1543, so the courtier-poets of François constructed a more and more complex and explicit image of the female form with each printing of the poetic collection. But the comparison between the poets and the anatomist can be taken further. In Vesalius' own account of constructing a body, there is a disturbingly predatory tone. His exploits on the gallows, outside the city walls of Paris and (later) Louvain, were undertaken in the cause of knowledge. But this knowledge was hardly innocent, as the terms in which Vesalius himself describes the Louvain episode demonstrate so adroitly. Just as we have remarked upon the frisson which Leonardo seems to have experienced as he cut up bodies in the privacy of his studio, so there is something more than urgent about Vesalius' self-presentation, swinging like a carrion crow on the gibbet, 'burning with so great a desire . . . that I was not afraid to snatch in the middle of the night what I so longed for'.

The culture of dissection could encourage strange intellectual bedfellows. Vesalius' embrace (for that is what it must have been) of the corpse of an executed criminal did not involve merely the conquest of natural repugnance. It was likely that he was running a considerable personal risk. To be shut outside the city at night constituted just a small part of that danger. The penalties for removing the bodies of executed felons from the gibbet were high, as Vesalius must have been aware when he claimed that his Louvain 'construction' originated in Paris. In a bizarre series of parallels, however,

we are able to reconstitute the culture of dissection as it flowed between the erotic poetic texts of the court of the French king, and the scientific researches of the great anatomist Both sought to gaze upon the body which they dismantled, piece by piece. Both, too, progressively 'constructed' a new body made of the parts which they had examined. Just as Vesalius was to dismiss his scientific rivals in anatomical demonstrations, so the poetic texts struggled in competition with one another, brandishing the dissected female form as a token of mastery. Finally, we have to note that the language with which Vesalius arranged the nocturnal rendezvous with the object of his desire is the language of courtly love: illicit, secretive, impelled by 'so great a desire to snatch what I so longed for'. All that is missing is the balcony – an office supplied, however, by the gibbet upon which Vesalius clambered.

The fashion for the *blason* appeared in England in what might be thought of, initially, as a much less highly wrought ambience. Certainly, the immediate conjunction of anatomical investigation and erotic love – so apparent at the court of François I – seems, at first, to be absent. The English blazon, however, partitioned the female body within an atmosphere which was, if anything, even more erotically charged than that which prevailed at Fontainebleau. Elizabeth I, the 'virgin queen', was the ideal subject for the poetic blazon, a vehicle for the demonstration of a male wit which encircled the queen's body in a fetishistic adoration of her power, her virtue, her attraction, and (of course) her sexual allure, made all the more potent through her unavailability. The queen provided the perfect vehicle for initiating a complex linguistic interchange, uniting partition and division with the emerging, and determinedly expansionist language of colonization. And, just as in their French originals, within the English blazons the erotic and the anatomic were to co-exist, feeding off one another as female bodies were divided in a riot of aesthetic and scientific exploration.

But there was one crucial difference between the activities of the *blasonneurs* at the court of François, and Elizabeth's petrarchan sonneteers. That difference resided in the biological sex of the queen. The corporeal presence of the queen's body was linked to the vitality of the nation through metaphors of nutrition, partition, and commercial exchange – a variation on the familiar 'imperial' iconography surrounding the queen in portraiture.[36] Here was a paradox which ran deep into the heart of Elizabethan culture. The court of Elizabeth, just like the court of François I, was an eroticized venue, a place of competing male sensibilities despite (or, rather, because of) the central presence of the female monarch. As Louis Adrian Montrose observes, the queen presided over a court in which she 'was the source of her subjects' social sustenance, the fount of all preferments ... part Madonna, part Ephesian Diana'. The queen's natural body was presented to her surrounding

courtiers (by Elizabeth herself) in a fetishistic display. Bare-breasted, as were all her ladies at court prior to marriage (an event for which her permission was required), the queen circulated amongst her subjects. In 1597, a visiting French ambassador (Montrose records) described her as wearing:

> black taffeta, bound with gold lace . . . a petticoat of white damask, girdled, and open in front, as was also her chemise, in such a manner that she often opened this dress, and one could see all her belly, and even to her navel . . . she has a trick of putting both hands on her gown and opening it insomuch that all her belly can be seen.[37]

Chapuys's earlier poetic praise of the female stomach, the procreative focus of male fantasy in the period, is here endowed with a kind of visible blazon, which the queen controlled. Teasingly, she blazoned her own body, revealing to her courtiers what was at the same time denied to them. In essence, she had become a true anatomist of the body-politic, since, like the anatomical figures which populated the scientific texts of the age, Elizabeth appeared to control her own self-blazoning. It was she who, metaphorically, held the knife to her own body, and thus provided the pattern which her courtier-poets proceeded to embellish.

In the English blazon, the female body was partitioned once more, but partitioned in accordance with a political imperative which circulated around the temporal and spiritual body of the queen. Petrarchan conventions of poetic praise of the attributes of the beloved – hair, face, hands – had been appropriated by English poets since the time of Surrey and Wyatt, and they fed into the genre.[38] In England, the language of the blazon developed poetic tropes which were peculiarly consonant with an emerging 'science' or knowledge of the body. Discovery (in the geographical *and* rhetorical senses) determined this trope, which was soon allied with emerging discourses of commerce and trade. The English blazon, then, divided the female body to celebrate its partitioned exploration as a geographical entity. This organism could be 'discovered' (literally 'disclosed' – rendered open to sight) and then subjected to an economy of trade, commerce and mercantile distribution. Significantly, the terms in which this process was described – discovery, division, disclosure, distribution – were all rhetorical terms, so that the resources of charged, rhetorically apposite, poetic language seemed naturally embedded within a colonizing process of appropriation and exploitation.[39] Indeed, so interlinked were the circulating metaphors that it sometimes becomes difficult to decide *what* the poet was celebrating: are we reading about female bodies which are metamorphosing into continents, or continents which are to become bodies? Is the queen an emblem of the diversity of the world, or is the complexity of the world emblematic of the queen's dominance?

The free-flow of language within the blazon form over the female body was not a celebration of 'beauty' (the ostensible subject), but of male competition. This competition was located both within and on the surface of the blazoned body of the queen, where a language of sexual union and commerce met. And the queen could be glimpsed in the most unlikely contexts. So, the blazon section of Spenser's celebration of wedded love in the 'Epithalamion', which closed the collection *Amoretti and Epithalamion* (1595), and which celebrated the wedding of Spenser and Elizabeth Boyle in June 1594, praised the woman in the iconic language of the portraiture of Elizabeth I:

> Her long loose yellow locks lyke golden wyre,
> Sprinckled with perle, and perling flowres a tweene,
> Doe lyke a golden mantle her attyre,
> And being crowned with a girland greene,
> Seeme lyke some mayden Queene.
>
> (*Shorter Poems*, 668)[40]

Of course, the queen would not appear with her hair in 'long loose yellow locks' – that was Spenser's adaptation to the moment – but the gown 'sprinckled with perle', the crown, the image of the 'mayden Queene' were designed to remind Spenser's readers (amongst whom *was* the queen) of the truest image of earthly divinity. Surrounded by 'so many gazers, as on her do stare', Spenser deployed the language associated with the queen to praise his bride. The effect was to achieve a deliberate gesture of disavowal which the queen and her courtiers would understand. This gesture managed to suggest that this queen for a day was modelled on a real queen, before whom even his bride had to give place. As the poem moved into the blazon section proper – the praise of eyes like sapphires, an ivory white forehead, apple-like cheeks, lips like cherries which (a sudden erotic charge can be seen breaking through) charm 'men to byte', breasts like cream or lilies, a neck like marble – the woman became arrayed as an object of consumption for other men, flaunted before an audience as something not only there to be looked upon, but eaten. And with the similes of fruit and flowers, came the evocation of a mercantile world, for she was displayed before an audience which was addressed (and constructed) as part of a thriving metropolitan commercial culture:

> Tell me ye merchants daughters did ye see
> So fayre a creature in your towne before,
> So sweet, so lovely, and so mild as she,
> Adorned with beautyes grace and vertues store . . .
>
> (*Shorter Poems*, 669)

To which the answer was, of course, 'Well, yes, the last time we saw the queen, or read *The Faerie Queene*.' No matter that the town where the wedding took place was Cork. Imaginatively, this was a public royal progress through the streets of London, or through the pages of Spenser's epic. So, the blazoned woman was paraded before the eyes of men and other women – the daughters of merchants – as an ideal of virginal womanhood who was *nearly* as ideal as the queen, evoked a few lines later as enthroned elsewhere in solitary grandeur, where, like virtue, she 'giveth laws alone'.

Controlling the steady progress of similes and metaphors in Spenser's text were the twin dynamics of partition and commercial consumption. Presiding over these metaphors (or hovering in the background) was the glittering form of the queen. The queen, of course, had already been the subject of one Spenserian blazon by the time the 'Epithalamion' was published in 1595, and one that was overtly erotic – the description to be found in *The Faerie Queene* of Belphoebe (*FQ* II.iii.21–31) which had appeared just five years earlier. In Belphoebe/Elizabeth all the attributes of the bride who was to be blazoned in the 'Epithalamion' are discovered, but evoked at greater length and in more detail: the golden hair like wire ('crisped', rather than 'loose', however), the 'besprinckled' gown, the ivory forehead, and so on. It was as if, in a poetic fantasy, Spenser had imagined the possibility of partitioning his bride so that she could be re-created as a second Belphoebe/Elizabeth, and what greater compliment could the old queen have enjoyed?[41]

The creation or 'construction' of the ideal woman, then, was the axis upon which the blazon turned. The 'Epithalamion' carried forward the rhetoric of division, partition, and construction which was such a feature of its co-text – the sonnet sequence 'Amoretti'. Within the oxymoronic language of 'Amoretti', the petrarchan oscillation between a cruel mistress and a compliant and ensnared woman, lay the image of trade, once more:

> Ye tradefull Merchants that with weary toyle
> do seeke most pretious things to make your gaine:
> and both the Indias of their treasures spoile,
> what needeth you to seeke so farre in vaine?
> <div align="right">(Shorter Poems, 609)</div>

So begins Sonnet XV of 'Amoretti', a blazon which divides the female body into a pile of treasure: sapphire eyes, ruby lips, pearl teeth, ivory forehead, gold hair, and silver hands. Once more, the familiar conceit of a poem which flourishes the divided female before other men is apparent. The narrator of the sonnet 'owns' a capital investment (the heaped up body-treasure) which makes all the merchants' wearying 'toyle' (a word frequently reserved for sex), their restless search for precious 'things', futile by comparison. The poet's hoard is more costly than theirs, *and* it is to be found safely at home.

The sonnet marks a moment of conspicuous consumption, a chance for the narrator to 'display' his wealth. And, as though to stamp the mark of ownership, the sonnet cannot resist one last triumphant proclamation:

> But that which fairest is, but few behold,
> her mind adornd with vertues manifold.
>
> (*Shorter Poems*, 609)

Of course, it was her mind – what else could it have been? By playing off the convention of physicality against the petrarchan convention of idealized female virtue, Spenser created the classic double-entendre – a snigger of male complicity.

These Spenserian blazons are representative of the English appropriation of the genre to be found in texts published, or circulating, throughout the late sixteenth century. Sidney, Shakespeare, Daniel, Drayton, Barnabe Barnes, Bartholomew Griffin, Thomas Campion, John Marston, the list of competing poets whose sonnet sequences blazoned their mistresses (real or imagined) seems endless. Very rarely (as in Surrey's elegy 'Wyatt resteth here, that quick could never rest' or Shakespeare's homoerotic Sonnet 20) do we find men blazoning one another. Rarer still are the occasions when women emblazoned men, as did Lady Mary Wroth.[42] In the hands of Gascoigne, Davies of Hereford, and Donne (as we have seen) a 'reverse-blazon' could be attempted, where the iconography of anatomic science seemed to step into the courtly world, in a masochistic display of a partitioned male body. The dominant conceit, nevertheless, was that of competing males exercising their wit at the expense of partitioned females. But the blazon did not only flourish within the refined atmosphere of the sonnet. It was possible to witness the partitioning of the female body on the stage. In its early performances, *Twelfth Night* would have offered a singularly powerful moment of emblazoning. Viola (a boy actor disguised as a woman disguised as a boy) confronts Olivia (another boy actor in disguise) who refuses at first to show her face. But, lifting the veil, the familiar gesture of both scientific revelation and erotic encounter, Olivia reveals 'the picture' which prompts Viola to embark upon a conventional blazon:

> *Viola.* 'Tis beauty truly blent, whose red and white
> Nature's own sweet and cunning hand laid on.
> Lady you are the cruell'st she alive
> If you will lead these graces to the grave
> And leave the world no copy.
>
> (*Twelfth Night* I.v.242–6)

But there she is interrupted. The entirely appropriate echo of Shakespeare's Sonnet 20 ('A woman's face, with nature's own hand painted') in which a

man offers another man an erotic blazon, is stilled by Olivia, who proceeds to (ironically) divide her own body according to a commercial schedule:

> *Olivia.* O sir, I will not be so hard-hearted: I will give
> out divers schedules of my beauty. It shall be
> inventoried, and every particle and utensil labelled
> to my will. As, item, two lips indifferent red;
> item, two grey eyes, with lids to them; item, one
> neck, one chin, and so forth. Were you sent hither
> to praise me?
>
> (*Twelfth Night* I.v.247–53)

The force of the joke resides in the very impropriety of this appropriation of such a determinedly male form. If the blazon was a form of homosocial mediation amongst men, in which the female body was the currency, then here, on the contrary, two women (who are not women) have commandeered both the form and the competitive nature of the contest. Viola begins with the formal opening of a blazon, but is immediately trumped by Olivia's linguistic refusal to play the game, and to assert her 'will'. Rather than submit to the rich adjectival partitioning of her body, she counter-attacks by reducing the blazon to its essential components: a spare commercial division of the female body. This formal appropriation of a male genre, a blazoning competition which doesn't quite take place between the two women characters, serves to underlie the complex erotic negotiations of 'mastery' and 'submission' which the play seems intent on exploring.[43] For the courtly audience before whom *Twelfth Night* was played in the early years of the seventeenth century, the joke would have been even better had it been played out before the ageing queen who (like Olivia) controlled with such skill the blazoning of her body before her court.[44]

In England, in the last years of the sixteenth century and the early years of the seventeenth, the anatomic intensity of the blazon became a more overtly misogynist exercise, particularly in the hands of John Donne. Under a different, masculinized, court culture, the blazon began to shift its focus. Donne, though clearly not a 'court' poet in the sense of Marot, nevertheless moved within the enclosed circles of court wits, lawyers, and place-men. Famously, he was, eventually, to write of his poetry (particularly his satires) that in them was matter for 'some feare' – a classic anxiety of the courtier-poet. But of his elegies which were the chief vehicles for his exercises in the blazon form and which circulated amongst a select group of male wits, there was not only fear but cause for 'perhaps shame'.[45] Of what order was this 'shame'? Did it lie (as modern criticism has tended to assume) in the heterosexually explicit nature of the verses? Or was it, rather, the recourse to a language of profound misogyny – tempered by homophobic anxiety – from which Donne was seeking to disengage?

So, the anti-blazon which is Elegie VIII ('The Comparison') carved up one female body, Donne's mistress, at the expense of another, the body of the mistress of the male rival with whom Donne was competing. Female body-parts are traded between the two poets in a violent, explicit, series of images which leave two female bodies in metaphorical tatters. Whilst his competitor penetrates the mistress (whom Donne has dismembered) in an act which is 'harsh and violent,/As when a Plough a stony ground doth rent', the narrator's own moment of congress moves from the kisses of turtle-doves ('devoutly nice'), through the sacramental act of the eucharist, to a chillingly cold image of penetration:

> And such in searching wounds the surgeon is
> As wee, when wee embrace, or touch, and kisse.
>
> (Donne, *Poems*, 82)

The anatomic core of the blazon has returned. John Carey writes of this image that Donne was:

> trained to regard a body as a specimen you dissect as well as a sensitive envelope you walk around in. . . . An image such as that of the surgeon's probe inserted into the girl, in 'The Comparison' unites the technical and the tender.[46]

Well, perhaps. But what is at issue in the 'comparison' of the poem's title is not the comparison of the women's bodies, but the comparison of two degrees of male discrimination: an anatomical confrontation over the female body which (in its final lines) begs the competitor to leave his mistress in a plea for the reassertion of the ties of male friendship: 'Leave her, and I will leave comparing thus/She, and comparisons are odious'.[47] Which prompts the question: to whom does the 'wee' of the last line of the poem actually refer? Donne and his mistress? Or Donne and his male friend now that mistresses have been fragmented?

Donne's 'The Comparison' made explicit what the *blason* or blazon evoked implicitly in a formal context. Comparisons in these poems *appear* to be metaphoric tournaments, but, as Donne's Elegie demonstrates, the true comparison was not between tenor and vehicle (eyes and sapphires, say) but between women's bodies as they were claimed in ownership by men. Hence the circulation of tropes around richness or wealth. If a man's social status in the courtly world inhabited by the *blasonneur* was trumpeted not just by his deeds, but by his possessions, then the mistress formed part of that commodificatory process. A glance at any contemporary advertisement for motor cars will remind us that such forms of sexual commodification are still with us. In the Renaissance court, in much the same way, not only a man's prowess at arms, his lands, his horse, his armour, his scholarship, and his wealth, were to be displayed, but also his mistress. But, lurking within the

rhetoric of consumption, was the fear of appearing too much the courtier, of tottering over the edge into a grotesque parody of gentility. It was this fear which animated the aggression of the *blasonneur*, and underlined the importance to these poets of the female body as the site where masculinity could be displayed. Castiglione's manual of courtship, the *Libro del Cortegiano* (1528), offered clear guidance on this point. The courtier's 'countenance' (by which Castiglione's English translator, Sir Thomas Hoby, meant 'demeanour') must not be:

> so soft and womanish as many procure to have, that doe not only courle the haire, and picke the browes, but also pampre themselves in everie point like the most wanton and dishonest woman in the world: and a man would think them in going, in standing, and in all their gestures so tender and faint, that their members were ready to flee one from another.[48]

Castiglione's image reveals the interior anxiety at the core of the blazon. To be too much the courtier is to risk being made a subject of a blazon oneself, to have one's own 'members' scattered over the countryside in satiric asides, gossip, or comment. Against this possibility, therefore, the courtier deployed a rhetoric of aggressive masculinity. If, like the subject of a blazon, the courtier had to be 'displayed', as Castiglione goes on to remark, 'in open shewes in the presence of people, women, and princes', he had to control the display at every point in open competition with his fellow courtiers. To be, for example, 'a perfect horseman for everie saddle' and thus to 'wade in everie thing a little farther than other men' might counter the charge of effeminacy.[49]

This anxiety motivated Shakespeare's satirical deployment of blazon-like structures when he evoked the French court in that most stridently masculine of plays, *Henry V.* Waiting for battle, the Dauphin – the image of effeminacy – tries to provoke his fellow-knights into a blazon-contest. The contest centres, absurdly, around whose horse is the finest. Seizing on this icon of masculinity, Shakespeare suggests that, in a series of blazon-like comparisons, the heir to the French throne has a relationship with his horse which verges on the unnatural. So, like Viola in *Twelfth Night*, the Dauphin embarks upon a sonnet which is interrupted by the Constable: 'I have heard a sonnet begin so to one's mistress' (*Henry V* III.vi.41), which prompts the surrounding courtiers to vie with one another in a series of comparisons between mistresses and horses, in an attempt at recouping the masculinity which their prince has so foolishly undermined. Against the *blasonneurs* of the French camp, is set Henry – the 'bawcock', the 'lovely bully' – the true chivalric hero, casting off the earlier charge of effeminacy, who circulates through the night amongst his men, and yet manages to forestall (as Alan Sinfield puts it) 'the disastrous slide back into the female'.[50] That sexual

security (which emphatically does *not* involve a valorization of women in the play since this a play for and about men) is possible because the French have been displayed as sexually 'other', feminized and effete. It is this confrontation between overt masculinity and covert effeminacy which is displayed in the meeting between Henry's messengers and the French court prior to Harfleur. France has become, in the words of the Dauphin, like Castiglione's effeminate courtier: a 'sick and feeble' disjointed confederation of 'parts' (*Henry V* II.iv.22). Amongst these parts, like a terrible blazoner, Henry will rummage, raking for the crown and scattering the anatomy of the polity, in a tumble of 'hearts' and 'bowels' which will prompt (in a sexualized pun) 'the privy maidens' groans' (*Henry V* II.iv.97–107). France will be distributed, like the mistress's body, in a refashioned and war-like blazon, as Exeter promises in his telling description of the 'caves and womby vaultages' of France once it has been emblazoned by England, and transformed into an eviscerated and hollowed female body (*Henry V* II.iv.124).

In *Henry V* we can see the stirring of an anti-court aesthetic which is, again, deeply misogynistic. Henry's wooing of Katherine at the close of the play is another demonstration of masculinity. But it is also emblematic of a view of men's relationships with women which will, eventually, abandon the concealed gestures of the *blasonneur*, and refuse to 'rhyme' itself into 'ladies favours'. Katherine, the French princess who had earlier rehearsed with her maid the components of the blazon on her own body, must learn that this seemingly delicate language of courtly gesture is now out of fashion. But such a refashioned language of the body – the plain speaking of the soldier king – in reality, lay in the future. If we return to Donne's texts of comparison, we can see how the homosocial bond of the blazon still offered itself as a ready means of asserting male prowess through the commodification of the female body. In Donne's Elegie XVIII ('Loves Progresse'), the blazon is harnessed to a commercial rather than a warlike venture. 'Loves Progresse' is an erotic voyage of discovery down the female body which finally encounters the object of desire, which all such blazons evoke even as they pretend (as Spenser pretended in 'Amoretti' XV) to be interested in abstract virtues. The physicality of the form – the fact that its setting is corporeal – precludes such abstract and innocent meditations from being taken at face value. At heart, as every *blasonneur* knew, the goal was conquest, the end result a mocking male laughter at the ways in which a courtly language of adoration could be deployed to such purely physical ends. This is where Donne's Elegie XVIII is, if nothing else, honest. The poem knows its readers, and knows that those readers know its devices for what they are.[51] Sailing from the north to the south of the female body, crossing the meridian on a voyage of commerce 'towards her *India*', intent on arriving 'where thou wouldst be embayed', the voyager at last arrives:

> Rich Nature hath in women wisely made
> Two purses, and their mouths aversely laid:
> They then, which to the lower tribute owe,
> That way which that Exchequer looks, must go:
> He which doth not, his error is as great,
> As who by Clyster gave the Stomack meat.
>
> (Donne, *Poems*, 106)

Even by Donne's standards, the syntax here is remarkable for its involuted quality. For Donne, gold and wombs (as John Carey observes) were topics that 'he could seldom stop thinking about for long'.[52] Gold and wombs were precisely the *topoi* of the blazon. Yet, only rarely does an English example of the form approach such homophobic anxiety – such sudden awareness that the boundary between 'friendship' and 'sodomy' may have been crossed – and all concealed behind the familiar snigger of the *blasonneur*.[53] Displayed for other men, the woman lies with her vagina and her anus available: 'aversely' meaning backwardly (*OED*) and not, as some commentators have insisted, at an angle.[54] To perform anal intercourse with her, the poem advises, the man must 'go' in the same direction 'which that Exchequer looks' – i.e. from behind. The female body has become a receptacle into which (literally) the male can deposit his treasure. But to 'go' to the woman from any other direction is to fall into an error as great as to attempt to gain nutrition via an enema. At which point, unable to resist the joke, Donne invokes a secondary series of puns (circulating around 'clyster' – the tube inserted into the anus – and 'meat') to close the poem off with an allusion to the 'error' of anal intercourse, which the poem seems, nevertheless, to be endorsing as a problem of technique rather than morality.[55] Quite clearly, Donne's blazon was meant for an anatomically and sexually literate audience, who would have appreciated the teasingly convoluted language within which the joke was encloaked.

Donne's Elegie XVIII, with its anxious closing series of ambiguous sexual puns, seems to underline the truth of Eve Kosofsky Sedgwick's perception:

> The heterosexuality that succeeded in eclipsing women was also . . . relatively unthreatened by the feminization of one man in relation to another. To be feminized or suffer gender confusion within a framework that includes a woman is, however, dire; and . . . *any* erotic involvement with an actual woman threatens to be unmanning. Lust itself (meaning, in this context, desire for women) is a machine for depriving males of self-identity.[56]

It might be possible to quarrel with that 'relatively', but only briefly. For Sedgwick has identified, here, the animating force of the *blasonneur*'s hatred for the object of his ostensible veneration. What he claims, again and again, to desire so completely, may also (he senses) lead to his own loss of identity.

Only violence, turned back against the self within the prevailing conceit of the petrarchan sonneteer, will close up the breech. So, the *blasonneur* is caught in a dizzying game of circularity. Why is she so cruel, he asks, in a fit of self-abnegation. The answer, of course, is because he has made her so, in a generic rather than actual sense. And once he has concluded the construction of the mistress as a fragmented physical entity, animated by vicious delight at his plight, then he can begin the game once again. Here, then, is the basis for that frisson of desire inscribed within the conceit of the beloved as an anatomist. The anatomist is the type of cruel disinterest. But the anatomist is also a self-reflexive figure – a dissector and a dissectee – which perfectly mirrors the erotic exchange of the petrarchan sonnet, the oscillation between donor and recipient which these poems dramatize.

Here, we encounter a link between science and erotic poetry, once more, but in a slightly different form from that witnessed within (say) the Fontainebleau milieu. If lust is, indeed, understood as a 'machine for depriving males of self-identity', then science was to offer an equally forceful means of reclaiming that identity. The stirring of this counter-force can be glimpsed at moments which, on the surface, seem merely to be rehearsing the gestures which Donne or Spenser developed to such extremes. For example, in the hands of a poet such as Edward, Lord Herbert of Cherbury, the blazon was less obviously a vehicle of male anxiety. Herbert's 'A Description' (available prior to 1624 in manuscript form within the court circles in which he moved) appears to be an altogether more sedate performance, when compared with some of his contemporaries. But even here the familiar cycle of puns was in evidence:

> At th'entrance of which hidden Treasure,
> Happy making above measure,
> Two Alabaster Pillars stand,
> To warn all passage from that Land;
> At foot whereof engraved is,
> The sad *Non Ultra* of Mans Bliss.[57]

'Treasure' was by now gaining a new set of connotations. The treasure of Herbert's 'A Description' is sexual, but to voyage beyond the 'ne plus ultra' of the pillars of Hercules, as the title-page of Bacon's *Instauratio magna* (1620) eloquently demonstrated, was to become the project of seventeenth-century natural science, rather than simply the preserve of courtly *blasonneurs*.

The union of natural science – particularly the science of anatomy – and sexuality, so visible at the French court, was not mirrored in the more fragmented world of the Caroline court. Only in the poetry of Thomas Carew (written in the 1630s) do we approach any cycle of texts which are situated so centrally in the blazon tradition. But by the time Carew's courtly

volume of erotic and occasional poems appeared in 1640, the Caroline court was itself soon to become a dismembered entity. During the 1640s, Carew's erotic raptures, together with the anxious familiarity with court personalities which he sought to display in his verses, were features which were to be held up (by puritans) as emblematic of all that was most degenerate about Royalist culture.[58] This was the closet world in which (so one story goes) Carew, lighting the king on his way to bed, stumbled upon Henrietta Maria in the arms of her favourite. In accordance with the courtly code, Carew pretended to fall, extinguished the candle, and thus allowed the queen's lover to escape – an act for which he received the queen's devoted admiration.[59] Carew, a devoted admirer of Donne, as his 'Elegie upon the death of the Deane of Pauls' proclaimed, glanced backwards to the homosocial world of the *blasonneurs* which the civil war was to destroy almost completely. Carew's poetry (like that of Herrick) celebrated the fetishistic moment – objects glimpsed from the corner of the eye, a voyeur's fantasy of glances and blushes, the queen half-glimpsed in an illicit embrace, the sight of a damask rose 'sticking upon a Ladies breast', a meditation on a fly 'that flew into my Mistris her eye', a poem upon a ribbon revered at night in a 'superstitious kisse', and, above all, the reflective exchange of the mirror. Beyond the mirror, however, a different kind of exchange was to be found. It was not enough to seduce the object of desire, rather, the stages of seduction had to be *seen* (or reflected) in order to be appreciated by the poet's peers. The event, in other words, had to be rehearsed for the poet's public – exactly the dynamic of display which lay behind the blazon. So, in the second poem of the 1640 collection ('To A. L. Perswasion to Love'), other connoisseurs – other men – are evoked in the opening lines, even while the desired woman is the ostensible addressee: 'Thinke not cause men flattering say,/Y'are as fresh as Aprill sweet as May' (Carew, *Poems*, 3).[60] It was what other men said which was important in this competition. Sometimes the exchange was overtly commercial, as in the poem 'My mistris commanding me to returne her letters' which begins:

> So grieves th' adventrous Merchant, when he throwes
> All the long toyld for treasure his ship stowes,
> Into the angry maine, to save from wrack
> Himselfe and men . . .
>
> (Carew, *Poems*, 12)

Love letters, the spoils of a prosperous commercial adventure, are sacrificed in order to save, inevitably, not just the poet-lover but his fellow adventurers. The long 'toyle' (in the sexual sense) must be abandoned. The poem 'Secresie Protested' may begin 'Feare not (deare Love) that I'le reveale/Those houres of pleasure we two steale' (Carew, *Poems*, 16) but, in the very

act of protestation, the curtain has been twitched aside and the intimate moment transformed into a public spectacle.

Carew's 'The Comparison' (Carew, *Poems*, 168–9) is his most obvious appearance as courtly *blasonneur*. Here, he glances knowingly at the literary tradition ('Dearest thy tresses are not threads of gold') in the poem's opening, before proceeding to catalogue that to which she is not to be compared. Such (false) comparisons – eyes like diamonds, cheeks like roses, teeth like ivory, skin like alabaster, and so on – are reserved for other men's mistresses: 'Such may be others Mistresses, but mine/Holds nothing earthly'. The competition between men has become an issue of fashion. Other men who praise women in these terms, Carew insists, are failing as poets, failing as lovers, and failing (above all) to keep abreast of the latest fashion. But, in the poem's final lines, the familiar male anxiety surfaces. What if, for all his reduction of the opposition, he is betrayed by the very object of his desire? Hence the urgent plea of the last couplet:

> But as you are divine in outward view
> So be within as faire, as good, as true.
> (Carew, *Poems*, 169)

It is possible (as Kevin Sharpe has attempted to demonstrate) to read Carew's poetry – particularly lines such as those which close 'The Comparison' – as being part of a 'quest for a reconciliation of sensual passion and virtue'.[61] Understood thus, Carew becomes the spokesman for a courtly aesthetic of regeneration circulating around a cult of Platonic love. But, as Sharpe also acknowledges, Carew's poetry offers itself as a series of 'mirrors for men and magistrates'.[62] Sharpe's image is telling. Like the corrupt magistrate Angelo, in *Measure for Measure*, Carew's poetry may have acknowledged the place wherein virtue resided, but its very understanding of the rigours of virtue makes its manipulation as part of the rhetoric of seduction all the more powerful, and the joke (at women's expense) all the more acute. Whether, then, we can read Carew's two most famous (or notorious) erotic poems – 'A Rapture' and 'The Second Rapture' – as being (as Sharpe insists) a vision of a 'paradise in which man's innocence removes the need for a restraint' is, at least, open to a fairly basic series of objections.[63] This may be the critic's fantasy, but it is not Carew's. Carew's fantasy is more violent, more sinister, and more consuming. The titles of Carew's two essays in erotic conquest make this obvious enough. In the seventeenth century the word 'rapture' carried a dual connotation. In its primary sense it meant capture, particularly capture of a woman. In effect the term was a euphemism for rape. The sense of ecstatic transportation, the sense upon which the 'innocent' reading of Carew turns, only became current in the later seventeenth century and during the eighteenth century. That is not to say that Carew's

209

'raptures' are not ecstatic transportations, but the female ecstasy promised in 'A Rapture' is contingent upon her submission to the imperious command of the male narrator with which the poem opens: 'I will enjoy thee now my *Celia*, come'.[64]

'The Second Rapture', by the same token, far from being a vision of innocence, is an essay in violence, couched in the language of mythic seduction. Here, a man reprimands another man in order to demonstrate his virility. In keeping with this programme, and in the characteristic convention of the blazon, the poem opens by addressing not the woman, but another man.

> No wordling, no, tis not thy gold,
> Which thou dost use but to behold;
> (Carew, *Poems*, 182)

Nowhere in the poem's twenty-eight lines is the young girl who is the object of desire addressed. Instead, the text (like the girl) exists only for consumption amongst other men:

> Give me a wench about thirteene,
> Already voted to the Queene
> Of lust and lovers, whose soft haire,
> Fann'd with the breath of gentle aire,
> O're spreads her shoulders like a tent,
> And is her vaile and ornament:
> Whose tender touch, will make the blood
> Wild in the aged, and the good.
> Whose kisses fastened to the mouth,
> Of threescore yeares and longer slouth,
> Renew the age, and whose bright eye,
> Obscure those lesser lights of skie;
> Whose snowy breasts (if we may call
> That snow, that never melts at all)
> Makes *Jove* invent a new disguise,
> In spite of *Junoes* jealousies:
> Whose every part doth re-invite
> The old decayed appetite:
> And in whose sweet imbraces I,
> May melt myselfe to lust, and die.
> This is true blisse, and I confesse,
> There is no other happinesse.
> (Carew, *Poems*, 182–3)

Lifting the veil with all the scopic intensity of the *blasonneur*, or the aged Volpone, the poem must 'use' rather than simply 'behold' the body. That demand for a thirteen year old girl has caused not a few critical anxieties.

Sharpe, in his determination to exonerate both the poem and the court culture which produced it, has provided, no doubt unwittingly, the paedophile's charter: 'For all the explicit eroticism of the imagined sexual union with a young girl, the imagery is religious and the maiden remains chaste.'[65] But the 'true blisse' of the poem (for all its religious imagery) is to 'melt' and 'die' – an explicit rejection of any higher metaphysic. Sharpe's defence of the poem, however, continues a critical tradition which has sought to brush under the carpet what the text so clearly wants to place in the open. Thus, Carew's nineteenth-century editor – Joseph Woodfall Ebsworth – did not hesitate to rewrite the text. In Ebsworth's 1893 edition, 'about thirteen' became 'above thirteen' since, as the editor notes, 'Carew could have had no tainted passion for unripe fruit.'[66] But then neither was Carew (who died in 1640 aged forty-five) actually 'of threescore years and longer' when the poem was composed. The point is that these verses are imaginative exercises pandering to the tastes of fellow courtiers. Those tastes, which 'The Second Rapture' evokes in such detail, circulate the female body as a collection of fragments so that 'every part doth re-invite/The old decayed appetite'. Private fantasy circulates within the public domain, just as Carew and Suckling, in a poetic dialogue published in Suckling's posthumous collection, *Fragmenta Aurea* (1646), fantasized on a woman walking in Hampton Court gardens, mentally undressing her in order to see 'the parts denied unto the eye', creating the homosocial bond, once more, around which this culture revolved.[67]

To see 'the parts denied unto the eye' was, of course, the mainspring of the licensed explorations of the anatomist. Like the courtier, the anatomist's scopic desire alighted on the object, and took that which was once whole into pieces, so that it could be re-created as a new 'body'. In the court, this new body was constructed as a fantasy of male consumption and pleasure. The Elizabethan court, in contrast to its Caroline successor, manipulated the same set of poetic and aesthetic registers, but allowed those fantasies of domination and dissection to flow in a more complex articulation of fantasy around the queen's body. In the anatomy theatre, on the other hand (whether it is an Elizabethan, Jacobean, or Caroline structure that we have in mind), the re-created body was a fantasy object of knowledge, from whence flowed control and mastery. But the two worlds, the theatre of the court and the theatre of dissection, did not operate in divergent universes. Carew's poem '*Celia* bleeding, to the Surgeon', was emblematic of the correspondence we are tracing. The surgeon and the courtier-poet confront one another over the prone female body. 'Celia' is no more than a 'Crystall case' which the surgeon's 'steele' can 'incise'. But the compulsion to lay claim to the female body was impossible to resist on the part of either science or poetry. The dissective power of the surgeon (so the poet claims) is weaker

211

than the dissective gaze of the poet. To the surgeon's exclamation 'Behold she bleeds', the poet replies contemptuously:

> Fool, thou'rt deceived. . .
> Thou struckst her arme, but 'twas my heart
> Shed all the blood, felt all the smart
>
> (Carew, *Poems*, 42)

No clearer expression of male fantasy forcing female experience into redundancy could be imagined.

Female bodies were not just cut up within anatomy theatres. Within the court, they were cut up in literary texts in order to be circulated as a specifically *male* knowledge of women. The fact that this knowledge was grounded in fantasy is crucial to the symbolic representation of *Anatomia*, since the fantasy dissection of the female body in literary texts helped to fashion the actual dissection which took place in anatomy theatres. The European courtly tradition of the *blason* which we have traced through the courts of François I, Elizabeth I, James I, and Charles I, foregrounded, then, an erotic mode of partition and division of the body. Without an understanding of the courtly milieu in which women's bodies were both the vehicle and the currency of wit, it is difficult to understand the symbolic dimension of anatomy in the later seventeenth century. The court world may have been a closed book to most people alive in the period, but its values, nevertheless, permeated the community at large, even when the response to those values was resistance or even outright 'rebellion'. To those involved in the culture of dissection, moreover, the court was a magnet. Physicians anxious to gain preferment were, as would be expected, alert to the subtle nuances of meaning located in the court. And the anatomy theatres, second only to the playhouses as sites of large-scale public performances, provided the perfect stage upon which clever and ambitious men could demonstrate their skill. Just as the courtiers relished the opportunity to demonstrate their wit over and above the female body, so the physicians and anatomists could consume bodies – particularly female bodies – in front of an admiring, and largely male audience. Out of those scattered organs a career could be built, and even wealth, honour, and nobility attained. If a poetic reputation could be constructed, in the court, via the fantasy reduction of the female body into its constituent parts, then a scientific reputation could also be built at the expense (this time) of real as opposed to literary bodies. How, then, were the actual bodies of women understood in the seventeenth century? And what happened to the voyeuristic gaze of the courtier-poet, once the anatomists had provided him with something entirely fresh to gaze upon?

212

PITILESS RIGOUR: THE REPRODUCTIVE BODY

The erotic partition of the female body, which male poets of the sixteenth and early seventeenth centuries indulged to such extravagant lengths, was part of a wider regime of manipulation and control of women's bodies which stretched back through the European religious, philosophical, and literary traditions to St Paul and even earlier. The female body was, of course, somehow different from its male counterpart. But what, exactly, was the nature of that difference? In exploring that difference, the natural philosophers of the Renaissance could not shrug off either the erotic dimension which we have encountered in the courtly blazon, nor the scriptural tradition. But the two – the erotic and the scriptural – co-existed in an uneasy tension which circumscribed the female body. Any account of that body in early-modern culture has to be alert, first, to the competing influence of Aristotelian and Galenic theories of biological reproduction; secondly, to the tradition of patriarchal control grounded in St Paul's interpretations of the fall of humankind; and, thirdly, to religious traditions of representation of the Female both as the allegorized 'church' – the ideal partner of Christ – and as the ideal figure of womanhood: the Virgin. Woven within these three domains, however, was the more intangible (and for that very reason, more pervasive) tradition of the female body as the *licensed* site of male erotic desire, manifest, as we have seen, in the Renaissance penchant for erotic partition and division. But for the male body to become the explicit focus of male desire (where 'desire' could encompass both knowledge and sexuality) it first had to be re-created as female. It is this fourth element, for example, that helps us to understand the 'feminization' of the male body (akin to that 'feminization' of Christ in the passion which we have already encountered) when it lay on the dissecting slab; or the transformation of the body of Marsyas in Golding's translation of Ovid into 'one whole wound'. This 'feminization' of the male body was most apparent in the frontispieces to Renaissance anatomical works. Often, it is only with great difficulty that we are able to tell whether the subject of the dissection represented on the title-pages of sixteenth- and seventeenth-century anatomical texts is male or female. As Thomas Laqueur has reminded us, the politics of gender in anatomical illustration is not a simple matter.[68]

Modern commentators on Renaissance ideas about sexual difference have become increasingly indebted to the 'one-sex' model of understanding early-modern biology. Thus, so the argument goes, prior to the eighteenth century, there was only one sex, and that sex was male. As Laqueur has written:

Sometime in the eighteenth century, sex as we know it was invented. The reproductive organs went from being paradigmatic sites for displaying

> hierarchy ... to being the foundation of incommensurable difference. ...
> Here was not only an explicit repudiation of the old isomorphisms but also,
> and more important, a rejection of the idea that nuanced differences between
> organs, fluids, and physiological processes mirrored a transcendental order of
> perfection. Aristotle and Galen were simply mistaken in holding that female
> organs are a lesser form of the male's and by implication that woman is a lesser
> man.[69]

Setting aside the problem of whether or not it is possible to talk about a
single, unified, theory of reproduction in the period (or, indeed, in any
period), the 'one-sex' model rests on the interpretation of the Aristotelian
idea that (as Constance Jordan writes) the female was 'by nature a defective
male', and that, in the act of generation, a hierarchy of functions could be
observed with the male contributing 'motion and form to the embryo, and
the female only matter'.[70]

But, in exploring the 'one-sex' model, we need to be aware of the status
of metaphor within scientific discourse.[71] With more than thirty years of
practical experience behind her, the seventeenth-century English midwife,
Jane Sharp, described conception as an undoubtedly hierarchical process:
'Man in the act of procreation is the agent and tiller and sower of the
ground, woman is the patient or ground to be tilled'. But is this evidence
for the 'one-sex' view? Sharp suggests a more complex exchange. The
woman's role in conception is, she continued, to bring seed 'as well as the
man to sow the ground with'.[72] The key term, here, is 'ground' – Jane
Sharp's word for the specific anatomical structure which is the uterus. In
fact, attending to Jane Sharp's richly metaphoric language, it becomes
apparent that her biological theory is far more complex than the 'one-sex'
model tends to allow, since that model tends to ignore the quasi-autonomous
nature of the uterus – that Medusa's head – in early-modern physiological
discourse. Equally the 'one-sex' model tends to ignore the fluid metaphoric
language with which men and women in early-modern culture described
their own bodies. An illustration from a much earlier anatomical work makes
the point. Figures 26 and 27 show sequential dissective figures from
Berengarius' *Isagoge Breves* (1522). In the first image, the classical figure
emerges from under a cloak, and, like Pygmalion's unnamed creation, she
steps down from her pedestal in the familiar gesture of art becoming life. In
the second image, the woman gestures towards the excised uterus which has
been placed on the pedestal from which she herself has just stepped. As in
all such images, the details rehearse a complex pattern of meaning. The
woman's left foot comes to rest on closed books, whilst she gestures with her
right hand towards her uterus. A great cloak which she supports swirls about
her. What is she telling us? First, she demonstrates the primacy of ocular
evidence – the evidence of dissection – over classical (written) authority.

Secondly, the vigorous gesture with which she points to the uterus seems to demonstrate her mastery over that organ, an erstwhile independent agent of the body. But the conjunction of the two images points to a third meaning which centres upon the folds of the cloak. In the first image, the woman seems to step out of the cloak and into 'life', so that what we see is an image of birth. In the second image, the cloak still enfolds her, whilst the uterus is in the position she once occupied, signifying the belief that the cloak–uterus is mastering *her*, not the other way around. Her identity, moreover, is entirely determined by the uterus, to an extent that it is possible for her own position on the pedestal to be assumed by just one anatomical organ: the uterus, in effect, *is* the woman.[73]

In Jane Sharp's late seventeenth-century account, we can see that very little had changed from the time of Berengarius. What the woman provided was a 'place' for the uterus to reside where it received the offerings of both male and female: 'the womb is that field of nature into which the seed of man and woman is cast, and it hath also an attractive faculty to draw in a magnetic quality, as the lodestone draweth iron, or fire the light of the candle', Sharp wrote.[74] The relationship was analogous to the print allegory which we have already encountered. The woman was the *locus* for the 'matrix' from which is drawn the infant, or the printer's font. In order to make the font, from which discourse itself can be produced, the matrix must be 'filled' with lead.[75] A very different (in twentieth-century terms) kind of text provides an analogue to Sharp's description: Spenser's Garden of Adonis (*Faerie Queene* III.vi). In Spenser's poetic interplay of Aristotelianism, filtered through Neoplatonism, the cycle of conception, birth, death, regeneration, and rebirth is played out against a rich metaphoric backcloth of floral abundance, a sensual garden corresponding to Sharp's 'ground' of the 'field of nature'. At the centre of this garden of conception is a cavern of moist fertility:

> Right in the middest of that Paradise,
>> There stood a stately Mount, on whose round top
>> A gloomy grove of mirtle trees did rise,
>> Whose shadie boughs sharpe steele did never lop,
>> Nor wicked beasts their tender buds did crop,
>> But like a girlond compassed the hight,
>> And from their fruitfull sides sweet gum did drop,
>> That all the ground with precious deaw bedight,
> Threw forth most dainty odours, and most sweet delight.
>> > (*FQ* III.vi.43)

Within the female '*hortus anatomicus*' is located the *mons veneris*, beneath which in 'the thickest covert of that shade' is a 'pleasant arbour' (44) where

Adonis – the male principle of generation – lies 'in secret . . . /Lapped in flowres and pretious spycery' (46).[76]

Jane Sharp was writing some thirty years after the publication of Harvey's work on conception – *De generatione animalium* (1651, translated into English in 1653). Her understanding of the *process* of generation was, however, entirely consonant with the flow of images to be found in a poetic text published some seventy years earlier. This congruence of language in both science and poetry was perfectly expressed in contemporary images of the foetus shown *in situ*. The metaphoric creation of the uterus as a 'field' in which the foetus was nurtured came to be expressed in the extraordinary and beautiful 'flowering foetus' images which appeared in mid-seventeenth-century anatomical manuals, one of which appears in Jane Sharp's own text. In Spigelius' work on the formation of the foetus (*De formato foeto* of 1627), for example, we can see the metaphor of vegetative growth in pictorial form (Figure 28). The foetus lies, couched like Spenser's Adonis, a flowering bud encircled by petals. The shoot of new growth which bursts from the tree-stump upon which the woman rests her knee, equally, echoes Spenser's description of the cyclical garden of fertility.

Both the Spigelius and the Berengarius images also illustrate the fact that, like their male counterparts, the female subjects of Renaissance anatomical dissection were represented as willing participants in the complete process. This sense of participation is very different from later modes of female representation inherited from the nineteenth century. Elizabeth Bronfen, in her discussion of Gabriel von Max's painting *Der Anatom* (first exhibited in Munich in 1869), describes the picture's subject – an anatomist contemplating the female corpse which he is about to dissect – as a feminine body which:

> appears as a perfect, immaculate aesthetic form because it is a dead body, solidified into an object of art. The aesthetically pleasing unity this corpse seems to afford draws added power from the fact that implicitly we know it is about to be cut into.

Von Max's painting, Bronfen argues, is paradigmatic of nineteenth-century representations of 'feminine death' – where 'stillness, wholeness, perfection' presage 'the dissolution of precisely those attributes of beauty'.[77] The fracture of this ideal sense of completeness is a function of natural forces – the decay and putrefaction of the cadaver – rather than the anatomist's scalpel. Struggling to arrest this biological process, Bronfen suggests, is the *raison d'être* which underpins the creation, in the late eighteenth and nineteenth centuries, of waxwork anatomical museums such as La Specola in Florence.[78] For Renaissance artists, however, such a poised tension between wholeness and dissolution – an aesthetic investment in the liminal moment where an

216

active masculine science defines itself in relation to the passive female form – would have been inconceivable. Instead, the desire to explore the female body, to cut beneath the skin and open it to the admiring gaze of fellow observers (whether poets, painters, or anatomists) was impossible to resist. At the same time, the woman, just as much as the man, had to be shown to be aiding and abetting the process of her own deconstruction. Hesitation before the female form (of the kind that Bronfen describes) is a nineteenth-century invention, one entirely foreign to the ruthless dynamism of Renaissance explorations of the human figure – particularly the female human figure.

This dissective dynamism was rooted in a profound awareness of the conjunction between profane representation, empirical science, scripture, and ecclesiastical doctrine, circulating around the representation of the female body. This awareness, in turn, tended to stress the endless *divisibility* of the female body. The perfect body, of course, was male – entire, whole, complete – a harmonious union of form and matter. And the most perfect male body was that of Christ, who, despite (or rather because of) the mortification endured during the passion, and his depiction as the broken and passive object of contemplation in the numberless images of the *pietà*, nevertheless preserved his essential spiritual and aesthetic unity. Hence the symbolic importance of the self-division which was re-created in the Eucharist. The 'sacrifice' of the mass was not the offering of a broken or incomplete body, but a perfect object of adoration voluntarily subjected to partition as a means of redemption. Christ's body, moreover, was the pattern of unity upon which rested the super-structure of the church – *Ecclesia*. But, as we have already seen, there also existed a tradition of Christ represented as a nurturing female body. This tradition, as Gail Kern Paster suggests, determines the symbolic representation of the church as '*ecclesia lactans*' – the nurturing church.[79] *Ecclesia* was thus female, the nurturing body of Christ and the bride of Christ. According to St Paul, *Ecclesia* was composed of parts – members – gathered together to form the greater unity of the universal church. *Ecclesia*'s body was not, therefore, itself ideal. If Christ, as St Augustine explained, was the head of this body, its perfection lay at some future date when all the members had been gathered in order that completion would be achieved 'in due time'.[80]

The female body of the church was evident in St Augustine's interpretation of Genesis as a typological foreshadowing of the creation of the christian church.[81] In a passage which squarely confronted the nature of sexual difference (prompted by the question 'Will women retain their sex in the resurrected body?'), St Augustine demonstrated how the Eucharist, the body as a pattern of unity, and myths of division and origin, could be bound together in a harmonious fusion of scriptural interpretation and Neo-platonic reasoning:

Now in creating woman at the outset of the human race, by taking a rib from the side of the sleeping man, the Creator must have intended by this act, a prophecy of Christ and his Church. The sleep of the man clearly stood for the death of Christ; and Christ's side, as he hung lifeless on the cross, was pierced by a lance. And from the wound there flowed blood and water, which we recognize as the sacraments by which the Church is built up. This, in fact, is the precise word used in scripture of woman's creation; it says not that God 'formed' or 'fashioned' a woman but that 'he built it (the rib) up into a woman'. Hence the Apostle also speaks of the 'building up' of the Body of Christ, which is the Church. The woman, then, is the creation of God, just as is the man; but her creation out of man emphasizes the idea of the unity between them; and in the manner of that creation there is, as I have said, a foreshadowing of Christ and his Church.[82]

In the Renaissance, christian attitudes towards the human body (whether dead or alive) were informed at every level by an awareness of this potent symbolism of partition, division, and reunification. If anything, during the sixteenth century, when the schism of Reformation and counter-Reformation had divided the church, the language of union and disunion became even more relevant.[83] Such wide-ranging recourse to a symbolic language, however, meshed with a network of popular beliefs which understood the body as a fragile unity, all too easily rendered into its constituent parts. Once the body was dispersed, then it seemed to possess a new significance in the popular mind. As we have seen, the complex question of dispersed burial, for example, and the effect on bodily resurrection such a dismemberment of the cadaver might possess, was endlessly debated in the period, despite St Augustine's fifth-century ruling that the fate of the body was of no real consequence to its eventual resurrection.[84] But whatever St Augustine may have said, to those who took part in popular religious disturbances of the time, the body was a powerful signifier of an individual's own religious (and hence political) identity. Desecration and dismemberment of corpses, even the buying and selling of the genitalia and internal organs of one's religious opponents was, as Natalie Zemon Davis has observed, a recognizable feature of urban religious unrest. Such activities, Davis argues 'can be reduced to a repertory of actions, derived from the Bible, from the liturgy, from the action of political authority, or from the traditions of popular folk justice'.[85]

We have already seen how such patterns of belief could be incorporated into the representational vocabulary of anatomy in the early-modern period. Equally important, however, was the circulation of such beliefs within a complementary pattern of discourse which discovered the female body within a context that was overtly erotic. So, the divisibility of the female body sprang from what, to modern eyes, appear to be two contradictory impulses:

the religious figure of the church as the female partner in union with Christ, and the erotic court culture of the Renaissance – one of whose most influential representational gestures was the 'building up' (to use a term common to St Augustine and sixteenth-century anatomists) of the ideal female figure.

If anatomy was a science of *seeing*, and thus knowing and controlling the body, in order to harness its appetites and desires, then it would be more surprising still if the female body existed in a space reserved from erotic speculation. Art, in particular, mediated this encounter between (or rather creation of) a male science which observed and a female subject who was observed. But the encounter was not one determined simply by an active male gaze confronting a passive female subject. The exchange, in the Renaissance, was at once more complex, and more overt. Spenser's 'Bower of Blisse' in *The Faerie Queene* (*FQ* II.xii) perfectly captures the mediation of science through the devices of art. Like Adonis in Book III, Acrasia and her lover Verdant also lie in a '*hortus anatomicus*' – a natural landscape endowed with fertile corporeality. Within this landscape, Guyon and the Palmer approach Acrasia's bower, in order to 'display/That wanton Ladie': a moment in which the speculative and a kind of fearful desire merge into one another in a fashion which is overtly anatomic. The 'constant paire' – representatives of puritan and masculine 'rigour' – crawl through 'covert groves and thickets close' (a foretaste of the 'gloomy grove' and 'thickest covert' of the garden of Adonis) until Acrasia herself is discovered, like a foetal flower 'Upon a bed of Roses. . . faint through heat', which is the product of her 'late sweet toyle' (*FQ* II.xii. 77–8). This 'toyle' is the labouring work of conception which Guyon observes through a 'veyle of silk and silver thin,/That hid no whit her alabaster skin'. The veil through which Acrasia is observed is 'a subtile web', a 'fine net' – a membranous downy film which is described in terms of the sixteenth-century vocabulary of anatomy.[86] The post-coital reverie which Acrasia and her lover, Verdant, enjoy is the moment of conception where heat and moisture, form and matter, are mingled together. But the moment of conception also signals a loss of masculine identity. Here is that 'disastrous slide back into the female' which *Henry V* had set out to avoid, and which animated the courtly blazon. Acrasia's sexuality is all-mastering, able to transform the rational masculine intellect into a world of beast-like appetite associated with the feminine. Verdant (in whose name a vegetative principle is enshrined) is ensnared within this female principle, a principle which Guyon destroys 'with rigour pittilesse', smashing the delicate artistry – the 'groves . . . gardins . . . arbers . . . cabinets' of Acrasia's domain (83).

The destruction of Acrasia's bower with 'rigour pittilesse' is a paradigmatic moment where we can see the conjunction of art and speculative masculine

science triumphing over the 'dangerous' female body. Outside the confines of art, however, the female body, understood as the site of the labour of reproduction – what Cowley was later to call 'the great work' – was anxiously sought after by the anatomists. The juxtaposition of Spenser's luxurious poetic gestures with the brutal reality of the Renaissance execution site may seem gratuitous. Yet, 'rigour pittilesse' – the destruction of organic integrity played out at the expense of 'The Bower of Blisse' – was exactly what took place on the scaffold. And for women, in particular, this 'rigour' produced scenes of the most terrible cruelty. For, if the scaffold afforded male bodies for the anatomists with some degree of regularity, female bodies were an altogether rarer commodity. Thus, the prospect of obtaining a female body seems to have sharpened the appetites of the anatomists. Ironically, it was male attempts to police the very processes of female reproduction which, in the early-modern period, often led women to the scaffold and, thence, to the anatomy theatre. Anne Greene, for example, who was hanged at Oxford in 1651 and whose 'miraculous' revival on the anatomy table has already been described, was sentenced for the crime of infanticide, as was another unfortunate woman, known simply (in Anthony à Wood's account) as 'T'.

The history of 'T' is not only a story of cruelty. It (briefly) allows us a fleeting glimpse of the kind of resistance offered by women to this masculine science. In May 1658, 'T' was hanged at Greenditch, Oxford 'for murdering her infant-bastard'. Taken by William Coniers of St John's College, and other 'young physitians' to be anatomized, she was found to be still alive, where-upon the bailiffs, hearing of her 'revival':

> went between 12 and one of the clock at night to the house where she laid, and putting her into a cofin carried her into Broken hayes, and by a halter about her neck drew her out of it, and hung her on a tree there. She then was so sensible of what they were about to do, that she said, 'Lord have mercy upon me,' &c. The women were exceedingly enraged at it, cut down the tree whereon she was hang'd and gave very ill language to Henry Mallory, one of the baillives when they saw him passing the streets, because he was the chief man that hang'd her.[87]

This appalling account opens the door into the realities of the world of 'rigour pittilesse', in which a group of women struggled to preserve the life and the body that the law and science had demanded. Shortly after the hanging of 'T' another case of revival took place at Oxford. The bailiff, Mallory once more, attempted to re-hang a woman convicted of infanticide who had been cut down whilst still alive.[88] But these stories prompt another question. Is it coincidence that these well-documented accounts of 'anatomical revival' involved women? Women were executed with much less frequency than men in the early-modern period. In the 1650s following the

publication of Harvey's *De generatione* and in the vicinity of the university and the physicians' college, trainee physicians would have been eager – over-eager – to seize upon female corpses, particularly the corpses of women of a child-bearing age.[89] Just as Rembrandt was drawn to the scaffold in order to see, and record, a hanged woman, so the young physicians seized their opportunities when they came.

A more famous account of a woman being anatomized (though one drawn from an entirely different locale, and a chronologically earlier period) gives some substance to this speculation. Figure 29 shows Vesalius' notorious image of the vagina and uterus conceived of as a 'penis'. This image has been much commented on by adherents to the 'one-sex' model of the history of the understanding of sexual difference.[90] Vesalius' text does, however, go some way towards explaining why this extraordinarily phallic rendition of the female reproductive organs should have been produced. Only very rarely, Vesalius records, was he able to procure female bodies, and hence he had to rely on the evidence culled from autopsies, and from grave-robbing.[91] This image was the product of one such expedition. According to Vesalius' modern commentators, the uterus was obtained:

> from the body of a woman who had been the mistress of a certain monk. Vesalius and his pupils, hearing of her death, snatched the body from the tomb, but, unfortunately, [sic] the monk together with the parents of the girl complained of the outrage to the city magistrates so that the anatomist and his students were compelled to dismember and free the body from all skin as rapidly as possible in order to prevent its being recognized. Since they had stolen the body expressly to examine the female organs, the best they could do was to encircle the external genitalia with a knife.[92]

And thus was produced an image which has often been termed monstrous and grotesque.

But, of course, that was exactly the point. The female body *was* held to be monstrous and grotesque, a region of erotic desire governed by the quasi-autonomous uterus, which lurked, like Acrasia in her bower, ready to transform heroic masculine rigour into luxurious sensual excess. The story of Vesalius' expedition to the tomb of the unnamed woman who was so hastily stripped of the marks of her humanity and reduced to the metonymic presence of a single (male) organ, conceals a profoundly significant feature of the Renaissance culture of dissection. Classical myth and narrative, so popular in the period, were replete with stories of male figures conquered by an ungovernable female principle. These narratives became the subject matter, again and again, of artistic representation: Botticelli's *Mars and Venus* repeated the theme, as do the stories of Hercules and Omphale, Bacchus and Ariadne, and, of course, Antony and Cleopatra. The woman's role, as

Diana Coole has described the christian tradition which stemmed from St Augustine, was associated with the control of her 'subversive appetite'.[93] The literature of the Renaissance was populated with sinister female figures – the sisters of Acrasia – who, in the guise of Alcina in Ariosto's *Orlando Furioso* (1532) or Armida in Tasso's *Gerusalemme liberata* (1581), traced their origin to Circe in the *Odyssey*. What was so sinister (to men) about this female principle was its attractiveness to the male observer: the 'covert groves', as Spenser expressed it, were endlessly fascinating to 'hungrie eies'. The observation and anatomical reduction of the female body explicitly confronted this masculine erotic desire whilst at the same time it claimed to master that desire within the fracturing impulses of science, or knowledge. Spenser's image of the destruction of the 'Bower of Blisse' was the poetic counter-point to the anatomical 'rigour' with which the contemporaries of Vesalius sought to trace the principle of the creation of life, located within the all-consuming womb or matrix.

The search for this principle encouraged the appetites of the anatomists. Those women who suffered such extremes of cruelty in the seventeenth century were the victims not only of the emerging science of biology, but of a European artistic tradition which located within the female body the source of a disturbing and dislocating power. Certainly, there was something congruent in the cold, male fury with which Spenser's knight of 'temperance' destroyed the subversive female principle of Acrasia, and the voracious appetite of the Renaissance anatomist willing to risk the law and public outrage in pursuit of his understanding and scientific mastery over the female body. The literary tradition, which sought to master the female body in such widely varying historical and artistic moments, was constantly looking back over its shoulder to that moment of origin, the myth of separation which, as Jonathan Dollimore writes, was to 'help legitimate the subjection of women and violence against them for centuries to come'.[94]

The womb or uterus was an object sought after with an almost ferocious intensity in Renaissance anatomy theatres. Here was not only the principle of life, but the source of all loss of rational (male) intellect. Once the uterus was seen, however, it had to be mastered in a complex process of representation. Mastery over and above the uterus informs some of the most beautiful (and disturbing) images of anatomy that have survived from the early-modern period. In those images, too, we can see the ways in which the female body could be reconstructed (as the *blasonneurs* had reconstructed it) as something both fetishistically adored, and violently suppressed. In Figure 30 (taken, once more, from Spigelius' work of 1627) the woman's abdomen has been dissected. The image is, however, more than a representation of the female body. The figure's pose and gestures are reminiscent of Baroque images of the Virgin, gesturing in benediction towards her devotees. But

even here, within such a sacred frame of reference, the great cloak, symbol-izing the all-mastering uterus, swirls around the figure, as it had in the images published by Berengarius over one hundred years earlier. A more disturbing set of images of the female interior was produced in the same period. Around 1618, Pietro Berrettini da Cortona produced a series of drawings made from dissections undertaken at the Santo Spirito hospital in Rome (Figure 31). The drawings remained unpublished until 1741, when they were engraved by Gaetano Petrioli, surgeon to the King of Sardinia (Figure 32).[95] Petrioli's engraving compensated for the lack of detail in Berrettini's drawing by suspending against the rigid architectural back-ground, the reproductive organs under discussion. If anything, the 1741 duplication of the opened anatomical structure emphasized the opposition between the flowing human form, and the oppressive, triumphalist, rigidity of the architectural background, a device which serves to display the female body as all the more sensual and, at the same moment, fragile. The organic female form had to be shown to be subjected to the severe super-imposition of architectural order which reared above it. But, older, symbolic, patterns of representation were also at work. Berrettini's figure peels back the surface tissue of her body, and, in so doing, she appears to create grotesquely misplaced genital labia, as though her body is no more than the vehicle for a vagina which dominates the complete abdomen. Amidst this 'shameless' display, however, the old religious motif of 'shame' is repeated. If she is casually made to open herself to the gaze of science, then science could not resist moralizing her body even as it stared into her: the 1741 engraving of the enlarged uterus fixed to the suddenly corporeal background wall discloses a tiny foetus *in situ*, which covers its eyes as though in recoil from the act of disclosure to which it and she are subjected.

We have already seen how such an image has its place in the transforma-tion of scientific representation out of religious art in fifteenth-century representations of the *gravida* figure – a tradition to which Spigelius' image (Figure 30) was also indebted. But we can trace Berrettini's act of disclosure even further back, to the *sheela-na-gig* figures to be found, carved in stone, on the corbels and capitols of churches in England and Ireland in the middle ages. Margaret Miles has argued that such images, where 'female grotesques ... displayed their splayed vaginas', were reminders of the 'dangerous power of female sexual organs'.[96] The sexual organs of the female were the visible sign of the woman as the 'vessel' within which (men hoped) legitimate children were conceived and nurtured. It was only through controlling this reproductive process that the male's name and property could be transferred from one generation to the next. At this point, the conjunction of the female form and the monumental architecture in the background of the Berrettini image seems to underline the relevance of the

223

older *sheela-na-gig* motif. The Renaissance *sheela-na-gig*, just like her medieval counterpart, is displayed as an architectural motif. But, in keeping with a rational philosophy of enquiry, her overt function is no longer either to celebrate fertility or to warn of the dangers of female sexuality (though both may be implied). Rather, she opens herself to a gaze which is anchored in the regime of knowledge which, by the early years of the seventeenth century, was rapidly displacing older networks of religious belief.

But those same networks of belief still provided the symbolic core of the 'performance' of anatomy. To open the female body was not just to embark upon a voyage of scientific discovery, but it was also to trace the lineaments of the rebellious nature of womankind. That rebellious nature could undermine the smooth transfer of material goods from one generation to the next, just as, in the garden of Eden, it had *seemed* to undermine the divine plan itself. Every female body which found its way into the anatomy theatre was, therefore, a potential second Eve, just as every male body was a potential second Adam. To be an Eve, however, was very different from being an Adam within the patriarchal structure of early-modern culture. If the Renaissance anatomy theatre, in its modes of ritual and representation, offered the suggestion of redemption to the male cadaver, what it offered to the female was the reverse: a demonstration of Eve's sin, a reinforcement of those structures of patriarchal control which, so the argument ran, were necessary to avoid a repetition of that first act of rebellion in the garden of Paradise.[97] Thus, the Leiden anatomy theatre, and its counterpart in England – Inigo Jones's lost temple of mortality – both featured the founding moment of human transgression in their ornate decoration. In the predominantly protestant cultures of the Low Countries and England, with their theological and social stress on the significance of the Fall, the anatomy theatres looked back to that original moment for their most arresting visual motif. In other words, what we have already identified as the punning conceit on the iconography of Adam and Eve within the anatomy theatre (the invention of death within the temple of death), was, as it were, refocused, once it was Eve rather than Adam who was being dissected. Once Eve was transported into the theatre, then the investigation of the origin of death was buttressed by the pressing theological, social, and scientific need to master her aberrant sexual nature. The anatomical knowledge of Eve, therefore, was perhaps a *more* important project than knowledge of Adam who was, after all, no more than the 'victim' of her unruly desires.

With the production and dissemination of ever more detailed accounts of the body understood as a *mechanism*, however, some authorities began to grow distinctly uneasy at the circulation of these images and accounts. If we think of the fantastic decoration of the anatomy theatres, together with the mannered articulation of the illustrations in the textbooks, as devices which were

explicit attempts at controlling how the body was to be understood within a predominantly religious context, then a point was to come when the power of such devices was itself questioned. Were architecture, illustration, ritual, and the endless protestations of the 'divine' nature of this science enough to preserve a predominantly patriarchal view of the nature of human sexual difference? If the female body existed in the same Cartesian universe as the male, and both were no more than machine-like entities, then what guarantee could maintain patriarchal structures, with their dense layers of hierarchical and determinedly organicist metaphors? The female body was already acknowledged to be an unruly entity, and the very seat of that potential rebellion was the 'field of nature' described by Jane Sharp, the uterus. How could this body be controlled under the pressure of Cartesian analysis?

If the detailed investigations of the scientists were to lead to a challenge to the more simple verities of St Paul, then this knowledge of the body, particularly the female body, might have to be policed more rigorously, if not suppressed completely. In England, it is possible to date this struggle to establish control over knowledge of the female body almost to the month. We have already encountered Helkiah Crooke's syncretic work in which many of the images under discussion were published in England. But Crooke's *Microcosmographia* appeared only after considerable debate. Parts of the text were in circulation in November 1614, when John King, Bishop of London, was reported to have been affronted by passages from Books 4 and 5 of Crooke's work. The passages objected to were those describing 'the parts belonging to generation'. The Bishop secured the support of the President of the College of Physicians, who condemned the volume and informed Crooke's printer, William Jaggard, that if the work appeared without alteration it would be destroyed.

The condemnation of Crooke's work has been understood by medical historians as, essentially, a matter of professional dispute. At issue was the whole question of whether such works should be published in the vernacular, and thus be allowed to circulate before a wider audience.[98] From the record of the *Comita* of the College, held on 11 November 1614 in order to investigate the affair, the question of vernacular publication was debated:

> several thought that a few subjects and more indecent illustrations should be removed, and other points ought also to be corrected, while many considered that book four with the pictures of the generative organs should be destroyed and that he [Crooke] should be enjoined to confess that it was a translation, that is of many subjects from Laurentius . . . and of . . . Bauhin.[99]

The point, of course, was that such illustrations (derived from numerous continental sources, including Vesalius and Valverde) had been in circulation in England for the past fifty years or more, and that the production of

syncretic works was, equally, hardly an innovation on Crooke's part. Instead, Crooke's 'crime' was to conjoin the illustrations and an English text at a moment when theological sensitivity was particularly intense. Scripturally based notions of patriarchal rule were part of the very fabric of puritanism, at a time when domestic religious policy was one of constant compromise and negotiation between competing factions within the (predominantly) protestant establishment.[100] So, whilst it is easy to dismiss the objections of Crooke's fellow physicians as a combination of prudery and obscurantism, it was also the case that there was an *ideological* stake in controlling the ever more detailed dissemination of public information on the operation of the reproductive body. If, in the main, as Diana Coole writes, 'patriarchalism provided a horizon for all English political thought in the seventeenth century', then we can more readily begin to explain the growing sensitivity, on the part of medical professionals in England, to the implications of the discoveries of continental anatomists in this sphere.[101] In England, in the early years of the seventeenth century, *any* vernacular discussion of the mechanism of generation was potentially a dangerous topic. In 1618, for example, Sir William Paddy, president of the College of Physicians and a friend of Archbishop Laud, was to object to Crooke's election as a Fellow of the College of Physicians because the candidate had written, so it was claimed, a letter to the king describing how, in public dissections, members of the College 'exhibited the human body of either sex to be seen and touched and that they cut up indecent parts and explained each separately in the vernacular'.[102] Paddy's objection was that Crooke, once more, was guilty of encouraging public discussion of sexual differentiation. Who could know where such discussion would eventually lead?

The evidence that we possess for tracing the understanding of the female reproductive body in the early-modern period is still contradictory and hazy. Part of the contradiction, however, lies in our modern unwillingness to allow our early-modern forebears access to a dense, subtle, interlocking language of simile and metaphor. All understanding of the body was mediated through such a metaphorical web, which was spun, in particular, out of scriptural texts. Female sexuality was *known* to be a potentially transgressive force, because that was the message of the scriptures interpreted and reinterpreted through patristic authority, catholic and protestant exegesis, and the spoken word of the pulpit. The metaphors which surrounded the female body – metaphors such as we have encountered in Spenser's poetry, or in medical images – may have expressed the body's fertility, but they also underlined its existence as a source of a dangerous male delight. Thus, metaphors acted not only to explain function (or dysfunction) and struc-ture, but to constrain the body within the overarching organization of patriarchal authority. As long as the metaphors were in place the female

body was a subject entity. It was for this reason, more than any other, that the fantastic codes of representation – their complex and detailed affirmation of the harmony of scripture and science – informed Renaissance anatomical investigation of the female body.

For women, subject to the dangers of childbirth, the primacy of scriptural experience was paramount as a comfort and as a related means of understanding the pain and danger which they endured. For pregnancy and labour were not only biological activities, but reminders of every woman's direct participation in 'the fallen procreation of Eve and her Old Testament daughters'.[103] Thus, scriptural texts also acted as a means of fashioning an internalized system of suppression and domination. Very occasionally, we can glimpse a woman struggling against this pervasive system, questioning the analogical discourses within which her own language (of necessity) was formed. But usually, the result was failure. Mary Carey's moving meditation of 1657 – 'Upon the Sight of My Abortive Birth' – seems to deploy the network of metaphors which enclose the female body in order to assert her own identity (and body) as a free agent, rather than as the vehicle of scriptural exegesis. But the struggle was unequal. The prevailing system of metaphor anchored her words to the predominant discourse of surveillance and control as firmly and inevitably as did the marginal scriptural references:

. . . It is in Christ; he's mine, and I am his;	Cant.2.16
this union is my only happynese:	
But lord since I'm a Child by mercy free;	
Lett me by filial frutes much honour thee;	John.15.8
I'm a branch of the vine; purge me therefore;	John.15.2
father, more frute to bring, than heertofore;	
A plant in God's house; O that I may be;	Psal.92.13.
more flourishing in age; a growing tree:	
Lett nott my hart, (as doth my wombe) miscarrie;	
but precious meanes received, lett it tarie;	
Till it be form'd; of Gosple shape, & sute;	Phil.1.27
my meanes, my mercyes, & be pleasant frute:	
In my whole Life; lively doe thou make me:	Isa:4.1
for thy praise. And name's sake, O quicken mee;	Psal.143
Lord I begg quikning grace. . .[104]	

This poem is a demonstration of Mary Carey's acceptance of God's will, made all the more poignant by our knowledge that the stillbirth which it commemorates represented the sixth child she and her husband had buried. But the poem also demonstrates just how the prevailing systems of metaphor structure the devastating but, in seventeenth-century terms, familiar experience of child-loss, and the threat to the woman's life which

pregnancy and labour represented.[105] For Mary Carey, even as she demands of God a 'quikning grace', has already located the source of her sadness (and her religious consolation) in her own physiology which is itself a product of her own sinful nature. Earlier in the poem, questioning 'of my sweet God/ The reason why he took in hand his rodd?' she provides the theologically inevitable answer:

> Methinks I hear God's voyce, this is thy [the] sinne;
> And Conscience justifies the same within:[106]

God's patriarchal voice is internalized. Her own puritan conscience will confirm the harsh judgement. As another woman, the Countess of Lincoln, put the matter in 1622: 'We have followed Eve in Transgression. . . . Let us follow her in Obedience.'[107] As though she had heard the Countess's admonition, Carey offers the fruit of her body to Christ as cement to the bond which unites her and her saviour. Her religious identity, too, is determined by the familiar metaphors of conception and growth ('I'm a branch of the vine. . . . A plant in God's house'), whilst, in keeping with the images we have already explored, her womb is understood as a dangerously rebellious entity, denying her, through its stubborn resistance, the (theologically acceptable) role as fruitful mother, and prompting the anxious reflection that her religious zeal ('my hart') must not, like her womb, 'miscarie'.

Comparing Carey's poem with a similar text by a male writer – and Ben Jonson's 'On My First Son' is an immediate and obvious point of comparison – we may well be prompted to agree with Charlotte Otten that Carey's use of 'female reproductive metaphors . . . establishes her female identity, and . . . brings her female experience into an area free from male mediation'.[108] Certainly, Jonson's chronologically earlier poem (his son died of the plague in 1603), when we come to it after reading Carey's meditation, appears to speak from a different world, one in which poetic device is altogether more consciously on display – a display encapsulated in the famous lines:

> Rest in soft peace, and, asked, say here doth lie
> Ben Jonson his best piece of poetry;[109]

where Jonson's identity as a poet (no matter how 'sincere' the epithet may be) is asserted over and above his identity as a bereaved father. But this freedom from male mediation which Carey's poem may, at first, suggest is only momentary. Reproductive metaphors – webs, flowers, fruit, cloaks – ensnared women, rather than guaranteed them autonomy. Once we have replaced Carey's poem within the metaphorical domain of sixteenth- and seventeenth-century accounts of the female body, accounts produced primarily by men for other men, then whatever freedom may have been attained by women is severely circumscribed. Mary Carey's verses were structured

through her experience of the Psalms, puritan theology, and the prevailing metaphors of medical understanding which were, themselves, embedded within the parameters of a theologically driven society. To escape those parameters (even if such an imaginary escape could have been envisaged) was more than could be achieved by any one individual.

Anatomia – the cultural domain of the Renaissance science of the body – was a hungry goddess, feeding off the bodies of condemned men and women in the cities of early-modern Europe. But the anatomy theatre was not, it seems, the only place where she held sway. Appearing in different forms, she could be discovered not only at the scaffold, but in the very centres of political power. Given the absolute centrality of the body to Renaissance culture – whether understood as a source of fearful anxiety or hierarchical patterns of government – then the perverse vitality of *Anatomia* is readily comprehensible. But *Anatomia* operated according to a rigidly gendered set of rules and prohibitions. To those rules and prohibitions, the art, literature, and science of the body were subservient. With the advantages of historical hindsight, the courtly world of the blazon, and the internalized world of a puritan such as Mary Carey, may seem, now, to be poles apart from one another. But reposition the body – particularly the female body – within either of those cultural spheres and a curiously similar structure emerges: a culture of erotic partition and scientific fragmentation which operated through the same network of metaphors and codes of representation. The question we now have to consider is what happened to the body when that world fell apart. How did *Anatomia* survive the dual pressures of the new science of the later seventeenth century, and, in England, the cataclysm of a political revolution?

'ROYAL SCIENCE'

AUTOGENESIS: THE MASCULINE DISCOURSE OF SCIENCE AND REASON

At some point during the seventeenth century, the great super-structure of Renaissance medical practice and theory – the world of interlocking metaphors of affinity and dissimilarity which held Mary Carey and her contemporaries in such an unyielding grasp – began to crumble, to be replaced by the technological regime in which a new, labouring, body was created. It is impossible to date that moment with any degree of precision. But that something had indeed shifted was suggested by Margaret Cavendish, Duchess of Newcastle, when, in 1655, she complained: 'I never read of anatomie nor never saw any man opened, much less dissected, which for my better understanding I would have done.'[1] Cavendish's plaintive comment indicates an awareness of a new arena of knowledge in which evidential experience of phenomena was of the very highest priority. As a woman, however, Cavendish felt herself to be excluded from that arena to a greater extent, even, than the old medical regime had allowed. The female occupation of midwife, for example, was soon to become a male prerogative. The network of traditional remedies which surrounded the body (male as well as female) and which were administered mainly by women, though they lingered on, were to become the primary health-care system of the rural poor, as opposed to the wealthy, who now had access to a growing urban and commercial system of health maintenance. This transformation can be traced in the growing 'professionalization' of medicine and medical knowledge in the later seventeenth and eighteenth centuries. Prior to that period, as Roy Porter has observed: 'The medical culture of pre-industrial England was . . . centred upon the individual, and God's purposes . . . more than upon disease or the might of medicine.' Within such a context, as Porter goes on to explain, 'educated lay-people might reasonably feel – unlike nowadays – that they could understand medicine on a par with the profes-

sional.'[2] The metaphors through which this traditional society understood the body and its physiology were part of the common stock of received knowledge, so that the distance between 'professional' and 'lay' understanding was simply not that great: the remedies of the village wise woman rested upon a 'theory' of the body which was not so dissimilar to the corresponding 'theory' of the body held by a learned university-trained physician.[3]

Fundamental to the creation of a technological regime of the body, a regime which can be traced to the acceptance of the 'mechanic philosophy' derived in part from Descartes, was the reform of the very language of science.[4] But that reform also had an explicitly gendered dimension; indeed, it is possible to think of the 'new science' of the later seventeenth century as a determinedly 'masculine' creation. That is not to say that older modes of understanding – informed by webs of metaphor and correspondence – were somehow intrinsically 'feminine' whilst the new were intrinsically 'masculine'. To argue thus would be an absurd reduction. But, with the new forms of understanding of the body occasioned by the work of Harvey and his followers, the dominant codes of analysis and description *structured* knowledge in a way which was not only implicitly gendered (as it had always been), but explicitly reliant on a conscious deployment of a gendered language of discovery. In order to understand this new regime, we also need to understand the political implications of a linguistic debate which, in England, in the mid-seventeenth century, was now raging over the body-interior. It was as though the confrontation which had taken place in the fields and hedgerows of the battle-fields of the civil war had been transposed, so that the body became the *locus* of a confrontation between two radically different conceptions of the natural world. The problem in trying to trace these debates, however, is that, just as it is difficult to anchor political allegiance during the civil war years to a specific class, occupation, or locality, so, in the parallel world of the human microcosm, the 'reformers' of the language of the body were not of necessity politically radical.[5] Equally, their opponents, defenders of a more traditional framework of understanding, were not invariably conservative when it came to taking sides within the political sphere.

The study of anatomy was in the forefront of the new philosophical regime. Indeed, for some, it *was* the new science. The exploration of the body was paradigmatic of the possibilities of science itself. So, John Hall, the poet and pamphleteer, a friend of both Hobbes and Samuel Hartlib, who was complaining in 1649 that England was falling behind continental rivals in provision for anatomical study, saw the exploration of the body as expressive of all discourses of reason, which were 'no better way attempted, then if the veynes of things were rightly and naturally cut up'.[6] In 1649 there were many who understood the events in Whitehall in the January of that

year as nothing less than a radical surgery on the body-politic. By then, a new rationalism (or so its supporters claimed) in all investigations of the natural (and hence political) world had become evident. The year before the publication of Harvey's *De Motu Cordis* (1628), George Hakewill, the former chaplain to Prince Charles, cited anatomy as evidence for this new rationalism: 'The noble and useful practise of *anatomizing* mens bodies was never brought into the bodie of a perfect art, till this later age.'[7] The term 'useful' was, of course, the key word. 'Usefulness' was the touchstone of knowledge, the means of judging whether or not an observation or a theory formed part of the new programme of learning, or was merely a retreat back into the vain scholasticisms of what would eventually be known as the pre-scientific age. Everything was to be judged by its potential usefulness, a process which Abraham Cowley, in a telling phrase, was later to describe as 'vertuous covetousness'.[8] It was at this point that anatomy underwent what amounted to an intellectual explosion. By the 1650s, it has been calculated, an average of eighteen anatomical texts were being published in England each year, a threefold increase when compared with the situation in the period before the civil war.[9] By 1653, Nicholas Culpepper – the prolific author and translator of medical texts – was apologizing for adding to a market in medical knowledge which was in danger of being swamped by the sheer volume of material now being produced.[10]

Older certainties, however, still existed. Paracelsianism – the fusion of chemistry, alchemy, christian Neoplatonism, and Hermeticism, based on the teachings of Philippus Aureolus Theophrastus Bombastus von Hohenheim ('Paracelsus' or 'Greater than Celsus') – was central to the defence of the old intellectual order. Emphasis within Paracelsianism on the unity and order of the cosmos appealed to those who were anxious to defend older political and intellectual hierarchies.[11] Robert Burton, who had brilliantly perceived the organizational possibilities inherent within the anatomical enterprise, was nevertheless entirely conservative in his fundamental adherence to the Paracelsian belief in divine order. Burton was not alone. Within the political sphere, we have to recall the ways in which the natural world was scrutinized, by Republican and Royalist alike, for the smallest sign or token of political significance. Thus, the Royalist natural philosopher Sir Kenelm Digby, in the triumphant (for Royalists) year of the Restoration, observed the growth of a bean with all the new-found enthusiasm of scientific empiricism. But he derived from the bean's cracking open and sprouting, a political lesson. When the bean sprouts, Digby wrote: 'inferiour members which should study nothing but obedience, have gotten the power into their own hands: for then everyone of them following their impetuous inclinations, the whole is brought into confusion.'[12] No matter that the bean must crack in order for it to grow. If this much political significance could be

invested in a bean, how much more significant was the human body? Nicholas Culpepper, for one, looked back to those certainties when, in prefacing his translation of Johann Veslingus' *The Anatomy of the Body of Man* in 1653, he echoed the familiar microcosmic claims of earlier generations of anatomists: 'he that knows himselfe aright cannot but know all the world, because he is an Epitome of it'.[13] The following year, in his translation of a Paracelsian work by Simon Partlicius, Culpepper was to repeat this defence of an older system of reasoning. Anatomy taught 'the harmony between one part of creation and another . . . the analogical comparation and reductions of all things' since:

> whatsoever is in the universal world is also in man; not according to a certain superficial similitude as some fools prattle; but in deed and in reality, are contained in him whatsoever is in the whole theatre of the world.[14]

In the same year (1654) that Culpepper published this attack, another Paracelsian, Robert Turner, was describing the heart as: '*primum vivens & ultimatum moviens* . . . seated severally by himselfe, in the midst of the breast as Lord and King over all the members, and all the members receive the blood of life from the heart.'[15] But what happened when the 'heart' had been expelled from the body-politic, as had happened in England? In fleeing back to the world of microcosmic order, Culpepper and Turner were aligning themselves with a network of intellectual conservatism which found itself fighting a rear-guard action against the encroaching forces of post-Cartesian, post-Harveian rationalism. Ironically, in the case of Culpepper, his allegiance to Paracelsian modes of analysis placed him in the same intellectual camp as those he had fought against as a soldier in the Parliamentarian armies. The same was true of Henry Pinnel, a former chaplain in the Parliamentarian army, and a translator of the Paracelsian, Oswald Croll. In 1657, Pinnel published his intellectual manifesto, *Philosophy Reformed and Improved in Four Profound Tracts* (a translation of writings by Croll and Paracelsus), which asserted the cosmological hierarchies running throughout the natural world. Anatomy, in particular, was seen as vital to the underpinning of these hierarchies, providing that it was seen as a holistic undertaking: 'It is not the local anatomy of a man and dead corpses, but the essential and elemental anatomy of the world and man that discovereth the disease and the cure.'[16] It was a sentiment which almost perfectly expressed the rationale of Donne's Anniversary poems of 1611–12. The politics of seventeenth-century science, however, were no more clear-cut than the politics of the civil war period itself. Harvey was, of course, a loyal subject of the king. But the political implications of his work were clearly understood by his contemporaries. If the analogical system were to collapse, then what would sustain the complex linguistic structure which supported the mon-

arch's centrality in the 'healthy' body-politic, or, the father in the family, or even God's seat in heaven as the true *ultimatum moviens*? We can see the enormous political importance which was attached to the interpretation and understanding of the human body in the work of Alexander Ross, chaplain to Charles I, Vicar of Carisbrooke, and author of an attack on Galileo in 1634, which, in its title (*De terrae motu circulari*), also glanced at Harvey's work on the blood. Ross's attack on Galileo was renewed in 1646, when he published *The Newe Planet No Planet*, a work which contained an explicit defence of the political status of the body:

> I said that the sun in the world is as the heart in mans body, but the motion of the heart ceasing, none of the members stirre; so neither would there be motion in the world if the sun stood still: *This* (you say) *is rather an illustration, than a proof.* I grant it . . . Illustrations oftentimes are forcible proofs, and used they are both by Divines and Philosophers.[17]

'Illustrations oftentimes are forcible proofs' – in that phrase Ross was summarizing a language of natural philosophy which was already redundant. But Ross understood, perhaps better than many of his contemporaries, the implications of the anatomists' discoveries. A world of affinity was collapsing, and the most ardent agent of its destruction was the anatomist – the incarnation of a new atheism, according to Ross who warned his audience: 'take heed you play not the anatomist . . . in the curious and needless search . . . you may well lose your selfe, but this way you shall never find God.'[18]

The anatomist's credo – Know Yourself – had become exhausted. In 1651, prompted by the publication of Harvey's second major work, *De generatione animalium*, Ross entered the lists once more with the publication of his *Arcana microcosmi*, the very title of which ('the secrets of the microcosm') hinted at its conservative agenda. *Arcana microcosmi* undertook to refute 'Doctor Browne's VULGAR ERRORS, the Lord Bacon's NATURAL HISTORY and Doctor Harvey's DE GENERATIONE'.[19] Attacking Sir Thomas Browne, the great discoverer of endless similitudes, might appear to be something of an own goal on Ross's part, but it was Browne who, in *Pseudodoxica epidemica*, of 1646, had specifically turned against 'all deductions from Metaphors, Parables, Allegories, unto real and rigid interpretations'.[20]

Browne's objection to analogical methods of reasoning was to echo throughout the 1650s and beyond, as the move to establish a reformed language of science gathered force. We have already seen how Harvey, as though responding to political change, subtly altered his own system of comparison when his translation of *De Motu Cordis* appeared in English after the execution of Charles I. Harvey's finely nuanced linguistic shift foreshadowed the larger programme for linguistic reform which, in England, was gathering pace during the final years of the Commonwealth. The

reshaping of the language of science – a manifesto for a new language stripped of embellishment and decoration – can be linked to a wider, predominantly protestant, suspicion of all forms of decorative discourse. Insistence on the 'plain sense' of scripture, as Margarita Stocker has observed, led to a puritan mode of address which 'favoured a vigorous directness' felt by many (though not all) to be consonant with an emerging scientific rationalism.[21] But the appeal to 'vigorous directness' in the 1650s did not just spring from those whose politics and religion aligned them with Republicanism. It was, after all, Thomas Hobbes in *Leviathan* (1651), who had been foremost amongst those calling for a new language of science, since:

> In . . . all rigourous search of Truth, Judgement does all; except sometimes the understanding have need to be opened by some apt similitude; and then there is so much use of Fancy. But for Metaphors, they are in this case utterly excluded. For seeing they openly professe deceipt; to admit them into Councell, or Reasoning, were manifest folly.[22]

Hobbes's dislike of 'Metaphors, Tropes, and other Rhetoricall figures' within the 'Discourse of Reason and Science' was shared, too, by such 'irrationalists' as the iatrochemist Jean Baptiste Van Helmont, whose works were being translated into English in the 1650s.[23] In 1662, when Van Helmont's *Oriatrike* was published in England (it had first appeared as *Ortus Medicinae* at Amsterdam in 1648) the anti-Paracelsian sentiments which were expressed were entirely in accord with Hobbes's views:

> The name therefore of Microcosm or Little World is Poetical, heathenish, and Metaphorical, but not natural or true . . . the life of man is too serious, and also the medicine thereof, that they should play their own part of a parable or similitude, and metaphor with us.[24]

Van Helmont's objection to the 'poetical' nature of Paracelsian language was mirrored by the more 'orthodox' scientist Joseph Glanvill. In his *Vanity of Dogmatizing*, of 1661, Glanvill warned against the habit of using words 'arbitrariously' or 'distorted from their common use' – a seemingly random dislocation associated with metaphor – which, so he argued, leads the mind into 'confusion and misprision . . . and so things plain and easy in their naked natures, are made full of disputable uncertainty'.[25]

Glanvill's post-Restoration ideal of a reformed scientific language – nakedly simple – was to be the much-vaunted linguistic touchstone of the Royal Society. At issue, of course, was a search for a type of linguistic origin, a moment of Edenic purity of expression. It was as though language, just like the body, had become bifurcated or fractured within Eden. Thomas Sprat, in his *History of the Royal Society* (1667), argued that, during the civil war (understood by many as a second devastating Fall), language itself had

become anarchic. It had developed 'many fantastical terms . . . and outland-ish phrases'.[26] From this babel of 'jangling noise' – Milton's phrase for the scriptural Babel in *Paradise Lost* (XII. 55) – Sprat argued that the task of the natural philosopher was to restore order, to develop a language of 'useful-ness' once more:

> to reject all the amplifications, digressions, and swellings of style: to return back to the primitive purity, and shortness, where men deliver'd so many *things*, almost in an equal number of *words* . . . preferring the language of Artizans, countrymen, and Merchants, before that of Wits and Scholars.[27]

Language had to be put to work, rescued from an effete court culture, and harnessed to the enterprise of a mercantile economy. Or, as John Wilkins put the matter, language had to appear in all its 'native simplicity' un-disguised with any 'false appearance'.[28] The distrust of 'appearance' – the surface glitter of things or words – was a function of what Peter Dear has described as the dominant rhetorical ethos of the Royal Society, where individual 'experience' of the 'actuality of a discrete event was the central point to be established'.[29] This stress on individual experience (experience from which Margaret Cavendish was aware that she was now excluded), combined with the demand for a mode of address unmediated by the embellishments of figurative language, was clearly derived from puritan roots, whatever the precise ideological and religious allegiances of particular individuals may have been.

Of course, it is easy to see how the terms with which the natural scientists were describing their own attempts at linguistic reform – 'native simplicity', 'primitive purity', and 'naked natures' in opposition to 'false appearance' – could mesh with an ideal of protestant womanhood which also intersected with a predominantly puritan ideal of the early church. The language of science should be like the appearance of the protestant church itself – plain, unadorned, simple. Perhaps, even, it should accord with the language of devotion as George Herbert had described it before the civil war, in his poem 'Jordan (1)':

> Must all be vail'd, while he that reades, divines
> Catching the sense at two removes?[30]

'Catching the sense at two removes' was precisely what the Royal Society sought to avoid. Instead, like Spenser's pitiless knights, crawling towards the bower of Acrasia intent on lifting the veil and demolishing the world of artifice and sensual delight – the deceptive surface of representation – the linguistic reformers of the 1650s and 1660s envisaged their task to be a heroic and 'vigorous' assertion of male prowess over a protean and recalcit-rant 'female' natural world.

The triumph of a strident masculinity over a submissive and cowed feminine Nature within the discourses of science was entirely in accord with the poetico-political language of the moment.[31] But the attempt at purging the language of science of all its 'specious TROPES and FIGURES' (as Sprat thundered in his *History*) required a certain degree of rewriting of allegorical tradition. So, Cowley's 'Ode to the Royal Society' (prefaced to Sprat's 1667 *History*) began by rearranging the gender of the protagonist. A female *Philosophia* would never do for this resolutely masculine endeavour. Philosophy was a 'He' since (Cowley noted in parenthesis): 'whatsoe'r the Painters fancy be,/It a male virtue seems to me'. The problem, Cowley explained, was that Philosophy has been 'feminized' by a sickly-sweet diet of poetic tropes and figures. Just as Verdant, languishing in Acrasia's bower, had lost the use of his 'warlike armes', so Cowley's Philosophy has been seduced:

> That his own bus'ness he might quite forget,
> They amus'd him with the sports of wanton Wit,
> With the Deserts of Poetry they fed him,
> Instead of solid meats t'encrease his force;
> Instead of vigorous exercise they led him
> Into the pleasant labyrinths of ever fresh Discourse:
>> Instead of carrying him to see
> The Riches which do hoorded for him lye
>> In Natures endless Treasury,
>> They chose his Eye to entertain
>> (His cur'ous, but not cov'tous Eye)
> With painted Scenes, and Pageants of the Brain.[32]

Too much poetry, it seems, addles the mind and shrinks the male organ. From active participation, science had become ensnared in voyeuristic entertainment. To be simply curious was, therefore, not enough. What was needed was a 'cov'tous Eye' – a rapacious and Comus-like consumption of the world's riches – which would be able to distinguish (as both Herbert and Hobbes had argued in quite different contexts) the 'True' from the merely 'painted'.[33] It was as if, Cowley seems to say, Philosophy had wasted his days in the 'effeminate' ambience of court culture, gazing at masques ('painted Scenes and Pageants of the Brain') whilst nibbling on a delicate (probably French) sweetmeat.

Cowley's account of the progress of philosophy, liberated from the 'sports of wanton Wit', denounces both scientific endeavour in a generalized past which stretches back into antiquity, and the historically specific culture associated with the pre-civil war Caroline court's 'cult of Love'.[34] As such, the 'Ode to the Royal Society' answered those pro-Republican texts of the early and mid-1650s, such as Marvell's 'Horatian Ode' and 'The First

Anniversary of the Government under O.C', which abounded with images of penetration and male generation in order to celebrate the 'virility' of the Commonwealth which was embodied in Cromwell. Cowley's 'Ode', then, sets itself up as a specific challenge to the Republican discourse of political virility. Marvell's 'Cromwellian' poetry was the target. Just as male Philosophy in the 'Ode' had been lost in 'pleasant labyrinths of ever fresh Discourse' until invigorated by 'solid meats', so in Marvell's 1655 celebration of the first year of Cromwellian government we read that the English polity is 'Like the vain Curlings of the Watry Maze' until it is disturbed by Cromwell who 'with greater Vigour' is imagined as gushing over the nation in a 'fertile Storm' which not only impregnates the land but even (in a memorable understatement) 'wet the king' (Marvell, *Poems*, 108, 114). In much the same way, in 'To His Coy Mistress' (composed *c.* 1646–53), Marvell had dismissed the elaborate structures of courtly blazon – the languishing years spent in division and redivision of the female body – in favour of a Cromwellian 'rough strife' which will 'tear' its way through 'Iron gates' (Marvell, *Poems*, 28).[35] A new, perhaps monstrous, birth was in prospect.

Cowley's determined gendering of the language of scientific poetry reflected a more general Royalist desire to recuperate a masculinity which had been challenged by the mid-seventeenth-century reversal of the natural order. At the same time, if Harvey had robbed the body of all its hierarchical metaphors of kingship, then a new 'Royal' body would need to be created. That creation involved the explicit (once more) appropriation of science to a political view of the world. Science was to become associated with Royalism as a re-emergent, revivified, ideological and intellectual practice. Here, the principle of male generation was the key concept, and William Harvey was the apotheosis of the heroic masculine scientist. Cowley's Harvey, therefore, answered Marvell's Cromwell. Central to the poetic encomia which surrounded Harvey was the fascination with which his work on generation was greeted. When, in 1653, Harvey's *De generatione animalium* appeared in an English translation (following the publication of the first latin edition in 1651) it was prefaced with celebratory verses by Martin Lluelyn which set a tone that was deeply misogynist:

> Experiment, and Truth both take thy part:
> If thou canst scape the Women! There's the Art.
> Live *Modern Wonder*, and be read alone,
> Thy *Brain* hath *Issue*, though thy *Loins* hath none.
> Let fraile *Succession* be the Vulgar Care;
> Great *Generation*'s Selfe is now thy Heire.[36]

The final line is a somewhat laboured gesture towards the childlessness of the marriage of Elizabeth and William Harvey. The point, however, was that

male intellectual autogenesis was the ideal, since it could produce a Harvey who *was* the principle of generation.

No other scientist of the period (in an age of extraordinary scientific endeavour) seems to have been the recipient of *quite* as many celebratory verses as Harvey. This flourish of adulation was not simply a response to the scientific work of the anatomist. Rather, it was the combination of a political imperative and the imaginative recuperation of masculinity to which Harvey's work seemed to answer, that guaranteed his place within the poetic pantheon of post-civil-war, Royalist, intellectual heroism. It did not, then, really matter *what* (culturally speaking) Harvey's discoveries in themselves amounted to. What was important was the language of 'potency' which his work seemed to substantiate. To his contemporaries and his successors, Harvey was an English colossus. These were the terms in which the Royalist physician and poet John Collop addressed Harvey in his *Poesis Rediviva* of 1656. Surging beyond the pillars of Hercules, Harvey needed no Herculean club since his instrument was altogether finer, more deadly, and more accurate:

> . . . thy knife can soon divide:
> *Augean* filth's no work when vy'd with thee,
> Do'st cleanse the Jakes of all antiquitie . . . [37]

All of these tropes, however, were to become crystallized in the extraordinary performance which was Abraham Cowley's 'Ode upon Doctor Harvey'. Cowley's Ode was written prior to Harvey's death in 1657, but not published until 1663 when its final stanza, a gloomy evocation of decay and mortality, became a posthumous memorial to his friend. The publishing history of the poem seems to reflect its content, for it begins as a celebration of Harvey and his work, but ends with a meditation on war and human futility. As a celebratory poem, the Ode is one of a trio of verses which Cowley composed in the late 1650s, celebrating Sir Charles Scarborough (or Scarburgh), Hobbes, and Harvey. What united these three figures, for Cowley, was not just their philosophical pre-eminence, but their politics and their adverse fortunes in the civil war years. Hobbes, of course, had spent the years 1641–52 in exile in Paris, a period during which he was tutor to Charles II. Scarborough was ejected from his Fellowship at Caius College, deprived of his library, and forced to take sanctuary with Harvey in Royalist Oxford. Harvey, who was the king's physician until early 1647, had suffered the loss of his extensive anatomical collections and experimental material when his lodgings in Whitehall were pillaged in 1641.[38] These three intellectual 'victims' of the civil war were emblematic for Cowley of what he termed, in his Harvey Ode, 'a barbarous War's unlearned Rage'.[39]

But it was not as a victim of war that Harvey first appears in Cowley's Ode.

Rather, Harvey is a Cromwellian force (in Marvell's vigorous sense of the Horatian Ode), a violent and revolutionary disturber of old hierarchies, a new Apollo, a heroic voyager of the microcosm, an Ovidian hunter, and (the poem is unambiguous) a rapist:

> Coy Nature (which remain'd, though aged grown,
> A beauteous Virgin still, injoy'd by none,
> Nor seen unveil'd by any one)
> When *Harvey's* violent passion she did see,
> Began to tremble and to flee,
> Took Sanctuary, like *Daphne* in a Tree:
> There *Daphne's* Lover stopt, and thought it much
> The very Leaves of her to touch:
> But *Harvey* our *Apollo*, stopt not so,
> Into the Bark and Root he after her did go:[40]

Here, once more, are the familiar *topoi* of Renaissance scientific revelation – the lifting of a veil (as in Acrasia's bower) and the explicit evocation of male sexual excitement at this act of seeing which is soon to become one of possessing. Cowley's 'Coy Nature' has replaced Marvell's 'Coy Mistress', and where Marvell's poem can only hope to persuade the woman whom it addresses (or threatens), Cowley's poem announces its triumphal possession as an achieved fact. At the same time, we should also note how Cowley's evocation of the flight of Nature is strangely congruent with Carew's pursuit of the female body in the Caroline court.[41] But Cowley's aim was to harness this 'violent passion' to the rigidities of science rather than to courtly luxury. Hence, the reworking of Ovid's account of the story of Daphne and Apollo with which the poem opens. In Ovid (*Metamorphoses* I.450–570), the pursuing god was arrested by the waters of the river Peneus, where the transformation of Daphne into a laurel tree took place. In Cowley's recasting of the myth, the pursuit continues until Nature/Daphne leaps into the circulatory systems of the human body itself and hides within the (hitherto) mysterious ventricles of the beating heart. Harvey, however, is not to be denied. Following his quarry through the blood stream, Harvey eventually holds 'this slippery *Proteus*. . ./Till all her mighty mysteries she descry'd'. Just as in the anatomical representations of the female body which were to be found in textbooks of the period, it is Nature who shows herself to Harvey. To look, however, is not enough. In keeping with the emergent ethos of the Royal Society's stress on actuality, Harvey must experience nature himself. Following the pursuit (in which the circulatory discoveries of 1628 are the focus) come the processes of generation, where Harvey is transformed (just as in Lluelyn's celebratory verses of 1653) into an active participant in the process of procreation, masterminding the creation of life itself:

> He so exactly does the work survey,
> As if he hir'd the Workers by the day.[42]

Of course, the poem does not end on this note of male triumph. Like a modern argonaut, Harvey returns with his golden fleece of knowledge only to see his vessel sunk 'eve'n in the Ports of *Greece*'. Subject to the consuming force of war and time, the poem's conclusion imagines the decay of Harvey in old age, and the triumph, ironically, of his own body over his wit. Nature is revenged on her hunter, and the reader reminded that this female principle remains a rebellious and factional entity, in constant need of male surveillance.

Cowley's Ode to Harvey, with all its masculine codes of sexual possession and male generation, echoes the codes within which both Hobbes and Scarborough had been celebrated when the Pindarique Odes had appeared in Cowley's earlier *Poems* of 1656. At the end of the 'Ode to Mr Hobs', Cowley had invited his subject to 'Enjoy the *Manhood*, and the *Bloom* of *Wit*,/And all the *Natural Heat*, but not the *Feaver* too'. Whilst Scarborough was described as wedded to the arts of Apollo, to an extent that (in a bizarre manipulation) seemed to restore his (female) patients not only to health, but to virginity.[43] But this conceit was a reversal of Cowley's more familiar array of images in the Odes. Rather, images of conception and birth – reproductive metaphors of all kinds – were constant presences within the collection of 1656.[44] Again and again, Cowley turned to the language of the womb. Contemporary fascination with the problem of generation – particularly after the publication of Harvey's work in 1651 and (in English) in 1653 – may account for something of Cowley's intense interest in the topic, as, obviously, would the friendship he had formed with Harvey in 1641. But there was something more than the celebration of male friendship at work in these texts.

To understand this recourse to a language of generation and birth in the work of the foremost poet of the new science, we need to replace these texts in the precise political moment of their creation. Equally, the attempt at linguistic reform on the part of the early Fellows of the Royal Society, with such a stress on the stripping away of the ornaments of language, can be understood as part of the same, fundamentally political, dynamic. We have seen how Marvell, in his celebrations of Cromwell, for example, chose a deliberately 'virile' series of images to celebrate the new, Republican, model of masculine virtue. It was to this paradigm that Cowley was answering. As David Norbrook has argued, one of the chief rhetorical devices mobilized by Republican apologists during the 1650s was the celebration of 'Republican activism' at the expense of 'monarchical lethargy'.[45] As Lawrence Stone has also pointed out, prior to the civil war, in the 1620s, and in the years immediately preceding the regicide in 1649, attacks on the degeneracy of

241

the court circulated widely, encouraging the view that Whitehall represented a 'sink of financial corruption and sexual depravity, fit only to be destroyed by men of integrity'.[46] The determined 'masculinization' of science, then, with its stress on the 'potency' of Royalist scientific intellectuals such as Harvey or Scarborough, answers to this sustained Republican critique of Royalist *virtu*. Science, after 1660, had entered the political arena with a vengeance. Harvey (a victim of the war, but a heroic example of intellectual fortitude), with his rhetorically apposite work on generation and embryology, provided the perfect vehicle for shaking off the charge of 'languor', of asserting a potent, masculine, heroic and Royalist view of the political world. We can see a similar aesthetic at work in the verses of John Collop. Collop's collection *Poesis Rediviva* appeared in 1656, and its attitudes seem to encapsulate the Royalist concern to counter Republican charges of degeneracy with the assertion of vigorous science. Collop's poem on Harvey, who (as we have seen) was imagined as clearing the sewers of antiquity, ends with a violent series of allusions to Harvey's work on circulation, pictured as a revitalization of the nation's blood, which will result in the 'bloody victory' of 'Truth'. In Collop's poem on George Ent, one of the earliest defenders (in 1641) of Harvey's doctrine of circulation, Harvey again dominated the stage. William Harvey was a new William the conqueror: 'Not conqueror of a Land, but whole worlds name./Intitled to it by each drop of blood'. The entitlement (a charged word both in mid-seventeenth-century Republican and monarchical discourse) of this new Norman conqueror was, of course, a red rag to the bull of fundamentalist Republicanism, and one that, in 1656, would have been immediately understood by the contemporaries of the Levellers and True Levellers, who drew so extensively on the 'Norman Yoke' theory in order to explain the establishment of monarchism.[47] For Collop, Harvey was a new conqueror whose 'dissecting hand' would make 'errors bleed', and 'lash whimp'ring folly' in order to become the 'Midwife' of a reborn Nature.[48]

Challenged, internally, by mechanism, and externally by the forces of a new order of government, the body had to be entirely remoulded. This was the task which Royalist science set itself in the years following the civil war. Stability, order, rationality, systematization, solidity, the privileging (as Helen Burke notes, following Deleuze and Guattari) of homogeneity over heterogeneity, these were the hallmarks of 'Royal Science'.[49] Firmness, solidity, proportion, concord, were also the attributes of the new nature celebrated by Cowley in his Ode to Hobbes. To the contemporaries and immediate successors of Hobbes and Harvey, the understanding and (hence) conquest of the body now seemed a distinct possibility. No longer was the mystery of the body to be allowed to dazzle the eye of contemplation, as it had Donne's eyes in the early years of the century when, looking into his own body, he

saw only fluid dissolution. Rather, the body contained a mechanistic *process*, no different in kind from other processes and systems which operated in the natural and social worlds. The circulation of money, for example, within the economy (a problem which had much exercised the Commonwealth authorities in their concern to maintain confidence in the currency) could be understood as, essentially, a Harveian process.[50] Thus, the anatomist Walter Charleton, in his later (1683) anatomical lectures was to look back to Harvey (mediated by Hobbes's comments on currency circulation in *Leviathan*) when he observed that money was:

> the blood of all states, as well monarchies as republicks, for the support of the government: so the office and work of the heart is to stamp the character of vitality upon the mass of the blood, for the maintenance of life in the whole animal oeconomy.[51]

Though this might, at first, appear to be a flight back into the metaphoric world of the microcosm, what Charleton was stressing was the essential mechanism of circulation rather than any analogical resemblance. The heart was no longer enthroned as a passive object of contemplation, nor was it supposed to be exerting a quasi-mystical monarchical influence on its surrounding tributary members. Instead, it had an 'office' and work to perform within the larger structure of a mechanical process.[52] Circulatory systems indebted to Harvey – this time in the realm of trade and commerce – provided the opening motif of Dryden's *Annus Mirabilis* (1667), where a blockage in trade 'which like blood should circularly flow' had to be removed so that, as the poem's final lines expressed the matter, trade, commerce, and 'Eastern wealth' could be attained.[53] Knowledge, too, was imagined as blood circulating through the intellectual world, as Sir John Denham's poem 'The Progress of Learning' affirmed.[54] For Dryden, the link between science (particularly the science of the body), prosperity, and (after 1660) monarchy was quite clear. In his poem prefaced to Walter Charleton's work on Stonehenge – *Chorea Gigantum* (1663) – Dryden understood the huge stone circle to be emblematic of a monarchical tradition which stretched back into antiquity. Charleton, in revealing Stonehenge to be a throne, rather than a temple, had thus, Dryden claimed, demonstrated the *political* validity of Royalist science. Stonehenge 'proved' the antiquity of kings, and this proof could be added to the catalogue of scientific triumphs (the work of Bacon, Gilbert, Boyle, Ent, and, of course, Harvey) which mirrored the martial and commercial vitality of the newly restored nation.[55]

The newly restored nation, then, was being imagined as a true participant in a greater psycho-sexual union, a union which Dryden celebrated in his Restoration Ode of 1660 – a poem which abounds in images of sexual union between the restored and potent king and the revitalized (female) nation.[56]

243

Harvey's work on embryology and the mechanics of sexual reproduction seemed to address this new-found potency in an extraordinarily fortuitous manner. Embryology was *Royalist* science at its very best. Nurtured (if that is the word) at Royalist Oxford during the civil war, the investigation of the mysteries of generation became emblematic of a refashioned intellectual life. How could such a culture be understood as 'degenerate' (so post-Restoration propaganda asserted) when the central mystery of life itself was being unravelled by its scientific representatives, even as war raged around them?

The scientific culture of the Restoration celebrated the body in a way which was deeply enmeshed within the political moment. But that celebration also hinted at a profound psycho-sexual fear. If, during the civil war, the puritan Lady had triumphed over the aristocratic fecundity of Comus (to draw on Milton's 1634 'Masque'), now it was the turn of Comus to assert his masculine desire, and unlock and enjoy the splendid hoard of natural wealth which austere abstinence had refused him. The emasculation of 1649 had to be restored not just by a returning king, but by a cultural reinscription of masculine intellectuality. Hence the significance of Milton's 'Comus'. '*Comus* is about Rape', Catherine Belsey has trenchantly written:

> the recurring tale of the helpless virgin depends on the recognition of female vulnerability, of wide-spread and apparently inevitable male rapacity . . . constructing two complementary stereotypes: for women feminine dependency and for men a virility which can be committed to good or evil.[57]

As early as 1634, Milton had begun to understand the tendency of the emerging scientific character of his age. Comus' speech in praise of the bounties of nature, which the lady in the masque set out to refute, was much more than a dismissal of stoicism and austerity. It was also an invitation to possess nature, to master and hence control the superfluity of the natural world:

> Wherefore did Nature pour her bounties forth,
> With such a full and unwithdrawing hand,
> Covering the seas with spawn innumerable,
> But all to please, and sate the curious taste?
> And set to work millions of spinning worms,
> That in their green shops weave the smooth-haired silk
> To deck her sons, and that no corner might
> Be vacant of her plenty, in her own loins
> She hutched the all-worshiped ore, and precious gems
> To store her children with . . .
>
> (Milton, *Poems*, 211–12)

Here, uncannily, are the paradigms of seventeenth-century 'dominion over

nature' which Baconian enterprise had promised. The fecundity of nature is there to 'please' and 'sate' a rapacious taste which (as the Royal Society was to proclaim so vigorously) should remain for ever 'curious'. Such curiosity would engender industry – the 'green shops' of the 'millions of spinning worms' seem to prophecy a coming revolution in industrial process – one of the foremost promises of material gain which the Royal Society sought to encourage.

It was precisely these stereotypes – feminine dependency and luxury plundered by male virility – that 'Royal Science' sought to establish. 'Royal Science' developed a stridently aggressive language of appropriation and domination from which science, particularly biological science, has never recovered.[58] Of course, we can understand the Royalist celebration of scientific achievement as an attempt at uncovering a genuinely a-political species of national endeavour. The nation may have been riven by the convulsions of civil war – a monstrous birth to some – yet science is supra-political. But to see the poetic celebration of the reproductive Restoration 'body' in this optimistic and (I would argue) naive way is to ignore the psycho-sexual dynamic that texts such as Cowley's Odes conjure with at every turn. This, after all, was the culture which bred an exaggerated machismo, ruled by a king whose 'sceptter and his Prick are of a length' as Rochester wrote in 1673. It was also a culture busily asserting its 'masculine' prowess as a (fairly desperate) form of psycho-sexual reintegration.[59]

Rochester's poetry, indeed, gives us the true dimensions of the darker side of the new science of the body and the assertion of 'masculinity' inherent within the dominant metaphors of conception explored by 'Royal Science'. If Cowley looked to the acceptable, rationalist, progressive frame of scientific culture (never mind that his central image for the triumph of rational will was rape), then Rochester alerts us to an equally violent desire to master the rebellious female body. The difference, however, is that, in the changed world of the 1670s, Rochester understood the futility of such a project. In poem after poem, Rochester turned to the female body only to encounter fluidity which seemed to consume all male solidity, so that his masculinity was forced to 'dissolve', 'melt', and 'spend at ev'ry pore' ('The Imperfect Enjoyment').[60] These visions of male surrender culminated in the fury of the famous 'Ramble in St James's Park', which looked back (from 1673) to the historical 'birth' of the 'strange woods' which sprang from 'the teeming Earth', as though reordering Harvey's pursuit of his mistress through 'all the moving wood/Of Lives' in Cowley's Ode.[61] More than this, Rochester's park was a place of 'promiscuous' inter-mingling of classes, kinship relations, and sexual preferences. The civil war had been a time of tempestuous anarchy, disunion, and a splitting apart of that which, formerly, was held to be indivisible. The ultimate image of dislocation (as Lovelace's 'A Mock Song'

expressed it) was the radical surgery of the scaffold of 1649 (Lovelace, *Poems*, 154–5). But a figure such as Harvey could be imagined as representative of a new order of material 'restoration' of the natural world. Cowley, Harvey, and Rochester were all three explorers of the reproductive body, though their results differed wildly. If Harvey appeared to have conquered the 'mystery' of nature's reproductive processes, then it was left to Cowley to transform that conquest into the matter of myth, and Rochester to warn of the alternative path that might have been pursued: one that led into the tangled and promiscuous groves of St James's Park.

Milton, of course, tried to see the matter differently. For Milton, in *Paradise Lost*, enquiring Adamic (that is human) reason should heed the angelic warning of Raphael: 'Be Lowly wise. . . . Dream not of other worlds' (*PL* VIII. 173–5). But against this example of self-limitation ranged rebellious Eve (once more) and the Satanic potency of 'Royal Science'. Satan, indeed, was a figure who would have found his peers amongst the newly created Fellows of the Royal Society. His impulses were scientific in that new sense which the Society sought to cultivate – a restless, covetous, enquiring curiosity. Milton's Satan, with all his delight in the trappings of monarchy was a supreme (and self-deluding) example of the restless endeavour of rationalism without God. Leaving the technological world of Hell behind him, as though he were the embodiment of the Royal Society's enquiring voyager who sets out, like Collop's Harvey, to journey beyond the pillars of Hercules, Satan embarks on a colonizing voyage to discover and plunder 'another world' (*PL* II.346) of which he has, hitherto, heard nothing but mythic traveller's tales. This 'Bold design' (*PL* II.386) seems to echo the enterprises of the Royal Society. In a revealing phrase – one with which (apart from its polite restraint) Satan might have addressed the infernal conclave – the first secretary of the Royal Society, Henry Oldenburg, wrote to John Winthrop, Governor of Connecticut, just two months after *Paradise Lost* was licensed: 'Sir, you will please to remember, that we have taken to taske the whole Universe, and that we were obliged to doe so by the nature of our dessein [sic].'[62] The Satanic 'bold design' and the Royal Society's grand designs of taking to task 'the whole Universe' seemed to answer one another. John Collop had imagined Harvey as setting up sail, voyaging through the body in order to discover 'new worlds', where would be found true knowledge, not the 'dust' mistaken for knowledge proffered by 'the serpent'. For another Royalist scientific poet, Barten Holyday – a former chaplain to Charles I – Harvey was the new Columbus, creating through his discoveries a new world: 'Man's new *America* speakes Harvies Art.'[63] Hobbes, too, was imagined by Cowley as 'thou great *Columbus*' who had heroically crossed a 'vast *Ocean*' of ignorance not only to discover an '*America*', but to colonize it so that it would appear '*planted, peopled, built,* and *civiliz'd*' by

Hobbesian intellect. For these Royalist enthusiasts, the metaphor of the scientific voyage expressed boundless optimism. Ironically, for the scientists themselves, the metaphor of discovery had already given way to the metaphor of mechanical invention.

Nevertheless, a similar language of heroic scientific discovery possessed Milton's Satanic voyager – an ironic icon of failure, as the ultimate design of *Paradise Lost* reveals. Milton's Satan is described (*PL* II.636–42) metaphorically as a trading fleet, or, in an allusion which Cowley had fixed to Harvey, as the Argo herself (*PL* II.1017). Satan crosses a sea which is not quite sea, and land which is never land, a place of confusion where 'Hot, Cold, Moist, and Dry . . ./Strive . . . for mastery' (*PL* II.897–8), as they had once done in the temper and humour of the body itself. Cowley's Harvey had swum through the human microcosm; Milton's Satan transforms that microcosm into the universe itself. But Satan and Harvey, for Milton, stood closer still. Just as Harvey was celebrated for his intellectual autogenesis, so that he was imagined as the generative principle of generation itself, so Satan is a figure of generation and self-generation. Self-generation, the denial of fatherly authority – 'self-begot, self-raised/By our own quickening power' (*PL* VI.860–1) – is the retort of Satan to Abdiel's reminder of filial duty.

For Milton, then, the potency of 'Royal Science' – the fertile world of Comus – was entirely untrustworthy. Where Cowley saw a new harmony and concord in the mastery of 'coy Nature', Milton saw a transgressive and vain desire, a vision of monstrous birthing. Paradoxically, Milton shared that vision with Rochester who was equally sceptical of rational optimism and equally pursued by visions of strange births. Rochester's incestuous encounters within the 'all-sin-sheltering Grove' of St James's Park, with the 'pensive lover' who:

> Wou'd frigg upon his Mothers face
> Whence Rowes of Mandrakes tall did rise
> Whose lewd Topps Fuckt the very Skies
> . . .
> And nightly now beneath their shade
> Are Buggeries, Rapes, and Incests made[64]

seems like an echo of the 'pensive' (the word is Milton's), pregnant figure of Sin encountered by Satan in an alternative image of generation to that proposed by Harvey and celebrated by his peers. Ranging through the universe (like Rochester's restless narrator in 'The Ramble'), Satan's voyage brings him face to face with a different species of embryology. Sin, born (like Athene from Zeus) out of the head of Satan, becomes the mother of Satan's son, Death, who, Sin recounts, 'breaking violent way/Tore through my entrails' (*PL* II.782–3). Death, with all the 'violent passion' which Cowley

had celebrated in Harvey's pursuit of Nature in his Ode, pursues his Mother 'ingendering' the Cereberian dogs who shelter and feed in the womb that bred them.

Milton's circulating images of incestuous and never-ending conception and birth, encountered by the scientific Satan in his colonizing journey to Paradise, announced a corrosively alternative metaphoric frame within which to appreciate the triumph of male science. For Milton, knowledge without divine understanding was the incarnation of transgression, which is exactly what his images of sexual transgression and transgressive birth in Book II of *Paradise Lost* are designed to express. Satan's voyage of discovery stands, then, as the repost to Cowley's boundless optimism voiced in his scientific poetry generally, but more specifically in his Royal Society Ode of 1667 with its image of the 'orchard open now, and free'.[65] When the scientific Satan in *Paradise Lost* circled the orchard of Paradise – yet another *hortus anatomicus* – and, 'with new wonder' surveyed 'in narrow room nature's whole wealth' (*PL* IV.205–7), then Comus had, finally, emerged from the wood.[66]

THE INNOCENCE OF TRUTH: MARGARET CAVENDISH AND THOMAS TRAHERNE

The return of Comus was the point at which the conquest of the interior world of the body seemed, if not achieved already, then at least within the grasp of the intellectuals who had campaigned for a new language of scientific exploration. The establishment of the Royal Society, the masculine interpretation of the 'mechanical laws' by which a feminized nature was held to function, the conquest of the body's interior spaces and cavities by a science which was, at once, colonizing, self-justified, and, ultimately, in need of no divine sanction, all of these elements conspired at the end of the seventeenth century, to establish the paradigms of 'science' with which we have now grown familiar. This was also the point at which 'national science' emerged. As Dryden's poem *Annus Mirabilis* proclaimed, there was, in the second half of the seventeenth century in England, a growing understanding of the economic benefit to be reaped from the application of the technologies of science to everyday commercial and proto-industrial processes.[67]

But the demand for technological solutions to commercial problems does not wholly explain the rise of the scientist in the seventeenth century. Rather, science was part of an emerging vision of national identity. Where, formerly, the prestige of a city, a prince, or a nation, would have been promulgated via a combination of artistic, literary, scientific, and architectural works, now science was to play an ever increasing role in the maintenance of that sense of a community's worth or value. The anatomy

theatres of early-modern Europe, then, had been the precursors of the great scientific institutions of the seventeenth century. A new measure of a nation's sense of identity was available. No longer would it be taken as the norm for a Harvey to study abroad in order to gain access to the latest knowledge and methodologies. Instead, science had become one of the touchstones of a community's sense of self-evaluation. Thus, at the inaugural meeting of the Royal Society in November 1660, the founders expressed the hope that 'a more regular way of debating things' would be established:

> and that, according to the manner in other countries, where there were voluntary associations of men into academies for advancement of various parts of learning they might do something answerable here for the promoting of experimental philosophy.[68]

As Michael Hunter observes, this was a clear allusion to the formation of the *académies privées* in France, or the Academia del Cimento in Florence. The formation of these scientific organizations, then, can be thought of as part of that process, identified by historians, which has come to be understood as the creation of the 'active state'.[69] Within this *political* context, the restrictions on science which, as we have seen in the instance of anatomy, constrained human enquiry in the earlier period, were simply irrelevant. What restricted science, now, was only the resources of human ingenuity itself, together (it has to be said) with financial support. Nothing exterior to science – no philosophy, no aesthetic, and certainly no divinity – was strong enough to establish any limit to that enquiry.

It is for these reasons, just as much as its devotion to any programme of rationalism, that science as an institutional endeavour proclaimed its autonomy from other branches of human enquiry. Of course, buildings (for example) appropriate to the 'dignity' of science should be reared. Equally, paintings and poems, expressive of the intellectual prowess of the practitioners of science and (more importantly) their patrons should also be commissioned. But the idea that a building, say, could now express anything fundamental about scientific methodology was fast becoming redundant. To imagine, for example, an anatomy theatre, such as that which had been created at Leiden at the end of the sixteenth century, to have been considered a fitting place in which to undertake any form of enquiry into the physiology and morphology of the human body in any later period is virtually inconceivable. A structure such as the theatre at Leiden (or, for that matter *The Purple Island*) belonged, now, to the realm of 'art' – Baroque fantasies of the imagination, which had no place in the austere communion with nature which the natural scientists proclaimed as both their end and their right.

There were, however, alternative visions of the body – and hence of

science – in the final years of the seventeenth century. Margaret Cavendish we have already met, protesting against her exclusion from the circulation of knowledge which was the aim of 'Royal Science'. The poetry of Thomas Traherne also provides us with an alternative to the frenetic creation of male myths of psycho-sexual scientific domination. What do they have to tell us? Given the 'masculinized' language of scientific exploration, it is not difficult to see why Margaret Cavendish could have complained of her own exclusion from new forms of knowledge. No matter that, as a Royalist and as an aristocrat, Cavendish was eventually to be associated with the political victors; as a woman, she was almost entirely excluded from the emerging scientific ethos of her day. Of course, Cavendish (famously) visited the Royal Society. But from the records of both Pepys and Evelyn, the occasion of Cavendish's visit (11 April 1667) was more in the nature of a public celebration of science rather than a serious attempt to include her in the Society's circle of virtuosi.[70] She was (just as her prose style was later to be misunderstood) an ornament, a decorative embellishment to the serious matter of reflection put in hand by the early Royal Society. Thus, it comes as no surprise to find Pepys (as well as Evelyn) commenting on the appearance of the 'Romantick' Duchess – her 'antick' clothes, her patches, the children crying after her in the streets – all of which labelled her as a great eccentric, a judgement that modern criticism is only slowly revising.

That sense of exclusion can be discerned not just in what she says, but in her deliberate choice of a particular mode of expression. When, in 1653, Cavendish published her first volume – *Poems and Fancies* – she began with a justification of why she wrote poetry rather than prose, even when dealing with 'scientific' subjects:

> I cannot say, I have not heard of *Atomes*, and *Figures*, and *Motion*, and *Matter*; but not thoroughly reason'd on: but if I do erre, it is no great matter; for my *Discourse* of them is not to be acounted authentick. . . . And the reason why I write it in *verse*, is, because I thought *Errours* might better passe there then in *Prose*; since Poets write most *Fiction*, and *Fiction* is not given for *Truth*, but *Pastime*.[71]

This disclaimer is written in the generic style of all such seventeenth-century prefaces to poetic collections. But Cavendish's deliberate choice of poetry, as a mask behind which her scientific interest could be concealed, points to a more serious frame of reference in which her work can be understood. It was as if she had anticipated the linguistic reformers of the Royal Society and elected to defy their harsh stylistic proscriptions. Writing on the brink of the transformation of scientific discourse, Sir Philip Sidney, rather than Hobbes or Sprat, seemed to provide a surer guide to her task. For it was Sir Philip Sidney who had observed, in the *Apology for Poetry* (1595), that the poet

'nothing affirms, and therefore never lieth'.[72] Sidney's example provided Cavendish, writing in the proto-scientific world of the Royal Society, with a linguistic refuge. As Kate Lilley has observed (in the context of Cavendish's utopian *The Description of a New World, called the Blazing World* of 1666), her writing: 'revels in design, ornament, rhetorical description and amplification, a material and linguistic opulence which is self-consciously extravagant and excessive, even parodic'.[73] It was precisely such features of language which the Royal Society and its devotees were now claiming to be redundant in philosophic discourse. Cavendish's recourse to the fanciful (expressed in the very title of her 1653 collection, and restated in her second volume published in 1653, the *Philosophical Fancies*) would thus appear to be of a piece with her eccentricity of dress, manner, and intellectual interests. Such an understanding of Cavendish would be quite wrong. Her project was at once more ambitious, and more skilfully executed than her detractors (either then or now) gave her credit for. Her interest was science; her particular interest was the science of the body. As a woman, however, she was excluded from the burgeoning institutions which were to be the chief arena for scientific discourse – the colleges, institutions, and academies which were springing up all over Europe. The problem was to find her place within an establishment which, though it recognized her social position, would never acknowledge her intellectual ambitions.

Cavendish's writing, then, even when it is taken seriously, is easily read as a conservative gesture, a longing, backwards glance at the old webs of metaphor from which new science was to 'liberate' the body. Her thought has been dismissed as the product of an auto-didact, a woman untrained and ill-educated, but born up in her own conceit. The point, of course, was that in the late seventeenth century, just as in the late twentieth century, knowledge was now considered to be particularized. But to read Margaret Cavendish's verse and prose as simply the product of an 'untrained' mind is to misunderstand the nature of her self-proclaimed task, and it is also to forget the ways in which all 'discourse of reason' was being recast as a purely 'masculine' endeavour.

If Sidney suggested poetry as the appropriate mask behind which to shelter, the *Apology* also suggested more. It provided Cavendish with a *raison d'être*, a place in the scientific world which she could make peculiarly her own. For it was Sidney who pointed to the educative value of poetry and its power, not only to describe, but to reproduce experience for the reader. Sidney's own description of this process accords, strikingly, with the kind of proto-scientific exchange which the Royal Society was to foster, on the one hand, but deny as 'fanciful' (in respect of the resources of 'poetic' language) on the other. The value of poetry, as we have seen Sidney arguing, lay in its ability to produce a 'speaking picture':

> For as in outward things, to a man that had never seen an elephant or a rhinoceros, who should tell him most exquisitely all their shapes, colour, bigness and particular marks. . . yet should never satisfy his inward conceits with being witness to itself of a true lively knowledge; but the same man, as soon as he might see those beasts well painted . . . should straightways grow, without need of any description, to a judicial comprehending of them.[74]

This was the task that Cavendish set herself: to adapt the pedagogic defence of imaginative literature, in the realm of moral education, to the scientific education of those who (as her own experience showed her) were excluded by institutional, cultural, and social prohibition from entering the scientific world which was now being created. Cavendish, then, far from being a bizarre figure on the margins of scientific reform, realized far better than her contemporaries that the scientific revolution was, in effect, ignoring one half of the population: women.[75]

This educative task informed all of Cavendish's writing in the many different genres in which she wrote. She sought to show her contemporary readers, particularly women, first by her own example, and, secondly, by the manipulation of the conventional genres of lyric poetry and romance, that the new world of science could indeed (in Cowley's phrase) be 'open now, and free'. In the preface to *Poems and Fancies* (addressed 'to all noble and worthy ladies'), Cavendish spelt this project out. 'Poetry', she wrote, 'which is built upon Fancy, women may claim as a work belonging most properly to themselves' and she continued:

> but I imagine I shall be censured by my own sex; and men will cast a smile of scorn upon my book, because they think thereby women encroach too much upon their prerogatives, for they hold books as their crown, and the sword as their sceptre, by which they rule and govern.[76]

For Cavendish, knowledge was the preserve of a monarchically endowed masculinity. But, even when we have acknowledged the contradiction (this is the Duchess of Newcastle who is speaking, not the Fifth Monarchist prophet Anna Trapnel), the depth of Cavendish's sense of exclusion has to be registered. It was that sense of exclusion which led her, in 1666, to create *The Blazing World* – a utopian fantasy of female science and a Royal Society of the imagination or fancy. Cavendish's 'Fancy', however, should not be confused as anti-rational or irrational, as the preface to *The Blazing World* made clear. If 'the end of reason is truth, [and] the end of fancy is fiction', nevertheless, both reason and fancy have their part to play in the unfolding of the natural world, for fancy may 'divert' the reader through 'delight' and 'variety, which is always pleasing'.[77] *The Blazing World* first appeared appended to Cavendish's *Observations upon Experimental Philosophy*, which was a critique, as Paul Salzman notes, of Robert Hooke's microscopic observa-

tions published in 1665.[78] Hooke was a devotee of the mechanical impulse. Observing the feet of a fly, for example, his observations led him to conclude that:

> Nature does not only work mechanically, but by such excellent and most compendious, as well as stupendious contrivances, that it were impossible for all the reason in the world to find out any contrivance to do the same that should have more convenient properties.[79]

As Descartes had predicted, human ingenuity would never be able to construct an engine which would be mistaken for an organic entity: a view echoed by Walter Charleton, when he claimed that the heart was 'an engine never to be imitated by human art'.[80] The substance of Cavendish's critique lay in her awareness, as Hooke himself had confessed, that 'all the reason in the world' would never be able to replicate an equivalent structure. In other words, there were limits to masculine reason. Keenly aware of such limits, *The Blazing World* stood as the fanciful half of what was, in effect, a dialogue between 'rational search' and a 'voluntary creation of the mind'. The *Observations* and *The Blazing World* should, therefore, be read together as a composite educative text, whose true subject is the reasoning power of the human mind, a power which Cavendish was implicitly suggesting should be perceived as an amalgam, rather than a rigidly defined bifurcation, of reason and imagination.

Sidney's defence of the poet's art in terms of creating 'judicial' comprehension – the 'lively knowledge of the rhinoceros' – was echoed by Cavendish in the publication of her 1653 volume, *Poems and Fancies*. Her characteristic poetic trope was the 'similizing' poem. 'Similizing the Braine to a Garden' was the title of one piece, and 'Similizing the Head of Man to the World' the title of another.[81] But, as with all her writing, the end of these texts was educational in Sidney's sense of creating 'judicial comprehending'. Her project was not to demonstrate her own wit before an admiring and sophisticated, scientifically literate audience, but, rather, to achieve something altogether more difficult. Realizing that the complexities of new science were changing the world around her, and realizing, too, that for one half of the population those changes were unknown, Margaret Cavendish set out to educate and inform women whose access to these new discourses of knowledge was so severely circumscribed. Often, her poems were footnoted as though in defiance of her own manifesto that 'fiction is not given for truth'. But the poem and the prose commentary also operated together as an educational device. Taken together, they are the miniature equivalent of her critique of Hooke and her fanciful creation of a world of the imagination. Her technique was to appeal to women's everyday experience of work and recreation, and then anchor that experience in scientific terms.

One poem announces itself, for example, as 'Similizing the Heart to a Harp, the Head to an Organ, the tongue to a lute, to make a consort of music'.[82] This was not an appeal to Neoplatonic reasoning (though it could certainly be read as such). Instead, it evoked the everyday experience of domestic music-making in small groups, or the production of church music.[83] Again, the poem 'Nature's Oven' describes the function of the brain:

> The *Braine* is like an *Oven*, hot, and dry,
> Which bakes all sorts of *Fancies*, low, and high . . . [84]

Having anchored the observation to the world of seventeenth-century women's labour, Cavendish, in the prose commentary on the poem, then explains in more detail how a structure can be observed. She reminds her readers, for example, that, despite the fact that they (like she) may not have had the chance to see an anatomical dissection, nevertheless, much can be learned from preparing and dressing meat. In this way, the female domestic economy – the supervision of which was the traditional vocation of seventeenth-century women of the middle classes – intersects with what Annette Kramer has termed a 'male linguistic economy'.[85] In some sense, we can think of these texts as perhaps the earliest examples of a scientific 'primer', or, even, scientific journalism, where the lay reader is assumed to have little or no prior knowledge of the subject under discussion.

Read in this way, Cavendish's *Poems and Fancies* of 1653 soon appears to be a far more sophisticated text than conventional literary criticism has allowed. In particular, the political function of science in Cavendish's scheme becomes apparent. *Poems and Fancies* contains a long prose allegory, 'The Animall Parliament', which is a thinly veiled commentary on contemporary political events couched in terms of the structure and function of the human body. The reader who comes to 'The Animall Parliament' after the scientific poems and prose explications of the volume, had already received a 'judicial comprehending' of the body's structure and function. Thus, the political allegory of 'The Animall Parliament' was anchored to 'reason' rather than adrift as 'fancy'. In 'The Animall Parliament' Cavendish created a royal body which offered a commentary on the usurpation of the Commonwealth via an elaborate allegory constructed out of a combination of Galenic and post-Galenic physiology. So, the soul sits as king in the upper house 'in a *kernel* of the *Braine*', surrounded by his nobility – the spirits – and receiving the pleas of the '*commonality* . . . the *Humours* and *Appetites*'. Cavendish's '*Soul King*' is seated in a '*Chaire* of state by himself alone', from whence he dispenses justice.[86] The soul's singularity, and its location in a 'kernel' of the brain may suggest a Cartesian frame of reference, but it suggests, too, Milton's Satan who is enthroned at the opening of Book II of *Paradise Lost* in monarchical and splendid isolation. Cavendish's royal body

functions according to the model provided by the organic body. The heart acts as the house of commons (an impeccably loyal gathering), which conveys writs via the nerves that are then executed by the muscles, whilst communication between the lower and upper houses is by the arteries. The occasion for the sitting of the animal parliament is to attend to the growing disorder in the body caused by a combination of vanity, 'erroneous opinion', and 'evil consciences'. The parliament's task is to 'beat out the incroaching falshoods, which make inrodes, and doe carry away the *innocency* of Truth, and to quench the rebellion of superfluous words'.[87] 'Superfluous words', of course, were to become exactly what the Royal Society strove to extinguish, and it is as a proto-Royal Society that Cavendish's 'Animall Parliament' is best understood. The rebellion in the body-politic is a rebellion of misapprehension, an inability to see the natural world properly, as the programme of legislation advanced by 'the Rationall Lord' (literally reason itself) makes clear. A programme of scientific reform must be initiated if the body-politic is to regain its internal harmony – a programme which will enact the following precepts:

> that all light is in the eye, not in the Sun. That all colours are a perturb'd light; and so are reflections. . . . That all sound, sent, sight is created in the Braine. That no beast hath remembrance, numeration, or curiosity. That all passions are made in the head, not in the heart. That the soul is a kernal in the Braine. That all the old Philosophers were fooles, and knew little. That the moderne Philosophers have committed no errours. . . . That the bloud goeth in circulation. That all the fixt stars are suns. That all the planets are other worlds.[88]

Cavendish's satirical, restless and extreme rationalism at this point (if we take the 'Rationall Lord' to be a spokesman for her views) was not disconsonant with the emerging scientific rationalism which was to be advanced by the Royal Society. But neither was it at variance with her desire to yoke reason and fancy together, since this affirmation of the values of the Royal Society was already cloaked in the garb of 'Fancy' – an imaginative creation. Indeed, in some ways it was a remarkable anticipation of some of the most distinguished proponents of the mechanical philosophy. For Thomas Willis, for example, whose anatomical work on the brain and nervous system was to be published in 1664, all mental operations could be understood as 'a sequence of anatomical structures'. What distinguished human beings from animals was the absence of any evidence of higher mental faculties, a line of thought that Cavendish seems to be tracing when the rational lord excludes the possibility of memory, computation, and curiosity existing amongst animals.[89]

Though Cavendish was to deny that her work was anything other than an attempt to 'passe way *idle Time*' (this being the usual disclaimer that she attached to her own publications), her own voluminous writings testify to an

altogether more serious endeavour.[90] Nor was she alone in constructing poetico-political fantasies on top of the human form. We have already seen the 'somatic epic' of Phineas Fletcher aiming at just such an end. In the 1640s, in England, others attempted very similar projects, as though attempting to comprehend the disaster of civil war as a purely natural phenomenon. So Joseph Beaumont, a Royalist divine, published, in 1648, his *Psyche or Loves Mysterie* – a twenty-two canto fantasy on the disturbances within the natural body. The enormous work was, he wrote, a remedy for 'meer idleness' following his ejection from his Cambridge Fellowship by the Commonwealth authorities.[91] But neither the extravagant fantasies of Beaumont nor Cavendish's educational anatomies challenged, in any fundamental way, the paradigms of the scientific revolution which had superseded the political revolution of the mid-seventeenth century.

This was not, however, the case with the 'mystical' late seventeenth-century poet, Thomas Traherne. Like Cavendish, Traherne has been considered a remarkable oddity. Writing in the 1660s and 1670s, in the midst of the scientific reform of that period, Traherne seemed entirely blind to the transformation of knowledge which, everywhere, encompassed his visionary poetic. Hence, as modern literary criticism has understood Traherne, he appears to be not only *sui generis*, but a representative of an older, and vanished, order of intellectual life. It was, says Graham Parry, 'Traherne's immense good fortune to be born in Paradise', whilst Malcolm Day has remarked on his 'intuitive perception of spiritual things'. Here was a figure who appeared to be enmeshed in webs of Neoplatonism, scripture, patristic authority, and christian mysticism, so that, despite the 'practical and empirical perspectives of new science . . . the old truths remain'.[92] He was, in other words, the intellectual sibling of Margaret Cavendish. At odds with the rational world into which he was born, Traherne was committed to the pursuit of the irrational, the inward, the insubstantial.

Such a view of Traherne is hard to combat, so pervasive has it been as a means of approaching his writing. This view is deeply embedded in a late nineteenth-century understanding of the paradigms of seventeenth-century literary culture. When Traherne's poetry began to appear at the end of the nineteenth century (his works having vanished for over 200 years), it was as though Wordsworth or Blake had been reborn, one hundred years before their time. It was as an alternative Wordsworth, indeed, that Traherne was read. He was the poet of 'infancy' and of visionary childhood states, which appeared to echo from a different world from that inhabited by Milton or Rochester – his actual poetic peers.[93] Traherne was thus made the spokesman for an English romanticism *avant la lettre*. Just as in the case of Cavendish, this estimation of Traherne is quite wrong, since it misunderstands the complex nature of the culture of late seventeenth-century science.

Crucially, it misunderstands the science of the body. Like Cavendish, only more so, Traherne was fascinated by the human body. The body was the constant subject of his poetry, an enduring object of scrutiny and transformation. But what kind of body was Traherne peering at, or into? In the poem designed to function as a guide to reading his work, 'The Author to the Critical Peruser', Traherne established the body's co-ordinates. It was composed out of 'precious hands', 'Tongues and lippes divine', 'polisht Flesh'. This body appears to be all surface, endowed with the pallid plasticity of Baroque devotional statuary. But, as the poem moves forward, adjectival opulence gives way to something more concrete and, by now, familiar. The body is a meeting point where:

> ... whitest Lillies join
> With blushing Roses and with saphire Veins
> The Bones, the Joints, and that which els remains
> Within that curious Fabrick, *Life* and strength,
> I'th'wel-compacted bredth and depth and length
> Of various Limbs, that living Engins be
> > Of glorious worth;
>
> > (Traherne, *Poems*, 3)[94]

The language of the blazon (lilies and blushing roses) reaches down into the bones and discovers an altogether different rhetoric of discovery. Suddenly, the body is a 'curious Fabrick', susceptible to measurement, and, crucially, devised in the form of a Cartesian 'living' engine.

But of course, Traherne could not be a Cartesian. His fascination with the body, we are told, stemmed from his understanding of 'sacred anatomy', or something very much like it. Thus, the body:

was a source of infinite wonder to him. Whereas his contemporaries anatomized man to counter atheism ... Traherne praised man's 'organized Joynts, and azure veins' ... as manifestations of God's overflowing love ... a curious poetical-prosaic mixture of physiology and theology.[95]

This view needs to be qualified. Traherne has long been read as the poetical spokesman for what has, equally, been understood as the last bastion of anti-rationalism in the seventeenth century: Cambridge Platonism. But, as we have come to know more about Henry More, Nathaniel Culverwel, Ralph Cudworth and their intellectual associates, so we have also come to learn that the mystical tendencies of these figures, their devotion to the 'inward light' of spiritual revelation, rather than the light of Baconian reason, was not 'irrational'. Instead, numerous points of sympathy could link Henry More and Samuel Hartlib, or Cudworth with Samuel Collins and the high priest of mechanism, Thomas Willis.[96] Henry More, for example, in the early

1650s, had composed a long latin poem, entitled *Circulatio sanguinis* (1679), which praised Harvey as the discoverer of circulation, and included a careful transcription of Harveian methodology culled from close reading and understanding of Harvey's writings.[97] Just as Helkiah Crooke had set out, thirty years earlier, to explore the human body with the help of *The Faerie Queene*, so, in the 1650s, the intersection of art and science had not entirely vanished.

And it was that intersection that Traherne struggled to promote. Generations of critics who have discovered in Traherne either mystical certainty, blind to the advancement of science, or conservatism, ignorant of science, have failed to appreciate the subtle attempt at tempering the power of science with a different vision of human endeavour.[98] That attempt can be seen in Traherne's opening poem, which clearly acknowledged its debt to the theories of language promoted by the Royal Society, when it spoke of creating a poetic which would avoid 'curling metaphors that gild the sence' or 'painted eloquence' (Traherne, *Poems*, 2). Of course, similar sentiments could be found in George Herbert's divine poetic. But, after 1660, and amidst the linguistic propaganda against ornamentation, Traherne understood the flavour of the times. His task, then, was as complex and as subtle as that of Margaret Cavendish. How would it be possible to create a new language of the body which, whilst it acknowledged the discoveries within the microcosm, could retain the dimensions of sacred anatomy? Confronted with a body reduced to a compilation of mechanical structures, could the vision of Spenser's knights be recaptured, so that the body could be the matter of 'gazing wonder'? To simply deny the force of Cartesian analysis was hopeless. But to *reinvent* the body as its own peculiar, reserved space, was an altogether different possibility.

Robert Ellrodt has described Traherne as fortunately abstaining from the desire to wield the scalpel, and in this he is supposed to be entirely different from Donne.[99] In some measure, this is true. But Traherne, unlike Donne, had no need to reach out and grasp the scalpel, since others were now performing the task far more effectively than he could hope to achieve. Instead, Traherne stood, like an enquiring spectator at an anatomy demonstration, at the shoulder of the anatomist, peering with delighted inquisitiveness at what the scalpel would reveal. His task was to transform what the anatomist displayed into a richer prospect than science could imagine, since he sought to reinvest the body with a species of awe and wonder. If the anatomist believed that the Medusa's glance could now be mastered, then Traherne's visionary poetic promised an alternative. Celebration, rather than conquest, was his goal.

What that alternative amounted to was a whole-hearted reinterpretation of the body's significance. The body was a receptacle of infinite capacity and

infinite wonder. Its volumes were immense and unchartable, since, created by God, they existed at (or beyond) the outer limits of human reason. In a passage published in 1699, in his 'Thanksgivings' poems, Traherne described the body as:

> Those blinder parts of refined earth,
> Beneath my skin;
> Are full of thy Depths,
> For { Many thousand uses,
> Hidden operations,
> Unsearchable Offices.
>
> (Traherne, *Poems*, 216)

Like Donne, the inner recesses of Traherne's own frame possessed him, even while they defied him. The body – more particularly, his own body – was a source of 'Amazement', 'admiration', 'joy' (Traherne, *Poems*, 215–16). It was so because, just as the Spenserian knights had observed, it was fundamentally strange or 'unheimlich'. In the poem entitled 'The Person', Traherne recommends an anatomy of this uncanny structure: 'Survey the skin, cut up the flesh, the veins/Unfold' (Traherne, *Poems*, 76). But having opened the body as though it were an anatomical textbook, its essence remained intangible:

> The glory there remains.
> The muscles, Fibres, Arteries, and Bones
> Are better far than Crowns and precious stones.
>
> (Traherne, *Poems*, 76)

In rejecting the terms of possible comparison, however, Traherne was acting in full accord with the programme announced by the Royal Society. Rather than seek to embellish the natural world, the task was simply to list and categorize what was to be observed in natural structures.

But all such taxonomies relied on language, and language (despite the manifestos of Sprat and his contemporaries) was a slippery medium. Words carried with them significations and connotations which might slide from a harshly empirical view of the world, into one which was more fluid, even more poetic. That very slipperiness lay at the core of Traherne's vision and his own poetic. In other words, Traherne had uncovered (though not resolved) a central paradox in the programme of 'new science'. Willis, Hooke, Ent, Boyle, Collins – the new masters of the internal frame – had not grasped this paradox which Traherne, in poem after poem, demonstrated. The body did not simply exist as something ineluctably 'there'. There could be no easy familiarity with the newly discovered mechanical motions at work within the human frame. Instead, the body's essential strangeness (a strangeness which had been amplified rather than dispelled by Descartes) still

remained as the chief object of attention. In his *Centuries of Meditation*, Traherne pursued this theme, anchored, as always, to his own experience of embodiment: 'my Lims and members when rightly prized are comparable to fine gold', he wrote, before concluding 'the topaz of Ethiopa and the Gold of Ophir are not to be compared to them' (*Centuries* I. 34). Here, of course, is the Cartesian problem once more. Are 'they' a part of 'me'? But, in thus preferring 'fine gold' (i.e. refined gold) to the gold of Ophir, Traherne was rejecting the wealth of Solomon (1 Kings 9.28) who, as Francis Bacon had not been slow to grasp, had been offered a 'mighty empire in Gold' as a reward for having written 'a natural history of all that is green from the cedar to the moss'.[100] At the same time, Traherne was embracing another golden body, that foretold in Isaiah 13.12: 'I will make a man more precious than fine gold; even a man than the golden wedge of Ophir' – the body of Christ.

Traherne's body, then, was the 'pattern' (to use Fletcher's phrase) of the body incarnate, and it was in this sense the true source of wealth. Baconian reason may have proffered gold, but it was fool's gold:

> What diamonds are equal to my eyes; what labyrinths to mine Ears; what Gates of Ivory, or Rubie leaves to the double portal of my Lips and teeth? Is not sight a jewel? Is not hearing a treasure? Is not speech a glory?
>
> (*Centuries* I.34)

Donne, in the second of his Anniversary poems, had claimed that, spiritually reborn after death, the body would be sloughed off:

> Thou shalt not peepe through lattices of eyes,
> Nor heare through Labyrinths of eares . . .
> (Donne, *Poems*, 235)

But, for Traherne, the body did not intervene in this frustratingly limited way. Instead, its glory was in its labyrinthine complexity. And, in that complexity, the world of Comus could be subsumed, if not vanquished. Comus had emerged from the wood as an icon of 'Royal Science'. But even his abundant desire could never be satisfied by the splendour which he now contemplated. Traherne offered a different answer from that which Milton's masque had envisaged. Like Comus (and like the virtuosi of the Royal Society), Traherne glimpsed a world of limitless abundance: iron, brass, copper, lead, tin, carbuncles, emeralds, pearls, diamonds, all glitteringly evoked in 'Thanksgivings for the Glory of God's Works'. Having evoked them, Traherne saw them as:

> . . . given to our bodies,
> Subjected the same to the use of our hands.
> (Traherne, *Poems*, 245)

Here was the credo – subjection and use – of both Comus and 'Royal Science'. Rather than being a childlike innocent, or a seventeenth-century Blake, Traherne was fully conversant with that rapacious consumption of the world's riches which new science promised its devotees. But the consumption of the world's riches could, his poetry suggested, lead to a different end. Sensory experience could be transformed into a hymn of praise, an awareness of mystery. Traherne understood that the problem was not to contest this new language of mastery and dominion, but to reinvent it in much the same way that the body had been reinvented by the mechanic philosophers. Thus, Traherne could cloak himself in the language of science, in order to recast science:

> He that knows the secrets of Nature with Albertus Magnus, or the Motions of the Heavens with Galilao, or the Cosmography of the Moon with Hevelius, or the Body of Man with Galen, or the nature of Disease with Hippocrates, or the Harmonies in Melody with Orpheus, or of Poesie with Homer, or of Grammer with Lilly, or of whatever else with the greatest Artist; he is nothing. If he knows them meerly for Talk or idle speculation, or Transeunt and External Use. But he that knows them for Valu, and knows them His own: shall profit infinitly.
>
> (*Centuries* III.41)

Just as the Royal Society had dismissed 'Talk or idle speculation', so Traherne was just as vigorous in urging an active pursuit of the 'secrets of Nature'. And, just as the Royal Society had understood the conquest and colonization of nature as a 'useful' project which promised 'Valu' and 'profit', so Traherne reached out for what appears to be the same prize. But the prize was, in reality, quite different. The endeavours of 'Royal Science' were aimed at what Traherne describes as 'Transeunt and External Use' – a transitory and deeply illusionary grasping after the chimerical shadows of the vestiges of reason.

Thus Traherne saw Comus, and understood that this creature had to be controlled, if he was not to metamorphose into Frankenstein's monster. It was this attempt at control which resulted in Traherne's adoption of the weapons of science to counter science. In common with the Cambridge Platonists, Traherne realized that, in order to resist the mechanical philosophy, with all its 'vertuous covetousness' it was necessary, as Charles Webster has suggested, to 'collect examples of phaenomena which could only be explained by reference to divine agency'.[101] From this attempted appropriation of the methodology of the Royal Society, with its seemingly obsessive urge to form lists and taxonomies of nature, stemmed Traherne's own (equally obsessive) catalogues of plenitude. Eventually, these catalogues were to become a stylistic device in their own right, an attempt at suggesting endless complexity which the discourses of reason would never succeed in refining into a system. Even conventional grammar and syntax, insofar as

they form part of an organizing system, had to be rejected. Traherne went further than Hobbes, Wilkins, Glanvill, and Sprat could have conceived. The organizational structure of language collapsed, in his poetry, into a new language which appeared simply to replicate the complexity of the created world. In thus undermining the very structures of language, Traherne offered a world which was ordered neither by human reason, nor by the conventional patterns of linear time and narrative progression. Instead, as Carl Selkin writes, he created a 'static eternality' where the reader's eye:

> must become like the organ of God as described by Nicholas of Cusa, who contrasts man's limited vision with God's unlimited sight by comparing them as readers; the first reads a page linearly, each word in succession, but God sees the entire page at once.[102]

The synchronic and the diachronic polarities of language no longer existed. Instead, the reader was faced with a world which was a mere collection of fragments, a jumble of alternatives, with no rational principle of construction, save the possibility of a divine order which exists outside the scope of human reason:

> But for the diviner Treasures wherein Thou has endowed
> My Brains Mine Eyes,
> My Heart, Mine Eares,
> My Tongue, My Hands,
> O what praises are due unto thee,
>
> (Traherne, *Poems*, 216)

This divinely ordered disorder was most visible when it was perceived in the human body. Rather than recoil, as Du Bartas had recoiled, before such complexity, Traherne chose, deliberately, to evoke the complex structure of the human form as continually evading linguistic order. So, the interior features of the body are listed in conventional (even conservative) terms. But the system of comparison soon collapses:

> Limbs rarely poised,
> And made for Heaven:
> Arteries filled
> With Celestiall Spirits:
> Veins, wherein Blood floweth,
> Refreshing all my flesh
> Like Rivers.
> Sinews fraught with mystery
> Of wonderful strength,
> Stability,
> Feeling.
> (Traherne, *Poems*, 215)

The problem, then, was that the rational impulse appeared to rob the body of its mystery, while it left nothing in its stead. In 'Thanksgivings for the Body', Traherne asserted that the human frame was a 'mine of riches', but, once it was spread on the anatomy table, those riches 'when bodies are dissected fly away' (Traherne, *Poems*, 216). Only a few lines later, he returned to the anatomy slab since the body was nevertheless:

> A Treasury of Wonders,
> Fit for its several Ages;
> For Dissections,
> For Sculptures in Brass,
> For Draughts in Anatomy,
> For the Contemplation of Sages.
> (Traherne, *Poems*, 217)

The contradiction was deliberate. The 'mine' which is the body may be dug into, but the true 'Valu' of the riches uncovered cannot be understood by the rational eye of the beholder.

The 'visiv Eye' (Traherne, *Poems*, 133) would never be able to see the body for what it was. The urge to look was understandable, but, as the Platonist Henry More had predicted, the onlooker would inevitably be disappointed, since the scopic intensity of science (where looking was understanding) could never penetrate such a divine structure. In 1653, the very same year that Harvey had concluded his researches into the process of generation, More conducted his own dissection of the brain. What he discovered was a region of fabulous narratives, an exotic (and oriental) world, which was no sooner looked at than dismissed as being simply beyond the grasp of reason because it appeared so ordinary, whilst its task was, nevertheless, immense. Descartes was wrong:

> If you head but the magnificent stories that are told of this little lurking Mushrome, how it does not onely heare and see, but imagines, reasons, commands the whole fabricke of the Body more dextrously than an *Indian* boy does an *Elephant*, what an acute *logician*, subtle *Geometrician*, prudent *Statesman*, skillfull *Physician*, and profound *Philosopher* he is, and then afterward by dissection you discover this worker of Miracles to be nothing but a poor silly contemptible knobb, or protuberancy consisting of a thin *Membrane* containing a little pulpous matter . . . would you not sooner laugh at it then go about to confute it?[103]

More's Indian boy sitting astride an elephant answered the Cartesian problem as to whether the soul was like a pilot in a ship. The disparity was too great. But for Traherne, the body was too important to be thus dismissed in the mocking laughter of anti-Cartesian logic. Rather, the 'visiv eye' had to be retrained, and taught to see the familiar as unfamiliar. In his most

riddlingly complex description of this process, which was his address to the body in 'The Person', Traherne promised a 'sacred anatomy' which would 'Glorify by taking all away' (Traherne, *Poems*, 75). But the anatomy is soon revealed to be a counter-blazon (of the sort we have already encountered) in which not only the body, but language itself has to be dissected. This linguistic dissection is required, since language is not a means of revelation (as the confederates of Sprat and Wilkins maintained) but of concealment. So, words (and the body) should be 'naked things' since it is only then that they can be 'seen' as opposed to 'seem'. The poem continues:

> Their worth they then do best reveal
> When we all Metaphores remove,
> For Metaphores conceal
> And only vapours prove.
> They best are blazoned when we see
> The Anatomie,
> Survey the Skin, cut up the Flesh, the Veins
> Unfold: The Glory there remains.
> The Muscles, Fibres, Arteries and Bones
> Are better far then Crowns and precious Stones.
> (Traherne, *Poems*, 76)

Not one word of this could have been rejected by the linguistic reformers of the seventeenth century. Yet, its sentiment entirely sabotages the endeavours of 'masculine science'. The poem is a brilliant appropriation of the language of investigation, which even seems to echo the claims of John Hall, in the 1640s, that anatomy was akin to the very discourses of reason providing that 'the veynes of things were rightly and naturally cut up'. Traherne had cut up not just the body, but language too, and revealed the possibility that, despite the keenest scalpel of all – the scalpel of reason, 'the Glory there remains'. This 'glory' could not be glimpsed by the 'visiv eye' of science, but by what Traherne termed the 'invisible eye'. The invisible eye was a purely fideistic creation, an impossibly disembodied eye of which science possessed merely a weak approximation. In the poem 'Sight', Traherne described this alternative speculum:

> This Ey alone,
> (That peer hath none)
> Is such, that it can pry
> Into the End
> To which all things tend,
> And all the depths descry
> That God and Nature do include.
> (Traherne, *Poems*, 133)

Traherne's mirror and his knife were not the same instruments that were being seized by the anatomists. Their intention was, indeed, to 'peer' into the 'depths', and thus achieve mastery over God and Nature. It was Traherne's belief that such a project was hopeless.

Of course, the story does not end there. Traherne's voice was virtually silenced for over 200 years, with only a few of his works (and very few of his poems) ever appearing in print. He was 'discovered' in 1896, with the chance purchase of a manuscript on a London bookstall. Following this discovery, other Traherne manuscripts began to appear, culminating in the extraordinary recovery (in 1967) of his *Commentaries of Heaven* from a burning Lancashire rubbish dump, by a man looking for spare parts for his car.[104] There is something entirely appropriate about this tale of disappearance and reappearance. Unearthed from amidst the detritus of technology, Traherne's voice, like that of Cavendish, had been unheard throughout the age of 'reason'. Both Cavendish and Traherne were ghostly footnotes to literary history; the one consigned to oblivion by her sex and 'eccentricity', the other simply abandoned in order to be re-created, at the end of the nineteenth century, as a childlike visionary. But both Traherne and Cavendish mounted a form of resistance against the aggressive dynamic of 'new science' which was rooted (as, ironically, that science had once been) within the imaginative world of the human body. Cavendish took science at face value, believing that its promises of liberation were genuine, and that the ideal of knowledge 'open and free' to all should be pursued. Traherne, however, saw something more sinister at work in the age of science. Realizing the transgressive nature of this knowledge, he attempted to reinvent the domain of the Medusa. Only if his contemporaries could understand and embrace the body as the abode of the 'uncanny stranger', he argued, would it be possible to achieve 'felicity'.

Traherne's attempt at commandeering the language of science – an attempt which has been all but ignored by his critics and commentators from the late seventeenth century onwards – concludes this study. We end here, since the very unreadability of Traherne (let alone his unavailability) is itself evidence of the triumph of mechanism which was announced at the end of the seventeenth century, and confirmed over the following three hundred years of scientific culture. From henceforth, poetry, or the world of the human imagination, which had once seemed perfectly harmonious with the discourse of reason, was held to exist as an entirely separate area of enquiry. Thus, the fantastic culture of the human body which emerged in Europe during the sixteenth and seventeenth centuries can perhaps best be understood as a kind of birth. What was born was an infant who sought to become an orphan, who would acknowledge no parentage other than its own processes of reason. The autonomy of reason was proclaimed amidst the

devices of art, poetry, architecture, ritual, law, and philosophy, which we have uncovered in this account. So complete was this process of self-authoring and authorization that, during the eighteenth, nineteenth, and twentieth centuries, the idea of a fundamental cultural dualism, a belief in 'two cultures', took root, and then became the paradigm within which human knowledge, in the west, was constituted. For all the many attempts informed by religious or philosophical analysis to build a bridge between these two cultures, any structure which emerged was bound to look fragile. The fragility of any overarching structure was inevitable, given the historical foundations we have been tracing in this book.

Science promised to conquer the realm of the Medusa, to banish that fear of interiority, with a mechanical survey of the Medusa's kingdom. But could the promise ever be made good? We began this study with three images of sickness, or of the body in rebellion. John Donne showed us the language of internal mystery and secrecy against which 'new science' was to wage such a determined war. With Robert Boyle's meditations on sickness we glimpsed the vindication of that science. But in the account offered by a wounded British soldier, in the late twentieth century, whose life was rescued by the invasive technology of modern medicine, we may begin to understand that, in reality, very little had changed since Donne's pious devotions of the early seventeenth century. What has not changed (even though the world and our ways of understanding the world have been transformed since the time of Donne) is that sense of fear or mystery at the prospect of our own interior demesne. The taboo is still in force, exercising its peculiar power to fascinate and horrify. And in essence that fear and horror is based on the knowledge of our own mortality, a knowledge we share with the men and women of early-modern Europe. But like them, and like Hamlet, we cannot quite believe that this can be a conclusion.

POSTSCRIPT: THE HUMAN MILLING MACHINE

In Richard Fleischer's 1966 science fiction film *Fantastic Voyage*, a group of scientists are 'shrunk' to the size of viruses so that they can be injected into the body of a wounded nuclear scientist. Their mission is to journey through the body's cavities and locate the damaged area. Through the deployment of laser technology, they hope to repair the effects of a 'brain clot', the result of a gunshot wound. As a mid-1960s cold war film, of course, the plot is complicated by the presence amongst the group of a traitor whose plan is to sabotage the mission, preferably by causing the death of the 'host' body which is the object of the mercy mission. The film thus conjures with a spectrum of 'enemies': the 'soviets' from whom the scientist has escaped; the 'traitor' within the group voyaging through the body; and time, since there

is only a short period during which the group (and their inner-space vehicle) will remain in a miniaturized state.

But the most dangerous enemy of all is the body through which they travel. Introduced as the means of that body's salvation, the group are 'understood' by the body as disease organisms. Thus, the body mounts its defences, and a series of gruelling encounters with 'antibodies' ensues – during the course of which the 'traitor' is killed. Thus, the body expels the concealed and dangerous threat to its own integrity, whilst the heroic defenders of 'democracy' both cure the host into which they have journeyed, and emerge triumphant (and full-size) at the film's conclusion.

In its central theme – the encounter with a sub-microscopic world – the film alludes to other exercises in the genre, particularly the 1950s science fiction film, *The Incredible Shrinking Man*, which ends with a quasi-mystical evocation of the sub-atomic world into which this 'traveller of the future' is now journeying. As we have seen, such fantasies of interior voyaging pre-date the scientific age. The homunculi injected into the symbolic body of science and knowledge are only the latest in a long line of such visitors, which included John Donne and Edmund Spenser. But *Fantastic Voyage* aped its Renaissance predecessors in more ways than simply evoking the age-old metaphor of macrocosmic correspondence. Just as Spenser's knights were alert to the 'wonder' of the body when viewed from within, so the voyagers in the film are silenced by the extraordinary sights which they encounter, as they journey through the body's different systems.

It is not difficult to understand *Fantastic Voyage* as a fantasy exploration of the ideological tensions of the post-McCarthyite period. The problem that the film poses is this: how will we recognize the 'other', the monster who is not merely in our midst, but perhaps inside us as well? How do we know that we are not the 'other'? Expressed thus, the film is not merely a post-Cartesian fantasy of alieneity, but a forerunner of postmodern cybernetic cinema, where the distinction posited by Descartes between the machine and the human has, finally, broken down. Machine and human are indistinguishable from one another . . . indeed they are one another. But *Fantastic Voyage* also speaks of another fear. Made at the time of the earliest experiments in transplant surgery, the film conjures with a new possibility.[105] How will we know that all of 'us' actually 'belongs' to 'us'? Where, now, are the bounds of body-property which the anatomists struggled so hard to establish? What will 'I' be if I am, at least in part, composed of someone else?

In other words, the technology of medicine, rather than silencing the Medusa in the interior and averting her gaze for ever, has succeeded only in introducing new manifestations of the fear of interiority. That fear, though it now appears in different forms, would appear to be entirely traditional: a knowledge that, eventually, our bodies will indeed cease to

function, and that our identity will, in similar measure, disappear. A similar fantasy (and fear) to that encountered in *Fantastic Voyage* can be found in the early-modern period. In 1688 Jane Barker published her *Poetical Re-creations*, amongst which was to be found her 'Degression on Anatomy'. In the 'Degression', Barker traces the self-taught course in anatomy she pursued. The controlling conceit of the poem is the anatomic journey, once more. So, the poet-narrator, in company with renowned anatomists of the early and later seventeenth century – Bartholin, Willis, Harvey, and Lower – moves through the human body admiring its architecture, its processes, and its interior landscape. This body appears to be not merely familiar, but a place of instruction, delight, and recreation. It is only when Barker and her guides reach the heart that the Medusa is discovered, and the body through which they are wandering suddenly appears as alien. For, in journeying through the body, Barker remembers the body of her dead brother who was himself an anatomist. Her anatomical guide (Lower) rests from his interior labours, 'surveighing the whole structure of the heart' to pronounce an epitaph in the final lines of the poem:

> But ah alas, so cruell was his fate,
> As makes us since allmost our practice hate
> Since we cou'd find out nought in all our art
> That cou'd prolong the motion of his heart.[106]

How close do we need to get to the body-interior before this fear of its reserved space is banished? The question is as impossible to answer as that with which we began this enquiry. What is, however, clear is that a series of prohibitions *still* surrounds the body, even within a scientific culture such as our own. As this book was nearing completion, a number of such instances began to appear in the press. For example, since 1975, it has been claimed, researchers at the University of Heidelberg have been using human corpses in order to test the reliability of dummies in car accident tests.[107] Following an outcry, the tests have been suspended. There are, here, uncomfortable echoes of other twentieth-century uses of the human body for 'medical' research. When the German tabloid *Bild Zeitung* referred to one of the Heidelberg researchers as a 'horror professor', the echo was unmistakably that of the disgust aroused by 'research' on concentration camp prisoners during the Nazi era. But we can hear, in this outcry, another echo. In the early-modern period and well into the eighteenth century, the bodies of those who, by virtue of their criminality, were deemed to be outside the bounds of human society were turned over to the anatomists for dissection as the most complete form of (useful) punishment which human ingenuity could devise. When was the last such dissection? In our own century, it is easy to assume that such a practice belongs to the distant past. This is not

the case. In Germany, in 1944, following the unsuccessful assassination attempt on Adolph Hitler, those responsible for the plot were executed, and their bodies then conveyed to the Anatomical Institute of Berlin University, for dissection.[108]

The human body – especially the dead human body – is an object still surrounded by taboos and prohibitions. Even amidst the chaos of Berlin in 1944, and at the centre of an inhuman regime, those prohibitions were still in force. For an assault on the sovereign body of a dictator, the anatomical dispersal of the bodies of the outlaws was deemed the only appropriate punishment. Clearly, there was little scientific utility to be uncovered in such an act. In this respect, the early-modern progenitors of the scientists at least believed that their undertaking was dedicated to a higher end. But they too had to negotiate a set of prohibitions. The story we have been tracing is how those taboos and prohibitions were embraced, evoked, or evaded, in the very founding moments of a modern, western, science of the body.

In our own predominantly technological regime of the body, technology has been invoked in order (paradoxically) to preserve the taboo surrounding the human form. The establishment of the 'Visual Human Project' (VHP) in the United States might be cited as evidence for the continued existence of this deep-seated anxiety. On the surface, the VHP is certainly intended as a technological aid to the study of human morphology. But is this all it represents? In September 1993, a group of American scientists convened by 'teleconference' to arrange what may, eventually, prove to be the very last human dissection ever to be performed.[109] Their purpose was to choose two (male and female) 'perfect specimens' of humanity. To date, only the male has been chosen. The criteria for selecting the corpses is strict: in good physical health at the point of death, they had to represent the perfect 'average' human. Unlike their Renaissance forebears, they had to have willed their bodies to science.

Once the specimens have been selected, the VHP can unfold. At the University of Colorado Health Sciences Center in Denver first 'cross-sections of Denver man will be recorded using . . . magnetic resonance imaging'. Then X-rays will be made. Finally, each corpse will be ground away, 'millimetre by millimetre from head to toe'. As each wafer-thin slice of tissue is removed, it will be photographed. The photographs will be digitized, and stored on computer. The whole operation is scheduled to take four months, and will cost approximately $1,000,000. Once completed, the computerized record will be available on 70 CDROMs. In the future, this record may well be available to the computer technologists of virtual reality, so that 'we will eventually be able to navigate our way through the human body on screen'. The anonymity of the donors is to be preserved, but they have already been given new identities. Amongst the scientists working on the VHP they are

known as (what else?) Adam and Eve. Dispersed through computer networks, their bodies will now exist in an altogether different medium. No longer there as physical entities, the bodies will be like that of Cutwolfe, in Nashe's *The Unfortunate Traveller*, 'flesh legacied amongst the fowls of the air'. Their new identity as electronic cadavers secured, Adam and Eve will be available to be dissected and redissected in a series of infinite demonstrations. And with that dispersal of the body and its re-creation in electronic form, the culture of dissection will, at last, have come to an end. Undoubtedly, the Medusa will survive.

NOTES

1 THE AUTOPTIC VISION

1 John Foxe, *The Acts and Monuments* (London, 1563) III.879.
2 In using the term 'scientific revolution' I am, of course, guilty of an anachronism. *Scientia* in the Renaissance denoted 'knowledge'. The preferred term (in English) was 'natural philosophy'. Nevertheless, the term has become so much part of the currency of the history of science when it takes as its subject natural philosophy of the period *c.* 1500–1700 that its use seems unavoidable.
3 Burton's *Anatomy of Melancholy*, when it first appeared in 1621 contained some 350,000 words. By the time the sixth (posthumous) edition was published, in 1651, it had grown to over 500,000 words. For an account of this process of textual accretion see the invaluable 'textual introduction' in Robert Burton, *The Anatomy of Melancholy* ed. Thomas C. Faulkner, Nicholas K. Kiessling, and Rhonda L. Blair with a commentary by J. B. Bamborough and Martin Dodsworth (Oxford: Clarendon Press, 1992), I, xxxvii–lx.
4 See Ruth Richardson, *Death, Dissection and the Destitute* (London: RKP, 1988).
5 See Cressida Fforde, 'The Royal College of Surgeons of England: A Brief History of its Collections and a Catalogue of Some Current Holdings' *World Archaeology Bulletin* 6 (1992), 22–52 (22).
6 Henrik Egede, 'Invasion of the Body Snatchers', *The Times Higher Educational Supplement* (8 February 1994), 9.
7 See Ivan Illich, 'A Plea for Body History', *Michigan Quarterly Review* 26 (1987), 342–8 (346). For an overview of recent sociological work on the body see Arthur W. Frank, 'For a Sociology of the Body: An Analytical Review' in Mike Featherstone, Mike Hepworth, and Bryan S. Turner (eds), *The Body: Social Process and Cultural Theory* (London: Sage Publications, 1991), 36–102.
8 Michael Dibdin, 'The Pathology Lesson', *Granta* 39 (spring 1992), 99.
9 Edward Shorter, *A History of Women's Bodies* (Harmondsworth: Penguin Books, 1984), 17.
10 Caroline Walker Bynum, 'The Female Body and Religious Practice in the Later Middle Ages' in Michael Feher, Ramona Nadaff, and Nadia Tazi (eds), *Fragments for a History of the Human Body, Part One* (New York: Zone Press, 1989), 171.
11 F. Gonzalez-Crussi, *Notes of an Anatomist* (London: Picador, 1986), 69.
12 Richard Selzer, *Confessions of a Knife: Meditations on the Art of Surgery* (London: Triad/Granada, 1982), 16.
13 Willy Haas (ed.), *Letters to Milena* trans. Tania and James Stern (1953, rpt. London: Minerva, 1992), 123.

14 The *aegis*, as the goddess's distinguishing garment, according to Marina Warner, could be imagined as a cloak, a breastplate, or a sling, worn 'obliquely across the breast' (107). For a discussion of the Athena–Medusa relationship, see Marina Warner, *Monuments and Maidens: The Allegory of the Female Form* (London: Picador, 1985), 104–26.

15 For the various different accounts of the Medusa story, see Robert Graves, *The Greek Myths* (1955, rpt. Harmondsworth: Pelican Books, 1962), I, 44–5, 127, 174–5, 238–9.

16 Sigmund Freud, 'Medusa's Head' in Freud, *Posthumous Writings* vol. 18 (1955) of *Complete Psychological Works* ed. James Strachey (London, 1953–74), 273–4.

17 Hélène Cixous, 'The Laugh of the Medusa' trans. Keith Cohen and Paula Cohen in Elaine Marks and Isabelle de Courtivron (eds), *New French Feminisms* (Brighton: The Harvester Press, 1985), 250.

18 For further discussion of the theoretical status of the concept of 'the body' within discourses of gender, see Judith Butler, *Gender Trouble: Feminism and the Subversion of Identity* (New York: Routledge, 1990) in particular the chapter 'Subversive Bodily Acts' (79–149).

19 Peter Stallybrass, 'Patriarchal Territories: The Body Enclosed' in Margaret Ferguson, Maureen Quilligan, and Nancy J. Vickers (eds), *Rewriting the Renaissance: The Discourses of Sexual Difference in Early Modern Europe* (Chicago: Chicago UP, 1986), 123–42 (126).

20 Shorter, *A History of Women's Bodies*, 286.

21 Ibid., 287.

22 Ibid., 287, 373; Vieda Skultans, 'The Symbolic Significance of Menstruation and the Menopause', *Man* 5 (1970), 639–51; Mary Douglas, *Purity and Danger: An Analysis of Concepts of Pollution and Taboo* (Harmondsworth: Penguin Books, 1970); Emily Martin, *The Woman in the Body: A Cultural Analysis of Reproduction* (Milton Keynes: Open University Press, 1989), 97–9; Jane Ussher, *The Psychology of the Female Body* (London: Routledge, 1989), 41–5. For an account of the cultural and symbolic dimension of menstruation in the early-modern period, see Gail Kern Paster, *The Body Embarrassed: Drama and the Disciplines of Shame in Early Modern England* (Ithaca: Cornell UP, 1993), 82–4.

23 Keith Thomas, *Religion and the Decline of Magic: Studies in Popular Belief in Sixteenth and Seventeenth-Century England* (1971, rpt. Harmondsworth: Penguin Books, 1978), 520. For accounts of menstrual taboos and prohibitions in European pre-industrial culture see Shorter, op. cit., 287–8.

24 K. B. Roberts and J. D. W. Tomlinson, *The Fabric of the Body: European Traditions of Anatomical Illustration* (Oxford: Clarendon Press, 1992), 13–15.

25 See Bolton G. Corney, 'The Behaviour of Certain Epidemic Diseases in Natives of Polynesia with Especial Reference to the Fiji Islands', *Transactions of the Epidemiological Society of London* ns 3 (1883–4), 76–95.

26 The response to Leenhardt's question is recorded in David Le Breton, 'Dualism and Renaissance: Sources for a Modern Representation of the Body', *Diogenes* 142 (1988), 47–69 (47). The terms 'inside' and 'outside', indicative of a 'closed' body, do not adhere in an 'open' body culture such as Melanesia where (according to Bruce Knauft) 'self and body are transactionally constituted through social relationships and through beliefs in spiritual forces'. See Bruce Knauft, 'Bodily Images in Melanesia: Cultural Substance and Natural Metaphors' in Michael Feher *et. al.*, *Fragments, Part Three*, 203.

27 Cecil Helman, *Body Myths* (London: Chatto and Windus, 1991), 121.

28 Linda Williams, *Hard Core: Power, Pleasure, and the 'Frenzy of the Visible'* (London: Pandora Press, 1991), 49. See also Lynne Segal and Mary McIntosh (eds), *Sex Exposed: Sexuality and the Pornography Debate* (London: Virago, 1992).

29 G. W. F. Hegel, *Introductory Lectures on Aesthetics* trans. Bernard Bosanquet (1886, rpt. Harmondsworth: Penguin Books, 1993), 36.

30 Selzer, *Confessions of a Knife*, 17.

31 John Lawrence and Robert Lawrence MC, *When the Fighting is over: Tumbledown A Personal Story* (London: Bloomsbury, 1988), 152.

32 It is important to note, here, that I am not suggesting that there was a *conscious* decision on anyone's part to produce pornographic images out of Lawrence's ordeal. Rather, I am simply noting the similarities (particularly in the reactions of those to whom the images were shown) between these photographs and images designed to quite different ends.

33 As Nancy J. Vickers has written, the image of the Medusa is 'the other side of the beautiful; the obsessively spoken part – the face – the other side of the obsessively unspoken but violated part – the genitalia'. See Nancy J. Vickers, 'This Heraldry in Lucrece' Face' in Susan Rubin Suleiman (ed.), *The Female Body in Western Culture: Contemporary Perspectives* (Cambridge, Mass.: Harvard UP, 1985), 209–22, 220.

34 Roland Barthes, *Roland Barthes* trans. Richard Howard (London: Macmillan, 1977), 36.

2 THE RENAISSANCE BODY

1 Plato, *Phaedo* 80B–81C, in Plato, *Euthyphro, The Apology, Crito, Phaedo* trans. Hugh Tredennick (Harmondsworth: Penguin Books, 1954), 133–4.

2 Augustine, *De Civitate Dei* trans. Henry Bettenson (Harmondsworth: Penguin Books, 1972), II, XIII, 16 (525). See also Augustine, Sermon 361 in *Augustine on Immortality* trans. J. Mourant (Villanova UP, 1969), 52; Augustine, *The Care to be Taken for the Dead* ('De cura pro mortuis gerenda') in Roy J. Defferati (ed.), *The Fathers of the Church*, vol. 15 (New York, 1955); Aquinas, *Summa Theologia* Suppt. to Pt. III. Q. 80. Art. 1, Obj. 2. For discussion of medieval debates on corporeality see Elizabeth A. R. Brown, 'Death and the Human Body in the Later Middle Ages: The Legislation of Boniface VIII on the Division of the Corpse', *Viator* 12 (1981), 221–70; R. C. Finucane, 'Sacred Corpse, Profane Carrion: Social Ideas and Death Rituals in the Later Middle Ages' in Joachim Whalley (ed.), *Mirrors of Mortality: Studies in the Social History of Death* (New York: St Martin's Press, 1981), 40–60.

3 St Athanasius, the fourth-century Patriarch of Alexandria, argued in his *De incarnatione* that, although the body was 'the medium of a person's concrete and physical presence', to think of the soul as 'entrapped' in some way within the body is to argue that Christ, considered as *Logos*, suffered such an entrapment. The idea that the body *contains* a soul, Athanasius reasoned, serves only to promote a dualism which places body and soul in a mutually antagonistic relationship to one another. An alternative conception is to try and see body and soul as complementary to one another – to understand the role each plays as components of a larger whole. 'True humanity', Athanasius claimed, 'is both corporeal and incorporeal'. See Alvyn Pettersen, *Athanasius and the Human Body* (Bristol: The Bristol Press, 1990), 6–8, 21.

4 Thus Calvin: 'But anyone who knows how to distinguish between body and soul, between the present transitory life and the eternal life to come, will not find it difficult to understand that the spiritual kingdom of Christ and civil government are things far removed from one another.' Jean Calvin, *Institutio Christianae Religionis* (1536) IV.20 in Harro Höpfl (ed.), *Luther and Calvin on Secular Authority* (Cambridge: CUP, 1991), 48.

5 John Donne, *Poetical Works* ed. Sir Herbert Grierson (London: OUP, 1933). Unless otherwise specified, all references to Donne's poetry are to this edition.

6 George R. Potter and Evelyn M. Simpson (eds), *The Sermons of John Donne* (Berkeley and Los Angeles: California UP, 1953–62), III, 235. All references to Donne's sermons are to this edition.

7 It was passages such as these which prompted some commentators to conclude that Donne

must have known of Harvey's work since the proof of circulation in *De Motu Cordis* rested in part on measurement of the rate of blood flow in relation to the cubic capacity of the heart. That possibility looks unlikely when it is recalled that, in his anatomical lectures of 1616, Harvey did not develop his ideas on circulation. *De Motu Cordis* was not, of course, published until 1628 – long after the sermon under discussion.

8 François Rabelais, *Gargantua* trans. Sir Thomas Urquhart (1653) ed. D. B. Wyndham Lewis (London: Dent, 1949), I, 17.

9 See Mikhail Bakhtin, *Rabelais and His World* trans. Hélène Iswolsky (Cambridge, Mass.: MIT, 1968) particularly chs. 5 and 6.

10 Peter Stallybrass and Allon White, *The Politics and Poetics of Transgression* (London: Routledge, 1986), 21, 23.

11 For a discussion of the literary use such 'touchstones' of interiority could be put to, see the reading of the significance of the handkerchief in *Othello* in Peter Stallybrass, 'Patriarchal Territories: The Body Enclosed' in Margaret Ferguson, Maureen Quilligan and Nancy J. Vickers (eds), *Rewriting the Renaissance: The Discourses of Sexual Difference in Early Modern Europe* (Chicago: Chicago UP, 1986), 137–9.

12 Burton's discussion of the soul in the *Anatomy* is a comprehensive digest of traditional and early seventeenth-century thought on a subject which he describes as 'pleasant, but . . . doubtful'. See Burton, *The Anatomy of Melancholy* ed. Thomas C. Faulkner, Nicholas K. Kiessling, Rhonda L. Blair with a commentary by J. B. Bamborough and Martin Dodsworth (Oxford: Clarendon Press, 1992), 1.1.2.5–9. For a recent study of the subject see Emma Ursula Harriet Seymour, 'Dangerous Conceits: Mind, Body and Metaphor 1590–1640' (University of Cambridge, PhD diss. 1993).

13 Sir Thomas Browne, *Selected Writings* ed. Sir Geoffrey Keynes (London: Faber and Faber, 1968), 58.

14 See Andrew Wear, 'Puritan Perceptions of Illness in Seventeenth-Century England' in Roy Porter (ed.), *Patients and Practitioners: Lay Perceptions of Medicine in Pre-Industrial Society* (Cambridge: CUP, 1985), 56–7.

15 Andrew Marvell, *The Poems and Letters* ed. H. M. Margoliouth (3rd edition, Oxford: Clarendon Press, 1971), I.22. All references to Marvell's poems are to this edition. For a discussion of the convention of body–soul debates in the seventeenth century see Rosalie Osmond, 'Body and Soul Dialogues in the Seventeenth Century', *ELR* 4 (1974), 364–403.

16 Quoted in Richard van Dülmen, *Theatre of Horror: Crime and Punishment in Early Modern Germany* trans. Elisabeth Neu (Cambridge: Polity Press, 1990), 97. Van Dülmen cites (p. 168) other instances of this formula in use in Germany which feature the exposure and dispersal of the body amongst the birds. Compare such instances to the final moment of Thomas Nashe's *The Unfortunate Traveller* (1594) where Cutwolfe's body is 'legacied amongst the fowls of the air'. See Thomas Nashe, *The Unfortunate Traveller and Other Works* ed. J. B. Steane (Harmondsworth: Penguin Books, 1972), 369.

17 Van Dülmen, *Theatre of Horror*, 97.

18 William Harvey, *The Movement of the Heart and Blood in Living Creatures* trans. Gweneth Whitteridge (Oxford: Blackwell Scientific Publications, 1976), 75. It is important to keep in mind the fact that William Harvey's formulation of the theory of circulation, in 1628, owed far more to Aristotelian habits of thought than it did to mechanistic principles. On the growth of Harvey's ideas, see Gweneth Whitteridge, *William Harvey and the Circulation of the Blood* (London: MacDonald and Co., 1971), 59–114; Jerome J. Bylebyl, 'The Growth of Harvey's *De Motu Cordis*', *BHM* 47 (1977), 427–70.

19 Michel Foucault, *The Order of Things* (1966, trans. London: Tavistock Press, 1970), 55. The literature exploring ideas of correspondence in the Renaissance, ideas which are rooted as much in St Paul as in the writings of pre-Socratic philosophers, is vast. A selection would

include: C. P. Conger, *Theories of Microcosm and Macrocosm in the History of Philosophy* (New York: Columbia UP, 1922); Arthur A. Lovejoy, *The Great Chain of Being* (Cambridge, Mass.: Harvard UP, 1936); Rudolph Allers, 'Microcosmos from Anaximandros to Paracelsus', *Traditio* 2 (1944), 319–407; J. B. Bamborough, *The Little World of Man* (London: Longmans Green and Co., 1952); Joseph Mazzeo, 'Metaphysical Poetics and the Poetry of Correspondence', *JHI* 14 (1953), 221–34; C. A. Patrides, 'The Microcosm of Man: Some References to a Commonplace', *NQ* (1960), 54–6; Leonard Barkan, *Nature's Work of Art: The Human Body as Image of the World* (New Haven: Yale UP, 1975); Don Parry Norford, 'Microcosm and Macrocosm in Seventeenth-Century Literature', *JHI* 38 (1977), 409–28.

20 With reference to architecture, for example, Wittkower long ago observed that the Vitruvian figure of the human body measuring geometric proportion 'seemed to reveal a deep and fundamental truth about the world'. See Rudolph Wittkower, *Architectural Principles of the Age of Humanism* (London: Academy Editions, 4th edition, 1977), 14.

21 On the creation of the hero-figure in scientific investigation, see John M. Steadman, 'Beyond Hercules: Bacon and the Scientist as Hero', *Studies in the Literary Imagination* 4 (1971), 3–47.

22 Browne, *Selected Writings*, 44.

23 Michel de Montaigne, *Essays* trans. J. M. Cohen (Harmondsworth: Penguin Books, 1958), 117.

24 For an analysis of the ideological role of the term cannibalism in European colonialism in the sixteenth century, see Peter Hulme, *Colonial Encounters: Europe and the Native Caribbean 1492–1797* (London: Routledge, 1986), 78–87. For a wide-ranging discussion of European encounters with 'alien' cultures in the early-modern period see Urs Bitterli, *Cultures in Conflict: Encounters between European and Non-European Cultures, 1492–1800* trans. Ritchie Robertson (1989, rpt. Cambridge: Polity Press, 1993).

25 Thus, in 1663, Henry Power was to write: 'The process of art is indefinite, and who can set a *non-ultra* to her endeavours'. See Henry Power, *Experimental Philosophy in Three Books* (London, 1663), sig. C3.

26 John Donne, *Selected Prose* ed. Neil Rhodes (Harmondsworth: Penguin Books, 1987), 198–9.

27 On the boundless optimism of seventeenth-century science, with particular reference to the links between natural philosophy and spiritual regeneration in puritan culture, see Charles Webster, *The Great Instauration: Science, Medicine and Reform 1626–1660* (London: Duckworth, 1975), 324–483.

28 Christopher Columbus, 'Letter on his First Voyage' (February 1493) in J. M. Cohen (ed.), *The Four Voyages of Christopher Columbus* (Harmondsworth: Penguin Books, 1969), 122.

29 Margarita Zamora has written of Columbian narratives of discovery, that the very term 'Indies' came to function as 'a feminized and ultimately eroticized sign . . . inscribed into Western culture figurally, as a feminine value, intended for consumption in a cultural economy where femininity is synonymous with exploitability'. See Margarita Zamora, 'Abreast of Columbus: Gender and Discovery', *Cultural Critique* 17 (1990–1), 127–49 (149).

30 See Thomas Healy, *New Latitudes: Theory and English Renaissance Literature* (London: Edward Arnold, 1992), 145–6.

31 Joseph Glanvill, *The Vanity of Dogmatizing* (London, 1661), 42.

32 Abraham Cowley, *The Advancement of Experimental Philosophy* (London, 1661), sig. A5.

33 Walter Charleton, *Enquiries into Human Nature in VI Anatomic Praelectiones* (London, 1680), sig. E.

34 René Descartes, *Discourse on the Method of Properly Conducting One's Reason and of Seeking the*

Truth in the Sciences (1637) trans. F. E. Sutcliffe (Harmondsworth: Penguin Books, 1968), 73.

35 For a critical discussion of the biological implications of mechanism, see Owsei Temkin, *The Double Face of Janus and Other Essays in the History of Medicine* (London and Baltimore: Johns Hopkins UP, 1977). Temkin makes the point that the body and the machine are, strictly, incomparable since the body does not conform to the 1st Law of Thermodynamics: that a *perpetuum mobile* cannot be constructed (279). Seventeenth-century mechanism has been scrutinized in E. J. Dijksterhuis, *The Mechanization of the World Picture* trans. C. Dikshoorn (Oxford: Clarendon Press, 1961). On the scientific implications of the 'mechanical philosophy' see Michael Hunter, *Science and Society in Restoration England* (Cambridge: CUP, 1981), 173–4.

36 Though Harvey did not, as was once thought, develop his mechanical analogy as early as 1616, it has certainly been argued that it was the example of hydraulic engineers which enabled him to address the dynamics of the circulatory system. For a discussion of this topic see Charles Webster, 'William Harvey and the Crisis of Medicine in Jacobean England' in Webster (ed.), *William Harvey and his Age: The Professional and Social Context for the Discovery of Circulation*, The Henry E. Sigerist Supplements to *The Bulletin of the History of Medicine* ns 2 (Baltimore and London: Johns Hopkins UP, 1979), 21–2.

37 Harvey, *The Movement of the Heart and Blood*, 3.

38 William Harvey, *De Motu Cordis* (London, 1653), sig. 2*.

39 For a discussion of the political implications of the changes in Harvey's text between 1628 and 1653 see the exchange which took place between Christopher Hill and Gweneth Whitteridge in *Past and Present* (April 1964 to July 1965). The exchange is reprinted in Charles Webster (ed.), *The Intellectual Revolution of the Seventeenth Century* (London: RKP, 1974), 160–96. Recently, the debate between Hill and Whitteridge has been revisited in I. Bernard Cohen, 'Harrington and Harvey: A Theory of the State Based on the New Physiology', *JHI* 55 (1994), 187–210.

40 C. H. Wilkinson (ed.), *The Poems of Richard Lovelace* (Oxford: Clarendon Press, 1930), 155.

41 Samuel Collins, *A Systeme of Anatomy*, 2 vols (London, 1685), I.xxviii.

42 Paul Barbette, *The Chirurgical and Anatomical Works* trans. anon. (London, 1672), 206. Barbette's work *Anatomia Practica* had first appeared in Dutch in 1659.

43 Francis Bacon, *Works* ed. J. Spedding, R. L. Ellis, and D. D. Heath, 7 vols (London, 1858–61), I.202–3.

44 'Thou hast ordered all things in measure, and number, and weight' (*Wisdom* 11.21). The English anatomist Walter Charleton was to echo the scriptural text when he wrote that the anatomist, when opening the body, should 'chiefly consider number, weight, and measure, i.e. the MECHANISM'. See Walter Charleton, *Three Anatomic Lectures* (London, 1683), 3.

45 Thomas Willis, 'Of Musculary Motion' in *The Remaining Medical Works* trans. Samuel Pordage (London, 1681), 35.

46 Henry Power, *Experimental Philosophy in Three Books* (London, 1664), sigs. C2^{r-v}.

47 On Harvey's use of measurement see F. G. Kilgour, 'Harvey's use of Quantitative Method', *Yale Journal of Biology and Medicine* 26 (1954), 410–21.

48 Isaac Walton, *The Lives of Dr. John Donne, Sir Henry Wotton, Mr. Richard Hooker, Mr. George Herbert* ed. George Saintsbury (London: OUP, 1927), 59–60.

49 References to Donne's *Devotions* (1624) are to John Donne, *Devotions upon Emergent Occasions* ed. Anthony Raspa (Montreal and London: McGill-Queen's UP, 1975).

50 On the 'medical model', and the 'sickness culture' of the Tudor and Stuart period, see Roy Porter, *Disease, Medicine and Society in England 1550–1860* (London: Macmillan, 1987), 24–6.

51 Michel Foucault, *Discipline and Punish: The Birth of the Prison* trans. Alan Sheridan (Harmondsworth: Penguin Books, 1977), 48. A more detailed historical account (though one still clearly indebted to Foucault) of the theory and practice of torture in the period may be found in van Dülmen, *Theatre of Horror*, 13–23.

52 Francis Osborne, *Traditionall Memoires of the Reigns of Queen Elizabeth and King James* (London, 1658), Pt. 2, sig. A4ᵛ–A5. I am grateful to Dr Susan Wiseman for this reference.

53 Robert Boyle, *Occasional Reflections upon Several Subjects* (London, 1665), sigs N6ᵛ–N7.

54 See John Dillenberger, *Protestant Thought and Natural Science* (London: Collins, 1961), 115.

3 THE BODY IN THE THEATRE OF DESIRE

1 For a description of this 'anatomical Renaissance' see A. Rupert Hall, *The Revolution in Science 1500–1750* (London: Longman, 1983), 39–53.

2 For the history of classical and medieval medicine and its transmission to the early-modern period, see Charles Singer, *A Short History of Anatomical and Physiological Discovery to Harvey* (London: Kegan Paul and Co., 1925); the relevant sections of A. C. Crombie, *Augustine to Galileo: The History of Science AD 400–AD 1650*, 2 vols (London: Heinemann, 1961); Owsei Temkin, *Galenism: Rise and Decline of a Medical Philosophy* (Ithaca: Cornell UP, 1973); D. C. Lindberg (ed.), *Science in the Middle Ages* (Chicago: Chicago UP, 1978); C. Hoolihan, 'The Transmission of Greek Medical Literature from Antiquity to the Renaissance', *Medical Heritage* 2 (1986), 430–42. Works dealing specifically with arabic medicine include: D. Campbell, *Arabian Medicine and its Influence on the Middle Ages* (London: Kegan, Paul, Trench, Trubner, 1926); M. Ullmann, *Islamic Medicine* (Edinburgh: Edinburgh UP, 1978); C. Elgood, *A Medical History of Persia and the Eastern Caliphate* (Amsterdam: APA-Philo Press, 1979). A helpful account of the 'pre-Vesalian' anatomists (Benivieni, de Laguna, Günther, Dryander, Canano, Estienne) can be found in L. R. Lind, *Studies in Pre-Vesalian Anatomy: Biography, Transactions, Documents* (Philadelphia: The American Philosophical Society, 1975), 3–19.

3 Thomas Gale, *Certaine Workes of Galens called Methodi Medendi* (London, 1586), sig. A2.

4 The standard introduction to the transmission of classical texts into the early-modern period describes the work of arabic commentators as requiring no more than a 'brief digression in order to mention a rather neglected chapter in the history of transmission'. See L. D. Reynolds and N. G. Wilson, *Scribes and Scholars: A Guide to the Transmission of Greek and Latin Literature* (2nd edition, Oxford: Clarendon Press, 1974), 48.

5 Edward Said, *The World, The Text, and the Critic* (London: Faber and Faber, 1984), 22.

6 General works on humanism and the rise of science include Marie Boas, *The Scientific Renaissance 1450–1630* (1962, rpt. London: Fontana, 1970); Antonia Mclean, *Humanism and the Rise of Science in Tudor England* (London: Heinemann, 1972). On the influence of print culture, in particular, on the transmission of medical knowledge, see Elizabeth L. Eisenstein, *The Printing Press as an Agent of Change: Communications and Cultural Transformations in Early-modern Europe* (Cambridge: CUP, 1979), I, 268; II, 502–36; II, 566–74. For the effect on western science of protestantism see Dorothy Stimson, 'Puritanism and the New Philosophy in Seventeenth-century England', *BIHM* 3 (1935), 321–34; S. F. Mason, 'The Scientific Revolution and the Protestant Reformation' in Hugh F. Kearney (ed.), *Origins of the Scientific Revolution* (London: Longmans Green and Co., 1964), 100–5; S. F. Mason, 'Science and Religion in Seventeenth-century England' in Charles Webster (ed.), *The Intellectual Revolution of the Seventeenth Century* (London: RKP, 1974), 197–218; Nicholas Tyacke, 'Science and Religion at Oxford Before the Civil War' in Donald Pennington and Keith Thomas (eds), *Puritans and Revolutionaries: Essays in Seventeenth-century History*

Presented to Christopher Hill (Oxford: Clarendon Press, 1978), 73–94. For more recent accounts of the social history of early medicine, see in particular Vivian Nutton, 'Healers in the Medical Market Place: Towards a Social History of Graeco-Roman Medicine' in Andrew Wear (ed.), *Medicine in Society: Historical Essays* (Cambridge: CUP, 1992), 15–58 and Katherine Park, 'Medicine and Society in Medieval Europe' in Wear (ed.), *Medicine in Society*, 59–90.

7 Giovanni Ferrari, 'Public Anatomy Lessons and the Carnival: The Anatomy Theatre at Bologna', *Past and Present* 117 (1987), 50–106. Ferrari's article is an invaluable source for cultural historians of anatomy. See also Jan C. C. Rupp, 'Matters of Life and Death: The Social and Cultural Conditions of the Rise of Anatomical Theatres, with Special Reference to Seventeenth-century Holland', *History of Science* 38 (1990), 263–87; David Harley, 'Political Post-mortems and Morbid Anatomy in Seventeenth-century England', *Social History of Medicine* 7 (1994), 1–28.

8 Ernest Rhys (ed.), *The Diary of John Evelyn* (London: J. M. Dent, 1907), I, 29. Harvey, who had trained at Padua, visited Leiden in the course of his continental journey with the Earl of Arundel in 1636 (Geoffrey Keynes, *The Life of William Harvey* (Oxford: Clarendon Press, 1978), 261). On connections between Leiden and England in the seventeenth century see: R. W. I. Smith, *English Speaking Students of Medicine at the University of Leyden* (Edinburgh and London: Oliver & Boyd, 1932).

9 Sir William Davenant, *Gondibert* ed. David F. Gladish (Oxford: Clarendon Press, 1971), 155. On the identification of Leiden as the original for the 'Cabinet of Death' see Jonathan Sawday, 'The Leiden Anatomy Theatre as a Source for Davenant's Cabinet of Death in *Gondibert*', *Notes & Queries* 30 (1983), 437–9.

10 George Hakewill, *An Apology or Declaration of the Power and Providence of God in the Government of the World* (3rd edition, London, 1635), 275.

11 John Hall, *The Advancement of Learning* ed. A. K. Croston (Liverpool: Liverpool UP, 1953), 27.

12 Richard Wilson, *Will Power: Essays on Shakespearean Authority* (Hemel Hempstead: Harvester Wheatsheaf, 1993), 59.

13 Louis de Bils, *The Copie of a Certaine Large Act . . . Touching the Skill of a Better Way of Anatomy of Mans Body* trans. R. B. (London, 1659), sig. A5. The translation, credited to Robert Boyle, was in fact undertaken by Dr John Pell, though Boyle was involved in the dissemination of de Bils's proposals. For further discussion of this project, see Hartlib's correspondence with Worthington in 1659 in *Remains Historical & Literary Connected with the Palatine Counties of Lancaster and Chester* (The Chetham Society, 1847), XIII, 159–60. I am grateful to Prof. D. D. C. Chambers of the University of Toronto for drawing my attention to this correspondence.

14 Philipe Ariès, *The Hour of Our Death* trans. Helen Weaver (New York: Alfred A. Knopf, 1981), 369.

15 In addition to the texts by Lyly, Stubbes, Nashe, and Burton, I have noted the following 'anatomies' which appeared between 1570 and 1653. All were published at London: Thomas Rogers, *The Anatomy of the Minde* (1576); John Woolton, *A New Anatomie of Whole Man* (1576); John More, *A Livelie Anatomie of Death* (1596); Anon., *The Anathomie of Sinne* (1603); Thomas Bell, *Anatomy of Popish Tyranny* (1603); Robert Prickett, *Times Anatomie* (1606); George Strode, *The Anatomie of Mortalitie* (1618); Thomas Robinson, *The Anatomy of the English Nunnery at Lisbon* (1622); Anon., *Abuses of the Roman Church Anatomized* (1623); George Lauder, *Anatomy of the Roman Clergy* (1623); O. A., *Anatomie of Protestancie* (1623); R. W., *The Anatomy of Warre* (1642); Anon., *A Briefe Anatomie of Women* (1653). Undoubtedly, this list is not exhaustive. For a discussion of the anatomy genre see T. J. Arthur, 'Anatomies and the Anatomy Metaphor in Renaissance England' (University of Wisconsin-

Madison, PhD diss., 1978); Devon Leigh Hodges, *Renaissance Fictions of Anatomy* (Amherst: U. of Massachusetts P., 1985).

16 Walter J. Ong, *Ramus, Method, and the Decay of Dialogue* (Cambridge, Mass.: Harvard UP, 1958), 315.

17 For the early stage history of *The Anatomist* see William van Lennep (ed.), *The London Stage 1660–1800* (Carbondale, Ill.: Southern Illinois UP, 1965), I.469–70. On the play's source see Raymond E. Parshall, 'The Source of Ravenscroft's *The Anatomist*', *RES* 12 (1936), 328–33.

18 Ravenscroft's *The Anatomist* was first performed with Garrick's *Romeo and Juliet* on 16 November 1756. For information on Garrick's version of the Shakespearean text see G. Blakemore Evans (ed.), *Romeo and Juliet*, The New Cambridge Shakespeare (Cambridge: CUP, 1984), 35–40.

19 William Shakespeare, *Romeo and Juliet* ed. Brian Gibbons, The Arden Shakespeare (London: Methuen, 1980), 270.

20 John Lahr, *Prick up your Ears: The Biography of Joe Orton* (Harmondsworth: Penguin Books, 1980), 228. Orton's admiration for Restoration comedy is also perhaps worth noting in this context.

21 Thomas Ravenscroft, *The Anatomist or The Sham Doctor* (London, 1697), 18.

22 Ibid., sig. A2.

23 Ruth Richardson, *Death, Dissection and the Destitute* (Harmondsworth: Penguin Books, 1989), *passim*. Richardson's widely acclaimed book is of the greatest importance to any study of the social dimension of anatomy from the eighteenth century onwards.

24 Thomas Nashe, *The Unfortunate Traveller and Other Works* ed. J. B. Steane (Harmondsworth: Penguin Books, 1972), 351.

25 George Gascoigne, *A Hundreth Sundrie Flowers Bounde Up In One Smalle Poesie* (London, n.d.), sigs S4ᵛ–T. This work, possibly the first edition of Gascoigne, was published *c.* 1573.

26 John Davies of Hereford, *Wittes Pilgrimage* (London, 1605), sonnet 33 (sig. D2).

27 This phrase is usually expressed as 'hung, drawn, and quartered', where 'drawn' somehow suggests evisceration. In fact, what was meant by the term in early-modern England was, first, the 'drawing' of the victim to the place of execution on a sledge, secondly, their hanging, and finally their quartering. The imaginative transposition of these elements is an example of that later 'morbid fascination' of which Ariès has spoken.

28 C. H. Wilkinson (ed.), *The Poems of Richard Lovelace* (Oxford: Clarendon Press, 1930), 132.

29 My analysis of these texts of anatomic desire is informed by the work of Linda Williams on cinematic sado-masochism. See Williams, *Hard Core: Power, Pleasure, and the 'Frenzy of the Visible'* (London: Pandora Press, 1991), 195–228.

30 W. A. Ringler, Jr (ed.), *The Poems of Sir Philip Sidney* (Oxford: Clarendon Press, 1962), 174.

31 Sigmund Freud, 'The Economic Problem of Masochism' (1924) in Sigmund Freud, *On Metapsychology: The Theory of Psychoanalysis* ed. Angela Richards (Pelican Freud Library, vol. 11) (Harmondsworth: Penguin Books, 1984), 411–26.

32 On the difficulties associated with psychoanalytic analysis of Renaissance texts see Stephen Greenblatt, 'Psychoanalysis and Renaissance Culture' in Patricia Parker and David Quint (eds), *Literary Theory/Renaissance Texts* (Baltimore and London: Johns Hopkins UP, 1986), 210–24.

4 EXECUTION, ANATOMY, AND INFAMY

1 Quotations are from the 1752 'Murder Act' ('An Act for Better Preventing the Horrid Crime of Murder') 25 Geo.II. c. 37. For a discussion of the Act, see Ruth Richardson

Death, Dissection and the Destitute (Harmondsworth: Penguin Books, 1989), 35–7.

2 Popular belief that denial of burial involved the punishment of the soul appears to have been widespread in the early-modern period, despite the fact that neither the protestant nor catholic churches regarded intact christian burial as a prerequisite for obtaining posthumous grace. On death practices and beliefs in the period, see David E. Stannard, *The Puritan Way of Death: A Study in Religion, Culture, and Social Change* (New York: OUP, 1977), *passim.*; R. C. Finucane, 'Sacred Corpse, Profane Carrion: Social Ideas, and Death Rituals in the Later Middle Ages', in Joachim Whalley (ed.), *Mirrors of Mortality: Studies in the Social History of Death* (New York: St Martins Press, 1981), 60. Clare Gittings has pointed out how, in the protestant context of seventeenth-century England, popular demand for often elaborate liturgical rites at the point of burial of the dead persisted, despite the best efforts of the authorities to deflect attention away from a ceremony held to be tainted with 'papist' superstition. See Clare Gittings, *Death, Burial and the Individual in Early Modern England* (London and Sydney: Croom Helm, 1984), 54–9. The seventeenth-century antiquary John Weever offers perhaps the clearest account of the conflict between stated christian doctrine and popular views on the importance of burial. See John Weever, *Ancient Funerall Monuments* (London, 1631), 30–2.

3 Michel Foucault, *Discipline and Punish: The Birth of the Prison* trans. Alan Sheridan (Harmondsworth: Penguin Books, 1977), 48.

4 The relevant sections of the act allowed the Barber-Surgeons to 'have and take without co[n]tradiction foure persons condempned adjudged and put to death for feloni by the due order of the kynges lawe of thys realme for anatomies without any further sute or labour made to the kynges highnes his heyres or succesors for the same'. The whole Act (32 Hen. 8 c. 42) is published as an appendix to Sidney Young, *Annals of the Barber-Surgeons of London* (London, 1890), 586–90.

5 Information on the early history of anatomical teaching in England is derived from the following sources: Sidney Young, *Annals of the Barber-Surgeons of London* (London, 1890); A. Chaplin, 'A History of Medical Education in the Universities of Oxford and Cambridge', *Proceedings of the Royal Society of Medicine* 13 (1920), 83–107; Phyllis Allen, 'Medical Education in Seventeenth-century England', *JHM* 1 (1946), 115–43; W. S. Copeman, 'The Evolution of Anatomy and Surgery under the Tudors', *Annals of the Royal College of the Surgeons of England* 32 (1964), 1–21; Sir George Clark, *A History of the Royal College of Physicians* (Oxford: Clarendon Press, 1964); W. Brockbank, 'Old Anatomical Theatres and What Took Place Therein', *MH* 12 (1968), 371–84; K. F. Russell, 'Anatomy and the Barber Surgeons', *Medical Journal of Australia* 1 (1973) 1109–15; Frances Valdez, 'Anatomical Studies at Oxford and Cambridge' in A. G. Debus (ed.), *Medicine in Seventeenth-century England* (Berkeley and Los Angeles: U. California P., 1974) 393–420.

6 This figure, and the figures given below for execution rates in the early seventeenth century are taken from Alfred Marks, *Tyburn Tree: Its History and Annals* (London: n.d), 77. The figures should be treated with caution, though they tally with those calculated by other authorities. See, in particular, L. Radzinowicz, *A History of English Criminal Law and its Administration from 1750* (New York: The Macmillan Company, 1948–68), I.140–8. See also J. A. Sharpe, *Crime in Seventeenth-century England* (Cambridge: CUP, 1983), 143–4; J. A. Sharpe, *Crime in Early Modern England 1550–1750* (London and New York: Longman, 1984), 63–72.

7 Tyburn was the chief, but not the only source of bodies for the Barber-Surgeons and the Physicians. Other execution sites included Putney and Kennington Common, St Thomas a Watering (the Old Kent Road), and Execution Dock at Wapping for pirates. See Radzinowicz, *A History of English Criminal Law*, 199–200.

8 A 'public' anatomy was one conducted on the body of any executed felon which had arrived in the college under statutory provision for the supply of corpses from the hangman. The College of Physicians also conducted 'private' anatomies, where the corpse was supplied by the anatomist himself. Strict rules governed the performance of both public and private anatomies. In the early eighteenth century, as Richardson (*Death, Dissection and the Destitute*, 39) notes, private anatomy schools were undoubtedly flourishing in London. We have no means (as yet) of knowing of the extent to which such schools flourished in the seventeenth century.

9 The Charter of James I to the Company of Barber-Surgeons (dated 30 January 1605) expressly prohibits these companies from performing dissections or embalming, which suggests that the practice was indeed current. See Young, *Annals of the Barber-Surgeons*, 114.

10 Valdez, 'Anatomical Studies at Oxford and Cambridge', 398.

11 See Richardson, *Death, Dissection and the Destitute, passim*. It is important to note that fear of the Resurrectionists was not confined to the anatomy schools of Europe. In America too, in the late eighteenth century, a growing fear of exhumation and dissection was widespread. These fears were ultimately manifested in the anti-dissection riots of 1788 in New York and Baltimore. See Steven Robert Wilf, 'Anatomy and Punishment in Late Eighteenth-Century New York', *Journal of Social History* 22 (1989), 507–30.

12 Clarendon Hyde Cresswell, *The Royal College of Surgeons of Edinburgh: Historical Notes 1505–1905* (Edinburgh: Oliver & Boyd, 1926), 193.

13 Louis de Bils, *The Copie of a Certain Large Act . . . Touching the Skill of a Better Way of Anatomy of Mans Body* trans. R. B. (London, 1659), 3.

14 The market value of a dissected corpse, prepared under de Bils's supervision, seems to have been considerable. Hartlib, in his letter to Worthington (*Remains Historical & Literary Connected with the Palatine Counties of Lancaster and Chester* (The Chetham Society, 1847), 160), records having received notice in October 1659 that de Bils was offering four bodies, two men and two women 'so anatomized that he can shew the inward state . . . for all the parts of the body are in the body, except the guts and brains whch lye by'. For these bodies de Bils asked 10,000 florins, adding that Paris and Amsterdam had both purchased similar preparations at similar rates.

15 Giovanni Ferrari, 'Public Anatomy Lessons and the Carnival: the Anatomy Theatre at Bologna', *Past and Present* 117 (1987), 50–106, 55.

16 For example, in April 1665 Charles II visited the College of Physicians and witnessed a dissection conducted by Dr George Ent, one of the earliest vindicators of Harvey's theory of circulation. Following the dissection, the king knighted Ent on the spot. For a discussion of the social context of Stuart medicine, see Harold J. Cook, *The Decline of the Old Medical Regime in Stuart London* (Ithaca & London: Cornell UP, 1986), *passim*.

17 Bernard Mandeville, *An Enquiry into the Causes of the Frequent Executions at Tyburn* (London, 1725), 26.

18 Cited in Young, *Annals of the Barber-Surgeons*, 102.

19 Ibid., 301.

20 For the rules ordering the provision of anatomy at the College of Physicians in the later seventeenth century, see *The Statutes of the College of Physicians* (London, 1693).

21 John Stowe, *The Annals of England* (London, 1594), 1261.

22 Valdez, 'Anatomical Studies at Oxford and Cambridge', 395, 396.

23 The preservation of skeletons at the Hall of the Barber-Surgeons seems to have run directly counter to a by-law of the Company, obtained in 1606, which ordered that corpses were to be decently buried after dissection (Young, *Annals of the Barber-Surgeons*, 115).

24 Henry Goodcole, *Heavens Speedie Hue and Cry sent after Lust and Murther* (London, 1635), 15. For the eventual display of the skeletons at the Barber-Surgeons' Hall, see Young, *Annals of the Barber-Surgeons*, 134. The story of 'Counterey Tom' and 'Canberry Bess' is told in Joseph H. Marshburn, *Murder and Witchcraft in England 1550–1640, as recorded in Pamphlets, Ballads, Broadsides, and Plays* (Norman, Okla.: Oklahoma UP, 1971) 228–33.

25 Such collusion was, in all probability, fruitless. Though popular belief may have been widespread (as it still is) that a criminal who 'cheated' the gallows in some way was therefore spared re-execution, the law deemed it otherwise. As Sir Matthew Hale, Lord Chief Justice of the King's Bench in the later seventeenth century, grimly expressed the matter: 'If the party be hanged and cut down and revive again, yet he must be hanged again, for the judgment is to be hanged by the neck *till he be dead.*' See Sir Matthew Hale, *Historia Placitorum Coronae* (London, 1736), II, 412.

26 Stowe, *Annals of England*, 1261.

27 A. H. T. Robb Smith, *A Short History of Anatomical Teaching at Oxford* (Oxford: OUP, 1950), 12.

28 Andrew Clark (ed.), *The Life and Times of Anthony à Wood Antiquary of Oxford, 1632–1695 described by Himself* (Oxford: Clarendon Press, 1891–1990), III, 311.

29 On eighteenth-century executions, in addition to Spierenburg (see note 63 below), see Peter Linebaugh, 'The Tyburn Riot against the Surgeons' in Douglas Hay, Peter Linebaugh, John Rule, and E. P. Thompson, *Albion's Fatal Tree: Crime and Society in Eighteenth-century England* (Harmondsworth: Penguin Books, 1975), 65–117; Randall McGowen, 'The Body and Punishment in Eighteenth-century England', *Journal of Modern History* 59 (1987), 651–79. One of the few attempts at looking at the problem from an earlier perspective is J. A. Sharpe, 'Last Dying Speeches: Religion, Ideology, and Public Execution in Seventeenth-Century England', *Past and Present* 107 (1985), 144–67.

30 For the idea of the 'economy' of punishment, see Foucault, *Discipline and Punish*, 75.

31 Richardson, *Death, Dissection and the Destitute*, 31.

32 The permanent anatomy theatre at Leiden, constructed in the 1580s, was built inside a church. On the history of the Leiden theatre see Th. H. Lunsingh Scheurleer, 'Un Amphithéâtre D'Anatomie Moralisée' in Th. H. Lunsingh Scheurleer and G. H. M. Posthumus Meyjes (eds), *Leiden University in the Seventeenth Century: An Exchange of Learning* (Leiden: Leiden UP, 1975), 217–23.

33 This model of dialectic engagement is derived from Ong's description of the scholastic disputation. See Walter J. Ong, *Ramus, Method, and the Decay of Dialogue* (Cambridge, Mass.: Harvard UP, 1958), 152–6. Where the Renaissance anatomy lesson might be thought of as fundamentally different from the model suggested by Ong, however, is in the transition from the authority of the text to the authority of the voice. This process is effectively the opposite of that sketched by Ong, in that rather than there being a 'retreat from the evanescent world of discourse (*verba volant*) to the more stable world of writing (*scripta manent*)', the anatomy demonstration (as opposed to disputation) foregrounded the speaking voice at the expense of the written word. The guarantee of the authority of the voice is the body itself: the body is, in this sense, the intellectual catalyst which precipitated a shift in the other elements forming the (hitherto) triadic relationship of the theatre.

34 For a reading of the *Fasciculo* scene, and the Vesalian title-page, see Jonathan Sawday, 'The Fate of Marsyas: Dissecting the Renaissance Body' in Lucy Gent and Nigel Llewellyn (eds), *Renaissance Bodies: The Human Figure in English Culture 1540–1660* (London: Reaktion Books, 1990), 111–35. Since proposing this reading, the appearance of a persuasive article by Jerome J. Bylebyl has made me reconsider a number of the interpretations which I had earlier offered. See Jerome J. Bylebyl, 'Interpreting the

Fasciculo Anatomy Scene', *JHM* 45 (1990), 285–316. For a comparative illustration of pre-Vesalian anatomization, see the title-page to Berengario da Carpi's *Isagoge Breves* (1523).

35 The title-page of the *Fabrica* has occasioned a vast amount of commentary on its symbolism, iconography, and authorship. See in particular Hermani Monteiro, 'Some Vesalian Studies' in E. Ashworth Underwood (ed.), *Science, Medicine, and History: Essays on the Evolution of Scientific Thought and Medical Practice in Honour of Charles Singer* (London: OUP, 1953), I, 371–3; C. E. Kellett, 'Two Anatomies', *Medical History* 8 (1964), 342–53; J. B. de C. M. Saunders and C. D. O'Malley (eds), *The Illustrations From the Works of Andreas Vesalius of Brussels* (New York: Dover Publications, 1950), 42–5, 248–52; Luke Wilson, 'William Harvey's *Prelectiones*: The Performance of the Body in the Renaissance Theatre of Anatomy', *Representations* 17 (1987), 62–95; Diane R. Karpe (ed.), *Ars Medica: Art, Medicine and the Human Condition* (Philadelphia: Pennsylvania UP, 1985), 159–61; Jonathan Sawday, 'Bodies By Art Fashioned: Anatomy, Anatomists, and English Poetry 1570–1680' (University of London, PhD diss., 1988), 184–7; Sawday, 'The Fate of Marsyas', 120–3; K. B. Roberts and J. D. W. Tomlinson, *The Fabric of the Body: European Traditions of Anatomical Illustrations* (Oxford: Clarendon Press, 1992), 131–5.

36 Wilson, 'William Harvey's *Prelectiones*', 71.

37 Saunders and O'Malley, *The Illustrations*, 42.

38 C. D. O'Malley, *Andreas Vesalius of Brussels, 1514–1564* (Berkeley and Los Angles: California UP, 1964), 140. See also Ferrari, 'Public Anatomy Lessons', 84–7.

39 For a discussion of Bramante's Tempietto, see Peter Murray, *The Architecture of the Italian Renaissance* (London: Thames and Hudson, 1969), 123–6; and Howard Colvin, *Architecture and the After-life* (New Haven and London: Yale University Press, 1991), 236.

40 Vitruvius, *The Ten Books of Architecture* trans. Morris Hicky Morgan (New York: Dover Publications Inc., 1960), 73.

41 The quotation is from Daniel Barbaro's (1567) edition of Vitruvius, cited (and translated) in John Peacock, 'Inigo Jones as a Figurative Artist' in Gent and Llewellyn, *Renaissance Bodies*, 162. For an extended discussion of the Vitruvian figure see Peacock, ibid., 162–6.

42 Robert S. Westman, 'Proof, Poetics, and Patronage: Copernicus's Preface to *De revolutionibus*' in David C. Lindberg and Robert S. Westman (eds), *Reappraisals of the Scientific Revolution* (Cambridge: CUP, 1990), 167–205. On the reception of Copernican theory within a religious context, see John Hedley Brooke, *Science and Religious Reform: Some Historical Perspectives* (Cambridge: CUP, 1991), 82–99.

43 Copernicus, *De Revolutionibus* (1543) quoted in Olaf Pedersen, *Early Physics and Astronomy: A Historical Introduction* (1974, rpt. Cambridge: CUP, 1993), 267, 271. It is worth noting that Copernican theory was itself in circulation well before 1543. The first communication of Copernicus' ideas was in the manuscript 'Commentarolius' of *c.* 1530. In 1540, Rheticus (after visiting Copernicus) published his *Narratio Prima de libris revolutionibus* – a work indebted to Copernican thought. In other words, as Pedersen notes (264), the ground was prepared well before 1543 when the *Fabrica* appeared at Basel and the *De Revolutionibus* at Nuremberg. Both the second editions of the *Fabrica* (1555) and the *Revolutionibus* (1566) appeared at Basel.

44 The presence of Time in the Vesalian theatre is underlined in the second (1555) edition of the *Fabrica*. In the 1555 re-engraving the skeleton was provided with a scythe.

45 The suggestion of a dissected arm may be of significance. In the *Fabrica* Vesalius' portrait shows him with a dissected arm and hand. In Rembrandt's famous 'Anatomy of Dr Tulp' (1632), the anatomist is shown dissecting the tendons of the arm which guide the mechanical movement of the hand. The hand, according to Aristotle and Galen, was not a specialist instrument, but, as William Schupbach has written in his account of

Rembrandt's painting, 'an instrument for using other instruments . . . the physical counterpart of the human psyche'. It is the muscles and tendons guiding the hand, together with human reason, which therefore build civilization. See William Schupbach, *The Paradox of Rembrandt's 'Anatomy of Dr Tulp'* (London: Wellcome Institute for the History of Medicine, 1982), 17.

46 The ape in the Renaissance was a fluid symbol. The ape could represent sloth, intemperance, amorous madness, and vanity. Interestingly, an attribute of the ape in the form of *vanitas* is a mirror. In this context, the appearance of the ape in the Vesalian theatre may represent the futility of mortal endeavour. On apes, see H. W. Janson, *Apes and Ape Lore in the Middle Ages and the Renaissance*, Studies in the Warburg Institute, vol. 20 ed. H. Frankfort (London: The Warburg Institute, University of London, 1952), ch. 8.

47 Sir William Davenant, *Gondibert* ed. David F. Gladish (Oxford: Clarendon Press, 1971), 155.

48 Ferrari, 'Public Anatomy Lessons', 64.

49 Ibid., 85. Ferrari observes that the anatomy theatre and the theatre proper should be understood as leading a 'parallel existence' (86). Similarly, Katherine Park has argued that criminal dissection 'resembled a sacrament – the penultimate act in a potential drama of redemption'. See Katherine Park, 'The Criminal and the Saintly Body: Autopsy and Dissection in Renaissance Italy', *RQ* 47 (1994), 1–33 (23).

50 For Jones's reading in continental architectural theory, see Peacock, 'Inigo Jones as a Figurative Artist', 162–5.

51 See John Harris, Stephen Orgel, and Roy Strong, *The King's Arcadia: Inigo Jones and the Stuart Crown* (London: Arts Council of Great Britain, 1973), 136.

52 Edward Hatton, *New View of London* (London, 1708), II, 597.

53 *Annals of the RCP*, II, 227 in *Historical MSS Commission*, 8th report (London, 1882), Appendix I.

54 Henry B. Wheatley (ed.), *The Diary of Samuel Pepys* (London: G. Bell and Sons Ltd, 1938), III, 51. Pepys's visit took place on 27 February 1662/3. The reader at the demonstration, 'Dr Tearne', was Christopher Terne, one of the original fellows of the Royal Society, and a medical graduate of Leiden.

55 Linebaugh, 'The Tyburn Riot', 109.

56 On the importance of these ceremonies, see Jonathan Sawday, 'Rewriting a Revolution: History, Symbol, and Text in the Restoration', *The Seventeenth Century* 8 (1992), 171–99 186.

57 *Royal Commission on Capital Punishment 1949–1953* (Report 261), 258. For the BMA's views as well as the views of the American Medical Association, and other American medical organizations, see Franklin E. Zimring and Gordon Hawkins, *Capital Punishment and the American Agenda* (Cambridge: CUP, 1986), 114–15. Zimring and Hawkins sardonically note the complacent acceptance on the part of the medical establishment in Britain and the USA of the institution of capital punishment 'as long as members of the profession did not become involved in it' (115).

58 George W. Corner (ed.), *Anatomical Texts of the Earlier Middle Ages: A Study in the Transmission of Culture with a Revised Latin Text of the Anatomia Cophonis and Translations of Four Texts* (Washington, DC: Carnegie Institution, 1927), 67.

59 Roberts and Tomlinson, for example, write that there is 'insufficient evidence to support the scurrilous accusations' that live dissection was performed at Alexandria in the period between 300 BC and 30 BC (Roberts and Tomlinson, *The Fabric of the Body*, 1–2).

60 L. R. Lind, *Studies in Pre-Vesalian Anatomy: Biography, Transaction, Documents* (Philadelphia: The American Philosophical Society, 1975), 82.

61 Mary Niven Alston, 'The Attitude of the Church towards Dissection before 1500', *BHM* 16 (1944), 221–38 (228).

62 Ferrari, 'Public Anatomy Lessons', 60.

63 Pieter Spierenburg, *The Spectacle of Suffering: Executions and the Evolution of Repression* (Cambridge: CUP, 1984), 31–3.

64 Ibid., 13–42, 87.

65 From Joseph de Maistre, *Les Soirées de Saint Petersbourg ou Entreins sur Gouvernement temporel de la Providence suivis d'un traité sur les Sacrifices* (Paris, n.d. [1821], I, 27–32. Quoted in (and translated by) Nina Althanassoglou-Kallmyer, 'Géricault's Severed Head and Limbs: The Politics and Aesthetics of the Scaffold', *The Art Bulletin* 74 (1992), 600–18 (607–8).

66 Lind, *Studies in Pre-Vesalian Anatomy*, 83.

67 Cyril Tourneur, *The Atheist's Tragedy* in A. H. Gomme (ed.), *Jacobean Tragedies* (London: OUP, 1969).

5 SACRED ANATOMY AND THE ORDER OF REPRESENTATION

1 Giorgio Vasari, *Lives of the Artists* (1550) trans. George Bull (Harmondsworth: Penguin Books, 1965), 336.

2 Sebastiano Serlio, *The First (-fift) Booke of Architecture made by S. Serly* (London, 1611), Bk II, fol. 6ᵛ.

3 Lucien Febvre, *The Problem of Unbelief in the Sixteenth Century: The Religion of Rabelais* (Cambridge, Mass.: Harvard UP, 1982), 100.

4 John White, 'Perspective' in J. R. Hale (ed.), *A Concise Encyclopedia of the Italian Renaissance* (London: Thames and Hudson, 1981), 244.

5 Sir Henry Wotton, *The Elements of Architecture* (London, 1624), 28–9.

6 C. A. Patrides (ed.), *The English Poems of George Herbert* (London: Dent, 1974). All references to Herbert's poetry are to this edition.

7 On the sources of Davies's philosophical poem, see Robert Kreuger (ed.), *The Poems of Sir John Davies* (Oxford: Clarendon Press, 1975), 325–8. All citations from Davies's poetry are to this edition. On doubt and scepticism in the Renaissance see Margaret L. Willey, *The Subtle Knot: Creative Scepticism in Seventeenth-Century England* (London: George Allen & Unwin, 1952); R. H. Popkin, *The History of Scepticism from Erasmus to Descartes* (Assen, rev. edition, New York: The Humanities Press, 1964); D. C. Allen, *Doubt's Boundless Sea: Scepticism and Faith in the Renaissance* (Baltimore: Johns Hopkins UP, 1964).

8 For an account of the reception and influence of Du Bartas in England see Susan Snyder (ed.), *The Divine Weeks and Works of Guillaume de Saluste, Sieur du Bartas Translated by Joshua Sylvester* (Oxford: Clarendon Press, 1979), I.73–95. All references to Du Bartas are to this edition.

9 William Wordsworth, 'Essay Supplementary to the Preface' in Nowell C. Smith and Howard Mills (eds), *Wordsworth's Literary Criticism* (1905, rpt. Bristol: Bristol Classical Press, 1980), 176.

10 Snyder, *Du Bartas*, I. 1.

11 Thus Plato: 'time came into being with the heavens in order that, having come into being together, they should also be dissolved together if ever they are dissolved; and it was made as like as possible to eternity, which was its model' (*Timaeus* 38B).

12 Aristotle, *Physics* IV, xi, 220a (as noted by Kreuger). For a discussion of the relationship between spatial and temporal order in Plato and Aristotle, see G. E. L. Owen, 'Aristotle on Time' in Peter Machamer and Robert Turnbull (eds), *Motion and Time, Space and*

Matter: Interrelations in the History of Philosophy and Science (Athens: Ohio State UP, 1976), 3–25.

13 See Brian P. Copenhaver and Charles B. Schmitt, *Renaissance Philosophy* (Oxford and New York: OUP, 1992), 193.

14 Thomas Hobbes, *Leviathan* ed. Richard Tuck (Cambridge: CUP, 1991), 463.

15 Analogies between 'the concept of spatial form . . . and to narrative sequence in literature' (i.e. the inter-relationship of temporal and spatial order) in the Renaissance have been suggestively made in Murray Roston, *Renaissance Perspectives in Literature and the Visual Arts* (Princeton: Princeton UP, 1987), *passim*. The importance of Euclidean investigations of space to the perspectival organization of a complete picture (as opposed to objects within the picture), formulated in 1924–5 by Erwin Panofsky, has recently been challenged in James Elkins, 'Renaissance Perspectives', *JHI* 53 (1992), 209–30.

16 Francis Bacon, *The Advancement of Learning* ed. G. W. Kitchin (1915 rpt. London: Dent, 1973), 113.

17 See Brian Vickers (ed.), *English Science, Bacon to Newton* (Cambridge: CUP, 1987), 1–5. A clear exposition of Bacon's scientific method can be found in Ralph M. Blake, Curt J. Ducasse, and Edward H. Madden, *Theories of Scientific Method: The Renaissance Through the Nineteenth Century* (1960, rpt. New York: Gordon and Breach, 1989), 50–74.

18 Vasari, *Lives of the Artists*, 25.

19 The problem of representation was compounded, for Du Bartas, by the fact that the structure he was describing – the 'admirable Nett' or *rete mirabile*, a network of vessels at the base of the brain – is a structure which, though it exists in cattle, does not exist in the human body. Du Bartas was simply following contemporary anatomists, including Vesalius, who, when dissecting the human head, kept the head of an ox to hand in order to illustrate a structure which defied the scalpel. See Marie Boas, *The Scientific Renaissance 1450–1630* (London: Collins, 1962), 132.

20 See Elizabeth A. R. Brown, 'Death and the Human Body in the Later Middle Ages: The Legislation of Boniface VIII on the Division of the Corpse' *Viator* 12 (1981), 221–70. As will be apparent, my account of 'dispersed burial' prior to the Renaissance is entirely indebted to Brown's fascinating work.

21 Piero Camporesi, *The Incorruptible Flesh: Bodily Mutation and Mortification in Religion and Folklore* trans. Tania Croft-Murray and Helen Elsom (Cambridge: CUP, 1988), 7.

22 See, for example, a German anatomical plate of 1943 taken from E. Pernkopf, *Topographische Anatomie des Menschen* reproduced in K. B. Roberts and J. D. W. Tomlinson, *The Fabric of the Body: European Traditions of Anatomical Illustration* (Oxford: Clarendon Press, 1992), 596 and described as 'a feast of colour and anatomy – almost too much of both', a comment which reminds us of the anthropophagistic tendency of earlier rituals of dissection.

23 J. B. de C. M. Saunders and C. D. O'Malley (eds), *The Illustrations from the Works of Andreas Vesalius of Brussels* (New York: Dover Publications, 1950), 164.

24 Glenn Harcourt, 'Andreas Vesalius and the Anatomy of Antique Sculpture', *Representations* 17 (1987), 28–61 (29). Harcourt's discussion offers a brilliantly incisive reading of Vesalian images to which I am indebted.

25 Ibid., 29.

26 In the east, such figures were still in circulation in arabic, Persian, and Indian manuscripts until the nineteenth century, and their origins may well have been arabic or Indian rather than Alexandrian (Roberts and Tomlinson, *The Fabric of the Body*, 19). For further information on pre-Renaissance medical illustration and practice see Roberts and Tomlinson, *The Fabric of the Body*, 13–67; F. H. Garrison, *The Principles of Anatomic*

Illustration before Vesalius: An Inquiry into the Rationale of Artistic Anatomy (New York: Hoeber, 1926), *passim*; H. P. Bayon, 'The Masters of Salerno and the Origins of Professional Medical Practice' in E. Ashworth Underwood (ed.), *Science, Medicine, and History: Essays on the Evolution of Scientific Thought and Medical Practice written in honour of Charles Singer* (London: OUP, 1953), I.203–19; Robert Herlinger, *History of Medical Illustration from Antiquity to AD 1600* (London: Pitman, 1970), *passim.*

27 This refusal to acknowledge the fact of death in the dissected body was to be overturned by Vesalius. For all his devotion to the model of antique statuary as the controlling *topos* of illustrations of the body's interior, Vesalius occasionally reminded the viewer of the origin of his anatomized subjects. The sixth book of the *Fabrica* (Saunders and O'Malley, *The Illustrations*, 178) opens with an image of the opened thoracic cavity which also shows the subject's contorted features, and a length of cord knotted around the neck.

28 Michael Baxandall, *Painting and Experience in Fifteenth-century Italy* (1972, 2nd edition, Oxford: OUP, 1988), 61. For further analysis of Renaissance languages of gesture see (in particular) the essays by Jean-Claude Schmitt, Peter Burke, Joaneath Spicer, Robert Muchembled, and Herman Roodenburg in Jan Bremmer and Herman Roodenburg (eds), *A Cultural History of Gesture From Antiquity to the Present Day* (Cambridge: Polity Press, 1991), 59–189.

29 *Mirrour of the World* (3rd edition, *c.* 1527), cited in Baxandall, *Painting and Experience*, 65.

30 Baxandall, *Painting and Experience*, 66.

31 See Renate Blumenfeld-Kosinski, *Not of Woman Born: Representations of Caesarean Birth in Medieval and Renaissance Culture* (Ithaca and London: Cornell UP, 1990), 55.

32 Baxandall, *Painting and Experience*, 63. Masaccio's *Expulsion from Paradise* of *c.* 1427 (Florence, The Church of S. Maria del Carmine) depicts Adam making a similar gesture expressive of shame at the Fall.

33 For a contemporary (Venetian) image, see for example Giovanni Bellini's *S. Giobbe Altarpiece* produced *c.* 1480 just over a dozen years before de Ketham's Venetian images. In this context it is also worth noting that the tradition of representing the birth of Christ as 'the moment after' came to predominate in christian iconography. See Blumenfeld-Kosinski, *Not of Woman Born*, 57.

34 Baxandall, *Painting and Experience*, 40.

35 The threefold division of purpose is from John of Genoa's *Catholicon* (Venice, 1497) cited and translated in Baxandall, *Painting and Experience*, 41, 161.

36 This problem has tended to be approached as a duel between proponents of 'science-centred' paradigms and those who would see such illustrations as forming part of an artistic tradition. For a discussion of the 'artist–scientist' problem see William Ivins, Jr, 'What about the *Fabrica* of Vesalius?' in S. W. Lambert, W. Wiegand, and W. M. Ivins, *Three Vesalian Essays to Accompany the 'Icones Anatomicae' of 1934* (New York: Macmillan, 1952); Erwin Panofsky, 'Artist, Scientist, Genius: Notes on the Renaissance-Dammerung' in Wallace K. Ferguson, Roland H. Bainton, Leicester Bradner, Robert S. Lopez, Erwin Panofsky, and George Sarton, *The Renaissance: Six Essays* (1953, rpt. New York: Harper Torchbooks, 1962), 123–82; James S. Ackerman, 'Science and Visual Art' in Hedley Howell Rhys (ed.), *Seventeenth-Century Science and the Arts* (Princeton: Princeton UP, 1961). More recently, an analysis based on the essential unity of 'art' and 'science' within Renaissance representation has begun to emerge; see Harcourt, 'Andreas Vesalius'; 32–4; Jonathan Sawday, 'The Fate of Marsyas: Dissecting the Renaissance Body' in Lucy Gent and Nigel Llewellyn (eds), *Renaissance Bodies: The Human Figure in English Culture 1540–1660* (London: Reaktion Books, 1990), 117–28; Eileen Fitzgerald Daggett, 'The Incorporation of Power: Human Dissection as a Micro-system of Dominance', *Diatribe* 1 (1993), 55–68.

37 Sir Thomas Browne, *Works* ed. Sir Geoffrey Keynes (London: Faber and Faber, 1964), I, 44.

38 Francis Herring, *The Anatomyes of the True Physition and the Counter-feit Mounte-Banke* (London, 1602), 10.

39 John Woolton, *A Treatise of the Immortalitie of the Soule* (London, 1576), sig. 2ᵛ. Woolton's image of 'handling' God in this way is dangerously close to the anthropomorphite heresy attributed to Audius of Mesopotamia in the fourth century. Anthropomorphites argued that the words of Genesis I.26 – 'Let us make man in our image, after our likeness' – should be understood literally, so that God could be thought of as possessing all the attributes of a physical body. Anthropomorphism, in essence, informs virtually all the descriptions of 'sacred anatomy' that I have explored. Certainly John Donne's thinking revolved around anthropomorphite ideas. Woolton, however, tries to steer a *via media*: 'as they doo offende in excesse, that ascribe this image of God to mans body only: so doo they also erre in defect, that place it onely in the minde' (Woolton, *A New Anatomie of Whole Man* (London, 1576), sig. B2). For an account of the anthropomorphites see William E. Addis and Thomas Arnold (eds), *A Catholic Dictionary* (10th edition, London: Virtue and Co., 1928), 33.

40 Woolton, *A New Anatomie of Whole Man*, sig. A2ᵛ.

41 John Weemes, *Works* (London, 1636), 23.

42 Francesco Giorgio, *De harmonia mundi* trans. (into French) Guy and Nicholas Lefevre de la Boderie (Paris, 1579), 183 (my translation).

43 Pontus de Tyard, *Les Discours Philosophiques* (Paris, 1587), 124–5 (my translation). On de Tyard see Frances A. Yates, *The French Academies of the Sixteenth Century*, Studies of the Warburg Institute (vol. 15), (London: The Warburg Institute, 1947), 95–105; Kathleen M. Hall, *Pontus de Tyard and the Discours Philosophiques* (Oxford: Clarendon Press, 1963), *passim*.

44 For an account of the French encyclopedic writers of the sixteenth century, see Peter Sharratt (ed.), *French Renaissance Studies 1540–1570: Humanism and the Encyclopedia* (Edinburgh: Edinburgh UP, 1976), *passim*.

45 For an account of the complicated publishing history of *L'Academie Françoise* and its translation into English between 1586 and 1618 see Yates, *French Academies*, 123–4.

46 All quotations from Donne's sermons are from John Donne, *The Sermons* ed. George R. Potter and Evelyn M. Simpson (Berkeley and Los Angeles: California UP, 1953–62).

47 All quotations from La Primaudaye are from Pierre de La Primaudaye, *The French Academie* trans. Thomas Bowles, R. Dolman, and 'W. P.' (London, 1618).

48 Quoted in Saunders and O'Malley, *The Illustrations*, 234.

49 The first edition of *Microcosmographia* of 1615 was followed by reissues of 1616 and 1618. A second edition appeared in 1631 and was followed by a third edition in 1651. For an account of Crooke's work see C. D. O'Malley, 'Helkiah Crooke, MD, FRCP (1576–1648)', *BHM* 42 (1968), 1–18.

50 Helkiah Crooke, *Microcosmographia* (London, 1615), 12.

51 William Schupbach, *The Paradox of Rembrandt's 'Anatomy of Dr Tulp'* (London: Wellcome Institute for the History of Medicine, 1982), 66–102, has collated the injunction *Cognito sui, cognito dei* in sixteenth- and seventeenth-century anatomical texts.

52 See Andrew Wear, 'Puritan Perceptions of Illness in Seventeenth-Century England' in Roy Porter (ed.), *Lay Perceptions of Medicine in Pre-Industrial Society* (Cambridge: CUP, 1985), 56–7.

53 Leonardo da Vinci, *The Notebooks* ed. Irma A. Richter (Oxford: OUP, 1980), 151.

54 Martin Kemp, *Leonardo da Vinci: The Marvellous Works of Nature and Man* (London: Dent,

1981), 124. On Leonardo's anatomical work see C. D. O'Malley and J. B. de C. M. Saunders, *Leonardo da Vinci on the Human Body* (New York: H. Schuman, 1952), *passim*; J. H. Randall, 'The Place of Leonardo da Vinci in the Emergence of Modern Medicine', *JHI* 14 (1955), 191–202; Elmer Belt, 'Leonardo the Anatomist', *Logan Glendening Lectures on the History and Philosophy of Medicine* Series 4 (1955); K. D. Keele, 'Leonardo da Vinci's Influence on Renaissance Anatomy', *MH* 8 (1964), 342–53; K. D. Keele, *Leonardo da Vinci and the Art of Science* (Brighton: Harvester Press, 1977).

55 For a discussion of the 1489 programme see Carlo Pedretti, *The Literary Works of Leonardo da Vinci edited by J. P. Richter* (Oxford: Phaidon Press, 1977), I, 228.

56 Da Vinci, *Notebooks*, 164.

57 See John Peacock, 'Inigo Jones as a Figurative Artist' in Lucy Gent and Nigel Llewellyn (eds), *Renaissance Bodies: The Human Figure in English Culture 1540–1660* (London: Reaktion Books, 1990), 160–5. For further discussion of anthropomorphic artistic theory, see Rudolph Wittkower, *Architectural Principles of the Age of Humanism* (London: Academy Editions, 4th edition, 1977), 14; William Alexander McClung, 'The Matter of Metaphor: Literary Myths of Construction', *Journal of the Society of Architectural Historians* 40 (1981), 279–88.

58 See Erwin Panofsky, 'The History of the Theory of Human Proportions as a Reflection of the History of Styles' in Panofsky, *Meaning in the Visual Arts: Papers in and on Art History* (New York: Doubleday Anchor, 1955), 55–107.

59 Saunders and O'Malley, *The Illustrations*, 92.

60 Devon L. Hodges, *Renaissance Fictions of Anatomy* (Amherst: Massachusetts UP, 1985), 5. See also Harcourt, 'Andreas Vesalius', 47–9.

61 Michel Foucault, *Discipline and Punish: The Birth of the Prison* trans. Alan Sheridan (Harmondsworth: Penguin Books, 1977), 47.

62 Clare Gittings, *Death, Burial and the Individual in Early Modern England* (London and Sydney: Croom Helm, 1984), 19.

63 It has been argued that the topography of the *Fabrica* can be identified either as the region to the south west of Padua or the environs of Rome. See Saunders and O'Malley, *The Illustrations*, 29; Diane R. Karpe, *Ars Medica: Art, Medicine and the Human Condition* (Philadelphia: Pennsylvania UP, 1985), 160.

64 See the ironic reading of the grammar of the motto '*et in arcadia ego*' which Panofsky traced in his (1936), essay '*Et in Arcadia Ego*: Poussin and the Elegiac Tradition' in Panofsky, *Meaning in the Visual Arts*, 295–320.

65 See, for example, Johannes Eichmann's (Dryander), *Anatomiae . . . corporis humani dissectionis* (Marburg, 1527), sig. gi.r, where an open-mouthed skull is shown, supported by an hour-glass, resting on a plinth carrying the motto *inevitabile fatum* – a depiction of the triumph of time and death. As Roberts and Tomlinson in *The Fabric of the Body* comment (86), this 'call for the reader to remember the end of life was appropriate to a professor in a Protestant university in the middle of Europe during the years of Reformation and counter-Reformation'. On Renaissance depictions of time see Erwin Panofsky, *Studies in Iconology: Humanistic Themes in the Art of the Renaissance* (New York: Harper and Row, 1962), 69–93.

66 See for example Piranesi's response to Vesalius and eighteenth-century links between archaeology and anatomy, discussed in Barbara Maria Stafford, *Body Criticism: Imaging the Unseen in Enlightenment Art and Medicine* (Cambridge, Mass.: MIT Press, 1991), 58–70.

67 It should be noted that the Estienne figures, as Roberts and Tomlinson have demonstrated (*The Fabric of the Body*, 169–70), date back to 1530, so that, despite the post-Vesalian date of publication, the illustrations to the *De dissectione* cannot be derived from the *Fabrica*.

68 Roberts and Tomlinson (ibid., 171–2) estimate that, for some of the figures, the

anatomical structure which is the 'subject' of the image occupies less than one-fiftieth of the printed area on the page.

69 Ibid., 171. Modern commentators have found the Estienne illustrations profoundly disturbing. Criticism has been levelled at the 'strange and offensive positions' of the cadavers, whilst the work has been described as being amongst the 'ugliest anatomical work known'. See Robert Herrlinger, *History of Medical Illustration from Antiquity to AD 1600* (Nijkerk: Pitman Medical and Scientific Publishing Co. Ltd, 1970), 87.

70 Roberts and Tomlinson, *The Fabric of the Body*, 172.

71 Formal devotion to the heart of Jesus originated in France in the late seventeenth century, but the principle itself was ancient, having been defined at the Council of Ephesus in 431. The heart was an object of adoration since it was 'a natural symbol of Christ's exceeding charity, and of His interior life'. See Addis and Arnold, *Catholic Dictionary*, 401.

72 On this topic see the important essay by Regina Stefaniak, 'Replicating Mysteries of the Passion: Rosso's *Dead Christ with Angels*', *Renaissance Quarterly* 45 (1992), 677–738.

73 Berengario's *Commentario . . . super anatomia Mundini* was republished in an abbreviated form (but with the illustrations) as *Isagogae Breves* at Bologna in 1523, and subsequently reissued throughout the sixteenth century. As late as 1664, this illustration was in circulation in England when an English translation of the *Isagogae Breves* appeared as *Microcosmographia or a Description of the Body of Man*.

74 Stefaniak, 'Replicating Mysteries', 695.

75 See John Pope-Hennessy, *Italian High Renaissance and Baroque Sculpture* (1963 rpt. New York: Vintage Books, 1985), 106.

76 Ibid., 108.

77 Crashaw's *Steps to the Temple* was first published in 1646, but I follow Thomas Healy in preferring the 1648 version of the text. See Thomas Healy, *Richard Crashaw* (Leiden: E. J. Brill, 1986), 5.

78 References to Crashaw's poetry are to George Walton Williams (ed.), *The Complete Poetry of Richard Crashaw* (New York: W. W. Norton & Co. Inc., 1974).

79 Stefaniak, 'Replicating Mysteries', 713.

80 Gail Kern Paster, *The Body Embarrassed: Drama and the Disciplines of Shame in Early Modern England* (Ithaca: Cornell UP, 1993), 107. The medieval tradition of Christ as female is traced in Caroline Walker Bynum, *Jesus as Mother: Studies in the Spirituality of the High Middle Ages* (Berkeley: California UP, 1982).

81 See R. M. Adams's oft-quoted comment on Crashaw's 'On the Wounds of our crucified Lord': 'If we resist the poet's imaginative unification of his feelings about Christ on the grounds that kissing wounds is unlovely and perverse, and counting out change is vulgar, [then] we may seem to quarrel with the poet's central point, that love of Christ includes all extremes and reconciles all contraries'. R. M. Adams, 'Taste and Bad Taste in Metaphysical Poetry', *Hudson Review* 8 (1955), 61–77 (68).

82 'Joann. 20. *Christus ad Thomam*. The latin is as follows:

> Sæva fides! voluisse meos tractare olores?
> Crudeles digiti! sic didicisse Deum?

Translation by G. W. Williams.

83 Numerous commentators have speculated on Donne's formal and informal links with the medical profession. See D. C. Allen, 'John Donne's Knowledge of Renaissance Medicine', *JEGP* 42 (1943), 322–42; W. Murray, 'Donne and Paracelsus: An Essay in Interpretation', *RES* 25 (1949), 115–23; F. N. L. Poynter, 'John Donne and William Harvey,' *JHM* 15 (1951), 23–246; D. H. M. Woolam, 'Donne, Disease and the Doctors', *MH* 5 (1961),

144–53; Frank Kermode, *Shakespeare, Spenser, Donne: Renaissance Essays* (London: Routledge, 1971), 119; Thomas Willard, 'Donne's Anatomy Lesson: Vesalian or Paracelsian?' *John Donne Journal* 3 (1984), 34–61.

84 Joan Webber, *The Eloquent 'I': Style and Self in Seventeenth-Century Prose* (Madison: Wisconsin UP, 1968), 51.

85 Louis Martz's influential interpretation of Donne's sonnets according to the structures of meditation, tends to ignore the centrality of the poetic 'I' in these texts. It is not just that Donne is 'vividly present at the scene' (as Martz would have it). Rather the speaker of the sonnet is at the centre of the drama of pain. See Louis Martz, *The Poetry of Meditation: A Study in English Religious Literature of the Seventeenth Century* (1954, rpt. London and New Haven: Yale UP, 1978), 49–50.

86 John Carey, *John Donne: Life, Mind, Art* (London: Faber and Faber, 1981), 136. For Carey's influential account of Donne's fascination with the structure and functions of the body see pp. 131–66.

87 John Donne, *Essays in Divinity* ed. Evelyn M. Simpson (Oxford: Clarendon Press, 1952), 20.

88 On the trope of 'sin as sickness' in Donne's writing see Winfried Schleiner, *The Imagery of John Donne's Sermons* (Providence, RI: Brown UP, 1970), 80–4. 'Sin as sickness' is one of the informing visual conceits in the work of Robert Fludd, in particular his *Medicina catholica* (Frankfurt, 1629). See Joscelyn Godwin, *Robert Fludd: Hermetic Philosopher and Surveyor of Two Worlds* (London: Thames and Hudson, 1979), 56, 59.

89 See Jean Hagstrum, *The Sister Arts: The Tradition of Literary Pictorialism in English Poetry from Dryden to Gray* (Chicago and London: Chicago UP, 1958), 113. By contrast, Roston's work on the relationship between art and literature in the Renaissance suggests a rather closer link between the visual and the literary; though even here the concentration on (for the most part) 'high' art (as opposed to the evidence of illustrations of the human figure in contexts other than ornate manifestations of mannerism) tends to overlook other pictorial possibilities. See Roston, *Renaissance Perspectives*, 301–42.

90 In addition to Willard, 'Donne's anatomy lesson' see Frank Manley (ed.), *John Donne: The Anniversaries* (Baltimore: Johns Hopkins UP, 1963), 1–61, 119–201. Other accounts include: Marjorie Nicholson, *The Breaking of the Circle: Studies in the Effect of the New Science Upon Seventeenth-Century English Poetry* (Evanston: Northwestern UP, 1950), ch. 3; Ralph Maud, 'Donne's *First Anniversary*', *Boston University Studies in English* 2 (1956), 218–25; O. B. Hardison, Jr, *The Enduring Monument: A Study of the Idea of Praise in Renaissance Literary Theory and Practice* (Chapel Hill, NC: North Carolina UP, 1962), ch. 7; George Williamson, 'The Design of Donne's Anniversaries', *MP* 60 (1963), 183–91; Harold Love, 'The Argument of Donne's First Anniversary', *MP* 64 (1966), 125–31; Richard E. Hughes, 'The Woman in Donne's *Anniversaries*', *ELH* 34 (1967), 307–26; Rosalie L. Colie, 'All in Peeces: Problems of Interpretation in Donne's Anniversary Poems' in P. A. Fiore (ed.), *Just so Much Honour: Essays Commemorating the Four-hundredth Anniversary of the Birth of John Donne* (Pittsburgh: Pennsylvania State UP, 1972); Barbara K. Lewalski, *Donne's Anniversaries and the Poetics of Praise* (Princeton: Princeton UP, 1973); Thomas Docherty, *John Donne: Undone* (London: Methuen, 1986), 227–31. The classic account (to which many of the above studies are responding) remains, however, Martz, *The Poetry of Meditation*, 211–48. For a bracingly sceptical account of the attempt to unravel the 'meaning' of the Anniversary poems, see Carey, *John Donne*, 101–4.

91 For a chronology of the composition and publication of the Anniversary poems, see R. C. Bald, *John Donne: A Life* (1970, rpt. Oxford: Clarendon Press, 1986), 240–3.

92 David Novarr, *The Disinterred Muse: Donne's Texts and Contexts* (Ithaca and London: Cornell UP, 1980), 37.

93 Robert Burton, *The Anatomy of Melancholy* ed. Thomas C. Faulkner, Nicholas K. Kiessling, and Rhonda L. Blair with a commentary by J. B. Bamborough and Martin Dodsworth (Oxford: Clarendon Press, 1992), 1.1.2.2.

94 For an account of this taxonomic process see Thomas Gale, *Certaine Workes of Galens called Methodus Medendi* (London, 1586), 25; and Peter Lowe, *A Discourse of the Whole Art of Chirurgerie* (London, 1602), ch. 7. A helpful introduction to Galenic physiology is J. B. Bamborough, *The Little World of Man* (London: Longman Green and Co., 1952), *passim.*

95 The clearest contemporary account of this organicist argument can be found in Sir Edward Forset, *A Comparative Discourse of the Bodies Naturall and Politique* (London, 1606). The most famous example of 'hierarchical organicism' is James I (writing under the pseudonym of C. Philopatris) in his *The Trew Law of Free Monarchies* (Edinburgh, 1598). For an exploration of the topic see David George Hale, *The Body Politic: A Political Metaphor in Renaissance England* (The Hague: Mouton & Co., 1971), *passim.*

96 For an exploration of 'organicist' metaphors of society, see Raymond Williams, *Keywords: A Vocabulary of Culture and Society* (1976, rpt. London: Fontana, 1983), 225–9.

97 This point was made by Bertrand Russell in *The Prospects of Industrial Civilization* (1923) when he defined a machine as 'essentially organic, in the sense that it has parts which co-operate to produce a single useful result'. Quoted in Williams, *Keywords*, 229.

98 An exception to this three-day practice were the Lumleian lectures (founded in 1582) at the College of Physicians. Out of a desire to conduct a more complete investigation, more time was allowed to the dissection. But, even if more time was allotted, it was quite possible that the body's rate of decay would defeat the enterprise. The second (1586–7) edition of Holinshed's *Chronicles* records that the first year's lectures were to culminate in a dissection of 'all the bodie of man especiallie the inward parts for five days together, as well before as after dinner, if the bodies may so last without annoie'. Quoted from Keynes, *The Life of William Harvey* (Oxford: Clarendon Press, 1978), 85.

99 Ruben Eriksson (ed.), *Andreas Vesalius' First Public Anatomy at Bologna 1540: An Eyewitness Report By Baldasar Heseler Together with his Notes on Mathaeus Curtius' Lectures on 'Anatomia Mundi'* (Uppsala: Almqvist & Wiksells, 1959), 177.

100 In this context, the January 1540 dissections of Vesalius seem to have faltered at some point. Heseler records that although the 'next subject was hanged this morning (there were two of them) during Curtius' lecture' they were still hanging when the time came to commence once more, so that 'the students in the meantime. . . killed a pregnant bitch' (Eriksson, *Andreas Vesalius' First Public Anatomy*, 177). The *rapacious* quality of the Renaissance anatomy lesson is underlined: a body – any body – had to be found.

101 Crooke, *Microcosmographia*, 36.

102 On the body as a sacred architectural structure, see, for example, John Bannester (or Bannister), *The Historie of Man Sucked from the Sappe of the Most Approved Anathomists* (London, 1578), 3; William Hill, *The Infancie of the Soule, Or, The Soule of an Infant* (London, 1605), sig. E2v.

103 Jacob Mosau, *A General Practice of Physick* (London, 1598), sig. A2v.

104 Roberts and Tomlinson, *The Fabric of the Body*, 21. An example of this kind of dissection, where the body is sliced in the mid-sagittal plane, is shown in two early fifteenth-century manuscript drawings from the work of John Ardene, reproduced in Roberts and Tomlinson, 29.

105 Vesalius' text was first published in England in 1545 under the title *Compendiosa totius anatomie delineato*. This text (published by the printer, engraver, and sometime surgeon to Edward VI, Thomas Geminus) was comprised of the illustrations from the *Fabrica* together with a latin text from Vesalius' *Epitome* of the *Fabrica* – the two works having

been originally published simultaneously in 1543. When, in 1553, Geminus published an English version of the *Compendiosa*, the text which accompanied the illustrations was taken from Thomas Vicary's *A Profitable Treatise of the Anatomy of Man's Body* (London, 1548). The 'compiler' of this hybrid text was the playwright Nicholas Udall. Udall, in electing to juxtapose the Vesalian images with Vicary's account of the body, produced a work more suitable for the purposes of practical dissection since Vicary did not offer a 'construction' of the body fabric, but followed the old 'order of anatomy' inherited from Mondino. For an account of the appearance of the Vesalian text in England see S. V. Larkey, *The Vesalian Compendium of Geminus and Nicholas Udall's Translation: Their Relation to Vesalius, Caius, Vicary, and De Mondeville* (London: Bibliographic Society, 1933), *passim.*

106 Quotation from Harvey's 'General Rules for An Anatomy' to be found in his lecture notes of 1616, the *Prelectiones*. For a complete text of the Rules see Keynes, *Life of Harvey*, 90–1. The text of the 1616 lectures can be found in Gweneth Whitteridge (ed.), *The Anatomical Lectures of William Harvey* (Edinburgh and London: E. & S. Livingstone Ltd, 1964).

107 The development of this system can be traced back to the twelfth-century invention of artificial finding devices within texts which superseded memory as the chief tool of searching for information. See Richard H. Rouse and Mary A. Rouse, '*Statim invenire*: Schools, Preachers, and New Attitudes to the Page' in Robert L. Benson and Giles Constable (eds), *Renaissance and Renewal in the Twelfth Century* (1982, rpt. Oxford: Clarendon Press, 1985), 201–25.

108 The earliest machine illustrations were to be found in Georgius Agricola's *De re metallica* of 1556, and subsequent late sixteenth-century works devoted entirely to mechanical devices. A similarity of function between Vesalius' anatomical illustration and machine illustration has been suggested in Kenneth J. Knoespel, 'Gazing on Technology: *Theatrum Mechanorum* and the Assimilation of Renaissance Machinery' in Mark L. Greenberg and Lance Schachterle (eds), *Literature and Technology*, Research in Technology Studies 5 (London and Toronto: Associated University Presses, 1992), 99–124.

109 In this respect, the late twentieth-century fascination with the confusion of the boundary between human and machine – evidenced in the rise of 'Cyberfiction' – could be said to have its foundation in the paradoxically pre-Cartesian moment of the machine's first appearance on the printed page. The visual language with which we understand the internal configuration of the machine is itself inherited from the visual language with which early-modern culture began to understand the body. A chronology of investigation can thus be posited: first came bodies, then, with Descartes, came bodies understood as machines, and finally – the postmodern inflexion to this traditional lexicon of difference which rapidly collapses – came machines understood as bodies. This chronology of the evolution of the cyborg casts an ironic light on Donna Haraway's influential essay, a self-styled 'ironic dream', of 'cyborg incarnation'. Without disputing the importance of the cyborg to postmodern culture, it may nevertheless be the case that the distinction between 'man' and 'machine' is one which has *always* been uneasy. See Donna Haraway, 'A Manifesto for Cyborgs: Science, Technology, and Socialist Feminism in the 1980's' in Linda J. Nicholson (ed.), *Feminism/postmodernism* (London and New York: Routledge, 1990), 190–233. On the machine–body 'interface' see also Umberto Eco, *Travels in Hyperreality* trans. William Weaver (London: Picador, 1987), 44–8; Tom Shippey, 'Inside the Screen: Virtual Reality and the Broceliande of Electronic Hallucination', *Times Literary Supplement* 4700 (30 April 1993), 3–4.

110 On the cultural significance of pre-Renaissance maps and map-making, see Sylvia

Tomasch, '*Mappae Mundi* and "The Knight's Tale": The Geography of Power and the Technology of Control' in Greenberg and Schachterle, *Literature and Technology*, 66–98.

111 On the importance of print conventions to anatomy, see Elizabeth L. Eisenstein, *The Printing Press as Agent of Change: Communications and Cultural Transformations in Early-modern Europe* (Cambridge: CUP, 1979), II, 566–74.

112 For a discussion of the Platonic origin of the conceit of the world as a book, and its transmission in medieval culture, see Gabriel Josipovici, *The World and the Book* (London: Macmillan Press, 1971), 45–69.

113 The Vesalian *Epitome* of the *De Humani Corporis Fabrica* consisted of eleven plates taken from the larger volume together with a brief explanatory text. As Saunders and O'Malley (*The Illustrations*, 204) note, the *Epitome* followed a 'topographical' approach, in that the viewer was supposed to start at the centre of the work which shows the nude figures of the male and female, and then proceed backwards watching the human figure dissected. Having completed this section of the task, the viewer then turned back to the nude figures, and moved forwards through the remainder of the work, looking at the different structures – the nervous system, the cardiovascular system, and the abdominal viscera. A feature of the *Epitome* was that some of the plates were printed in such a way as to allow the viewer to cut out different structures and assemble them into two 'mannikins' – male and female. Thus the *Epitome* offered two different methods of spatial organization: a progressive dissection complemented by the viewer's own progressive reconstruction of the fragmented body.

114 Pierre Charron, *Of Wisedome* trans. Samson Lennard (London: n.d.), sig. B4ᵛ.

115 For a more detailed account of Burton's *Anatomy* as an example of 'intellectual anatomy', see Jonathan Sawday, 'Shapeless Elegance: Robert Burton's Anatomy of Knowledge' in Neil Rhodes (ed.), *History, Language, and the Politics of English Renaissance Prose* (Binghmaton, NY: MRTS, forthcoming).

116 On 'method' in anatomy and medicine, see J. H. Randall, 'The Development of Scientific Method in the School of Padua', *JHI* 1 (1940), 117–206; Neal W. Gilbert, *Renaissance Concepts of Method* (New York: Columbia UP, 1960), ch. 5; C. E. Kellett, 'Sylvius and the Reform of Anatomy', *MH* 5 (1961), 101–16; W. P. D. Wightman, '"Quid sit methodus?" "Method" in Sixteenth-century Medical Teaching and "Discovery"', *JHM* 19 (1964), 360–76; Patrick Grant, *Literature and the Discovery of Method in the English Renaissance* (London: Macmillan & Co., 1985), *passim*.

117 Walter J. Ong, *Ramus, Method, and the Decay of Dialogue* (1958 rev., Cambridge, Mass.: Harvard UP, 1983), 310.

118 Crooke, *Microcosmographia*, 26.

119 Ramus, *Dialecticae Institutiones* (1543), fol. 54, quoted and trans. Ong, *Ramus, Method*, 193.

120 Alexander Richardson, *The Logicians School-master: or, A Comment upon Ramus Logicke* (London, 1629), 197.

121 Ibid., 199.

122 For further (English) examples of this correspondence, see Dudley Fenner, *The Artes of Logicke and Rhetoricke* (n.p., 1584), Book. I, ch. 5 and Book II, ch. 7; Abraham Fraunce, *The Lawiers Logicke* (London, 1588), Book II, ch. 17; Thomas Spencer, *The Art of Logick* (London, 1628), chs. 38–40; Robert Fage, *Peter Ramus . . . his Dialectica* (London, 1632), 48–55. A helpful introduction to the development of Ramist logic in England can be found in Catherine Dunn's edition of Roland MacIlmaine's (1574) translation of the *Dialectica* into English. See Roland MacIlmaine, *The Logicke of the Most excellent Philosopher P. Ramus Martyr* ed. Catherine Dunn (Northridge, Ca.: San Fernando Valley State

College, 1969), xi–xxii. For a succinct account of Ramism see Copenhaver and Schmitt, *Renaissance Philosophy*, 227–39. On Ramist method, see Ong, *Ramus, Method*, 225–68.

123 This procedure did not begin with Ramus, though Ramism, with its stress on spatial order, certainly mirrors anatomical method most clearly. Prior to Ramus, however, we find Rudolph Agricola in his *De inventione dialectica* of 1515 considering such anatomically informed ideas as 'natural order' (governing the relationship, for example, of genus to species, or parts to whole) and 'geographical order' (west to east or head to feet). Agricola's 'artificial order', equally, would appear to be the correlative of anatomical practice in that, according to Lisa Jardine, it is a method which 'reverses natural order for dramatic or other effect'. See Lisa Jardine, *Francis Bacon: Discovery and the Art of Discourse* (Cambridge: CUP, 1974), 33–4.

124 Sir Philip Sidney, *Poems* ed. W. A. Ringler, Jr (Oxford: Clarendon Press, 1962), 199.

125 See Q1 (1591) text of *Astrophil and Stella*, in Sidney, *Poems*, 199 (note). Unfortunately, most modern editors prefer the less incisive 'trie' to the more voyeuristic 'prie'.

126 L. C. Martin (ed.), *The Works of Henry Vaughan* (2nd edition, Oxford: Clarendon Press, 1957), 36. Cited as Vaughan, *Works*.

127 See also Vaughan's poem 'On Sir Thomas Bodley's Library' in *Thalia Rediviva* (1678) where books are imagined as reanimated bodies, and the act of writing becomes a metamorphosis of blood into ink (Vaughan, *Works*, 633–4).

6 THE UNCANNY BODY

1 Frank Budgen, *James Joyce and the Making of Ulysses* (London: Grayson and Grayson, 1934), 21.

2 David Kynloch, *De hominis procreatione, anatome, ac morbis internis priores libri duo heroico carmine donati* (1596) in Arthur Johnson (ed.), *Delitiae poetarum Scotorum* (Amsterdam, 1637).

3 John Norden, *Vicissitudo rerum* (London, 1600) and *The Labyrinth of Mans Life* (London, 1614); John Hagthorpe, *Visiones rerum* (London, 1623); Henoch Clapham, *Aelohim-triune* (London, 1601). 'Ro. Un.' has been identified as Robert Underwood. His *The Little World* (London, 1605, 2nd edition 1612) now exists in only two extant copies, one in the Folger Library, the other in the Huntington Library.

4 William B. Ashworth, Jr, 'Natural History and the Emblematic World View' in David C. Lindberg and Robert S. Westman (eds), *Reappraisals of the Scientific Revolution*, (Cambridge: CUP, 1991), 303–332.

5 The modern equivalent of writers such as Norden, Hagthorpe, Clapham and 'Ro. Un.' is probably to be found in the work of 'popularizing' scientists such as Stephen Hawking or Richard Dawkins. A television series such as (in Britain) *Equinox* also bears some comparison to these early seventeenth-century texts.

6 Bennett (following Johnson) suggests that, in the period 1560–1635 'the average illustrated book was priced 75–100% higher than other books of the same number of sheets'. Small pamphlets sold for a minimum of 2d., compared with 6d. for a play, and 3d. for a masque. See H. S. Bennett, *English Books and Readers 1475–1640* (Cambridge: CUP, 1970), III, 228; Francis R. Johnson, 'Notes on English Retail Book-Prices 1550–1640', *The Library* 5th series 5 (1950), 83–112. During the same period, the daily wage of the ubiquitous agricultural day labourer was under 1s. a day, assuming that work was available 365 days a year. Figures derived from J. A. Sharpe, *Early-modern England: A Social History 1550–1760* (London: Edward Arnold, 1987), 215–16.

7 See for example John Bate, *The Mysteries of Nature and Art* (London, 1634) or Nathaniel

Wanley, *The Wonders of the Little World: Or, A General History of Man* (London, 1654). Appealing to secrecy and mystery was a device exploited in particular by Hermetic writers such as Robert Fludd. See William Eamon, 'From the Secrets of Nature to Public Knowledge' in Lindberg and Westman (eds), *Reappraisals of the Scientific Revolution*, 333–65.

8 George Puttenham, *Arte of English Poesie* (London, 1589), 35.

9 On the 'recovery' of these classical texts, see L. D. Reynolds and N. G. Wilson, *Scribes and Scholars: A Guide to the Transmission of Greek and Latin Literature* (Oxford: Clarendon Press, 3rd edition, 1991), 108–46.

10 On didactic poetry (of which Fracastoro's poem *Syphilis sive morbus gallicus* of 1530 is perhaps the best-known Renaissance example) see R. Durling, *The Georgic Tradition in English Poetry* (New York: Columbia UP, 1935), ch. 1; C. S. Baldwin, *Renaissance Literary Theory and Practice* (Gloucester, Mass.: Peter Smith, 1959), 155–89; Alistair Fox, 'Didactic Poetry' in John Higginbotham (ed.), *Greek and Latin Literature: A Comparative Study* (London: Methuen and Co., 1969), 124–69; Kenneth Quinn, *Texts and Contexts: The Roman Writers and Their Audience* (London: RKP, 1979) 120–33.

11 The confusion easily arises since both Davieses were living in London in the final years of the sixteenth century, and both wrote long 'syncretic' poems on the harmony of the cosmos. Presumably it was to distinguish himself from his more famous namesake that Davies adopted the epithet 'of Hereford'. Even so eminent a scholar as Frances Yates found herself in a terrible muddle between the Davieses in her *Astraea: The Imperial Theme in the Sixteenth Century* (1975, rpt. Harmondsworth: Penguin, 1977) 66. What little is known of Davies of Hereford can be found in Francis Peck, *Desiderata Curiosa* (London, 1732–5) 461; H. E. G. Rope, 'John Davies of Hereford, Catholic and Rhymer', *Anglo-Welsh Review* 11 (1961) 20–36.

12 Of these three texts, *Microcosmos* appears to have achieved a considerable degree of popularity, with further editions of 1605 and 1611.

13 John Davies of Hereford, *Microcosmos* (London, 1603), 85.

14 On the encyclopedic quality of Davies of Hereford in particular, see Ruth L. Anderson, 'A French Source for John Davies of Hereford's System of Psychology', *PQ* 6 (1927) 57–66; R. J. Schoek, '*Nosce Teipsum* and the Two John Davies' *MLR*, 50 (1955), 307–10.

15 John Davies of Hereford, *Mirum in Modum* (London, 1602), sig. B^v; *Microcosmos*, 29.

16 René Descartes, *Philosophical Letters* ed. and trans. Anthony Kenny (Oxford: Basil Blackwell, 1970), 142.

17 René Descartes, *Discourse on the Method and other Writings* trans. F. E. Sutcliffe (Harmondsworth: Penguin Books, 1968), 164.

18 The composition of most of Donne's 'Songs and Sonnets' would now be dated prior to 1614. See Theodore Redpath (ed.), *The Songs and Sonnets of John Donne* (1956, rpt. London: Methuen, 1983), 3.

19 Descartes, *Philosophical Letters*, 63–4.

20 Descartes, *Philosophical Letters*, 25 (editor's note). See also Geoffrey Gorham, 'Mind–Body Dualism and the Harvey–Descartes Controversy', *JHI* 55 (1954), 211–34.

21 For information on Descartes's life during the 1630s, see John Cottingham, *Descartes* (Oxford: Basil Blackwell, 1986), 11.

22 J. Bruyn, B. Haak, S. H. Levie, P. J. J. van Thiel, and E. van de Wetering, *A Corpus of Rembrandt's Paintings* trans. D. Cook-Radmore (Dordrecht: Martinus Nijhoff Publishers, 1986), II, 187.

23 Svetlana Alpers, *Rembrandt's Enterprise: The Studio and the Market* (Chicago: Chicago UP, 1990), 79.

24 Ibid., 81.

25 Anatomy can thus be thought of as a later manifestation of 'civic humanism' within this

context. On the humanism of the Netherlands, see James K. Cameron, 'Humanism in the Low Countries' in Anthony Goodman and Angus Mackay (eds), *The Impact of Humanism on Western Europe* (London and New York: Longman, 1990), 137-63.

26 For the circumstances surrounding the composition of Rembrandt's painting, in addition to the information provided in Bruyn *et. al, Corpus of Rembrandt* II, 172-89, I have drawn substantially on Gary Shwartz, *Rembrandt His Life His Paintings: A New Biography* (Harmondsworth: Viking, 1985), 143-6.

27 Francis Barker, *The Tremulous Private Body: Essays on Subjection* (London: Methuen, 1984), 74.

28 For the iconography and 'paradox' of the painting, see William Schupbach, *The Paradox of Rembrandt's 'Anatomy of Dr Tulp'* (London: Wellcome Institute for the History of Medicine 1982), *passim*. Schupbach's persuasive account has come to supersede the earlier (though still important) account of W. S. Heckscher, *Rembrandt's Anatomy of Dr Nicolaas Tulp: An Iconological Study* (New York: New York UP, 1958).

29 It was this whiteness that Reynolds remembered when he recalled seeing the *Anatomy Lesson* in the course of his tour of the Low Countries in 1757: 'Nothing can be more truly the colour of dead flesh', he wrote. Quoted in Bruyn *et. al., Corpus of Rembrandt*, 188.

30 'Cogitet tantum de naturali rationis lumine augendo ... ut in singulis vitae casibus intellectus voluntati praemonstret quid sit eligendum.' Quoted (and translated) in Antony Kenny, *The Anatomy of the Soul: Historical Essays in the Philosophy of Mind* (Oxford: Basil Blackwell, 1973), 84-5.

31 René Descartes, *Meditations on First Philosophy with Selections from the Objections and the Replies* trans. John Cottingham (Cambridge: CUP, 1986), 40. The latin (quoted by Kenny) is as follows: 'Lateas pateat voluntas quam intellectus.' For a discussion of the problem of the will in Descartes, see Kenny, *Anatomy of the Soul*, 81-112.

32 See Schupbach, *Paradox of Rembrandt's 'Anatomy'*, 27.

33 The picture was severely damaged by fire in 1723. For details of the original composition, see Michael Kitson, *Rembrandt* (1969 rpt. Oxford: Phaidon, 1982), 36. The original can be 'reconstructed' on the basis of Rembrandt's own preparatory sketch for the composition, now in the Rijksprentenkabinet in the Rijksmuseum at Amsterdam. See Otto Benesch, *The Drawings of Rembrandt* ed. Eva Benesch (1957, rpt. London: Phaidon, 1973), V, 314.

34 For a discussion of Mantegna's painting, see Ronald Lightbown, *Mantegna with a Complete Catalogue of the Paintings, Drawings, and Prints* (Oxford: Phaidon/Christie's, 1986), 136-9, 421-3. See also Caroline Elam's account in David Chambers and Jane Martineau (eds), *Splendours of the Gonzaga*, Catalogue of an Exhibition at the Victoria and Albert Museum, London, 4 November 1981 to 31 January 1982 (London: V&A, 1981), 123-4. On foreshortened images see R. Smith, 'Natural Versus Scientific Vision: The Foreshortened Figure in the Renaissance', *Gazette des Beaux-Arts* 84 (1974), 239-47.

35 On the perspectival distortion in Mantegna's picture, see Lightbown, *Mantegna*, 136-7, and Elam, *Splendours*, 123.

36 J. B. de C. M. Saunders and C. D. O'Malley, (eds), *The Illustrations from the Words of Andreas Vesalius of Brussels* (New York: Dover Publications, 1950), 186.

37 Cottingham, *Descartes* 121.

38 Ibid.

39 See Descartes's letter to Lazare Meyssonnier of 29 January 1640 in Descartes, *Philosophical Letters*, 69.

40 Ibid., 72.

41 Baruch (Benedictus) Spinoza, *Ethics and Treatise on the Correction of the Understanding* trans. Andrew Boyle (1910, rpt. London: Dent, 1959), 199-202 (*Ethics*, preface to Pt. V).

42 See Lightbown, *Mantegna*, 421–2.

43 Descartes, *Discourse on the Method*, 73–4.

44 Sigmund Freud, 'The Uncanny' (1919), in Sigmund Freud, *Art and Literature* ed. and trans. James Strachey and Albert Dickson, Pelican Freud vol. 14 (Harmondsworth: Penguin Books, 1985), 340, 346.

45 Ibid., 368.

46 Eugène Marais, *The Soul of the White Ant* (1937 rpt. Harmondsworth: Penguin, 1973), 72.

47 For a discussion of the 'Ideal House' in seventeenth-century (English) culture, see William A. McClung, *The Country House in English Renaissance Poetry* (Berkeley: California UP, 1977), 28–38.

48 A. K. Coomaraswamy, 'An Indian Temple: The Kandarya Mahedo' in R. Lipsey (ed.), *Coomaraswamy: Selected Papers* (Princeton: Princeton UP, 1977), II, 5.

49 See William C. Johnson, '*The Ruin* as Body-city Riddle', *PQ* 59 (1980), 400.

50 C. L. Powell, 'The Castle of the Body', *SP* 16 (1919), 197–205. For an exploration of this theme see Archie Taylor, 'A Metaphor of the Human Body in Literature and Tradition' in Arno Schirokauer and Wolfgang Paulsen (eds), *Corona: Studies in Celebration of the Eightieth Birthday of Samuel Singer* (North Carolina: Duke UP, 1941), 3–7; Ellen Eve Frank, *Literary Architecture: Essays Towards a Tradition* (Berkeley and Los Angeles: California UP, 1979), 229–33.

51 Edmund Spenser, 'A Letter of the Authors To . . . Sir Walter Raleigh' (1589), in Edmund Spenser, *The Faerie Queene* ed. A. C. Hamilton (New York and London: Longman, 1977), 737. All references to *The Faerie Queene* are to this edition.

52 Stephen Greenblatt, *Renaissance Self-Fashioning from More to Shakespeare* (Chicago and London: Chicago UP, 1980), 3.

53 Alistair Fowler, *Spenser and the Numbers of Time* (London: RKP, 1964), 9–10.

54 Though it is not difficult to understand the description of the 'mouth' of the House of Alma as an overt reference to the female sexual organs, 'open' to friends and 'closed' to foes, decorated with a 'wanton yvie twinne' (*FQ* II.ix.24). In Spenser's coded language 'wanton ivy' is a sure sign of sexuality; see *FQ* II.xii – the Bower of Blisse.

55 See Spenser's description of the Irish in his *View of the Present State of Ireland* (1633). This issue is discussed in Patricia Coughlan, 'The English Anatomy of Ireland' in Thomas Healy and Jonathan Sawday (eds), *Literature and the English Civil War* (Cambridge: CUP, 1990), 205–223.

56 On the formalist concept of 'defamiliarization', see Viktor Shklovsky, 'Art as Technique' (1917) in Robert Con Davies (ed.), *Contemporary Literary Criticism* (New York and London: Longman, 1985), 55. On interpreting the allegory of the House of Alma, see Harry Berger, Jr, *The Allegorical Temper: Vision and Reality in Book II of Spenser's Faerie Queene*, Yale Studies in English 137 (New Haven: Yale UP, 1957), 71; Anthea Hume, *Edmund Spenser: Protestant Poet* (Cambridge: CUP, 1984), 121; James Nohrnberg, *The Analogy of The Faerie Queene* (Princeton: Princeton UP, 1976), 344; Crystal Nelson Downing, 'The Charmes Back to Reverse: Deconstructing Architectures in Books II and III of *The Faerie Queene*', *Comitatus* 13 (1982), 64–83. On the idea of 'levels' of allegorical meaning, see Angus Fletcher, *Allegory: The Theory of a Symbolic Mode* (Ithaca, NY: Cornell UP, 1964), 73.

57 See Gilles Deleuze, 'The Schizophrenic and Language: Surface and Depth in Lewis Carroll and Antonin Artaud' in Josué V. Harari (ed.), *Textual Strategies: Perspectives in Post-structuralist Criticism* (London: Methuen and Co., 1980), 277–95, 286–7; Jacques Lacan, 'The Mirror Stage as Formative of the Function of the I as Revealed in Psychoanalytic Experience' in *Écrits* trans. Alan Sheridan (London: Tavistock, 1977), 5.

58 Neil Hertz has described this 'illusion of infinite regress' where 'a writer or painter by incorporating within his own work a work that duplicates in miniature the larger structure'

creates an 'apparently unending metonymic series' of 'wildly uncontrollable repetition'.
See Neil Hertz, 'Freud and the Sandman' in Harari (ed.), *Textual Strategies*, 296–321, 311.

59 Helkiah Crooke, *Microcosmographia* (London, 1615), 907.

60 Digby's was not, however, the first attempt at interpreting the stanza. Hitherto, that priority has been accorded to William Austin's *Haec Homo; wherein the excellency of the Creation of Women is described* published in 1637. See Carroll Camden, 'The Architecture of Spenser's "House of Alma"' *MLN* 58 (1943), 262–5. It could, however, be argued that Crooke's use of the House of Alma in *Microcosmographia* represents the earliest attempt at 'translating' the allegory into a rationalist account of the body's functions.

61 Sir Kenelm Digby, *Observations on the 22. Stanza . . . in Edmund Spenser, The Works A Variorum Edition* ed. E. Greenlaw, C. G. Osgood, and F. M. Padelford (Baltimore: Johns Hopkins UP, 1933), II.474.

62 Digby, *Observations*, 472.

63 See Burton's opening to I.1.2.9. of the *Anatomy* ('Of the Rationall Soule'). Robert Burton, *The Anatomy of Melancholy* ed. Thomas C. Faulkner, Nicholas K. Kiessling, and Rhonda L. Blair with a commentary by J. B. Bamborough and Martin Dodsworth (Oxford: Clarendon Press, 1992).

64 The critical history of Fletcher's poem has been surveyed in R. G. Baldwin, 'Phineas Fletcher: His Modern Readers and his Renaissance Ideas', *PQ* 40 (1961), 462–75.

65 Baldwin, 'Phineas Fletcher', 464.

66 Virginia Woolf's comments are quoted in Richard Ellmann, *James Joyce*, (1959, rev. ed. Oxford: OUP, 1982), 528.

67 Baldwin, 'Phineas Fletcher', 44.

68 Gosse, letter to Louis Gillet (June 1924) quoted in Ellmann, *James Joyce*, 528.

69 Ellmann, *James Joyce*, 521.

70 Spenser, *The Faerie Queene*, 738. For an exploration of the numerological patterning of *The Faerie Queene* see Fowler, *Spenser and the Numbers of Time*, *passim*.

71 Milton's time-scheme is explicated in John Milton, *Paradise Lost* ed. Alistair Fowler (Harlow: Longman, 1971), 25–8.

72 Spenser, *Faerie Queene*, 738.

73 See Ricado Quinones, *The Renaissance Discovery of Time* (Cambridge, Mass.: Harvard UP, 1972), *passim*; Lawrence Manley, *Convention 1500–1700* (Cambridge, Mass.: Harvard UP, 1980), 226–31.

74 Ellmann, *James Joyce*, 554.

75 Ellmann, *James Joyce*, 436.

76 The Gorman-Gilbert plan of *Ulysses* is much less corporeal than the Linati schema. The Linati schema had begun circulating in November 1920, when Joyce passed the scheme to Carlo Linati. In connection with a similar scheme (devised in November 1921), Joyce was (characteristically) anxious to dissociate himself. It was devised, he claimed, 'in order to help . . . to confuse the audience a little more. Perhaps I should not have done so.' See Ellmann, *James Joyce*, 519.

77 Giles and Phineas Fletcher, *Poetical Works* ed. F. S. Boas, 2 vols (Cambridge: CUP, 1908–9). All references to *The Purple Island* (*PI*) are to this edition.

78 Though the poem was not published until 1633, it had been composed some years previously, perhaps as early as 1609. For information on Fletcher and the historical circumstances of the composition of *The Purple Island*, see A. B. Langdale, *Phineas Fletcher: Man of Letters, Science, and Divinity* (New York: Columbia UP, 1937).

79 On protestant pastoral and the retreat from the present, see Joan Grundy, *The Spenserian Poets* (London: Edward Arnold, 1969), 72–3; David Norbrook, *Poetry and Politics of the English Renaissance* (London: RKP, 1984), 175–94, 207.

80 Thomas Healy, 'Sound Physic: Phineas Fletcher's *The Purple Island* and the Poetry of Purgation', *Renaissance Studies* 5 (1991) 341–52.

81 See Conrad Russell, *The Crisis of Parliaments: English History 1509–1660* (1971, rev. ed. London: OUP, 1985), 208–9.

82 It has been suggested (Langdale, *Phineas Fletcher*, 205) that Fletcher would have had ample opportunity to witness dissections whilst he was at Cambridge and a Fellow of King's College prior to 1611. Rather more likely (given the density of anatomical information on display in *The Purple Island*), is that Fletcher used a text such as Geminus' 1553 'edition' of Vesalius in which the English text was taken from Thomas Vicary's *A Profitable Treatise of the Anatomy of Mans Bodie* (1548), 're-ordered' by the dramatist Nicholas Udall. See S. V. Larkey, *The Vesalian Compendium of Genius and Nicholas Udall's Translation: Their Relation to Vesalius, Caius, Vicary, and De Mondeville* (London: Bibliographic Society, 1993), 368.

83 See Horace, *Ars Poetica*, 361, in T. S. Dorsch (ed. & trans.), *Classical Literary Criticism* (Harmondsworth: Penguin Books, 1965), 91.

84 See August T. Pohlan, 'The Purple Island by Phineas Fletcher: A Seventeenth-century Layman's Conception of the Human Body', *Johns Hopkins Hospital Bulletin* 18 (1907), 317–21; Samuel W. Lambert, 'Phineas Fletcher and Francis Quarles and The Purple Island of Phineas Fletcher', *Annals of Medical History* n.s. 3 (1931), 568–78.

85 See Michael Riffaterre, 'Syllepsis', *Critical Inquiry* 6 (1980), 625–38; Jacques Derrida, *Dissemination* trans. Barbara Johnson (London: The Athlone Press, 1981), 202–3; Jonathan Culler, *On Deconstruction* (London: RKP, 1983), 139–40.

86 See Richard H. Rouse and Mary A. Rouse, '*Statim invenire*': Schools, Preachers and New Attitudes to the Page' in Robert L. Benson and Giles Constable (eds), *Renaissance and Renewal in the Twelfth Century* (1982, rpt. Oxford; Clarendon Press, 1985), 222–3.

87 Sir Philip Sidney, *An Apology for Poetry* (1595) ed. Geoffrey Shepherd (Manchester: MUP, 1965), 101.

88 Julius Caesar Scaliger, *Poetics libri septem* (Heidelberg, 1617), IV, i, 401 cited in Sidney, *Apology*, 160.

89 On seventeenth-century voyage narratives, see Claire Jowitt, 'Old Worlds and New Worlds: The Politics of the Voyage Narrative in the Early-modern Age', PhD thesis (University of Southampton, forthcoming), *passim*.

90 Joseph Hall, *The Discoverie of a Newe World* (London, n.d.), sigs qi3^{r-v}. Other examples of such mythic 'interior voyages' are Thomas Tomkis, *Lingua: or the Combat of the Tongue, and the Five Senses for Superiority* (London, 1607); Bartholomew Delbene, *Civitas veri* (Paris, 1609); Richard Bernard, *The Isle of Man: Or the Legall Proceedings in Man-shire against Sinne* (4th edition, London, 1627). These (together with *The Purple Island*) are the texts which provide the antecedents for John Bunyan's *The Holy War* ('The losing and taking again of the town of mansoul') of 1682.

91 Walter Charleton, *Enquiries into Human Nature in VI Anatomic Praelections* (London, 1680), sigs C3^{r-v}.

92 Charleton, *Enquiries*, sig. B.

93 Isbrand de Diemerbroeck, *The Anatomy of Human Bodies* trans. William Salmon (London, 1689), 1.

7 THE REALM OF *ANATOMIA*: DISSECTING PEOPLE

1 The title-page expresses a latin pun. *Spicilegium anatomicum* translates as 'anatomical gleanings'. The *putti* who offer her stalks of corn are thus expressing *Anatomia*'s role as

'harvester' of the human body, who must separate the wheat from the chaff; a symbolic expression of her affinity with death and time.

2 Bidloo's title-page may have owed its theatrical quality to the fact that, as well as being an anatomist of great distinction, Bidloo was also a dramatist and librettist for the New Amsterdam Theatre. See K. B. Roberts and J. D. W. Tomlinson *The Fabric of the Body: European Traditions of Anatomical Illustration* (Oxford: Clarendon Press, 1992), 309.

3 See Robert Graves, *The Greek Myths* (1955, rpt. Harmondsworth: Pelican Books, 1962), I, 46.

4 Plato, *Symposium* 190b trans. W. Hamilton (Harmondsworth: Penguin Books, 1951), 60.

5 See Carla Freccero, 'The Other and the Same: The Image of the Hermaphrodite in Rabelais' in Margaret Ferguson, Maureen Quilligan, and Nancy J. Vickers (eds), *Rewriting the Renaissance: The Discourses of Sexual Difference in Early Modern Europe* (Chicago: Chicago UP, 1986), 145–58; Jerome Schwartz, 'Aspects of Androgyny in the Renaissance' in D. Radcliffe-Umstead (ed.), *Human Sexuality in the Middle Ages and the Renaissance* (Pittsburgh: Centre for Medieval and Renaissance Studies, Pittsburgh UP, 1978), 121–31.

6 Mieke Bal, 'Sexuality, Sin, and Sorrow: The Emergence of Female Character (A Reading of Genesis 1–3)' in Susan Rubin Suleiman (ed.), *The Female Body in Western Culture: Contemporary Perspectives* (Cambridge, Mass.: Harvard UP, 1985), 320. The word *ha-'adam* is derived, Bal suggests, 'from the word used to indicate the material aspect of the earth, *ha-ʾudamâ*' (320).

7 Ibid., 322.

8 Edgar Wind, *Pagan Mysteries in the Renaissance* (London: Faber, 1958), 173. See also Leonard Barkan, *The Gods made Flesh: Metamorphosis and the Pursuit of Paganism* (New Haven and London: Yale UP, 1986), 79–80.

9 W. H. D. Rouse (ed.), *Shakespeare's Ovid Being Arthur Golding's Translation of the Metamorphoses* (1902, rpt. London: Centaur Press, 1961), 128.

10 See Katherine Eisaman Maus, 'Proof and Consequences: Inwardness and its Exposure in the English Renaissance', *Representations* 34 (1991), 29–52; Elizabeth Hanson, 'Torture and Truth in Renaissance England', *Representations* 34 (1991), 53–84.

11 See Roberts and Tomlinson, *The Fabric of the Body*, 214; Leo Steinberg, 'Michelangelo and the Doctors', *BHM* 56 (1982), 543–53; Samuel Y. Edgerton, *Pictures and Punishments: Art and Criminal Prosecution During the Florentine Renaissance* (Ithaca: Cornell UP, 1985), 217–19.

12 See Claudia M. Champagne, 'Adam and his "Other Self" in *Paradise Lost*: A Lacanian Study in Psychic Development', *Milton Quarterly* 25 (1991), 48–59.

13 In November 1637, the College of Physicians was instructed by the Privy Council to examine James Leverett, a gardener, who had claimed to be able to cure scrofula through 'touching', and who was accused of dismissing the power of the king to heal. Harvey, as king's physician, and William Clowes, as Sergeant-Surgeon to the king, were both closely involved in the case. See Geoffrey Keynes, *The Life of William Harvey* (Oxford: Clarendon Press, 1978), 264–8.

14 Jessie Dobson, *Barbers and Barber-Surgeons: A History of the Barbers' and Barber-Surgeons' Companies* (Oxford: Blackwell Scientific Publications, 1979), 120.

15 Ibid., 121.

16 David Norbrook and H. R. Woudhuysen (eds), *The Penguin Book of Renaissance Verse 1509–1659* (Harmondsworth: Penguin Books, 1992), 43.

17 See Robert E. Pike, 'The "Blasons" in French Literature of the Sixteenth Century', *Romanic Review* 27 (1936), 223–42.

18 Thomas Laqueur, *Making Sex: Body and Gender from the Greeks to Freud* (Cambridge, Mass.: Harvard UP, 1990), 130.

19 Eve Kosofsky Sedgwick, 'A Poem is Being Written', *Representations* 17 (1987), 110–43 (129–30).

20 'Eroticism' considered as a cultural phenomenon within a historical period is a notoriously difficult subject with which to deal. But, if we follow Carol Duncan's distinction that the erotic is not a 'self-evident universal category, but a culturally defined concept' then interwoven strands of religious expression, literary fables of desire, and scientific investigation become easier to trace. See Carol Duncan, 'The Aesthetics of Power in Modern Erotic Art', *Heresies* 1 (1977), 46–50. The most obvious (modern) example of a linguistic conjunction between science and male sexuality can be located in the language of those scientists who have worked on twentieth-century weapons systems. See Evelyn Fox Keller, 'From Secrets of Life to Secrets of Death' in Mary Jacobus, Evelyn Fox Keller, and Sally Shuttleworth (eds), *Body/Politics: Women and the Discourses of Science* (New York and London: Routledge, 1990), 177–91.

21 On the *Grands Rhétoriqueurs* in general and Marot in particular, see A. J. Krailsheimer (ed.), *The Continental Renaissance 1500–1600* (Sussex: The Harvester Press, 1978), 173–6.

22 Pike, 'Blasons in French Literature', 230.

23 *S'Ensuivent Les Blasons Anatomiques Du Corps Fémenin* (1550, rpt. Amsterdam, 1866), 31. 'O stomach, more white than alabaster, and more cold than plaster, which to touch freezes the hand, but makes I'm not sure what hot and stiff.'

24 Nancy J. Vickers, 'This Heraldry in Lucrece' Face', in Suleiman (ed.), *The Female Body*, 219.

25 See Frances Yates, *Astraea: The Imperial Theme in the Sixteenth Century* (1975, rpt. Harmondsworth: Penguin, 1977), 121–6.

26 Roberts and Tomlinson, *The Fabric of the Body*, 100.

27 For a discussion of anatomical printing under the patronage of François I, see ibid., 166–8.

28 C. E. Kellett, 'Perino del Vaga et les illustrations pour l'anatomie d'Estienne', *Aesculape* 37 (1955), 74–89.

29 Laqueur, *Making Sex*, 130–1. On Perino del Vaga, see David O. Frantz, *Festum Voluptatis: A Study of Renaissance Erotica* (Columbus, Ohio: Ohio State UP, 1989), 123–4.

30 For a (brief) account of Cellini's *Perseus* see J. R. Hale (ed.), *A Concise Encyclopedia of the Italian Renaissance* (London: Thames and Hudson, 1981), 76–7.

31 The male aggression to be witnessed in Cellini's *Perseus* gives substance to Peter Burke's aside, when he counts Cellini amongst those Renaissance artists who seemed to have exhibited symptoms of 'social deviancy' in their penchant for being involved in brawls and duels. See Peter Burke, *The Italian Renaissance: Culture and Society in Italy* (1972, rpt. Cambridge: Polity Press, 1987), 83. Such an overtly competitive masculine ethos flourished in an environment such as Fontainebleau. The wax model for the *Perseus* shows that Cellini had originally conceived the male figure as carrying a lowered sword, while the bronze model (in the Museo Nazionale, in Florence) shows the sword as being drawn back. Only in the final version of the composition does Cellini endow the statue with a fully realized symbol of male power. In this context, it is worth noting that the *Perseus* was joined, in 1583, by Giovanni Bologna's *Rape of the Sabines*, a composition which supplanted Donatello's *Judith and Holofernes* in the display area of the Loggia dei Lanzi. It is as if a programme was evolving in the Loggia which unambiguously traced the mythos of masculinity which Cellini had encountered in Fontainebleau. See John Pope-Hennessy, *Italian High Renaissance and Baroque Sculpture* (1963, rpt. New York: Vintage Books, 1985) 46–7.

32 Neil Hertz, *The End of the Line: Essays on Psychoanalysis and the Sublime* (New York: Columbia UP, 1985), 191.

33 The last sixteenth-century edition of *Blasons Anatomiques* (the tenth edition) appeared in 1570. The authorship, publishing history and bibliography of the *Blasons Anatomiques* is discussed in Pike, 'Blasons in French Literature', 232–3. No copy of the first (1536) edition appears to have survived. The only 'modern' edition available is a reprint of the 1550 edition (Amsterdam, 1866), the text which I have consulted. For further bibliographical information see George Draudius, *Bibliotheca Exotica* (Frankfurt, 1625), II.201.

34 Quoted in M. F. Ashley Montagu, 'Vesalius and the Galenists' in E. Ashworth Underwood (ed.), *Science, Medicine, and History: Essays on the Evolution of Scientific Thought and Medical Practice Written in Honour of Charles Singer* (London: OUP, 1953), I.374–85, 376.

35 J.B. de S. M. Saunders and C. D. O'Malley, (eds), *The Illustrations from the Works of Andreas Vesalius of Brussels* (New York: Dover Publications, 1950), 14. Stephen Pender offers a spirited discussion of this passage and the parallel literature of the 'sutured' body in the Renaissance in his (as yet) unpublished paper: '"Nature's Diaresis half one another", Monsters, Somatic History, and the English Renaissance'. I am grateful to Stephen Pender for allowing me to see his paper.

36 See Yates, *Astraea*, 29–87; Andrew Belsey and Catherine Belsey, 'Icons of Divinity: Portraits of Elizabeth I' in Lucy Gent and Nigel Llewellyn (eds), *Renaissance Bodies: The Human Figure in English Culture 1540–1660* (London: Reaktion Books, 1990), 111–35.

37 Louis Adrian Montrose, '*A Midsummer Night's Dream* and the Shaping Fantasies of Elizabethan Culture: Gender, Power, Form' in Ferguson *et. al.* (eds), *Rewriting the Renaissance*, 65–87, 67.

38 The obvious example of this appropriation was the 'mock' blazon of Shakespeare's Sonnet 130 ('My Mistress' eyes nothing like the sun') described by Stephen Booth as 'gently mock[ing] the thoughtless, mechanical application of the standard Petrarchan metaphors'. See also Shakespeare's Sonnet 106 ('When in the chronicle of wasted time') with its evocation of the 'antique pen' which sets out to make a 'blazon of sweet beauty's best,/ Of hand, of foot, of lip, of eye, of brow'. See Stephen Booth (ed.), *Shakespeare's Sonnets* (New Haven and London: Yale UP, 1978), 452–4. For a stimulating analysis of rhetorical comparisons as they were deployed by women, see Lorna Hutson, 'Why the Lady's Eyes are Nothing Like the Sun' in Clare Brant and Diane Purkiss (eds), *Women, Texts and Histories 1570–1760* (London and New York: Routledge, 1992), 13–38.

39 See Rosemond Tuve's comments on 'merismus' – the figure (in the rhetorical sense) of the Distributer, described at length by George Puttenham in his *The Arte of English Poesie* (1589). See Rosemond Tuve, *Elizabethan and Metaphysical Imagery: Renaissance Poetic and Twentieth Century Critics* (1947, rpt. Chicago and London: Chicago UP, 1972), 306–7.

40 William A. Oram, Einar Bjorvand, Ronald Bond, Thomas H. Cain, Alexander Dunlop, and Richard Schell (eds), *The Yale Edition of the Shorter Poems of Edmund Spenser* (New Haven and London: Yale UP, 1989). All references are to this edition.

41 For an exploration of such a fantasy (in the form of dream) see Montrose, 'Shaping Fantasies', 65–9. Montrose writes (68) of the astrologer Simon Forman's dream of sleeping with the queen, that it 'epitomizes the indissolubly political and sexual character of . . . cultural forms' in the period.

42 For an account of Lady Mary Wroth's poetry, see Tina Krontiris, *Oppositional Voices: Women as Writers and Translators of Literature in the English Renaissance* (London and New York: Routledge, 1992), 121–40.

43 See Lisa Jardine, 'Twins and Travesties: Gender, Dependency and Sexual Availability in *Twelfth Night*' in Susan Zimmerman (ed.), *Erotic Politics: Desire on the Renaissance Stage* (New York and London: Routledge, 1992), 27–38. See also Valerie Traub's comments on the 'investment in erotic duality' in *Twelfth Night*: Valerie Traub, *Desire and Anxiety: Circulations of Sexuality in Shakespearean Drama* (London and New York: Routledge, 1992), 131.

44 *Twelfth Night* is first recorded as having been played at the Middle Temple on 2 February 1601/2. But there is a tradition (investigated by Leslie Hotson) that the play was commissioned for the visit of Orsino, Duke of Bracciano, to Elizabeth's court and performed (at court) on 6 January 1600/1. It has been suggested that the court audience was meant to recognize Olivia as Elizabeth, and Orsino as the distinguished visitor. Thus, the aged queen, the recipient of so many of these blazoning gestures, in the character of Olivia, dismisses the attempt of the young courtier (Viola) at the genre with a brusque dash of common sense in plain language – a device in which she delighted. See J. M. Lothian and T. W. Craik (eds), *Twelfth Night*, Arden Shakespeare (London: Methuen, 1975), lxxix. For Anne Barton's attempt at dismissing the occasional nature of the play, see her introduction to *Twelfth Night* in G. Blakemore Evans (ed.), *The Riverside Shakespeare* (Boston: Houghton Mifflin and Co., 1974), 403. For a suggestive reading of what she terms the 'inventory' offered by Olivia in *Twelfth Night* see Patricia Parker, *Literary Fat Ladies: Rhetoric, Gender, Property* (London and New York: Methuen, 1987), 130–1. See also Dympna Callaghan's bracingly sceptical account of body-criticism: '"And All is Semblative a Woman's Part": Body Politics and *Twelfth Night*', *Textual Practice* 7 (1993), 428–52.

45 R. C. Bald, *John Donne: A Life* (1970, rpt. Oxford: Clarendon Press, 1986), 121.

46 John Carey, *John Donne: Life, Mind, Art* (London: Faber and Faber, 1981), 158.

47 On the 'sin' of sodomy, as opposed to the acceptable signs of male friendship, see Alan Bray, 'Homosexuality and the Signs of Male Friendship in Elizabethan England', *History Workshop Journal* 29 (1990), 1–19.

48 Baldassare Castiglione, *Libro del Cortegiano* trans. Sir Thomas Hoby (1561, rpt. London: Dent, n.d.), 39.

49 Castiglione, *Cortegiano*, 41.

50 Alan Sinfield, *Faultlines: Cultural Materialism and the Politics of Dissident Reading* (Oxford: Clarendon Press, 1992), 134; and see Parker, *Literary Fat Ladies*, 131–2. See also Jonathan Goldberg's comment in his brilliant essay 'Desiring Hal': 'In *Henry V* Hal is still attempting to cast off the revolting male lover who makes the king a queen. In such ways the misogyny of the second tetralogy is complicit with homophobia. . . . But only a heterosexist criticism need read Shakespeare this way.' Jonathan Goldberg, *Sodometries: Renaissance Texts, Modern Sexualities* (Stanford, CA.: Stanford UP, 1992), 175.

51 As Bruce R. Smith observes: 'Beyond the lady (or ladies) so forcefully addressed in the love poems, only a small coterie of Donne's friends must have seen them.' See Bruce R. Smith, *Homosexual Desire in Shakespeare's England* (Chicago and London: Chicago UP, 1991), 241.

52 Carey, *John Donne*, 12.

53 In describing the close of Donne's Elegie XVIII in terms of 'homophobic anxiety', I am following Jonathan Dollimore's distinction: 'Instead of positing psychoanalytically repressed homosexuality as the necessary and/or sufficient cause of homophobia, we might better regard socially proscribed homosexuality as one of homophobia's several interconnected and enabling conditions, none of which is independently either necessary or sufficient.' See Jonathan Dollimore, *Sexual Dissidence: Augustine to Wilde, Freud to Foucault* (Oxford: Clarendon Press, 1991), 246.

54 Thus, C. A. Patrides who, with some editorial courage in a 'student' edition of Donne, even in 1985, confronts the sexually explicit joke at the end of Elegie XVIII, but turns it into a joke about oral sex. By glossing 'aversely' as 'lying at an angle to one another', Patrides concludes that the two 'purses' are the woman's mouth and her vulva. But seventeenth-century usages cited in the *OED* are unambiguous: aversely is 'backwardly', a meaning which is cognate with a sense of moral repugnancy. This, of course, is the point

of Donne's concluding joke. See C. A. Patrides (ed.), *The Complete English Poems of John Donne* (London: Dent, 1985), 182.

55 Smith (*Homosexual Desire in Shakespeare's England,* 174), describes Donne as 'a spokesman for the moral arguments against sodomy'. This may well be the pose of the persona of the satires, but Elegie XVIII might require us to modify this view.

56 Eve Kosofsky Sedgwick, *Between Men: English Literature and Male Homosocial Desire* (New York: Columbia UP, 1985), 36.

57 G. C. Moore Smith (ed.), *The Poems English and Latin of Edward Lord Herbert of Cherbury* (Oxford: Clarendon Press, 1923), 4. Though the poem was not published until 1665, Moore Smith suggests (xxxi), that the poem was circulating prior to 1624.

58 Carew was made a gentleman of the privy chamber in April 1630 and, shortly after, 'Sewer in Ordinary' (that is, personal waiter to the king). This latter office, Kevin Sharpe points out, was a mark of the king's 'special favour'. See Kevin Sharpe, *Criticism and Complement: The Politics of Literature in the England of Charles I* (Cambridge: CUP, 1987), 111–12. Both titles were prominently displayed on the title-page of Carew's *Poems* of 1640 (see note 60 below).

59 The story is recounted in Sharpe, *Criticism and Complement,* 112. Sharpe doubts the veracity of the story, but concludes that, true or false, it illustrates the 'intimacy' Carew enjoyed with (at least one half) of the royal pair, and the 'delicate tact' such intimacy involved.

60 References are to Thomas Carew, *Poems 1640 together with the Poems from the Wyburd Manuscript* (Menston: The Scolar Press, 1969).

61 Sharpe, *Criticism and Complement,* 119.

62 Ibid., 115.

63 Ibid., 119.

64 As Thomas Clayton notes, amongst Carew's models for 'A Rapture' was Donne's Elegie XIX. See Thomas Clayton (ed.), *The Cavalier Poets* (London: OUP, 1978), 182. In both 'A Rapture' and 'The Second Rapture', Carew's verses are replete with echoes and images culled from the work of his other great poetic mentor, Ben Jonson. Jonson's depiction of the prelude to (attempted) rape in *Volpone* (III.ii.140–267), clearly provided Carew with a model for both his 'rapture' poems.

65 Sharpe, *Criticism and Complement,* 119.

66 Joseph Woodfall Ebsworth (ed.), *The Poems and Masque of Thomas Carew* (London: Reeves and Turner, 1893), 223. Ebsworth was anxious to defend Carew not just from the charge of paedophilia, but something 'unmanly' which he associated (222), with 'the sickly sentimental pruriencies and pruderies of our *Fin de Siècle* poets'. Carew, on the other hand 'was a man', and a man could not have written 'about thirteen'. Surely Carew must have meant 'above thirteen' or, better still, 'above fifteen' which is the age (Ebsworth observed) William Cartwright chose for the young girl in his play *The Ordinary*. And of Cartwright, Ebsworth notes approvingly, Jonson had said that he 'writes like a man'. Clayton (*Cavalier Poets,* 211), cites Thomas Randolph in suggesting '13–15 as the ideal age for the inamoratas of paedophiles'.

67 'Upon my *Lady Carlyle's* walking in Hampton Court Garden' in Clayton, *Cavalier Poets,* 221–2. It is not difficult to understand the poem as a (male) joke about menstruation when we recall the seventeenth-century euphemistic meaning of 'flowers'.

68 On the identification of the 'sex' of the cadavers to be found on Renaissance title-pages, see Laqueur, *Making Sex,* 72–5.

69 Laqueur, *Making Sex,* 149.

70 Constance Jordan, *Renaissance Feminism: Literary Texts and Political Methods* (Ithaca and London: Cornell UP, 1990), 30–1. Emily Martin has argued that the 'one-sex' model, in

which women's internal organs were seen as 'structurally analogous' to men's external organs, prevailed as a metaphoric system until well into the nineteenth century; see Martin, *The Woman in the Body: A Cultural Analysis of Reproduction* (Milton Keynes: Open University Press, 1989), 29–32. For further discussion of male–female sexual difference in a religious context see Elizabeth Castelli, '"I will make Mary Male": Pieties of the Body and Gender Transformation of Christian Women in Late Antiquity' in Julia Epstein and Kristina Straub (eds), *Body Guards: The Cultural Politics of Gender Ambiguity* (London and New York: Routledge, 1991), 29–49; Margaret R. Miles, *Carnal Knowing: Female Nakedness and Religious Meaning in the Christian West* (Tunbridge Wells: Burns and Oates, 1992), 53–77.

71 This is one of the chief criticisms which Laqueur's work has attracted. See in particular, Katherine Park and Robert Nye, 'Destiny is Anatomy', *The New Republic* (18 February 1991), 53–7.

72 Jane Sharp, *The Midwives Book* (London, 1671), rpt. (abridged) in Charlotte F. Otten (ed.), *English Women's Voices, 1540–1700* (Miami: Florida International UP, 1992), 197.

73 Laqueur (*Making Sex*, 79), has read this image as a 'flamboyant' assertion of the one-sex model. 'You see' (Laqueur paraphrases the meaning of the image) 'how the neck of the womb resembles a penis'.

74 Sharp, *Midwives Book*, 199.

75 For a similar example of the metaphor of discourse as child-birth, see the opening sonnet of Sidney's *Astrophil and Stella*: 'Thus great with child to speake' in Sir Philip Sidney, *Poems* ed. W. A. Ringler, Jr (Oxford: Clarendon Press, 1962), 165.

76 The stanza (43), which describes the centre of the garden of Adonis is itself placed at the very midpoint of the 1590 edition of Book III of *The Faerie Queene* – a formal arrangement akin to Vesalius' placing of the opened womb at the centre of his anatomical theatre of the world on the title-page of the *Fabrica* of 1543. On Spenser's formal arrangement, see Michael Baybak, Paul Delany, and A. Kent Hieat, 'Placement "in the middest" in *The Faerie Queene*', *Illinois Papers on Language and Literature* 5 (1969), 227–34. For the anatomical identification of the 'mount' see Alistair Fowler, *Spenser and the Numbers of Time* (London: RKP, 1964), 137.

77 Elizabeth Bronfen, *Over Her Dead Body: Death, Femininity and the Aesthetic* (Manchester: MUP, 1992), 5.

78 Bronfen, *Dead Body*, 99. See also Barbara Maria Stafford, *Body Criticism: Imaging the Unseen in Enlightenment Art and Medicine* (Cambridge, Mass.: MIT Press, 1991), 64. The undoubted popularity of waxwork anatomical displays during the eighteenth century (of which the collection in Florence at the Palazzo Pitti was the most famous) may also be attributed to a more mundane set of circumstances: a wax model is an undoubted substitute where the demand for human cadavers outstrips supply.

79 Gail Kern Paster, *The Body Embarrassed: Drama and the Disciples of Shame in Early Modern England* (Ithaca: Cornell UP, 1993), 107.

80 St Augustine, *Concerning the City of God Against the Pagans* trans. Henry Bettenson (1972, rpt. Harmondsworth: Penguin Books, 1984), 1059.

81 The symbolic gender of the church in St Paul's account is uncertain. Whilst the 1611 (AV) translation of Ephesians 5.23 leaves the question open ('Christ . . . is the saviour of the body'), the 1609 (Douai) version is less ambiguous: 'Christ . . . is the saviour of *his* body.' For a discussion of this key passage in St Paul and its interpretation by Augustine and (later) Aquinas, see Diana Coole, *Women in Political Theory From Ancient Misogyny to Contemporary Feminism* (New York and Hemel Hempstead: Harvester Wheatsheaf, 1993), 40–52.

82 Augustine, *City of God*, 1057.

83 The Calvinist Company of Pastors in Geneva, in May 1575, anxious to assert the supra-doctrinal solidarity of the reformed churches, recorded that 'despite differences between us and the Lutherans on the matter of the Lord's Supper, nevertheless we all profess the true communion of the Body of Jesus Christ together with the other principal points of faith, and that the diversity of the supper should not divide us.' See Alistair Duke, Gillian Lewis, and Andrew Pettegree (eds), *Calvinism in Europe 1540–1610: A Collection of Documents* (Manchester: MUP, 1992), 207. In both catholic and protestant propaganda of the Reformation and counter-Reformation, the opposition were characterized as 'monstrous' fusions of distorted bodies and many-headed creations; travesties, in other words, of the ideal body–head relationship described by St Paul. See R. W. Scribner, *For the Sake of Simple Folk: Popular Propaganda for the German Reformation* (Cambridge: CUP, 1981).

84 See St Augustine, 'Of the Care to be Taken of the Dead' ('De cura pro mortuis gerenda') in Roy J. Deferrati (ed.), *The Fathers of the Church* vol. XV (New York, 1955), ch. 2. For an example of contemporary fascination with this problem, see Donne's famous evocation of God's power to recompact the dispersed bodies of the dead at the Resurrection in *Sermons*, VIII.98.

85 Natalie Zemon Davies, *Society and Culture in Early Modern France* (Oxford: Polity Press, 1987), 178–9.

86 The *OED* records a thirteenth-century use of the word 'web' to describe the membrane enclosing the foetus. The term was still in use by the time that Copeland translated Guido's *Questionary* (1541). Both 'web' and 'net' are terms used to describe membranes, as in Helkiah Crooke's *Microcosmographia* (London, 1615, 466), where the 'rete mirabile' is translated literally as 'the wonderful net'.

87 Frances Valdez, 'Anatomical Studies at Oxford and Cambridge' in A. G. Debus (ed.), *Medicine in Seventeenth-century England* (Berkeley and Los Angeles: U. California P., 1974), 405.

88 Ibid.

89 In this connection, female midwives were often suspected of procuring abortions or being accomplices of the infanticide of unwanted babies. See Roy Porter, *Disease, Medicine and Society: in England 1550–1860* (London: Macmillan, 1987), 20.

90 Laqueur, *Making Sex*, 82. See also Martin, *The Woman in the Body*, 27–30.

91 It was for this reason that, in the first (1543) edition of the *Fabrica*, Vesalius used a canine placenta to illustrate the human placenta. His excuse was that he had not had the opportunity to see the human foetus, and that Sylvius had assured him that 'the arrangement of the dog also held for man [sic]' (Saunders and O'Malley, *The Illustrations*, 174).

92 Ibid., 170.

93 Coole, *Women in Political Theory*, 47.

94 Dollimore, *Sexual Dissidence*, 147.

95 On the history of Berrettini's images, see Roberts and Tomlinson, *The Fabric of the Body*, 272–6.

96 Miles, *Carnal Knowing*, 156.

97 On patriarchal structures, see Jordan, *Renaissance Feminism*, 21–9. Within an explicitly puritan framework, see Marilyn J. Westerkamp, 'Puritan Patriarchy and the Problem of Revelation', *Journal of Interdisciplinary History* 23 (1993), 571–95. It is important, in any discussion of seventeenth-century patriarchy, to distinguish between the 'theory', where women 'had little or no formal part in government, education, or the hierarchy of the established religion', and actual practice where 'domestic patriarchal authority was

challenged, argued, and undermined by both men and women throughout the seventeenth century'. See Margaret J. M. Ezell, *The Patriarch's Wife: Literary Evidence and the History of the Family* (Chapel Hill and London: University of North Carolina Press, 1987), 161–3.

98 Such texts usually contained some sort of defence of the decision to publish in English rather than latin. The need to publish in English arose from the fact that the Barber-Surgeons were not expected to possess the same level of education as their counterparts, the Physicians. Representative 'defences' of vernacular medical publication can be found in Robert Copeland's translation of Guy de Chauliac's *Chirurgia Magna* (a Galenic work of the fourteenth century) published as *The Questyonary of Cyrurgyens* (London, 1542), sig. 2A^v. As late as 1634, the translation of Ambroise Paré's *Works* contained an elaborate defence (sig. 2^v) of the decision to publish in English. On the question of the vernacular publication of medical works see H. S. Bennett, *English Books and Readers 1475–1640* (Cambridge: CUP, 1970), III, 140.

99 Keynes, *Life of Harvey*, 73.

100 The political complexities of religious debate in the period are traced in Kenneth Fincham and Peter Lake, 'The Ecclesiastical Policies of James I and Charles I' in Kenneth Fincham (ed.), *The Early Stuart Church 1603–1642* (London: Macmillan, 1993), 23–49.

101 Coole, *Women in Political Theory*, 54.

102 Keynes, *Life of Harvey*, 74.

103 Margaret Olofson Thickstun, *Fictions of the Feminine: Puritan Doctrine and the Representation of Women* (Ithaca and London: Cornell UP, 1988), 9.

104 Text from Germaine Greer, Jeslyn Medoff, Melinda Sansone, and Susan Hastings (eds), *Kissing the Rod: An Anthology of Seventeenth-century Women's Verse* (London: Virago Press, 1988), 160–1.

105 For a (highly descriptive) account of the dangers of childbirth in early-modern and pre-industrial society, see Edward Shorter, *A History of Women's Bodies* (Harmondsworth: Penguin Books, 1984), 69–102. On the 'virtually perpetual pregnancy' endured by seventeenth-century women, see Antonia Fraser, *The Weaker Vessel* (New York: A. Knopf, 1984), 59–80. On maternal mortality, see Debbie B. Willmott, 'An Attempt to estimate the True Rate of Maternal Mortality in the Sixteenth to Eighteenth Centuries', *MH* 26 (1982), 79–90. On women's diary accounts of pregnancy and labour, see Sara Heller Mendelson, 'Stuart Women's Diaries and Occasional Memoirs' in Mary Prior (ed.), *Women in English Society 1500–1800* (London: Methuen, 1985), 181–210 (particularly 196–7).

106 Greer, *Kissing the Rod*, 159.

107 Elizabeth Clinton, Countess of Lincoln, *The Countess of Lincoln's Nursery* (Oxford, 1622), quoted by Fraser, *The Weaker Vessel*, 80. For a discussion of 'mother's advice books' such as Clinton's, see Elaine V. Beilin, *Redeeming Eve: Women Writers of the English Renaissance* (Princeton: Princeton UP, 1987), 266–85.

108 Otten, *English Women's Voices*, 225.

109 Ben Jonson, 'On My First Son' in Ben Jonson, *Poems* ed. Ian Donaldson (London: OUP, 1975), 27.

8 'ROYAL SCIENCE'

1 Margaret Cavendish, *The Philosophical and Physical Opinions, written by Her excellency the Lady Marchioness of Newcastle* (London, 1655), 101. On Margaret Cavendish's access to scientific

thought, see Lisa T. Sarahsohn, 'A Science Turned Upside Down: Feminism and the Natural Philosophy of Margaret Cavendish', *HLQ* 47 (1984), 289–307.

2 Roy Porter, *Disease, Medicine and Society in England 1550–1860* (London: Macmillan, 1987), 28, 29. See also Roy Porter (ed.), *Patients and Practitioners: Lay Perception of Medicine in Pre-Industrial Society* (Cambridge: CUP, 1985), *passim.*

3 See Alice Clark, *Working Life of Women in the Seventeenth-Century* (1919, rpt. London: Routledge, 1992), 243–89; Jean Donnison, *Midwives and Medical Men: A History of Interprofessional Rivalries and Women's Rights* (London: Heinemann Educational, 1977); Lucinda McCray Beier, *Sufferers and Healers: The Experience of Illness in Seventeenth-century England* (London: RKP, 1987), 8–50. For an example of women protesting against their exclusion from practising the skills of midwifery, see Elizabeth Cellier, *To Dr.——— An Answer to his Queries, Concerning the College of Midwives* (London, 1688), rpt. in Charlotte F. Otten (ed.), *English Women's Voices, 1540–1700* (Miami: Florida International UP, 1992), 206–11. For examples of women undertaking traditional health-care, see the extracts from the Diary of Lady Margaret Hoby (1599), and Mrs Elizabeth Freke (1675), in Otten, *English Women's Voices*, 186–9, 259–61.

4 For a critical discussion of the biological implications of 'mechanism', see Owsei Temkin, *The Double Face of Janus and Other Essays in the History of Medicine* (Baltimore and London: Johns Hopkins UP, 1977), 279. On 'mechanism' in general, see E. J. Dijksterhuis, *The Mechanization of the World Picture* trans. C. Dikshoorn (Oxford: Clarendon Press, 1961), *passim.* On the seventeenth-century debate, see Michael Hunter, *Science and Society in Restoration England* (Cambridge: CUP, 1981), 173–4.

5 On the difficulty of establishing political allegiance in the civil war, see John Morrill, *The Nature of the English Revolution* (London and New York: Longman, 1993), 188–9.

6 John Hall, *The Advancement of Learning* ed. A. K. Croston (Liverpool: Liverpool UP, 1953), 38.

7 George Hakewill, *An Apology or Declaration of the Power and Providence of God in the Government of the World* (3rd edition, London, 1635), 274.

8 Abraham Cowley, *The Advancement of Experimental Philosophy* (London, 1661), sig. A5. For a discussion of the 'dominion over nature' which the touchstone of 'usefulness' promised in the seventeenth century, see Charles Webster, *the Great Instauration: Science, Medicine and Reform 1625–1660* (London: Duckworth, 1975), 324–484.

9 Webster, *Great Instauration*, 66–7; Robert G. Frank Jr, 'The Physician as Virtuoso in Seventeenth-century England' in Barbara Shapiro and Robert G. Frank Jr, *English Scientific Virtuosi in the 16th and 17th Centuries* (Los Angeles: William Andrews Clark Memorial Library, 1977), 98.

10 Johann Veslingus, *The Anatomy of the Body of Man* trans. Nicholas Culpepper (London, 1653), sig. A2^{r-v}.

11 The assumption that interest in 'chymical' philosophy was a mark of political radicalism has been challenged by J. Andrew Mendelsohn, 'Alchemy and Politics in England 1649–1665', *Past and Present* 135 (1992), 30–78. On Paracelsianism see in particular Walter Pagel, *Paracelsus: An Introduction to Philosophical Medicine in the Era of the Renaissance* (Basel and New York: Karger, 1958), *passim*; P. M. Rattansi, 'Paracelsus and the Puritan Revolution', *Ambix* 11 (1963), 24–32; Allen G. Debus, *Man and Nature in the Renaissance* (Cambridge: CUP, 1978), 19–33; Charles Nicholl, *The Chemical Theatre* (London: RKP, 1980), 55–80; A. Rupert Hall, *The Revolution in Science 1500–1750* (London and New York: Longman, 1983), 80–9; Brian Vickers, 'Analogy versus Identity: The Rejection of Occult Symbolism, 1580–1680' in Brian Vickers (ed.), *Occult and Scientific Mentalities in the Renaissance* (Cambridge: CUP, 1984), 95–163.

12 Sir Kenelm Digby, *A Discourse Concerning the Vegetation of Plants* (London, 1661), 10–11. On Digby, see Jonathan Sawday, 'The Mint at Segovia: Digby, Hobbes, Charleton, and the Body as a Machine in the Seventeenth Century', *Prose Studies* 6 (1983), 21–35, 26–7.

13 Veslingus, *Body of Man*, sig. A.

14 Simon Partlicius, *A New Method of Physick; Or, A Short View of Paracelsus and Galens Practice; in 3 Treatises* trans. Nicholas Culpepper (London, 1654), sigs. U7ᵛ–U8.

15 Robert Turner, *Microcosmos. A Description of the Little World* (London, 1654), 19.

16 Henry Pinnel, *Philosophy Reformed and Improved in Four Profound Tracts* (London, 1657), 43. On Pinnel, see Marie Boas, *The Scientific Renaissance 1450–1630*, (1962, rpt. London: Fontana, 1970), 152; Webster, *Great Instauration*, 280–1.

17 Alexander Ross, *The Newe Planet No Planet* (London, 1646), 99.

18 Ross, *Newe Planet*, 117.

19 Alexander Ross, *Arcana microcosmi* (2nd edition, London, 1652), title-page.

20 Sir Thomas Browne, *Selected Writings* ed. Sir Geoffrey Keynes, (London: Faber and Faber, 1968), 248.

21 Margarita Stocker, 'From Faith to Faith in Reason? Religious Thought in the Seventeenth Century' in T. G. S. Cain and Ken Robinson (eds), *Into Another Mould: Change and Continuity in English Culture 1625–1700* (London: Routledge, 1992), 70. On the question of the link between 'new science' and puritanism see Dorothy Stimson, 'Puritanism and the New Philosophy in Seventeenth-century England', *BIHM* 3 (1935), 321–34; Barbara J. Shapiro, 'The Universities and Science in Seventeenth-century England' *Journal of British Studies* 10 (1971), 47–82; Robert G. Frank, Jr, 'Science, Medicine, and the Universities of Early Modern England:, Background and Sources', *History of Science* 11 (1973), 194–269; S. F. Mason, 'Science and Religion in Seventeenth-century England' in Charles Webster (ed.), *The Intellectual Revolution of the Seventeenth Century* (London: RKP, 1974), 197–218; Webster, *Great Instauration*, 116–21; Nicholas Tyacke, 'Science and Religion at Oxford Before the Civil War' in Donald Pennington and Keith Thomas (eds), *Puritans and Revolutionaries: Essays in Seventeenth Century History Presented to Christopher Hill* (Oxford: Clarendon Press, 1978), 73–94; Simon Schaffer, 'The Political Theology of Seventeenth-century Natural Science', *Ideas and Production* 1 (1983), 2–14; Helen M. Burke, '*Annus Mirabilis* and the Ideology of the New Science', *ELH* 57 (1990), 307–34.

22 Thomas Hobbes, *Leviathan* ed. Richard Tuck (Cambridge: CUP, 1991), 52.

23 Lotte Mulligan's use of the term 'irrationalist' to describe Van Helmont aligns him with other 'extreme examples of irrationalism like that of the Ranters, [and] the Muggletonians'. But, as Mendelsohn points out, we should remember that the first translations of Van Helmont's work were undertaken by Walter Charleton, the Royal Physician from 1643. See Lotte Mulligan, '"Reason", "Right Reason", and "Revelation" in mid-seventeenth-century England' in Vickers (ed.), *Occult and Scientific Mentalities*, 375–401, 376; Mendelsohn, 'Alchemy and Politics', 33. For a critique of the opposition of the 'rational' and 'irrational' in the discourses of early-modern science, see Paula Findlen, 'Jokes of Nature and Jokes of Knowledge: The Playfulness of Scientific Discourse in Early Modern Europe', *RQ* 43 (1990), 292–331. On Van Helmont, see Walter Pagel, 'Religious and Philosophical Aspects of Van Helmont's Science and Medicine', *BHM* supplement 2 (Baltimore: Johns Hopkins UP, 1944); Lester S. King, *Medical Investigation in Seventeenth-century England*, Papers read at a Clark Library Seminar (Los Angeles: William Andrews Clark Memorial Library, 1968), 29–49; Ladislao Reti and William C. Gibson, *Some Aspects of Seventeenth-century Medicine and Science*, Papers read at a Clark Library Seminar (Los Angeles: William Andrews Clark Memorial Library, 1969), 1–19; N. R. Gelbart, 'The Intellectual Development of Walter Charleton', *Ambix* 18 (1971), 149–68; Sawday, 'Bodies

By Art Fashioned: Anatomy, Anatomists, and English Poetry 1570–1680', (PhD diss. University of London, 1988), 250–4.

24 J. B. Van Helmont, *Oriatrike or Physicke Refined* trans. John Chandler (London, 1662), 323.

25 Joseph Glanvill, *The Vanity of Dogmatizing* (London, 1661), 160.

26 Thomas Sprat, *The History of the Royal Society* (1667), ed. Jackson I. Cope and Harold Whitmore Jones (St Louis, Missouri: Washington University Studies, 1958), 42.

27 Sprat, *History*, 113.

28 John Wilkins, *An Essay Towards a Real Character, and a Philosophical Language* (London, 1668), 17–18. On the (attempted) reform of the language of science in the seventeenth century, see R. F. Jones, 'Science and English Prose Style in the Third Quarter of the Seventeenth-century', *PMLA* 45 (1930), 977–1009; Joan Bennett, 'An Aspect of the Evolution of Seventeenth-century Prose', *RES* 17 (1941), 281–97; R. F. Jones, *The Seventeenth Century: Studies in the History of English Thought and Literature from Bacon to Pope* (Stanford: Stanford UP, 1951), 10–40; Stephen Medcalfe, *Joseph Glanvill, The Vanity of Dogmatizing: The Three Versions* (Sussex: Harvester Press, 1970); Brian Vickers (ed.), *English Science, Bacon to Newton* (Cambridge: CUP, 1987), 212–17; Tony Davies, 'The Ark in Flames: Science, Language and Education in Seventeenth-century England' in Andrew E. Benjamin, Geoffrey N. Cantor, and John R. Christie (eds), *The Figural and the Literal: Problems of Language in the History of Science and Philosophy 1630–1680* (Manchester: MUP, 1987), 83–101. On linguistic shifts, with particular reference to William Harvey's use of the vernacular, see Roger K. French, 'The Languages of William Harvey's Natural Philosophy', *Journal of the History of Medicine and Allied Sciences* 49 (1994), 24–51.

29 Peter Dear, '*Totius in Verba* Rhetoric and Authority in the Early Royal Society', *Isis* 76 (1985), 145–61 (152–3).

30 C. A. Patrides (ed.), *The English Poems of George Herbert* (London: Dent, 1974), 75.

31 On the 'feminization' of nature and the 'masculinization' of science, see Brian Easlea, *Fathering the Unthinkable: Masculinity, Scientists, and the Nuclear Arms Race* (London: Pluto Press, 1983), 10–39.

32 Abraham Cowley, *Works* (7th edition, London, 1681), 38.

33 On Cowley's intellectual debt to Hobbes, see David Trotter, *The Poetry of Abraham Cowley* (London: Macmillan, 1979), 2–6, 127–33.

34 On the 'cult of Love' in the court of Charles I, see Kevin Sharpe, *Criticism and Complement: The Politics of Literature in the England of Charles I* (Cambridge: CUP, 1987), 197–211.

35 On the dating of 'To his Coy Mistress' see Andrew Marvell, *The Poems and Letters* ed. H. M. Margoliouth, 2 vols (3rd edition, Oxford: Clarendon Press, 1971), I. 253.

36 Martin Lluelyn, 'To the Incomparable Dr. Harvey . . .' in William Harvey, *Anatomical Exercitations concerning the Generation of Living Creatures* (London, 1653), sig. A4.

37 John Collop, *Poesis Rediviva: Or, Poesie Revived* (London, 1656), 57–8. Besides the poems by Abraham Cowley, Margaret Cavendish, and Jane Barker (see below) which celebrated Harvey in the later seventeenth century, commendatory or celebratory verses were written by Peter Bowne, William Cartwright, Sir John Birkenhead, Martin Llewellyn, Robert Grove, John Dryden, and Barten Holyday. For a discussion of these texts see Sawday, 'Bodies By Art Fashioned', 292–335.

38 See Geoffrey Keynes, *The Life of William Harvey* (Oxford: Clarendon Press, 1978), 304–29.

39 Cowley, *Works*, 14. The interruption of the intellectual labours of Hobbes, Harvey, and Scarborough seems to have struck a chord in Cowley, since he, too, had been forced to abandon and 'burn the very copies' of his own epic poem *The Civil War*, following the Royalist defeat at Newbury in September 1643. See Jonathan Sawday, 'Civil War, Madness, and the Divided Self' in Thomas Healy and Jonathan Sawday (eds), *Literature and the English Civil War* (Cambridge: CUP, 1990), 127–43 (138–9).

40 Cowley, *Works*, 12.

41 Indeed, Carew's 'A Rapture' had invoked precisely the same myth of pursuit when the poem imagined Daphne as breaking out of her bark prison to 'meet th'embraces of the youthfull Sun' (Thomas Carew, *Poems 1640 together with the Poems from the Wyburd Manuscript* (Merston: The Scolar Press, 1969), 88).

42 Cowley, *Works*, 13.

43 Cowley, *Poems* (London, 1656), sigs 3E2v, 3F2v.

44 See in particular 'The First Nemean Ode to Pindar' (stanza 5), 'The Resurrection' (stanza 1), 'The Muse' (stanza 4), 'Destinie' (stanza 3), 'To the New Year' (stanza 3), 'Life' (stanza 3), all in *Poems*, sigs 3C2–3G3v.

45 David Norbrook, 'Marvell's "Horatian Ode" and the Politics of Genre' in Healy and Sawday (eds), *Literature and the English Civil War*, 147–69, 153.

46 Lawrence Stone, *The Family, Sex and Marriage in England 1500–1800* (1977, rpt. Harmondsworth: Penguin Books, 1984), 335.

47 See Christopher Hill, *Puritanism and Revolution* (1958, rpt. Harmondsworth: Penguin Books, 1986), 58–125.

48 Collop, *Poesis Rediviva*, 59.

49 Burke, '*Annus Mirabilis* and the Ideology of the New Science', 314.

50 On currency discussions in the 1640s and 1650s, see Webster, *Great Instauration*, 403–20.

51 Walter Charleton, *Three Anatomical Lectures* (London, 1683), 72.

52 For a discussion of the mechanism of blood and money circulation, see Sawday, 'The Mint at Segovia', 21–35.

53 John Dryden, *The Poems and Fables* ed. James Kinsey (London: OUP, 1970), 52, 105.

54 Sir John Denham, *Poetical Works* ed. Theodore Howard Banks, Jr (New Haven: Yale UP, 1928), 120–1.

55 Dryden, *Poems and Fables*, 32–4.

56 See Jonathan Sawday, 'Re-writing a Revolution: History, Symbol and Text in the Restoration', *The Seventeenth Century* 8 (1992), 171–99 (181–2).

57 Catherine Belsey, *John Milton Language, Gender, Power* (Oxford: Basil Blackwell, 1988), 46.

58 Ruth Beier writes of sociobiology, for example, that it deploys a language which moulds the world to a particular (and profoundly violent) male reality when it speaks of 'rape' in the natural world of plants and animals, of insects being 'coy', and of 'harems' existing amongst primates. See Ruth Beier, *Science and Gender: A Critique of Biology and Its Theories on Women* (New York and Oxford: Pergamon Press, 1984), 32–4.

59 John Wilmot, Earl of Rochester, *The Poems* ed. Keith Walker (Oxford: Basil Blackwell, 1983), 74.

60 Rochester, *Poems*, 31.

61 Cowley, *Works*, 12; Rochester, *Poems*, 64.

62 Letter from Oldenburg to Winthrop, 13 October 1667, quoted in Hunter, *Science and Society*, 37. *Paradise Lost* was licensed on 20 August 1667; see John Milton, *Paradise Lost* ed. Alistair Fowler (Harlow: Longman, 1971), 7. Oldenburg's unusual spelling of 'dessein' harks back to his German origin and education. The word 'Dasein', meaning existence or being, suggests the Royal Society's project as self-authored, a further moment of autogenesis which, for Milton, was to link science and Satan to one another.

63 Barten Holyday, *A Survey of the World* (Oxford, 1661), stanza 190.

64 Rochester, *Poems*, 64.

65 Cowley, *Works*, 39.

66 'Do not overlook *hairy*', C. S. Lewis wrote in 1942 before observing, in a wonderfully anxious Freudian moment: 'The Freudian idea that the happy garden is an image of the

human body would not have frightened Milton in the least.' C. S. Lewis, *A Preface to Paradise Lost* (1942, rpt. London: OUP, 1975), 49.

67 See Webster, *Great Instauration*, 360–419.

68 Quoted in Hunter, *Science and Society*, 35.

69 See Michael Braddick, 'State Formation and Social Change in Early Modern England: A Problem Stated and Approaches Suggested' *Social History* 16 (1991), 1–17.

70 Cavendish's visit to the Royal Society is recorded in Thomas Birch, *The History of the Royal Society of London* (London, 1756–7), II, 178. Significantly, Birch refers to 'the experiments appointed for her entertainment'.

71 Margaret Cavendish, Duchess of Newcastle, *Poems and Fancies* (London, 1653), sig. A5.

72 Sir Philip Sidney, *An Apology for Poetry* (1595) ed. Geoffrey Shephard (Manchester: MUP, 1965), 123.

73 Kate Lilley, 'Blazing Worlds: Seventeenth-century Women's Utopian Writing' in Clare Brant and Diane Purkiss (eds), *Women, Texts and Histories 1570–1760* (London and New York: Routledge, 1992), 102–33 (120). For recent accounts of Cavendish, see Lisa T. Sarashon, 'A Science Turned Upside Down: Feminism and the Natural Philosophy of Margaret Cavendish', *Huntington Library Quarterly* 47 (1984), 299–307; Paul Salzman, *English Prose Fiction 1558–1700* (Oxford: Clarendon Press, 1985), 293–9.

74 Sidney, *Apology*, 107.

75 On scientific education (or rather, lack of it) for women in the seventeenth century, see Webster, *Great Instauration*, 114, 219–20, 242.

76 Cavendish, *Poems and Fancies*, sig. A3^{r-v}.

77 Margaret Cavendish, 'The Blazing World' in Paul Salzman (ed.), *An Anthology of Seventeenth-century Fiction* (Oxford: OUP, 1991), 252.

78 Salzman, *English Prose Fiction*, 294.

79 Robert Hooke, *Micrographia* (London, 1665), 171.

80 Charleton, *Three Anatomical Lectures*, 73.

81 Cavendish, *Poems and Fancies* 136, 148.

82 Ibid., 137.

83 Technically, Cavendish is describing a 'broken consort' of the type often to be found in French church music of the period. I am grateful to Dr Daniel Leech-Wilkinson of the Department of Music at the University of Southampton for this information.

84 Cavendish, *Poems and Fancies*, 128.

85 See Annette Kramer, "Thus by the Musick of a Ladyes Tongue": Margaret Cavendish's Innovations in Women's Education', *Women's History Review* 2 (1993), 57–79, 58.

86 Cavendish, *Poems and Fancies*, 199.

87 Ibid., 200.

88 Ibid., 204.

89 R. K. French, *Robert Whytt, The Soul, and Medicine* Publications of the Wellcome Institute for the History of Medicine, n.s. 17 (London: The Wellcome Institute, 1969), 130. On Willis, see Hunter, *Science and Society*, 12, 22–3.

90 Cavendish, *Poems and Fancies*, 212.

91 Joseph Beaumont, *Psyche or Loves Mysterie* (London, 1648), 'Preface to the Reader' sig. A4. See Jonathan Sawday, 'Civil War, Madness, and the Divided Self' in Healy and Sawday (eds) *Literature and the English Civil War*, 136–7.

92 Graham Parry, *Seventeenth-century Poetry: The Social Context* (London: Hutchinson, 1985), 117; Malcolm M. Day, *Thomas Traherne* (Boston, Mass.: Twayne's English Authors Series, 1982), 3, 17; A. L. Clements, *The Mystical Poetry of Thomas Traherne* (Cambridge, Mass.: Harvard UP, 1969), 8. On Traherne's intellectual conservatism, see S. Sandbank, 'Thomas

Traherne on the Place of Man in the Universe' in Alice Shalvi and A. A. Medilow (eds), *Scripta Hierosolmitana: Studies in English Language and Literature*, Publications of the Hebrew University, Jerusalem no. 17 (Jerusalem: The Magnes Press, 1966). For the patristic sources of Traherne's writing, see Patrick Grant, 'Original Sin and Fall of Man in Thomas Traherne', *ELH* 38 (1971), 40–61. For Traherne's debt to S. Bonaventure, Ignatian patterns of meditation, and St Augustine, see Louis L. Martz, *The Paradise Within: Studies in Vaughan, Traherne, and Milton* (New Haven and London: Yale UP, 1964), 35–43.

93 Thus, Margoliouth's edition of Traherne, published in 1958, is continually alert to echoes of Blake or Wordsworth. See Thomas Traherne, *Centuries, Poems, and Thanksgivings* ed. H. M. Margoliouth (Oxford: Clarendon Press, 1958), *passim.* Margoliouth had recently completed an edition of Wordsworth before embarking on Traherne. All references to Traherne's poems, Centuries, and Thanksgivings are to this edition.

94 In quoting Traherne's poetry, I refer to the 'D' version (poems contained in Bodleian MS Eng. Poet C. 42), rather than the 'F' version (Poems contained in BM MS Burney 392), where there are two versions of the same poem, one of which contains revisions by Philip Traherne.

95 Carol Marks, 'Thomas Traherne and Cambridge Neoplatonism' *PMLA* 81 (1966), 521–34, 524.

96 On Traherne and Platonism, see T. O. Beachcroft, 'Traherne and the Cambridge Platonists', *Dublin Review* 186 (1930), 278–90; Francis L. Colby, 'Thomas Traherne and Henry More', *MLN* 62 (1947), 490–2; Carol Marks, 'Thomas Traherne's Commonplace Book', *Papers of the Bibliographical Society of America* 58 (1964), 458–65; K. W. Salter, *Thomas Traherne: Mystic and Poet* (London: Edward Arnold, 1964), 80–91. For evidence of acceptance and/or rejection of Cartesianism amongst the Platonists, see in particular Marjorie Nicholson, 'The Early Stages of Cartesianism in England', *SP* 26 (1929), 356–74; J. Saveson, 'Descartes' Influence on John Smith, Cambridge Platonist', *JHI* 20 (1959), 255–63; J. Saveson, 'Differing Reactions to Descartes among the Cambridge Platonists', *JHI* 21 (1960), 560–7; Charles Webster, 'Henry More and Descartes: Some New Sources', *The British Journal for the Advancement of Science* 4 (1969), 359–77; Sawday, 'Bodies By Art Fashioned', 349–61.

97 See Henry More, *Philosophical Poems* ed. Geoffrey Bullough (Manchester: MUP, 1931), 169–72; Wallace Shugg, 'Henry More's *Circulatio Sanguinis*: An Unexplained Poem in praise of Harvey' trans. Walter Sherwin and Jay Freyman, *BHM* 46 (1972), 180–9.

98 One of the rare exceptions to the consensual view of Traherne is James J. Balakier, 'Thomas Traherne's Dobell Series and the Baconian Model of Experience', *English Studies* 3 (1989), 233–47.

99 Robert Ellrodt, 'Scientific Curiosity and Metaphysical Poetry in the Seventeenth Century', *MP* 61 (1964), 197.

100 Quoted in Webster, *Great Instauration*, 328.

101 Ibid., 149.

102 Carl M. Selkin, 'The Language of Vision: Traherne's Cataloguing Style', *ELR* 6 (1976), 92–104, 97.

103 Henry More, *An Antidote Againste Atheisme* (London, 1653), 39–40.

104 For an account of the recovery of the various Traherne MSS, see Margoliouth's introduction to his edition, together with Douglas Chambers's account in Thomas Traherne, *Commentaries of Heaven: The Poems* ed. D. D. C. Chambers, Salzburg Studies in English Literature (Salzburg: Universität Salzburg, 1989), ii–iii.

105 The first human to human organ transplant took place in 1951. In 1967, the first heart transplant was performed. See Andrew Kimbrell, *The Human Body Shop: The Engineering*

and Marketing of Life (London and San Francisco: HarperCollins, 1993), 26–35.

106 Jane Barker, '. . . a long degression on anatomy' in Germaine Greer, Jeslyn Medoff, Melinda Sansone, and Susan Hastings (eds), *Kissing the Rod: An Anthology of Seventeenth-century Women's Verse* (London: Virago Press, 1988), 365.

107 *The Times Higher Education Supplement* 1100 (3 December 1993), 6.

108 Joachim C. Fest, *Hitler* trans. Richard and Clara Winston (London: Weidenfeld and Nicolson, 1974), 716. The director of the Anatomical Institute, Fest records, had friends amongst the conspirators, and refused to use the bodies as cadavers.

109 The account of the conference can be found in Rob Stepney, 'Anatomy without Scalpels' *The Independent on Sunday*, 19 September 1993, 57.

INDEX